OXFORD STUDIES IN ANCIENT CULTURE AND REPRESENTATION

General Editors

The late Simon Price R. R. R. Smith Oliver Tap
Peter Thonemann Tim Whitmarsh

OXFORD STUDIES IN ANCIENT CULTURE AND REPRESENTATION

Oxford Studies in Ancient Culture and Representation publishes significant inter-disciplinary research into the visual, social, political, and religious cultures of the ancient Mediterranean world. The series includes work which combines different kinds of representations which are usually treated separately. The overarching programme is to integrate images, monuments, texts, performances, and rituals with the places, participants, and broader historical environment that gave them meaning.

Statues and Cities

Honorific Portraits and Civic Identity in the Hellenistic World

JOHN MA

OXFORD
UNIVERSITY PRESS

Great Clarendon Street, Oxford, OX2 6DP,
United Kingdom

Oxford University Press is a department of the University of Oxford.
It furthers the Universitys objective of excellence in research, scholarship,
and education by publishing worldwide. Oxford is a registered trade mark of
Oxford University Press in the UK and in certain other countries

First published 2013
First published in paperback 2015

Published in the United States of America by Oxford University Press
198 Madison Avenue, New York, NY 10016, United States of America

British Library Cataloguing in Publication Data
Data available

Library of Congress Cataloging in Publication Data
Data available

ISBN 978–0–19–966891–5 (Hbk.)
ISBN 978–0–19–873893–0 (Pbk.)

To Ma Hunghsiang (1934–2012) and Li Hsinkai, my parents, and to Amy and Edgar, my sister and my brother.

To Paraskevi Martzavou, and Vassiliki and Menas, our children.

PREFACE TO THE PAPERBACK EDITION

In this edition, I have made a number of small corrections in the test (to repair some of the more embarrassing slips, or at least those which caught my eye), and in a final section, I have listed some additions to text and footnotes. I am am aware these are just a tiny section of evidence that could be adduced to complete, prolong and update the limited archaeological, documentary and literary dossier upon which this books rests; and that *Lesefrüchte, repentirs* and catch-up exercises could be prolonged indefinitely. But these complements included in the short postface, and the inevitable future complements these complements call for, illustrate the main point of this book. Reading monuments from the Hellenistic period is an open exercise in contextualizing works of art as a holistic exercize (rather than looking for the lost specific context for individual works), and exploring this deep context: the non-elitist political culture of democratic institutions, communitarian ideology and civic interactions in the Hellenistic city-states.

I am glad to thank, for discussion or for help, V. Azoulay, E. Baltes, J. Connelly, C. Dickenson, S. Dillon, J. Elsner, A. Filges, Paraskevi Martzavou (for bibliographical help), W. Raeck, R. R. R. Smith, J.-Y. Marc, M. Melfi, M. Whittow (for taking a copy of this book around Asia Minor, notably to the site of Priene which is so important for the arguments made here; I hope the paperback might encourage more moments of that kind). Responsibility for all shortcomings rests with me.

PREFACE

Greek cities set up statues of individuals in return for services: the transaction tells us a lot about the history of these cities, in the three and a half centuries during which the practice emerged and developed—the Hellenistic period (*c*.350 BC–*c*.AD 1), marked notably by the twin pressures of the interactions between cities and supra-local masters (kings, and later, the Roman state), and between cities and their elites. This book explores the power of civic ideology to control powerful outsiders and insiders—as well as the limits of this power; processes of competition and assertion on the ground; and the role of families in these processes. It also explores the workings of images, representations, and memory, since honorific statues, as public art, tell us a lot about these themes.

In attempting these two projects, I draw on epigraphical sources, but also archaeology and art history: whereas my first book, *Antiochos III and the Cities of Western Asia Minor* (rev. edn, Oxford, 2002) was an attempt to read inscriptions, as documents, in multiple ways, this second book has been an attempt at multiple readings of space as social text in addition to readings of documents. Tonio Hölscher, when kindly encouraging me, observed that archaeologists and art historians found the study of honorific statues daunting because it required that one be 'a very good epigraphist'. I have come to realize that this was a gentle way of saying that this project also required one to be a good archaeologist and art-historian—but this realization came perhaps a little late in the day (around the time I started writing this preface), at the moment when the fields of epigraphy, archaeology, and art history are each exploding, bibliographically but also intellectually speaking, in different directions. This book is an attempt at bridging the gap between the three fields.

It would have been pointless to gather a full corpus of all the honorific decrees, all the statue bases, all the mentions in literary sources that refer to honorific statues. Nonetheless, I have tried to give a good sense of the shape of the phenomenon through a roster of examples, which without being exhaustive, aims at giving depth of phenomenological perception; in addition, a number of test cases (quite familiar to epigraphists and archaeologists) recur throughout the book, approached from a variety of angles—Athens, Priene, the Oropian Amphiaraion, the Epidaurian Asklepieion: perhaps they may seem newer when seen in the round. In practice, this means that in parts I–III, the opening chapter is always a scene-setter, gathering evidence, engaging with it (hence an accompaniment of remarks and suggestions, and corrections to epigraphical texts throughout the footnotes, for those who read them) and pointing out patterns in this evidence (Chaps. 1, 3, 5); the follow-up chapter is always an analysis of the

phenomenon, and an attempt to tie any findings with the bigger concerns of the book (Chaps. 2, 4, 6). There is hence a slight (if sleight-of-hand) handbook feel to some of the chapters; this results from the desire to make explicit that which 'everyone knows' about honorific statues. The result is to sharpen the argument in some ways (by giving very precise outlines of events), but to blur it in others (by looking for general patterns rather than specific explanations); I do not think there is any way of avoid the tradeoff which determines what kind of book this will turn out to be. The shape of the book will also determine the type of readers, or reading, it deserves or rather receives; but it amounts to a plea for the dynamic and fruitful use of the apparently humdrum tools of typology and classification.

The theme of the work was suggested by François Queyrel, while he was a Visiting Fellow at the Institute for Advanced Study in Princeton (and I was an Assistant Professor in the Department of Classics at the University) during the academic year 1998–9; it was developed during four joyful seminars at the École Pratique des Hautes Études, IVth section (philological and historical sciences), during the hot summer of 2000, in front of a daunting but forgiving audience of (then) students and masters, including P. Gauthier, J.-M. Bertrand, F. Queyrel, D. Feissel, M. Jost, F. Lissarrague; and V. Azoulay, P. Fröhlich, A. Heller, S. Lalanne, P. Martzavou. I published a summary in the *Annuaire* of the EPHE; the shape of the seminars, given quite a while ago, is not very different from that of the book you are now reading. Since then, the book has been nourished by some trips to look at statues in their sites—but the task is not always easy on the ground, at least or especially when done informally, as a tourist—even though I received a great deal of help, as I make clear below. Many more trips would be instructive to major and minor sites (for instance I do wonder about various statue bases at the shrine of Apollo Pythios at Kalymna), and I hope I will visit them another time, as I keep thinking about statues.

Research on statues, in the form of time, support for travel, and help with production, was helped by a Philip Leverhulme Prize, and grants from the Craven Fund, the John Fell Fund, and Corpus Christi College in Oxford: to which bodies I record gratitude. In the writing of this book, over the many years (the files performed exodus over six computers), I have incurred a great many personal debts, and it is a pleasure to acknowledge some of them. So I thank I. Akamatis (for showing me Pella and Macedonia), J. Masséglia (for Plate 7.1, a major piece of research in its own right, which draws on archaeological but also practical knowledge), V. Aravantinos (for help in Boiotia), V. Azoulay, A. Bresson (especially for help on ancient Greek families), John McK. Camp, A. Chaniotis, J. Connelly, C. Crowther, J. Curbera, S. Dillon (for constant exchange of ideas on statues), P. Ducrey, S. Fachard, J. Fournier, the late P. Fraser, P. Fröhlich, the late P. Gauthier, B. Gray, J. Griesbach, P. Haarer, C. Habicht, K. Hallof, W. Hoepfner, T. Hölscher, S. C. Humphreys, N.

Kaltsas, D. Knoepfler, H. Kritzas, R. Krumeich, F. Lissarrague, H. Malay, P. Martzavou, M. Mathys, F. Millar, S. Mitchell, J.-C. Moretti, D. Mulliez, C. Papas-tamati-von Moock, F. Pirson, J. Prag, F. Prost, F. Queyrel, C. Ratté, M. H. Sayar, A. Slawisch, S. Skaltsa, M. Stamatopoulou, P. Themelis, P. Thonemann, R. van Bremen, R. von den Hoff, S. Walker, T. Whitmarsh (whose remarks at a seminar in Exeter ten years ago gave rise to several of chapters in this book), G. Zimmer, and the anonymous readers for the Press. I also thank the staff at the Sackler Library in Oxford for patience and for help in many matters. C. Thurston, A. Vacek, and especially A. Ellis-Evans helped me finish the book, with remarkable speed and accuracy (and, in the case of Mr Ellis-Evans, great learning and judgement). F. Wade and E. Rix compiled the general index and the *index locorum* respectively. Responsibility for all mistakes and oversights remains mine.

The greatest influences on this work were exerted by two authoritative scholars of, and innovative thinkers about, ancient art, whom I'm very fortunate to count as colleagues: Jaś Elsner and Bert Smith. They both read and discussed everything with me, even if they did not agree with everything (nor, of course, each other).

John Ma

TABLE OF CONTENTS

List of Illustrations xv

List of Plans xvii

List of Abbreviations xix

Introduction I

I STATUES AND STORIES

1. Towards a Grammar of Honours 15
 1. Image and Text 15
 2. Towards a Grammar of Honours 17
 3. The 'Dedicatory' Formula 24
 4. The Honorific Formula 31
 5. The Power of the Base 38

2. The Politics of the Accusative 45
 1. In Search of Relationality 45
 2. Being Honoured 49
 3. Statues, Stories, Meanings 55
 4. Idealism and Ideology: The Honorific Statue within 'Civic Culture' 62

II STATUES AND PLACES

3. Statues in their Spaces 67
 1. Locating Honorific Statues 67
 2. Public Spaces and their Statues 70
 3. Civic Sites: From Typology to Grammar 75
 4. Priene, Pergamon, Athens 98
 5. Spatial Dynamics: The Civic Shrine 107
 6. Spatial Dynamics: The Epidaurian Asklepieion 108
 7. From Spatial Grammar to Spatial Discourses 109
 Appendix: The Statue of Astydamas in the Theatre of Dionysos
 at Athens 110

4. Statues in their Places 111
 1. Statuescapes in Practice 111
 2. On the Ground: Principles of Organization 113

3. Singularity and Series 126
4. Honorific Statues, Space, Place 130
5. On the Ground: Sedimentation and Horizontal Stratigraphy 135
6. Unity and Segmentation 148
7. Civic Places and/as Civic Agents 150

III STATUES AND FAMILIES

5. The Shape of Private Monuments 155
 1. Noticing the Private Monument 155
 2. Reading the Private Monument 159
 3. Setting up a Private Statue: Occasions, Reasons, Motivations 168
 4. Seeing the Private Statue 187
 5. Placing the Private Honorific Monument 190
 6. Private, Public 193

6. Public Spaces, Private Statues 195
 1. The Private Monument and the City 195
 2. A History of the Private Honorific Monument 196
 3. Making Families (Visible) 202
 4. Private and Public 212
 5. Family Monument, Public Monument 233

IV STATUES AS IMAGES

7. Making an Honorific Portrait 243
 1. Political Work 243
 2. Artwork 249
 3. The Art Worlds of the Hellenistic Honorific Statue 257
 Appendix: The Cost of Honorific Monuments 264

8. Looking at an Honorific Portrait 267
 1. Types and Diversity 267
 2. Honorific Portraits in Context: Athens in the 280s 273
 3. Honorific Portraits in Context: Polybios in the Peloponnese 279
 4. Honorific Statues in Context: Priene and Delos c.120 284
 5. Private Honorific Portraits 286
 6. Contexts for Seeing 289

Conclusion 291
 1. Discourse, Space and Place, Friends and Families 291
 2. 'Unified Statue Theory' from Priene to Aphrodisias 294

3. The Honorific Statue between Agency and Expression 297
4. City of Images 306

Plans 309
Bibliography 327
Index Locorum 349
General Index 370

LIST OF ILLUSTRATIONS

1.1. The text on the statue base sometimes privileges the mention of the statue. *Inscr. Lindos* 243. 37

1.2. Statue base of Leon son of Ariston, of Samos. *IG* 12.6.285 (mid-second century BC). 39

1.3. Statue bases at the Amphiaraion near Oropos, third century BC. 41

1.4. Inscribed crowning block, Athenian Agora. *IG* II² 4161, first century AD. 41

1.5. Paper impression of inscribed statue base, Priene Agora. *Inschr. Priene* 237, *c.*200. 42

1.6. Inscribed statue base, Kalaureia, shrine of Poseidon. *IG* 4.846, second century. 42

1.7. Inscribed base of monument for the benefactor Polemaios, Klaros, *c.*100. 43

2.1. Relief from the monument of C. Julius Zoilos, Aphrodisias, first century AD, marble. 47

2.2. Funerary *stele* of Archippos, second century BC, marble. 52

2.3. Base of the monument in honour of the benefactor Menippos, Klaros, *c.*100. 60

3.1. Row of bases in front of north-west stoa, Agora of Thasos. 76

3.2. Aerial view of Askepieion, Messene. 83

3.3. Honorific statue bases, south-east angle, main temple, Epidaurian Asklepieion. 83

3.4. View of theatre, Priene. 92

3.5. Reconstruction of theatre of Delos, seen from the north-west. 92

3.6. Terraced esplanade on the Sacred Way at Delphi ('Aire'). Photogr. S. Dillon. 96

3.7. Esplanade in front of the shrine of Demeter at Priene. 100

3.8. Temple of Hera, Pergamon: view of the *cella* from above. 102

4.1. Roman copy, marble, of Tyrannicides (477/476 BC). 114

4.2. View of the Agora and Akropolis, Athens. 117

4.3. Bases of statues of Hadeia and Agrippa (reused), Oropian Amphiaraion. 119

4.4. Row of equestrian bases, Olympia (south of Altis). 125

4.5. Bases south of main temple, Epidaurian Asklepieion. 130

4.6. Statue bases, Agora of Priene. 132

4.7. Northern end of the Dromos at Delos. 136

4.8. Bases at an angle, in front of the *Echohalle*, Olympia. 137

4.9. Proxeny decrees inscribed on base of Agrippa (reused), Oropian Amphiaraion. 141

4.10. Bases of statues for Apollorodos, Agora of Priene, *c.*200. 143

4.11. Awkward dead ends in the Agora at Priene. 145

4.12. New statue growth in the Agora of Priene. 147

5.1. Stemma of family of Euphranor, first-century BC Rhodes. 162

5.2. *IDélos* 1962 (stemma) 164

5.3. *IDélos* 1962, second century BC: a five-statue family monument. 165

5.4. Statue of Aristonoe, priestess of Nemesis at Rhamnous, mid-second
century BC. 171

5.5 Statues of Kleopatra and Dioskourides in their house on Delos, 137. 172

5.6. Monument set up by Demokrite at the Oropian Amphiaraion, third
century BC. 189

6.1. *IG* II² 3860, Athenian Agora, *c*.300? 205

6.2. Stemma for Echedemos, his uncle, and their relatives (*IG* II² 3854). 206

6.3. The 'kindred' of Demokrite of Oropos, in stemma representation. 207

6.4. The kindred of young Euphranor of Rhodes. 209

6.5. Reconstruction of Aitolian family monument at Delphi, mid-third century
BC (*FD* 3.4.129–31). 224

6.6. Reconstruction of monument honouring Ptolemy II and Arsinoe II,
Olympia, before 270 BC. 227

6.7. *I. Délos* 1957, later second century BC. 231

7.1. The 'indirect lost-wax' process. 252

7.2 Kertch, 'sarcophagus found in 1900', with interior painting; first century
AD? 256

7.3. Excavated casting pit, Rhodes (Mylonas plot), third century BC. 257

8.1. Bronze statue preserving traces of gilding, found at sea off Adana,
first century BC. 268

8.2. Bronze portrait of a Hellenistic prince, mid-second century BC. 269

8.3. Reconstruction of family group from Aphrodisias, first century AD? 270

8.4. Honorific portrait of Menander. 274

8.5. Roman-era marble herm, labelled with the name of Olympiodoros. 276

8.6. Posthumous statue of Demosthenes (cast of Roman copy). 277

8.7. Cast of relief of Polybios, formerly in Berlin. 281

8.8. Statue from the Lower Gymnasion in Priene. 285

8.9. Marble statue of C. Ofellius Ferus, Delos, 'Agora des Italiens'. 286

8.10. Marble statue of Kleonikos, set up by his friend Amphikrates, Eretria. 288

LIST OF PLANS

1. Athenian Agora in the mid-Hellenistic period. After a plan by the Agora Excavations, American School of Classical Studies at Athens. 309

2. Theatre of Dionysos, Athens, with known honorific statue bases, from the fourth century BC to the first century AD. 310

3. Espalande before the Amphiaraion near Oropos: honorific statues near the temple. The statue growth took place between *ca.* 285 and *ca.* 200 BC; the majority of the public honorific monuments were reused by the Oropians in the first century BC. Based on V. Pertrakos' plan of the esplanade. 311

4. Asklepieion near Epidauros. The statuescape was 'full' by the first century BC; many of the exedras were reused around that time. After a plan by M. Melfi. 312

5. Olympia, Altis. The state of the shrine by the time of the Roman empire still preserved the structuring trace left by dedications and honorific monuments of the earlier periods. 313

6. Delphi, shrine of Apollo: the plan shows some of the many honorific monuments set up in the Hellenistic period. 314

7. Dodona, with close-ups on three zones of statue growth: near the temples, at the intersection of two roads and at the entrance to the civic zone, and along the southern stoa. The plan probably shows the prosperous shrine of the years before 167 BC, when it was sacked. 315

8. Delos: the final state of statue growth, by the early first century BC, developed across many zones, away from the former areas of display (the Tetragonal Agora, the prytaneion, the zone east of the Neorion). The Dromos was a particularly favoured area for public and private honorific monuments, starting in the late third century BC. 316

9. The Agora at Thasos, by the first century AD, showed segmentation into mini-spaces, according to multiple dynamics. After a plan drawn up by J.-Y. Marc and realized by S. Blin, based on M. Wurch-Kozelj. 317

10. The main urban zone of Pergamon, with different contexts for honorific statues in the Hellenistic (Attalid and post-Attalid) period. After a plan by the Pergamon Excavation, German Archaeological Institute in Istanbul. 318

11. The gymnasia in Pergamon occupy three terraces; the Upper Terrace contained honorific statues both on the edges of the palaistra, and in specially arranged rooms (such as H and B where the statue of Diodoros Pasparos was set up). After a plan by the Pergamon Excavation, German Archaeological Institute in Istanbul. 319

12. General view of the city Priene *ca.* 100 BC, with several monumental contexts for honorific statues. 320

13. Agora of Priene *ca.* 100 BC, showing a trace of the older, organic statue growth, the reorganization of the civic space, and the reactions on the ground. 321

14. Shrine of Athena, Priene, *ca.* 100 BC, showing the temple and altar, and also the two zones with foundations for bases, some of which almost certainly bore honorific monuments (including honorific pilasters). 322

15. Theatre, Priene, *ca.* 100 BC, with statue bases along the stage building 323

16. Upper and Lower Gymnasion at Priene, *ca.* 100 BC. 324

17. Klaros, with some of the monuments visible on the 'Sacred Way' between the entrance to the shrine and the temple of Apollo. 325

LIST OF ABBREVIATIONS

AAPat	*Atti e memorie dell'Accademia Patavina di Scienze, Lettere ed Arti già Accademia dei Ricovrati*
ABSA	*Annual of the British School at Athens*
Agora 16	A. G. Woodhead, *Inscriptions: The Decrees*, Athenian Agora, 16 (Princeton, 1997)
AION	*Annali dell'Istituto universitario orientali di Napoli*
ALA	C. Roueché and J. M. Reynolds, *Aphrodisias in Late Antiquity* (London, 1989)
AJA	*American Journal of Archaeology*
AJP	*American Journal of Philology*
Amyzon	J. and L. Robert, *Fouilles d'Amyzon en Carie* (Paris, 1983)
AncSoc	*Ancient Society*
ArchAnz	*Archäologischer Anzeiger*
ArchDelt	*Archaiologikon Deltion*
ArchEph	*Archaiologiki Ephemeris*
ArchRep	*Archaeological Reports (Society for the Promotion of Hellenic Studies)*
ArchZeit	*Archäologische Zeitung*
ASAtene	*Annuario della Scuola archeologica di Atene e delle Missioni italiane in Oriente*
Asklepieion von Epidauros	W. Peek, *Inschriften aus dem Asklepieion von Epidauros* (Berlin, 1969)
AthMitt	*Mitteilungen des Deutschen Archäologischen Instituts, Athenische Abteilung*
BCH	*Bulletin de correspondance hellénique*
BE	*Bulletin épigraphique* (cited by abbreviated year and rubric)
BJb	*Bonner Jahrbücher des rheinischen Landesmuseums in Bonn und des Vereins von Altertumsfreunden im Rheinlande*
BMCR	*Bryn Mawr Classical Review* (online)
Bulletin Archéologique	*Bulletin Archéologique du Comité des travaux historiques et scientifiques: Antiquité, archéologie classique*
CEG	P. A. Hansen, *Carmina Epigraphica Graeca*, 2 vols (Berlin, 1983–9)
Choix	J. Pouilloux, *Choix d'inscriptions grecques* (Paris, 1960)
Choix Délos	F. Dürrbach, *Choix d'inscriptions de Délos* (Paris 1921–2)
CID 4	F. Lefèvre, *Corpus des inscriptions de Delphes*, iv. *Documents amphictioniques* (Paris, 2002)
CIG	*Corpus Inscriptionum Graecarum*
CIL	*Corpus Inscriptionum Latinarum*

CIRB	V. Struve, *Corpus inscriptionum regni Bosporani* (Moscow, 1965)
CJ	*Classical Journal*
CQ	*Classical Quarterly*
CR	*Classical Review*
CRAI	*Comptes rendus des séances de l'Académie des Inscriptions et Belles-Lettres*
DAA	A. E. Raubitschek, *Dedications from the Athenian Akropolis: A Catalogue of the Inscriptions of the Sixth and Fifth Centuries* BC (Cambridge, Mass., 1949)
EA	*Epigraphica Anatolica*
EKM	L. Gounaropoulou and M. V. Hatzopoulos, *Epigraphes Kato Makedonias* (Athens, 1998)
FD	*Fouilles de Delphes*, iii. *Épigraphie*, 6 fasc. (Paris, 1929–39)
FGrHist	F. Jacoby, *Die Fragmente der griechischen Historiker*, 3 vols (Berlin, 1924–58)
GIBM	*The Collection of Ancient Greek Inscriptions in the British Museum*, 4 vols (London, 1874–1916)
GRBS	*Greek, Roman and Byzantine Studies*
Guide de Délos	P. Bruneau and J. Ducat, *Guide de Délos* (4th rev., edn Paris, 1983)
Guide de Delphes	J.-F. Bommelaer, *Guide de Delphes: Le Site* (Athens, 1991)
Guide d'Érétrie	P. Ducrey *et al.*, *Érétrie: Guide de la cité antique* (Fribourg, 2004)
Guide de Thasos	Y. Grandjean and F. Salviat, *Guide de Thasos* (2nd edn, Athens, 2000)
Halasarna	G. Kokkorou-Aleura, *Halasarna I: Oi Epigraphes* (Athens, 2004)
Holleaux, *Études*	M. Holleaux, *Études d'épigraphie et d'histoire grecques*, 6 vols (Paris, 1938–68)
HTC	P. Debord and E. Varnlo lu, *Les Hautes Terres de Carie* (Pessac, 2001)
I. Adramytteion	J. Stauber, *Die Bucht von Adramytteion*, 2 vols (Bonn, 1996)
IAG	L. Moretti, *Iscrizioni agonistiche greche* (Rome, 1953)
I. Alexandreia Troas	M. Ricl, *The Inscriptions of Alexandreia Troas* (Bonn, 1997)
I. Arai Epitymbioi	J. Strubbe, *Arai Epitymbioi: Imprecations against Desecrators of the Grave in the Greek Epitaphs of Asia Minor* (Bonn, 1997)
I. Assos	R. Merkelbach, *Die Inschriften von Assos* (Bonn, 1976)
I. Central Pisidia	G. H. R. Horsley and S. Mitchell, *The Inscriptions of Central Pisidia* (Bonn, 2000)
ID	*Inscriptions de Délos*, 7 vols (Paris, 1926–72)
I. Ephesos	*Die Inschriften von Ephesos*, 8 vols (Bonn, 1979–84)
I. Erythrai	H. Engelmann and R. Merkelbach, *Die Inschriften von Erythrai und Klazomenai*, 2 vols (Bonn 1972–3)

I. Estremo Oriente	F. Canali de Rossi, *Iscrizioni dello estremo oriente: Un repertorio* (Bonn, 2004)
IG	*Inscriptiones Graecae*
IGBulg	G. Mikhailov, *Inscriptiones Graecae in Bulgaria repertae*, 5 vols (2nd edn, Sofia, 1970)
IGLS	*Inscriptions grecques et latines de la Syrie* (Paris, 1929–)
IGR	*Inscriptiones graecae ad res romanas pertinentes*
IGUR	L. Moretti, *Inscriptiones Graecae Urbis Romae*, 4 vols (Rome, 1968–90)
I. Iasos	W. Blümel, *Die Inschriften von Iasos*, 2 vols (Bonn, 1985)
I. Ilion	P. Frisch, *Die Inschriften von Ilion* (Bonn, 1975)
I. Keramos	E. Varinlioğlu, *Die Inschriften von Keramos* (Bonn, 1986)
I. Kibyra	T. Corsten, *Die Inschriften von Kibyra* (Bonn, 2002)
I. Kios	Th. Corsten, *Die Inschriften von Kios* (Bonn, 1985)
I. Knidos	W. Blümel, *Die Inschriften von Knidos* (Bonn, 1992)
I. Kyme	H. Engelmann, *Die Inschriften von Kyme* (Bonn, 1976)
I. Perge	S. Şahin, *Die Inschriften von Perge*, 2 vols (Bonn, 1999–2004)
I. Metropolis	B. Dreyer and H. Engelmann, *Die Inschriften von Metropolis* (Bonn, 2003)
I. Miletupolis	E. Schwertheim, *Die Inschriften von Kyzikos und Umgebung*, 2. *Miletupolis, Inschriften und Denkmäler* (Bonn, 1983)
I. Mylasa	W. Blümel, *Die Inschriften von Mylasa*, 2 vols (Bonn, 1987–8)
Inschr. Bubon	F. Schindler, *Die Inschriften von Bubon* (Vienna, 1972)
Inschr. Didyma	A. Rehm, *Didyma*, ii. *Die Inschriften* (Berlin, 1958)
Inschr. Dor. Inseln	W. Peek, *Inschriften von den Dorischen Inseln* (Berlin, 1969)
Inschr. Kaunos	C. Marek, *Die Inschriften von Kaunos* (Munich, 2006)
Inschr. Magnesia	O. Kern, *Die Inschriften von Magnesia am Maeander* (Berlin, 1900)
Inschr. Olympia	W. Dittenberger and K. Purgold, *Die Inschriften von Olympia. Olympia*, 5 (Berlin, 1896)
Inschr. Pergamon	M. Fränkel, *Die Inschriften von Pergamon*. Altertümer von Pergamon, 8/1–2 (1890–5)
Inschr. Priene	F. Hiller von Gaetringen, *Inschriften von Priene* (Berlin, 1906)
Inscr. Bouthrotos	P. Cabanes and F. Drini, *Corpus des inscriptions grecques d'Illyrie méridionale et d'Épire*, ii/2. *Inscriptions de Bouthrôtos* (Athens, 2007)
Inscr. Eleusis	K. Clinton, *Eleusis, the Inscriptions on Stone: Documents of the Sanctuary of the Two Goddesses and Public Documents of the Deme*, 3 vols (Athens, 2005–8)
Inscr. Lindos	C. Blinkenberg, *Lindos: Fouilles et recherches, 1902–1914*, ii. *Inscriptions*, 2 fasc. (Berlin, 1941)
Inscr. Napoli	E. Miranda, *Iscrizioni greche d'Italia: Napoli*, 2 vols (Rome, 1990–5)

Inscr. Scythiae Minoris Inscriptiones	*Daciae et Scythiae Minoris Antiquae: Series Altera. Inscriptiones Scythiae Minoris graecae et latinae*, 4 vols (Bucharest, 1980–2000)
Inscr. Thrac. Aeg.	L.-D. Loukopoulou, M.-G. Parissaki, S. Psoma, and A. Zournatzi, *Inscriptiones antiquae partis Thraciae quae ad ora maris Aegaei sita est* (Athens, 2005)
Inscr. Tyr	J.-P. Rey-Coquais, *Inscriptions grecques et latines de Tyr* (Beirut, 2006)
IOSPE	V. V. Latyshev, *Inscriptiones antiquae orae septentrionalis Ponti Euxini Graecae et Latinae*, 4 vols (St Petersburg, 1885–1901), i, *Inscriptiones Tyriae, Olbiae, Chersonesi Tauricae* (2nd edn, St Petersburg, 1916)
I. Prusa	T. Corsten, *Die Inschriften von Prusa ad Olympium*, 2 vols (Bonn, 1991–3)
I. Rhod. Peraia	W. Blümel, *Die Inschriften der rhodischen Peraia* (Bonn, 1991)
Iscr. di Cos	M. Segre, *Iscrizioni di Cos* (Rome, 1993)
ISE	L. Moretti, *Iscrizioni storiche ellenistiche: Testo, traduzione e commento*, i–ii (Florence, 1967, 1975); iii. F. Canali de Rossi (2nd edn, Rome, 2006)
I. Side	J. Nollé, *Side im Altertum: Geschichte und Zeugnisse*, 2 vols (Bonn, 1993–2001)
I. Smyrna	G. Petzl, *Die Inschriften von Smyrna*, 2 vols (Bonn 1982–90)
IstMitt	*Istanbuler Mitteilungen*
I. Stratonikeia	M. Ç. ahin, *Die Inschriften von Stratonikeia*, 3 vols (Bonn, 1981–90)
I. Tralleis	F. B. Poljakov, *Die Inschriften von Tralleis und Nysa* (Bonn, 1989)
JDAI	*Jahrbuch des Deutschen Archäologischen Instituts*
JHS	*Journal of Hellenic Studies*
JRS	*Journal of Roman Studies*
JSav	*Journal des savants*
Kition	M. Yon, *Kition dans les textes: Testimonia littéraires et épigraphiques et Corpus des inscriptions*. Kition-Bamboula, 5 (Paris, 2004)
Kock	T. Kock, *Comicorum Atticorum fragmenta*, 3 vols (Leipzig, 1880–8)
Kourion	T. B. Mitford, *The Inscriptions of Kourion* (Philadelphia, 1971)
La Carie	L. and J. Robert, *La Carie: Histoire et géographie historique avec le recueil des inscriptions antiques*, ii. *Le Plateau de Tabai et ses environs* (Paris, 1954)
LBW	P. Le Bas and W. H. Waddington, *Inscriptions grecques et latines recueillies en Grèce et en Asie Mineure*, 3 vols (Paris, 1853–70)
Le Guen, *Technites*	B. Le Guen, *Les Associations de Technites dionysiaques à l'époque hellénistique* (Nancy, 2001)

LIMC	*Lexicon iconographicum mythologiae classicae*, 8 vols (Zurich, and Munich, 1981–97)
LSCG	F. Sokolowski, *Lois sacrées des cités grecques* (Paris, 1969)
LSJ	*A Greek-English Lexicon* (9th edn, Oxford, 1996)
MAMA	*Monumenta Asiae Minoris Antiqua*
Michel	C. Michel, *Recueil d'inscriptions grecques* (Paris, 1900)
Milet 1.2	C. Fredrich, in H. Knackfuss and C. Fredrich, *Das Rathaus in Milet*. Milet: Ergebnisse der Ausgrabungen und Untersuchungen seit dem Jahre 1899, 1/2 (Berlin, 1908), 100–24
Milet 1.3	A. Rehm, *Das Delphinion in Milet, Inschr. Delphinion*, in G. Kawerau and A. Rehm, *Das Delphinion in Milet*. Milet: Ergebnisse der Ausgrabungen und Untersuchungen seitdem Jahre 1899, 1.3 (Berlin, 1914), 162–42
Milet 6	P. Herrmann, *Inschriften von Milet*, 3 vols (Berlin, 1997–2006)
ML	R. Meiggs and D. M. Lewis, *A Selection of Greek Historical Inscriptions to the End of the Fifth Century* BC (rev. edn, Oxford, 1989)
MRR	T. R. S. Broughton, *The Magistrates of the Roman Republic*, 2 vols (New York, 1951–60); suppl. (2nd edn, New York and Atlanta, Ga., 1986)
New Documents from Lydia	P. Herrmann and H. Malay, *New Documents from Lydia* (Vienna, 2007)
Nouveau choix	*Nouveau choix d'inscriptions grecques* (Paris, 1971)
Nouveau choix de Délos	C. Prêtre and M. Brunet, *Nouveau choix d'inscriptions de Délos: Lois, comptes et inventaires* (Athens, 2002)
Nuova Silloge	A. Maiuri, *Nuova silloge epigrafica di Rodi e Cos* (Florence, 1925)
OGIS	W. Dittenberger, *Orientis Graeci Inscriptiones Selectae*, 2 vols (Leipzig, 1903–5)
JOAI	*Jahreshefte des Österreichischen archäologischen Instituts in Wien*
OpAth	*Opuscula Atheniensia*
Oropos	V. C. Petrakos, *Hoi epigraphes tou Oropou* (Athens, 1997)
Pérée rhodienne	A. Bresson, *Recueil des inscriptions de la Pérée rhodienne* (Paris, 1991)
PH	W. R. Paton and E. L. Hicks, *The Inscriptions of Cos* (Oxford, 1891)
PM	E. Pfuhl and H. Möbius, *Die ostgriechischen Grabreliefs*, 2 vols (Mainz am Rhein, 1977–9)
PSI	*Papiri greci e latini* (Pubblicazioni della Società Italiana per la ricerca dei Papiri greci e latini in Egitto), 15 vols (Florence, 1912–79)
PW	*Paulys Realencyclopädie der classischen Altertumswissenschaft*
RA	*Revue archéologique*
RC	C. B. Welles, *Royal Correspondance in the Hellenistic Period: A Study in Greek Epigraphy* (London, 1934)

REA	*Revue des études anciennes*
REG	*Revue des études grecques*
RevPhil	*Revue de philologie*
Rhamnous	V. C. Petrakos, *Ho dimos tou Rhamnountos: Synopsi ton anaskaphon kai ton erevnon (1813–1998)*, i. *Topographie*, ii. *Epigraphes* (Athens, 1999)
RIJ	R. Dareste, B. Haussoullier, and T. Reinach, *Recueil des inscriptions juridiques grecques*, 2 vols (2nd edn, Paris, 1898–1904)
RivFil	*Rivista di filologia e di istruzione classica*
RO	P. J. Rhodes and R. Osborne, *Greek Historical Inscriptions, 404–323 BC* (Oxford, 2003)
Robert, *Coll. Froehner*	L. Robert, *Collection Froehner* (Paris, 1936)
Robert, *Documents*	L. Robert, *Documents d'Asie Mineure* (Athens, 1987)
Robert, *Hellenica*	L. Robert, *Hellenica*, 13 vols (Limoges, 1940–65)
Robert, *OMS*	L. Robert, *Opera Minora Selecta*, 7 vols (Amsterdam, 1969–90)
RömMitt	*Mitteilungen des Deutschen Archäologischen Instituts, Römische Abteilung*
RPC	A. M. Burnett, M. Amandry, and P. P. Ripollès, *Roman Provincial Coinage*, i. *From the Death of Caesar to the Death of Vitellius (44 BC–AD 69)* (London, 1992)
Salamine de Chypre	J. Pouilloux, P. Roesch, and J. Marcillet-Jaubert, *Salamine de Chypre*, xiii. *Testimonia Salaminia*, 2. *Corpus épigraphique* (Paris, 1987)
Sardis	W. H. Buckler and D. M. Robinson, *Sardis VII: Greek and Latin Inscriptions* (Leiden, 1932)
SEG	*Supplementum Epigraphicum Graecum*
SH	H. Lloyd-Jones and P. J. Parsons, *Supplementum Hellenisticum* (Berlin, 1983)
Sinuri	L. Robert, *Le Sanctuaire de Sinuri près de Mylasa*, i. *Les Inscriptions grecques* (Paris, 1945)
Steinepigramme	R. Merkelbach and J. Stauber, *Steinepigramme aus dem grieschischen Osten*, 5 vols (Stuttgart, 1998–2004)
Syll.	W. Dittenberger, *Sylloge inscriptionum graecarum*, 4 vols (3rd edn, Leipzig, 1915–24)
TAM	*Tituli Asiae Minoris*
TAPA	*Transactions of the American Philological Association*
TGrF	B. Snell, R. Kannicht, and S. L. Radt, *Tragicorum Graecorum Fragmenta*, 5 vols (Göttingen, 1971–2004)
Thespies	P. Roesch, *Les Inscriptions de Thespies* (online: http://www.hisoma.mom.fr/thespies.html)
Tit. Cal.	M. Segre, 'Tituli Calymnii', *ASAtene*, 22–3 (1944–5), 1–248
Tit. Cam.	M. Segre and G. Pugliese Carratelli, 'Tituli Camirenses', *ASAtene*, 27–9 (1949–51), 141–318

Tod	M. N. Tod, *A Selection of Greek Historical Inscriptions*, 2 vols (Oxford, 1933–48)
Wehrli	F. Wehrli, *Die Schule des Aristoteles: Texte und Kommentar*, 10 vols and 2 suppls. (Basel, 1944–59)
Wilhelm, *Akademieschriften*	A. Wilhelm, *Akademieschriften zur griechischen Inschriftenkunde*, 3 vols (Leipzig, 1974)
Wilhelm, *Beiträge*	A. Wilhelm, *Neue Beiträge zur griechischen Inschriftenkunde*, 6 vols (Vienna, 1911–32)
Wilhelm, *Inschriftenkunde*	A. Wilhelm, *Abhandlungen und Beiträge zur griechischen Inschriftenkunde*, 4 vols (Leipzig and Vienna, 1984–2002)
ZPE	*Zeitschrift für Papyrologie und Epigraphik*

Introduction

φυσικὰς καὶ ἀναγκαίας ἡγεῖται ὁ Ἐπίκουρος τὰς ἀλγηδόνος ἀπολυούσας, ὡς πότον ἐπὶ δίψους· φυσικὰς δὲ οὐκ ἀναγκαίας δὲ τὰς ποικιλλούσας μόνον τὴν ἡδονήν, μὴ ὑπεξαιρουμένας δὲ τὸ ἄλγημα, ὡς πολυτελῆ σιτία· οὔτε δὲ φυσικὰς οὔτε ἀναγκαίας <...>, ὡς στεφάνους καὶ ἀνδριάντων ἀναθέσεις.

Epicurus considers natural and necessary those pleasures which bring relief from pain, such as drinking when thirsty; natural but non-necessary those which merely vary pleasure but do not remove the pain, such as expensive foods; unnatural and non-necessary (those which . . .), such as crowns and the erection of statues.

(Scholion to Epicurus, *Kyriai Doxai* (*Key Doctrines*), 29[1])

[ἡ β]ουλὴ καὶ ὁ δῆμος
Γάϊον Ἰούλιον Σωσιγένους υἱὸν
Ἀμυνίαν, τὸν καλούμενον Ἰσοκράτη,
φιλόσοφον Ἐπικούρηον, πλεῖ[σ]τα
τὴν πόλιν ὠφελήσαν[τα,] Ἥρηι.

The council and the people (have dedicated a statue of)
Gaius Julius, son of Sosigenes,
Amynias, also known as Isokrates
Epicurean philosopher, for the very many deeds
which he did for the city's benefit, to Hera.

(*IG* 12.6.1.293: Samos, Augustan era)

A nicely shaped stone cylinder—quite large, a metre tall, 80 cm across, so that its girth is wider than your embrace. It is adorned, architectonically, with mouldings at its top and its bottom (where the mouldings rest on a square plinth which in fact is carved from the same block as the cylinder). The mouldings frame a plain shaft, which bears, in its upper part, a four-line, centred, inscription, carved in large letters. The inscription talks about a community (the Demos, the 'People'), and a person. In addition to 'bearing' letters, the cylinder literally bears a (that) person—or rather, the representation of a person, in bronze, standing there, well dressed in draped, freshly pressed clothes, doing nothing in particular.

Next to this assemblage (stone, inscription, image), there is another one just like it, inscribed slightly differently (with the names of a person—the same as that on the first cylinder—and his children). These two monuments are located in an open rectangular space. But this open space is barred with a long line of very similar monuments—dozens and dozens of them: inscribed stone blocks or multi-block pedestals of various shapes (some quite complex), topped with bronze people (mostly draped men, draped and veiled women) standing or, rarely, sitting on elaborate high-backed chairs, or even armoured men riding bronze horses. This public space is thronged, and defined, by a veritable population of statue monuments.

[1] Quoted in A. A. Long and D. N. Sedley, *The Hellenistic Philosophers*, 2 vols (Cambridge, 1987), ch. 21, sect. i (i. 116; ii. 120). The scholion is embedded within Diogenes Laertius' quotation of the *Key Doctrines*; I believe that something has fallen out of the text as now preserved—the Epicurean definition of non-natural, non-necessary pleasures, as illustrated by civic honours.

The above description is (as easily recognized) a sketch of the agora of Priene, around 120 BC—a public space in a *polis*, a city-state, one of many such political communities in the Hellenistic world. This book is devoted to giving deep descriptions and readings of this scene, as the result of a social practice which reflects a whole world—such examples could be multiplied almost endlessly. This practice is the habit of responding to benefactions with publicly displayed honours—a 'crown', literal in the sense of a wreath of leaves or of precious metals, or figurative in the form of a reward: among these rewards, one marked as most valuable was the setting up of the image of the benefactor—an εἰκών (*eikon*, whence, distantly, the English 'icon'—a semblance, likeness, or portrait). The term comes from the verb ἔοικα, 'to be like', 'to seem (like)', but also 'to be fittingly, seemly' (*LSJ*), and the conjunction of resemblance and appropriateness is telling for the purpose of the image. The honorific portrait thus belongs to the nexus of social relations studied under the modern term 'euergetism', derived from the Greek εὐεργέτης (*euergetes*, benefactor), the figure whose good deeds, political and financial, were acknowledged and rewarded in a delicate balance of reciprocity and symbolical gestures.[2] The statue was not given to the benefactor for him to keep, but set up, as a dedication, in public space—so what was the benefactor left with? What was the nature of the return to him? 'Memory, and honour'—but these need to be unpacked. The question, and the answer, take on more force if we bear in mind that, from the late second century onwards, the honorand increasingly paid for the statue himself (below, Chap. 7).

The symbolical gesture represented by the *eikon* took a very material form—an honorific statue (also called ἀνδριάς, **andrias**, which designates not so much the 'likeness' as the material support of that likeness, the work of art).[3] The nature, or at least the material, of the *eikon* is usually specified in the epigraphical material: it can be bronze (the most usual, with gilt bronze appearing as a high honour), marble, or a painted portrait on a wooden panel;[4] it usually took the form of a standing representation, but could also be a sitting, or even an equestrian image (below, Chaps. 7–8). The materials changed according to need, practical requirements, local tradition, and the historical development of the genre. The *eikon*, as a portrait, designates the human image (usually in bronze), in contrast with the *agalma*, which can designate any offering to a god, then comes to mean, specifically, the image of a god (often in marble). However, the *agalma* was gradually used, from the late Hellenistic period onwards, to mean a marble honorific statue for a human being (often with a cultic connotation, or in the context of cultic honours for a benefactor).[5]

[2] A major topic in Hellenistic history, and of this book: for instance P. Veyne, *Le Pain et le cirque: Sociologie historique d'un pluralisme politique* (Paris, 1976); P. Gauthier, *Les Cités grecques et leurs bienfaiteurs* (Paris, 1985)—on both civic and royal benefactors; C. Habicht, 'Ist ein 'Honoratiorenregime' das Kennzeichen der Stadt im späteren Hellenismus?', in M. Wörrle and P. Zanker (eds), *Stadtbild und Bürgerbild im Hellenismus* (Munich, 1995), 87–92; the essays in the section devoted to 'Euergetism and Epigraphy', in M. Christol and O. Masson (eds), *Actes du Xe Congrès International d'Épigraphie Grecque et Latine, Nîmes, 4–9 octobre 1992* (Paris, 1997), 168–396; recently, P. Fröhlich, 'Dépenses publiques et évergétisme des citoyens dans l'exercice des charges publiques à Priène à la basse époque hellénistique', in P. Fröhlich and C. Müller (eds), *Citoyenneté et participation à la basse époque hellénistique* (Paris, 2005), 225–56; O. Curty, S. Piccand, and S. Coudourey (eds), *L'Huile et l'argent: Gymnasiarchie et évergetisme dans la Grèce hellénistique* (Fribourg, 2009). I look forward to M. Domingo Gygax's forthcoming book on the origins of euergetism.

[3] On εἰκών and ἀνδριάς *Syll.* 284 and *ISE* 128 illustrate the usage (and the way they designate, though sometimes in different contexts, the same object, a statue); Robert, *OMS* i. 243, with further examples.

[4] H. Blanck, 'Porträt-Gemälde als Ehrendenkmäler', *BJb* 168 (1968), 1–12; Roberts at *BE* 76, 344; M. Nowicka, *Le Portrait dans la peinture antique* (Warsaw, 1993).

[5] Wilhelm, *Akademieschriften*, i. 701 (impressionistic); Robert, *Hellenica*, xi–xii. 124 n. 2, with further bibliography; *OMS* ii. 316–24 (on *eikones* in imperial cult); K. Tuchelt, *Frühe Denkmäler Roms in Kleinasien: Beiträge zur archäologischen Überlieferung aus der Zeit der Republik und des Augustus* (Tübingen, 1979), 68–89; for earlier periods, A. Hermary, 'Les Noms de la statue chez Hérodote', in M.-C. Amouretti and P. Villard (eds), *EUKRATA: Mélanges offerts à Claude Vatin* (Aix-en-Provence, 1994), 21–9. See generally A. Bresson, 'Painted Portrait, Statues and Honors for Polystratos at Phrygian Apameia', in K. Konuk (ed.), *Stephanèphoros: De l'économie antique à l'Asie Mineure. Hommages à Raymond Descat* (Bordeaux, 2012), 203–20.

Hellenistic honorific portrait-monuments must have been plentiful: judging by the available evidence, the townscape of Priene might have been graced (or disfigured) by around 150 honorific statues, and we should imagine many times that figure in a *polis* such as Athens— combining a large, old town with many shrines, a harbour town, and a huge territory with several important shrines. Across a world of city-states and great shrines, there existed a distributed statuescape of several thousand monuments, erected during the late Classical and Hellenistic periods. This statuescape has disappeared: most of the bronze *eikones* were melted down, and it is only in exceptional cases, such as late Hellenistic Delos, that we can identify marble statues as honorifics, thanks to association with inscribed bases and specific sites in public spaces (below, Chap. 8).

What survive are material and textual traces of the honorific monument. Material traces: the existence of full honorific monuments is suggested by the actual material support of the statues, the cylinders and blocks that make up the bases that once bore statues, usually torn from their contexts but robustly surviving spoliation and reuse.[6] The spatial contexts themselves also exhibit the traces of monuments, in the form of the stone foundation courses that once bore the bases and their statues. We gaze wistfully at the holes and cavities in which the statues were fixed with lead beddings (occasionally a single foot remains attached after the statue broke away from its base). This awareness of absence haunts the sober, conscientious archaeological and epigraphical publication of bases, but was already experienced by Pausanias in Arkadia.[7] Honorific statues are often mentioned in literary sources, for instance the narrative of the early Diadochs by Diodoros, or in Polybios; they also are discussed in other literary sources, such as biographies or speeches. An example is Dio's *Oration to the Rhodians* (31), entirely devoted to the issues surrounding monument, memory, and the relation between benefactor and community; Dio criticizes the Rhodian practice of 'reusing' or 'recycling' honorific statues by rededicating them to other benefactors than the original honorands.[8] Much more frequent, and more direct, are the textual traces left on, or around, the monument themselves. The statue bases are inscribed with captions that make them part of honorific monuments; the monuments are the product of public decisions that are inscribed, on the bases or on slabs (*stelai*) often set up next to the base-statue assemblage (Chaps. 1–2).

The epigraphical sources allow us to reconstruct a whole social world around the honorific monuments. Statues were set up by communities for benefactors. This transaction covers a diversity of specific situations, since both ends of the transaction vary. The communities were, mostly, *poleis*, city-states, of diverse size; but statues could also be set up by subdivisions of cities (for instance a local 'tribe', or a grouping such as the *neoi*, the young men in the gymnasion), or by other human groups—for instance, a group of exiles, or of soldiers.[9] I will consider all of these portrait monuments, set up by groups, as public honorifics. In addition, statues could also be set up by individuals, as 'private honorific portraits', often within a family context, and the relations between these monuments and the public monuments will need investigation (see below, Chaps. 5–6). The recipient of statue honours were deserving individuals, in several categories. First, foreign benefactors, such as kings, royal officials, powerful officers of external powers, or simply individuals. Second, civic benefactors, namely citizens who had defended the community's interests, as military officers, or as politicians, statesmen, advocates, magistrates, or generous donors (or lenders), or in a combination of these capacities. Much more rarely, we find poets or victorious athletes, honoured

[6] Robert, *OMS* v. 89.

[7] Pausanias 8.30.5; 49.1. For examples of publication: *Inscr. Lindos* or *Oropos*.

[8] V. Platt, 'Honour Takes Wing: Unstable Images and Anxious Orators in the Greek Tradition', in Z. Newby and R. Leader-Newby (eds), *Art and Inscriptions in the Ancient World* (Cambridge, 2007), 247–71.

[9] *FD* 3.4.239 (Achaian exiles honour an Aitolian with a statue at Delphi, late 3rd cent.); *Inschr. Pergamon* 64 (Achaian soldiers who fought at the battle of Magnesia honour the future Attalos II; early 2nd cent., probably 188); *ID* 1517 (Cretan soldiers in Egypt honour a Ptolemaic official, mid-2nd cent.).

by their own communities. Finally, cities could set up statues of other cities as a honorific gesture of intra-community cordiality.[10]

The practice was not an indiscriminate mish-mash, but varied according to context—and to history.[11] The practice of setting up statues to commemorate deeds by humans is extremely rare in the Archaic period. Three well attested examples—the statues of Kleobis and Biton set up by the Argives at Delphi (c.600?), the statuary group of the two Athenian aristocrats who killed one of the Peisistratid tyrants and were commemorated after the subsequent fall of the tyranny in 510, the equestrian statue set up as a *mnemeion* by the Parians for a Thracian who fell fighting near (and for) Eion—share the characteristics of being exceptional gestures, and of leaving a public memorial for deceased honorands.[12] The same characteristics continue into the Classical period. The statues of generals (such as Perikles) or athletes on the Athenian Akropolis were in fact private dedications.[13] In this period, public statuary monuments representing humans are exceedingly rare, and still funerary in connotation, as in the case of a large statuary group dedicated at Olympia, by the city of Messina, in Sicily, commemorating a chorus of youths lost at sea.[14] When the Athenian-led fleet defeated the Persian forces at Eurymedon, the Athenians set up a monument with epigrams commemorating the victory—but neither the statuary elements (herms, representing the god Hermes in an archaizing form combining a pillar with a human head) nor the epigrams referred to the Athenian generals (especially the leading figure of Kimon) by name.[15] This monument was famously noticed by ancient observers (starting in late Classical Athens, a hundred and thirty odd years later) as being distinctly different from later honorific and commemorative practice.

The honorific statue proper, as defined above, emerges as a recognizable, rapidly widespread genre in the very late fifth and the early fourth centuries. The phenomenon can be organized in three rough categories. The first is that of statues for victorious, powerful outsiders (or even potentates or 'masters'); this category emerges first, with the statues attested for Lysandros,

[10] Robert, *OMS* v. 792, for examples; J. Ma, 'Notes on Honorific Statues at Oropos (and Elsewhere)', *ZPE* 160 (2007), 89–96.

[11] Early treatments of the subject include H. K. E. Köhler, 'Geschichte der Ehre der Bildsäule bei den Griechen', in L. Stephani (ed.), *Gesammelte Schriften*, vi (St Petersburg 1853), 243–366 (originally in *Denkschriften der königlichen Akademie der Wissenschaften zu München für die Jahre 1816 und 1817*, 6); M. K. Welsh, 'Honorary Statues in Ancient Greece', *ABSA* 11 (1904–5), 32–49.

[12] Kleobis and Biton: Hdt 1.31.1–5 (but it is unclear if the two *kouroi* found at Delphi are in fact the statues of Kleobis and Biton: D. Sansone, 'Cleobis and Biton at Delphi', *Nikephoros*, 4 (1991), 121–32; A. Magnelli, 'Kleobis e Biton a Delfi: Realtà o leggenda', in A. Martínez Fernández (ed.), *Estudios de Epigrafía Griega* (Santa Cruz de Tenerife, 2009), 81–91. Eion: *SEG* 27.249.

[13] R. Krumeich, *Bildnisse griechischer Herrscher und Staatsmänner im 5. Jahrhundert v. Chr.* (Munich, 1997); C. Keesling, *The Votive Statues of the Athenian Acropolis* (Cambridge, 2003). The 'bronze generals' in the Theatre of Dionysos, attested for 415—Andokides 1.38; W. Judeich, *Topographie von Athen* (2nd edn, Munich, 1931), 314 n. 4; D. M. MacDowell, *Andocides: On the Mysteries* (Oxford, 1962), *ad loc.*—are likewise private dedications, not public honorifics.

[14] Pausanias 5.25.24. The herald Anthemokritos, killed by the Megarians around the time of the outbreak of the Peloponnesian War, was honoured with a public grave, which has been supposed to have been topped by a bronze statue: Isaios fr. 21 Thalheim, Pausanias 1.36.3 (no mention of statue), [Demosthenes] 12.4, in what purports to be a letter of Philip II—on authenticity, e.g. F. R. Wüst, *Philipp II von Makedonien und Griechenland in den Jahren von 346 bis 338* (Munich, 1938), 133–6. W. R. Connor, 'Charinus' Megarean Decree', *AJP* 83 (1962), 225–46, at 243–6, compellingly argues against a 5th-cent. memorial-honorific statue: the death of Anthemokritos may be a 4th-cent. incident, and even if the event is 5th-cent., the statue could have been set up later (Connor's arguments on statue practice are not dispelled by K. J. Dover, 'Anthemocritus and the Megarians', *AJP* 87 [1966], 203–9). The fragment of Isaios is in fact simply a mention of 'the bathhouse near the statue (*andrias*) of Anthemokritos'. I find it difficult to imagine such a building among the public tombs on the Sacred Way (Pausanias 1.36), and suggest that this 'statue of Anthemokritos' is another monument, unrelated to the tomb of Anthemokritos the herald. I further propose emending [Demosthenes] 12.4 to read ὑπομνήματα δὲ τῆς ἀδικίας ἔστησαν <ἀνδριάντα> πρὸ τῶν πυλῶν, 'they set up a memorial of this injust deed before the gates' (that is, I excise 'a statue' as a later gloss). If these two suggestions are correct, there was no 5th-cent. public-funerary statue of Anthemokritos the herald (but only a later, perhaps 4th-cent. and probably private, statue of an Anthemokritos elsewhere in Athens).

[15] Aiskhines 3.183–5; Plutarch, *Kimon* 7.4–6; D. L. Page, *Further Greek Epigrams* (Cambridge, 1981), no. 40.

and set up in the aftermath of the Spartan victory in 404, by communities of Asia Minor.[16] Likewise, the victorious Athenian admiral (in Persian service) Konon, and later his son Timotheos, were honoured with statues in cities of Asia Minor.[17] The richly attested series of statues set up by cities for the Hekatomnid satraps,[18] or the statues of Philip II set up in Ephesos after his first successes in his campaign of 336 are similar responses to the presence of a powerful outsider.[19]

The second, related, category is that of statues for outside 'benefactors', often in the military and political realm, as in the case of the statuary honours by the Athenians for Evagoras of Salamis in 394,[20] by the citizens of Kios for the mercenary Athenodoros,[21] by the citizens of Miletos for Idrieus and Ada (at Delphi).[22] Messene set up two statues of Epameinondas, who had (re)founded the city after Leuktra;[23] the Thessalians honoured Pelopidas with a statue (an early work by Lysippos) in Delphi,[24] and with many statues after Pelopidas' death, when 'all the cities of Thessaly granted the slain Pelopidas golden crowns and bronze statues, and much land to his children';[25] the Athenians set up a statue of Alexandros of Pherai (c.364?).[26] All these monuments form a cluster, belonging to a particular geographical and historical context, the politics of mainland Greece in the complex 360s.

The third category is that of statues for 'local benefactors', when cities honoured their citizens: in the fourth century, such honours were granted predominantly for military services. In 394, the Athenians set up a statue of Konon (as well as of the Cypriot dynast Evagoras);[27] similar statues are those set up for Chabrias in 376,[28] Timotheos in 375 (the statue was set up next to that of Konon),[29] and Iphikrates (either in 371 or perhaps in 389).[30] Outside Athens, Epameinondas and Pelopidas were honoured with statues in Thebes;[31] the Phokians set up equestrian statues of Philomelos and Onomarchos at Delphi (during the opening years of the Third Sacred War),[32] and even the Spartans set up a statue of their king, Archidamos III, at Olympia.[33]

[16] J.-F. Bommelaer, *Lysandre de Sparte: Histoire et traditions* (Paris, 1981), 13–16 on Pausanias 6.3.14–16: Olympia (by Samians, who probably also set up a statue in Samos: at the Heraion?), Ephesians in their Artemision.

[17] *I. Erythrai* 6; *Inschr. Kaunos* 81; Pausanias 6.3.16; C. Löhr, *Griechische Familienweihungen: Untersuchungen einer Repräsentationsform von ihren Anfängen bis zum Ende des 4. Jhs. v. Chr* (Rahden, 2000), nos. 91, 100.

[18] *I. Erythrai* 8, *Inschr. Kaunos* 46–7, *I. Mylasa* 2, *SEG* 55.1251bis (Latmos). A Maussolleion at Iasos (G. Maddoli, *Epigrafi di Iasos: Nuovi Supplementi*, i. *Parola del Passato*, 62 (2007), 11A–B, 12A) probably included statues; a large multi-statue monument of the Hekatomnids (with a statue of Ada, and of Idrieus, honoured with an epigram), awaits full publication (G. Maddoli, 'Du nouveau sur les Hékatomnides d'après les inscriptions de Iasos', in R. van Bremen and J.-M. Carbon (eds), *Hellenistic Karia*, Ausonius Études, 28 (Talence, 2010), 123–31, at 127–8 and the comments of R. Fabiani, N. Masturzo, and M. Nafissi in F. Berti, R. Fabiani, Z. Ziziltan, and M. Nafissi (eds), *Marmi erranti: I marmi di Iasos presso i musei archeologici di Istanbul* (Istanbul, 2010), at 55–7, 115–17, and 175–7 respectively.

[19] Arrian 1.17.11. [20] Isokrates 9.56–7; *RO* 11. [21] *I. Kios* 2.

[22] *FD* 3.4.176; Löhr, *Familienweihungen*, 113, no. 134.

[23] Pausanias 4.31.10, 32.1.

[24] Pelopidas: *SEG* 35.480, but much better is J. Bousquet, 'Inscriptions de Delphes', *BCH* 87 (1963), 206–8. On the date of the statue, J. Bousquet, *RA* 14 (Oct.–Dec. 1939), 125–32 (posthumous statue), Wilhelm, *Inschriften-kunde* i. 805–18 (369, on the grounds of his restoration of prayers for future victories in the epigram accompanying the statue).

[25] Nepos, *Pelopidas* 5.5.

[26] Plutarch, *Pelopidas* 31.4; the statue is dated before the death of Pelopidas in 364.

[27] Isokrates 9.56–7; below, 104.

[28] S. Dillon, *Ancient Greek Portrait Sculpture: Contexts, Subjects, and Styles* (Cambridge, 2006), 102, 107, with earlier bibliography.

[29] Löhr, *Familienweihungen*, 74–5, no. 85.

[30] Aiskhines 3.243, Demosthenes 23.130, 136; Gauthier, *Bienfaiteurs*, 97–8, 177–80.

[31] Pausanias 9.12.6 and 9.15.6; *SEG* 44.643, P. Ducrey and C. Calame, 'Notes de sculpture et d'épigraphie en Béotie II: Une base de statue portant la signature de Lysippe de Sicyone a Thèbes', *BCH* 130 (2006), 63–91, with D. Knoepfler, *BE* 09, 259.

[32] G. Roux, 'Les Comptes du IVe siècle et la reconstruction du temple d'Apollon à Delphes', *RA* (1966), 245–96, at 272–3; the statues were later removed.

[33] Pausanias 6.4.9, 6.15.7, speculating that the statue was set up after the king's departure for Sicily, and indeed death abroad, but could it not have been set up during his lifetime? G. M. A. Richter, *The Portraits of the Greeks*, abridged and revised by R. R. R. Smith (Oxford, 1984), 92, on the proposal to identify a Roman-era bust now in the Archaeological Museum of Naples as a copy of the statue of Archidamos.

These three categories overlap: the distinction between 'threatening' and 'helpful' outsider is not clear cut (as when the Amphissians set up a statue of Philip II at Delphi, or the Eleians set up his statue at Olympia),[34] nor even that between 'helpful outsider' and 'good citizen' (as when the Athenians honoured Konon, an Athenian, but also an admiral in the Persian king's service, bringing Achaimenid subsidy). All the same, these three categories can be seen, very broadly, in the following periods, during the early Hellenistic period (very late fourth and very early third centuries), and during the 'high Hellenistic' period (third and early second centuries): cities used statues as public honours for kings (as when the Athenians honoured the dynasts Antigonos and Demetrios, or the Teians honoured Antiochos III);[35] for royal officers;[36] for external friends who performed great services[37] (including kings);[38] for local benefactors,[39] citizens who led civic troops to freedom and victory, or simply who fought for their father-land,[40] statesmen,[41] generous lenders or even givers of funds.[42] In addition, cities could set up statues of victorious athletes—as the Sidonians did for one Diotimos, a member of the local elite who competed at Nemea.[43] Statues were part of the Hellenistic landscape, and the Roman troops and officers campaigning in mainland Greece often met statues of their royal antagon-ists;[44] Roman officers also themselves were honoured with statues, starting with T. Quinctius Flamininus, who defeated the Macedonian king Philip V at Kynoskephalai and subsequently proclaimed the freedom of the Greeks.[45] Towards the end of the third century and the early second century, statuary honours grow more common, especially for non-royal, civic bene-factors,[46] some of whom accumulated statues given by numbers of cities across the Hellenistic world.[47]

[34] E. Arena, 'L'eikon delfica di Filppo II e la dedica degli Anfissei a Delfi', *Ancient Macedonia*, 7 (Thessaloniki, 2007), 293–326; Pausanias 6.11.1.

[35] Diod. 20.46.2; *ISE* 7; *SEG* 41.1003. Generally, H. Kotsidu, Τιμή. καὶ δόξα: *Ehrungen für Hellenistische Herrscher im griechischen Mutterland und in Kleinasien unter besonderer Berücksichtigung der archäologischen Denk-mäler* (Berlin 2000), to be used with occasional caution; J. Ma, 'Le Roi en ses images: Essai sur les représentations du pouvoir monarchique dans le monde hellénistique', in I. Savalli-Lestrade and I. Cogitore (eds), *Des rois au prince: Pratiques du pouvoir monarchique dans l'orient hellénistique et romain (IVe siècle avant J.-C.–IIe siècle après J.-C.* (Grenoble, 2010), 147–64.

[36] *IG* 12.9.196 with D. Knoepfler, *Décrets érétriens de proxénie et de citoyenneté* (Lausanne, 2001), 175–85; Robert, *Coll. Froehner*, no. 52; S. Isager and L. Karlsson, 'A New Inscription from Labraunda. An Honorary Decree for Olympichos. Labraunda no. 134 (and no. 49)', *EA* 41 (2008), 39–52 (colossal statue of the Demos of Mylasa crowning the dynast Olympichos). A special case is that of the statues of Demetrios of Phaleron, who governed Athens for the dynast Kassandros: Diogenes Laertius 5.75–7, V. Azoulay, 'La Gloire et l'outrage: Heurs et malheurs des statues honorifiques de Démétrios de Phalère', *Annales: Histoire*, 64 (2009), 303–40.

[37] The Samians, after recovering their island in 322, passed decrees to thank many individuals for helping them during their period of exile, but only one benefactor was honoured with a statue—Antileon of Chalkis, who stopped the Athenians from executing Samian returnees: *IG* 12.6.1.42. An Astypalaian was honoured by the Epidaurians with a statue at the Asklepieion (*IG* 4² 1.615), a unique honour before the mid-Hellenistic period; the statue probably dates to the late 4th cent. See also C. Habicht, 'Die Ehren der Proxenoi: Ein Vergleich', *Museum Helveticum*, 59 (2002), 13–30, notably 17–20 (rarity of statuary honours for Delian *proxenoi*).

[38] Diod. 20.93.6 (Rhodes, for Antigonos and Demetrios, before the great siege).

[39] The Astypalaians granted a statue for Kleombrotos son of Pheres, after a whole series of euergetical interactions (*IG* 12.3.212); the same man was honoured at Epidauros (above).

[40] On Olympiodoros of Athens, see below, Chap. 8; also *Syll.* 361; *SEG* 18.26; *FD* 3.4.218–22; *Oropos* 366, 389; *ISE* 13...

[41] On Demosthenes, see below, Chap. 8; especially useful is R. von den Hoff, 'Die Bildnisstatue des Demos-thenes als öffentliche Ehrung eines Bürgers in Athen', in M. Haake, C. Mann, and R. von den Hoff (eds), *Rollenbilder in der Athenischen Demokratie: Medien, Gruppen, Räume im politischen und sozialen System* (Wiesbaden, 2009), 193–220. Or see *I. Erythrai* 28 and *SEG* 33.963 (for a statesman at Erythrai); T. L. Shear Jr., *Kallias of Sphettos and the Revolt of Athens in 286 BC* (Princeton, 1978); Gauthier, *Bienfaiteurs*, 127 n. 154.

[42] *SEG* 33.794 (with *BE* 84, 276), Olbia, early Hellenistic; the honorand perhaps lent a large sum of money for fortification works.

[43] *IAG* 41 (c.200). Other examples of mid-Hellenistic public statues for victorious athletes: *IAG* 46 (Olympia); J. Bousquet, 'Inscriptions de Delphes', *BCH* 83 (1959), 146–92, at 174–5 (a Klazomenian athlete honoured at Delphi, c.250), *I. Erythrai* 87, 89a.

[44] Livy 31.23, 36.20.

[45] *IG* 5.1.1165, also *Syll.* 592 (Gytheion); *PH* 128 (Kos); *Syll.* 616 (Delphi).

[46] *Milet* 1.2.12a (*Steinepigramme* 1, 01/20/33).

[47] e.g. *Syll.* 654, *FD* 3.2.135; *I. Alexandreia Troas* 5.

The change in honorific and more generally civic culture starting in the second half of the second century also brought modifications in the honorific statue habit. These modifications include an increase in the number of statues granted by the cities, a shift of royal-style honours (including cult or 'super-eminent' monuments such as honorific columns or pilasters) onto great benefactors, especially once the kings disappear as major power actors in the Hellenistic world, the honouring of family members of honorands alongside the latter,[48] the grant of multiple portraits to individual honorands, often in different forms (bronze, gilt bronze marble, painted),[49] the payment of honorific statues by the honorands themselves, or their families.[50] All these shifts have sometimes been considered as the sign of an 'inflation of honours' in the late Hellenistic period.[51] The long late Hellenistic decrees from Priene,[52] or the honours for the great benefactor Diodoros Pasparos of Pergamon, illustrate these developments.[53] It must be noted, though, that 'normal' honorific statues, public and private, continued during and beyond the late Hellenistic period, into (at least) the first two centuries AD. In parallel, and in the absence of royal masters over the Hellenistic cities, statuary honours continued to be used for Roman officials, often statuefied alongside family members. A noticeable practice of this period is the rededication of honorific statues for Roman officials. This is richly attested at the Amphiaraion at Oropos (in fact most inscribed public statue bases still visible on the site bear the second inscription of the phase of reuse, not the original, high-Hellenistic dedicatory inscription), on the Athenian Akropolis — and on Rhodes, in a speech by the orator Dio Chrysostom (31) as well as an inscription from Lindos.[54] The outcome of granting statue honours for Romans was the proliferation of statues for Roman dynasts — Pompey, Caesar, and ultimately Augustus and the imperial house.[55]

History as statues: the shape of the honorific statue habit varied in time, according to the pressure of events. Events produced statues — as in the early fourth-century moment, or the time of the supremacy of Philip II. Crises produced statues:[56] the (partial) liberation of Athens in 292,[57] or the successful defeat of the Galatians in 279, were commemorated by statues[58] — as were the civic wars of defence or liberation waged in the early Hellenistic age (above). One such conflict was the repeated uprising of the Boiotians against Demetrios Poliorketes, between 294 and 292; the Boiotian city of Akraiphia commemorated the heroic deeds of one of its citizens, one Eugnotos, who led civic cavalry (unsuccessfully) against royal troops. But Akraiphia came to honour leading Romans — P. Cornelius Lentulus, during the Third Macedonian War (which saw the end of the Boiotian League), and Sulla, during the latter's campaign against Mithradatic troups.[59] Statuescapes in cities or shrines gave images of local histories, reflected in patterns of honorific statues and of shifting spatial practices. Such histories are visible in the Asklepieion near Epidauros (first used by cities other than Epidauros

[48] See below, Chap. 6.

[49] e.g. *CIG* 3065 (Teos); *Inschr. Priene* 117; *TAM* 5.1.468B; *ISE* 3.136 (Messene, early 1st cent.). Striking examples from Roman-era Asia Minor, *I. Iasos* 85, 248; *I. Assos* 18; *I. Perge* 14; *Sardis* 27; Bresson, 'Painted Portrait'. Generally, R. van Bremen, *The Limits of Participation; Women and the Civic Life in the Greek East in the Hellenistic and Roman Periods* (Leiden, 1996), 170, 188–9.

[50] See below, Chap. 7.

[51] Gauthier, *Bienfaiteurs*.

[52] e.g. *Inschr. Priene* 108–9.

[53] A. Chankowski, 'La Procédure législative à Pergame au Ier siècle au J.-C.: A propos de la chronologie relative des décrets en l'honneur de Diodoros Pasparos', *BCH* 122 (1998), 159–99.

[54] H. Blanck, *Wiederverwendung alter Statuen als Ehrendenkmäler* (Rome, 1969); Platt, 'Honour Takes Wing', 247–71; J. L. Shear, 'Reusing Statues, Rewriting Inscriptions, and Bestowing Honours in Roman Athens', in Leader-Newby and Newby, *Art and Inscriptions*, 221–46; *Inscr. Lindos* ii. 419.

[55] J. M. Højte, *Roman Imperial Statue Bases: From Augustus to Commodus* (Aarhus, 2005).

[56] A crucial point in K. Höghammar, *Sculpture and Society: A Study of the Connection between the Free-Standing Sculpture and Society on Kos in the Hellenistic and Augustan Periods* (Uppsala, 1993).

[57] Below, Chap. 8.

[58] C. Habicht, *Pausanias' Guide to Ancient Greece* (Berkeley, Calif., 1985), 85–6.

[59] *ISE* 69 (with Conclusion, pp. 300–2), 70; N. Pharaklas, 'Enepigraphon vathron ex Akraiphniou', *ArchDelt* 23/1 (1968), 293–4.

as a showcase, then used to honour Romans, and finally to honour local notables), or on the Akropolis in Athens, used sparingly until the late Hellenistic period, when statues of foreign dignitaries and Romans become common.⁶⁰ A similar pattern can be read at the Heraion of Samos (where the mid-first century BC ushers in a series of statues for Roman officials). Succinctly, Dio (31.43) imagines his Rhodian audience reacting defensively to his remonstrances against the reuse of statues—and categorizing honorific statues as those of Romans, Macedonians, Spartans: the first group is that of first-century (and later) honorands, the second must be that of Hellenistic rulers and officers, and the 'Spartans' are probably early fourth-century military commanders, a remnant of a very old story dating to the beginning of the honorific statue habit.

The study of the honorific statue habit in the Hellenistic period *lato sensu* (roughly speaking, 350 BC–AD 50) lies at the intersection of several disciplines: epigraphy, the study of the public permanent writing that formed a 'public literature' in the Hellenistic cityscapes and shrinescapes; art history, the study of the works of art that were part of the honorific monuments, considered formally but also sociologically, even though they are often only known through Roman-era copies; archaeology, the study of the material remains of the monuments but also of the built spaces that were the contexts for them. These three disciplines enable the study of three basic themes. The first, 'epigraphical', theme is the honorific, inscribed, culture of the Hellenistic *polis*, with its insistence on the euergetical exchange of public recognition for individual service (already mentioned above); as seen in the historical sketch of the honorific statue habit, the benefactors include powerful outsiders (kings and their men), as well as increasingly powerful, and perhaps problematic, insiders (civic benefactors).⁶¹ The second, 'art-historical' theme is constituted by the social functions and contexts of Greek art (and ancient art in general): much emphasis has been laid recently, not (only) on 'Greek sculpture' as art works, but on statues embedded within social contexts and performing acts and gestures within a specific world.⁶² The third, 'archaeological' theme is monumental space in the Hellenistic city, and the ways in which space was shaped by, and simultaneously contributed to shape, civic ideologies and interactions.⁶³ Space was as important as text and image in constructing the Hellenistic *polis* and its members, especially because it was an explicit part of how the honorific transactions worked: by the granting of a 'most prominent place' (*epiphanestatos topos*).⁶⁴

In fact, these three themes all draw on all three disciplines: epigraphical, art-historical, and archaeological, and many recent works have successfully integrated them in holistic

⁶⁰ Below, Chaps. 3–4.

⁶¹ e.g. Robert, *OMS* v. 561–83 (on Theophanes of Mytilene); Gauthier, *Bienfaiteurs*; J. and L. Robert, *Claros I: Décrets hellénistiques* (Paris, 1989); K. Bringmann and H. von Steuben (eds), *Schekungen Hellenisticher Herrescher an griechische Städte und Heiligtümer* (Berlin, 1995); van Bremen, *Limits of Participation*; J. Ma, *Antiochos III and the Cities of Western Asia Minor* (rev. edn, Oxford, 2002).

⁶² R. R. R. Smith, *Hellenistic Royal Portraits* (Oxford, 1988); A. Stewart, *Greek Sculpture: An Exploration* (New Haven, 1990); R. R. R. Smith, *Hellenistic Sculpture: A Handbook* (London, 1991); A. Stewart, *Faces of Power: Alexander's Image and Hellenistic Politics* (Berkeley, Calif., 1994); P. Zanker, *The Mask of Sokrates: The Image of the Intellectual in Antiquity* (Berkeley, Calif., 1995); J. C. Eule, *Hellenistische Bürgerinnen aus Kleinasien: Weibliche Gewandstatuen in ihrem antiken Kontext* (Istanbul, 2001); F. Queyrel, *Les Portraits des Attalides: Fonction et représentation* (Athens, 2003); P. Stewart, *Statues in Roman Society: Representation and Response* (Oxford, 2003); J. Tanner, *The Invention of Art History in Ancient Greece: Religion, Society and Artistic Rationalisation* (Cambridge, 2006); Dillon, *Ancient Greek Portrait Sculpture*; P. Schultz and R. von den Hoff (eds), *Early Hellenistic Portraiture: Image, Style, Context* (Cambridge, 2007); J. B. Connelly, *Portrait of a Priestess: Women and Ritual in Ancient Greece* (Princeton, 2007); S. Dillon, *The Female Portrait Statue in the Greek World* (Cambridge, 2010).

⁶³ G. J. Oliver, 'Space and the Visualization of Power in the Greek Polis: The Award of Portrait Statues in Decrees from Athens', in Schultz and von den Hoff, *Early Hellenistic Portraiture*, 181–204; L. Mercuri, 'Contributi allo studio degli spazi pubblici delii: L'agora di Teofrasto', *ASAtene* 86 (2008), 193–214; A. Matthaei and M. Zimmermann (eds), *Stadtbilder im Hellenismus* (Berlin, 2009); also G. Zimmer, *Locus Datus Decreto Decurionum: Zur Statuenaufstellung zweier Forumsanlagen im römischen Afrika* (Munich, 1989), on Roman Africa.

⁶⁴ See esp. Oliver, 'Space and the Visualization of Power'; below, Chap. 4.

approaches.[65] This sort of integration matters, because the embedding of art and monument in its social context (one of the major, transformational developments in the field of Classics) requires a constant and dynamic dialogue with the picture that has been patiently elaborated by the epigraphically focused historians.[66] Thus interpretations about images (concrete and textual) of Hellenistic manhood need to take into account the continued or even increasing importance of civic engagement in a multitude of forms, including the often overlooked military and political activity by the good citizens of the Hellenistic *polis*.[67] In other words, the challenge is to map Louis Robert-style epigraphy onto the archaeology of the Hellenistic world. The exercise is not always facilitated by the disciplinary boundaries; epigraphical publications often do not include notes on the monumental aspects of the stones bearing the inscriptions (the top or back of blocks tell a great deal about the statues they bore)—or about the place where the inscription was set up; archaeological publications sometimes favour typology (mouldings, more mouldings, chronology) rather than trying to answer questions about context and function. But practices are changing, and this picture just given is increasingly outdated.[68]

The payoff of the exercise, in the specific test case of the honorific statue habit (itself part of the broader euergetical culture), will be to give a holistic sense of the post-Classical *polis*, which constitutes one of the main problems of Hellenistic history. The various specific components of this problem are the following: first, the balance between subordination and agency; secondly, the interaction of elite and community, within the parameters of a constraining civic culture, of elite self-promotion and familial strategies, and of changes in the social, economic, and political context; thirdly, the interaction between public and private within the social space of the *polis*. The study of these themes leads to general considerations on the theme of change and continuity, and hence the debate on the 'decline' or 'vitality' of the Hellenistic *polis*, a debate which it is worth transcending.

The study of the honorific statue in the Hellenistic *polis* also touches on three related themes in cultural history. The first is the practical workings of representations and images (notably in relation to texts).[69] At first sight, the honorific portrait is a very specific work of 'art', which can be given a flat, matter-of-fact interpretation in terms of benefaction and honours. To embed it within civic culture is of course justified and necessary, to give it the historically appropriate social context for interpretation; however, it may also make us oblivious to the strangeness of the honorific statue. The fact that honorific statues were 'reused' raises the problem of what the *eikon* actually is, or does; it is not enough to answer that 'the Greeks did not care about resemblance'. Hence the honorific portrait also has something to say about images in general

[65] In addition to the works quoted above (especially Schultz and von den Hoff, *Early Hellenistic Portraiture*), a model is provided by R. R. R. Smith with S. Dillon, C. H. Hallett, J. Lenaghan, and J. Van Voorhis (eds), *Roman Portrait Statuary from Aphrodisias* (Mainz am Rhein, 2006). For a parallel from modern history, J. Wilson, 'Elite Commemoration in Early Modern England: Reading Funerary Monuments', *Antiquity*, 74 (2000), 413–23.

[66] See above, n. 59; also P. Fröhlich and C. Müller (eds), *Citoyenneté et participation à la basse époque hellénistique* (Paris, 2005); P. Hamon, 'Élites dirigeantes et processus d'aristocratisation à l'époque hellénistique', in H.-L. Fernoux and C. Stein (eds), *Aristocratie antique: Modèles et exemplarité sociale* (Dijon, 2007), 77–98.

[67] Lack of awareness of Hellenistic civic engagement and military identity reduces the usefulness of important studies such as P. Zanker, 'The Hellenistic Grave Stelai from Smyrna: Identity and Self-Image in the Polis', in A. Bulloch, E. S. Gruen, A. A. Long, and A. Stewart (eds), *Images and Ideologies: Self-Definition in the Hellenistic World* (Berkeley, Calif., 1993), 212–30, or Tanner, *Invention of Art History* (where a demilitarized post-Classical *polis* is simply taken for granted, e.g. 27; and where the history of honorific culture is calibrated inaccurately in terms of chronology). On the military history of the Hellenistic *polis*, J. Ma, 'Fighting *Poleis* of the Hellenistic World', in H. van Wees (ed.), *War and Violence in Greek Society* (London, 2000), 337–76; A. Chaniotis, *War in the Hellenistic World: A Social and Cultural History* (Malden, Mass., 2005).

[68] See Matthaei and Zimmermann, *Stadtbilder im Hellenismus*, as an example of boundary crossing and disciplines uniting.

[69] See J. Elsner (ed.), *Art and Text in Roman Culture* (Cambridge, 1996); J. Elsner, 'Reflections on the "Greek Revolution" in Art: From Changes in Viewing to the Transformation of Subjectivity', in S. Goldhill and R. Osborne (eds), *Rethinking Revolutions through Ancient Greece* (Cambridge, 2007), 68–95, and the essays collected in J. Elsner (ed.), *Roman Eyes: Visuality and Subjectivity in Art and Text* (Cambridge, 2007).

(just as the nineteenth-century 'statuemania', at first sight the epitome of *art pompier*, fascinated the Surrealists[70])—and in fact about a whole nexus of issues involved in art: agency, idealism and realism; presence and absence; life (and the lifelike) and death; truthfulness and fiction. All these issues underlie the whole book; they will be treated in full in the last chapter.

The second, closely related theme is the history of the body, shaped by images yet lived by individuals. This shaping is eminently social: the portrait is framed, through context and writing, so as to show you a person in its physical, active, and moral dimensions. This is the body of the dynamic yet benevolent ruler, or of the actively involved citizen, or the good wife. The honorific portraits of the Hellenistic age hence represent the physical manifestation, in somatic shape and in physiognomy, of social norms, namely the civic norms of restraint or images of power specifically meant to answer and surpass these civic norms. The honorific portrait also belongs to a wider portrait genre, expressed in naturalistic terms, which touched on the nexus of questions surrounding personhood: for instance, what it means that ideals took the physiognomically specific traits of a person; or what remains of a person's essence in spite of change, time, and death, especially once those who could judge the truthfulness of the portrait have disappeared along with the real-life model.

The possible persistence of persons and personhood in spite of time is bound up with the third theme in cultural history involved in the study of honorific statues, namely the history of memory in the Hellenistic city. Honorific statues are the result of a decision to memorialize: they are part of monuments that form 'places of memory', to use the concept developed by Pierre Nora to study memory and its workings in the modern period (in the case of the modern nation-state of France). It is still applicable to the Hellenistic period: in spite of what is sometimes claimed, there is nothing specially modern about the constructedness of collective memories, and the honorific monument is a prime example of the political, strategic use of memory in the context of interaction between powerful individuals and communities. The importance of the theme of memory also comes from the promise memory holds of resisting oblivion after death, a promise which touches the individual, as a mortal, bodily entity, in his relationship with the community which will do the remembering; the relationship is mediated by the statue, which will do the work of memorializing. All of these themes are explicitly treated in the epigrams that often accompany the statues.

These are the six themes which this book is built around: the political themes of civic discourse within society, the social function of 'art', and monumental space, and the cultural themes of images, bodies, and memory—as elements for a political, cultural, and social history of the Hellenistic *polis*. All these themes underlie each of the chapters in the book, inextricably and dynamically linked; they are treated explicitly in the concluding chapter. However, they are also organized in broader parts, which focus on a particular theme through the relevant body of evidence. Part I describes, then analyses, the epigraphical practices that made the honorific monument. I will examine the 'grammar' of the honorific statue (Chap. 1), in the most literal sense of registering the near-universal employment of the accusative case, before trying to unpack the political implications of the pragmatics of the statue formulas (Chap. 2). The main focus of Part I, beyond the analysis of epigraphical practice, is to establish the assumptions of civic control over identity and honour in public space, eloquently embodied by public texts, short and long.

Public space is the theme of Part II, which starts by establishing a 'grammar of space' in the Hellenistic cityscape (Chap. 3), and moves on to analysing how space works (Chap. 4). The payoff in this section is to point to ways of reading space not just in the abstract, but also as a historical lived entity—as place. This reading shows how the Hellenistic *polis* was also a space of competition, 'ecological' in nature, and leaving 'sedimentary' traces, between a variety of actors, internal and external, the 'public' seems to be, at times, only one of these competitive actors or

[70] J. Hall, *The World as Sculpture: The Changing Status of Sculpture from the Renaissance to the Present Day* (London, 2000).

personalities within social space. The upshot is that a civic history does not have to be the history of the rise and fall of a hegemonical civic ideology—rather, a history of conflict and pressures. One of the actors in public space is constituted by elite families in the city: these are the theme of Part III in this book. This phenomenon has not received sustained attention in the cultural history of the Hellenistic period, and I try to establish the shape of the phenomenon of 'private' or 'family' statues in public space (Chap. 5). This phenomenon poses further problems to any simple interpretation of honorific statues in public space as the story of hegemonical civic ideology; elite families clearly are one of the major 'competitive actors' in the race for space and attention. At the same time, the phenomenon is not simply one of elite capture of space, and I explore a number of possibilities for interaction between the civic and the private (Chap. 6). Finally, in Part IV of this book, I examine actual statues and portraits: how they were made (Chap. 7), both by political and by artistic processes; and what they looked like (Chap. 8), based on a sample of honorific statues about which we can say something.

The starting point, in Part I of this work, is the effective working of civic ideology to constrain elites within communitarian norms—the vitalist paradigm ('la cité grecque n'est pas morte à Chéronée', in the words of Louis Robert). The rest of the book is not quite given over to the deconstruction of this idea; nor is it a demonstration that civic ideology faltered and gave way, as the Hellenistic era progressed, before processes of elite affirmation. What I found was that the performativeness of civic ideology and discourse took place within specific places. By this, at an elementary level, I mean such monumental sites as Athens, Pergamon, Priene, Delos, the Amphiaraion near Oropos, the Asklepieion near Epidauros, Olympia, which are well excavated and provide test cases which will recur throughout the present book. More importantly, I also mean that civic ideology and discourse were accepted (in order to be performative at all) by social groups which were complex, existed in time as the product of historical forces and processes, and 'on the ground' as actors competing or simply interacting with other actors—the social archaeology proposed in this book hence amounts not just to the necessary exercise of mapping Louis Robert on to Hellenistic archaeology, but also to a political reading of Hellenistic spaces on the ground.

Epicurean philosophy distinguished between different types of pleasure, in a matrix created by two pairs of opposites: natural/non-natural, necessary/non-necessary. Drink was natural and necessary, as it relieved the pain of thirst. Culinary refinement was natural and non-necessary, as the refinement in itself did nothing to remove the pain of hunger. And finally, some pleasures were non-natural and non-necessary. The example given in the surviving commentary (of unknown date) on the Epicurean principle was no doubt provocative in view of the pervasiveness of civic honorific culture as a basic component of public life in the Hellenistic cities: crowns and the setting up of (honorific) statues. They did not, in the Epicurean view, relieve the pain of any natural need, either directly or with unnecessary refinement of the nature of the pleasure. Yet statues fulfilled some sort of need, and many people felt pleasure, or at least satisfaction, at being honoured with permanent portraits, captioned and set up in public space at the behest of communities—as was done by the Samians for C. Julius Amynias, the Epicurean philosopher. This book is devoted to exploring the feelings and needs (non-natural, non-necessary, yet somehow essential) involved in the transaction; or to answering a simple question: why say thank you with a statue?

I
Statues and Stories

Towards a Grammar of Honours

Allein man stelle sich den Statuenwald z.B. in dem berühmtesten Heiligtume von Delphi vor: welcher Besucher gab sich dort die Mühe, nur alle Statuen zu betrachten, geschweige denn sämmtliche Inschriften, noch dazu bei ihrer so unbequemen Form durch zubuchsta-biren?

(E. Kuhnert, 'Statue und Ort in ihren Verhältniss bei den Griechen', *Jahrbücher für classische Philologie*, suppl. 14 (1885), 265)

Let us just imagine the 'forest of statues', for instance in the most famous shrine of Delphi: which visitor there took the trouble just to look at all the statues, let alone to read letter by letter, the many inscriptions, especially in their particularly inconvenient form?

This first chapter examines the various ways in which honorific statues were captioned, through writing on their base: in the nominative, but mostly in the accusative, as part of a formula, more or less developed. The workings of the formula are instructive: the way the honorand, the honourer, and the act of honouring are described has consequences for the nature of the transaction. In addition to unpacking the workings of the formula, I also examine how the statue base functions in presenting the statue as part of an institutionalized relation.

I. IMAGE AND TEXT

What made an honorific statue honorific? An event, a relation, a gesture. But the statue is part of a monument: its point is to record a transaction (X does something, Y reacts by honouring), and to keep the honouring going in time, for ever. This happens through the statue, but also through inscription, which acted in two ways: by bringing identification and information, and by functionalizing the work of art.

Identification: text captioned an image, 'This (image) *is* that (person)'—with all the problems and paradoxes involved, since it is our wilful ignorance of the ways that relate an image of a pipe, the words 'a pipe', and an actual pipe that allows images to work.[1] This is the first way in which inscription was performative: it ascribed identity to the work-as-object, made it into a 'subject', thus enabling the game of reference and representation. What am I looking at? The image offers possibilities, but the text will tell me: the Macedonian mythological figure Olganos (on a second-century AD bust); athletes, probably from the victorious team in a torch-race during a festival, each team-member labelled with his name and his demotic (on a fourth-century BC Athenian victory dedication); this or that deceased man or woman,

[1] M. Foucault, *Ceci n'est pas une pipe: Deux lettres et quatre dessins de René Magritte* (Montpellier, 1973). On the interaction between word and image, S. Goldhill and R. Osborne (eds), *Art and Text in Greek Culture* (Cambridge, 1994); Elsner, *Art and Text in Roman Culture*; Z. Newby and R. Newby-Leader (eds), *Art and Inscription in the Ancient World* (Cambridge, 2007); a version of the treatment of the issues in this, and the following, chapters was presented in J. Ma, 'Hellenistic Honorific Statues and their Inscriptions', in Newby and Newby-Leader, *Art and Inscriptions*, 203–20.

on countless funerary *stelai* (though this is not as straightforward as one might expect).[2] Ancient viewers were aware of the hermeneutic issues involved in viewing, reading, and understanding, and a whole genre of epigrams concerns these problems.[3] The ancient reflex was to look for words to elucidate the visual: at Delphi, the inscription on the treasury of the Akanthians (Brasidas and the Akanthians dedicated this) was associated with a marble statue, located in the treasury and assumed to be Brasidas (erroneously, Plutarch assures us: it represented Lysander).[4]

The inscription tells you what the statue represents; and also a little bit more. Beyond mere nomination, inscription enacted functionalization. In the erroneous case of the Akanthian treasury, the viewer saw the inscription—'Brasidas did this'—and associated it with the image, as a representation of the dedicator, a situation which does sometimes occur in votive works of art. Inscriptions recorded actions, and also the relations at the root of actions, perpetuated through the work of art, which was made to present the relation in material form: this is the second way in which the inscription is performative. It is true that the modern form of captioning of public portraiture often omits any reference of who set the statue up, just giving a name (and indications such as date of birth and achievement, as in a dictionary entry and with the same air of disembodied authority):[5]

> Gustave Moynier,
> 1826–1910,
> membre fondateur,
> président du CICR.

But these modern cases only raise the question of why the statue is there, and the pragmatics of the work of art imply the relation (this person was important to people who set this statue up), which in fact can be spelt out. A huge equestrian statue set up at El Paso International Airport was meant to represent the conquistador Don Juan de Oñate—until he was deemed too controversial a *subject*, and the statue simply dubbed 'The Equestrian', to general dissatisfaction.[6]

Issues of nomination and performativeness concern knowledge about assumptions of value and worth. They are intrinsically political, the more so in the case of the honorific statue, where the transaction is eminently social and public. Furthermore, inscription is not mere 'captioning' in the modern sense, i.e. subordinate to the image, minor, unnoticed, utilitarian, part of framing in its discretness (and its discreteness). Without getting into debates about literacy, legibility, and reading, it is enough to observe that epigraphy is a major cultural form, and monumental in its own right. Awareness of the perenniality and publicity achieved by permanent, expensive inscription on the high-prestige medium of stone or metal was a constant feature of Graeco-Roman civilization; inscription is an 'official transcript', highly valorized. Funerary culture, public state expression, and private religious life made an important place for inscription as a mode for self-expression and self-definition; honorific statue practice needs this

[2] Olganos: P. Amandry, 'Chronique des fouilles et découvertes archéologiques en Grèce en 1947', *BCH* 71–2 (1947–8), 423–71, at 438, no. 4, I. M. Akamatis, *LIMC* 8.922, s.v. Olganos (my thanks to P. Paschidis for helping me with his Macedonian expertise). Athletes: F. Rausa, 'Due donari agonistici dall' Acropoli', *AthMitt* 113 (1998), 191–234. Funerary *stelai*: J. Bergemann and K. Hallof, 'Hieron und Lysippe: Inschriften, Ikonographie und Interpretation eines bekannten attischen Grabreliefs', *AthMitt* 112 (1997), 269–80 (on a particular case illustrating the iconographical and epigraphical problems of who is represented and who is named, who living and who dead, on the funerary *stelai*).

[3] Generally, Goldhill and Osborne, *Art and Text*.

[4] Plutarch, *Lysander* 1.1–3; Bommelaer, *Lysandre de Sparte*, 13–14. The reasons for the identification by Plutarch are unclear.

[5] The example is drawn from the honorific busts in the Parc des Bastions in Geneva. On modern statuemania (and the vogue of *fonte bronzée* statues in the 19th cent.), Hall, *World as Sculpture*.

[6] R. Blumental, 'Many Months Away, El Paso's Giant Horseman Stirs Passions', *New York Times*, 10 Jan. 2004. This is apparently the world's largest equestrian statue, at 36 feet tall (G. Rodriguez, 'El Paso Confronts its Messy Past', *Los Angeles Times*, 25 Mar. 2007).

highly privileged 'speech on stone'. Inscription meant memory and publicity; an inscription in itself could be a votive offering, and hence the medium should be considered as the same in nature as the more spectacular (at least for the modern viewer) artistic objects dedicated in public spaces. The Delphic amphictiony, in the late third century, towards the end of the Aitolian-dominated period, granted honorific statues to hieromnemones from Chios; yet it was inscription, in this case on a *stele*, which created memory, by acting as a *hupomnema*, a memorial.[7]

Of course, this is the 'epigraphist's view', written in the library, surrounded by published, re-edited, versions of the ancient texts on stone. There are immediate problems with implying that the text has primacy over the image—that I must read a caption to be able to understand the work of art. The act of captioning is not simple; art tells its own stories, and gives out its own signals, that have to be decoded by viewers. This is true of an ancient honorific statue: the face, hairstyle, dress, posture, of the image bore meanings, conveyed by the life-size or over-life-size scale, physicality, uncanny lifelikeness, and visual power of anthropomorphic images in painted marble or shining bronze, made to look like people through the virtuosity of naturalistic artists. Ancient inscriptions were painted, to make them stand out; but, when captioning statues, they had to compete with spectacular, expensive bronze, or marble images made the more striking because they, too, were painted. At Klaros, the gilt statue of the benefactor Polemaios, and that of another benefactor, Menippos, gleamed on top of a column 6 m high, towering above the viewer, and the inscription was carved over a hundred dense lines on the base: where did the eye go first?

Yet at Klaros, the long texts were summarized in short *cartouches* on the shaft of the honorific columns, half way up. If the viewer's eye travelled straight to the gilt statue, it also caught on, and took in, the short inscription captioning and fixing the meanings of the portrait: Menippos (and not another man), benefactor in difficult times, good citizen. All the issues raised above do not reduce the importance of epigraphy, as nomination and as functionalization, in animating the work of art into its meaningful monumentality. Inscription on honorific statues is (mostly) narrative, a little sentence in the past tense, which tells a story, and locates the statue in a social world; the workings of such sentences will be the main theme of this chapter. This function of telling stories is political: narrative requires collaboration between the text and the viewer, and hence represents a contract, whose implications need to be teased out.[8] In all cases, the inscription represents a political act, whose efficacy is recognized and embodied by the statue. The present chapter, and the following, are devoted to reading the politics of inscription on honorific monuments in the Hellenistic age.

2. TOWARDS A GRAMMAR OF HONOURS

What constituted normal practice for inscriptions as part of honorific monuments? To answer this question requires the survey of a grammar of honorific inscriptions, as a first stage. In this context, 'grammar' is metaphorical: the word will designate the rules and conventions that govern the epigraphical habit in the case of honorific statues. Establishing such a grammar will enable us, from the start, to point out cases that are anomalous, and hence interesting. It will also serve as a springboard for a later section in this chapter, devoted to test cases (rather than a general 'historical grammar' of honorific statues).

[7] *CID* 4.86 and 88. Inscription as honorific per se: G. Klaffenbach, *Bemerkungen zum griechischen Urkundenwesen* (Berlin, 1960), 26–42 on *stelai* as embodying public acts; Veyne, *Le Pain et le cirque*, 267–9; Chankowski, 'Diodoros Pasparos', 197.

[8] On the importance of inscription in ascribing meaning and function, E. Perrin-Saminadayar, '*Aere perennius*: Remarques sur les commandes publiques de portraits en l'honneur des grands hommes à Athènes à l'époque hellénistique. Modalités, statut, réception', in Y. Perrin with T. Petit (eds), *Iconographie impériale, icogographie royale, iconographie des élites dans le monde gréco-romain* (St.-Etienne, 2004), 135–7.

'Grammar' implies handbook, and many of the issues have been covered in epigraphical textbooks—constantly from the same synchronic angle, as in M. Guarducci's treatment of statue inscriptions.[9] The exercise implies induction, and simplification of local variation. It is made possible by a striking degree of uniformity and consistency of practice across the Greek world, which in itself is an important historical phenomenon. The material rehearsed here will be familiar to epigraphists; but reviewing epigraphical practice for honorific statues will allow us to unpack the implications of various formulas, especially in the ideological realm of social relation, since the grammar of inscriptions is also a political issue. In several ways, this is an exercise in 'reading the obvious'—achieving and demonstrating competence in what was obvious to the ancient viewer, repeating what seems to be obvious to epigraphists, and unpacking the political and ideological implications of phrasing. Finally, 'grammar' also has a literal force. Ancient Greek is an inflected language, and the various forms of statue inscriptions concern grammatical cases: dative, nominative, accusative. These, too, have political implications to be unpacked—after establishing the range of possibilities.

As a starting point, it may be helpful to compare contemporary practice in Western countries. The majority of captions falls in two categories: labelling ('Gustave Moynier'), or formulas of homage, of the type 'X to Y', or even more generally, 'to Y', in the dative. Such expressions valorize the subject of the statue, especially in the absolute forms, namely those with a simple name label, or the homage without any indication of the source of the homage: statues go 'to' someone, whom they also represent, in a tranquil paradox and redundancy. The modern homage formula is paralleled in, and perhaps imitates, ancient Roman practice, *datif d'hommage*, as P. Veyne pointed out in a classic article.[10] → Hellenistic Greece

A consideration of modern practice brings out the contrast with Classical and Hellenistic practice: communities do not put up statues to someone, as a gesture of homage to a superior. This only applies to the gods, recipients of offerings. The dative in inscriptions completes verbs of dedication: the inscription functionalizes the object by making it into an offering, clearly indicating the donor in the nominative, and the divine recipient in the dative. It is hence both recording and enacting the transaction.[11] The object can be indicated (when an Italian trader dedicated Nikai, Erotes, and Anterotes to Poseidon and Amphitrite on Tenos, the inscribed base noted this[12]) or left implicit (this helmet, this building, this altar, this relief, this statue). The statue might represent the recipient of the homage (the 'valorizing redundancy' mentioned above). C. Keesling has recently argued that *korai* on the Athenian Akropolis are both offerings to Athena, and images of Athena (rather than of the male dedicators, or generic female worshipper images);[13] the goddess is present in the dedicatory transaction, and her presence migrates into the identity of the image. At Rhamnous, the statue of Themis (identifiable by type and size, and also by context and the pragmatics of the inscription) was dedicated to

[9] M. Guarducci, *Epigrafia greca*, 4 vols (1967–78), ii. 126–62; iii. 89–110. See also Robert, *OMS* v. 475; P. Veyne, 'Les Honneurs posthumes de Flavia Domitilla et les dedicaces grecques et latines', *Latomus* 21 (1962), 49–98; G. Klaffenbach, *Griechische Epigraphik*, 62–6; D. Knoepfler, 'Contributions à l'épigraphie de Chalcis', *BCH* 101 (1977), 304–5; A. Jacquemin, 'Ordre des termes des dédicaces delphiques', *AION* NS 2 (1995), 141–57; Smith, *Roman Portrait Statuary from Aphrodisias*, 21–8 (for formulas of a later period). Of the older treatments, I. Franzius (J. Franz), *Elementa Epigraphices Graecae* (Berlin, 1840), 328–36, is surprisingly useful; also S. H. Reinach, *Traité d'Epigraphie grecque: précédé d'un essai sur les inscriptions grecques* (Paris, 1885), 373–87; E. Gerlach, *Griechische Ehreninschriften* (Halle, 1908); W. Larfeld, *Griechische Epigraphik* (3rd edn, Munich, 1914), 432–65.

[10] Veyne, 'Honneurs postumes', esp. 75–81. *Oropos* 461, a fragmentary statue base dedicated to the Areiopagos, must have represented the council (personified and standing next to a *stele*, perhaps representing its role as 'guardian of the laws'), but it also was a homage to the council; the phrasing is Roman (V. Petrakos's suggestion that the statue represented the dedicator should not be accepted).

[11] Guarducci, *Epigrafia*, ii. 124–42; iii. 1–89; K. Carroll, *The Parthenon Inscription* (Durham, 1982); J. Bodel, '"Sacred Dedications": A Problem of Definitions', in J. Bodel and M. Kajava (eds), *Dediche sacre nel mondo greco-romano: Diffusione, funzioni, tipologie* (Rome, 2009), 17–30 (arguing for contextual flexibility rather than the rules on which this chapter is predicated).

[12] *IG* 12.5.917 (1st cent. BC).

[13] Keesling, *Votive Statues*.

Themis, by a Rhamnousian (who also used the occasion to record his achievements, public and agonistic).

Μεγακλῆς Μεγακ[λέους Ῥαμ]νούσ[ι]ος ἀνέθηκεν Θέμιδι στεφανωθεὶς ὑπὸ τῶν δημοτῶν δικαι-
οσύνης ἕνεκα ἐ[πὶ ἱ]ερείας Καλλιστοῦς καὶ νικήσας παισὶ καὶ ἀνδράσι γυμνασιαρχῶν καὶ
καὶ Φειδοστράτης Νεμέσει ἱερέας κωμωιδοῖς χορηγῶν
Χαιρέστρατος Χαιρεδήμου
Ῥαμν<ο>ύσι<ο>ς ἐπ<ό>ησε.

Megakles son of Megakles, of Rhamnous, dedicated (this statue of Themis) to Themis, having been crowned by the demesmen, on account of his righteousness, when Kallisto was priestess, and also having been victorious as gymnasiarch for the boys and the grown men, (*added on*) and when Pheidostrate was priestess of Nemesis, (having been victorious) as *choregos* of comedies.

Chairestratos son of Chairedemos, of Rhamnous, made this.[14]

The Rhamnousian example shows how the act of dedicating is a sacred gesture, but also the occasion for the dedicator to make himself seen and to leave a memorial trace;[15] the politics of dedicating must be taken into account when trying to think of the balance of power involved in the gesture of public statue making (below, Chaps. 2 and 6). For now, I wish to observe a rule, which itself will prove useful for understanding statues and their genres[16] as well as form the basis for historical interpretation.

What matters is that datives do not designate the human recipient of statue honours, but divinities who are offered gifts. Datives are very rare on the inscribed bases of statues for humans in the Hellenistic period.[17] If one excepts late Hellenistic examples which reflect Roman influence, the dative has the force of a religious gesture of homage and dedication, and hence is likely to indicate statues set up as part of, and used in, Hellenistic ruler cult.[18] The stone inscribed βασιλεῖ Σελεύκω<ι> | τῶν ἐν Θυατείροις | Μακεδόνων οἱ ἡ|γεμόνες καὶ οἱ στ|ρατιῶται, 'To King Seleukos (I), the officers and soldiers of the Macedonians in Thyateira', is likely the base of such a cult-statue for the king, set up by the 'military colony'.[19] The people of Elaious, in the Chersonese, set up, between 148 and 138, a dedication reading Βασιλεῖ Ἀττάλωι | βασιλέως Ἀττάλου | Φιλαδέλφου, σωτῆρι καὶ | εὐεργέτηι τῆς πόλεως | ὁ δῆμος, 'To King Attalos (II)—son of king Attalos (I) Philadelphos—saviour and benefactor of the city, the people (has dedicated this statue)'.[20] The stone is described by its finder, Sergeant Major R. S. Jones (Royal Engineers), who copied the stone shortly before his death in action in December 1916, as 'carved on a square piece of pure white marble', probably the front orthostate of the base bearing a cult-statue decreed by the city of Elaious. These two blocks might also belong to altars for the king;[21] other inscriptions in the dative might be dedications

[14] *IG* II² 3109; *Rhamnous* 120 (mid-4th cent. with commentary to *Rhamnous* 122). As is well known, the statue, found in the small temple at Rhamnous, is in the National Archaeological Museum in Athens (EAM 231), and figures importantly in discussions of late-Classical Athenian sculpture.

[15] Keesling, *Votive Statues*, 24–5.

[16] As an example of the use of rules: *Oropos* 461, was a monument of the Areiopagos (represented next to a *stele*: above, n. 10), but also a homage to this body. *IG* II² 1955 is a dedication by 4th–cent. horsemen 'to Salamis'—of a statue of Salamis, or another object? The latter is possible: the inscription makes it clear that the primary function of the monument is homage, not representation.

[17] e.g. *GIBM* 899 (Halikarnassos, cent.1st cent. BC?).

[18] C. Habicht, *Gottmenschentum und griechische Städte* (2nd edn, Munich, 1970), notably 142–3; *SEG* 41.1003 II, lines 31–3 (Teos, for Antiochos III, *c*.203). The word 'cult-statue' (ἄγαλμα) appears in *IG* 11.4.514 (*Choix Délos*, no. 16 (early 3rd cent.) for images of both Asklepios and Queen Stratonike. The dative is noticeably rare in the epigraphical sources collected in Kotsidu, Τιμὴ καὶ δόξα. On the workings of the cultic statue (a difficult category), S. Bertinetti, *La statua di culto nella pratica rituale greca* (Bari, 2001); J. Mylonopoulos (ed.), *Divine Images and Human Imaginations in Ancient Greece and Rome* (Leiden, 2010).

[19] *TAM* 5.901 (same document in *OGIS* 211), with commentary; V. Tscherikower, *Die hellenistischen Stadtegründungen von Alexander dem Grossen bis auf die Römerzeit* (Leipzig, 1927), 22 ('wohl unter einer Statue des Königs').

[20] G. Norwood, 'A Greek Inscription Copied from Gallipoli', *CQ* os 11 (1917), 1–2, correcting a copy by Sgt. Major R. S. Jones; whence T. Reinach, 'Une inscription grecque d'Eléonte', *CRAI* (1917), 29–30 (misattributing the article to *CR* 1917).

[21] An inscription in the dative for Lysimachos, from Philippoi, is a fake: Robert, *OMS* ii. 1294 n. 2.

to the king (rather than statues representing the king and offered to him), as for the dedication to Zeus and Philip (V) at Maroneia.[22]

Honorific statues are not statues to someone, but of someone: this is the standard expression when such statues are mentioned in prose documents.[23] If one excepts a late, eccentric example from second-century AD Uruk,[24] in Parthian-dominated Babylonia, the standard practice is documented, with perfect regularity, in countless examples found in honorific decrees, the texts that decided on the monuments: στῆσαι δὲ αὐτοῦ καὶ εἰκόνα χαλκῆν, '(it was resolved) also to set up a bronze image of him' (vel sim.).[25] An example outside the context of honorific decrees is the mention of a statue in an entry in the accounts of the hieropoioi of Delos: 300 drachmai were borrowed for the kerosis (modelling in wax: see below, Chap. 7) 'of the statue which [the people] is setting up [of king P]tolemy', τοῦ ἀνδριάντος οὗ ἀνατίθησιν [ὁ δῆμος βασι|λέως Π]τολεμαίου.[26]

However, the genitive on its own is never used to caption honorific statues, as an image 'of X'.[27] Such formulations, used for kings, denote altars, owned by rulers as deities,[28] just as blocks inscribed with the names of gods in the genitive mark the divine ownership of their altars, an important focus of cultic activity[29] as in the case of the block inscribed 'of King Antigonos, Saviour' at Geronthrai in Lakonia,[30] or the round blocks 'of King Attalos (II) Philadelphos' and 'of Queen Apollonis, goddess, Eusebes', from Metropolis in Ionia, which are almost certainly altars for the cult of these rulers.[31] Likewise, a 'base' bearing the inscription Βασιλέως Ἀττάλου Σωτῆρος, 'of King Attalos, Saviour', at Herakleia under Latmos, must be an altar for a cult of Attalos I, set up during a brief Attalid occupation of the city c.230.[32] The genitive in labels for honorific statues only appears during the Roman empire.[33] Another use of the genitive in Roman-era Asia Minor is for heroic or cultic statues, or statues of founders: for

[22] Aeg. Thr. 186; the dedication 'to King Philip Soter (Saviour)' at Thasos might be an altar from a private context (C. Dunant and J. Pouilloux, Recherches sur l'histoire et les cultes de Thasos, ii (Paris, 1958), no. 405). Generally, M. Mari, 'The Ruler Cult in Macedonia', Studi Ellenistici, 20 (2008), 219–68.

[23] It is true that the dative is used in epigrams: e.g. HGE 114, with IG 5.2, p. xxxi, and nos. 304 (Mantineia), 370 (Kleitor), but not 537, and P. C. Bol and F. Eckstein, 'Die Polybios-Stele in Kleitor/Arkadien', Antike Plastik, 15 (1975), 83–93: honorary reliefs set up in several Arkadian cities, with a large, indeed life-size, figure of the statesman and historian Polybios, son of Lykortas (below, Chap. 8), described as an agalma set up for the honorand.

[24] I. Estremo Oriente 140 (decree of a group called the Dollamenoi).

[25] e.g. IG II² 646 (Athens, 295/4); L. Robert, Nouvelles Inscriptions de Sardes: Ier fascicule (Paris 1964), no. 1 (Sardeis, between 216 and 190). See also BE 76, 581 and 78, 401, concerning I. Kyme 19, ll. 34–5: ὀντέθην δὲ αὐτῷ καὶ εἰκόνας should be translated 'and let there be set up dedicated images of him', not 'to him' (αὐτῷ is an Aeolic genitive). A dative does seem to appear in an Augustan-era decree from Cyrene for a benefactor: ἀνθέμεν δὲ αὐτῶι [ἐς τὸ Ἀπόλλωνος] ἱαρὸν ὅπλον ἐπίχρυσον καὶ ἀνδρίαντ[α κτλ.], but the pronoun is probably a genitive with a parasite iota (Robert, OMS ii. 1315, l. 22).

[26] ID 290, ll. 129–31.

[27] The sole exception is from Syracuse: IG 14.2, but the formulation in the genitive is anomalous, and in fact the nature of this base 'of king Hieron', dedicated to the gods, is unclear. The genitive labels for statuettes found in the shrine of Athena at Pergamon (Inschr. Pergamon 164) suggest captions under captured works of art, like others from the same context (M. Fränkel ad loc.).

[28] The inscription of an altar for a ruler in the genitive is explicitly described in an honorific decree from Ilion: OGIS 212, ll. 5–7; same document I. Ilion 31, SEG 41.1052 (the latter reference registers the discussion by F. Piejko, who assigns the document to Seleukos II).

[29] BE 66, 294; see also BE 62, 361: a 'round base' inscribed Ἁλίου Ῥόδου is not a statue base but an altar for two deities, the Sun and Rhodes.

[30] IG 5.1.1122 (Antigonos Doson, c.222).

[31] I. Ephesos 3407–8 with BE 82, 293. Both stones are now apparently lost (my thanks to Dr Serdar Aybek for this information).

[32] OGIS 289 with B. Haussoullier, 'Inscriptions d'Héraclée du Latmos', RevPhil 23 (1899), 283–4 ('certainement un autel'); for a parallel from Pergamon, Inschr. Pergamon 45 (if complete).

[33] A base from Halikarnassos, inscribed with the names of Tiberius Iulius Caesar (the emperor Tiberius) and Drusus Iulius Caesar in the genitive probably bore statues, since it also has an artist's signature (CIG 2657, once in the Strangford Collection); a long inscription for a Stratonikeian benefactor is phrased in the genitive (I. Stratonikeia 1025). See already Franz, Elementa, 331–2. IG II² 3601 records a base baldly inscribed Ἡρῴδου τοῦ Ἀττικοῦ (but is the text complete?).

instance at Sillyon ('Of Mopsos') and at Didyma, where the statue of Mastauros, eponymous hero of a Karian city, Mastaura (modern Nazilli).[34] The usage may derive from the sacral use of the genitive for altars (and also other possessions) of gods. The general point is that honorific statues may be *described* as 'images of X' (above), but are not *inscribed* '(images) of X'. Gods or heroes 'own' or 'hold sway over' altars or cult-statues: divine power and presence are mediated through possession, and the inscription (by saying e.g. 'Of Zeus Soter') both constitutes this relation, performatively (the inscription makes the possession happen), and recognizes it thereafter. The object's own sacred status is created and stated by the inscription in the genitive; the relation of possession reflects the god's power. → honourable statues

The honorific statue is not a statue to the honorand; it is generally not labelled as the possession of the honorand. The convention was to name the statue: this could take place, in the simplest way, by presenting the subject as the statue, or indeed the statue as subject. In the system of grammatical cases in the Greek language, this takes place in the nominative. In this way, the statue 'is' the person; designation and representation, or more precisely the fiction of representation and the convention of nomination, buttress each other in making present a person. These are the workings of naturalism, which make the image and its caption tend towards calligrammatic agreement, word and image complementing each other as substitutes for the absent object.[35]

It is worth looking at the broader practice of nominative labels and its historical development, to try to understand how the nominative was used for honorific statues. Generally, the nominative appears in the following cases: for gods or heroes (reverential nominative);[36] for famous figures ('Great Men' nominative); and for athletes. Thus, a statue of Health, set up by an Athenian, Euxenippos, at Oropos (second half of the fourth century), gives the goddess's name in the nominative, Ὑγίεια, independently from the dedicatory sentence.[37] At Delos, a monument represented heroes from the area around Pergamon, and Attalid rulers (Eumenes I, Attalos I), with the same formulation, their name in the nominative, and both parents: for instance Μιδίας Γύρνου καὶ | Ἁλισάρνης or Βασιλεὺς Ἄτταλος | [Ἀττάλου τ]οῦ Ἀττάλου τοῦ Φιλεταίρου | [καὶ Ἀντι]οχίδος, 'Midias, son of Gyrnos and Halisarne' or '[King] Attalos, son of [Attalos] son of Philetairos, and of Antiochis' (late third or early second century BC).[38]

Great men were labelled in the nominative in the library at Pergamon, where several statues of writers were identified by name and *ethnikon*, for instance Ἡρόδοτο[ς] Ἁλικαρνασσε[ύς], 'Herodotos of Halikarnassos'.[39] At Paphos, in the shrine of Aphrodite: a monument grouping at least two, and probably several more, statuettes of famous philosophers, designated in the nominative alone, without patronymic or *ethnikon* (but the nominative is restored): 'Epikouro[s]', 'Herakl[eitos]' (late third century BC?).[40] Later, in the Roman period, the 'cultural' nominative is common, found on a very large number of bases in Rome, probably from libraries or private houses; there are similar statues from Roman Athens.[41]

[34] Sillyon: D. Hereward, 'Inscriptions from Pamphylia and Isauria', *JHS* 78 (1958), 57–9, no. 1 (with *BE* 59, 450). Mastauros: *Inschr. Didyma* 561 with Robert, *OMS* iii. 1636. Also Side: *I. Side* 267, possibly from statue base.

[35] Foucault, *Ceci n'est pas une pipe*.

[36] Generally, Robert, *Hellenica* xii. 116–19, discussing notably *IG* 4.656 (Argos, Hypermestra); *MAMA* 8.416 (Aphrodisias, Euphrosune, Aglaia, Th[aleia]); see also *Hellenica*, i. 16, discussing *IG* II² 4797 (Horai); *BE* 66, 387; 67, 187 for further discussion.

[37] *Oropos* 347.

[38] *IG* 11.4.1107–8, 1206–8, with L. Robert, 'Sur des inscriptions de Délos', in A. Plassart (ed.), *Études déliennes*, *BCH* suppl. 1 (Athens, 1973), 478–85, expanding on A. Wilhelm.

[39] *Inschr. Pergamon* 198–200. 201–2, naming Balakros Meleagrou and [A]pollonios Philo[tou] are difficult to place; in view of the different formulation, rather than attribute them to lesser writers, I would see them as part of familial monuments (see below, Chap. 5).

[40] T. B. Mitford, 'The Hellenistic Inscriptions of Old Paphos', *ABSA* 56 (1961), 1–41, nos. 10–11 (statuettes rather than busts). Mitford notes a mention of a bronze statue of Zeno in the same shrine, and spared by Cato in 58 BC: Pliny, *NH* 34.92; part of the same monument?

[41] Rome: *IGUR* 1491–1552. Athens: *IG* II² 4256–7, 4259, 4260, 4263–8.

The labels for statues of athletes, giving their names in the nominative, was noted by W. Dittenberger ('erklärende Beischrift'); identity is completed by patronymic and *ethnikon*, important for assigning agonistic glory to family and country.[42] The practice seems to start in the early to mid-fourth century. There are many examples at Olympia; Ἀθήναιος Ἀρπαλέου Ἐφέσιος, 'Athenaios, son of Harpaleos, of Ephesos' (fourth century, on palaeographical grounds); Παιάνιος Δαματρίου Ἠλεῖος, 'Paionios, son of Damatrios, of Elis' (victor in 216 BC).[43]

The use of the nominative does occur for honorific statues, especially in the case of honorific statues dating to the fourth century and in the early Hellenistic period. The statue of Konon set up at Kaunos is simply captioned with his name, patronymic, and *ethnikon*;[44] this example must date to the very beginnings of the honorific statue habit, the late 390s BC. Also in the fourth century, honorific statues for the Hekatomnids were labelled in the nominative, at Delphi (set up by the Milesians), and at Latmos.[45] There are no surviving bases of honorific statues of Alexander, but on Kos, a statue of an officer of Antigonos Monophthalmos, Nikomedes son of Aristandros, was captioned in the nominative;[46] three statues from Chalkis, also labelled with a simple nominative, are probably honorific statues set up c.300.[47] In the first years of third century, the Prienians voted a statue for Megabyxos, the priest of Ephesian Artemis; the decree awarding the statue is preserved, as well as the base—with the honorand captioned in the nominative.[48] Around the same time, in Athens, a statue set up in the Theatre of Dionysos told the viewer who the subject was:[49] Μένανδρος, with no patronymic or other indication—the comic poet Menander (whose statue monument can be reconstructed with some degree of certainty); this practice was followed in the case of other statues of poets.[50] On the Akropolis stood statues of Philokles, king of the Sidonians, and the statesman Chremonides, both set up in the first half of the third century and both labelled in the nominative.[51] On Samos and Priene, in the early third century, statues of individuals could also be set up with nominative labels.[52]

However, the use of the nominative for honorific statues, set up by a community for an individual, is uncommon by the time chosen for this synchronic survey of a grammar of statue inscriptions, c.200. The use of the bald, 'great-man' style nominative has semiotic implications, but also political ones. These are of interest, precisely because the Hellenistic honorific statue

[42] *Inschr. Olympia* 148–238, with cols. 237–7; discussed by Knoepfler, 'Chalcis'.

[43] *Inschr. Olympia* 168, 179.

[44] *Inschr. Kaunos* 82.

[45] *FD* 3.4.176; *SEG* 51.1504 (noted again *SEG* 55.1251bis, from republication).

[46] Kos: *PH* 221; Höghammar, *Sculpture and Society*, no. 1; on Nikomedes, C. Habicht, 'Neues zur hellenistischen Geschichte von Kos', *Chiron*, 37 (2007), 127–9. But the statue might have been a privately dedicated statue: the block is incomplete, and R. Herzog interpreted it as part of a multi-statue family monument (on which genre see below, Chap. 5): 'Symbolae Calymniae et Coae', *RivFil* NS 20 (1942), 19.

[47] Knoepfler, 'Chalcis'.

[48] *Inschr. Priene* 3 and 231; C. V. Crowther, 'I. Priene 8 and the history of Priene in the Early Hellenistic Period', *Chiron*, 26 (1996), 195–250.

[49] *IG* II² 3777 (on the statue of Menander, K. Fittschen, 'Zur Rekonstruktion griechischer Dichterstatuen, 1. Teil: Die Statue des Menander', *AM* 106 (1991), 243–79; C. Papastamati-von Moock, 'Menander und die Tragikergruppe: Neue Forschungen zu den Ehrenmonumenten im Dionysostheater von Athen', *AthMitt* 122 (2007), 273–327; also below, Chap. 3, 90–1, on the site, and pp. 105, 273–4).

[50] *IG* II² 3775, 3778, 3845; restored for the base of the statue of Lykourgos, *IG* II² 3776. The practice was imitated in Roman-era statues of earlier, Hellenistic poets, statuefied in the theatre of Dionysos: *IG* II² 4257, 4267, 4268, perhaps 4266.

[51] *IG* II² 3425; *ISE* 21, reused in late fortifications on the Akropolis.

[52] Samos: *IG* 12.6.1.281 (the absence of a dedicatory verb shows this to be an honorific statue and not a man setting up his own statue, as the first editor S. V. Tracy writes); Priene: *Inschr. Priene* 283 (278, from c.200 BC, might be from a family monument). *SEG* 55.513 seems to be the statue of an *agonothete*, captioned in the nominative, in the theatre of Messene (3rd cent.), but I wonder if it is a dedication by the *agonothete*; at Pergamon, a base which once bore an unfluted column is labelled with a name in the nominative (2nd cent.): Bakchios son of Protarchos, but the nature of the monument is unclear: H. von Prott and W. Kolbe, 'Die 1900–1901 in Pergamon gefundenen Inschriften', *AthMitt* 27 (1902), 44–151, 98–9, no. 96.

soon eschewed this 'great-man' formulation. It assumes the existence of the represented subject, whose fame and status are such that there is no need to explain the statue's identity, nor declare the reason for the statue. The statue does not need to be explicitly located in a specific space or time, be it that of the represented person, that of the persons setting up the statue, or that of the viewing and reading audience. Homer, Epicurus are simply there, and it is assumed that the viewer knows who they are and why they are worth representing.

This function of the nominative—to give the subject of the statue his or her full autonomy—explains its prevalence for heroes, gods, or famous men, including the heroic figure of the victorious athlete. Great men exist in the absolute (this is also how many modern statue inscriptions work). They are not objects, but subjects endowed with agency. Hence their readiness to appear as actors in the epigraphical texts. The name of a victor is often followed by the contest, in the accusative, as direct object of the action of winning (the participle 'having won', is optional): Τηλέμαχος Τηλεμάχ[ου]‖ Ὀλύμπια τεθρίππωι, Πύθια κέλητ[ι]. | Φιλωνίδης ἐποίησε. 'Telemachos, son of Telemachos, (having won) the Olympia, with the four-horse chariot; the Pythia, with the horse. Philonides made it' (Olympia, c.300).[53] The origins of the formula lie in the votive offering, 'X offered to such and such a deity, having won such and such a contest', the participle giving the occasion of the victory and the reason for gratitude and requital; the athletic statue is formally a thank-offering, as well as an image of the athlete.[54] But by the omission of the dedicatory verb, the inscription has shifted to become a celebration of the athlete's agency and selfness, sometimes celebrated in narrative epigrams or texts expanding on the caption.[55]

Honorific statues eschew this dimension of absolute existence and agency, implied by the nominative: just like avoidance of the sacral dative for honorands keeps the statue from being a gesture of homage, the suppression of the nominative means the statue is not (primarily) an act of celebration. In addition, the point of the honorific statue is making clear who is doing the honouring. At the simplest, this need could be fulfilled by a caption providing this informa-tion, 'X has dedicated an image of Y'—all of the conditions and cultural constraints are satisfied (avoidance of cultic-like homage, sacral possession, or celebratory autonomy; specific social contextualization). In the late Hellenistic period, the Iasians set up the statue of a young man, honouring him for the appropriate virtues, and declaring their action:

ὁ δῆμος Ὀβρίμου τοῦ Ἀρτέμω[νος]
παιδὸς τὴν εἰκόνα, ἀρετῆς
ἔνεκεν πρὸς τὸ[ν δῆ]<μ>ον καὶ εὐταξ[ίας]
καὶ φιλομαθίας [καὶ τ]ῆς πρὸς το[ὺς]
γονεῖς φιλοστοργίας, θεοῖς.

The people (has dedicated) this portrait of Obrimos, the boy of Artemon, on account of his goodness towards the people and his well-behavedness and his love of learning and his affection towards his parents, to the gods.

However, such flat formulas are rare, confined to Iasos and Mylasa, and late Hellenistic and Roman.[56] More canonical, and in fact more intriguing, are the two specific types of narrative formulas, constructed around a nominative-accusative pairing, and omitting any mention of

[53] Olympia: *Inschr. Olympia* 177 (also in *IAG* 34); also e.g. *Inscr. Lindos* 2.699 (*IAG* 47); *IAG* 20 (Olympia, Xenokles of Mainalia, early 4th cent.; inscription followed by epigram where athlete/statue speaks out); 21 (Thasos, Theogenes, early 4th cent., with list of victories, introduced by sentence: Θευγένης Τιμοθέου Θάσιος ἐνίκησεν τάδε, 'Theogenes son of Temoxenos, of Thasos, won the following'); 40 (Sikyon, Kallistratos son of Philothales, c.260–220 BC, Kallistratos' name followed by long list of contests); 44 (Tegea, Damatrios son of Aristippos, late 3rd cent.); 49 (Xenothemis son of Kleostratos, Miletos, mid-2nd cent.).

[54] e.g. *IAG* 3 (same document in *SEG* 11.90, *ML* 9), Nemea, mid-6th cent.; 35 (from *Inscr. Lindos* 1.68), Lindos, c.300–290 BC.

[55] e.g. *IAG* 22 (from *IG* II² 3125; also J. Ebert, *Griechische Epigramme auf Sieger an gymnischen und hippischen Agonen* (Berlin, 1972), no. 40); *FD* 3.3.128.

[56] *I. Iasos* 120; also 99, *I. Mylasa* 121, *Sinuri* 16, *SEG* 49.1423 (Bargylia).

the statue. At Herakleia under Latmos (along with the altar of Attalos I, inscribed in the genitive as befitted the possession of a divine figure, receiving cultic honours and holding sway over some specially set-aside sacred space), a block bears the name of Attalos in the accusative—almost certainly part of the formula from an honorific statue for the same king.[57] These two formulas rapidly achieved canonical force—with some exceptions, notably at Athens, and some local diversity in practice. The first is a 'dedicatory' formula, sometimes abbreviated; the second is an 'honorific' formula, constructed around verbs meaning 'to honour'. Both formulas need examining in some detail, to elucidate their history but also their workings, in terms of their semiotics (which will be the theme of this chapter) and of their politics (which will be unpacked in the following chapter).

3. THE 'DEDICATORY' FORMULA

The first, and most frequent, type, can be illustrated easily. An example, chosen out of countless possibilities, comes from Delphi:

$$Λιλαιέω[ν ἁ πόλις Πάτρωνα τοῦ δεῖνος Λιλαιέα],$$
$$ὅτι τὰν πόλιν [ἠλευθέρωσε, τὸν <ἑ>αυτᾶς εὐεργέταν]$$
$$Ἀπόλλωνι Πυθ[ίωι ἀνέθηκ]εν.$$

The city of the Lilaians dedicated to Apollo Pythios [its benefactor Patron, son of . . .], of Lilaia, because he [freed] the city.[58]

The verb 'to dedicate' could be omitted, as on a first-century base from Pagai:

$$ὁ δᾶμος$$
$$Σωτέλην Καλλινίκου, τὸν ἑαυτοῦ$$
$$εὐεργέταν, ἀρετᾶς ἕνεκεν καὶ$$
$$εὐνοίας θεοῖς.$$

'The people (has dedicated) Soteles son of Kallinikos, its benefactor, on account of his goodness and his goodwill, to the gods'.[59]

This type of formula[60] is extremely widespread, documented in just about any part of the Hellenistic world, from Sicily[61] and Italy[62] to Babylon and Iran,[63] from the Black Sea[64] to Egypt and Libya. Cities, civic bodies, associations use it when honouring benefactors (*passim*), athletes,[65] magistrates, and priests or priestesses upon exit of office.[66] Its elements are the mention of the community doing the honouring in the nominative, the name of the person (or

[57] Haussoullier, 'Inscriptions d'Héraclée du Latmos', 283–4.

[58] *SEG* 16.328 (also *ISE* 2, p. 31), c.207?

[59] *IG* 7.193, with Wilhelm, *Inschriftenkunde*, i. 261–76.

[60] Veyne, 'Honneurs posthumes'; Klaffenbach, *Griechische Epigraphik* (2nd edn, Göttingen, 1966), 62–6; J.-L. Ferrary, *Philhellénisme et impérialisme* (Paris, 1988), 556–7; C. A. Mango, 'Epigrammes honorifiques, statues et portraits à Byzance', republished in *Studies in Constantinople* (Aldershot, 1993), 23; J. M. Højte, 'Cultural Interchange? The Case of Honorary Statues in Greece', in E. N. Ostenfeld, K. Blomqvist, and L. C. Nevett (eds), *Greek Romans or Roman Greeks? Studies in Cultural Interaction* (Aarhus, 2002), 59; already M. Holleaux, 'L'Inscription de la tiare de Saïtaphernès', *RA* 29 (1896), 159–71 (on the inscription of the forged 'tiara of Saitaphernes' and honorific inscription practice).

[61] e.g. *ISE* 58 (from Olympia; between 263 and 215 BC); in Sicily itself, e.g. *IG* 14.287 (Segesta), possibly 288 (Segesta, found in theatre: honorific statue base rather than 'epistylium'?), 353–5 (Halaisa), 359, 366, 368–9 (Halountion), 448 (Katane).

[62] e.g. *Iscr. Napoli* 30, 33 (1st cent. BC).

[63] *I. Estremo Oriente* 102, 183, 208.

[64] An early example: *IOSPE* I² 25 (*SEG* 32.794), end of the 4th cent. BC. The base is inscribed with a decree, and the final formula ὁ δῆμος Διὶ Σωτῆρι: did this formula involve the name of the honorand in the accusative, carved on the now lost upper part of the base, or was he implied by his apparition in the body of the decree?

[65] *Inschr. Olympia* 186 (set up by the Erythraians for a *periodonikes*); *IG* 12.6.1.336, 338 (Samos, Heraion, 1st cent.).

[66] *IG* 14.287 (Egesta).

occasionally the community)[67] being honoured, a verb of dedication (nearly always ἀνέθηκεν, literally 'has set up'), a mention of the divine recipient of the statue offering (a specific god, or in general terms θεοῖς / τοῖς θεοῖς),[68] and a phrase explaining why the statue was set up. This phrase could be constructed out of names of qualities in the genitive, with ἕνεκεν, 'on account of'; or by a participle in the accusative, agreeing with the dedicated person; or, from the late Hellenistic period onwards, by longer descriptions of the honorand's actions and qualities (see below for an example: Aiskhylos of Eretria). The formula is canonical enough to influence the way in which Pausanias describes statues. After Patron led the Lilaians in their successful attempt to free themselves from an Antigonid garrison, Λιλαιεῖς δὲ αὐτὸν ἀντὶ τῆς εὐεργεσίας ταύτης ἀνέθεσαν ἐς Δελφούς, they 'set him up in Delphi in return for this good deed', the expression being exactly the same as on the inscription on the base of Patron's statue.[69] Honorific epigrams, when describing public statues, occasionally also describe communities as 'setting up' the honorand.[70]

In practice, there is variation in the use of the formula, according to dialect, geography, history: the city can be called ὁ δῆμος (more often in the Eastern Greek world) or ἡ πόλις (in central Greece, the Peloponnese, Naukratis); from the late first century BC onwards, the city often describes itself as ἡ βουλὴ καὶ ὁ δῆμος rather than simply indicating 'the people' or 'the city' as the honouring authority.[71] The specification of group identity of dedicator and dedicated varies, according to context and pragmatic need. The caption of a statue set up at Eretria told the viewer who the honouring body was (the city of the Delphians), but did not give an *ethnikon* for the honorand (Aiskhylos son of Antandrides)—an eminent Eretrian (notably known as the political opponent of the philosopher Menedemos), he needed no identifier in his home town, and the inscription conveys this by the very absence of explicit indication:[72]

> Δελφῶν ἡ πόλις
> Ἀ[ἰ]σχύλον Ἀντανδρίδου ἱερομνημο[νεύσαντα]
> καὶ εὐεργετήσαντα αὐτὴν τοῖς [θεοῖς].
> Τεισικράτης ἐποίησεν.

The city of the Delphians (has dedicated) Aiskhylos son of Antandrides, who was *hieromnemon* and who did good to the city, to the gods.

Teisikrates made (it).

The order of the elements can shift around: the dedicator can come first, or the dedicated honorand,[73] or even the gods, according to the perceived importance.[74] When the Samians

[67] *IG* 12.6.1.350, from the Samian Heraion, is a pilaster monument bearing a statue of the Roman People, set up by the *demos* of Samos. On the Capitol in Rome, many communities set up similar statues: *IGUR* 6, C. Reusser, *Der Fidestempel auf dem Kapitol in Rom und seine Ausstattung* (Rome, 1993). C. Habicht, 'Samos weiht eine Statue des *populus Romanus*', *AthMitt* 105 (1990), 259–68; Ma, 'Oropos (and Elsewhere)'.

[68] The formula τοῖς θεοῖς has been interpreted to mean that the statue was set up in the agora rather than a shrine: R. Étienne and D. Knoepfler, *Hyettos de Beotie et la chronologie des archontes fédéraux entre 250 et 171 avant J.-C.*, *BCH* suppl. 3 (Paris, 1976), 159–60 and nn. 484, 487; D. Knoepfler, 'L. Mummius Achaicus et les cités du golfe euboïque méridional: A propos d'une nouvelle inscription d'Érétrie', *Museum Helveticum*, 48 (1991), 252–80 (but the rule is less absolute than it seems: *Inschr. Kaunos* 59, a dedicatory epigram on an exedra set up in the shrine of Apollo, mentions 'all the immortals' as recipients of the offering).

[69] Pausanias 10.33.3.

[70] *IG* 4² 1.144; possibly *I. Knidos* 103 (but the verb is lost).

[71] C. Habicht, *Die Inschriften des Asklepieions*, Altertümer von Pergamon 8/3 (Berlin, 1969), 157–8. The inscription on the statue base of Philip V at Hierakome (Hierokaisareia) in Lydia, [βα]σιλέα Φίλιππον | [ἡ βου]λὴ κ(αὶ) ὁ δῆμος (*TAM* 5.1261A), is clearly Roman in date, judging by the formulation as well as the lettering (and the abbreviation). The description of the city as ὁ δῆμος καὶ ἡ βουλή, in that order, occurs earlier (*SEG* 57.1104, Tralleis, for Q. Mucius Scaevola, early 1st cent.).

[72] *SEG* 32.856; Knoepfler, *Décrets érétriens de proxénie*, 258–9.

[73] *Milet* 1.3.158 (Seleukos I, named first); J. Wallensten, and J. Pakkanen, 'A New Inscribed Statue Base from the Sanctuary of Poseidon at Kalaureia', *OpAth* 35 (2010), 156–65 (Ptolemy II and Arsinoe II, named first, on statue base from Kalaureia, set up by Arsinoe-Methana). I thank C. Habicht for help with this inscription.

[74] *IG* 7.556 (Tanagra).

honoured Berenike, the daughter of Ptolemy II (and future wife of Antiochos II), they made sure every element was in its 'right' place, in a striking example of the 'regnal order':

$$\beta\alpha\sigma\iota\lambda\acute{\epsilon}\omega\varsigma\ \Pi\tau o\lambda\epsilon\mu\alpha\acute{\iota}ov$$
$$\tau o\hat{v}\ \Pi\tau o\lambda\epsilon\mu\alpha\acute{\iota}ov\ \Sigma\omega\tau\hat{\eta}\rho o[\varsigma]$$
$$\theta v\gamma\alpha\tau\acute{\epsilon}\rho\alpha\ \beta\alpha\sigma\acute{\iota}\lambda\iota\sigma\sigma\alpha\nu$$
$$B\epsilon\rho\epsilon\nu\acute{\iota}\kappa\eta\nu\ \acute{o}\ \delta\hat{\eta}\mu o\varsigma\ \acute{o}\ \Sigma\alpha\mu\acute{\iota}[\omega\nu]$$
$$"H\rho\eta\iota.$$

4

Of King Ptolemy—the son of Ptolemy Soter—the daughter, Queen Berenike, the people of the Samians (dedicated her) to Hera.[75]

In this particular case, the hierarchical order distorts the syntax, the king coming first, then his filiation, then his relation to Berenike, then, at last, the body putting up the statue, the city-state of Samos.

Finally, the verb 'to dedicate' and any mention of the gods as recipients of the dedication is often omitted—this formula, with a name in the nominative and a name in the accusative, is widespread, and its implications with be discussed in the following chapter. Even so, a statue with such an inscription can be perceived as a dedication. On Delos, a statue in the gymnasion simply read ὁ δῆμος ὁ Δηλίων | Σώσιλον Δωριέως—but when Athenian officials described it in an inventory, upon the Athenian takeover of the island in 167, they classified it with the other offerings: the statue appears as 'dedication, ἀνάθεμα, of the Delians'.[76]

In spite of significant variation, the nature of this type of formula remains constant: it frames the act of setting up a statue as a permanent gift to a god or gods (often explicitly named), recorded in permanent writing—a religious act. The verb, ἀνατιθέναι, 'to dedicate', is religious in connotation. A decree of the garrisons in Eleusis, Panakton, and Phyle, in Attica, for the *strategos* Aristophanes, mentions the making and setting up of a statue of the honorand, but stipulates the proclamation of the ἀνάθεσις, the consecration, of the statue, and the men chosen to take care of the statue (eleven Athenians, forty-eight non-Athenian mercenaries) are to be 'those elected for the dedication of the statue and those of the mercenaries who joined in the dedicating', συνανέθηκαν.[77] The verb καθιερόω, 'to consecrate', is used for (probably) an hon-orific statue in late Hellenistic Lydia.[78] Grandly, the verb appears on the statue base of a monument set up by the *demos* of Philadelphia for Pompey (who is named first in the formula, just as happens for some Hellenistic kings);[79] most spectacularly, it is carved on the very large base found in the shrine of Athena at Pergamon, for a statue of Augustus set up by the *demos* and the Roman residents.[80] In the Roman empire, the verb is used exclusively for the statues of emperors; it may represent an attempt at recapturing the sacred force of the verb of dedication in statue inscriptions, and thus attest a gradual weakening of the force of ἀνέθηκεν, but also the original potency of the verb.[81]

The most widespread way of labelling an honorific portrait was thus to make it a dedication. The 'dedicatory' formula is an adaptation of the old formulas for dedications and votives, which appear in the Archaic period already.[82] These formulas often take the form 'X dedicated

[75] *IG* 12.6.1.347 (*c*.270). Also *Inschr. Pergamon* 64; *OGIS* 320–1; an example from Dion in Macedonia, discussed in *BE* 01, 273.

[76] *IG* 11.4.1087, *ID* 1412, l. 19, and 1417, l. 134, with D. Knoepfler, 'La Base de Sôsilos à la synagogue de Délos', in Plassart, *Études Déliennes*, 233–7, A. Jacquemin, 'Notes sur quelques offrandes du Gymnase de Délos', *BCH* 105 (1981), 155–7, and J.-C. Moretti, 'Le Gymnase de Délos', *BCH* 120 (1996), 617–38, 'Les Inventaires du gymnase de Délos', *BCH* 121 (1997), 125–52.

[77] *Syll.* 485. [78] *SEG* 49.1559. [79] *TAM* 5.1427.

[80] *Inschr. Pergamon* 383 (with F. Felten, 'Römische Machthaber und hellenistische Herrscher: Berührungen und Umdeutungen', *JÖAI* 56 (1985), Beiblatt, 119.

[81] *Carie*, II no. 16 (Tabai, Augustus); *Amyzon* 70 (Amyzon, Antoninus Pius); *PH* 393 (koan demes, Claudius); *Tit. Cal.* 109 (Kalymna, Gaius); *IG* 12.1.39 (Rhodes, Poppaea); *CID* 4.136 (Delphi, Tiberius).

[82] M. L. Lazzarini, *Le formule delle dediche votive nella Grecia arcaica* (Rome, 1976); P. Pucci, 'Inscriptions archaïques sur les statues des dieux', in M. Detienne (ed.), *Les Savoirs de l'écriture en Grèce ancienne* (Lille, 1988), 480–97. On the derivation of the formula from dedications, M. L. Lazzarini, 'Epigrafia e statua ritratto: Alcuni problemi', *AAPat* 97 (1984–5), 93–7. Most recently, Keesling, *Votive Statues*.

to the god' (with direct object omitted), or 'X dedicated me to the god' (with the so-called 'oggetto parlante' or 'speaking object' formulation).[83] A well-known example, illustrious in the history of Greek sculpture is the so-called 'Geneleos group' from Samos: [---]νάρχης ἡμέας ἀνέθηκε τῆι Ἥρηι, '... narchos dedicated us (a group of statues) to Hera' (c.550).[84] The earliest honorific statues were labelled in the nominative (as suggested by the statue of Konon at Kaunos, c.394, and the statues of the Hekatomnids in the following decades); the statues of Idrieus and Ada set up at Delphi by the Milesians combine a dedicatory formula without an object with the name of the honorands in the nominative, two juxtaposed (yet causally linked) formulas that convey the importance and autonomy of the honorands as well as the origin of the monument in the dedicatory gesture of a particular community:

> Μιλήσιοι ἀνέθεν Ἀπόλλωνι Πυθίωι.
> Ἰδριεὺς Ἑκατόμνω. Ἄδα Ἑκατόμνω.
> [Σ]άτυρος Ἰσοτίμου ἐποίησε Πάριος.
>
> The Milesians set up to Pythian Apollo.
> Idrieus son of Hekatomnos. Ada daughter of Hekatomnos.
> Satyros son of Isotimos made this, of Paros.[85]

This type of formula may have been widespread. It appears on an Athenian dedicatory relief, where the divine figure is left to exist in the nominative (e.g. 'Theseus'), and the dedicatory formula declares who set up—something left unsaid: the relief, the image, the whole monument.[86] The epigram under the statue of Lysandros set up c.404 at Olympia combines a mention of the dedication of the monument in the first distich (ἀνθέντων δημοσίᾳ Σαμίων) with a second distich that celebrates Lysandros' glory and *arete*, moral quality:[87] the dynamic of the epigram resembles the juxtaposed dedication and nominative on the monument at Delphi.

However, by the time the Milesians set up the statues of the two powerful Hekatomnid dynasts, the full dedicatory formula, of the canonical type described above, had already emerged. It appeared in the early fourth century, c.370–360: Pelopidas appears in the accusative in a dedicatory formula on the base of a statue set up by the Thessalians at Delphi (369 BC)[88]— as indeed do Hekatomnos, Maussollos, and (probably) Artemisia, on the bases of statues set up in their honour at Kaunos.[89] By the end of the fourth century, the dedicatory formula, with all of its variants, is widespread and, indeed, can be considered to have achieved institutionalized, normal status (with exceptions, such as Athens, which continued to use the nominative). The shift to this formula is caused by the emergence of the genre of the honorific statue itself, within the pre-existing dominant mode of setting up statues, as dedications to divinities. In Archaic and Classical votive and dedicatory situations, the identity of the dedicator was commemorated in monumental writing, since his involvement within the religious act of exchange with the divine, and addressing the divine, was the point of the monument. As mentioned above, the nature and identity of the represented person, or indeed the thing dedicated, was often left unspoken, for the viewer to understand from the image and the

[83] M. Burzachechi, 'Oggetti parlanti nelle epigrafi greche', *Epigraphica*, 24 (1962), 3–54 (dominant in the Archaic period, declines afterwards); J. Svenbro, *Phrasikleia: Anthropologie de la lecture en Grèce ancienne* (Paris, 1988), qualifying the notion of 'speaking object'.

[84] Lazzarini, *Dediche votive*, no. 166.

[85] *FD* 3.4.176.

[86] *IG* II² 4553 (early 4th cent.), with G. Ekroth, 'Theseus and the Stone: The Iconographic and Ritual Contexts of a Greek Votive in the Louvre', in J. Mylonopoulos (ed.), *Divine Images and Human Imaginations in Ancient Greece and Rome* (Leiden, 2010), 143–69 (such labelling in the nominative is in fact rare on the surviving votive material).

[87] Pausanias 6.3.14.

[88] *SEG* 22.460, 35.48—not as good as Bousquet, 'Inscriptions de Delphes' (1963), 206–8, with earlier bibliography (Bousquet, Wilhelm).

[89] *Inschr. Kaunos* 46, 47, with J. Ma, 'Notes on the History of Honorific Statues in the Hellenostic Period', in P. Martzavou and N. Papazarkadas (eds), *New Documents, New Approaches: The Epigraphy of the Post-Classical Polis* (Oxford, 2012), 165–6.

context. In the case of the honorific statue, the formula was adapted to add an important feature to the name of the dedicating/honouring entity: the name and identity of the honorand, whose identity has to be revealed, celebrated, and eternized in image and in word—his identity is hence half of the point of the whole monument. The honorand is not in the dative, but in the accusative; not the recipient of homage, but a middle term within a process and a transaction (next chapter).

The dedicatory formula is widespread, and the rules that govern its use can be established consistently; its origin and history can also be reconstructed and illustrated, from Archaic practice to the emergence of a formula specifically directed at conveying the necessary information about an honorific monument, when the honorific statue habit spreads during the fourth century. The widespread currency and regularity, combined with the formula's history, only make it more interesting that it is rather difficult to translate, as may have appeared already from the examples above. 'The people has dedicated X to the gods' is a literal translation; more frequently, in the secondary literature or in publications of inscriptions, translations must paraphrase and expand, along the lines of 'The people has dedicated (this statue of) X/X (qua statue) to the gods'. This awkwardness is interesting, and deserves attention, rather than being passed over as simply a linguistic phenomenon: 'LSJ s.v. ἀνατίθημι II—'ἀ. τινά *set up a statue of* . . . ' is lexically correct and resolves any awkwardness for the reader or translator of Pausanias, but it leaves out the semiotic oddness of the formula.

'The people has dedicated (this statue of) X'. The little phrase between brackets should give us pause. It takes us, insistently, to the heart of what images do: they confront the viewer with a presence which is also an absence. The game between presence and absence is already present for the nominative, whose workings should be unpacked here as a prelude to examining the strangeness of the dedicatory formula. 'Megabyxos' designates (a statue of) Megabyxos; the nominative caption does not say 'statue of Megabyxos', but 'Megabyxos' *tout court*. The ellipsis in the caption makes the text directly refer not to the statue, but to the person, just as the statue claims to be the person: the workings of the image are reinforced by the direct referentiality of the caption. I must be ready to accept that the bronze image I see, the letters I read, 'Megabyxos', *are* Megabyxos, a living person; word and image, nomination and representation, interlock, as mutually reinforcing substitutes for the absent Megabyxos, in a calligrammatic effect:

(statue of Megabyxos)

+

'(statue of) Megabyxos'

(= Megabyxos)

This effect is created by the nominative's affirmative force, in declaring presence and realness: the issues of absence and representation are silenced by the nominative's authority, when we see the statue and read the inscription. This effect is preserved in the pseudo-'oggetto parlante' formula ('X dedicated us to Hera'), because of the mystifying authority of the first-person pronoun. The utterance is supposedly emanating from both the person and the image; it focuses attention on the here and now, and reinforces the naturalistic effect of the artwork that says 'this is a person/this particular person' and stands in for the person:

(statue of Megabyxos)

+

'I am (the statue of) Megabyxos'

(= Megabyxos)

But what happens when this ellipsis is offset by being embedded in the dedicatory formula ('the city of the Lilaians has dedicated Patron, to Apollo')? The paradoxes of representation and nomination are taken one step further. The text, with its ellipsis, underlines the fact of representation: representation is itself represented, and the statue, not mentioned but immediately summoned when the text is read, is both absent (in the text) and present (in indisputably physical form, bronze or marble, before the reader-viewer), like the represented person, personally absent yet present through the image. The referent of the caption needs elucidating:

(Statue of Patron)

+

'The people has set up (a statue of) Patron'

(= ?)

The unspoken presence of the statue is clear in the case of a late second-century base, set up in the theatre at Priene by a woman named Megiste:

> Μεγίστη Ἀπολλοδώρου
> θυγάτηρ, κληρονόμος
> οὖσα τῶν τοῦ ἀνδρὸς
> ὑπαρχόντων Θρασυβούλου τοῦ
> Φιλίου, ἔστησεν τὸν ἑαυτῆς
> ἄνδρα Θρασύβουλον Φιλίου
> ἧι ἐτίμησεν αὐτὸν ὁ δῆμος,
> ἀρετῆς ἔνεκεν καὶ εὐνοίας
> τῆς εἰς αὐτόν.

4

Megiste, daughter of Apollodoros, being the heiress of the property of her husband, Thrasyboulos son of Philias, set up her husband, Thrasyboulos, son of Philias, (in the form of the statue) with which the people honoured him, on account of his *arete* and goodwill towards it.[90]

Admittedly, this particular inscription does not come from the simple case of public honorific statue, but from a public statue erected privately (the phenomenon is analysed extensively below, Chaps. 5–6), and the formula is slightly different from the normal dedicatory formula used in public honorific monuments (and indeed, in private family monuments). However, the Prienian inscription is of great interest in showing the workings of the narrative captions to statues: the statue (εἰκών in Greek, 'likeness', a feminine noun), a public decreed honour, appears as a ghostly *sous-entendu* in the dative relative pronoun ἧι, which reveals the way in which the statue is both present and absent in the workings of the captioning formula.

The dedicatory formula arises out of the combination of the desire to identify the dedicator, the body doing the honouring, and the need to fix clearly the identity of the honorand—all the various elements which make up the honorific transaction: the phrases to describe dedication were grafted onto the name caption, and the play of syntax intervened, by converting the name caption from nominative into the accusative, to weld the elements together. The result is nonetheless slightly strange: the accusative means that the dedicatory formula intrudes within the name-object copula; the dedicatory disturbs the repose of the calligrammatic formula by which the viewer/reader, in ignoring the ellipsis of the statue in the formula, agrees to see the person when he views the statue and reads the caption. The *mise en abyme* means that the viewer/reader is being made aware of his agreement to the workings of the image, even as he is reading a sentence where they stop making quite so much sense: did the people set up Patron, the living, flesh-and-blood person, as the inscription tells us? No, of course: they set up (a statue of) Patron, and the reader knows *ce que parler veut dire*. The point is not to see the

[90] *Inschr. Priene* 255 (still *in situ* in the theatre, at the foot of the stage building); here Plan 15 and 92–4, Fig. 3.4.

dedication 'of the person', rather than of an image of the person, as a simulacrum of human sacrifice or metaphor of sacred bondage (that would amount to overinterpreting the religious content of the formula)—but to solve a semiological puzzle, posed and dissimulated by the adaptation of the dedicatory formula.

The solution to the puzzle of the dedicatory formula comes with several consequences. The first is to accept the pragmatic relevance of a narrative formula, which in itself is objective and could be uttered anywhere: 'The Lilaians set up (a statue of) Patron' can be read on a page of Pausanias, far from Delphi. The formula lacks explicit deictics, such as 'this statue' or 'I, Patron'; however, by being inscribed under the statue, it compels the viewer/reader to relate it to the statue, and hence endows the name, 'Patron', with deictic force—(this statue of Patron). The second consequence is that the (re)acceptance of the calligrammatic efficacy of the monument entails the agreement to the general force of the formula. What is being captioned? The transaction itself:

(Statue of Patron)

+

'The people has set up (a statue of) Patron'

(= the people has set up a statue of Patron)

The formula demands the collaboration of the reader/viewer to make sense ('X has dedicated Y' is equivalent to 'X has dedicated *this statue* of Y'), the statue no longer is designated by a name or a caption, but is caught within a narrative of relation, between dedicator and dedicated— and deity; the honorand is only one part of a story and a transaction, within which the euergetical relationship is masked. In this book, the dedicatory formula will be translated literally, 'X has set up Y to Z', leaving out the statue, and keeping the strangeness.

The relation between dedicator and honorand re-emerges, as what remains when the verb and recipient of dedication are left out:

ὁ δῆμος
Ἀπολλόδωρον Ποσειδωνίου
ἀρετῆς ἔνεκεν καὶ εὐνοίας
τῆς εἰς αὐτόν.

The people (has dedicated? has statuefied? has honoured?—at least, has done something to, has a relation with) Apollodoros son of Poseidonios, on account of his excellence and his goodwill towards it. (Priene, early second century)[91]

This frequent, highly abbreviated formula, describes the interpenetration of the two copulas, the name-object copula, and the dedicator-honorand copula, in a short expression of the nature of the honorific monument. As used for honorific statues, it emerges later than the full dedicatory formula (which it never completely displaced); it also appears in many other contexts than the bases of honorific monuments. Apollodoros son of Poseidonios also appears in the accusative in the heading of a decree of Phokaia, inscribed at Priene—the formula acts as a short hand for the whole euergetical transaction.[92] The emperor Nero was named in the accusative in an honorific inscription—on the architrave of the Parthenon, not because the temple was dedicated to Nero, but because this was a place of maximum publicity to inscribe an honorific text summarizing and enacting an honorific decree, also symbolized by a crown.[93] Such inscriptions make clear the honorific force of the nominative-accusative copula, and its suitability as the caption, and creator, of the honorific monument.

[91] *Inschr. Priene* 237.
[92] *Inschr. Priene* 65.
[93] *SEG* 32.251 (summarizing Carroll, *The Parthenon Inscription*).

4. THE HONORIFIC FORMULA

The second, much more explicit, way of designating an honorific monument is by accompanying it with a little narrative sentence structured around the verb ἐτίμησεν, 'honoured'. It has received far less attention than the dedicatory formula.[94] Here is one example, taken among many others; it comes from the shrine of Athena at Lindos, where the Rhodian deme of the Lindians honoured one of its members in the early second century BC.



[Λίν]διοι ἐτίμασαν
[Ἀγή]σανδρον Μικίωνος
χ[ρυ]σέωι στεφάνωι·
εἰκόνι προεδρίαι ἐ[ν] τοῖς
ἀγῶσι· ἀρετᾶς ἕνεκα καὶ
εὐνοίας ἂν ἔχων διατελεῖ
περὶ τὸ πλῆθος τὸ Λινδίων.

Πυθόκρι[τ]ος Τιμοχάριος Ῥό[διος] ἐπόησε.



4

The Lindians honoured Hagesandros, son of Mikion, with a golden crown, a portrait, front seating in the contests, on account of his excellence and the goodwill which he continually has towards the community of the Lindians.

Pythokritos son of Timocharis, of Rhodes, made this.[95]

This type of formula is less widespread than the dedicatory formula and its abbreviation, the nominative + accusative formula (which may account for its relative neglect in the scholarly literature). The earliest examples appear in the late fourth and early third centuries, with no fixed wording.[96] The formula gained in popularity in the late third century, and is very often (though never exclusively) used in Rhodes, from the early second century onwards, in the shape exemplified by the Lindian inscription quoted above: a narrative sentence, giving the name of the organization doing the honouring, the honorand, a list of the honours, and an indication of the honorand's qualities.[97] This 'Rhodian-style' formula is found in areas that were exposed to Rhodian influence or control, most notably the Rhodian Peraia, Karia, and Lykia, from the early second century onwards.[98] It also found in free cities of Karia, for instance Mylasa and Halikarnassos, or in the islands, such as Kos, Samos, Melos.[99] Shorter variants are found outside Rhodes, for instance at Miletos.[100] On Rhodes itself, it declines from the first century AD onwards; in Karia and Lykia, the full formula survived into the period of the

[94] It is mentioned in Franz, *Elementa*, 330–1 (an account which has aged well, though needs modifying: unlike what Franz writes, the 'full', Rhodian style formula did not come after the 'short' formula, but is attested earlier; see below for these definitions).

[95] *Inscr. Lindos* 1.169.

[96] *IG* 4² 1.615 (with the verb στεφανόω), 4th cent. (the Argive examples, restored, *IG* 4.585, 592, might be related); *Tit. Cam.* 92 with Chr. Blinkenberg, *Lindos. Fouilles et recherches, 1902–1914*, ii. *Inscriptions*, 2 fasc. (Berlin 1941), 51 no. 10, early 3rd cent. (Blinkenberg's *c.*290–280 BC is perhaps a little high), *ISE* 80.

[97] *Inscr. Lindos* 123, 125 (*c.*225); *I. Rhod. Peraia* 551–2 (2nd half of the 3rd cent.); *IG* 12.7.269 (statue set up by the Samians on Minoa) might date to the 3rd cent. BC, from the letter forms and the prosopography (*IG* 12.6.2.1217, a decree of the Samians on Oinoe of Ikaria, stipulates a very similar inscription; 2nd-cent.).

[98] *I. Stratonikeia* 1418 (early 2nd cent., whatever the context; decree of the Chrysaorians), Kedreai: *I. Rhod. Peraia* 556, same document *Pérée rhodienne* 7; Robert, *OMS* ii. 1368–70 (Antiphellos); *SEG* 37.866 (Keramos, 1st cent. BC); *Amyzon* 24 (early 2nd cent.); *TAM* 2.498 (Xanthos, early cent.1st cent., and hence after Rhodian domination: in contrast, in the decree of the *neoi* passed in 196 BC, *SEG* 46.1721, the honorific text stipulated for the statue of the gymnasiarch Lyson is a nominative + accusative: no trace of Rhodian influence); *I. Iasos* 23, 119, 85.

[99] Halikarnassos: A. Maiuri, 'Viaggio di esplorazione in Caria. Parte III. Inscrizioni. Nuove Iscrizioni dalla Caria', *ASAtene*, 4–5 (1921–2), 467, no. 6 (*SEG* 4.184), 1st cent. BC according to Maiuri; his facsimile would admit 2nd cent.; also *IG* 12.4.1 34 (earlier *Iscr. Cos* EV 19), set up at Kos. Mylasa: *I. Mylasa* 110, 119. Islands: *IG* 12.6.1.284, 286 (Samos), *PH* 409 (Kos) and *Tit. Cal.* 139–40 (Kalymna), *IG* 12.3.1097 (Melos: statue of Rome).

[100] *Inschr. Didyma* 141 (150s BC, W. Günther in A. Filges, *Skulpturen und Statuenbasen* (Mainz am Rhein, 2007), 168); *Milet* 1.7.248 (late 2nd or early 1st cent. BC).

Roman empire, long after the end of Rhodian control.[101] It also appears, sporadically, in other places, for instance in late second-century Mysia and Lydia, or in first-century Pergamon.[102]

From the late Hellenistic period onwards, the full mention of honours was sometimes shortened to a single phrase, of the type ταῖς μεγίσταις τιμαῖς, 'the people honoured (X) with the greatest honours'.[103] A simplified (though not necessarily shorter) type of honorific formula gained popularity, from the first century BC onwards, especially for monuments in honour of Roman officials; it is found in Asia Minor (where it seems to originate; the earliest examples are from post-133 Pergamon),[104] and on some islands.[105] The elements are the honouring body, the verb of honouring, the honorand, and often long descriptions of the honorand's qualities, either through adverbial phrases, or through participial clauses.[106] The formula also influenced the practice in the private funerary (non-statue-related) epigraphy of Roman Asia Minor.[107]

A statue base from Pergamon (49 BC) illustrates the form:

> ὁ δῆμος [ἐτίμησεν]
> Λεύκιον Ἀντώ[ν]ιον Μ[αάρκου υἱόν, ἀντι]-
> ταμίαν καὶ ἀντιστράτη[γον, τὸν πάτρω]-
> να καὶ σωτῆρα, δικαιοδοτ[οῦντα κατὰ τὴν]
> ἐπαρχείαν καθαρῶς καὶ δη[μοτικῶς καὶ]
> ὁσίως.
>
> Μηνόφιλος Μηνογένου ἐπόει.

4

The people has honoured Lucius Antonius, son of Marcus, *quaestor pro praetore*, patron and saviour, having given justice in the province incorruptibly and with love of the people and with purity.
Menophilos son of Menogenes made (it).[108]

Apart from the major typological division between 'Rhodian style' formula (full list of honours) and the 'Anatolian style' formula (honorific verb + participial phrase), there exists a range of minor variants in phrasing, spelling, dialect, and word order.[109] The verb might combine with, or be replaced by, στεφανοῦν, 'to crown', ἐπαινεῖν, 'to praise'.[110] At Kaunos, the

[101] *I. Stratonikeia* 509 (Nerva); 527; *La Carie*, no. 11 (Tabai, late 1st cent. BC or early 1st cent. AD); *TAM* 2.660 (found at Kadyanda, but showing the official use of the 'Rhodian style' formula by the Lykian league) 495, 499 (Xanthos); 580, 593 (Tlos).

[102] *Inschr. Pergamon* 459; *TAM* 5.374 (Kollyda: 1st cent. BC?).

[103] e.g. *I. Knidos* 53–5; *La Carie*, no. 13 (Tabai, Roman period).

[104] *Inschr. Pergamon* 2.252, at ll. 40–4, late 2nd cent.; 455, aftermath of the First Mithradatic War; *TAM* 5.918, probably the front orthostate of a statue base (Thyateira, for Lucullus, hence dating to his pro-quaestorship in Asia, 86–80 BC), 1365 (Magnesia under Sipylos); *I. Kyme* 19 (Kyme, Augustan in date); *MAMA* 6.68 (Attouda; not Attalid, but 1st-cent.: J. and L. Robert, *La Carie: Histoire et géographie historique avec le recueil des inscriptions antiques*, ii. *Le Plateau de Tabai et ses environs* (Paris, 1954), 119); *I. Perge* 14 (Roman-era: 1st cent. AD, from the lettering in Lanckorowski's facsimile?). Generally, Tuchelt, *Frühe Denkmäler*, 57–66, on inscriptions for Roman officials, with chronological indications (participial formulas start in the 80s, become generalized in the 60s BC). *La Carie*, no. 8 (Tabai) might be an earlier example (2nd cent.?).

[105] Well attested on Paros: *IG* 12.5.273–7, 279–81. See also *IG* 12.3.494–9, 501–2 (Thera); *IG* 12.3.247 (Anaphe, variant formula). Kos: Höghammar, *Sculpture and Society*, no. 46 is a very early 1st cent. example. The formula is mistakenly restored in Höghammar, *Sculpture and Society*, no. 45 for the statue of Flamininus set up by the Koans (between 196 and 194 BC); on this text, see C. Habicht, 'Beiträge zu koischen Inschriften des 2. Jahrhunderts v. Chr.', in N. Ehrhardt and L.-M. Günther (eds), *Widerstand, Anpassung, Integration* (Stuttgart, 2002), 103–7.

[106] The practice may be alluded to in Cicero, *Pro Flacco* 31 (perhaps referring to the text of proclamations, on which see below, rather than statue inscriptions).

[107] Robert, *OMS* ii. 1344–6. The practice is richly documented in *TAM* 5; 702 (AD 36/7) and 775 (46/5 BC), both from Julia Gordos, are funerary *stelai* with both public and familiar honorific formulas, in these particular cases completed with mention of a golden crown.

[108] *Inschr. Pergamon* 410; same formulation in *OGIS* 438, 439. See C. F. Eilers, *Roman Patrons of Greek Cities* (Oxford, 2002), 225.

[109] *Milet* 1.7.248; *IG* 12.3.1116 (Melos, 1st cent. AD); *TAM* 2.760, 3.36.

[110] *Tit. Cam.* 83, 110 (Kamiros, 2nd cent.), *IG* 12.1.1032 (Karpathos, 2nd cent.); *IG* 12.6.1.464 (Samos, 1st cent.?); *I. Stratonikeia* 1010 (1st cent.).

people declared on monuments that it was 'praising and crowning, and honouring with a statue' the honorand:

ὁ δῆμος ὁ Καυνίων ἐπαινεῖ καὶ στε-
φανοῖ Λεύκιον Λικίνιον Λευκίου
υἱὸν Μουρήναν αὐτοκράτορα,
εὐεργέτην καὶ σωτῆρα γεγενη-
μένον τοῦ δήμου χρυσῶι στεφά-
νωι, τιμᾶι δὲ καὶ εἰκόνι χαλκῆι ἐφίππωι
ἀρετῆς ἕνεκεν καὶ εὐνοίας τῆς εἰς ἑαυτόν.

4

The people of the Kaunians honours and crowns L. Licinius, son of Lucius, Murena, *imperator*, who was benefactor and saviour of the poeple, with a gold crown, and honours him with a bronze equestrian statue, on account of his goodness and his benevolence towards it.[111]

Beyond the variants, the general coherence of the formula is clear, and it can be studied as a single phenomenon. The origins of the honorific formula lie in two Hellenistic practices. The first is the practice of 'short epigraphy', namely the publication of abbreviated minutes of official acts. The honorific formula for statues, both in the 'long', Rhodian-style version and the later 'short' version, belongs to this broader context of abbreviated monumental writing.[112] The content of honorific decrees could be summarized in a terse inscribed sentence, for instance in proxeny lists, or in the abbreviated headings found at Priene: the short honorific text recording that the people of the Phokaians (honoured) Apollodoros, son of Poseidonios is an example.[113] The text of such headings is extremely close to the 'Rhodian'-style honorific inscriptions on statue bases, but the Prienians never resorted to such formulas for their own honorific statues: the Prienian abbreviated headings thus clearly illustrate the origin of the honorific formula, as used for statues, in epigraphically published summaries.[114] The award of honours by a community or corporate body could be recorded, often within the representation of a crown (there are very many examples from fourth-century and Hellenistic Athens); such texts are very similar, in structure if not in phrasing, to the 'short' honorific formula.[115] In late Hellenistic Karia, public funerary honours to a good citizen could be recorded in a short notice that the community had 'honoured and buried' him.[116] A particular case is that of the 'Ehrentafel', the collected publication on a single *stele* of abbreviated honorific notices from a large number of cities to the benefit of the same person:[117] the formula usually takes the form of the nominative-accusative copula, with the honours granted in the dative.

[111] *Inschr. Kaunos* 103; also 90 (earlier and simpler), 98, 99, 102, 104–13, 115, 119–22: the formula enjoyed popularity in Kaunos from the late 2nd to the 1st cent. AD.

[112] Gerlach, *Ehreninschriften*.

[113] *Inschr. Priene* 65.

[114] A. Wilhelm, *Beiträge zur griechischen Inschriftenkunde mit einem Anhange über die öffentliche Aufzeichnung von Urkunden* (Vienna, 1909), 280 (discussing *Inschr. Priene* 13; also *Inschr. Priene* 108). *Inschr. Magnesia* 103 gives a non-Prienian example. The epigraphy of Iasos abounds in such abbreviated decrees; among these, one should put *I. Iasos* 85, not a statue base, but part of an architectural element bearing several abbreviated summarized decrees. *Sardis* 51–2 are probably similar documents. *La Carie*, no. 10, is a series of honours for gymnasiarchs of the *geraioi*, presumably carved on the walls of the gymnasion. *MAMA* 4.151 (Apollonia in Phrygia) might be from a wall bearing abbreviated decrees, rather than a statue base. *I. Kios* 5 is probably not a statue base, but an abbreviated decree. M. Ç. Şahin, 'Recent Excavations at Stratonikeia and New Inscriptions from Stratonikeia and its Territory', *EA* 41 (2008), 57–8, no. 7, is a pair of abbreviated decrees on a block from the *bouleuterion* of Stratonikeia (the first recording honours, the second public burial).

[115] For Athens, there is a whole section in *IG* II² (3.1.7), but generally *passim* in that fascicle; also e.g. *SEG* 37.146; 39.187; 41.148. Outside Athens, see for instance *TAM* 5.468B (modern Ayazviran, ancient *polis* unclear; post-133 BC), 678 (Charakipolis, 9/8 BC); *Oropos* 502–10 (for *epimeletai* of sacred matters).

[116] Robert and Robert, *La Carie*, 176, for examples and discussion. See for instance *MAMA* 8.464, 468. 469–73, 477 (Aphrodisias, Roman-era); *I. Rhod. Peraia* 571; *SEG* 31.899 (Antiocheia on the Maeander for the rhetor Diotrephes, first half of 1st cent. BC). I am not sure the 'parallelipipeds with torus' found in South-Western Karia are funerary monuments (*HTC* nos. 4, 5).

[117] For instance, *I. Alexandria Troas* 613; *I. Assos* 9; *I. Mylasa* 401 (actually headed 'the praises of Sibilos'); G. Cousin and C. Diehl, 'Inscriptions d'Alabanda en Carie', *BCH* 10 (1886), 308–10 and 311–14 for two examples from Alabanda with G. Cousin, 'Note sur une inscription d'Alabanda', *BCH* 32 (1908), 203–4; *Syll.* 654A (list of

The genre of the short honorific inscription on stone itself must be seen as part (albeit the only surviving part) of the widespread practice of *anagraphai*: as A. Wilhelm showed, the official acts of the Greek city-states were regularly published in summary form, in stone, but also in cheap, legible media (painting on specially prepared walls or on 'white-boards'; carving on boards); such minutes could also be retained, in cartulary form by magistrates for important decrees, or in chronicle form for archival or reference purposes. Minutes would also be written on the outside of official documents or correspondence on papyrus (the papyrologists' *scripta exterior*).[118] The honorific formula on statue bases, emerging in the late third and early second centuries ('Rhodian' style), then the late second and early first centuries ('Anatolian' style), thus drew on the forms of 'short' public writing: statue inscriptions were part of the terse summaries of decisions that enabled monumental legibility and publicity for civic decisions, and more generally the world of summary publication was an important part of administrative communication in the cities.

The second practice is the proclamation of honours at festivals (*anakeruxis, anangelia, anagoreusis*). It is first attested in Classical Athens (for instance, in 336, the proclamation in the theatre of a crown for Demosthenes was attacked by Aiskhines as illegal). In the Hellenistic period and later, the practice is widespread, for honours granted by cities and by corporations: the herald, or magistrates, proclaim honours during festivals, at specific contests, in the theatre or in the gymnasium, before an assembled crowd of citizens and foreigners.[119] The Athenian crown for the people of Sikyon was proclaimed at the Great Dionysia, in 322 BC;[120] the Oropians, in 151/0, decreed a statue for an Achaian from Aigeira, who had helped them fend off the Athenian take-over bid, and took care to publicize and proclaim the honour:[121]

$$\sigma\tau\epsilon\phi\alpha\nu[\hat{\omega}]\text{-}$$
$$\sigma\alpha\iota\ {}^{\prime}I\epsilon\rho\omega[\nu]\alpha\ T\eta\lambda\epsilon\kappa\lambda\epsilon\text{'}ous\ A\i\gamma\epsilon\iota\rho\acute{\alpha}\tau\eta\nu\ \epsilon\i\kappa\acute{o}\nu[\iota]$$
$$\chi\alpha\lambda\kappa\epsilon\hat{\iota}\ \dot{\alpha}\rho\epsilon\tau\hat{\eta}s\ \ddot{\epsilon}\nu\epsilon\kappa\epsilon\nu\ \kappa\alpha\grave{\iota}\ \kappa\alpha\lambda o\kappa\dot{\alpha}\gamma\alpha\theta\acute{\iota}\alpha s\ \mathring{\eta}\nu$$
$$\ddot{\epsilon}\chi\omega\nu\ \delta\iota\alpha\tau\epsilon\lambda\epsilon\hat{\iota}\ \epsilon\i s\ \tau\grave{o}\nu\ \delta\hat{\eta}\mu o\nu\ \tau\grave{o}\nu\ {}^{\prime}\Omega\rho\omega\pi\acute{\iota}\omega\nu,\ \dot{\alpha}\nu[\alpha]\text{-}$$
$$\gamma o\rho\epsilon\hat{\upsilon}\sigma\alpha\iota\ \delta\grave{\epsilon}\ \tau\grave{\eta}\nu\ \tau\hat{\eta}s\ \epsilon\i\kappa[\acute{o}]\nu os\ \sigma\tau\acute{\alpha}\sigma\iota\nu\ {}^{\prime}A\mu\phi\iota\alpha\rho\acute{\alpha}[\omega\nu]$$
$$\tau\hat{\omega}\mu\ \mu\epsilon\gamma\acute{\alpha}\lambda\omega\nu\ \tau\hat{\omega}\iota\ \gamma\upsilon\mu\nu\iota\kappa\hat{\omega}\iota\ \dot{\alpha}\gamma\hat{\omega}\nu\iota.$$

. . . (it was resolved) to crown Hieron son of Telekles, of Aigeira, with a bronze statue, on account of the goodness and the excellence which he continuously shows towards the people of the Oropians, and to proclaim the setting up of the statue in the gymnic contest of the Great Amphiaraia.

In both these cases, the verbs used are in the aorist tense; this clearly indicates, through the syntax, that the proclamation took place once, as an act of communication and publicity. When the citizens of Dionysopolis decreed that the benefactor Akornion would 'be crowned ($\sigma\tau\epsilon\phi\alpha\nu\omega\theta\hat{\eta}\nu\alpha\iota$) at the Dionysia with a gold crown and a statue', they referred to the one-off proclamation of the honours.[122] An inventory from 304/3 BC mentions a set of crowns decreed over several years, but proclaimed subsequently, on the occasion of a single Dionysia.[123]

statues granted to Hagesandros of Delphi); *Oropos* 433 (with bibliography); *IG* 12.4.1.129–30 (Nikomedes of Kos; I thank Ancurin Ellis-Evans for this reference). Some Athenian lists of honours granted by civic bodies are very similar: *IG* II² 3206.

[118] Wilhelm, *Beiträge*, 229–99, qualified by Klaffenbach, *Bemerkungen*.

[119] A. Chaniotis, 'Theatre Rituals', in P. Wilson (ed.), *The Greek Theatre and Festivals* (Oxford, 2007), 48–66, esp. 54–9. Earlier, J. Oehler, *PW* xi. 349–57, s.v. Keryx (2), but I have not seen C. Osterman, *De praeconibus graecis* (Marburg, 1845); E. Pottier in C. Daremberg and E. Saglio (eds), *Dictionnaire des antiquités grecques et romaines* (Paris, 1877–1919), s.v. Praeco—iv/1. 607–9, esp. 608. Classical Athens: Aiskhines. 3.32–42, 246; Demosthenes 18.120–1. *Syll.* 493 (cf. *IG* 12.9.1188) shows the Histiaians proclaiming an honorific crown 'during the procession of the Antigoneia' rather than in the theatre (*c.*230). Recently, *SEG* 49.1195, ll. 27–8 (decree of Kyme for Philetairos, early 3rd cent.). *SEG* 39.972, a funerary-civic epigram from Lato, describes *Areta* proclaiming the honours of the defunct in Hades, in allusion to civic proclamations.

[120] *Syll.* 310 (the decree was reinscribed in 318/317 BC).

[121] *Oropos* 307.

[122] *IGBulg* I² 13 (48 BC).

[123] *SEG* 38.143, with Chaniotis, 'Theatre Rituals', 55–6.

The purpose of such proclamations is occasionally specified, in hortative clauses attached specifically to the decision to make a proclamation: to publicize the honours, and to achieve a protreptic effect through publicity. The Prienian decree honouring Megabyxos specifies that 'the herald should proclaim at the Dionysia the grants made to him (Megabyxos), in order that all should know that the people of the Prienians is able to return marks of gratitude to those who do good to it'.[124] When the 153 *neoi* and *epheboi* of the gymnasion at Kolophon honoured their gymnasiarch with a statue, they asked for the honour to be proclaimed (once) at the Dionysia and the Klaria—proclamation multiplied the effect of the honour.[125]

In other cases, the proclamation was repeated yearly, 'for ever': it became an honour in itself, the proclamation entered the realm of festival time.[126] The inhabitants of Halasarna, a deme on Kos, inscribed a list of honorific proclamations at a particular festival (οὓς δεῖ ἀναγορεύεσθαι ἐν τοῖς Πυθαίοις, 'those which are to be proclaimed in the Pythaia'). The list no doubt acts as a reminder, as a commitment towards the honorands (priests) on the part of the honouring bodies (colleges of priests). But it also is a monumental perpetuation, in the eternal present of the proclamation and the inscribed text, of the act of honouring: 'The men who had served as priests crown Polymnastos son of Zopyros with a golden crown on account of his goodness and their benevolence towards him', τοὶ ἱερατευ|κότες στεφανοῦντι | Πολύμναστον Ζωπύρου | στεφάνῳ χρυσῷ ἀρετᾶς ἕνεκα καὶ| εὐνοίας τᾶς ἐς αὐ|τόν.[127]

Some Prienian decrees specify that the proclamation should explain the reasons for the honouring;[128] many other documents give us the actual text of the *kerugma*, the proclamation. The verb is usually στεφανόω, 'to crown', in the present tense: ὁ δῆμος στεφα[νοῖ] | Δύμαντα Ἀντιπάτ[ρ]ου χρυσῶι στεφάνωι ἀρετῆς ἕνεκεν καὶ εὐν[οίας] | τῆς εἰς αὐτόν, 'the people crowns Dymas son of Antipatros, of Iasos, with a gold crown, on account of his goodness and his goodwill towards the people'.[129] Through the present tense, the proclamation is not just a historical statement about a past grant of honours, but also an honorific act in its own right, a performative enacted in front of an audience; this is especially true for yearly repeated proclamations.[130] In Leukas, the inscribed epigram expanded on an honorific statue for a benefactor: the monument acted as the embodiment of affection, as seen in the act of crowning, thus perpetuating moral attitudes in the eternal present of the physical monument. The monument, as verbalized by the epigram, was an allusion to, and a re-enactment of the festival proclamation:

ὧν ἕνεκεν Λευκὰς τὸν ἀεὶ σωτῆ[ρα- - - -]
εἰκόνι καὶ πίστει καὶ φιλίᾳ στεφανοῖ.

On account of these deeds, Leukas crowns him, the constant saviour..., with a statue, trust, and friendship.[131]

[124] *Inschr. Priene* 3, ll. 24–7. For other examples of the hortative clause describing the proclamation of honours, *IG* 7.18 (Megara, 1st cent. BC?); *Syll.* 912 (cf. *IG* II² 1214), decree of the deme of Peiraieus, first half of the 3rd cent.; *Syll.* 1045 (cf. *IG* 12.7.22), decree of Arkesine, mid-3rd cent.

[125] *SEG* 55.1251 (*c.*200 BC), republished by P. Gauthier, 'Un gymnasiarque honoré à Colophon', *Chiron*, 35 (2005), 101–12.

[126] Repeated proclamation: e.g. *Syll.* 587 (Peparethos); 1099 (Athenian thiasos, 278/7 BC); *SEG* 39.1243–4 (Klaros decrees).

[127] *SEG* 54.747 (*Halasarna* 4). I write αὐτόν, '(the priests' disposition) towards him': on this usage of *eunoia* as the honorers' and not the honorand's, Ma, 'Oropos (and Elsewhere)', on *SEG* 54.787 (from Kos), with E. Nachmanson, 'Zu den Motivformeln der griechischen Ehreninschriften', *Eranos*, 11 (1911), 180–96, republished by E. Pfohl, *Inschriften der Griechen* (Darmstadt, 1972), 153–72.

[128] *Inschr. Priene* 18, 21, 81.

[129] *I. Iasos* 153, 2nd cent. (Samothrakian decree, inscribed at Iasos). The practice of specifying the text of the proclamation starts in 4th-cent. Athens already: *IG* II² 212 (Spartokos), 1187.

[130] The perpetual proclamation of a crown is mentioned as an additional honour in the decree of the Dionysiac Artists of Ionia and the Hellespont for Kraton, Michel 1016A, 14–19 (the 'crownings' must be the proclamation of crowns by the herald, in the στεφανοῖ form).

[131] *IG* 9.1² 4.1233 (date unclear).

In spite of this difference with the honorific formula,[132] *anangelia* and the honorific inscriptions on statue bases are closely related in structure: cities sometimes spelt out that the inscription should be 'the same as the proclamation'.[133] The relation is made clear in some documents, where both the text of the proclamation and the honorific inscription are explicitly stipulated. A second-century honorific decree of the *synagonistai* ('co-performers') among the Dionysiac Artists of Ionia and the Hellespont gives nearly the same wording for a proclamation and for the inscription on a painted portrait of the honorand, the famous *auletes* (pipe-player) Kraton.[134]

'The same' wording could refer to the spirit of the proclamation rather than the letter. The late second-century Kolophonian decree for Menippos specifies that his statue is to be set up in the shrine of Apollo, and 'the proclamation is to be inscribed'. The text of the proclamation is given earlier, in the normal form: ὁ δῆμος στεφανοῖ Μένιππον Ἀπολλωνίδου, τὸμ φύσει Εὐμήδου[ς], χρυσῶι στεφάνωι καὶ εἰκόνι χρυσῆι εὐεργέτην ὄντα καὶ περὶ τὴν πολιτείαν ἐκτενῆ καὶ φιλάγαθον καὶ προστάντα τῆς πατρίδος ἐν καιροῖς ἀναγκαίοις. 'The people crowns Menippos son of Apollonides, natural son of Eumedes, with a gold crown and a gilt statue for being a benefactor and zealous for the state and a lover of virtue and for having led his fatherland in difficult times'. The inscription of Menippos' statue survives (see Introduction) on a drum from his honorific column: the wording of the proclamation has been tailored to fit the form of the statue inscription (in this case, a nominative + accusative copula, without the verb nor the indication of crown and statue). What has remained is the long participial phrase from the herald's proclamation: the standard formula ἀρετῆς ἕνεκεν, 'on account of his goodness', found so frequently on statue bases, was replaced with specific details about the honorand's services.[135] These formulas may have determined the apparition of the 'short', Anatolian-style honorific inscription, with its bald verb and participial phrases. Later, under the Roman empire, statue inscriptions drew on another source for details of benefactor's character and services: acclamations in the assembly, transcribed on stone.[136]

The origins of the honorific formula underline its dominant characteristic: its derivation from elsewhere than the here-and-now of the statue before the viewer. The relation between the ceremonies of crowning and the monumental remainder of such moments, the statue, is made clear by the expression 'to crown someone with a statue.[137] 'The people has honoured X with praise, a gold crown, a statue, front seating'. The sentence is an objective statement about a past transaction,[138] which could, and in fact did, appear in another context than the statue base (civic writing, festival proclamation); the formula is an allusion to other texts, written and spoken, and even a quotation of such texts. The statue itself is in fact downplayed. In the Rhodian-style formula, it is not named alone, but as part of a package of honours; it is not named first; it is not named with a deictic (not *'the people has honoured X with the statue which you see')—such deictics are rare, only appear early (fourth century) or late (first

[132] The verb τιμάω, 'to honour', in the aorist tense, is sometimes used in proclamations: *IG* 12.1.155 (decree of an association; but the honorific formula is completed by a verb of giving in the present tense, δίδωτι); M. Holleaux, 'Décret de Chéronée relatif à la première guerre de Mithridate', *Études*, i. 143–59, [ἐτίμησ]εν (restored by E. Bourguet; the last two letters can be made out on the photograph of the squeeze).

[133] *Inschr. Magnesia* 101, ll. 22–4: στῆσαι δὲ αὐτοῦ καὶ εἰκόνα χαλκῆν ὡς καλλίστην ἐν τῶι ἐπι[φα]νεστάτωι τόπωι τῆς πόλεως, ἐφ᾽ ἧς καὶ ἐπιγραφῆναι τὴν αὐ[τ]ὴν ἐπιγ[ρα]φὴν | τῆ[ι ἀν]αγγελίαι, literally: 'on which (statue) the same inscription is to be inscribed (as the proclamation)'; *Inschr. Priene* 117.

[134] Michel 1019B; other examples: *Tit. Cam* 83, a statue base inscription formulated exactly in the same way as an honorific proclamation: ἐπαινεῖ καὶ στεφανοῖ, 'praises and crowns', a phrase which turns up in actual proclamations: *IG* 12.1.1032, from the Rhodian deme Brykous, on Karpathos; *Tit. Cam.* 106, 110.

[135] Similarly, in *Syll.* 730 (Olbia, 1st cent. BC), the proclamation is to be the same as 'the contents of the inscription of the statue'. This inscription is earlier specified as a nominative-accusative copula, without verb; presumably the herald added a verb such as 'honours' or 'crowns', and retained the epithets and participial description of the honorand.

[136] Robert, *OMS* vi. 254–7; 349 n. 2, with earlier references, notably *Hellenica*, xiii. 215–16.

[137] Robert, *OMS* vi. 92 for parallels and analysis.

[138] A. Wilhelm: 'die Feststellung einer geschehenen Handlung', 'the registering of an action that has taken place' (*Beiträge*, 284).

century): the Confederacy of Athena Ilias honoured a benefactor 'with this statue', εἰκόνι τῆδε.[139] The statue is often not mentioned at all when the honours are summarized ('with the greatest honours', 'with worthy honours')[140] or simply omitted (as in the 'Anatolian' style). There is a gap between the presence of the statue, and the experience of reading a text appended to the statue, but referring to it in a hyper-objective fashion, in a discourse originating elsewhere; in that gap, the statue vanishes, at least textually.

This gap was felt by the producers of at least some monuments. On some Rhodian statue bases, without the wording being changed, emphasis is laid on the statue in the layout of the inscription, by having the formula εἰκόνι χαλκῆι, 'with a (bronze) statue', centred and occupying a whole line by itself (Fig. 1.1).[141] In another Rhodian statue inscription, from Kameiros,

Fig. 1.1. The text on the statue base sometimes privileges the mention of the statue (*Inscr. Lindos* 243).

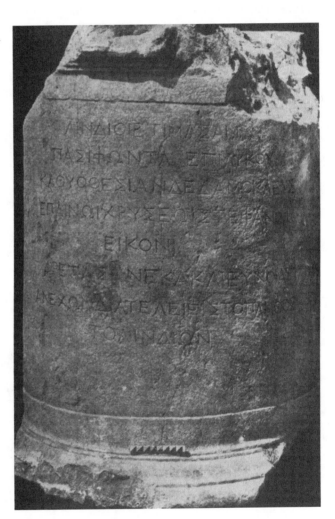

 [139] 4th cent.: *IG* II² 3838 (a 'private honorific'), *IG* 4.2 1. 615 (Epidauros); 1st cent.: *I. Ilion* 12 (quoted here), *IG* 12.3.247 (painted portrait, Anaphe: mention is made of honouring 'with the dedication of the portrait'); 2nd cent. AD: *Asklepieion* 54 (Pergamene Asklepieion: the council of Pergamon honoured a benefactor 'with this honour').
 [140] *Inschr. Bubon* 14.
 [141] *IG* 12.1.680, 847, 853, 857; *I. Rhod. Peraia* 556 (cf. *Pérée rhodienne* 7); *Inscr. Lindos* 123, 125, 234, 243, 244H, 273, 281 (probably), 305, 309, 333, 384 (probably), 389, 404. (However, centring is not always meaningful: in *Tit. Cam.* 96, the conjunction καί, 'and', is centred; *IG* 12.3 Suppl. 215, the word ἐπαίνωι, 'with praise', is centred).

the wording, without using a deictic, gives separate mention to the grant of a statue.[142] The same inscription also combines the honorific formula with a mention of the gods, in the dative, imported from the dedicatory formula.[143] The point seems to be to complement the remoteness of the honorific formula with a pointer to the statue and its presence as dedicated object.

The honorific formula refers the statue back to its origin, the civic decree; or rather, it puts the civic transaction of honouring, with its complicated economy, at the origin of the statue. More specifically, the honorific formula writes the statue into the culture of civic communication. The viewer-reader, ideally a citizen of one of the Hellenistic city-states, brought his own knowledge to read the statue into this civic culture of public texts. In the text inscribed beneath the statue, 'the people has honoured...', he recognized a quotation from official minutes and a transcription of spoken words. He saw a monumental version of *anagraphai* whose regular publication was an important part of the *polis*'s openness and transparency, values which the inscription also monumentalized, quoting not just words but also the whole process of 'writing up'.[144] If the viewer-reader did read the inscription out aloud, he re-enacted the honorific proclamation in front of festival audiences, an act which displayed the *polis* as a moral community, based on goodness in relation to the community, rewards, exemplarity. To think of the proclamation of honours as civic event evoked another collective event, the actual passing of the decree by the assembled community. The honorific formula represents civic process in a short narrative form, with descriptions, more or less standardized, of character and of action, and the implicit desire to grant recognition in as visible a fashion as possible.

5. THE POWER OF THE BASE

By speaking out the *polis*'s proclamation, the viewer-reader gave speech to the *polis*, rather than to the statue—this action resembled, but also subverted, to the profit of the community, the old aristocratic *topos* of 'voiced statues', where statues were made to speak, or made a reader speak, the glory of an individual.[145] On Samos, the statue of an eminent citizen was captioned with a 'normal' statue inscription (Fig. 1.2):



ὁ δῆμος ὁ Σαμίων
Λέοντα Ἀρίστωνος
Ἥρηι.



The people of the Samians (has dedicated) Leon son of Ariston to Hera.

But next to this dedicatory inscription, an epigram extended over four elegiac couplets:



γηράσκει καὶ λᾶας ὑπὸ χρόνου ἠδὲ μὲν ἁγνός
χαλκὸς ἀπ' ἠερίας δρυπτόμενος νιφάδος,
καὶ τὸ σιδάρειον κάμνει σθένος· ἁ δ' ἀπὸ δόξας
ἄθραυστος φάμα πάντα μένει βίοτον.
τᾶς δὲ Λέων ἐκύρησε κατὰ πτόλιν, ὃς περὶ πάτρας
πράξιας εἰς πινυτὰς ἄγαγεν ἱστορίας
ὑμνήσας Ἥραν αὐτόχθονα καὶ πόσα ναυσίν
ῥέξαντες σκύλοις ἱερὸν ἀγλάισαν.



[142] *Tit. Cam.* 86: the honorific formula is completed with the indication that the Kamireis, in addition to praising and crowning a benefactor, 'have also set up a bronze likeness of him', ἐστάκαντι δὲ αὐτοῦ καὶ ἰκόνα χαλκέαν.

[143] Other examples: *IG* 12.6, 284, 286, and 327–8 (probably), all from the Heraion at Samos; also *I. Knidos* 89 (1st cent. AD), and almost certainly 52–3 (Augustan period). See already Gerlach, *Ehreninschriften*, 99 (but *CIG* 2653 should be removed from Gerlach's list).

[144] On the public culture of transparency and communication, Wilhelm, *Beiträge*, 274–5.

[145] e.g. *IG* 4² 1.619; G. Konstantinopoulou, 'Epigraphai ek Rhodou', *ArchDelt* 18/1 (1963), 8–11, no. 13.

Fig. 1.2. Statue bases may have complex texts, for instance prose texts combined with epigrams. Statue base of Leon son of Ariston, of Samos. *IG* 12.6.285 (mid-second century BC). Photogr. Kl. Hallof, 1994; from the archive of the *Inscriptiones Graecae*, Berlin-Brandenburgische Akademie der Wissenschaften.

Stone too, and holy bronze, age with time, rent by airy showers, and the strength of iron, too, is worn down; but the infrangible glory that comes from repute remains for all life. Leon gained it in the city, he who cast the deeds of his fatherland into judicious histories, singing Hera born in the land, and the deeds which the Samians accomplished on their ships when they adorned the shrine with spoils.[146]

The contrast between glory and the statue is an old *topos*, piquantly appropriate for the honorific statue of a historian. The opening priamel evokes the normal materials for statues, marble and bronze; the addition of iron shifts attention away from statues, to the realm of materiality in general. In contrast, *phama*, cognate with the verb $\phi\eta\mu\iota$, 'to speak', describes the repute enjoyed by the honorand, which is greater than the statue. This is the repute which was created by the honorific transaction, which the rituals of public crowning announced and perpetuated; this is the context within which we are meant to view the statue, but also look beyond it. The left-hand part of the inscription serves the statue, by giving it a name and explaining its origin; the second, right-hand part, playfully, explodes this relation, by claiming to give voice to *phama* (through the actual voice of the reader) and commenting on the power of repute over the statue.[147]

[146] *IG* 12.6.1.285 (mid-2nd cent. BC).
[147] A similar dynamic in reading the inscription as two parts in a left–right field is at work on the base of the base of Diotimos of Sidon (*IAG* 41, also Ebert, *Griechische Epigramme auf Sieger*, 64).

The power of the inscription as text to constitute the monument by ascribing meaning to the material work of art has been the starting point and the focus of this chapter, and the politics of this power will be the theme of the following. But text did not exist in the abstract, in spite of the insistence on *phama* in the Samian epigram quoted above; it existed as inscription, too, and is carved on the same stone that could be used for statues, by the same iron tools that made statues. Inscription had materiality and spatiality—two dimensions which interacted with text and with image, to constitute the monument and create meanings. This material dimension, and its role in mediating and interacting, appears in the case of the workings of the Rhodian inscriptions discussed above, which present the objective phrasing of the 'honorific' formula but try to modulate it by giving emphasis to the mention of the statue. Likewise, the 'regnal order', in which the honorand is named first, shows how the 'layout' influenced meaning.

The statue base[148] elevated the statue, distanced it, and removed it from the level of the viewer and the passerby: its rhetorical function is hence to draw attention[149] to the statue and to declare its privileged status—postmodern sculpture has played with this effect, by doing away with the plinth, or problematizing it (as in the various works of art displayed on the 'Fourth Plinth' in Trafalgar Square in London). The reifying artificiality, and hence the artfulness, of the work of art is emphasized: a rearing horse and fighting horseman, a pensive citizen, a coy yet stately woman (see further Chap. 8), perched on top of a stone confection, are both lifelike because of naturalism at work, and unrealistic because of the extraordinary nature of the assemblage, as a piece of art. The most common form has the statue standing on a moulded course, which on its own adds height above the main shaft of the base, and literally underlines the work of art. The top moulding is echoed by a bottom moulded course, itself occasionally standing on an extra course of its own; the effect is to insist on verticality and removal from the normal plane (Fig. 1.3).

This top moulding course (sometimes a single massive slab, *Deckplatte* in German, acting as a platform on which the statue was fixed) could be inscribed: in effect, the inscription fitted within an elongated frame, the sharp-edged rectangular front end of the *Deckplatte* (Fig. 1.4). The framing had the effect of partly subordinating the inscription to the image: the exiguity of the space left for the inscription and the contiguity to the work of art make the inscription a caption, serving the work of art by telling us what we want to know about it.

However, the normal way of presenting writing in honorific monument works differently. The top and bottom mouldings on the base, symmetrically balanced, also framed the shaft of the base as a unit in its own right: the front orthostate present a smooth, extended surface—the 'pure square of white marble' that so impressed Sergeant Major R. S. Jones when he found a fragment of a statue base (above, 19)—suitable for the impressive display of large-scale writing, as a monumental element deserving of the attention within the pause created by ornament framing a space off from the statue. Writing was privileged by material shape: relief ornaments almost never occur on the bases of Hellenistic honorific monuments,[150] thus leaving the shaft as a blank, clean surface on which writing could choose its place.

On this clean surface, the most common type of inscription was the dedicatory, or the nominative-accusative copula. The layout very often gave one line, centred, to each important

[148] H. Bulle, *Griechische Statuenbasen* (Munich, 1898); M. Jacob-Felsch, *Die Entwicklung griechischer Statuenbasen und die Aufstellung der Statuen* (Waldsassen, 1969) and I. Schmidt, *Hellenistische Statuenbasen* (Frankfurt am Main, 1995); Smith, *Roman Portrait Statuary from Aphrodisias*, 33–4; Filges, *Skulpturen und Statuenbasen*; J. J. Coulton, 'Pedestals as "Altars" in Roman Asia Minor', *Anatolian Studies*, 55 (2005), 127–57; Dillon, *Female Portrait Statue*, 27–38. On the workings of the statue base in modern times, the terrific volume of essays collected by A. Gerstein (ed.), *Display and Displacement* (London, 2007), with pieces by V. Avery, E. Jollet, M. Baker, A. Yarrington, P. Ward-Jackson, D. Getsy, S. Malvern, J. Wood, has much inspired these pages.
[149] On 'attention' as an art-historical context, E. Jollet, 'Objet d'attention: L'Intérêt pour le support en France à l'époque moderne', in Gerstein, *Display and Displacement*, 33–61 (drawing notably on Alois Riegl).
[150] On sculptured bases in earlier periods, Bulle, *Statuenbasen*, 27–31; A. Kosmopoulou, *The Iconography of Sculptured Statue Bases in the Archaic and Classical Periods* (Madison, Wis., 2002).

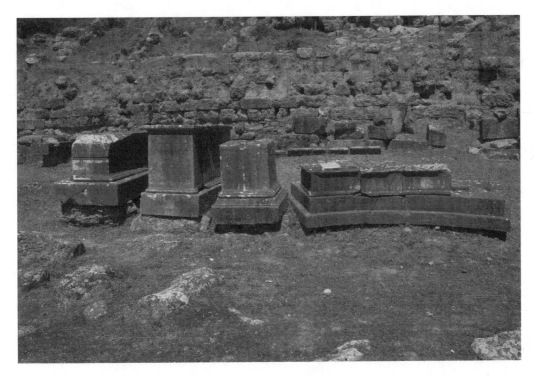

Fig. 1.3. Statue bases come in a variety of shapes and relations. Statue bases at the Amphiaraion near Oropos, third century BC.

element (Fig. 1.5). The people, the honorand, the qualities shown (by the honorand), the beneficiary of the qualities (the people doing the honouring)—the close relation between the city and the honorand, be it a king, a foreigner, or a citizen, is expressed by the layout of the formula. On the inscription for Leon of Samos (see Fig. 1.2), the first two lines leave a parting in the middle, so that the eye is drawn down to the name of the goddess, Hera, and thence, perhaps, back to the statue: the vertical relationality puts statue and divine recipient in contact, with the elements of identity of honorand and dedicator picked up on the way. There are variants on this basic layout: in the shrine of Poseidon at Kalaureia, a base conflates honorand (Agasikles son of Sosikles, named first) and the city of Kalaureia in a single line, so that reading the first line welds the two entities into a single relation—which is then consummated in the

Fig. 1.4. The inscriptions can also be placed on the final element of the statue base, the slab that tops the block and bears the statue. Inscribed crowning block of statue base, Athenian Agora. *IG* II² 4161, first century AD.

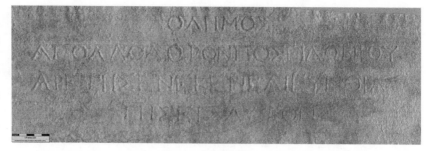

Fig. 1.5. The inscription, in its lay-out on the stone, favours legibility by distributing the significant elements in the available space. Paper impression of inscribed shaft of statue base, Priene Agora. *Inschr. Priene* 237, *c*.200. Scan by C. V. Crowther, reproduced cour-tesy of the Centre for the Study of Ancient Documents, Oxford.

verb, ἀνέθηκεν, given a whole line to itself (the emphasis on the religious act is appropriate in a sacred precinct, even if the god is not named), balancing the mention of the city being the beneficiary, which in turn justifies the act of dedicating and honouring (Fig. 1.6, *IG* 4.846). The similitude of the base for the honorific statue to bases used for dedications to gods reinforced the effect of the dedicatory formula, by bringing out the sacred connotations of formula and space. The effect of the clear, line-distributed layout, combined with large-scale letter (2 cm high or more) was to favour legibility and immediate intelligibility, especially because the elements in the dedicatory formula or the nominative-accusative copula were stereotypical and institutionalized. The relation could be caught and instantly assimilated at a glance—and the politics of the formula accepted, or understood, as the meaning or the 'subject' of the monument.

Other layouts favoured presenting the inscription as a block of continuous text, justified on both sides.[151] The text was no longer easily legible: the viewer-reader, to find out who was represented in the statue, had to scan the lines of text; whether or not he read aloud, he was made to wait while the formula unveiled itself to read the name of the honorand, followed by his qualities and services, a process which subordinated the revelation of the subject of the work of art to the enactment of the rituals of honouring, as perpetuated in the 'honorific' formula on statue bases as well as repeated proclamation in the theatre. The base for honorific statues may also have evoked, in its materiality, other types of 'base' used in political life,

Fig. 1.6. The act of dedicating can be given a whole line to itself: the honorific statue is also an offering to the gods. Inscribed statue base, Kalaureia, before site of shrine of Poseidon. *IG* 4.846, second century.

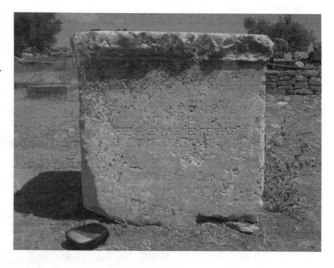

[151] See also *Didyma* 141 (Filges, *Skulpturen und Statuenbasen*, pl. 41).

Fig. 1.7. The 'block of text' might take the form of hundreds of lines of narrative, as on this large base from Klaros (which once bore a column with a simple formula, and finally the statue itself). Inscribed base of monument for the benefactor Polemaios, Klaros, *c*.100. Photogr. J.-C. Moretti.

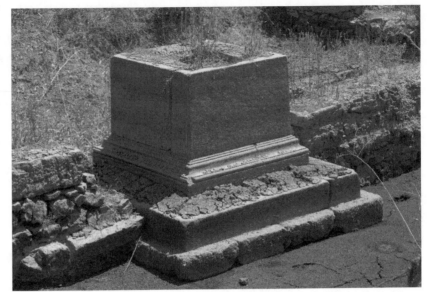

namely the platforms on which speakers, heralds, victors, teachers stood in front of crowds; this may have held especially true for the simpler bases where the statue stood directly on a block without a moulded crowning course.[152] The evocation of the speaking platform thus recalled the benefactor's civic identity, the act of standing up before a crowd that was central to civic politics, as well as the proclamation of honours by the herald; these allusions collaborated with the implications of the 'honorific' formula to embed the statue within civic culture and institutions. The extreme case of a 'block of text' as caption to the image was the inscription of whole decrees, either on the base, as for the monuments of the Kolophonian benefactors set up in Klaros (Fig. 1.7, see also Fig. 2.3), or on a *stele* set up next to the base. The block of text, under or next to the statue, acts as an ambitious *parergon* which aims at converting the work of art into the illustration of a story, as given in the narrative formulas.[153] The nature of these stories is the topic of the next chapter.

[152] e.g. Filges, *Skulpture und Statuebasen*, 145–6 (private honorific statues set up for prophets of Apollo Didymeus).

[153] On the impact of the 'block of text' within mid-18th-cent. statuary monuments (often of astonishingly complexity and playfulness), M. Baker, 'Playing with Plinths in Eighteenth-Century Sculpture', in Gerstein, *Display and Displacement*, 62–71.

TWO

The Politics of the Accusative

J'aimerais tenir l'enfant de Marie
Qui a fait graver sous ma statue
'Il a vécu toute sa vie
Entre l'honneur et la vertu'.

I'd love to get my hands on the son of a . . .
Who had them carve under my statue
'He lived his whole life
Between honour and virtue'.

(Jacques Brel, 'La statue')

The workings of the caption are political: they embed the honorific statue in a particular relation, as shown in the previous chapter, and in a particular culture. In this chapter, I argue that captioning prevents the honorific statue from being an artefact of elitist eminence: the statue is about a transaction, where the community doing the honouring is primary; the 'subject' of the honorific monument is not the person represented, but the relationship. The honorific monument is about re-establishing the symbolical balance involved in the euergetical exchange, and about displaying the primacy of the community—operations which affirm civic ideology and its power.

1. IN SEARCH OF RELATIONALITY

The typology of grammatical cases in statue inscriptions, as sketched above, is broadly true. There are exceptions to the rather old-fashioned 'grammar' which I offer as a scheme—inscriptions on statue bases that do not fit the categories or combine freely from different categories or do not follow exactly the rules I have sketched previously (especially the 'objective' omission of the definite article when mentioning the statue), variants in verbs.[1] Practice was flexible, as seen in a well-known Hellenistic decree. The citizens of Pergamon decided to set up, or literally consecrate (καθιερῶσαι) a colossal marble cult statue (ἄγαλμα) of Attalos III, in the temple of Saviour Asklepios, in order that the king receive cultic honours as a *sunnaos theos*, sharing the temple with the god. However, they did not inscribe it in the dative, as one might have expected from the examples which I gave in the previous chapter (19–20); they specifically decided to inscribe it with a formula in the accusative, rather than the cultic dative, completed by participles: ὁ δῆμος βασιλέα | Ἄτταλον φιλομήτορα καὶ εὐεργέτην θεοῦ βασιλέως Εὐμένου σωτῆρος ἀρετῆ[ς] | ἕνεκεν καὶ ἀνδραγαθίας τῆς κατὰ πόλεμον, κρατήσαντα τῶν ὑπεναντίων, 'The people (has set up) King Attalos *Philometor* and Benefactor, son of the god King Eumenes, Saviour, on account of his goodness and his courage in war, after he has defeated his enemies'. The decree also stipulated what should be inscribed below the equestrian statue (εἰκών) of the same king: ὁ δῆμος βασιλέα Ἄτταλον φιλομήτορα καὶ εὐεργέτην θεοῦ

[1] For instance, there are instances of definite articles used on statue inscriptions from Mylasa, starting in the 2nd cent.: *I. Mylasa* 121, *I. Mylasa* 404 (not set up by the demos, but by a corporation or civic subdivision), 405, 412, 414, *SEG* 54.1101. *I. Erythrai* 25–6 illustrates the occasional use of ἔστησεν rather than a verb of dedication.

βασ[ιλέ]||ως Εὐμένου σωτῆρος ἀρετῆς ἕνεκεν καὶ φρονήσεως τῆς συναυξούσης τὰ πράγ[μα]||τα καὶ μεγαλομερείας τῆς εἰς ἑαυτόν, 'the people [has set up] King Attalos, *Philometor* and Benefactor, son of the god Eumenes, Saviour, on account of his goodness and his judgement, which brings the state to greater prosperity, and his generosity towards the people'.[2] The text for both statues is civic in spirit, and in syntax, built around the nominative-accusative copula, and it is only context and use that makes one a 'cult-statue', and the other an 'honorific statue'.

Such exceptions do not jeopardize the generally observable rules and practices that do not constitute a normative grammar but a loose cluster of meaningful habits. Hence we do achieve something like linguistic competence in the various conventions governing inscriptions for honorific statues. One consequence is to impose precision of language, and interpretation, on the epigraphical documents and hence of the (usually) lost monuments: this matters, for the interpretation of material remains and generally of material culture; designation, and concepts are often used loosely by scholars of the archaeology and art history of the Hellenistic world. We should distinguish between altars (inscribed in the genitive) and statue bases; we should not, strictly speaking, say that (e.g.) the Kolophonians set up a statue to Polemaios, but that they set up a statue of him; we should not speak too freely of 'honorific decrees' when dealing with honorific inscriptions that refer to, but do not reproduce, such decrees *verbatim*.[3]

Some more general points, beyond the pleasures of correction (and correcting) and philology, must be emphasized. In spite of the differences in the way the two formulas, the dedicatory and the honorific, manage issues of viewing, reading, presence, absence, the crucial point is their similarity. What both formulas share is that they offer a trace of a past action, but also the statement of a present relation—the people (has dedicated/has honoured/has acted upon) an individual. The inscriptions on the bases, in all their various forms explored in the previous chapter, claimed to 'give rise' to the statue; in so doing, they shifted the meaning of the monument away from iconicity to the narrative of social event, of transaction and relation. The subject of the monument (constituted by the art and the text) is not the person represented by the work of art, but the relation between various elements involved in civic politics: individual, society, political institutions, and, often, the gods or specific gods linked to place (Hera at Samos, Athena at Lindos . . .). The space of agency represented by the nominative— preferred for Great Men and athletes—is now occupied by 'the people', which appears active, in two roles. The community can be seen as active in dedicating—an ancient, glorious activity, and one of the privileged social roles implying agency, visibility, and memorableness in the ancient Greek world:[4] dedication brings 'everlasting *kleos* for always to the dedicator as well', in the expression inscribed on an Archaic dedication of cauldrons. In this context, the honorand is caught as the middle term within a relation of verticality, where the exchange between community and benefactor is enclosed within the gesture of homage and offering between community and divinity, in a relation which sanctions but also immobilizes the human interaction. The other role is that of determining honour, and hence claiming the right to decide status and distinction, as an entity which exists as prior and superior to the individual's actions and character, even as the individual is granted public recognition.

This shift in the subject of the honorific monument is itself reflected in the ways the relation is monumentalized: since the subject of the monument, and perhaps even of the statue, is not,

 [2] *OGIS* 332, *Inschr. Pergamon* 246; L. Robert, *Documents d'Asie Mineure* (Athens and Paris, 1987), 460–77; P. Hamon, 'Les Prêtres du culte royal dans la capitale des Attalids: Note sur le décret de Pergame en l'honneur du roi Attale III (OGIS 332)', *Chiron*, 34 (2004), 169–85.

 [3] L. Robert in J. Des Gagniers (ed.), *Laodicée du Lycos* (Quebec, 1969), 305 n. 6: 'confusion très fréquente et toujours décevante entre décrets honorifiques et inscriptions honorifiques sur bases de statue'; also *OMS* vi. 22–3, *BE* 84, 307 ('confusion fondamentale qui se répand beaucoup en ces temps-ci . . . un décret avait été rendu, mais ce n'est pas le texte gravé sur la pierre').

 [4] For examples of boasting by dedicators, *DGE* 316 (same document *CEG* 344) from Krisa, quoted here; *Milet* 1.7.245; *Inscr. Lindos* 189; 195. On dedication (notably of honorific statues) and the immortality of the dedicant in a Roman context, W. Eck, 'Statuendedikanten und Selbstdarstellung in römischen Städten', in Y. Le Bohec (ed.), *L'Afrique, la Gaule, la religion à l'époque romaine* (Brussels, 1994), 650–62.

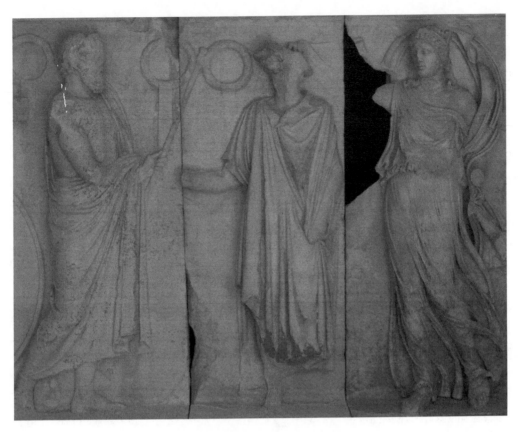

Fig. 2.1. The honorific relation can be visualized as the crowning of the benefactor by the personified community. Relief from the monument of C. Julius Zoilos, Aphrodisias, first century AD, marble. Photogr. R. R. R. Smith.

(e.g.) Soteles, but 'the people has dedicated/honoured Soteles', and the relation that is created by this transaction, this transaction and this relation can in turn be given the concrete form of a statue group representing the People honouring Soteles. At Kyme, the great benefactress Archippe was honoured not just with a statue, but also with a colossal statue of the Demos towering over her statue and crowning it.[5] The technical term for such a statue is παράστημα τοῦ Δήμου, a 'standing-next of the People'; the existence of such a term shows that the example from Kyme is not an exception.[6]

The same relation appears clearly in the reliefs adorning the tomb of the Augustan benefactor of Aphrodisias, C. Iulius Zoilos (Fig. 2.1).[7] The honorific monument, set up at the Oropian Amphiaraion for Diomedes of Troizen, liberator of his fatherland c.275, probably showed Troizen personified, crowning the civic hero to her right (and also Anthas, Diomedes'

[5] SEG 33.1035; on date (160–150 rather than after 133?), R. van Bremen, 'The Date and Context of the Kymaian Decrees for Archippe (SEG 33, 1035–1041)', REA 110 (2008), 357–82.

[6] IGBulg I² 320 (Mesambria), with L. Ruscu, 'Eine Episode der Beziehungen der westpontischen Griechenstädte zu Mithradates VI. Eupator, König von Pontos', Tyche, 15 (2000), 119–35; Isager and Karlsson, 'Labraunda', 9 (colossal statue of the Demos of Mylasa crowning the dynast Olympichos); Polybios 5.88.8; Wilhelm, Akademieschriften, ii. 65–7, BE 68, 444; Habicht, 'Samos weiht eine Statue des populus Romanus'. Crowning is represented on Augustan-era coins of Pergamon (RPC i. 2364), with an honorific inscription in the accusative-nominative form: Σιλβανὸν Περγαμηνοί, 'The Pergamenes have (honoured) Silvanus' (the proconsul M. Plautius Silvanus). However, it is not clear whether the image represents a statue group, or gives visual form to the honorific relation, exactly like the parastema does (Tuchelt, Frühe Denkmäler, 92).

[7] R. R. R. Smith, The Monument of C. Julius Zoilos (Mainz am Rhein, 1993).

ancestor, to her left)—a spectacular confection of a statuary group, standing on a long and curved, if rather low, base in the middle of the terrace of the shrine (see Fig. 1.3).[8] The statue of the historian Leon son of Ariston, at the Samian Heraion (above, 38–9), might have been crowned by a statue of personified Samos, judging by the base, where the dedicatory formula, carved below the statue of Leon, was accompanied by an epigram to its right—this might have been inscribed underneath the hypothetical second statue (Fig. 1.2).[9] There is one such group surviving, albeit in the realm of private rather than public honorific statues: the famous statues of Kleopatra and Dioskourides, set up in their house on Delos, represents the relationship between the person who set up an honorific statue, Kleopatra, and the statuefied person, Dioskourides (Fig. 5.5).[10]

The statuary *parastema*, though not very frequent (if only for reasons of cost: below, Chap. 7), is still widely attested across the Hellenistic world. It appears in the late fourth century already (in Olympia, Elis crowned Demetrios Poliorketes and his officer, Ptolemaios), quite early in the history of the honorific genre.[11] Similar themes appear on fourth-century Attic document reliefs, which may have served to show what was possible in the realm of visual honouring.[12] More generally, the *parastema* is a possibility inherent in the honorific monument itself, and implied by it; it illustrates the workings of the honorific monument, as a representation of the process of honouring, rather than (or as well as?) a homage to the honorand.

This relational aspect of the honorific monument, as constructed by the inscription, is confirmed by two phenomena. The first is the use of statue bases as a surface for the inscription of documents perceived as relevant to the meaning of the monument. An Amphiktyonic decree honouring Pausimachos, a citizen of Antiocheia-Alabanda, and the city, and granting a request for *asylia* was inscribed on the base of an equestrian statue of Antiochos III (probably granted by the Amphiktiony): Pausimachos had made a speech in which he praised the king, and the Aitolian-dominated Amphiktiony was building its relations with Antiochos. The carving of the decree shows that the statue is not simply a statue of Antiochos III, but also an expression of the relation between the Amphiktiony and the king.[13] The base of Eugnotos, a cavalry commander from Akraiphia, heroically fallen in battle in 292 and statuefied c.285, was inscribed with four lists of citizen conscripts in the early second century, a century after the statue was set up: these echoed the text of the epigram on the statue base, which invited the young men of the city to imitate Eugnotos and defend the city (below, 300–4).[14] A similar example is the monument for Apollonios, the commander of the contingent sent by Metropolis in Ionia to fight on the Roman side against Aristonikos: after his death in battle, the city set up his statue, and at the same time used the statue base to inscribe the name of fellow citizens who had fallen with him. The statue was instantly used as a monument, not just to the leader but also to the

[8] *Oropos* 389 (also *ISE* 62), with Ma, 'Oropos (and Elsewhere)'.
[9] The *Deckplatte* does not survive, so certainty is impossible.
[10] *ID* 1987, with *Guide de Délos*, no. 119 ('Maison de Kléopatra', in the 'Quartier du Théâtre'); B. S. Ridgway, *Hellenistic Sculpture*, ii. *The Styles of ca. 200–100* BC (Madison, Wis., 2000), 144–5.
[11] The colossal statue of the demos of Athens being crowned by the Demos of Byzantion and Perinthos, in the decree quoted in Demosthenes 18.90 is a fake. Other examples: Pausanias 6.16.3, with T. Kruse, 'Zwei Denkmäler der Antigoniden in Olympia: eine Untersuchung zu Pausanias 6.16.3', *AthMit* 107 (1992), 273–93, Kotsidu, Τιμὴ καὶ Δόξα), 125–7.
[12] C. L. Lawton, *Attic Document Reliefs* (Oxford, 1995).
[13] *OGIS* 234; see J. Ma, *Antiochos III et les cités d'Asie Mineure* (Paris, 2004), document 16, better than Ma, *Antiochos III*. Likewise, an Oropian decree for Phormion of Byzantion, a friend of Ptolemy IV, carved, upon explicit decision, on the base of statues of Ptolemy IV and Arsinoe (*Oropos* 175). At Delphi, the Aitolian decree acknowledging the Nikephoria as 'sacred' was inscribed on the pillar bearing a statue of Eumenes II decreed by the Aitolians: K. Rigsby, *Asylia: Territorial Inviolability in the Hellenistic World* (Berkeley, Calif., 1996), no. 178, with A. Jacquemin, *Offrandes monumentales à Delphes* (Athens, 1999), 334, no. 291. An Amphiktyonic decree on the same subject (Rigsby, *Asylia*, no. 179) was inscribed on the pillar bearing a statue of Attalos I, and a Delphian decree on a donation by Attalos II (*Choix*, no. 13) was inscribed on the base of a statue of 'king Attalos', but the dedicators of those two monuments is unknown.
[14] *ISE* 69; the whole monument is published in J. Ma, 'The Many Lives of Eugnotos of Akraiphia', *Studi Ellenistici*, 16 (2005), 141–91.

city's participation in the war of Aristonikos, and its attachment to its independence;[15] the monument was not just about an individual, but about his community, present as the dedicator on the base, the decree inscribed on the list, as well as the list of dead citizens who fought and fell with Apollonios.

The second revealing phenomenon is the way in which the workings of the monument were sometimes deliberately neutralized and slighted, most often because the community no longer had the desire to display an honorific relationship with an individual. Simplest is physically to destroy the monument, by taking away the base and the statue, as happened to the equestrian monuments for the Phokian generals at Delphi, after the Sacred War.[16] In other cases, the monument's physical state is untouched, but its meaning is modified by modifying the 'caption' to the image. By cutting out the name of the honorand, what is left is simply a public dedication of a (nameless) statue.[17] More radically, on a base from Rhodes, the names of the people and of the honorand have been cut out, as well as the artist's signature simply leaving the word θεοῖς, 'to the gods'.[18] On two bases from Egypt, bearing statues of Ptolemy VI, the name of the dedicator, probably an official fallen out of grace, has been erased, and replaced with the name of the gods, Isis and Osiris (oddly implying that the gods are dedicating the statue, perhaps to themselves).[19] In Pergamon, a statue base, later reused as an altar, was first 'neutralized' as a constituent part of an honorific statue: all the elements (dedicator, honorand, honorific reasons) were erased, merely leaving the artists' signature—what was left was a work of art.[20] In these examples, what is left is pure monumentality, a statue as monument to itself as work of art, doing whatever it is works of art do; this situation is very different from the embedded workings of the civic honorific monument. In a slightly different process, socialized objects were reduced to works of art, when statues were taken from the 'Hellenistic East', and relabelled Ἀντισθένης φιλόσοφος. Φυρόμαχος ἐποίει, 'Antisthenes, philosopher. Phyromachos made it': the original relation between dedicator and dedicated, honourer and honorand, has been lost, because it did not matter to the Roman collector.[21] In these examples, the destruction of a monument has left a trace, in the scars on the stones, or the brutally mutilated new, connoisseur-antiquarian labels affixed to old images: what has been cut out is the groundedness in a relationship. This phenomenon, again, shows by contrast what civic honorific monuments do: commemorate a relation.

2. BEING HONOURED

A particular mark of relationship is expressed by grammatical case, as surveyed in the previous chapter. The honorand appears in the accusative, 'l'éternel accusatif grec' (P. Veyne). The grammar itself casts the honorand in the role of the 'acted-upon' rather than the Great-Man actor of the nominative inscriptions; the honorand is literally the object of the transaction. In proxeny decrees from Corcyra, the name of the honorand appears at the bottom of the *stele*, in

[15] *I. Metropolis* 1, with C. P. Jones, 'Events Surrounding the Bequest of Pergamon to Rome and the Revolt of Aristonicos: New Inscriptions from Metropolis', *JRA* 17 (2004), 469–86.

[16] Roux, 'Comptes', 5–272–3.

[17] *SEG* 39.755; *Oropos* 455.

[18] Konstantinopoulos, 'Epigraphai ek Rhodou', 6, no. 5.

[19] *OGIS* 121, 122, with Wilhelm, *Akademieschriften*, iii. 143–8, 150–1.

[20] *SEG* 36.1133 (the stone was found in the 'heroon' identified, to my mind unconvincingly, by W. Radt as the heroon of Diodoros Pasparos: M. N. Filgis and W. Radt, *Die Stadtgrabung*, i. *Das Heroon*. Altertümer von Pergamon, 15/1 (Berlin, 1986); W. Radt, *Pergamon: Geschichte und Bauten einer antiken Metropole* (Darmstadt, 1999), 248–51; C. Meyer-Schlichtmann, 'Neue Erkenntnisse zum heroon des Diodorus Pasparos in Pergamon: Keramik aus datierenden Befunden', *IstMitt* 42 (1992), 287–306).

[21] G. M. A. Richter, 'New Signatures of Greek Sculptors', *AJA* 75 (1971), 434–5; also *SEG* 46.1325; and from the Templum Pacis in Rome, *SEG* 51.1442–4, with *IGUR* 1571–2, 1580. On the seizure of artworks, M. M. Miles, *Art as Plunder: The Ancient Origins of Debate about Cultural Property* (Cambridge, 2008), to whose examples add e.g. P. Bernard, 'Vicissitudes au gré de l'histoire d'une statue en bronze d'Héraclès entre Séleucie du Tigre et la Mésène', *JSav* (1990), 3–68.

the accusative: this does not depend on any particular verb, but on the general honour embodied by the decree.[22] The benefactor, a rich notable, a Big Man or Woman in the local community, is represented publicly with his identity defined by a relation where he or she is not the main actor, and does not control the terms of his image; the honorand is literally the object of the transaction. Reading inscriptions shifts the meaning of honorific statues, once more; their frontality, immobility, and conventionality, all the attributes of their physicality, rather than express the majesty of power, now act as a visible product and synecdoche of the communal constraints that circumscribe the benefactor's identity, image, and body.

This frozen state of 'being honoured' exercised a powerful grip on the self-imagination of men and women in the Hellenistic age, beyond the sphere of honorific images. In a thirty-three-line-long dedication, perhaps somewhat uncouth in appearance and redaction, on a large *stele* to the Samothrakian gods, a Rhodian mentioned his numerous services, both in the sacred sphere (priesthoods, festivals—the latter mentioned unsyntactically, unattached to any verbal form), and in the sphere of military and political action, before ending with a declaration of gratitude to the aforementioned deities, no doubt for their protection and favour as evidenced in his achievements.

ἱερεὺς
θεῶν Σαμοθράκων
Διοπείθης
Ἀριστωνίδα Χαλκήτας
Ἄλεια καὶ τριητηρίδα καὶ
ἱερατεύσας vac. Ἀφρ[ο]δίτας
Ῥωμαῖα vac. καὶ τριητηρὶς
καὶ γενόμενος
ἐπιμελητὰς τοῦ ἱεροῦ
τῶν θεῶν τῶν Σαμοθράκων
καὶ πρυτανεύσας καὶ Ἄλεια
καὶ στεφανωθέντα
ὑπὸ πρυτάνεων καὶ βουλᾶς
γραμμ<α>τέων συναρχόντων
κοινοῦ χρυσέῳ στεφάνωι
καὶ ὑπὸ στρα[τ]αγῶν
συναρχόντων κοινοῦ
χρυσέῳ στεφάνωι καὶ
ὑπὸ ταμιᾶν συνα[ρ]χόντων
κοινοῦ χρυσέωι στεφάνωι
ἀρετᾶς ἕνεκα καὶ
εὐνοίας, ἂν ἔχων
διατελεῖ εἰς αὐτούςκαὶ
στεφανωιθέντα ὑπὸ
Πτολεμαιέων τᾶς ἱερᾶς
καὶ ἀσύλου καὶ αὐτονόμου
χρυσέωι στεφάνωι καὶ
λαβὼν πολιτείαν
παρὰ τᾶς πόλιος αὐτῶνκαὶ διασώσας τριήρη
τῶν κατὰ Λιβύαν τόπων θεοῖς τοῖς ἐν Σαμοθράκᾳ

χαριστήριον.

The priest of the Samothrakian gods, Diopeithes, son of Aristonidas, of Chalke—the Haleia and the *trieteris*—and having served as priest of Aphrodite—the Romaia and the *trieteris*—having become curator of the shrine of the Samothrakian gods and also having served as *prytanis*—the Haleia—and the *prytaneis* and the secretaries of the council who served with him crowned him jointly with a gold crown, and so did the generals who served with him, jointly, with a gold crown, and so did the treasurers who served with

[22] *IG* 9.1² 4.786, 789, 791–2.

him, jointly, with a gold crown, on account of the excellence and the goodwill which he shows continuously towards them; and the Ptolemaians, sacred and inviolate and autonomous city, crowned him with a gold crown—and having received citizenship from their city, having saved a trireme off the coast of Libya; to the gods in Samothrake, in gratitude.[23]

Diopeithes was eager to show off his agency, apparent not only in the active participles, but also in the reference to the festivals—the Haleia, the Romaia, and the Dionysiac festival of the *trieteris*—which appear in the enumeration of service. The exact meaning is unclear: Diopeithes may have been occupying various offices when these festivals took place, or he may have been involved in their celebration, for instance by paying for events, or sacrificing. In one case, the festival is named in the accusative—a construction reminiscent of the accusative used in athletic inscriptions, mentioning festivals where the athlete won in the accusative, as the object of the athlete's action (see above, 23); here, too, the festivals not only occur (in the nominative), during Diopeithes' activity as priestly or civic official, but also could be considered as something Diopeithes did. Yet among all his achievements, Diopeithes also mentions his being honoured by fellow magistrates and by a foreign community (Ptolemais/Ako): at two points in this long text, he snaps to attention, ungrammatically but revealingly, by shifting from the normal nominative of the dedicator to the accusative of 'being honoured', though when he mentions that he has 'taken' citizenship from Ptolemais and saved one of their triremes, he shifts back to the nominative, the appropriate case to describe his active benefaction towards a community, and to recast an honour of a citizenship grant as something Diopeithes did or appropriated. In its syntactical looseness, and the direct expressiveness of its syntactical ruptures, the Rhodian *charisterion* shows how 'being crowned' was, intrinsically, a state of being objectified and acted upon—'him-ness' rather than 'he-ness'.

The accusative of 'being-honoured' figures prominently on Hellenistic grave *stelai* in Asia Minor, where the name is often in the accusative, as the object of the people, named in a crown: a *stele*, now in the Ashmolean Museum (Oxford), bears (inside the crown) the name of the people in the nominative of agency, and the name of the honorand, Archippos son of Dion, in the accusative of being acted upon (Fig. 2.2).[24] The formula is extremely similar to that on the bases of honorific statues, just as the imagery of funerary *stelai* is heavily influenced by honorific statuary (below, 267–73);[25] the funerary formula probably imitates honorific statues, but also alludes to the rituals of public proclamation (just as the inscriptions on statue bases do: above, Chap. 1). Individuals, or their families, choose this particular way of presenting their final identity, after death: as caught in a relation with the community; this illustrates how the state of 'being-honoured' shaped individual identity: the private funerary *stele* is converted into a manner of honorific monument. A particularly suggestive case is provided by a funerary *stele*, now in some private collection (alas), which shows a young man in war or hunting garb, and above him, on a shelf, status symbols: tablets (?), a chest, and, kept within a 'picture frame' rather like those preserved for Fayoum portraits, an honorific crown in a frame: the crown is inscribed [ὁ | δῆμ]| ος, 'the people' in the nominative, and the honorand's name, Φανοκράτην | Φανοκράτου, is inscribed, in the accusative, on the small base supporting the frame. The image suggests the display of honorific crowns in homes, and hence the presence of the honorific relation within the private sphere of the house.[26]

[23] SEG 33.644, with V. Kontorini, *Inscriptions inédites relatives à l'histoire et aux cultes de Rhodes au IIe et au Ier S. av. J.-C.: Rhodiaka I* (Louvain-la-Neuve, 1983), no. 3; 1st cent. BC.

[24] *I. Smyrna* 67; also *I. Smyrna* 516, in the British Museum, and countless others. On the honorific formula with crown in funerary *stelai*, Robert, *OMS* iii. 1411–13 (concentration in area of Smyrna, and Ionia); *BE* 83, 325, on *I. Smyrna*, vol 1.

[25] On the 'Smyrnian' style images, Robert, *OMS* vii. 641 (with further bibliography); R. R. R. Smith, 'Kings and Philosophers' and Zanker, 'Hellenistic Grave Stelai', in A. Bulloch, E. S. Gruen, A. A. Long, and A. Stewart (eds), *Images and Ideologies* (Berkeley, Calif., 1993), at 202–11 and 212–30 respectively; P. Zanker, 'Brüche im Bürgerbild? Zur bürgerlichen Selbstdarstellung in den hellenistischen Städten', in Zanker and Wörrle (eds), *Stadtbild und Bürgerbild*, 251–73.

[26] SEG 44.1550, correcting the ill-informed original publication (2nd half of the 2nd cent.); the end of the inscription can clearly be made out on the photograph. On frames for painted portraits, below, 256.

Fig. 2.2. The funerary *stelai* from Hellenistic Ionia show elements of the civic vocabulary: dress, crown, and the honorific relation in the form of the name in the accusative. Funerary *stele* of Archippos, second century BC, marble. Courtesy of Ashmolean Museum, Oxford.

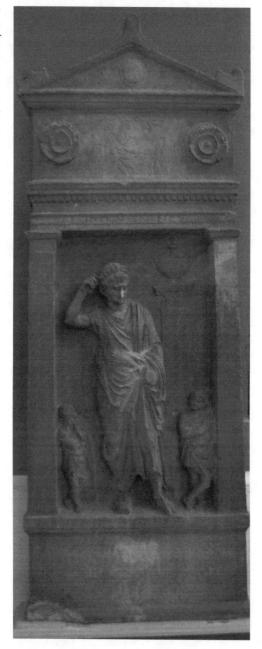

The politics of honouring was not always appropriate or welcome. In some cases, the honorands were very big men indeed, at least in relative terms, and to cast them in the honorific relation embodied by the accusative was awkward, with all of the transaction's implications of civic agency and control. The 'royal' order, with the honorand (usually a Hellenistic king) named first, albeit in the accusative, reflects the need to express hierarchy (above 25–6), in spite of the relation of active dedicator/honourer and passive dedicated/honoured; it scrambles the 'normal' succession of the mention of the actors of civic politics, derived from dedicatory practice, honorific proclamations, and civic ideology (community, individual, norms, gods), with a view to reordering them in a vertical hierarchy of assumed and enacted eminence: even if the city is doing the honouring, the king (e.g.) will be named first, and his name will appear as the first line beneath the statue.

In other cases, the honorand appears in the nominative, in conjunction with a dedicatory formula, especially in some examples dating to the early decades of the honorific statue habit. As mentioned above (27), when the Milesians set up statues of their powerful neighbours, the Hekatomnid dynasts, they juxtaposed a dedicatory formula with a respectful nominative. The explanation for the nominative is not just early experimentation with the right formula for the honorific statue, but the eminence of the honorands and the wariness of the honourers; the Kaunians, when they honoured the Hekatomnids, used the accusative, but their relation with the Hekatomnids was much clearer (they were their subjects), and the need for conciliation was lesser. Other examples of the respectful nominative occur for very eminent honorands. The presence of a respectful nominative for the honorands, in parallel with but autonomous from a dedicatory formula, can be explained by the status of the honorand.[27] In Erythrai, the use of a nominative for the subject of an honorific statue, juxtaposed with the unusual formula ὁ δῆμος ἀνέστησεν, 'the people has set up', probably implies the eminence of the honorands (one is known as a *strategos*, the other is a priest of Artemis).[28] The dedicatory formula locates the origin of the statue in a gesture by a community, but the formula does not have any 'bite' and does not quite succeed in embedding the individual within the context of the relation within a community, as explored above: the honorand exists autonomously, in the 'Great Man' nominative (above, 21–3). At Demetrias, when a statue base for a Roman official was reused for Julius Caesar, the earlier inscription with its nominative-accusative copula[29] was replaced with an inscription in the pure nominative, without any reference to the community which set up the statue:

Γαίος Ἰούλιος Καῖσαρ, αὐτοκράτωρ
Θεός.

C. Iulius Caesar, *imperator*
God.[30]

The formula constructed around the 'respectful' nominative is used in certain family monuments, for instance on Lindos (see below, Chap. 5); in general, the determination of elite families to vary images of individual identity, mingling public and private images, and various grammatical solutions to the problem of naming images, are to be understood as attempts to escape any public monopoly on image. This phenomenon will be examined later, in the context of 'private honorific' monuments. For the time being, what matters is that such family monuments show the determination of 'big men' not to allow the community to wholly determine their identities. A similar purpose may explain the images, on funerary *stelai*, of men crowning themselves, even though the main inscription refers to public crowns: the gesture claims a parcel of individual autonomy in the management of honour (Fig. 2.2).[31]

A striking illustration of elite reluctance to be caught in the politics of the accusative can be seen in a later author, Apuleius, as interpreted by Yun Lee Too. In the *Golden Ass*, Lucius is the butt of a 'folkloric' joke[32] during the festival of Laughter at Hypata.[33] The event culminates in the joke being revealed (the three 'men', for whose slaying Luciius has had to defend himself in

[27] e.g. *ISE* 45.

[28] *I. Erythrai* 25–6 (3rd cent.). It is true that nothing really seems to distinguish these figures from other civic benefactors. The respectful nominative is used, juxtaposed with an honorific formula in ἐτείμησαν ('have honoured') for the statue of a benefactor honoured in AD 169 by 'the *demos*, the *boule* and the *gerousia* of the Aytochoreitai': *SEG* 52.1333.

[29] Δημητριεῖς Γαίον Καίλιον Γαίον υἱὸν Ῥοῦφον κτλ, 'The Demetrians [have set up] C. Caelius C. fil., Rufus ...': A. S. Arvanitipoulos, *Polemon*, 1 (1929), 201–6, 424 with Broughton, *MRR* suppl. 44.

[30] Arvanitipoulos (see n. 29), also *SEG* 14.474; A. Raubitschek, 'Epigraphical Notes on Julius Caesar', *JRS* 44 (1954), 66 (the inscriptions on most statues for Caesar are in fact in the normal nominative-accusative formulation, with 'the people' doing the honouring mentioned first).

[31] *I. Smyrna* 67, 516.

[32] On collective 'folkloric' practices of riot and *charivari*, P. Veyne, 'Le Folklore à Rome et les droits de la conscience publique sur la conduite individuelle', *Latomus*, 42 (1983), 3–30.

[33] *Metamorphoses* 3.1–13.

a trial before the assembled people in the theatre, were really wine-skins, and the trial a carnivalesque caricature of civic judicial institutions). This takes place amidst gales of laughter that reduce Lucius to paralysis, 'turned into stone and frozen like one of the statues and columns in the theatre' (*fixus in lapidem steti gelidu, nihil secus quam una de ceteris theatri statuis vel columnis*). Later, the magistrates of Hypata solemnly visit Lucius: the city has voted an honorific decree for him, inscribing him as a patron and voting him a bronze statue—an honour which Lucius politely declines, declaring himself unworthy. The incident shows how the city is bigger than the individual, and holds all the cards; the power of collective decision to fix individual identity appears both in the civic decree and in civic play-acting. Apuleius, who in real life was the recipient of honorific statues granted by communities in Roman Africa, expresses unease about the capacity of statues to kill off individual identity in all its diversity, by freezing it in a rigor-mortis-like fixity, where being is socially determined (*Apology* 14; *Florida* 16). Apuleius' attitudes to honorific statues lay bare anxiety about the interplay between collective power and individual identity; too tellingly reads the incident as a deconstruction of the balance of power in the honorific transaction.[34]

In talking about honouring, both the 'dedicatory' and the 'honorific' formulas share an important characteristic: their refusal of deicticity, of 'hereness', of a mention of 'this' statue, the choice of objective phrasing as if written away from the statue. It was in fact possible to inscribe 'the people has set up this image of X', or 'the people has honoured X with this statue', as the rare examples of such formulas show; conventions were different, but to what purpose? Non-deicticity in honouring aims at downplaying, or ignoring, the most striking and visual element of the monument—the life-size, naturalistic image with its deployment of expensive technical skill. The viewer-reader knows the conventions, and immediately collaborates with the conventional, institutionalized workings of the formula, to supply the necessary information, the elements in brackets: 'the people has dedicated (this statue of!) X', 'the people has honoured X with a (this!) statue'; to do so is to consent to the implied politics of the formula. But what are these politics?

Apuleius writes as if the point of an honorific statue was to allow a benefactor to see himself, in the form of his own *simulacrum*; this position allows Apuleius to belittle the honorific statue as insufficient in conveying the mutability of personhood, and its variability in time (*Apologia* 14). However, the aim of the honorific statues, constructed as monuments and embedded as social narratives by the inscriptions on their bases, was different. To see an honorific statue was to read a caption that started with the words 'the people...'; the emphasis put on the party doing the honouring is reflected by the way in which certain captions try to defuse this effect by scrambling the usual order of elements. The epigram for a benefactor and 'constant saviour' of Leukas (discussed above, 35), was followed by a name in the nominative, centred (it seems) under the main block of text. It is worth quoting the text in full;

$$\phi\rho o\acute{\upsilon}\rho\iota\alpha\ \kappa\alpha\grave{\iota}\ \sigma\kappa o\lambda\iota\grave{\alpha}\nu\ AI\ \text{-----}$$
$$\mathring{\omega}\nu\ \mathring{\epsilon}\nu\epsilon\kappa\epsilon\nu\ \Lambda\epsilon\upsilon\kappa\grave{\alpha}\varsigma\ \tau\grave{o}\nu\ \mathring{\alpha}\epsilon\grave{\iota}\ \sigma\omega\tau\mathring{\eta}[\rho\alpha\ \text{- - -}]$$
$$\epsilon\mathring{\iota}\kappa\acute{o}\nu\iota\ \kappa\alpha\grave{\iota}\ \pi\acute{\iota}\sigma\tau\epsilon\iota\ \kappa\alpha\grave{\iota}\ \phi\iota\lambda\acute{\iota}\alpha\ \sigma\tau\epsilon\phi\alpha\nu o\mathring{\iota}.$$
$$\mathring{\omega}\ \pi\acute{o}\lambda\iota,\ \gamma\iota\gamma\nu\acute{\omega}\sigma\kappa\epsilon\iota\varsigma\ \gamma\grave{\alpha}\rho\ \acute{o}\lambda\alpha\ \chi\epsilon\rho\grave{\iota}\ \kappa\alpha\grave{\iota}\ \delta\iota\alpha\nuo\acute{\iota}\alpha$$
$$\tau o\mathring{\iota}\varsigma\ \mathring{\alpha}\gamma\alpha\theta o\mathring{\iota}\varsigma\ \mathring{o}\rho\acute{\epsilon}\gamma\epsilon\iota\nu\ \mathring{\alpha}\theta\alpha\nu\acute{\alpha}\tau o\upsilon\varsigma\ \chi\acute{\alpha}\rho\iota\tau\alpha\varsigma.$$
$$\Lambda\epsilon\upsilon\kappa\acute{\alpha}[\varsigma].$$

...the forts and the crooked...On account of these deeds, Leukas crowns him, the constant saviour..., with a statue, trust and affection—because, o city, you know how to distribute to good men deathless marks of gratitude with full hand and mind.

Leukas.[35]

[34] Y.-L. Too, 'Statues, Mirrors, Gods: Controlling Images in Apuleius', in J. Elsner (ed.), *Art and Text in Roman Culture* (Cambridge, 1996), 133–50.

[35] *IG* 9.1² 4.1233 (date unclear).

The name probably acted as a name label to an image of the city: in other words, the monument perhaps bore a *parastema* of Leukas next to the *eikon* of the benefactor. The prominent, centred, labelling in the nominative of the party doing the honouring is remarkable — it may have been a later addition, to clarify the identity of the most prominent party in a statuary group: a personification of the city, standing in the middle of the base, next to a smaller figure representing the honorand?

The honorific epigram from Leukas is equally instructive. The statue is coupled with the values it represents: the trust and affection (*philia*) of the city, and, more generally, the city's willingness to return gratitude to good men. The honorific statue hence stands for the whole civic ideology, the whole political culture. This is the point of the various operations by which, in referring the viewer-reader elsewhere, the honorific monument directed him to the relation between community and individual, to the public claim over the person, and generally to the collective culture in which the meanings of the statue were grounded. 'The people has dedicated/honoured X': the people is as important as the honorand — or more important? Yet where was 'the people' to be seen? In a few cases, as an image, the *parastema*; but this trope was finally rare (if found all over the Hellenistic world), and overliteral: a colossal statue of the Demos of Kyme was a visual metaphor, which in turn deserves unpacking, as does the civic culture of the *polis*, and indeed the whole notion of civic or political culture.

3. STATUES, STORIES, MEANINGS

'The people (has dedicated) X, on account of his goodness and his goodwill towards it, to the gods'. The dedicatory formula on a statue base inscribed the image into a social relation, on very particular terms. The reasons given, in the most widespead formula,[36] are an absolute quality of 'goodness' (or 'virtue'), ἀρετή, followed by the relational quality of 'goodwill', εὔνοια (more rarely 'justice', δικαιοσύνη), qualified in terms of relation with the community which set up the monument. The honorific monument is a moralizing artefact; it does not make a claim to foundational morals, but rather to the communitarian relation between behaviour, norms, individuals, and communities; communitarian, because it assumes that what ultimately grounds moral judgement is community and shared values, not abstract, rational, universal argument.[37] Even if 'goodness' is an absolute virtue, by being mentioned with *eunoia* towards a group, and embedded in the relational frame of the statue caption, it is rewarded and recognized not in the abstract, but as part of a relation.[38]

Of course, goodness towards the Athenians and goodness towards the Prienians are unlikely to be radically different, and participate from the same norms of goodness; but the Athenians or Prienians recognize a good man as a condition of a particular type of social behaviour ('goodwill') towards themselves, in specific circumstances; the community is not a foundational moral arbiter, but a judge of actions in relation to itself, and the honorand is acclaimed not (or not only, or primarily) for his qualities inherent to his being, but for contextualized action. These are the values that underlie the varied services and actions described in the honorific formula (in its 'Anatolian' variant), where various participles explain what the honorand has done: this is not simply a way of adding variation and individuality beyond the stereotypical formula, but also of describing actions which are implicitly about communitarian norms and values.

The relation is one of εὐχαριστία, 'good graces', a difficult concept to translate, which designates the capacity for requiting favours in an appropriate way. A Pergamene benefactor

[36] Gerlach, *Ehreninschriften*, lists the most common elements in honorific formulas.

[37] D. Bell, *Communitarianism and its Critics* (Oxford 1993) gives a strong statement, as well as some discussion of the problems with this philosophy. On morality in the Greek city, from Archaic to high imperial periods, see e.g. A. Zuiderhoek, *The Politics of Munificence in the Roman Empire* (Cambridge, 2009).

[38] Relationality of virtue as recognized by a community of citizens: Aristotle, *Politics* 1276a–b. I thank B. Gray for discussion of these issues.

set up a statue of Attalos III, but inscribed in the name of the people (something like ὁ δῆμος Βασιλέα Ἄτταλον κτλ.): literally, 'he put in common the requital of good graces of the inscription' (κοινὴν δὲ ὑπὲρ τοῦ δήμου [τ]ῆς ἐπιγραφῆς τῆς ἄμειψιν ἐποήσατο).[39] A statue inscription made visible a relation; more specifically, it created, performatively, the relation of 'good graces'. Hence the location of the monument for the Kolophonian benefactor Polemaios, 'next to the altar of the Charites', in the shrine at Klaros.[40] But this relation depended on more than just a few lines on a statue base. The inscriptions alluded not only in general terms to civic culture, but specifically to the act of collective will that had created the statue, namely a decision to grant recognition and honour in collective arenas: no honorific statue without an honorific decree. The passing of such decrees was one of the major activities of the civic assembly, as attested by the prolific epigraphy of honouring but also by Classical forensic oratory. The preponderance of the honorific among the epigraphical material does not mean that Hellenistic civic life was merely ceremonial mystification (financial administration, for instance, was considerably better organized and rational than sometimes assumed); it does mean that collective recognition of individual merits was an element which civic communities chose to monumentalize, through permanent writing and through public art, as part of their self-image.[41]

An honorific decree was a highly stylized text, built according to a formalized, universally known schema.[42] In broad terms, the honorific decree (like any other decree) worked as a single statement, prefaced with various formal elements (dating formula, indication of which civic institutions had presided over the decision-making), and structured in two parts. The first part is a motivating clause introduced by ἐπειδή, 'whereas', 'since', followed by the honorand's name, and describing the honorand's qualities and actions with conjugated indicative verbs. The second part is a decision clause introduced by a verb of decreeing (the 'sanction formula') at the fulcrum of the document (ἔδοξε, 'it seemed good', or a more complicated phrasing with ἔδοξε, 'it seemed good' at the start of the document, and the verb of deciding in the middle of document, in the infinitive tense, δεδόχθαι, 'that it should seem good'): this clause lists measures taken, in the infinitive tense—to praise the honorand, to crown him, to grant him a statue, to proclaim these honours, to inscribe these honours, to pay for these honours . . . The transition between the two clauses is often marked by a hortative clause, starting with ὅπως / ἵνα οὖν, 'in order therefore that', declaring the purpose of the honorific decisions: publicity, memory, and display. Many documents illustrate all of these elements—preamble ('In the archonship of . . .'), motivating clause ('since X has done this'), hortative clause ('in order therefore that the city be seen to requite gratitude'), decision formula ('it seemed good'), decision clause ('to set up a statue of X'). For instance, the Athenians honoured a Cretan, Eumaridas, for various services, in 228/7:

θεοί.
ἐπὶ Ἡλιοδώρου ἄρχοντος ἐπὶ τῆς Κεκροπίδος ἑνδεκά-
της πρυτανείας, Θαργηλιῶνος· Λυσίστρατος Φυλαρχί-
δου Οἰναῖος εἶπεν· ἐπειδὴ Εὐμαρίδας πρότερόν τε,
καθ᾽ ὃν καιρὸν συνέβη Βούκριν καταδραμόντα τὴν χώ-

4

[39] P. Jacobsthal, 'Die Arbeiten zu Pergamon 1906–7. II, Die Inschriften', *AthMitt* 33 (1908), 375–420, at 375–9, no. 1, ll. 20–3.

[40] *SEG* 39.1243, c.100.

[41] M. H. Hansen, *The Athenian Democracy in the Age of Demosthenes* (Oxford, 1991), 157; Gauthier, *Bienfaiteurs*. On civic finances, L. Migeotte, *L'Économie des cités grecques* (Paris, 2002).

[42] *Choix*, 17–18; J.-M. Bertrand, 'Formes de Discours politiques: Décrets des cités grecques et correspondance des rois hellénistiques', in C. Nicolet (ed.), *Du pouvoir dans l'antiquité: Mots et réalités*. Cahiers du Centre Glotz, 1 (Paris and Geneva, 1990), 101–15; N. Luraghi, 'The Demos as Narrator: Public Honors and the Construction of Future and Past', in L. Foxhall, H.-J. Gehrke, and N. Luraghi (eds), *Intentional History: Spinning Time in Ancient Greece* (Stuttgart, 2010), 247–63; S. Lambert, 'What Was the Point of Inscribed Honorific Decrees in Classical Athens?', in S. D. Lambert (ed.), *A Sociable Man: Essays in Ancient Greek Social Behaviour in Honour of Nick Fisher* (Swansea, 2011), 193–214.

ραν καταγαγεῖν εἰς Κρήτην τῶν τε πολιτῶν πλείους κα[ὶ]
τῶν ἄλλων τῶν ἐκ τῆς πόλεως, πολλὰς καὶ μεγάλας χρεί-
ας παρέσχετο τῶι δήμωι καὶ προεισήνεγκε χρήματα ἐ-
κ τῶν ἰδίων εἰς τὰ εἴκοσι τάλαντα τὰ συμφωνηθέντα ὑπὲρ
τῶν αἰχμαλώτων, ἐδάνεισε δὲ καὶ τοῖς ἁλοῦσιν εἰς ἐφόδια,
καὶ νῦν ἀποστείλαντος τοῦ δήμου πρεσβευτάς, ὅπως τά
τε φιλάνθρωπα διαμένει πρὸς πάντας Κρηταιεῖς καὶ ἵνα
εἴ που λάφυρον ἀποδέδοται τοῖς καταπλέουσιν, ἀρθεῖ τοῦ-
το, συνηγόρησεν εἰς τὸ πάντα πραχθῆναι τὰ συμφέροντα
τῶι δήμωι, συνεπρέσβευσεν δὲ καὶ εἰς Κνωσὸν καὶ τοὺς συμμά-
χους, ἔδωκε δὲ καὶ ἐπιστολὰς τοῖς πρεσβευταῖς εἰς Πολύ-
ρηνα πρὸς τοὺς φίλους, ὅπως συνπραγματεύωνται μετ' αὐ-
τῶν περὶ τῶν συμφερόντων, ἀναδέχεται δὲ τὴν πᾶσαν ἐπιμέ-
λειαν ποιήσεσθαι τοῦ διαμένειν τὰ φιλάνθρωπα τῶι δήμω[ι]
πρὸς τοὺς οἰκοῦντας ἐγ Κρήτει πάντας· ὅπως ἂν οὖν καὶ ὁ δῆ-
μος φαίνηται τιμῶν τοὺς ἀποδεικνυμένους ἣν ἔχουσιν αἵ-
ρεσιν ἐμ παντὶ καιρῶι· ἀγαθεῖ τύχει δεδόχθαι τῶι δήμωι,
ἐπαινέσαι Εὐμαρίδαν Πανκλέους Κυδωνιάτην καὶ στεφα-
νῶσαι αὐτὸν χρυσῶι στεφάνωι κατὰ τὸν νόμον εὐνοίας ἕ-
νεκα καὶ φιλοτιμίας τῆς εἰς τὴν βουλὴν καὶ τὸν δῆμον τὸ[ν]
Ἀθηναίων, στῆσαι δὲ αὐτοῦ καὶ εἰκόνα χαλκῆν ἐν ἀκροπό-
λει· εἶναι δ' αὐτῶι καὶ εἰς τὸ λοιπὸν χρείας παρεχομένωι
τιμηθῆναι καταξίως ὧν ἂν εὐεργετήσει. ἀναγράψαι δὲ τό-
δε τὸ ψήφισμα τὸν γραμματέα τοῦ δήμου εἰς στήλην λιθί-
[ν]ην καὶ στῆσαι παρὰ τὴν εἰκόνα· τὸ δὲ γενόμενον ἀνάλωμα
εἰς τὴν ἀνάθεσιν τῆς εἰκόνος καὶ τῆς στήλης μερίσαι τὸν
ταμίαν τῶν στρατιωτικῶν καὶ τοὺς ἐπὶ τεῖ διοικήσει.

Gods.

When Heliodoros was archon, in the eleventh prytany of Kekropis, in the month of Thargelion; Lysis-tratos son of Phylarchides, of Oinoe, proposed—since in earlier time, at the time when it happened that Boukris, plundering the land, took many of the citizens and of the others out of the city to Crete, Eumaridas provided many great services to the people, and offered a money advance out of his own fortune, towards the agreed ransom of 20 talents for the prisoners, and made loans to the captives for their travel expenses, and since now, the people having sent an embassy with an aim to preserve the privileges for all the Cretans and to obtain the abolition of any right of seizure against people upon disembarkation, Eumaridas by acting as an advocate advanced the achievement of all of the people's interests, and also joined in the embassy to Knossos and its allies, and gave letters to the ambassadors for Polyrrhenia, addressed to his friends, so that they might collaborate with the ambassadors in matters concerning our interests, and he undertakes to deploy all his attention towards preserving the privileges of the people towards all the inhabitants of Crete—in order therefore that the people clearly honour those who show the disposition they have in all circumstances—with good fortune, let it seem good to the people—to praise Eumaridas son of Pankles, of Kydonia, and crown him with a gold crown according to the law, on account of his goodwill and zeal towards the council and the people of the Athenians, and to set up a bronze statue of him on the Akropolis; and let it be possible for him, if he provides services in the future, to be honoured in a manner worthy of the benefactions he carries out; and to have the secretary of the people write up this decree on a stone *stele* and set it up next to the statue; and to have the treasurer of the military funds and the officials in charge of financial administration provide the monies for the dedication of the statue and of the *stele*.[43]

There are many variations in such decrees. The first reason for this diversity is the nature of the services that motivated the decreeing of a monumental portrait—services which are described in some detail, often over a significant period of time (the decree for Eumaridas is comparatively short, and some decrees expound services at considerable length). The second

[43] *IG* II² 844 (*Syll.* 535); A. Bielman, *Retour à la liberté: Libération et sauvetage des prisonniers en Grèce ancienne* (Lausanne, 1994), no. 31; date from M. J. Osborne, 'The Archons of Athens 300/299–228/7', *ZPE* 171 (2009), 83–99.

reason is the diversity of recipients of honorific statues: citizens (benefactors but also magistrates and priests);[44] civic-type foreign benefactors (men honoured for services to a community other than their home towns, but not in a position of power over this community);[45] extra-civic foreign benefactors (friendly kings honoured for benefactions but also as part of diplomatic relations);[46] kings in a position of dominance over a community;[47] royal officials, representing the supra-local power of a royal state.[48]

The honorific decree presents a narrative, or more specifically interlocked narratives:[49] in the motivating clause, a series of descriptions and actions, which are noted, in a conventional, moralizing vocabulary, as making visible the honorand's character; the city's reaction, in the form of a series of decisions. The economy of the decree equates the two narratives. Concrete and useful actions (embassies, acts of leadership, gifts of cash) first go through the converting apparatus 'city-speak', the moralizing, conventional language of the decree's narrative and the keynote struck by the hortative clause; this language is structured around cardinal notions such as collective interests, zeal, character. The conversion allows action to be cast as symbols of civic virtue, which can be fairly requited in turn by the actions described in the second, projected narrative of actions described in the mode of volition and decision—honorific gifts, fine words, and manifestations of honour, in the form of crowns, proclamations, and those most useless of objects, honorific statues. The decree converts the 'hot city' of history, event, and individuals, into the 'cold city' of institution, ritual, and memory. In the example quoted above, the dramatic events of pirate capture and ransom, and the detailed negotiation with Cretan cities (cast in the bland, face-saving, equality-proclaiming terminology of 'preserving privileges granted by the *demos*', whereas the issue is probably obtaining grants of privileges from the dangerous Cretans), give way to the unfolding of stylized, honorific gestures, and the play of civic institutions; the attention shifts from recognition to civic operations. In a decree passed by Eretria for a benefactor, Theopompos, who gave money for the gymnasion, the text veers, for a significant portion, into a piece of detailed legislation which portrays civic institutions at work[50]—again a way of making the city visible as 'cold' processes. In this respect, the honorific statue, as a work of art, aiming at permanent images of the impermanent, and seeking heightened reactions to its capacity to reproduce life with lifeless materials, also exists in a realm outside the 'hot' city of event history and individual action.

The first part of the decree narrates one individual's actions; the 'hortative clause' represents the city's response, phrased in the generalizing plural: the city proclaims its wish to honour 'good men' who show consistent character, rather than the precise individual in question; and also promises future benefactions in return for moral consistency. The city thinks in categories, both when considering the individual's actions, and when turning to requital. I have always found it difficult to remember the name of the individual honorand in any honorific decree: the moral equivalency narratives reduce him or her to a generic cipher of civic virtue, whereas civic action is lovingly recounted—in the abstract terms which are part of its nature. The processes also make a display of the city's disposition: the hortative clause makes clear that the city demonstrates its own capacity for *eucharistia*, and in some cases, the word *eunoia* in statue captions refers not to the honorand's qualities, but to the disposition of the city doing the

[44] e.g. *OGIS* 339 (the benefactor Menas honoured by his city, Sestos); *I. Erythrai* 28.

[45] e.g. *SEG* 41.332 (the sculptor Damophon of Messene, honoured by Lykosoura); *Oropos* 375; *IG* 12.6.1.42; or indeed the decree for Eumaridas of Kydonia.

[46] e.g. the Aitolian-decreed statue of Eumenes II, Jacquemin, *Offrandes monumentales*, no. 291.

[47] e.g. the statues of Attalos III decreed by Pergamon, discussed above, 45–6, 55–6.

[48] Robert, *Coll. Froehner*, no. 52; *IG* 12.9.196, with D. Knoepfler, *Décrets érétriens de proxénie*, 175–84, no. VII.

[49] J. Ma, 'The Epigraphy of Hellenistic Asia Minor: A Survey of Recent Research (1992–1999)', *AJA* 104 (2000), 107–11; Luraghi, 'Demos as Narrator'.

[50] *IG* 12.9.236 (also *IG* 12 suppl. 553, another copy of the same document; in fact, the 2nd *stele* bearing the decree).

honouring. The statue shows what the community feels, and generally the community in action:

τοὶ ἱερατευ|κότες στεφανοῦντι | Πολύμναστον Ζωπύρου | στεφάνῳ χρυσῷ ἀρετᾶς ἕνεκα καὶ| εὐνοίας τᾶς ἐς αὐ|τόν.[51]

Those who have served as priests crown Polymnastos son of Zopyros with a golden crown on account of his goodness and their goodwill towards him.

Besides recasting individual actions in terms of loaded categories, the hortative clauses perform the function of explicitly describing what the point of honorific decrees is. 'In order therefore that the people be seen clearly to honour those who strive towards goodness and repute, and that many others strive to obtain such rewards, since good men are honoured' (to quote the Eretrian decree for Theopompos): the goal is social reproduction, through exemplarity, both on the part of the honorand (whose actions are recounted by the city), and on the part of the city itself.[52] This protreptic aim explains the spectacularity and visuality of honours (proclamations, statues). A long epigram (one of a pair) on the statue base of Xanthippos, son of Ampharetos, liberator of Phokis (301 BC), ends with two lines, in effect a hortative clause in verse, that dramatize the experience of seeing the statue and entering its normative agendas:

ἀλλά τ[ις αὖ] Ξάν[θ]ιππον ἰδὼ[ν] Ἀμφα[ρέ]του υἱὸν
φάσθω·ἰδ᾽ [ὡς] μεγάλαι [τ]οῖς ἀγαθοῖς [χ]άριτες.

But let one say [in his turn], seeing Xanthippos son of Ampharetos: 'See how great are the *charites* for good men!'[53]

The decree presents a stereotypical, accepted narrative that is often set up next to the statue, or beneath it; the Athenian decree for Eumaridas is one example among many.[54] Hence the decree provides the back story, the full story, in order that citizen and foreigner might see the qualities of the benefactor and of the people as moral community realized through civic memory and institutions. The statue was 'about' the story: it represented a 'character', both in the sense of an actor in a particular narrative of good actions and rewards, and in the sense of a personality, appraised in terms of civic values. The image (εἰκών) of the benefactor, framed within a moralizing communitarian narrative, realizes in the strongest possible sense the moralizing potential of Greek art: it is also an image of that which is fitting (ἐοικός), of things as they must be/as they necessarily are.[55]

Reading the decree or the inscription on the base framed the viewer's gaze, laying out, implicitly or explicitly, what there was to see. The decree, inscribed close to the image, located the statue in a social narrative of exchange, and in the relevant civic ideology; it provided the birth certificate for the honorific statue; the image was converted into an illustration of a story, or indeed many stories. One of these stories was that of the actions of a good citizen; another was that of the city as agent. The redundancy, between the decree stipulating the setting up of a statue, and the sight of the statue, between the decree detailing the text on the statue base ('let there be inscribed on the statue base: the people has dedicated X'), and the actual text on the statue base ('The people dedicated X'), demonstrated the performativeness of the *polis*'s speech-act. The decree converts the meaning of the statue, from representation of a particular person to proof of the efficacy of popular will. At Klaros, the long decree inscribed on the base gave the story; a column bore, on a drum, a shorter version of the proclamation decided by the

[51] SEG 54.747 (*Halasarna* 4), with Nachmanson, 'Motivformeln'0–3–; discussed above, 35.

[52] For more examples of the hortative clause, Wilhelm, *Abhandlungen*, i. 654.

[53] *Syll.* 361 with J. Bousquet, 'Inscriptions de Delphes', *BCH* 84 (1960), 167–75.

[54] Knoepfler, *Décrets érétriens de proxénie*, 196, 326 n. 30, for examples and discussion of the practice. A priest on Anaphe was allowed to set up his painted portrait and adjoin a copy of the decree under the image (ὑποτάξαι τᾷ εἰκόνι): *IG* 12.3.247. On protreptic effects, Veyne, *Le Pain et le cirque*, 268.

[55] The connection between image and fittingness structures the epigram for the equestrian statue of a cavalry commander, heroically fallen in battle: *ISE* 69 (Akraiphia, early 3rd cent.), with Ma, 'Eugnotos'.

Fig. 2.3. Very long inscription on base which originally bore a column, which bore a statue: the sequence amounts to a demonstration of the efficacy of the popular will. Base of the monument in honour of the benefactor Menippos, Klaros, *c*.100; the original inscribed column drum is now mounted on a reconstruction of the whole monument. The base to the left bore the statue of Antiochos the son. Photogr. J.-C. Moretti. See also Fig. 1.7.

people; on the top of the column, the gilt-bronze statue of Menippos, the benefactor, showed that what the people had decided had indeed been realized (Fig. 2.3).

The honorific decree provided the context for the image, the political culture of the *polis*: the honorific monument, resulting from the combination of statue, inscription on the base, long inscribed decree, was a way of showing this political culture; it made society visible by showing the network of gestures, occasions, values, and memories that surrounded the statue and ensured its perenniality as a meaningful monument. The monument was born from a collective decision, and lived through collective memory; these took the form of honours for the benefactor and his descendants, but also gestures around the statue. The statue at Erythrai of the tyrannicide Philitas, restored after the fall of an oligarchical faction (during which period the statue had been deprived of its avenging sword), was kept polished, gleaming as new, not just as a measure against corrosion and tarnish, but as a symbol of living, caring memory; the statue was crowned at festivals, as an honour, but also as a way of making the statue, or Philitas himself, participate in the festival, as part of the throng of crown-wearing citizens.[56]

An honorific statue lived in and from stories that were prior to it. At Chaironeia, a statue was set up of Lucullus in gratitude for his protective intervention, both when a billeted Roman officer was murdered in a private dispute, in winter 88/87 BC, and later, when the Chaironeians

[56] *Syll.* 284 (also *I. Erythrai* 503), with P. Gauthier, 'Notes sur trois décrets honorant des citoyens bienfaiteurs', *RevPhil* 56 (1982), 215–21; further below, Conclusion, p. 306.

were accused, before the governor of Macedonia, presumably of anti-Roman sentiment. No doubt a decree next to the statue offered a stereotypical, allusive narrative; the statue inscription was certainly short and uninformative—perhaps giving Lucullus a title such as 'benefactor and saviour'.[57] Folk memory, prompted by the visual cue of the statue, preserved the details of events, over two centuries, from the early first century BC to the time of Plutarch, who records them in the first chapters of his life of Lucullus.[58] The honorific statue was grounded in a hideous story, of powerlessness in the stormy first century BC and of violence within the community (the young man who murdered the Roman officer, when condemned to death, returned from his hideout to slaughter the city magistrates); but it also manifested the community's perenniality, and its capacity to endure as a political community, endowed with such values as *eucharistia*, even in awful times.

In some cases, the statue could come later than the actual decision to set up a statue, and inscribe the decision. The *neoi* of Thessalonike honoured their gymnasiarch, Paramonos, with a crown of foliage, a bronze statue, and a full-size painted portrait;[59] however, their treasurers paid out κατὰ τὸ παρὸν, 'for the time being', the costs for the painted portrait and the *stele* on which the decree was inscribed: the honorific statue was, for the reader of the decree, a virtual one, an intended gesture; what mattered, for the community, was the accomplishment of the civic rituals of public rewarding, the enacting of decisions through the working of institutions, and the publicizing of this story of rewards and institutions, beyond the individuals' actions, as an example of communal values and order. What the honorands thought, and what this deferral of statuary honours implies for the financial aspect of civic honours, will be examined later (243–9).

Conversely, precisely because statues were the product of communal will, when memory faded and rituals lapsed (as Plutarch noted happened to most of the great honours passed in Peloponnesian cities for the Hellenistic statesman and general Aratos), the position of honorific statues within communities became problematic.[60] Honorific statues remained objects, at the mercy of the community where they were located, potentially forgetful or changing. Statue bases could be inscribed with extraneous documents which bore no relation to the original purpose: apart from the congruent inscriptions discussed above, which underlined and reinforced the relational nature of the honorific monument, such inscriptions are 'epigraphical pigeons', parasitical on the monument and simply using the available space on the base: at Akraiphia, the base of the heroic cavalry commander Eugnotos was inscribed with proxeny decrees and a decree for foreign judges, in the late second century.[61] All that was needed to reinsert the statue in a new set of narratives was to reinscribe, the well-known process of μεταγραφή, 'changing of inscription', documented both in a speech of Dio Chrysostom (31), and in actual examples of reused bases; there are many examples, for instance at Oropos.[62] Dio claims that the practice of reuse is threatening to the social order of the *polis*—but his view is tendentious, from the standpoint of a member of the social elite of the Roman empire, giving a hectoring, self-serving speech, as a foreigner defending the interests of his status group, to a local civic community—in similar ways to the elitist attitudes betrayed by Apuleius' wariness before statues and attempt to reframe honorific statues as the *locus* of auto-contemplation for the honorand (whereas the inscriptions make honorific monuments into communitarian

[57] As in *IG* 9.2.38 (Hypata, statue of Lucullus as benefactor, during his quaestorship in Greece); or *TAM* 5.918 (Thyateira, statue of Lucullus, during his pro-quaestorship, 'saviour, benefactor and founder of the people').

[58] P. Ellinger, 'Plutarque et Damon de Chéronée: Une histoire, un mythe, un texte ou autre chose encore?', *Kernos*, 18 (2005), 291–310.

[59] *IG* 10.2.1.4.

[60] Plutarch, *Aratos* 53.

[61] Ma, 'Eugnotos'; Knoepfler, 'Chalcis'. Also in the Oropian Amphiaraion: here, Fig. 4.9.

[62] *Inscr. Lindos* 419; *BE* 62, 137; 84, 183; H. Blanck, *Wiederverwendung alter Satuen als Ehrendenkmäler bie Griechen und Römern* (Rome, 1969); W. K. Pritchett, *Pausanias Periegetes*, 2 vols (Amsterdam, 1998–9), i. 87–97; J.-L. Ferrary, 'Les Inscriptions du sanctuaire de Claros en l'honneur de Romains', *BCH* 124 (2000), 331–76; Platt, 'Honour Takes Wing'.

displays of the honouring body). The practice of reusing statues shows how honorific statues were the product of a relationship, and their meaning could change, or die, as the relationship faded. *Les statues meurent aussi . . .*

At any rate, no matter how long memory persisted, the Hellenistic *poleis* and their culture ultimately vanished: right now, there is no people of the Eretrians or the Istrians or the Kolophonians to crown a benefactor for ever or offer front seating at contests (the last of which were celebrated long ago); there is no fellow citizen to be moved by feelings of emulation when they see a statue (which itself has been melted down); there are no passing visitors to see the fine rewards the city offers to good men. What remains is a strange fossilized trace of the existence of these communities and their social world. In other words, inscription, both in the form of the short inscriptions on the statue base and the extended honorific decree, not only embeds an image within a constraining social context, but also functions as a story about this process of embedding: it monumentalizes the process of monumentalizing.

4. IDEALISM AND IDEOLOGY: THE HONORIFIC STATUE WITHIN 'CIVIC CULTURE'

Public texts, appended to honorific statues, acted on the image to shape the viewer-reader's reactions. The statue, in itself, looked like a person, but did not necessarily signify anything particular: if plundered and relabelled, it could be viewed as a sign of art. Inscription turned the statue into: a token within a particular social transaction, the euergetic exchange and its civic politics; the immobile object of identity-defining action by the community; a participant in a world of social gestures; a demonstration of the efficacy of the *polis*'s writ; a symbol of socialized values (those of the good citizen) and socialization (the workings of *eucharistia*); the monument of this process of socialization.

The argument proposed here is a maximal, idealist version of the civic, *polis*-centred position; it is written within, and even by, the civic paradigms of the honorific decree and the honorific inscription. But precisely because of its status as an articulation of ancient ideology, it has a claim to validity as the baseline of how honorific statues were meant to work in the Hellenistic *poleis*. This position problematizes any modern claim that the honorific statue was an elite artefact reflecting and enacting aristocratic dominance, just as civic ideology problematized the honorific statue for ancient elites. To put it more succinctly—the statue, in its shocking lifelikeness, says 'Look at me'; the name caption in the nominative ('Herodotus'), in its deference, says 'Look at him'; the honorific formula, the honorific decree, in their determination to speak of civic culture, say 'Look around you'. Even more succinctly, an inscription on a statue base from Seleukeia in Pieria (early empire) reads:[63] ὁ δῆμος Γηραῖον Διφίλου, ἀγαθὸν πολίτην, 'The people [has set up] Geraios, son of Diphilos, good citizen'.

Yet the question remains of the impact of the politics of the honorific. In this chapter, I have gone along with its ideology, the 'implications of the implications' of the monument as constituted by image and text. Honorific monuments embed the individual within communitarian norms, through idealizing instruments such as the honorific decree, which are written in an accepted moralizing discourse predicated on simple notions about goodness: goodness is good for you, goodness can be in the form of concrete signs of 'goodwill' towards a wider community, the community is the right entity to judge good actions and reward them. The honorific statue is thus about the ontological primacy of community (manifested in culturally marked memorial and monumental forms) over individual.

[63] G. Downey, in R. Stillwell (ed.), *Antioch on the Orontes*, iii. *The Excavations 1937–1939* (Princeton, 1941), 98, no. 179. From the description of the block ('rough-picked' on the top and sides), this was part of a *Statuenreihe*, or more precisely a multi-statue monument, perhaps honouring several members of the same family and perhaps combining public and private statues (see below, pp. 121–6 on series of statues, and pp. 164–5, 219–30 on 'portfolio' monuments).

The very genericity of the discourse is an essential part of how it works; yet this genericity covers a diversity of situations. In other words, civic values, as enacted through the honorific statue, also constitute an ideology, working as a series of operations of choice, dissimulation, and privileging, to achieve political points. The first operation is of course to deny the aspect of the honorific statue which works as a homage and an admission of inequality: the recognition of the eminence of one individual, of his superior wealth, of his capacity for action. The tension is in inherent in a genre which talks about individual character, albeit by trying to frame it in terms of adequation of communitarian values.[64] This holds particularly true in the case of Hellenistic rulers, heavily represented among the recipients of honorific statues (above, 6–7). The honorific image was born of the need of cities to confront both powerful outsiders (the Hekatomnids, Boiotian war-leaders) and powerful insiders (generals); by the time Hellenistic honorific habits stabilized, the statue was part of a package of measures that aimed at the socialization and embedding of the outsiders of the royal states, the king's men, by locating them within civic transactions of euergetism—in other words, by talking to them like citizens. Yet the effect may also have been to make the honorific discourse amenable to talking about what it tried to circumvent, but had been there from the start: asymmetry, power, and inequality, which were present even if the decree and the honorific statue tried to talk them away. In other words, the honorific decree may have allowed elite citizens to think that they should be talked to as kings. This evolution may have played an important role in the shifts in the tone and style of Hellenistic civic life (see below, Conclusion, 294–7).

The notion of 'civic culture', the 'political culture of the *polis*' sounds attractive (at least to the ancient historian; political scientists have higher standards as to causality). But it might be too narrow or static. To assume the successful imposition of unitary communitarian norms—as I have done above, in unpacking the inscribed statue captions as social narratives and narratives of socialization—amounts to neglecting the possibility of change, conflict, and competition, and of such phenomena as the strategic exploitation of discourse, or shifts in the meaning of concepts or the use of ideas. These issues are of particular importance, because they touch on two central issues in the history of the Hellenistic city: its relations with powerful outsiders (Hellenistic kings, Roman officers, the Roman emperor in his world), and the position of civic elites within their cities; in other words, the problems surrounding liberty, agency, and domination; and elitism, democracy, and community. In the rest of this book, I propose to look at the honorific statue habit in precise physical and social contexts: the shared spaces of the city and the shrine, the web of family relations that paralleled public gesture. My intention is to try to track a series of pressures—pressures from outside, pressures exercised by the *polis* as state on individuals through honorific discourses, pressures from various actors within the *polis* as a social space—and to chart outcomes within the city. This, too, is a form of civic history— one which is not predicated on writing the traces of life in the Hellenistic cities within the communitarian narratives of the honorific as the only real form of civic existence (or 'civic culture'), and all else as oligarchical deviations, but one admitting of competition and dynamics.

[64] I owe much to discussion of these issues with B. Gray, and to my reading of his doctoral thesis, 'Exile and the Political Cultures of the Greek Polis, c. 404–146 BC' (D.Phil. thesis, University of Oxford, 2011). See now P. Martzavou and N. Papazarkadas (eds), *The Epigraphy of the Post-Classical Polis: Papers from the Oxford Epigraphy Workshop* (Oxford, 2012), esp. pp. 1–9.

II

Statues and Places

Statues in their Spaces

Lorsqu'on essaie d'étudier des espaces mis à jour par la fouille, force est de constater que ceci ne se fait pas sans une certaine difficulté.

When one tries to study the spaces revealed by excavation, there are no two ways about it: the operation only occurs with no small difficulty.

(P. Fraisse[1])

Honorific statues do not exist in the abstract, but took up space, somewhere. After the 'grammar' offered in Part I, the present chapter tries to establish a 'grammar of space', by listing and exemplifying the various sites where Hellenistic communities set up honorific portraits. I also examine several test cases—Priene, Pergamon, Athens, and the Asklepieion near Epidauros—to illustrate the 'grammar', but also to start to understand the placement of statues as a dynamic, interrelated set of meaningful possibilities.

I. LOCATING HONORIFIC STATUES

To set up a *stele* next to a statue in order that reading a decree and looking at a statue enrich each other; to carve a decree for a Friend of Ptolemy IV on the base of a statue group of the king and his queen (as at the Amphiaraion)—such acts are about producing meaning in space. An honorific statue was set up somewhere to be looked at and experienced by multiple viewers over a long period of time—its meanings determined by its spatial context, which in turn it contributed to determining. Meaning was produced by a variety of factors: the intentions of the community and the honorand, the expectations of the community of viewers at any one moment, the experience of viewing, reading, and moving about on a particular day in the particular space where the statue was set up, the relation between any one statue and its neighbours, the evolution of the monumental context over time.

Honorific statues were involved, and involved their viewers, in the construction of civic space. In this work, by 'space', I mean the general physical dimensions within which things and people exist, and which can be mapped geometrically; even though it designates a concrete state, it is socially defined—public space, sacred space, private space, in any Hellenistic city. How does space affect social meaning? How is the meaning read and interpreted by those who live it? More specifically: how exactly does the location where an honorific statue was set up produce meaning? And which meanings? This chapter starts off with the investigation of space, to describe phenomena; the following will try, in experimental fashion, to explore social interactions, using a number of concepts (theories of place) and metaphors (competitive ecology).

Honorific statues were set up in most prominent locations, *epiphanestatoi topoi*. This concept, too, needs thinking about: what, exactly, was an *epiphanestatos topos*? What did it look like? How did it work? The first problem in studying these questions is one of sources. The *epiphanestatoi topoi* are known first through epigraphy, mostly the honorific decrees,

[1] P. Fraisse, 'Analyse d'espaces urbains: les 'places' à Délos', *BCH* 107 (1983), 301–13.

occasionally inventories or descriptions mentioning the site of statues, and secondly through the archaeology of urban space. If epigraphical mentions are significant (though not plentiful), the archaeological evidence is much poorer and more problematic: there is no easily legible Hellenistic agora or public shrine to help us see honorific statues *in situ*; no test case comparable to late antique Aphrodisias, where inscribed statue bases, the actual statues, and their original sites are known and can be fruitfully interpreted.[2]

The agora at Priene is filled with the foundations of statue bases, but there is no meaningful sequence of statues, or urban geography of statues, to be drawn from a drastically incomplete record (which is not to say that there is no meaningful history to be written from the plan). The same holds true for the agora of Thasos, where site-specific patterns of clustering of statue bases can be observed from the surviving foundations (in front of the great north-east stoa or the smaller 'bâtiment à paraskénia'), but no names or absolute dates can be assigned in most cases; investigation is made more difficult by the rising of the water table.[3] The agora of Athens has its millennium-long archaeological record, and numerous bases from honorific statues can still be seen, displayed in front of the reconstructed Stoa of Attalos, and along the Panathenaic Way (Roman-era square plinths, equestrians, and columnar bases); but almost none can be securely assigned to a site within the Agora, whose long history has also entailed the shifting and moving around of statues (notably those of Hellenistic kings, moved to make way for Agrippa's Odeion). The shrine of Demos and the Charites, on the northern side of the Kolonos hill, would have provided a good example of a specific site for honorific statues—except that it was destroyed to make way for the deep trench of the Peiraieus–Kephissia electric train. The esplanade in front of the temple of Amphiaraos at Oropos preserves an impressive series of statue bases; however, the majority of the equestrian statues in the Western group, once representing (probably) Hellenistic kings and statesmen, were reused to honour Roman generals and their friends: the identity and date of the original honorands, and the meaning of the sequence of statues, are lost. The Asklepieion of Epidauros is thronged with statue bases, but it is impossible, in the present state of the record, to map out the development of the statuescape and its social meanings; for instance, it is only by collating diverse publications and comparing them with physical remains on the ground that one discovers that two adjacent monuments are public honorific statues for members of the same family. In addition, the statue landscape in the Epidaurian Asklepieion was affected by the spoliation of the shrine under Sulla, and the reuse of almost all early and mid-Hellenistic bases in the subsequent centuries.[4] A similar situation pertains for the shrine of Apollo at Klaros: the Sacred Way is insufficiently excavated or published, pirates probably inflicted damage in the early first century BC, monuments were reused to honour Romans.[5]

In other cases, the material is too profuse: Delphi, Olympia, and Delos, after decades of excavation, are extremely complex and do not allow us easily to understand the general

[2] On Aphrodisias, Smith, *Roman Portrait Statues from Aphrodisias*. The case of the Hellenistic cities is hardly unique in the archaeological record: the forum of Pompeii is also difficult to read, because of the loss of the inscriptions on the statue bases in the earthquake of AD 63: A. Mau, 'Die Statuen des Forums von Pompeji', *RömMitt* 11 (1896), 150–6.

[3] The case was highlighted in an exhibition organized by the French government in Strasbourg in Oct. 2008 ('Archéologie et changement climatique: un patrimoine menacé'). My visit to the agora in early summer 2005 took place in water-logged conditions (I fell gravely ill over the next few days, but am still grateful to Julien Fournier for welcoming me on Thasos and showing me around the ancient city-site).

[4] *IG* 4² 1 locates none of the statue bases; Peek's subsequent corrections make clear that he saw many of the stones, but he does not provide a map; S. von Thüngen, *Die freistehende griechische Exedra* (Mainz, 1994) helps locate many exedras, and points out cases of Roman reuse of Hellenistic exedras (though the exedras are organized typologically throughout her book). Adjacent monuments: *IG* 4² 1.654–5, 647–9 (third exedra from the west, von Thüngen, *Exedra*, no. 30, and the large base next to it, north of building E).

[5] R. Étienne and P. Varène, *Sanctuaire de Claros, l'architecture* (Paris 2004); J.-L. Ferrary and S. Verger, 'Contribution à l'histoire du sanctuaire de Claros à la fin du IIe et au Ier siècle av. J.-C.: L'Apport des inscriptions en l'honneur des Romains et des fouilles de 1994–1997', *CRAI* (1999), 811–50; Ferrary, 'Les Inscriptions du sanctuaire de Claros'.

workings of the statue landscape. All too often what we see on the site is misleading: the base of the private honorific for Q. Caecilius Metellus Macedonicus, found in a row of bases in the western part of the Altis (*Inschr. Olympia* 325) seems *in situ*, but in fact rests on the ground without a foundation, whereas the base shows cuttings for a lower block, as noted by Dittenberger: there is no certainty on the original site of this important monument.[6] Even in Messene and Megalepolis, where recent excavation has revealed much new evidence about honorific statues with cases *in situ*, the picture is still fragmentary. The immense agora of Messene itself is still being uncovered, as opposed to the well-excavated Asklepieion, south of the agora, densely peopled with statues. Only part of the similarly huge agora of Megalepolis has been uncovered, so that the dense cluster of statues before the *archeion* cannot be seen in a broader spatial and historical context.

Moreover, it is not simply a question of evidence, imperfect publication record, misleading published plans, and uninformative modern presentation of archaeological sites. Even if we had a site with a perfect archaeological record of Hellenistic honorific statues, the question of the *epiphanestatos topos* would not be simple to answer. In the Upper Gymnasion at Pergamon, one room was transformed into the setting for the statue of a great benefactor ('Room B').[7] Yet it is too pat to deduce that the presence of the statue of this Diodoros Pasparos and other honorific monuments in the south-east corner directly and unproblematically shows that that particular corner of the gymnasion was the most prominent spot. The Upper Gymnasion clearly shows the existence of multiple potential focuses for attention (Plan II); the space of the gymnasion can be articulated in different ways, starting with its symmetry and axiality, which emphasizes a room set aside for the cult of the Attalid kings ('Room H'). The south-east corner was not inherently prominent because of any physical fact about the gymnasion as space, but was made so by the accumulation of monuments there; the *epiphanestatos topos* is a dynamic reality, created performatively by gestures as part of a complex space. A modern parallel might give pause for thought before assuming that the 'most prominent site' in a city is easy to identify. The whole population of Oradour-sur-Glane, a village in central France (Haute-Vienne), was wiped out in 1944 by troops of a SS division. The atrocity is commemorated by a monument set up in 1996 in the departmental *chef-lieu*, Limoges: the monument, atop a 7 m high column, occupies a 'prominent' spot—a busy roundabout, at the intersection of the Limoges ring road and the Nationale 141. The then mayor of Limoges celebrated the spot as 'très en vue', since it was seen by thousands of motorists every day; yet the site is not meaningful, but trivial and unsatisfactory. Many similar examples of contested sites in modern towns have been studied: monuments and space are not simple issues.[8]

The case of the Upper Gymnasion at Pergamon could be set beside other examples of spaces where the richness of evidence shows the complexity of the construction of significant places out of civic space—for instance at Messene, where a particularly insistent memorial culture was mapped out on a new city founded in 369.[9] What emerges is the need for patience in decoding the workings of space and meaning in the Hellenistic city. In the following pages, I wish to study the sites of statues with examples drawn from archaeology and epigraphy—first, by establishing a roster of possible sites, and examining the motives behind, and the meanings emplotted within, these sites. But I also will examine these sites as part of lived, acted-upon spaces, by looking at detailed test cases, local and thematic—and try to open the way to think about actors and agency within apparently controlled civic spaces.

[6] The ongoing work by Christina Leypold will clarify the relation and chronological sequences of the honorific monument bases in the Altis; some of this work was presented in a workshop at Munich in Dec. 2009 ('Polis und Porträt').

[7] Chankowski, 'Diodoros Pasparos', 166–7.

[8] *L'Histoire*, 207 (Feb. 1997); P. Rainbird, 'Representing Nation, Dividing Community: The Broken Hill War Memorial, New South Wales, Australia', *World Archaeology*, 35/1 (June 2003): *The Social Commemoration of Warfare*, 22–34.

[9] P. G. Themelis, *Heroes at Ancient Messene* (Athens, 2003); 'Die Ägora von Messene', in H. Frielinghaus and J. Stroszeck (eds), *Neue Forschungen zu griechischen Städten und Heiligtümern* (Möhneberg, 2011), 105–25.

2. PUBLIC SPACES AND THEIR STATUES

The phenomenon of honorific statuary occurred in public settings, often urban, always monumental: the public spaces of the Hellenistic city.[10] What do we mean by public space in the Hellenistic city? There is to my knowledge no explicit theoretical, abstract discussion of the concept in late Classical or Hellenistic texts—no mention in Aristotle's *Politics* or Plato's *Laws*. Aristotle's remark that a *polis* is a community of place comes in the context of a general discussion of sharing, and is not quite about public space;[11] nor does public/private structure the discussion of the 'parts of a city' in the *Onomasticon* of Pollux.

However, the very absence of theoretical discussion of public space indicates to what extent its existence was taken for granted and co-terminous with that of the *polis* itself.[12] Homer's cities and communities already have public meeting-places and shrines, and publicness can be read in the archaeological record of the early *polis*, for instance in Dreros, Thasos, Naxos, or Eretria, or Megara Hyblaia and Kasmenai;[13] all these sites have public spaces for meeting and for cultic activities as an organic part of town plans and planning.[14] The concept of public space is clearly seen in the discussion of Hippodamos' urbanistic projects, or the structuring of Attica seen in the Kleisthenic reforms, or the ideal cities of Plato and Aristotle.[15] Public space appears in practical regulations such as the fifth-century law governing the streets of Thasos, the responsibilities of the *astynomoi* in fourth-century Athens, or the long *astynomikos nomos* of Pergamon, preserved in a Roman-date inscription but going back to Hellenistic times;[16] such officials notably protected public space such as streets from encroachment by private building (κατοικοδομεῖν), as well as by behaviour considered unsuitable. An inscribed regulation in Nisyros declares that 'the space is public for five feet from the wall' (to prevent private building too close to the city's defences).[17] The 'Hippodamian' grid-plan adopted in later cities is not (simply) about egalitarianism and orderliness, as often stated,[18] but also makes evident, in public form, what the difference is between the tightly packed but modular world of private space, and the significant public spaces, with their openness and complexity.

[10] Generally, B. S. Ridgway, 'The Setting of Greek Sculpture', *Hesperia*, 40 (1971), 336–56; earlier, E. Kuhnert, 'Statue und Ort in ihrem Verhältnis bei den Griechen', *Jahrbücher für classische Philologie*, suppl. 14 (1885), 245–338; also K. Stemmer (ed.), *Standorte: Kontext und Funktion antiker Skulptur* (Berlin, 1995). On Archaic and Classical urbanism, see the survey by G. Shipley, 'Little Boxes on the Hillside: Greek Town Planning, Hippodamos, and Polis Ideology', in M. H. Hansen (ed.), *The Imaginary Polis* (Copenhagen, 2005), 335–403. For a parallel, G. Zimmer, *Locus Datus Decreto Decurionum* (Munich, 1989), on the *fora* of Djemila and Timgad.

[11] Aristotle, *Politics* 1260b40–1.

[12] D. M. Lewis, 'Public Property in the City', in O. Murray and S. R. F. Price (eds), *The Greek City from Homer to Alexander* (Oxford, 1990), 245–64; J.-M. Bertrand, *Cités et royaumes du monde grec* (Paris, 1992); M. H. Hansen and T. Fischer-Hansen, 'Monumental Political Architecture in Archaic and Classical Greek *Poleis*: Evidence and Historical Significance', in D. Whitehead (ed.), *From Political Architecture to Stephanus Byzantius: Sources for the Ancient Greek* Polis. Historia Einzelschrift, 87 (Stuttgart, 1994), 23–90; M. H. Hansen, 'The *Polis* as an Urban Centre: The Literary and Epigraphical Evidence', in Hansen, *The Polis as an Urban Centre and as a Political Community* (Copenhagen, 1997), 9–86.

[13] Dreros: H. van Effenterre and C. Tiré, *Guide des Fouilles françaises en Crète* (Paris, 1978), 93–6; Naxos: V. Lambrinoudakis, 'The Emergence of the City-State of Naxos in the Aegean', in M. C. Lentini, *Le due città di Naxos* (Giardini Naxos, 2004), 61–74; C. Bérard, *L'Héróon à la porte de l'Ouest*. Eretria, 3 (Berne, 1970); Sicily: T. Fischer-Hansen, 'The Earliest Town-Planning of the Western Greek Colonies, with Special Regard to Sicily', in M. H. Hansen (ed.), *Introduction to an Inventory of* Poleis (Copenhagen, 1996), 317–73.

[14] Generally, T. Hölscher, *Öffentliche Räume in frühen griechischen Städten* (Heidelberg, 1998); F. de Polignac, 'Analyses de l'espace et urbanisations en Grèce archaïque: Quelques pistes de recherche récentes', *REA* 108 (2006), 203–23.

[15] Plato, *Laws* 739a–740a, 745b–c, 847c; Aristotle, *Politics* 7.1330a–1331b (I owe these points to B. Gray); P. Vidal-Naquet and P. Lévêque, *Clisthène l'Athénien* (Paris, 1964); Lewis, 'Public Property', notably on Aristotle, *Politics* 1267b.

[16] *SEG* 42.785 (Thasos law, ed. H. Duchêne); [Aristotle], *Constitution of the Athenians* 50.2 (with [Xenophon], *Constitution of the Athenians* 3.4: public prosecution of illegal building on τι δημόσιον), and *IG* II² 380 (*astynomoi* caring for wide streets in Peiraieus); *OGIS* 483; generally, D. Hennig, 'Staatliche Ansprüche an privaten Immobilienbesitz', *Chiron*, 25 (1995), 235–53.

[17] *Syll.* 936.

[18] W. Schuller, W. Hoepfner, and E.-L. Schwander (eds), *Demokratie und Architektur* (Munich, 1989).

The history of public space in the *polis* still remains to be written; what matters here is that public space is essential to the *polis*, as a human community rooted in a physical and concrete context. Of course, any community must have some form of common space, for circulation, meeting, and exchange; even the modern and postmodern Western, car-centred consumer city has its malls and multiplexes. The spaces of the Hellenistic *polis* are historically specific, in their clear physical definition of circulation axes and common open areas (contrast the medieval and early-modern 'Islamic' or 'Arab' city).[19] Order; emphasis on human craftedness;[20] clear division between public and private; shared memory and experience; *polis* culture and citizen values—all these elements underlie public space in the *polis*. This should not lead to idealizing the *polis* and seeing 'democratic values' everywhere: competition, injustice, and domination—in other words, history—can be read in its spaces, just as urban geographers detect anomie in the modern city (and indeed, something similar will be proposed further on in this book). But critical awareness does not preclude, as an opening move, examining the ways in which public space was articulated and made to work in the Hellenistic *polis*.

Space is absence; to put something within space is to take away from it. Public space is common property, legally owned by the whole community as a political entity—it is not anybody's, but everybody's: it is precisely not open for anybody to act on or in public space, and public permission has to be specifically granted for such an action. In the *polis*, this meant the supervision and control of the political community, through its institutions, the assembly, the council, the magistrates, with local variations on the exact forms of control and implementation. Control can be seen to be exercised negatively, by prohibitions. At Tymnos, in the Rhodian Peraia, a late Hellenistic decree orders the *hierothutas* to allow participants in public sacrifices to use a portico, but also to prevent anyone from lighting fires in the portico or nailing anything permanently to the portico's structure: the aim is declared to be to prevent offences towards the gods, and to protect their statues; enforcement is entrusted to the magistrate, the public slave, and 'whoever wishes among the demesmen'.[21] The decree regulates the correct use of public, in this case sacred, space, ensures its enforcement by legitimizing processes of coercion (if need be of a hue-and-cry kind), and in its inscribed presence makes visible public authority over space. Similarly, an early Hellenistic decree from Miletos restricts the dedication of *pinakes* in the 'new stoa' in the shrine of Apollo Delphinios to the walls, declaring roof woodwork and columns out of bounds, on pain of a fine of 10 staters;[22] at Delphi, an Amphiktyonic decree prohibits the setting up of dedications in the Stoa of Attalos, and the removal of any offending offerings.[23] Most interestingly, a decree from statue-mad Rhodes forbids anyone from 'applying for the setting up of a statue or any other dedication in the lower part of the sacred enclosure (of Asklepios)—from the entrance gate to those dedications for which applications were made earlier—or in any other spot in which dedications, if set up, would hinder circulation'. Any such request to set up a statue in the shrine would be considered void, and any dedication would be removed by the *astynomoi* to another spot.[24]

Other such examples could be mentioned, for instance from Delphi, or Athens.[25] All these examples concern the management of sacred space, from the point of view of practicality and

[19] H. Kennedy, 'From *Polis* to Madina: Urban Change in Late Antique and Early Islamic Syria', *Past and Present*, 106 (1985), 3–27; A. Raymond, 'Islamic City, Arab City: Orientalist Myths and Recent Views', *British Journal of Middle Eastern Studies*, 21 (1994), 3–18.
[20] B. Fehr, 'Kosmos und Chreia: Der Sieg der reinen über die praktische Vernunft in der griechischen Stadtarchitektur des 4. Jhs. v. Chr.', *Hephaistos*, 1 (1979), 155–85.
[21] *Pérée rhodienne* 102, same document *I. Rhod. Peraia* 201.
[22] *Milet* 1.3.32, with P. Herrmann, *Milet* 6.1, pp. 160–2, for bibliographical complements on this text.
[23] *CID* 4.85; Wilhelm, *Inschriftenkunde*, i. 230.
[24] G. Pugliese-Carratelli, 'Supplemento epigrafico rodio', *ASAtene*, 30–2 (1952–4), 247–9, no. 1; the letter-forms suggest a date in the first half of the 3rd cent..
[25] *CID* 4.85, Delphi, Amphiktyonic decree concerning the *stoa* of Attalos I; *LSCG* 43, 2nd-cent. Athenian decree regulating dedication of painted portraits in a shrine, with removal of offerings 'unworthy of the shrine';

decorum. But sacred space is part of public space; the specific cases adduced above, arising out of unsatisfactory or conflictual situations where state authority had to decide, manage, repress—and allowed itself to be seen to do these things. These decrees make clear the *polis*'s authority over its public spaces, in a way which is not preserved for the agora, the gymnasion, or the theatre, as far as I know: the laws whose prohibitions first-century Athenian ephebes had to observe, when allowed to set up portraits 'where the laws do not forbid it', are not explicitly recorded, and in any case were probably specific enactments, rather than general statements of principle.[26]

The act of setting up something permanent in public space entailed the involvement of public authorities, whose approval was needed.[27] Hence a city granted *topos* to outsiders who wanted to set up statues within its public space: the expressions used are δοῦναι (δεδόσθαι) / συγχωρῆσαι τόπον, to 'give' or, more grandly, to 'consent to' a location. The Kyzikenes acknowledged an honorific decree of the Parians for Apollodoros, son of Apollonios (a Kyzikene), the nesiarch (head of the League of Islanders) of the first two decades of the third century; the Kyzikenes acceded to the request for a spot in the agora at Kyzikos, where the Parians had wished to set up a statue of Apollodoros: δεδόσθαι δὲ αὐτ<οῖς> καὶ τό|πον ἐν ὧι στήσουσι τὴν εἰκόνα, παρὰ τὰς τραπέ|ζας πρὸ τῆς στοᾶς τῆς Δωρικῆς, 'let there be given to them (the Parians) a spot in which they will set up the statue, next to the (money-changing) tables before the Doric stoa'.[28] The Delians asked the citizens of Thessalonike 'to give the finest site possible' (δοῦναι τόπον ὡς βέλτιστον) for a statue of Admetos, son of Bokros, proxenos of the Delians.[29] The citizens of Apollonia on Pontos asked the Kallatians to 'grant' (συγχωρῆσαι) a site for the statue of a Kallatian honoured by Apollonia;[30] a contingent of Cretan soldiers, sent to aid Ptolemy VI in his campaign on Cyprus against Ptolemy Euergetes II, honoured Aglaos, son of Theukles, of Kos, with bronze statues to be set up on Kos and on Delos. The decree ends with the stipulation that an ambassador is to ask the Koans to designate the finest spot for the dedication of the statue, and likewise the Athenians to designate the most conspicuous spot on Delos, by then an Athenian possession (*c*.154 BC).[31]

Likewise, in response to requests from individuals or groups within a city, the latter grants sites for honorific portraits. At Kykizos, the priests and priestesses of Meter Plakiane, then the *kosmophylakes*, ask for the public grant of a *topos* in which to set up honorific portraits of Kleidike, daughter of Asklepiades. In the first case, the priests and priestesses ask for τόπον ἐν τῆι ἀνδρήαι ἀγορᾶι ἐπὶ τοῦ προγονικοῦ αὐτῆς συνεδρίου τὸν ἀπὸ δύσεως τοῦ ἀνδριάντος τοῦ ἀδελφοῦ αὐτῆς Διονυσίου τοῦ Ἀσκληπιάδου, 'in the men's agora, the location on (Kleidike's) ancestral

and 50, 1st-cent. Athenian decree concerning a shrine of Isis in the deme of Teithras; on this document, P. Martzavou, '"Isis" et "Athènes": Épigraphie, espace et pouvoir à la basse époque hellénistique', in M.-J. Versluys and L. Bricault (eds), *Les Cultes isiaques et le pouvoir* (Leiden, forthcoming). See generally Wilhelm, *Inschriftenkunde*, ii. 161–7. *IGLS* 1261 (a 2nd-cent. decree of the authorities of Laodikeia on Sea, in Seleukid Syria), though slightly different (concerning legal issues of land rights when dedications are made in a private shrine), illustrates the same point about public authority over space (J. D. Sosin, 'Unwelcome Dedications: Public Law and Private Religion in Hellenistic Laodicea by the Sea', *CQ* 55 (2005), 130–9). In Roman-era Nysa, the right to set up dedications in shrines was liable to a tax: F. Ertuğrul and H. Malay, 'An Honorary Decree from Nysa', *EA* 43 (2010), 31–42.

[26] *IG* II² 1006, 1008, 1009, 1011, 966 (fragmentary), 1039; discussed in Robert, *Hellenica*, iii. 29 n. 1, and A. S. Henry, *Honours and Privileges in Athenian Decrees* (Hildesheim, 1983), 300–1.

[27] W. W. Tarn, 'The Political Standing of Delos', *JHS* 44 (1924), 141–57; Perrin-Samindayar, '*Aere perennius*', 117–24.

[28] Michel 534; correct Michel's αὐτῶι. On Apollodoros (probably a Ptolemaic official), I. L. Merker, 'The Ptolemaic Officials and the League of the Islanders', *Historia*, 19 (1970), 152, 159; R. Bagnall, *Administration of the Ptolemaic Possessions Outside Egypt* (Leiden, 1976), 137–8; G. Hölbl, *Geschichte des Ptolemäerreiches* (Darmstadt, 1994), 25–6. For the 'tables', see the parallel material from Athens, gathered in R. E. Wycherley, *Literary and Epigraphical Testimonia*. Athenian Agora, 3 (Princeton, 1957), 192–3, to which add now *RO* 20 (law on testing silver coinage, proposed by Nikophon).

[29] *IG* 11.3.665 and 1053, also in *Choix Délos*, no. 49; (third quarter of the 3rd cent.).

[30] *IGBulg* I² 391 (3rd or 2nd cent.).

[31] *ID* 1517, with Chr. Habicht, 'Neues zur hellenistischen Geschichte von Kos', 146–7.

exedra, to the west of the statue of her brother, Dionysios son of Asklepiades'. Even in the case of what seems to have been a family monument, siting was in the gift of the city.[32] In Athens, the ephebes of the year 118/17 asked for the people to grant a site ($\dot{\epsilon}\pi\iota\chi\omega\rho\hat{\eta}\sigma\alpha\iota$ $\tau\acute{o}\pi o\nu$) for a statue. After the Hellenistic period,[33] from the first century AD onwards, the same principle of public permission for statues is found in the abbreviation $\psi(\eta\phi\acute{\iota}\sigma\mu\alpha\tau\iota)$ $\beta(o\upsilon\lambda\hat{\eta}s)$ / $\beta(o\upsilon\lambda\hat{\eta}s\ \kappa\alpha\grave{\iota})$ $\delta(\acute{\eta}\mu o\upsilon)$, 'by decree of the council/of the council and the people'; these often qualify privately erected statues, which are both authorized and dignified by the formal approval of the city's political institutions.[34]

When a community decided to honour someone with a statue, and set it up within its own monumental public space, it did not need to grant a location, by definition, since the transaction involved only itself, as honouring agent and as possessor of legal rights over the space. Mostly, cities simply decided to 'set up a statue', without details on process; when there are details, we see that the city has decided to designate, or more specifically to have the council or magistrates designate, a suitable site. The Milesians decided to set up an equestrian statue of Antiochos I in a site designated by the council.[35] The normal verbs are $\pi\alpha\rho\alpha\delta\epsilon\acute{\iota}\kappa\nu\upsilon\mu\iota$, or more frequently $\dot{\alpha}\pi o\delta\epsilon\acute{\iota}\kappa\nu\upsilon\mu\iota$, also used for the act of appointing officials or ambassadors, and hence belonging to the realm of political decisions. At Theangela, a benefactor is honoured with a statue in the agora; the location is to be indicated by the *prostatai*, $[\tau\grave{o}\nu\ \delta\acute{\epsilon}\ \tau\acute{o}]\pi o\nu\ o\mathring{\upsilon}\ \sigma\tau\alpha\theta\acute{\eta}\sigma\epsilon\tau\alpha\iota$ $\dot{\alpha}\pi o\delta\epsilon\iota\xi\acute{\alpha}\tau\omega[\sigma\alpha\nu\ o\mathring{\iota}]\ \pi\rho\acute{o}\sigma\tau\alpha\tau\alpha\iota$.[36] The statue decreed for the late second-century Kolophonian benefactor Menippos was to be set up 'in the shrine of Apollo Klarios, in the spot designated by the treasurer' ($\dot{\epsilon}\nu\ \tau\hat{\omega}\iota\ \pi\alpha\rho\alpha\delta\epsilon\iota\chi\theta\eta\sigma o\mu\acute{\epsilon}\nu\omega\iota\ \tau\acute{o}\pi\omega\iota\ \acute{\upsilon}\pi\grave{o}\ \tau o\hat{\upsilon}\ \tau\alpha\mu\acute{\iota}o\upsilon$).[37] When the city of Dionysopolis honoured a great benefactor, Akornion, with a statue, the benefactor in fact set the statue up (and hence paid for it), but the city still granted the 'most visible site of the agora'.[38]

The grant of honours by the Confederacy of Athena Ilias illustrates the distinctions in usage sketched out above. When the Confederacy honoured the gymnasiarch of the festival of Athena with a bronze statue, to be set up in the shrine of Athena at Ilion (there are two surviving decrees attesting this honour), the Confederacy sent envoys to ask the people of the Ilians to designate ($\pi\alpha\rho\alpha\delta\epsilon\hat{\iota}\xi\alpha\iota$) the site for the statue.[39] As L. Robert pointed out, the verb implies that the Confederacy enjoys control over space in the shrine; the Ilians are involved in the process, only to the extent of the administrative and practical matter of choosing the location for the statue. In contrast, when the Confederacy asks one of its member states, the *polis* of Abydos, to find a spot for a *stele* bearing the decree in honour of the Abydene gymnasiarch, Kydimos, the expression is $\delta o\hat{\upsilon}\nu\alpha\iota\ \sigma\tau\acute{\eta}\lambda\eta\iota\ \tau\acute{o}\pi o\nu$—the Confederacy does not control space within its constituent member states, only in the federal shrine, and must ask for a grant within Abydos, just like any other outside state. In contrast with the Confederacy of Athena Ilias, the decrees of the Delphic Amphiktiony never mention the *polis* of Delphi as

[32] Michel 537–8, with C. Habicht, 'Notes on Inscriptions from Cyzicus', *EA* 38 (2005), 93–100 (mid-1st cent.).

[33] Other examples of grants of sites in public space upon request by people within a city: *Inschr. Magnesia* 102 (*gerontes* honour their gymnasiarch) with Wilhelm, *Akademieschriften*, iv. 388, for further parallels. The wish of the Pergamene *neoi* to honour their gymnasiarch Metrodoros is met with a general 'granting', $\sigma\upsilon\gamma\chi\acute{\omega}\rho\eta\sigma\iota s$ (*Inschr. Pergamon* 252, ll. 39–40). On Athenian-controlled Delos, the Athenians granted a gymnasiarch the right to set up dedications in the gymnasion, and a statue 'next to the *archeion* (official building) of the Commisioners of the Emporion, on the left hand side as you go up': *SEG* 47.1218 (mid-2nd cent.); the deme of Melite granted permission to a priestess to set up a painted *eikon* in the Eleusinion: *SEG* 42.116 (early 2nd cent.).

[34] e.g. *IG* 4.672 (Argolid); 7.2520 (Thebes); 10.2.1.179 (Thessalonike); *I. Erythrai* 106. For variants, e.g. *PH* 58 (Kos); *IG* 5.2.312 with L. Robert, *A travers l'Asie Mineure* (Athens and Paris, 1980), 135; earlier bibliography in Wilhelm, *Abhandlungen*, ii. 179. These formulas are equivalent to the Latin L(*ocus*) D(*atus*) D(*ecreto*) Decurionum.

[35] *OGIS* 213, reading $\dot{\epsilon}\nu\ \tau\hat{\omega}\iota\ \tau\acute{o}\pi\omega\iota\ \mathring{\omega}\iota\ \mathring{\alpha}\nu\ \tau\hat{\eta}\iota\ [\beta o\upsilon\lambda\eta\iota\ \kappa\alpha\tau\alpha\nu\acute{\epsilon}]\mu\epsilon\iota\nu\ \delta\acute{o}\xi\eta\iota$, but the verb is unclear, as pointed out by A. Rehm (republishing the text as *Inschr. Didyma* 479). It also is the council which designates the 'finest spot' in Thessalonike for the statue set up by the Delians (*Choix Délos*, no. 49, III, ll. 30–2).

[36] Robert, *Coll. Froehner*, no. 54.

[37] *SEG* 39.1244, III, ll. 43–6. See also the Milesian decree for Eirenias, *Nouveau Choix*, no. 7 (also Queyrel, *Portraits des Attalides*, 287–9; originally published by P. Herrmann); *I. Rhod. Peraia* 402/*Pérée rhodienne* 45.

[38] *Syll.* 762.

[39] *I. Ilion* 2, *SEG* 53.1373 with L. Robert, *Monnaies antiques en Troade* (Paris and Geneva, 1966), 29–30.

designating a site for honorific statues, and may have been directly involved in the details of administering space in the shrine of Apollo.[40]

This distinction ('giving' sites to outsiders, 'designating' sites when decisions happen within the community) is widely documented, and significant, even if there are variations and exceptions. For instance, outside communities ask for spots for *stelai*—not statues—to be 'designated'. To 'give' and to 'designate' can be used interchangeably, and it is even possible for a body outside a *polis* to ask the latter to 'designate a site' for a statue, rather than to 'give a site', as would be expected on the basis of parallels; conversely, there may be an example, at Dionysopolis on Pontos, of an honorific decree 'giving', rather than designating, space within the city, for the statue of Akornion, a great benefactor.[41] What is significant about linguistic practice is how it makes explicit the assumptions about space involved in the transaction of setting up an honorific statue.

In this respect, the practice of displacement (*metaphora*) of statues illuminates the consequence of public control of space. Displacement provides a dramatic instance of such control: just as the city gave space, it could take it away, revoke its grant, and move a statue to a new site considered more suitable,[42] put another statue in front of it (see below), or do away with it altogether. In Lindos, in AD 17, it was possible to purchase and remove a statue from the shrine of Athena—after making a request to the Lindians, naturally.[43] Displacement of statues is akin to the reuse of statues by recarving the inscription: both make visible the absoluteness of civic control over these very special objects, situated within its space. Some attempts to pre-empt displacement and reuse attest to nervousness about the practice and, perhaps, its assumptions. The Chian decree for Lucius Nassius and his sons included an entrenchment clause, to ensure that the various portraits should not be displaced or reinscribed (ὅπως ταῦτά τε ἀγάλματα καὶ οἱ ἀνδριάντες οἱ ἀνασταθησόμενοι Λευκίου τε καὶ τῶν υἱῶν αὐτοῦ μὴ μεταρθῶσιν μηδὲ μετεπιγραφῶσιν: 'so that these (marble) statues and the statues which will be set up of Lucius and his sons shall not be displaced nor have their inscriptions changed').[44] A dedication (not necessarily a private honorific statue) from Hypata was entrusted to Rome and the Theoi Sebastoi 'to keep as un-displaced and un-reinscribed' ([φυ]λ[ά]ττεσθαι ἀμετάθετα καὶ ἀμ[ε]τεπίγραφα).[45]

The practices surrounding the granting and managing of space amount to a tautology: making explicit public control over public space. The point is obvious, but perhaps still worth exploring. The transaction of setting up an honorific statue within public space involves time, money, people; the ritual interplay of institutions, and the final monumental result, make civic control visible. The honorific portraits of Kleidike, at Kyzikos (above), were not simply subject to the grant of space, they also had to undergo *dokimasia*; approval by public institutions (the council or another board of magistrates).[46] Just as public inscriptions act to capture individual identity within civic terms (euergetical exchange, communitarian ethics) and a monumental time-frame (Chap. 1), the grant or designation of *topos* for a statue restates public control over individual identity within meaningful space. The passing of the decrees in council and assembly, and the inscription of decrees recording the grant of *topos* act as privileged narratives of the community defining and embedding identities; the statue itself offers a concrete statement of these processes and their imaginary spaces.

[40] F. Lefèvre, *L'Amphictionie Pyléo-delphique* (Athens, 1998), 45–6, is cautious on the difficulty of distinguishing control and ownership at Delphi.

[41] *IGBulg* I² 13 (but the text is perhaps in need of correction; the transaction is probably about allowing the benefactor to set up his own statue).

[42] Robert, *Hellenica*, vii. 241–3, on moving statues (the particular example analysed is the statue of an Augustan governor, moved but reinscribed in AD 171); earlier, Wilhelm, *Inschriftenkunde*, ii. 164–5.

[43] *Inscr. Lindos* 2.419, ll. 30–44.

[44] *IGR* 4.1703, improved by A. Wilhelm, 'Die Beschlüsse der Chier zu Ehren des Leukios Nassios', *Wiener Studien*, 59 (1941), 89–109, and J. Keil, 'Die Volksbeschlüsse der Chier für Lucius Nassius', *Jahreshefte*, 35 (1943), *Beibl.* 121–6.

[45] *IG* 9.2.32 (with Wilhelm, *Inschriftenkunde*, ii. 166–7; also *Inschriftenkunde*, i. 235).

[46] At Oropos, a special commission, *arche*, is seen to decide on the matter (*Oropos* 294).

As Wilhelm writes, 'when space was lacking, it had to be created'.[47] But the constraints were not simply about the tyranny of practicality. In offering *topos* for the monumental, permanent image of an honorand, the community granted and controlled access to scarce resources: not only public space, but also visibility, honour, and memory. The handling of these scarce resources, to meaningful effect, created public space in the Hellenistic *polis*: space was not simply 'produced' by economic or social forces, but the result of creative acts by a civic community. In addition to the mobilization and display of political institutions, civic space works through creative acts, which entailed the careful use of sites within the city, to generate meaning: the vocabulary of *topos* enables statue practice as spatial discourse.[48] That, at least, is the story which civic narratives would have us believe, just as inscriptions tell us a story of civic control; for now, to explore this culture, we have to follow these narratives and their fictions.

3. CIVIC SITES: FROM TYPOLOGY TO GRAMMAR

So where were honorific statues set up? 'In the most conspicuous spot', as honorific decrees often specify. The huge pillar base, supporting a four-horse chariot and the portrait of an Attalid ruler (later reinscribed as a monument honouring M. Agrippa), at the entrance of the Athenian Akropolis, occupies one such site (see below, 117). But such sites are rare; if all statues were truly to be placed in the most conspicuous spot, the result would be an anarchical competition for height, prime real estate, and visibility—in fact the state of affairs, as can be seen in international shrines such as the shrine of Apollo at Delphi, with its skyscraper-like jostling of high bases.[49] Hellenistic cities set up statues of their benefactors in a precise set of civic spaces, which it is easy to illustrate from the epigraphical, archaeological, and literary evidence, in order to establish a typology of the 'typical' honorific townscape:[50] the agora, the civic shrine, the gymnasion, and the theatre are the main rubrics of this typology.

However, to establish a typology is to raise questions about the workings of statues within their social context: when are honorific statues first erected in a specific type of location (for instance the gymnasion)? How uniform is practice? What governs the choice of a location? Later, I aim to examine broader questions of impact and meaning, and the embedding of civic ideologies within not simply civic space, but also civic *place* (Chap. 4); for now, I would like to nudge the typological survey of the spaces involved in the direction of a grammar of civic space—by taking each of the four venues mentioned above, examining where statues are set up within them, and asking why statues are set up in particular spots, to produce which meanings.

a. Agora

'To set up a statue of him in the most prominent spot of the agora': honorific statues are well attested in the agoras of the Hellenistic cities, by literary references, by explicit references in honorific decrees (such as the formula just quoted), and by archaeological finds of bases *in situ*, or of foundations. The earliest and most abundant evidence concerns Athens, from the early fourth century onwards.[51] Honorific statues were consistently erected in this particular site throughout the Hellenistic period, with a particularly dense development in the later Hellenistic period; clusters of statues can be traced on the map, in a variety of significant sites (see below, 103–7, and Plan 1). Other clear examples of honorific statuescapes in agoras are

[47] Wilhelm, *Inschriftenkunde*, ii. 165; on Paros, a benefactor is honoured with a statue which must not damage any of the dedications in the same space, the *agoranomion*: *IG* 12.5.129.

[48] Hansen, '*Polis* as an Urban Centre', 12–17, argues against the notion of 'civic space', but his understanding is limited.

[49] A. Jacquemin, *Offrandes monumentales*.

[50] Already Kuhnert, 'Statue und Ort'.

[51] The epigraphical evidence is discussed by H. A. Thompson and R. E. Wycherley, *The Agora of Athens* (Princeton, 1972); Henry, *Honours and Privileges*; Gauthier, *Bienfaiteurs*, 89. The material will be gathered in D. J. Geagan, *Inscriptions: The Dedicatory Monuments*, Athenian Agora, 18 (forthcoming). On context and development, Dillon, *Ancient Greek Portrait Sculpture*.

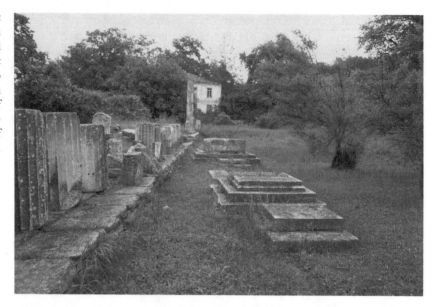

Fig. 3.1. Honorific statues took place in series, which can be read to talk about urbanistic pressures, but also competition between monuments. Row of bases in front of north-west stoa, Agora of Thasos.

provided by Priene (see below, 98–101, and Plan 13), where an impressive row of foundations allow for some analysis of planning, impact, and effect; and Thasos, where foundations of statues (probably honorific) are still visible in front of the 'north-west stoa' and the 'bâtiment à paraskénia' (Fig. 3.1), as well as in the centre of the open space, and where a row of five late Hellenistic exedras is relatively well preserved (Plan 9).[52]

In the late fourth century, Lykourgos fondly imagined Athenian practice to be unique, and the agoras of other cities to be full of statues of athletes rather than generals and politicians (*Leokr.* 51); even for this relatively early period, Lykourgos' statement does not seem to be accurate, and reflects Athenian exceptionalist self-image rather than real practice. In the Peloponnese, Megalopolis, a new city foundation, provides a fourth-century example of honorific statues in the agora;[53] in Ionia, Erythrai offers an early example, with an epigraphically attested statue of Maussollos set up in the agora; the statue of the tyrannicide Philitas (late fourth century BC?) was probably also erected in the agora.[54] An anecdote mentions Alexander revelling around, and crowning, a statue of the tragic poet Theodektes in the agora of Phaselis in 334. If authentic, the story would be another fourth-century example of a statue in the agora of a city in Asia Minor.[55] It is true that the statue might have been set up by Theodektes himself as a dedication, or by a relative (see below, Chaps. 5–6), as well as by the city of Phaselis; nonetheless, the location and dating of the anecdote at Phaselis imply a statue habit in a Hellenized city within the Achaimenid empire, and raise the possibility that public honorific monuments were already common in the agora of many Greek and Hellenized cities by the second half of the fourth century.

During the third century, as the honorific statue habit takes hold throughout the Hellenistic world, the agora appears as a prime site for publicly decreed, full-size bronze (and marble) statuary in honour of benefactors. At Erythrai, the agora contined in use as the site for

[52] J.-Y. Marc, 'L'Agora de Thasos du IIe siècle av. J.-C. au Ier siècle ap. J.-C.: État des recherches', in J.-Y. Marc and J.-C. Moretti (eds), *Constructions publiques et programmes édilitaires en Grèce entre le IIe siècle av. J.-C. et le Ier siècle ap. J.-C.*, *BCH* suppl. 39 (Athens, 2001), 495–516.

[53] Megalopolis: *SEG* 48.521, H. Lauter and T. Spyropoulos, 'Megalopolis. 3, Vorbericht 1996–1997', *ArchAnz* (1998) 415–51 (statues of Philip II and consort or son, in front of Stoa of Philip in the agora); H. Lauter, 'Megalopolis: Ausgrabungen aus der Agora 1991–2002', in E. Østby (ed.), *Ancient Arcadia* (Athens, 2005), 235–48.

[54] *I. Erythrai* 8 and 503.

[55] Plutarch, *Alexander* 17.9.

honorific statues, such as that of the great benefactor Polykritos, and that of his son, whose statue was set up next to his father's (and next to a *stele*, erected earlier, inscribed with the honours decreed for Polykritos before the statue).[56] Even if the evidence will never be complete enough for a complete dated list of all Hellenistic cities where honorific statues stood in the agora, and hence for an exact history of the spread of the practice, it is clear that this practice mirrored the honorific statue habit itself: rare examples appear in the first half of the fourth century; they grow more frequent towards the end of that century, spread during the third century, becoming common from the second century onwards. Most, or indeed all, Hellenistic *poleis* by 200–150 BC (at least in mainland Greece from the Peloponnese to Macedonia, the islands, Asia Minor, and the Black Sea region) had honorific statues and painted portraits in their agoras, as indicated by the combination of epigraphical, literary, and archaeological evidence. The statue of the benefactor Soteles (early first century) was set up 'wherever he wants, in the most prominent spot in the agora' of Pagai (as is known from the decree for Soteles; the base has also been found, though not *in situ*).[57] In Chaironeia, the citizens set up a statue of Lucullus in the agora (next to a statue of Dionysos), for his help after a terrible episode during the First Mithradatic War.[58] At Eretria, the agora has not been fully excavated, but its area is known, and a sounding has yielded a third-century statue base, from a monument set up by the Delphians in honour of an Eretrian *hieromnemon* (discussed above, 25), as well as two foundations for statues, probably equestrian.[59] On Chios, the statues of L. Nassius (above) were set up on columns in the agora. In Macedonia, honorific statues are attested in Thessalonike by an honorific decree,[60] and in the huge agora of Pella by foundations of bases in front of the north stoa, the bronze fragments of a splendid equestrian statue,[61] and more whimsically, a poem by Poseidippos:

Πελλαῖον γένος ἀμόν· ἔοιμι δὲ βίβλον ἑλίσσων
†αμφω† λαοφόρωι κείμενος εἰν ἀγορῆι

My race is from Pella; may I be set up, unscrolling a book, (*text corrupt*) in the bustling agora.[62]

In Asia Minor, the recently discovered base of the statue for Apollonios, who died in battle leading his fellow citizens of Metropolis in Ionia during the war of Aristonikos, was set up 'in the most conspicuous spot of the agora' (not found *in situ*); a painted portrait for the kitharode (and local 'boss') Anaxenor was set up in the agora of Magnesia on Maeander (presumably in a portico), as known from a reference in Strabo.[63] Statues of 'the kings' (Seleukids) in the agora of Magnesia under Sipylos are mentioned in the treaty between Smyrna and the colonists at Magnesia.[64] The example is noticeable, because the exact civic status of Magnesia at this moment is unclear; even so, the urban settlement has an agora, and statues in the agora. Furthermore, these statues are the scene of an oath by the colonists: the royal images, even though not strictly cultic (they are called *eikones* and not *agalmata*) are an important focal point for the urban landscape, and make the kings visible, and hence an object of loyalty and public gestures.

[56] *I. Erythrai* 28, *SEG* 33.963—1st half of the 3rd cent..

[57] *IG* 7.193 (the findspot, in the church of the Panagia in Alepochori, indicates a reuse), Wilhelm, *Inschriftenkunde*, i. 261–76.

[58] Plutarch, *Kimon* 1–2.

[59] *SEG* 32.856; Knoepfler, *Décrets érétriens de proxénie*, 258–9, and 179 n. 448 on the equestrian bases (found by V. Petrakos).

[60] *IG* 10.2.1.5 (1st cent. BC). The Hellenistic agora was not the same as the Roman 'forum' now visible in central Thessaloniki (as the newly opened site museum makes clear).

[61] I. M. Akamatis, 'Agora Pellas: 15 chronia archaiologikis erevnas', *Archaia Makedonia*, 6 (Thessaloniki, 1999), 28, with fig. 12: foundations along the northern stoa, bronze fragments. The fragments are now in the new Pella Museum, where I had the pleasure of viewing them with I. Akamatis.

[62] *SH* 705.

[63] *I. Metropolis* 1; Strabo 14.1.41.

[64] *OGIS* 229, l. 85.

Examples could be multiplied easily,[65] if tiresomely.[66] The cases mentioned above, as well as many others, illustrate the normalcy of the agora as a site for honorific monuments. When the Parians asked the Kyzikenes to grant space for a statue of one of their citizens (the nesiarch Apollodoros, discussed above), they took for granted that this statue should stand in the agora. In the Pisidian city of Adada, during the Roman empire, three *agoranomoi* were honoured for urbanistic works, including 'moving the columns and the bases and the statues from the agora'—the presence of honorific statues was a normal part of the rich, ornate *décor urbain* which characterized the Hellenistic and post-Hellenistic city.[67] (The three *agoranomoi* were in turn honoured by the council and the people with a gilt bronze statue.) At Oinoanda, it is the presence of honorific statues, along with the presence of stoas, that shows that the so-called 'esplanade' was the Hellenistic agora.[68] A special case is the shared space of the Italian traders on the island of Delos, the so-called 'Agora des Italiens'. This was an open square bordered by porticoes, in which the Italians set up honorific statues of Roman officials and of their benefactors, such as C. Ofellius Rufus, whose large marble statue survives: it showed him in a strikingly heroic pose, naked and leaning on a spear, a sheathed sword in his left hand and the chlamys draped over the left side of his body (below, 284–6).[69]

Within the agora, statues usually ended up sited in groups—collocations, clusters, alignments. The effect of repetition and replication give a visual form to the central trope of the honorific decree—the social reproduction of the good citizen. I will consider the politics of collocation and serialization later on (121–6); for now, what matters is to observe the tendency to construct long series of honorific statues when erecting such monuments in the agora— especially along the stoas which are one of the defining features of the agora as public space: this can be seen in many archaeological sites, for instance on Thasos (Plan 9), in Kassope, or in Athens (Plan 1: in front of the Metroon); the Prienian agora, in contrast, shows a row of statues across the whole space (Plan 13 and below, 98–9).

It is worth wondering, in the face of all this evidence, why the agora was so obviously the normal setting for honorific statues. It was the public space *par excellence*,[70] owned and controlled by the community, its ample dimensions contrasting with the tight network of private urban space, which was systemically structured around it. The agora was the appropriate setting to produce visibility and publicity, essential to the social-reproductive workings of the honorific monument, as the inscriptions make clear (especially through the exemplary and moral force of the 'hortative clause' at the fulcrum of nearly every honorific decree: above, Chap. 1). The agora also was civic space *par excellence*. It was the site for the workings of civic institutions and offices: meeting-places and public buildings often were located on the agora. It was a privileged site for public epigraphy, the monumental recording of civic decision-making, especially honorific,[71] the trace of public gestures such as dedications by magistrates—a site for civic stories, though of course the exact import of these stories needs examining: communitarian political culture or elite dominance? The answer to the question varies, according to

[65] Messene: *SEG* 45.312, 48.494–7, and perhaps *SEG* 47.393, 395 (honorific bases, found near or in the fountainhouse of Arsinoe west of the agora). Mantineia: G. Fougères, *Mantinée et l'Arcadie orientale* (Paris, 1898), 174. Kassope: W. Hoepfner and E.-L. Schwander, *Haus und Stadt im klassischen Griechenland* (Munich, 1994), 124–6 (foundations for fifty monuments). Andros: *BE* 70, 491; Eresos: *IG* 12.2.527, statue of benefactor set up 'in the most prominent spot in the agora' (*c.*240?). *I. Adramytteion* 17 is an honorific decree for Pamphilos, an Attalid courtier: his statue will be set up 'in the agora'.

[66] Ma, 'Eugnotos' (on the agora of Akraiphia, developing insights by P. Perdrizet).

[67] Robert, *Hellenica*, ix. 33, on *Wolfe Expedition* 433. On the adornment characteristic of the Roman-era city in Asia Minor, A.-V. Pont, *Orner la cité: Enjeux culturels et politiques du paysage urbain dans l'Asie gréco-romaine* (Bordeaux, 2010).

[68] N. P. Milner, 'A Hellenistic Statue Base in the Upper Agora at Oinoanda', *Anatolian Studies*, 48 (1998), 113–16.

[69] M. Trümper, *Die 'Agora des Italiens' in Delos* (Rahden, 2008).

[70] Likewise, the forum was the principal site for publicly displayed statues in Roman *municipia*: Zimmer, *Locus Datus Decreto Decurionum*.

[71] Some examples out of thousands: *Inscr. Thrac. Aeg.* 4, 5, 6, 7 (all from Abdera).

date, location, and theories about the nature of the post-Classical city. The importance of the agora as a privileged space, linked with the nature of citizenship, appears in a detail of a Teian decree regulating honours for Antiochos III: the first entrance of the Teian ephebes into the agora was, as an official group occasion, celebrated by a public sacrifice under supervision by the gymnasiarch, and probably marking their accession to the status of full adult citizens.[72]

At first, this sort of evidence might suggest that the agora was a purely civic space, dedicated to *polis* institutions and ideology. Archaeological and epigraphical examples illustrate this prejudice or ideal about the purely political nature of the agora. At Priene, the agora proper is separated from a smaller space, often identified as a market. In Thessaly, a 'sacred agora' was separated from the mercantile agora.[73] The 'men's agora' attested at Kyzikos (above, 72–3) is presumably an exclusively political agora. But the reality of the agora was more complex.[74] First, the agora was also a space open to strangers. In many cases, the agora was close to the harbour, as at Teos[75] or Kaunos. The presence of foreigners, and their gaze, was taken into account: the agora as civic space was itself a monument of the community of citizens, intended for outsiders to see. Secondly, the agora was a market, a space for economic exchange, for work and for selling, where the Greeks deceived each other under oath (as one Classical Greek imagined a Persian imagining the agora).[76] A permanent, monumental trace of these activities can be found in a particular type of evidence, the dedications made by the *agoranomos*: offerings to Hermes, or dedications of weights. The presence, then the profusion, of honorific images in the agora represents an attempt at controlling this space of exchange, by giving the euergetical discourse and the underlying civic ideology a permanent, privileged physical form. The daily, real dramas and changing transactions of the agora happened in the constant presence, simultaneously concrete and abstract, human and symbolical, of honorific portraits and their ethical force. From the raised position of their bases, bronze statues, with their faces and their gaze, defined and supervised the central open space, even though the actual human occupation of this space fluctuated according to time, season, and weather. The stoas were lined with honorific painted portraits, kept out of the weather but also repeating the effect of the statues, putting movement and exchange under the objectified, challenging gaze of good citizens, one after the other.

b. Shrine

When the citizens of Nisyros decided to honour a benefactor, they decreed a crown and a statue, the latter to be set up 'on the agora or in a shrine, whichever seems the most profitable'.[77] The equivalence (attested elsewhere)[78] is a symptom of the widespread import-ance of civic shrines as the site for the display of honorific portraits, comparable to the importance of the agora. As for the agora, the evidence, literary, epigraphical, and archaeo-logical, provides a plethora of examples of the practice of setting up honorific statues in shrines.

[72] *SEG* 41.1003B, ll. 38–44, with P. Gauthier, 'Un gymnasiarque honoré à Colophon', 102–3.

[73] Aristotle, *Politics* 1331a30–b3.

[74] S. von Reden, 'The Well-Ordered *Polis*: Topographies of Civic Space', and P. Millett, 'Encounters in the Agora', both in P. Cartledge, P. Millett, and S. von Reden (eds), *Kosmos: Essays in Order, Conflict and Community in Classical Athens* (Cambridge, 1998), 170–90 and 203–28 respectively; Hansen, above, n. 48; W. Hoepfner and L. Lehmann (eds), *Die Griechische Agora* (Mainz, 2006); K. Vlassopoulos, 'Free Spaces: Identity, Experience and Democracy in Classical Athens', *CQ* 57 (2007), 33–52; J. Shear, *Polis and Revolution: Responding to Oligarchy in Classical Athens* (Cambridge, 2011), 263–84.

[75] *OGIS* 309 with L. Robert, *Études Anatoliennes: Recherches sur les inscriptions grecques de l'Asie Mineure* (Paris, 1937), 9–20.

[76] Hdt. 1.153 (but in 3.139, Darius, the future Great King, eagerly bargains in the agora—as pointed out to me by Aneurin Ellis-Evans).

[77] *Inschr. Dor. Inseln* 63, with Peek on M. D. Chaviaras, 'Nisirou epigraphai', *ArchEph* (1913), 7–8, no. 1 (both 3rd-cent.).

[78] Other examples: Knoepfler, *Décrets érétriens de proxénie*, no. VII (Eretria, early Hellenistic); *IG* 12.3.249 (Anaphe, late Hellenistic, reading εἰ δὲ κα at l. 25); *I. Iasos* 99, decree for C. Iulius Capito, honouring him with a painted portrait, in whichever sacred or public place he wishes (1st cent. AD); *LBW* 1594 (Aphrodisias, imperial period; same document *IAph* 12.206).

Thus the Athenian Akropolis was the setting for honorific portraits of late Classical (probably), Hellenistic, and Roman grandees, Athenian and foreign (see below). At Priene, the statue of Megabyxos[79] was set up in the shrine of Athena, which also shows rows of base foundations which may have borne honorific monuments (see further below). At Erythrai, while the bronze statue of Maussollos was set up in the agora, the marble statue of his wife Artemisia was set up in the shrine of Athena; further bronze statues of Hekatomnid dynasts were set up in a shrine behind the harbour agora at Kaunos, a site which later received statues of Roman officials.[80] On Paros, the Ptolemaic official Aglaos, son of Theukles, of Kos, was honoured by the Parians with a four-cubit marble statue (high-grade stone being cheaper than bronze on the island): the monument was set up in the shrine of Hestia (mid-second century).[81] The citizens of Apollonia, on the Black Sea, honoured one Hegesagoras, sent c.200 as navarch by the allied city of Istros, with a bronze statue, in full arms, standing on a ship's prow: this naval monument was set up in the shrine of Apollon Iatros.[82] All these examples illustrate the practice of setting up statues in civic shrines within the urban centre of Hellenistic *poleis*. Cases could be multiplied,[83] and would illustrate the precocity and prevalence of the practice across the whole Hellenistic world: in Macedonia, a decree of the city of Dion stipulates the erection of an honorific statue—a relatively uncommon practice in Hellenistic Macedonia—in the shrine of Zeus Olympios.[84]

In other cases, communities set up statues in extra-urban shrines that belonged to them. The Samians set up honorific statues in the shrine of Hera, seven kilometres south of the urban centre, from the early second century onwards (with a hiatus during the first half of the first century, before a profusion of statues in the Julio-Claudian period).[85] Likewise, the Epidaurians set up honorific statues at the famous Asklepieion, starting in the fourth century, and continuing into the Roman period (when the city set up new honorifics, but also reused Hellenistic, probably private, exedras).[86] The Eretrians used the shrine of Artemis at Amarynthos, where three public honorific portraits were dedicated;[87] the Milesians set up statues in the shrine of Apollo at Didyma;[88] the citizens of Lykosoura, in Arkadia, set up an honorific portrait of Polybios not in their city, but in a nearby holy site: the shrine of Despoina, famous for the statues sculpted by the artist Damophon of Messene.[89] The shrine of Apollon at Klaros

[79] Discussed above, 22.

[80] *Inschr. Kaunos* 47–8, 102, 107–8, 109–11, 112, 113, 114; C. Marek and C. Işık, *Das Monument des Protogenes in Kaunos* (Bonn, 1997), 70.

[81] G. Despinis, 'Timitikon psephisma ek Parou', *ArchDelt* 20/1 (1965), 119–32, with *BE* 67, 441, and R. Bagnall, *Administration of the Ptolemaic Possessions*, 150. The shrine of Hestia is identified with the *prytaneion* of the city by G. Gruben, 'Naxos und Paros: Vierter vorläufiger Bericht über die Forschungskampagnen 1972–1980. II. Klassische und hellenistische Bauten auf Paros', *ArchAnz* (1982), 668–75, followed by V. Lambrinoudakis in V. Lambrinoudakis and M. Wörrle, 'Ein hellenistisches Reformgesetz über das öffentliche Urkundenwesen von Paros', *Chiron*, 13 (1983), 306–8; further below, n. 98.

[82] *ISE* 129.

[83] Thouria: *SEG* 11.954 (painted portrait in temple of Syrian Goddess, 1st cent.); Demetrias: B. Helly, 'Décrets de Démétrias pour les juges étrangers', *BCH* 95 (1971), 548 (foreign judges of Messene honoured with portraits set up in shrine of Zeus Akraios); Delphi: e.g. *FD* 3.4.63 (statue set up by citizens of Delphi).

[84] *SEG* 48.781 (unpublished); Polybios 4.62.2 does attest statues of the kings in Dion, and Livy 44.6.3 gilt statues in the same city (or perhaps rather small-scale gold dedications, since Perseus removed them to prevent them being captured).

[85] The majority of preserved honorific statue bases in *IG* 12.6.1 come from the Heraion. See A. Herda in Stemmer, *Standorte*, 133–9, with bibliography; P. Herrmann, 'Die Inschriften römischer Zeit aus dem Heraion von Samos', *AthMitt* 75 (1960), 68–183, esp. 96–169 (with considerations on findspot and the history of dedications in the shrine at 97); H. J. Kienast and K. Hallof, 'Ein Ehrenmonument für samische Scribonii aus dem Heraion', *Chiron*, 29 (1999), 205–23 (esp. 205–7), on an early 1st-cent. AD honorific monument found on the eastern edge of the shrine, to the south of the sacred way.

[86] *IG* 4² 1.615–16 for 4th-cent. examples; 589–90 for 3rd-cent. examples. For reused exedras, von Thüngen, *Exedra* (e.g. no. 32).

[87] C. Brélaz and S. Schmid, 'Une nouvelle dédicace à la triade artémisiaque provenant d'Érétrie', *RA* (2004), 227–58, rc. *IG* 12.9.99, 276–8; the last, found at Chalkis, might come from a hypothetical 'Artemision *intra muros*' (Knoepfler, *Décrets érétriens de proxénie*, 141), but transport from Kato Vathia/Amarynthos seems equally likely.

[88] *Inschr. Didyma* 107, 113, 114, 115, 140, 141, 143, 144, 147, 148; Günther in Filges, *Skulpturen und Statuenbasen*.

[89] Pausanias 8.37.2. On the remarkable honorific reliefs for Polybios, below, 279–84.

was used for honorific statues by the Kolophonians—specifically, the citizens of the compli-
cated city-state with two urban centres, Old Kolophon (which declined during the Hellenistic
period) and Notion (whose urban and institutional life continued in the Hellenistic period,
and which lay much closer to the shrine: a few hundred metres, as opposed to the seven or so
km that separate the shrine from Old Kolophon).[90] It can still be considered an extra-urban
shrine, albeit a special one.

Within the shrine, choices had to be made on the exact site of honorific statues. Most
prominently, honorific portraits could be located within the temple itself.[91] The earliest
documented case is probably an over-life-size statue of Ada, the Hekatomnid ruler, set up in
the *cella* of the temple of Athena at Priene (as shown by the findspot of the head of the statue).[92]
One of the many honorific reliefs for Polybios, the Achaian historian and statesman, was set up
in the temple of Leto at Mantineia.[93] A much later example is the statue of Adobogiona, the
Galatian lady, set up in the *cella* of the temple of Hera at Pergamon (the base is still *in situ*,
though a head found nearby should probably not be associated with it).[94] The first-century
Mytilenaian benefactor Potamon received a statue (among many others) in the *pronaos* of the
temple of Asklepios.[95] Location in the temple can often be explained as an honorific gesture
reserved for persons with particular connection with the cult. On Anaphe, a priest of 'the
greatest gods, Serapis and Isis and the gods around them' received permission to set up in the
temple a painted portrait of himself, inscribed as a public honorific image.[96] Athenian *orgeones*
(cult associations) regularly set up (painted) honorific portraits inside their temples, to
recompense members who had performed priestly duties to general satisfaction.[97] The statue
granted to Aglaos of Kos might have been set up within the circular temple which probably
sheltered the statue of Hestia on Paros.[98]

In some cases, the location of honorific statues in the temple had cultic connotations. An
akrolithic statue of Philetairos, called both *eikon* and *agalma*, was located by the Kymaians in
the *hieros oikos* of Philetairos: the statue was both honorific (in intent) and semi-cultic, in
nature, in setting, and in practice.[99] The colossal statue of Attalos III, in armour and trampling
on spoils, set up as a *sunnaos* image of Asklepios Soter, at Pergamon, was explicitly described
as an *agalma*, a sacred image.[100] Among the nine statues granted by the Knidians to their
super-benefactor Artemidoros, one was 'a gilt statue, to share the temple with Artemis

[90] Above, n. 5; P. Gauthier, 'Le Décret de Colophon l'Ancienne en l'honneur du Thessalien Asandros et la
sympolitie entre les deux Colophon', *JSav* (2003), 61–100.
[91] On statues in the temple of Hera at Olympia, as seen by Pausanias (not quite a 'museum'-style display),
R. Krumeich, 'Vom Haus der Gottheit zum Museum? Zu Ausstattung und Funktion des Heraion von Olympia
und des Athenatempels von Lindos', *Antike Kunst*, 51 (2008), 73–95.
[92] Ada: J. Carter, *The Sculpture of the Sanctuary of Athena Polias at Priene* (London, 1983), 271–6.
[93] Polybios 8.9.1–2 (in the 'double temple' of the city, one half being given to Asklepios, the other to Leto. on
these reliefs, below, 279–85.
[94] A. Ippel, 'Die Arbeiten zu Pergamon 1910–1911. II, Die Inschriften', *AthMitt* 37 (1912), 294–5, no. 20 (*IGR*
4.1683); Radt, *Pergamon*, 186–8. On the head, K. Fittschen, 'Von Einsatzbüsten und freistehenden Büsten: Zum
angeblichen Bildnis der 'Keltenfürstin Adobogiona' aus Pergamon', in C. Evers and A. Tsingarida (eds), *Rome et
ses provinces* (Brussels, 2001), 109–17 (free-standing bust, not head worked for insertion in statue); the identifica-
tion with Adobogiona was proposed (with dubious physiognomical arguments) by W. Hahland, 'Bildnis der
Keltenfürsten Adobogiona', in G. Moro (ed.), *Festschrift für Rudolf Egger* (Klagenfurt 1953), ii. 135–57. A male
statue found in the *cella* might represent Attalos II, the dedicator of the temple. This temple and the statues within
it are the subject of a forthcoming study by M. Mathys, to appear in J. Griesbach (ed.), *Polis und Porträt:
Standbilder als Medien öffentlicher Repräsentation im hellenistischen Osten*; I am grateful for M. Mathys' help with
this topic.
[95] S. I. Charitonidis, *Ai epigraphai tis Lesbou: Sympleroma* (Athens, 1968), no. 6, B line 9.
[96] *IG* 12.3.237.
[97] *IG* II² 1314, 1327, 1334.
[98] The decree clearly states that the statue will be set 'in the shrine' of Hestia; in contrast, a decree mentions a
stele to be set up 'next to the shrine'. Perhaps the 'shrine' proper was the circular building in the centre of the
porticoed enclosure (which would presumably be the *prytaneion* of the city). On the shrine, K. Müller, *Hellenis-
tische Architektur auf Paros* (Berlin, 2003).
[99] *SEG* 50.1195, l. 27.
[100] *OGIS* 332.

Hyakynthotrophos and Epiphanes', εἰκόνα χρυσέον σύνναον [τ]ᾶι Ἀρτάμιτι τᾶι Ἱακυνθοτρόφωι [κ]αὶ Ἐπιφανεῖ. It is true that Artemidoros was also the priest for life of Artemis, but the adjective makes the cultic intention clear; the honour was part of other *isotheoi timai*, such as an altar and a festival named for Artemidoros.[101] Such honours are well attested for the Roman emperors, starting with Augustus, whose statue was set up in the *cella* of the temple of Apollo at Klaros, and of Athena at Priene.[102] The practice here shades into that of ruler-cult for the Roman emperor.

If not in the actual temple, honorific statues could occupy spots close to the temple. The Prienian honorific decree for Megabyxos specifies that his statue will be set up 'in the shrine of Athena, in front of the *metopion* of the temple', in front of and aligned with one of the *antas*.[103] Pausanias saw statue bases in front of the shrine of the Mother of the Gods in the agora of Megalepolis; one of these at least was an honorific.[104] The equestrian statue immediately north of the temple of Amphiaraos, at the Oropian Amphiaraion, occupies a prominent, privileged spot, separated from the rest of the arrayed statues by the road that leads into the shrine; this statue may have been one of the earliest, and it was the first to be rededicated, to Sulla (Plan 3).[105] An elongated base (known by its foundation course) in front of the temple of Dionysos by the theatre of Eretria, may have borne an equestrian statue, located in a very prominent spot for visitors to the theatre, who would have seen the statue and the temple in the same glance.[106]

Finally, the multiplication of honorific statues (like that of other votive offerings) dictated the construction of series of monuments, as happened in the agora. Such series are visible in 'sacred ways', in the Samian Heraion[107] or within the shrine of Apollo at Klaros (the stretch between monumental entrance and temple was lined with a family group of the Attalids, statues for great civic benefactors such as Menippos and Polemaios, statues for Roman officials);[108] similarly, on Thasos, a row of exedras in the agora clearly lines the passage from the harbourside entrance, towards an altar (Plan 9). Series are also traceable in the shrines: the accumulation of bases around the temple of Asklepios at Messene (Fig. 3.2) or around the temple in the Epidaurian Asklepieion (Fig. 3.3), underline the focal nature of the building in the centre of a sacred precinct.

Why do communities set up statues in shrines? A number of general reasons can be proposed. As seen in the previous chapter, honorific statues are, in origin, votive offerings, as their inscriptions often make clear: dedication of such statues in shrines reflects their origin and nature. However, public votive offerings are possible in the agora (or indeed, anywhere else within the city's spaces); it is the inscription which determines, performatively, the nature of a statue as votive. The choice of a civic shrine is determined by its nature as a privileged site for dedication, because of repeated religious activity and, in the case of most *poleis*, because of the prestigious history of the shrine, embodied in its monumental appearance and the depth and continuity implied by past dedications, public and private.[109] As privileged sacred site, as the venue for ritual activity, the shrine also ensured publicity for honours: this is especially true

[101] *I. Knidos* 59. For a possible parallel at Halikarnassos, see the honorific decree *GIBM* 893 (where mention of a temple and the adjective σύνναον are restored).

[102] Ferrary, 'Les Inscriptions du sanctuaire de Claros', 357–9; S. R. F. Price, *Rituals and Power* (Cambridge, 1984), 150, with further examples.

[103] *Inschr. Priene* 3.

[104] Pausanias 8.30.5. The shrine has not been located.

[105] *Oropos* 442.

[106] Knoepfler, *Décrets érétriens de proxénie*, no. VII: perhaps Timotheos' statue? Bases in the western *parodos* (entrance passageway) of the theatre bore choregic victory monuments and not honorific statues: D. Knoepfler, *La Patrie de Narcisse* (Paris, 2010), 230.

[107] A. Herda in Stemmer, *Standorte*, 133–9; H. Kyrieleis, *Führer durch das Heraion von Samos* (Athens, 1981), 50; F. K. Dörner and G. Gruben, 'Die Exedra der Ciceronen', *AthMitt* 68 (1953), 63–76, with P. Herrmann, 'Samos', 128–30, 149 no. c.

[108] Above, n. 5.

[109] On votives, W. H. D. Rouse, *Greek Votive Offerings* (Cambridge, 1902); Bodel and Kajava, *Religious Dedications*.

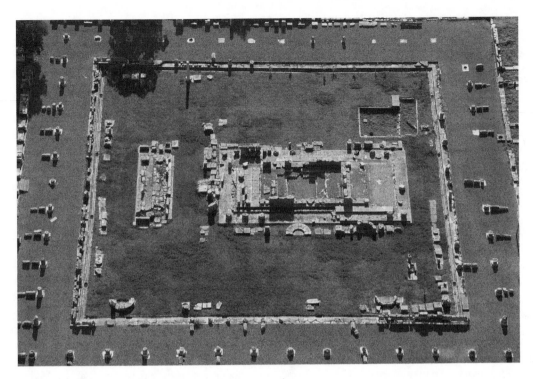

Fig. 3.2. 'Statue growth' led to spaces filled with statues. Aerial view of Asklepieion, Messene, with foundations of bases and exedras surrounding the temple. Courtesy of P. G. Themelis, Society of Messenian Archaeological Studies.

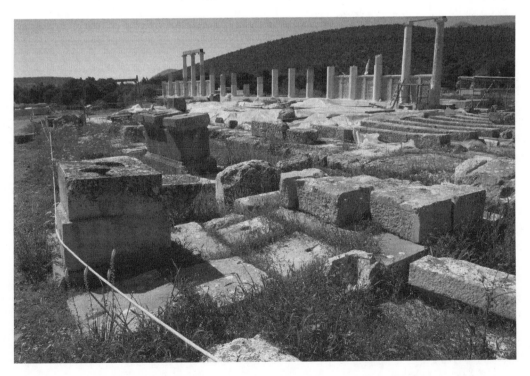

Fig. 3.3. The fullness of honorific monuments in sacred space must be taken into account when trying to understand the spatial workings of shrines. 'Gallery' of honorific statue bases at south-east angle of main temple, Epidaurian Asklepieion.

in the case of those famous shrines which could attract foreign visitors through some particular feature, such as a healing cult or a cult of great antiquity and fame. The Epidaurians and the Oropians set up statues in their famous extra-urban shrines (or reused statues already erected there); we have as yet no evidence to suggest that they did so in their agoras (because their urban sites are unexcavated, but also because the agora is not mentioned in surviving decrees).

The great civic shrines were closely linked to the political life and identity of their communities, in ritual and in monumental form. They served as political gestures, such as the inscription of public documents, diplomatic or honorific: the phenomenon is attested from the Classical period (notably on the Athenian Akropolis) onwards.[110] The shrine of Athena at Priene was probably used for honorific statues, and was certainly used for honorific inscription, as is clear from the patterns of surviving epigraphy. This is the context for the setting up of honorific statues, as part of a continuum of monumental culture: inscribed *stelai*, public votives, public sacred buildings. In turn, the presence of honorific statues contributed to the politicization or 'officialization' of sacred space, tipping the balance away from the private character lent by individual votive offerings.

In the case of subdivisions of the *polis*, a local shrine not only was the most prominent venue in the deme, but also could serve as monumental public space, especially since local identity was based on shared cultic activity. The mixed population of demesmen and soldiers in the Attic demes of Rhamnous and Eleusis set up their honorific monuments in the local shrines (the shrine of Nemesis at Rhamnous and the Eleusinion respectively);[111] local cult associations in Attica set up painted portraits in their shrines, starting in the early Hellenistic period.[112] At Mylasa, the *syngeneia of* Pormonou dedicated an honorific portrait at the shrine of Sinuri, a local deity; the inhabitants of Olymos, once an independent *polis*, later taken over by Mylasa, set up an honorific portrait in their temple of Apollo.[113] The Lindians, a subdivision of the synoikized city-state of Rhodes, used their spectacular shrine of Athena to put up their own honorific statues.[114] In analogous fashion, priests or sacred officials were honoured with honorific portraits in the shrines with which they are involved: at Demetrias, a cultic association of Sarapis honoured Kriton, son of Kritolaos, the priest appointed by the city, with a painted portrait 'in the most prominent spot of the Sarapieion', for his goodwill towards them and his piety towards the divine.[115] A *Koinon* of Heroistai, in second-century Lydia (Kaystros valley), honoured Stratonike, the mother of two of the leaders of the association, with a painted portrait in the *heroon* upon the news of her death.[116] The cult-officials termed *melanephoroi* set up honorific portraits in the Sarapeion C on Delos.[117]

Civic shrine, 'local' shrine—these general considerations should not hide the diversity and particularity of individual cases; and still leave the question of the specific choice of a shrine as a venue for honorific statues. An obvious reason to choose a shrine was the services of the honorand to a deity or particular shrine. The sculptor Damophon of Messene was honoured with bronze statues set up in shrines (at Lykosoura, in the shrine of Despoina; on Leukas, in the shrine of Aphrodite Limenarchis);[118] the setting was appropriate, since Damophon had worked on sacred sculpture in the relevant shrines. The marble statue of Aglaos, mentioned

[110] For a particular example, studied recently, see L. Beschi, 'I "disiecta membra" di un santuario di Myrina (Lemno)', *ASAtene*, 79 (2001), 191–251, at Lemnos.

[111] *Rhamnous* 10, same document *SEG* 41.86 (painted portrait in the Nemeseion; 252/1 or 251/0, as Aneurin Ellis-Evans points out to me: *SEG* 50.1); *Inscr. Eleusis* 196, same document *IG* II² 1299 or *Syll.* 485 (statue in *aule* of the shrine, 234).

[112] *IG* II² 1271, 1327.

[113] *Sinuri* 16; *I. Mylasa* 869.

[114] Starting in the late 3rd and early 2nd centuries (*Inscr. Lindos* 1.123, 125, 169).

[115] *IG* 9.2.1107B (2nd cent. BC).

[116] *New Documents from Lydia*, 96.

[117] *ID* 2075–8, 2081–2.

[118] *SEG* 41.332, 51.566. At Lykosoura, the painted portraits of a couple, set up in the shrine, recompense piety: *IG* 5.2.516.

above, was set up in the shrine of Hestia at Paros, because he had adorned the cult image of the goddess with a golden headband.

However, in many cases, the exact reasons for choosing to set up a statue in a shrine, rather than elsewhere, escape us. It is not easy to articulate precisely why the Erythraians choose to set up a marble image of Artemisia in the shrine of Athena, whereas Maussollos received a bronze statue in the agora (*I. Erythrai* 8): had Artemisia shown particular piety towards that deity and her shrine? Was the choice of marble, and of the shrine of the female goddess, felt to be more appropriate, in the early fourth century, for a female honorand? Furthermore, why did the Prienians first decide to set up a statue of the Seleukid officer Larichos (probably residing near Priene) in the shrine of Athena, before changing their mind and considering a site in the agora more suitable?[119] Why did the Smyrnians choose to honour foreign judges from Kyme with honorific statues in the shrine of Aphrodite Stratonikis, rather than the agora? In fact, we do not know where else the Smyrnians set up honorific portraits, of citizens and foreigners, during the Hellenistic period (the Hellenistic agora remains a mystery).[120] Likewise, it is unclear why some statues of Romans were set up in the agora of Kaunos, and others in the shrine just above the agora.

What remains clear is the major importance of civic shrines, as an element in the typological register of sites for statues, and hence in the grammar of spatial choices within the Hellenistic townscape, when communities decided to set up honorific monuments. In spite of the inscrutability, for modern observers, of decisions taken in the remote social contexts of the Hellenistic *poleis*, we may be sure that they reflected meaningful choices: for instance, at Pergamon, the statues set up by the *demos* in the shrine of Demeter and Kore are those of women (including a foreign queen), honoured for their womanly virtues (restraint, conjugal love) and their piety.[121]

c. Gymnasion

The third main venue for honorific statues was the gymnasion, an important element in the post-Classical *polis*: a publicly funded institution, specifically intended for boys, adolescents, and young men, devoted to physical exercise, education, military training, cultural and festive activities, open to citizens and, increasingly, to foreigners.[122] It was an important site for the performance of civic ideologies (especially the euergetical exchange of benefaction and *charis*) and Greek identity; it also existed as a concrete place, a *topos* (as the epigraphical documents often term it).[123] Its physical shape was shaped by its functions: an open central space for physical activities, lined with porticoes, completed by a series of rooms and enclosed spaces, and (often) a covered running track (*xystos*) and open-air racetrack (*paradromis*).[124]

[119] *Inschr. Priene* 18, with P. Gauthier, 'Les Honneurs de l'officier Séleucide Larichos à Priène', *JSav* (1980), 35–50.

[120] *I. Smyrna* 578. Statue bases from the Roman period have been found in the Agora: *SEG* 53.1327–32 (P. Herrmann, H. Malay).

[121] H. Hepding, 'Die Arbeiten zu Pergamon 1908–1909. II, Die Inschriften', *AthMitt* 35 (1910), 465–6, no. 47; 470–1, no. 54; H. Müller, 'Königin Stratonike, Tochter des Königes Ariarathes', *Chiron*, 21 (1991), 393–424.

[122] J. Delorme, *Gymnasion: Étude sur les monuments consacrés à l'éducation en Grèce (des origines à l'Empire Romain)* (Paris, 1960)—L. Robert promised a review in *BE* 62, 55; Gauthier, 'Trois décrets', 226–31 (eye-opening); P. Gauthier and M. V. Hatzopoulos, *La Loi gymnasiarchique de Beroia* (Athens, 1993); P. Gauthier, 'Notes sur le rôle du gymnase dans les cités hellénistiques', in Zanker and Wörrle, *Stadtbild und Bürgerbild*, 1–11; D. Kah and P. Scholz (eds), *Das hellenistische Gymnasion* (Berlin, 2004); S. Skaltsa, 'Hellenistic Gymnasia: The Built Environment and Social Dynamics of a *Polis* Institution' (D.Phil. thesis, University of Oxford, 2008), 75–125, systematic and exhaustive on honorific statues in the gymnasion, and generally on the institution. I am grateful to S. Skaltsa for corrections and complements to this section.

[123] e.g. Gauthier and Hatzopoulos, *Loi gymnasiarchique*, B 48–72; *Milet* 1.9.368; *IG* 12.7.233, 234 (Minoa on Amorgos, 1st cent. AD?).

[124] H. von Hesberg, 'Das griechische Gymnasion im 2 Jh. v. Chr.', in Zanker and Wörrle, *Stadtbild und Bürgerbild*, 13–27; Skaltsa, *Hellenistic Gymnasia*; R. von den Hoff, 'Hellenistische Gymnasia: Raumgestaltung und Raumfunktionen', in A. Matthaei and M. Zimmermann (eds), *Stadtbilder im Hellenismus* (Berlin, 2009), 245–75.

Honorific portraits, among the physical features of the gymnasion, appear at the very end of the third century BC.[125] Such portraits of gymnasiarchs become more popular from the second century BC, and there are many examples of bronze statues, or painted portraits, set up in the gymnasion, by the city, or by the young and less young users of the gymnasion itself. The Eretrian gymnasiarchs who were honoured with statues in the shrine of Artemis Amarysia also saw statues of themselves set up in the gymnasion in the town of Eretria.[126]

On the ground, a number of spots were available for honorific portraits. Statues were set up before the porticoes, often on the edges of the open space of the palaistra. At Ephesos, the statue of the gymnasiarch Diodoros was set up 'in front of the portico on the east side';[127] a colossal marble statue found in the Lower Gymnasion at Priene was perhaps set up on a large base in such a spot, in front of a column of the northern stoa, in the centre of the colonnade.[128] An exedra, once bearing a statue group, occupies the south-east corner of the palaistra of the Upper Gymnasion at Priene—in this case, sacrificing some small amount of palaistra space for the monument (Plan 16). In the gymnasion at Amphipolis, a base in front of the northern stoa perhaps belonged to an honorific statue for a benefactor.[129] In the Upper Gymnasion at Pergamon, an exedra occupies a very similar spot to the statue base in the palaistra of the Prienian lower gymnasion, in the centre of the colonnade of the northern stoa.[130] In addition, many statue bases were found in front of the three porticoes. The Middle Gymnasion also reveals statue bases in front of the main building.[131] The statue of the Pergamene benefactor Metrodoros was set up 'in the *paradromis*': though this has proved problematic to locate archaeologically,[132] it should designate an open race track parallel to a covered one; the location of the statue of Metrodoros might have resembled the statues set up before porticoes. At Eretria, the statues of a pair of benefactors (father and son) stood in some relation to a *bema*, a platform which might have been part of the stadium.[133]

In other cases, the honorific portraits were located within the covered spaces which were an important part of the gymnasion, for circulation and activities. The painted portraits of gymnasiarchs were certainly dedicated in such spaces, perhaps in the porticoes lining the central *palaistra*, as portaits of civic benefactors were set up in the stoas of the agora at Priene. At Eretria, the benefactor Theopompos was honoured with a statue probably located in the *elaiotheseion* ('room K'); the bases located in the northern stoa, at the point of transition to the complex of important rooms, may also have borne honorific monuments.[134] The gymnasion at Messene was reached through a covered walkway, whose colonnade, open onto the stadium, sheltered statues.[135] Honorific statues were also located within the rooms in the gymnasion. In the gymnasion at Amphipolis, the large statue of Apellas, son of Diogenes, dominated a small

[125] Gauthier, 'Un gymnasiarque honoré à Colophon' (*SEG* 55.1251); the decree for the gymnasiarch Aglanor at Eresos is another early example (*IG* 12, suppl. 122).

[126] *IG* 12.9.236–7, *IG* 12, suppl. 553.

[127] *I. Ephesos* 6.

[128] F. Krischen, 'Das hellenistische Gymnasion von Priene', *JDAI* 38–9 (1923–4), 133–50.

[129] K. Lazaridi, 'To gymnasio tis Amphipolis', in *Mneme D. Lazaridi: Polis kai chora stin archaia Makedonia kai Thraki* (Thessaloniki, 1990), 253.

[130] Radt, *Pergamon*, 124–5; P. Schazmann, *Das Gymnasion: Der Templebezirk der Hera Basileia*. Altertümer von Pergamon, 6 (Berlin, 1923), 47. My thanks to M. Mathys and F. Pirson for helping me see the gymnasion at Pergamon.

[131] Delorme, *Gymnase*, 370. Many of these bases may be Roman in date.

[132] Delorme, *Gymnase*, 190; Radt, *Pergamon*, 124.

[133] *IG* 12.9.237 A, ll. 8–9, restored by Wilhelm as ἐν τῶι ἐ[πιφανεστάτωι τόπωι πρὸ τοῦ] βήματος with D. Knoepfler, 'Débris d'évergésie au gymnase d'Érétrie', in O. Curty with S. Piccan and S. Codourey, *L'Huile et l'argent: Gymnasiarchie et évergétisme dans la Grèce hellénistique* (Fribourg, 2009), 232–4 ('tribune', i.e. special seating, in the *stadion*?).

[134] Knoepfler, 'Débris'.

[135] *SEG* 41.347–8; generally P. G. Themelis, 'Die Statuenfunde aus dem Gymnasion von Messene', *Nürnberger Blätter zur Archäologie*, 15 (1998–9), 59–84.

room to the north of the west stoa (the base is still *in situ*).[136] Among the honours for L. Nassius, at Chios, statues of his sons were set up in the *akroaterion* (lecture room) of the gymnasion.[137] At Delos, the gymnasiarch Sosilos was honoured with a statue in the *exedrion*, a large open lecture and assembly room, within which it probably stood in a shallow niche (the back of the base is curved).[138] In the excavated gymnasion (GD 76, probably the late second-century successor to an earlier gymnasion), a small room received two honorific statues, one on a base, the second on a 2.16 m high column, both set up by the *aleiphomenoi*.[139] The great benefactor of Pergamon, Diodoros Pasparos, already mentioned earlier, was honoured with two statues, one by the *neoi*, one by the people, set up in special rooms in the gymnasion.[140]

At first sight, the reason for the location of statues in closed rooms might seem practical, to avoid taking up the spaces reserved for violent physical movement. Yet the main effect of locating honorific portraits 'indoors' was to impose the presence of benefactors, at bottlenecks in the circulation of persons, in spaces where gatherings and activities occurred, or within spaces specifically designed to create an encounter with the image of the benefactor and heighten the image's impact. A slightly later example comes from the gymnasion at Messene, where two honorific statues, one clothed, one naked, were erected in 'Room IX', at the end of the main access into the gymnasion, presenting an imposing sight to the visitor.[141]

The recipients of statuary honours in the gymnasion are usually linked with that institution, especially gymnasiarchs honoured for their benefactions and for their behaviour in office, to the benefit of the gymnasion, as physical entity, as a civic institution, and as a human group. At Halikarnassos in the third century Diodotos, son of Philonikos, after loaning the city 33,400 drachmai free of interest for work on the gymnasion, was honoured with a crown, and a statue to be set up 'in the gymnasion, in order that there may be a memorial ($\dot{\upsilon}\pi\acute{o}\mu\nu\eta\mu\alpha$) of his zeal which he showed towards the gymnasion and towards the collection of money beyond his own abilities and towards other matters'.[142] Associations of men frequenting the gymnasion, when honouring benefactors, set up honorific portraits and *stelai* within the gymnasion.[143] Generally, the honouring of benefactors within the gymnasion reflects the latter's workings as an enclosed civic world with its own sociability, patterned on the values of the *polis*, but given physical and ritual form within the walls of the gymnasion.[144]

The details of honorific inscriptions for gymnasiarchs allow us to see this world in action, and the final choice of *topos* as the result of process, discourse, interaction, mobilized in a social narrative between various actors: the city, the users of the gymnasion (young and old), the benefactor. The gymnasiarch Euelthon was honoured by the *neoi* after they had gone en masse, in a 153-strong column, to petition the civic authorities of Kolophon.[145] The Ephesian gymnasiarch Diodoros, honoured with a statue in front of a stoa (above), was in fact the beneficiary of

[136] Lazaridi, 'Gymnasio', 251, 254; C. Wacker, *Das Gymnasion in Olympia: Geschichte und Funktion* (Würzburg, 1996), 141–4.

[137] *IGR* 4.1703, with further bibliography above, n. 44. On the *akroaterion*, Robert, *Études Anatoliennes*, 76–91; Delorme, *Gymnasion*, 324–5 (but his argument that the *akroaterion* at Chios must have been 'la salle principale puisqu'on y érigeait les statues honorifiques' is precisely not compelling).

[138] *IG* 11.4.1087; Knoepfler, 'Sôsilos'; A, Jacquemin, 'Gymnase de Délos'; Moretti, 'Inventaires', notably 143–4, based on his identification between the earliest gymnasion and the 'Palestre du Lac' (Moretti, 'Gymnase').

[139] *ID* 1929–30, with J. Audiat, *Le Gymnase*. Exploration Archéologique de Délos, 28 (Paris, 1970), 46; discussed in R. von den Hoff, 'Ornamenta $\gamma\upsilon\mu\nu\alpha\sigma\iota\acute{\omega}\delta\eta$? Delos und Pergamon als Beispielfälle der Skulpturen-ausstattung hellenistischer Gymnasien', in D. Kah and P. Scholz (eds), *Das hellenistische Gymnasion* (Berlin, 2004), 380.

[140] Chankowski, 'Diodoros Pasparos'.

[141] *SEG* 47.397, 400; Themelis, 'Statuenfunde'.

[142] Michel 456, with Wilhelm, *Inschriftenkunde*, i. 285–8.

[143] *I. Prose Égypte* 15, 27, 40, 27 (earlier edns in *SEG* 8.694, 641, 529), all from Egypt (in *I. Prose Égypte* 27, there is an indication of several statues in the gymnasion at Ptolemaios; the text should perhaps read $\delta[\iota\grave{\alpha}\ \tau\grave{o}\nu\ \alpha\grave{\upsilon}\tau\hat{\omega}\nu]$ $\tau\rho\acute{o}\pi o\nu$, 'on account of their character' rather than $\delta[\iota\grave{\alpha}\ \tau\grave{o}\nu\ \sigma\upsilon\nu\acute{\eta}\theta\eta]\ \tau\rho\acute{o}\pi o\nu$, 'on account of their usual manner'? 'in the usual manner'?); *IG* 12.3 Suppl. 331 (Thera).

[144] Gauthier, 'Notes sur le rôle du gymnase'.

[145] Gauthier, 'Un gymnasiarque honoré à Colophon'.

a petition by the *neoi* to the council, to ask for honours (including a statue) for their gymnasiarch, to acknowledge his care for their *eukosmia*, *euandria*, and *philoponia*: Diodoros' activity is described in highly moralizing, protreptic vocabulary.[146] Other honorific texts could be more concrete in their details—the inscription on a statue base from the gymnasion at Mylasa records that the gymnasiarch Leontiades provided oil, all day long, for the *paroikoi*, the *metoikoi*, and the *xenoi* who did 'not have a share of the anointment in the gymnasion'.[147]

In addition to these civic benefactors, Hellenistic cities set up statues of rulers in the gymnasion: the bronze statue of a Ptolemy adorned the gymnasion (named Ptolemaion) in Athens.[148] In Pergamon, a colossal gilt statue (*eikon*) of Attalos III stood in the gymnasion;[149] the inscription made it clear this was a public honorific statue.[150] However, this particular statue was in fact set up by the gymnasiarch; the fact that it was labelled as a public honorific was unusual, and worthy of comment in the honorific decree for the gymnasiarch. Many of the statues of rulers in gymnasia seem to have been set up by gymnasiarchs, often as cultic gestures (the statues are termed *agalmata*).[151] They hence belong to a particular subset of a particular genre within the honorific statue habit, namely the practice of setting up privately statues of very powerful outsiders (below, 185–6), as a gesture of visible loyalism and relationality; the practice of cultic honours also belongs to the same range of demonstrative loyalism and symbolic gestures in the face of external power.

Finally, the gymnasion was the site for funerary honours. Statues for deceased young men were set up by the city or by their relatives and friends, as a gesture of commemoration and consolation (the statues of the sons of Lucius Nassius, mentioned several times already, in fact belong to this category).[152] Furthermore, cultic statues were part of heroizing or cultic posthumous honours for great benefactors, such as those offered to C. Vaccius Labeo at Kyme, or C. Iulius Artemidoros at Knidos.[153] Both practices are attested only in the very late Hellenistic period, from the first century onwards.

In the inventory of the Delian gymnasion drawn up in the years after the Athenian take-over of the island, only two full-size male bronze statues are mentioned (of which one is almost certainly an honorific portrait).[154] In other cases, for instance at Messene, it is less easy to judge from the extant evidence what place the honorific genre occupied, as opposed to other strands of visual culture. It is true that in addition to honorific monuments, many other material signs

[146] *I. Ephesos* 6, with Robert, *OMS* v. 347–54. The same phenomenon appears in a late 2nd-cent. decree from Pergamon, for the gymnasiarch Metrodoros: H. Hepding, 'Die Arbeiten zu Pergamon 1904–1905. II, Die Inschriften', *AthMitt* 32 (1907), 273–8, no. 10.

[147] *OGIS* 339 (Menas); *SEG* 54.1101. See also, e.g., Michel 456 (Halikarnassos); *I. Iasos* 24; *Inschr. Magnesia* 102; *I. Kios* 6; *Inschr. Pergamon* 252; *IG* 12.7.235; 12.9.236–7; 12, suppl. 553; 10.2.1; *Inscr. Scythiae Minoris* 1.59 (Istros). On the services of gymnasiarchs, F. Quass, *Die Honoratiorenschicht in den Staedten des griechischen Ostens: Untersuchungen zur politischen und sozialen Entwicklung in hellenistischer und römischer Zeit* (Stuttgart, 1993), 206–7.

[148] Pausanias 1.17.2. I would like to suggest that this is the equestrian statue that overshadowed the statue of Chrysippos which was set up 'in the Kerameikos', i.e. the area of the Agora (Cicero, *De Finibus* 1.39, Diogenes Laertius 7.182), and which I hence identify with the statue of Chrysippos mentioned by Pausanias as located in the Ptolemaion, 'next to a bronze statue of Ptolemy'—this may be the statue set up by Chrysippos' nephew (Plutarch, *Moralia* 1033e). I thus propose that there existed one, and not three, statues of Chrysippos in Athens. It is true that there are no archaeologically attested equestrian bases in gymnasia; if my hypothesis is correct, it would entail imagining a suitable site in a Hellenistic gymnasion such as the Ptolemaion (on which see below, n. 265).

[149] Jacobsthal, 'Pergamon', 375–9, no. 1, ll. 20–3.

[150] Above, Chaps 1–2.

[151] Jacobsthal, 'Pergamon', 379–81, no. 2 (Pergamon); *MAMA* 6.173 (statues of Eumenes II and the future Attalos II in the gymnasion at Apameia), with *BE* 39, 400; Robert, *Hellenica* xi/xii. 117–25 (improving *IG* 12, suppl. 250: statue of Attalid king in gymnasion of Andros, 2nd cent.).

[152] *IGR* 4.1703; also *IG* 12.7.515 (as part of memorials in Aigiale, on Amorgos, 2nd cent.); Michel 545 with Wilhelm, *Akademieschriften*, i. 73–80 (Synnada, late Hellenistic?). Generally, J. Strubbe, 'Epigrams and Consolation Decrees for Deceased Youths', *Antiquité Classique*, 67 (1998), 45–75; who would date Michel 545 to the 2nd cent. AD (p. 70; further J. Strubbe, 'Cultic Honours for Benefactors in the Cities of Asia Minor', in L. de Ligt, E. A. Hemelrijk, and H. W. Singor, *Roman Rule and Civic Life* (Amsterdam, 2004), 318–19).

[153] *I. Kyme* 19; *I. Knidos* 59.

[154] Moretti, 'Inventaires'.

of honorific culture occupied the gymnasion. *Stelai* bearing honorific decrees were set up in the gymnasion;[155] the cultic statues of the kings, and later civic benefactors, mentioned above, were the recipients of certain types of viewing and behaviour.

Though honorific *stelai* and cult *agalmata* are close in origin, effect, and nature to the honorific statue, it must be also be recognized that the honorific was only one of the constituents of the visual and physical world of the gymnasion. The inventory of dedications in the gymnasion at Delos, in 155/154 BC, mentions a plethora of votive offerings (shields, many painted and even gilt, torches from torch-races, and 'very many votive plaques') and statues or, more frequently, statuettes of deities (especially Eros and Herakles), and forty-one herms.[156] In the first century AD, the gymnasion at Messene contained high-quality marble statues of Herakles and Theseus, replicas of famous Classical models (the Theseus notably seems to have been a replica of the Polykleitan Theseus).[157] Dedications in the gymnasia included high art: at Rhodes, the number of *anathemata* in the gymnasion is noted by Strabo (14.2.5). The Venus de Milo was probably such a dedication; at Tanagra, the painting of the poetess Corinna, seen by Pausanias, was almost certainly a dedication (by an individual or by the city).[158] The graffiti from the gymnasion, at Delos as elsewhere, reflect many of the same deities (especially Eros) as the sculptural evidence, and the ephebes' and young men's concern for competition and victory.[159] Another important concern is the social contacts and friendship between the users of the gymnasion: this appears in graffiti, but also in full-size statue dedications of 'private honorific' statues, as at Eretria (see Chap. 5 for the genre).

In this respect, it is excessive to call the gymnasion a 'second agora' of the Hellenistic *polis*;[160] its peculiar nature, as a space restricted to a particular category within the human population of the city, and to particular activities, remained constant: publicity was not the same in the gymnasion as in the two major venues for honorific monuments: the agora and the shrine. There is no document presenting the gymnasion as one of the 'default' sites for honorific statues, as there are for the agora and the shrine (above). The dominant note is the honouring of people related to the gymnasion (as well as the non-honorific adornment of the space and celebration of social relations within the gymnasion walls).

However, the gymnasion, even in the late Hellenistic period when it was open to non-citizens, was closely linked to the political identity of the city, because the paramilitary activities of the citizen youth manifested the city's capacity, real or imagined, to defend itself, and because it served as the site for the social reproduction of the city's values, inculcated to the growing male citizens-to-be. In addition, the late Hellenistic period saw the increasing adornment and beautification of the gymnasion, as a display piece of civic architecture in its own right.[161] Hence the gymnasion was an appropriate site for manifestations of the honorific exchange with benefactors, from the city on behalf of the users of the gymnasion, and from the latter constituency itself;[162] the gymnasion was thus receptive to the increase and changes within honorific practice, for instance the multiplication of statues in the late Hellenistic period. This receptivity (itself favoured by the increasing ornamentation and aestheticization of gymnasion spaces) tended to attenuate any specificity which honorific images might have shown in the space of the gymnasion: whereas the late third-century statue of the gymnasiarch

[155] For instance, from the gymnasion at Eretria, *IG* 12.9.234, 236, 237, 239.

[156] Moretti, 'Inventaires'; von den Hoff, 'Ornamenta γυμνασιώδη?'. An inventory of reliefs and sculpture from the Athenian Agora does not concern a gymnasion: J. Ma, 'The Inventory *SEG* 26.139 and the Athenian Asklepicion', *Tekmeria*, 9 (2008), 7–16.

[157] Themelis, 'Statuenfunde'.

[158] R. Kousser, 'Creating the Past: The Vénus de Milo and the Hellenistic Reception of Classical Greece', *AJA* 109 (2005), 227–50 (Kousser's view of the post-Classical *polis* as dominated by nostalgia should be rejected, notably in view of her outdated understanding of the gymnasion and the post-Classical *polis*); Pausanias 9.22.

[159] M.-T. Couilloud, 'Les Graffites du Gymnase', in Audiat, *Le Gymnase*, 101–34.

[160] Robert, *OMS* ii. 814; vi. 46.

[161] Von Hesberg, 'Das griechische Gymnasion'.

[162] From Messene, e.g. *SEG* 41.348, 47.400 B; 52.401.

(probably) Sosilos at Delos showed him naked, like other users of the gymnasion (albeit wielding a rod, a symbol of his power), there are later honorific statues in the gymnasion which wear the himation and chiton of the 'normal' good citizen.[163]

The gymnasion certainly operated—if not as the 'second agora'—at least as one among the repertoire of sites which a city had at its disposal for honorific statues. At Messene, several bases, from their captions, bore the statues of benefactors of the whole city, without any particular indication of service to the gymnasion.[164] Other cases suggest that the gymnasion could be chosen as a site for 'general' honorific statues, in euergetical transaction with benefactors who were not specifically benefactors of the gymnasion or former gymnasion officials; nonetheless, the choice of the gymnasion was meaningful and must have conveyed nuances in the honorific grammar of space. The city of Amphipolis set up the statue of a Cn. Cornelius Scipio—probably Scipio Corculum rather than Scipio Aemilianus—in the gymnasion: the reason might have been Corculum's youth, if the context is indeed the capture of the city in 168, as well as the shifting of the martial and honorific-commemorative culture of the gymnasion onto the person of a powerful, youthful Roman, taking the place that had been occupied by the king in the Antigonid gymnasion.[165] When the great benefactor Mithradates son of Menodotos (a friend of Caesar) was honoured by the people of Pergamon with a statue in the gymnasion in return for his very great services, the caption read (with the 'short honorific' formula so typical of the period, and of Pergamon in this period, as shown above, Chap. 1):

> ὁ δῆμος ἐτίμησεν
> Μιθραδάτην Μηνοδότου τὸν διὰ γένους ἀρχιερέ[α]
> καὶ ἱερέα τοῦ Καθηγεμόνος Διονύσου διὰ γέν[ους],
> ἀπο[κα]ταστήσαντα τοῖς πατρώιοις θεοῖς τ[ήν τε πόλιν]
> καὶ [τὴν] χώραν καὶ γενόμενον τῆς πατρίδος μ[ετὰ Πέργαμον]
> καὶ Φιλέταιρον νέον κτίστην.

The people has honoured Mithradates son of Menodotos, hereditary high priest and hereditary priest of Dionysios Kathegemon, who restored the city and the territory to the ancestral gods, and who became, after Pergamos and Philetairos, a new founder of the fatherland.[166]

The gymnasion was chosen as an appropriate setting for the statue of this great benefactor, to inculcate in new citizens the importance of gratitude towards this benefactor (and perhaps echoing the honours for another great benefactor, Diodoros Pasparos). However, at least one other statue for Mithradates was set up in Pergamon, with exactly the same caption;[167] the statue in the gymnasion was probably part of a package of several monuments, perhaps in different materials, proclaiming the city's gratitude towards a super-benefactor, by ensuring his ubiquity across a range of civic spaces—of which the gymnasion was one, no less meaningful than the agora or the shrine.

d. Theatre and Meeting-Place

Honorific statues were also set, more rarely, in theatres (and even more rarely, in analogous spaces, such as the *stadion* or the assembly halls for the *demos* or the *boule*: see below). There are a handful of well-documented cases for the Hellenistic period (Athens, Priene, Messene, Magnesia on Maeander, Delos), though archaeological remains suggest other possible cases (for instance, at the theatre of the Asklepieion at Epidauros or Delphi).[168] The earliest example

[163] Von den Hoff, 'Ornamenta γυμνασιώδη?'.

[164] *SEG* 41.347, 46.423, 47.399 (for a deceased honorand: perhaps a youth?).

[165] *SEG* 50.522, with J. Ma, 'Honorific Statues and Hellenistic History', in L. Yarrow and C. Smith (eds), *Imperialism, Cultural Politics and Polybius* (Oxford, 2011), 234–6.

[166] *IGR* 4.1682.

[167] H. Hepding, 'Mithradates von Pergamon', *AthMitt* 34 (1909), 329–40, for the evidence.

[168] Generally, C. Schwingenstein, *Die Figurenausstattung des griechischen Theatergebäudes* (Munich, 1977); H. von Hesberg, 'Hellenistische Theater: Zur Funktionalität der Räume und ihrer Bedeutung für die Polis', in

is the theatre of Athens (see below), which provides clear examples, starting in the second half of the fourth century, and continuing throughout the Hellenistic period (recently made visible through *anastylosis*, in my view slightly over-enthusiastic).[169]

The theatre building, with its architectural unity, provides clear access ways and converging sightlines. The building was the result of architectural refinements specifically designed to manage and focalize the sightlines of a gathered crowd. These refinements were exploited in siting honorific statues at the resulting 'visual chokepoints', namely the *parodoi* (as at Athens), the intersection between the orchestra and the retaining wall ('Orchestraecken'),[170] the edge of the orchestra, and the stage building itself (as at Priene, where two statue bases still remain *in situ*, but where there may have been as many as seven such statues: Fig. 3.4).[171] The stage building at Delos (Fig. 3.5) also was fronted by three monuments (one a private honorific monument by an Attalid ruler, one a public honorific monument for the pipe-player Satyros son of Eumenes, and another now nameless).[172] Such a development reflects the changing uses of the Hellenistic theatre: the orchestra no longer served the theatrical action, and the audience gave the full focus of its attention to the stage and stage building.[173] Furthermore, under the Roman empire, such statues could even be placed in the *frons scaenae*, as at Messene or Sikyon.[174]

The crowd gathering was itself political in nature.[175] At times, it would be the citizen body itself which met in the theatre to conduct assemblies (the statue for Lucius, the narrator of Apuleius' *Golden Ass*, was decreed at Hypata in a meeting in the theatre: above, 53); even during festivals, a large part of the crowd would be citizens, thus making the imagined civic community presently visible, and hence an appropriate audience for the proclamation of honours, of the type studied in Chapter 1. The theatre displayed living benefactors, in the form of the permanent *proedria* seats at the front of the seating area; occupation of these seats was one of the honours a city could decree. At Priene, as in many other cities, such honours

A. Matthaei and M. Zimmermann (eds), *Stadtbilder im Hellenismus* (Berlin, 2009), 277–303. Delos: P. Fraisse and J.-C. Moretti, *Le Théâtre*. Exploration Archéologique de Délos, 42 (Paris, 2007), 78–86. Epidauros: A. von Gerkan and W. Müller-Wiener, *Das Theater von Epidauros* (Stuttgart 1961), 23 (the *analemma* walls ended with some form of base or pedestal). Delphi: four bases are mentioned by N. Valmin, *FD* 3.6.7, 47, 56, but there is no epigraphical indication of the nature of the statues or offerings on them. J.-F. Bommelaer, *Guide de Delphes: Le Site* (Athens, 1991), 211, writes cheerfully: 'nombre d'artistes victorieux et d'intellectuels en renom eurent leur statue, dont, au mieux, la base seule subsiste', 'many victorious artists and famous intellectuals received a statue, whose mere base, at best, survives'; no indications in J.-F. Bommelaer, 'Observations sur le théâtre de Delphes', in J. F. Bommelaer (ed.), *Delphes: Centenaire de la 'grande fouille' réalisée par l'Ecole française d'Athènes, 1892–1903* (Leiden, 1992), 277–300.

[169] Fittschen, 'Statue des Menander'; K. Fittschen, 'Eine Stadt für Schaulustige und Müßiggänger. Athen im 3. und 2. Jh. v. Chr.', in Zanker and Wörrle, *Stadtbild und Bürgerbild*, 55–77; Papastamati-von Moock, 'Menander und die Tragikergruppe'.

[170] Below, 137–9, on *Inschr. Magnesia* 92 and F. Hiller von Gaertringen, 'Ausgrabungen im Theater von Magnesia am Maiandros. I. Inschriften', *AthMitt* 19 (1894), 1–53. At Priene, these spots are taken by votive offerings (of under-life-size male figures in violent movement: the ivy-adorned bases suggest e.g. satyrs rather than the athletes often reconstructed). *I. Ephesos* 2058 is the statue base set up at the end of the southern retaining wall of the theatre at Ephesos, by the Italians *quei Ephesi negotiantur* for L. Agrius l. f. Publeianus, in the Roman-style dative (mid-1st cent.).

[171] A. von Gerkan, *Das Theater von Priene, als Einzelanlage und in seiner Bedeutung für das hellenistische Bühnenwesen* (Munich, 1921), 47–8.

[172] Fraisse and Moretti, *Le Théâtre*, 78–81, on *IG* 11.4.1106 (portrait of Philetairos, set up by Attalos I; from the shape of the base, a seated statue), 1079.

[173] Von Hesberg, 'Hellenistische Theater'.

[174] Messene: *SEG* 52.380. Sikyon: Pausanias 2.7.5 (statue of Aratos: a relocated Hellenistic monument?). The statue of Apollonios, son of Epigonos, 'benefactor of the fatherland in many ways', was probably set on a (reused) columnar statue base in the Roman stage building of the theatre of Magnesia on Maeander: *Inschr. Magnesia* 132B. The *frons scaenae* could be used for elaborate sculptural programmes: E. Rosso, 'Le Message religieux des statues impériales et divines dans les théâtres romains: Approche contextuelle et typologique', in J.-C. Moretti (ed.), *Fronts de scène et lieux de culte dans le théâtre antique* (Lyon, 2009), 89–126.

[175] Von Hesberg, 'Hellenistische Theater', with earlier bibliography. For performance in Classical Athens, S. Goldhill, 'The Great Dionysia and Civic Ideology', *JHS* 107 (1987), 58–76.

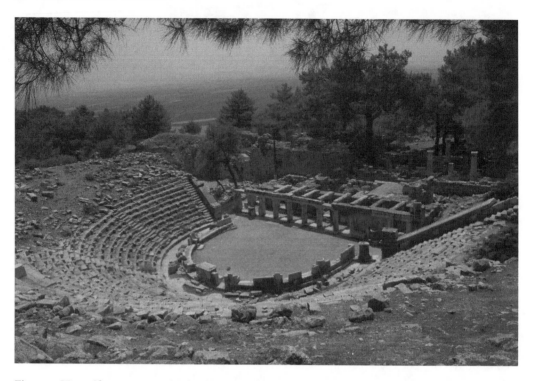

Fig. 3.4. Honorific monuments in the theatre took over sites of high visibility. View of theatre, Priene: two cylindrical statue bases are still *in situ*, and some of the foundations are still visible, before the stage building.

Fig. 3.5. We can only imagine the effect of Hellenistic theatres at work, complete with honorific statues in full view of the audience. Reconstruction of theatre of Delos, seen from the north-west. Watercolour by T. Fournet; reproduced from P. Fraisse and J.-C. Moretti, *EAD* 42, *Le Théâtre* (Athens, 2007), pl. III, fig. 425, by courtesy of the French Archaeological School in Athens.

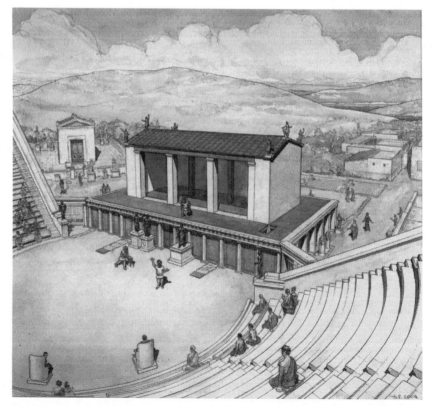

were proclaimed in the theatre, at the Dionysia, during the public libations: first the crown was announced, then a separate proclamation was issued: 'The people crowns Moschion son of Kydimos with a gilt portrait and a marble one, since he proved a good man as regards saving and benefitting the people'.[176] Such moments provided a context for the viewing of honorific statues such as that of Apollodoros: even if he was a benefactor of the theatre, the inscription does not mention this, and the broader context invites the viewer to read the statue as part of the civic culture of honours. This is not to say that the theatre seriously rivalled the agora and the shrine as a setting for the honorific: the case of the theatre at Priene, with possibly seven honorific statues arrayed in front of the stage building, remains an exception in our record, at least for the Hellenistic period. Practical reasons limited the use of the theatre for honorific purposes. There could only ever be two prime *Orchestraecken* spots; at Magnesia on Maeander, the statue of Anaxenor when set up in one of these spots was simply placed in front of the base of the earlier statue of Apollophanes.[177]

Who was honoured with a statue in the theatre? In many cases, the honorands seem to have a direct link with the theatre: poets (mostly in Athens; one case in Eretria, for an Athenian poet, Menander)[178] and performers (for instance the *auletes* Satyros son of Eumenes, of Samos, honoured at Delos);[179] benefactors of the theatre, as in the case of Apollophanes and a relative of his, who lent money to their city, Magnesia on Maeander, to help with construction work on the theatre.[180] The statue of Ariobarzanes II of Kappadokia may have been set up in, or near, the theatre of Dionysos in Athens in thanks for his restoration of the Odeion.[181] The kitharode Anaxenor, son of Anaxikrates, honoured by his city, Magnesia, with a statue in the theatre, was both a performer, and an important benefactor of the city, through his connection with Mark Antony.[182]

In other cases, it is not easy to see a direct link. The warlike Philopoimen, the Achaian statesman and general, was honoured by Megalepolis with a statue in the theatre, not because of any relation with drama, but because the theatre was one of the main civic spaces, and the Megalopolitans set up statues of Philopoimen in all of them.[183] The two men whose statues stood in the theatre at Priene are not described, on the statue bases, as particular benefactors of the theatre. At Messene, the theatre received statues of athletes and worthies, such as the posthumous Roman-era portrait of Ti. Flavius . . . krates, philosopher, new Plato, honoured on account of 'all his *arete*'.[184] Such statues make it likely that the theatre, like the gymnasion,

[176] *Inschr. Priene* 108, ll. 328–40.

[177] Above, 91; below, 137–9.

[178] Above, n. 169 for Athens; *IG* 12.9.280 for Eretria. The fragmentary marble statue of a himation-wearing man, standing next to an *omphalos* and found close to the theatre of Magnesia, may be a poet: C. Watzinger, in C. Humann, *Magnesia am Maeander: Bericht über Ergebnisse der Ausgrabungen der Jahre 1891–1893* (Berlin, 1904), 208–9 (but this does not have to be a public honorific).

[179] *IG* 11.4.1079, early 2nd cent.; (the form of the block and the formulation of the inscription seem to indicate an honorific statue; the relief decoration, with tripods and an ivy crown, is unusual, as are the traces of an added-on bronze plaque (bearing an epigram?). On Satyros, I. E. Stephanis, *Dionysiakoi technitai: Symvoles stin prosopographia tou theatrou kai tis mousikis ton archaion Hellinon* (Iraklio, 1988), no. 2240; Satyros is also attested on a famous Delphic inscription, *Syll.* 648A. On the theatre at Delos, above, n. 168.

[180] *Inschr. Magnesia* 92.

[181] The base, *IG* II² 3427, was found south of the theatre, before the temple of Dionysos: M. and E. Levensohn, 'Inscriptions on the South Slope of the Acropolis', *Hesperia*, 16 (1947), 72 and fig. 1. The base is columnar, and hence probably not a column from the Odeion (as Kotsidu writes, Τιμὴ καὶ δόξα, 99). On the restoration of the Odeion, Vitr. 5.9.1; on Ariobarzanes II, Herrmann, 'Samos', 99.

[182] *Inschr. Magnesia* 129.

[183] *Syll.* 624.

[184] *SEG* 53.404. *SEG* 48.492, a statue base found near the western *parodos* of the theatre at Messene, mentions no particular service in relation to the theatre; *SEG* 51.427 is a statue base for an athlete. A columnar statue base from Magnesia (*Inschr. Magnesia* 132A), honouring an athlete (1st cent. BC) may have stood in the theatre before being reused in the Roman-era stage building. An inscription from the theatre at Sikyon (*IG* 4.428) may be the orthostate from the base of an athletic statue (Kallistratos, son of Philothales; in the nominative). At Argos, the statue base of an athlete (nominative) and that of a public honorific for Marius, found reused in late contexts, may come from the theatre (P. Charneux, 'Chronique des fouilles et découvertes archéologiques en Grèce en 1956: Argos VIII, Inscriptions', *BCH* 81 (1957), 684, no. 2).

increasingly grew available as a site of high publicity, used as the number and frequency of the honorific monuments in the late Hellenistic and Roman townscape grew. But even two of the earliest known honorands, the poets Diodoros of Sinope and Philippides,[185] whose statues were set up in the theatre of Dionysos at Athens, seem to have been honoured primarily for political services rather than for their art: the theatre was a fitting context for their status as poets, but also had a political nature.

As mentioned above, honorific statues were occasionally set up in political meeting-places, but most examples are late. One Diokles was honoured in the second century (perhaps early in that century) by the city of Kyzikos, for services performed in spite of old age, with an 'eternal golden crown' proclaimed yearly at the gymnic contests of the city, and with a bronze statue, set up 'in the intercolumniation of the council-house' (ἐν τῷ μεσοστύλῳ τοῦ βουλευτηρίου).[186] The *bouleuterion* at Aigai was adorned with an extraordinary array of statues of benefactors, from the late Hellenistic period onwards.[187] Much later, the entrance into the *ekklesiasterion* (meeting hall for the assembly) at Messene was encumbered with a full-size equestrian statue, set up in the second century AD;[188] the small *bouleuterion* of Teos received honorific statues for local grandees, as did the rather larger *bouleuterion* at Aphrodisias (where two unpublished second-century AD private honorific statues perch on the end of the retaining walls). These practices reflect two later developments: the Roman-era appetite for the expansion of the grammar of the honorific space, and the rise of the council as the dominant institution in the late Hellenistic and Roman *polis*. Nonetheless, the choice of space is highly significant: it locates the honorific, and the euergetical, in a prominent spot in venues where political activity was conducted; the setting influenced both the nature of political activity (under the sign of euergetical gratitude) and the image of members of the elite, caught in a precise role, that of the citizen fulfilled only by complete communitarian devotion.

e. 'International' Shrines

Communities could dedicate honorific portraits outside their own townscapes: in other towns (by asking for a grant of public space by another *polis*, and hence by subjecting their honorific statue to local management of space, as discussed above) or in 'shared' shrines. An obvious example of this practice is the function of 'federal' shrines as a venue for honorific monuments. Just as religious life, and hence religious space, allowed civic subdivisions to make their corporate existence visible, in the form of festival activity but also common honorific dedications, so supra-*polis* organizations used festivals and common shrines as their 'public' spaces. The Confederacy of Athena Ilias set up statues for benefactors, for instance good gymnasiarchs, in the federal shrine.[189] The Ionian cities, in the very early third century, honoured a Friend of Lysimachos, Hippostratos, appointed 'general over the Ionian cities', with a statue set up in the shrine shared by the Ionians—the Panionion, near Priene (the decree is known from two copies, one from Miletos and one from Smyrna).[190] The *Koinon* of the Chrysaorians

[185] *IG* II² 648, 657; above, n. 169.
[186] *SEG* 28.952 (originally published by Hiller von Gaertringen, and again by L. Robert: *Documents d'Asie Mineure*, 148–56). On μεσοστύλιον, Robert, *OMS* ii. 901; perhaps the statue was set up in an intercolumniation of a stoa, in front of or around the council-house (rather than inside the building; discussion in W. A. Donald, *The Political Meeting Places of the Greeks* (Baltimore, Md., 1943), 269).
[187] These have been revealed by the current excavation by E. Doğer, whom I am pleased to thank for his hospitality at the site; the inscriptions are under study by H. Malay.
[188] *IG* 5.1.1455A, with G. P. Oikonomos, 'Anaskaphai en Messini', *Praktika* (1925–6), 60–2 (statue of e.g. emperor, set up by Ti. Claudius Saithidas—so a public honorific paid for by a notable, or a private honorific).
[189] *I. Ilion* 2; *SEG* 53.1373; *I. Ilion* 12, 14.
[190] *Syll.* 368; *I. Smyrna* 577. On the question of the location of the Hellenistic (and indeed Archaic) Panionion (at Otomatik Tepe near Güzelçaml 1, 2), A. Herda, 'Panionion-Melia, Mykalessos-Mykale, Perseus und Medusa: Überlegungen zur Besiedlungsgeschichte der Mykale in der frühen Eisenzeit', *IstMitt* 56 (2006), 43–102, and H. Lohmann, 'Forschungen und Ausgrabungen in der Mykale 2001–2006', *IstMitt* 57 (2007), 102–5.

can be seen to honour a statesman in a fragmentary decree, of unclear date (probably early second century).[191]

In mainland Greece, the Boiotian League set up honorific statues in its federal shrine of Athena Itonia: a statue of Antiochos III set up there provoked M. Acilius to ravage the territory of Koroneia in reprisal, before realizing that the statue had been set up not by the Koroneians, but the whole federal state of the Boiotians.[192] The Phokian *Koinon* honoured a benefactor, Krinolaos son of Xenopheithes, with a statue in the federal shrine at Hyampolis;[193] the Thessalian *Koinon* may have done the same in their federal shrines, that of Zeus Eleutherios at Larisa and that of Athena Itonia (near the modern village of Mavrachades, some 20 km south-east of Karditsa).[194] At Dodona, the *Koinon* of the Epirotes honoured two officers, Menelaos son of Krison, and Milon son of Sosandros, the latter with an equestrian statue.[195] The Delphic Amphiktiony set up honorific statues in the precinct of Apollo at Delphi;[196] in the Aitolian-dominated third century, a series of Chian hieromnemones were honoured with two statues each, one in Chios and one at Delphi.[197]

Much more rarely, member states of the Amphiktiony could also dedicate statues in the shrine of Apollo. An early example is due to the Thessalians, who honoured Pelopidas with a bronze statue by Lysippos.[198] Other cases of constituent states in federal formations setting up honorific statues in the federal shrines show the intention of ensuring publicity for honours, within the federal statues and to the outside world. The *Koinon* of the Bylliones honoured one Krison son of Sabyrtios (in fact the father of Menelaos, honoured by the Epirotes) with a statue at Dodona, set up next to his son's: Plan 7), and not, or not only, with a statue 'at home'.[199]

Delphi was the setting for honorific statues erected by more bodies than just the Amphiktiony, the city of the Delphians, or members of the Amphiktiony. Communities could decide to set up statues in prestigious shrines outside their territory or their control. Every shrine could receive such dedications. The spectacular monument set up by the Troizenians for Anthas, their compatriot, for services as a statesman and liberator, with an impressive monument at the Amphiaraion of Oropos in Boiotia, did not reflect their membership of the Boiotian League, but the choice of a well-frequented shrine (and perhaps links of kinship with Oropos,

[191] *I. Stratonikeia* 1418 (earlier *SEG* 53.1229).

[192] Livy 36.20. Another honorific portrait is attested in the federal shrine, but much later: *IG* 7.2711 (gilt painted portrait of Epameinondas of Akraiphia, set up in the shrine of Artemis Itonia, by decree of 'all the *naopoioi* in the festival of the Pamboiotoi' but in the name of the Boiotian confederation, AD 37). There are no attested statues for the other federal shrine at Onchestos. Many of the equestrian statues in the Oropian Amphiaraion, later reused, might have been set up by the Boiotians.

[193] *IG* 9.1.91 (Hyampolis); 101, from Elateia, mentions a statue or painted portrait to be set up ἐν τῷ κοινῷ (the common shrine?).

[194] Statues are found at Larisa, set up by the Thessalian League which emerged after 196: *ISE* 101 (M. Caecilius Metellus); C. Habicht, 'Neue Inschriften aus Thessalien', *Demetrias* 5 (Bonn 1987), 311–12 (the 1st-cent. proconsul of Achaia Q. Acutius Flaccus); however, none of these statue bases was found in an archaeological context suggesting a federal shrine, nor does the inscribed caption give any such indications. Two honorific statues set up by the Thessalian League are known through bases found at the shrine of Athena Itonia, but they date to the 3rd cent. AD (*SEG* 37.492–3; 54.558). On the shrine and its location, B. Intesiloglou, 'I Itonia Athina kai to Thessaliko omospondiako iero tis sti Philia Karditzas', *Archaiologiko Ergo Thessalias kai Stereas Elladas*, 1/2003 (Volos, 2006), 221–37; generally, D. Graninger, *Cult and Koinon in Hellenistic Thessaly* (Leiden, 2011), 43–86.

[195] *SEG* 24.449–50; P. Cabanes, *L'Épire de la mort de Pyrrhos à la conquête romaine (272–167 av. J.C.)* (Paris, 1976), 546–7; N. T. Katsikoudis, *Dodone: Oi Timetikoi Andriantes* (Ioannina 2006), with review by Ma, *BMCR* 2008.02.27.

[196] Twenty-three statues are noted in Jacquemin, *Offrandes monumentales*, 309–12.

[197] *CID* 4.86–9 (at least; other decrees, now fragmentary, could have included statues).

[198] Jacquemin, *Offrandes monumentales*; on Pelopidas, above, 5.

[199] *SEG* 24.449. When the Tloans set up the statue of Neoptolemos, a Ptolemaic high officer who fought off an incursion from the north in the early 3rd cent., they set it up in a shrine of the 'three brothers', mythical founders of Lykian cities (Robert, *OMS* vii. 531–47; S. Barbantani, 'The Glory of the Spear: A Powerful Symbol in Hellenistic Poetry and Art. The Case of Neoptolemus "of Tlos" (and Other Ptolemaic Epigrams)', *Studi Classici e Orientali*, 53 (2007) [2010], 67–138; this may have been a 'federal' Lykian shrine rather than located in Tlos.

which made the choice meaningful for the Troizenians).[200] The Asklepieion of Epidauros was adorned with statues set up by 'the *polis* of the Epidaurians', but also the cities of the Phleiasians, the Spartans (four extant bases), the Megarians, and 'the *Koinon* of the Asinaians' in the Argolid (all second century or later).[201] The most prestigious, and patronized, shrines were Delphi, Olympia, and Delos. These great pan-Hellenic shrines have long been excavated and published, illustrating the popularity of such shrines for dedications of honorific monuments (as well as all sorts of other monuments, sculptural and architectural) from cities all across the Hellenistic world.[202]

The exact details of the positioning of honorific statues in the great pan-Hellenic shrines reflect the particularities of local topography: in Delphi, the winding road inside the precinct itself, leading up to the temple terrace, with a broader terrace (the sacred space called the 'Threshing-floor', used for marshalling processions) in front of the stoa of the Athenians (Fig. 3.6, Plan 6, with honorific statues marked);[203] in Olympia, the tightly enclosed space of the Altis (Plan 5); on Delos, the sprawling urban complex of the sacred island, with a complicated history involving a radical change in status in 167, from free city to Athenian overseas possession undergoing Hong Kong-style mushrooming expansion (Plan 8).

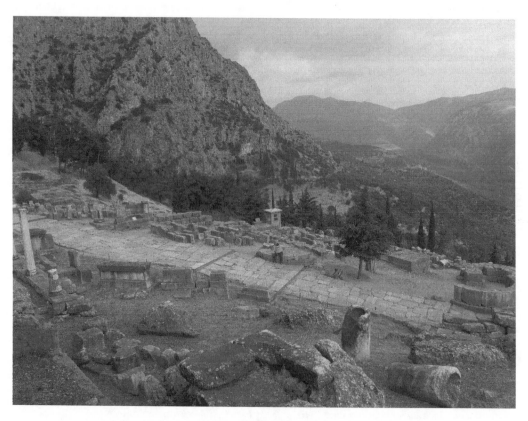

Fig. 3.6. In pan-Hellenic shrines, the position of honorific statues used the resources of topography to address the crowd of visitors and pilgrims. Terraced esplanade on the Sacred Way at Delphi ('Aire'), in front of the Stoa of the Athenians. Photogr. S. Dillon.

[200] *Oropos* 389 (also *ISE* 62 on the choice of the Amphiaraion), with Ma, 'Oropos (and Elsewhere)'.
[201] *IG* 4² 1.620, 621, 624–5, 644, 656.
[202] e.g. Jacquemin, *Offrandes monumentales*. For the archaic and classical periods, M. Scott, *Delphi and Olympia* (Cambridge, 2010). On Hellenistic Olympia, K. Freitag, 'Olympia as "Erinnerungsort" in hellenistischer Zeit', in M. Haake and M. Jung (eds), *Griechische Heiligtümer als Erinnerungsorte von der Archaik bis in den Hellenismus* (Stuttgart, 2011), 69–94.
[203] *Guide de Delphes* 146–7 ('Aire').

Nonetheless, the positioning of honorific statues in all three shrines shows common traits, shared with other shrines (above); the exploitation of high-visibility spots along access routes, alignment along stoas, clustering around the focal points of altar and temple, or secondary monuments—as analysed above for the Samian Heraion or the Asklepieion near Epidauros (which also were, to a certain extent, 'international' shrines). At Olympia, honorific statues are found around the temple of Zeus and along the path linking the temple to the ash altar (here honorific statues mingled with athletic statues and votives, some of great size); in front of the east stoa ('Echohalle') where their alignment responds to the façades of the stoa and the 'Southeastern building', as well as the alignment of the treasuries and the *Zanes* (statues set up by competitors convicted of cheating) to which they build a right angle; and along a route coming from the west, turning north along the Leonidaion, then east, along the early wall on the south side of the Altis—a row of thirteen honorific equestrian statues (starting in the later Hellenistic period, and probably for Roman officials) lines the southern side of this route, and prolongs a monumental row already constituted by earlier monuments, the *bouleuterion*, and the base of the Apolloniatai; this route finally joins the path from the altar of Zeus to the temple of Zeus. A few minor clusters of statues surrounded the multiple entrances into the sacred precinct.[204]

The difference from a 'normal' civic shrine is the wider audience reached by the honorific gesture made away from the home *polis*, in a site full of visitors, pilgrims, sacred ambassadors, a nodal point in the networks of the Hellenistic world. At Delphi, the equestrian statue of Philopoimen, set up by the Achaians on a highly visible site and turned towards the 'Sacred Way', greeted countless visitors, year after year, as they ascended towards the temple.[205] It is true that the catchment area of the great shrines was influenced by geography. Communities from the Peloponnese set up statues in Olympia (and Epidauros): the Achaian soldiers sent as allies to fight against the Galatians (the Boii) with Cn. Domitius Ahenobarbus in 192 set up an equestrian statue of their officer, Damon son of Alkisthenes, of Patrai.[206] Central and Northern Greece is well represented at Delphi (where the city of Lilaia honoured a liberator, Patron, with a statue and an epigram).[207] As for Delos, the statues set up there represent communities from the islands, but also the seaborne contacts between West and East: the envoys of the Prostaennoi Pisidai, from a community in Southern Anatolia, must have set up the statue which the city decreed in honour of M. Antonius during a stopover at Delos on a journey to or from Rome.[208] But the three pan-Hellenic shrines attracted the presence of dedicants from just about everywhere, and a dedication there took on the force of a statement about the relations between the dedicator, the shrine, and the wider Greek world. It contextualized a particular honorific transaction within a broader history, given concrete form by the experience of the architecture, the sightlines, the dedications left by past generations; the statue remained, left behind by its dedicators, as a monumental 'ideal spectator' participating in the monumental landscape, but also the regular religious and competitive rituals in the shrine.[209] The statue of Patron of Lilaia heightened a specific, rather local event, and set it among a narrative of Greek deeds, and even Greek freedom. The equestrian monument of Kallikrates, set up at Olympia by

[204] A. Mallwitz, *Olympia und seine Bauten* (Munich, 1972), 63, 105–6, 121. The 'southern route' past the Leonidaion, then along the southern edge of the 'Altis', was originally outside the 'Altis' itself: the Roman-era wall, which includes the equestrian statues within the sacred precinct, cuts off a few statues opposite the Leonidaion from the route. On spaces at Olympia, T. Hölscher, 'Rituelle Räume und politische Denkmaler', in H. Kyrieleis (ed.), *Olympia 1875–2000* (Mainz, 2002), 331–43.

[205] H. B. Siedentopf, *Das hellenistische Reiterdenkmal* (Waldsassen, 1968), no. 65 the base of Philopoimen; Jacquemin, *Offrandes monumentales*, 200, 308 no. 005.

[206] *ISE* 60. Other statues set up by the Achaian League or Achaian contingents: *Inschr. Olympia* 297, 301, 318, 328. Statues set up by Peloponnesian communities: *Inschr. Olympia* 294 (Psophis in Arkadia), 300 (Spartan exiles upon their return), 316 (Sparta, honouring Elis), 396 (*boule* and *demos* of Megalepolis), 398 (Tegea), 402 (Phigaleia). Most honorific statues in the shrine were set up by Elis; and most statues were those of athletic victors.

[207] *SEG* 16.28, with Moretti, *ISE* ii. 31; Pausanias 10.33.3; 3rd cent..

[208] *Choix Délos*, no. 123. [209] 'Ideal spectator': Siedentopf, *Reiterdenkmal*, 36.

the Spartan exiles upon their return, proclaimed their gratitude, but also their success and their story to a pan-Hellenic audience. The statue of M. Antonius, set up by a Pisidian city, allowed the latter to gain presence in an *haut-lieu* of Greekness, among celebrated works of art and a monumental landscape of high antiquity.

4. PRIENE, PERGAMON, ATHENS

Agora, shrine, gymnasion, theatre: these main sites for honorific statues have been illustrated above by (perhaps too) many examples, constructing an ideal cityscape. Actual individual cases show variation, the influence of local conditions and histories: their interest is hence not just in illustrating the general principles, but also in shedding light on the choices made by actors within the vocabulary of space. Three cases are of particular interest: Priene, Pergamon, and Athens, because of the fullness of the evidence, the historical circumstances of each, and the diversity between the three communities; they show the validity and significance, as well as (and through) the implementation of the general principles sketched above.

a. Honorific Portraits: Where in Priene?

In Hellenistic Priene,[210] public honorific statues were to be seen in at least six settings: the agora, the shrine of Athena, the theatre, the shrine of Demeter, and the two gymnasia; in addition, statues may have stood in two further shrines, the shrine of Asklepios and the shrine of the Egyptian gods; finally, the Panionion, a shrine shared by the Ionian cities, stood in its territory and may have been used for honorific monuments by the Ionians (above, 94). The main venue was undoubtedly, in Priene as in probably all Hellenistic cities, the agora. At Priene, in its late Hellenistic phase, the agora (Plan 13) shows a profusion of monuments, attested mostly through around sixty bases and foundations.[211] The majority of bases concentrated in the southern half of the agora, specifically in the form of a 'main series', 9 m to the south of the east–west street, aligned with the northern end of the shrine east of the agora (Asklepios or Zeus), with most facing on to the street; others, added later, on the west side, facing southwards into the open square. In effect, the statues define a northern part of the agora, constituted by the walkway in front of the Sacred Stoa and the 9 m wide strip south of the 'West Gate Street', and a southern part, limited not only by three stoas, but also by a fourth wall to the north, made up of statues. A few bases line the west stoa in the southern part of the agora; the east stoa is lined with two rows of statues, one somehow connected at right angles with the 'great row', a second set up close to the stoa; a large, multi-statue base is set at either edge of the space in front of the northern stoa. The open space of the southern part is occupied by a few large, rectangular foundations; one of these, exactly centred between the three stoas and the West Gate Street, is probably a monumental altar.

 Since the majority of monuments are attested only through the foundations, there is no clear chronological sequence. The bases in the southern open space could be monumental cult-statues, and the well-constructed equestrian bases before the West stoa probably belonged to the early Hellenistic statues of Larichos and other benefactors;[212] the few statue bases in the

[210] T. Wiegand and H. Schrader (eds), *Priene: Ergebnisse der Ausgrabungen und Untersuchungen in den Jahren 1895–1898* (Berlin, 1904); M. Schede, *Die Ruinen von Priene* (Berlin, 1964); F. Rumscheid, *Priene: A Guide to the 'Pompeii of Asia Minor'* (Istanbul, 1998); W. Raeck, 'Priene. Neue Forschungen an einem alten Grabungsort', *IstMitt* 53 (2003), 313–423; A. von Kienlin, 'Das Stadtzentrum von Priene als Monument bürgerlicher Selbstdarstellung', in E.-L. Schwadner and K. Rheidt (eds), *Macht der Architektur—Architektur der Macht* (Mainz am Rhein, 2004), 114–20; R. Bielfeld, 'Polis Made Manifest: The Physiognomy of the Public in the Hellenistic City with a Case Study on the Agora in Priene', in C. Kuhn (ed.), *Politische Kommunikation und öffentliche Meinung in der antiken Welt* (Stuttgart, 2012), 87–122.

[211] H. Schrader, in Wiegand and Schrader, *Priene*, 206–13, with map; A. von Kienlin, *Die Agora von Priene* (Ph.D. thesis, Universität München, 2004).

[212] *Inschr. Priene* 18. However, something is peculiar about 'base 18': the surviving remnant is clearly the top *Deckplatte* of an equestrian, but set at ground level, without the high base shaft which normally provided both visibility and an inscribed surface. Either what we now see as 'base 18' is a *Deckplatte* reused in a foundation, or it is in fact the *Deckplatte* from neighbouring 'base 19'.

north are later Hellenistic, and were installed after the remodelling of this part of the agora through the building of the northern stoa. In spite of the paucity of information, a number of features appear clearly. First, the statue bases show the attraction of the western intersection (whereas the eastern end, although marked by a monumental gate, is largely statue-free).[213] Secondly, the final state of the agora shows the importance of statues in shaping public space, and movement and experience within this space; it is striking that most of the bases in the western intersection and the row of statues south of the West Gate Street are exedras with benches for passersby to sit on, in cool marble shadow, under the statues and looking out on the passage in the street that crosses the agora. The constitution of this remarkable row of statues, after an earlier phase when statues had aligned the central space, parallel to the stoas, also hints at a complicated social history, involving social actors, collective and individual, within space. How did this space come to look the way it finally did? I attempt a sketch of a social history of space in the agora of Priene in the next chapter. For now, it is enough to note that soundings beneath the Sacred Stoa have revealed the foundation of one statue base, in front of an earlier stoa: building the Sacred Stoa involved moving at least one and probably several honorific statues on the now nearly statue-free northern side of the square.

Thirdly, the civic nature of this space appears clearly defined by architecture, but also by honorific inscriptions, images, and rituals: abbreviated decrees on the columns of the stoas in the southern half, the archive wall in the northern stoa, honorific statues and painted portraits, and the proclamation of crowns in the agora;[214] in Priene, the agora was the most normal site for public honorific statues. 'Die Fülle der Ehrenbilder muss fast erdrückend gewesen sein' ('the profusion of honorific images must have been almost oppressive').[215]

The other main venue for honorific statues in Hellenistic Priene was the shrine of Athena, dominated by the great and beautiful temple building (Plan 14).[216] Two early honorific statues for important figures have been mentioned above (22, 81–2): a marble statue of Ada, probably set up in the temple itself; a bronze statue of the Megabyxos, set up aligned with one of the *antas*, as is known from an honorific decree (the base itself has been found, but not *in situ*).[217] The statues of Seleukos I and Antiochos I mentioned in the decree for Larichos were probably set up in the shrine of Athena (since a second decree decided to move the statue of Larichos to another venue—the agora).[218] A small number of bases for honorific statues have been found in the area of the shrine (again not *in situ*).[219] From remaining foundations, it is clear that two areas were used for statues. First, a long row (16 bases) runs south of the temple and the *propylon*, on the southern side of the shrine terrace. Some of these bases are older than the southern (and southwards looking) stoa, dating to the mid-second century; the back wall of this stoa also helped define the row as it continued being set up.

Second, a row of bases occupies the western wall of the 'north-east extension' to the temenos, along a space in front of a distyle in antis building (a temple?); a few bases are scattered within this space. Four bases were particularly prominent: they took the form of rectangular pilasters, of considerable height (13 m or so), thus matching the height of the temple, whose ornament it echoed. These bases may have borne honorific statues, though there are no surviving inscriptions from the shafts of the pilasters.

The other sites for statues are the shrine of Demeter, in front of whose entrance three statues of priestesses were set up on a tiny esplanade formed between two terrace walls, one to the side, two in front of either door jamb of the entrance, narrowing the actual thoroughfare, and

[213] There are the foundations of one exedra; a family group was found in the area.
[214] *Inschr. Priene* 99, l. 17: proclamation in the agora; *Inschr. Priene* 113, 114: proclamation of crown in agora.
[215] Schrader, in Wiegand and Schrader, *Priene*, 206.
[216] Generally, Schrader, ibid. 81–136; W. Müller-Wiener, 'Neue Weihgeschenke aus dem Athena-Heiligtum in Priene', *ArchAnz* (1982), 691–702; A. von Kienlin and C. Schneider, in Raeck, 'Priene', 386–400.
[217] *Inschr. Priene* 3 and 231.
[218] Gauthier, 'Larichos', 47–8.
[219] *Inschr. Priene* 234, 240, 244, 252.

Fig. 3.7. A small
liminal space before
a shrine, quickly
crowded with
honorific statues.
Esplanade in front
of the shrine of
Demeter at Priene.

dominating the space (Fig. 3.7);[220] the theatre, in front of the stage building,[221] the gymnasia (with an exedra in the Upper Gymnasion, and a large marble statue on a prominently located base in the Lower Gymnasion).[222] There may have been honorific statues in the shrine of Asklepios east of the agora (there are foundations for bases in the northern part of the shrine),[223] as well as in the shrine of the Egyptian Gods,[224] but not in the *bouleuterion* (at least during the Hellenistic period, and even the early imperial period).[225] Though the Ionians set up an honorific statue in the Panionion, the Prienians themselves do not seem to have used this shrine for honorific statues of their own (though they do grant *sitesis* in the Panionion, which shows some measure of Prienian control and activity).[226]

The shrine of Athena appears first in the surviving record as the setting for an honorific statue; the earliest honorific monument attested in the agora is the equestrian statue for Larichos, decreed in *c*.280. Though the history of the agora is not yet completely established, it is clear that the agora became the main site for honorific monuments, set up by the *demos* (almost certainly), civic subdivisions, and private individuals (see below, Chap. 6) during the Hellenistic period, before the reorganization of the agora in the late second century; the agora and the shrine of Athena constitute the monumental heart of the city, where the Prienians chose to concentrate their honorific statues and display themselves as a civic community endowed with good citizens and the wherewithal to inspire and reward them. Within the limited space available, the theatre also shows concentrations of honorific monuments, as befitted a space where citizens met formally in political assembly and civic rituals. The gymnasion, and the various shrines within the city, remained marginal sites for the honorific. In other

[220] *Inschr. Priene* 172–3; Schrader, in Wiegand and Schrader, *Priene*, 147–63. The statues are captioned in the nominative, and it is not clear whether these are public honorifics (possible, since the statue of Megabyxos, also captioned in the nominative, is definitely an honorific: n. 219 and above, 22). A cylindrical base in the temple itself is probably a reuse, and in any case its context is unclear: von Kienlin and Schneider, in Raeck, 'Priene', 389–90.

[221] Above, 91–3; *Inschr. Priene* 237, 246.

[222] Above, 86; *Inschr. Priene* 251 is a fragment from the base of an honorific monument, found reused, south of the Upper Gymnasion.

[223] Foundations south of the temple are visible in the plan of the agora in Raeck, 'Priene'.

[224] *Inschr. Priene* 241.

[225] *Inschr. Priene* 246 is a 3rd-cent. AD statue set up in the *prytaneion* by 'the most illustrious city of the Ionian Prienians and the most powerful boule'.

[226] e.g. *Inschr. Priene* 109.

words, the Prienian honorific statuescape was intensely civic, in the choices made within the grammar of spaces, to emphasize the communitarian spaces of identity.

b. Honorific Portraits: Where in Pergamon?

In Pergamon (Plan 10), the placing of honorific portraits was shaped by the city's status as royal capital; this influenced practice subsequent to the disappearance of the Attalid monarchy and the emergence of the 'democratic city', with its late Hellenistic elites occupying the vacuum left by the dynasty.[227] As with any Hellenistic city, there were statues in the agora—except that the cities had two agoras. In the Lower Agora (dating to the expansion of the city under Eumenes II, say in the 170s or 160s), bases for statues have been detected in front of the northern and west stoas; these may have supported honorific monuments in this public space.[228] The older Upper Agora was certainly used early on for the display of epigraphy (the *stele* bearing documents honouring the *strategoi* of the city under Eumenes I was set up there);[229] later on, after reshaping by Eumenes II, it received several honorific statues, one (probably) on the large foundation south of the temple, a series (probably) on a long base next to the altars[230] and one of the statues decreed by the Pergamenes for Attalos III, a gilt-bronze equestrian statue on a marble pillar near the altar of Zeus Soter.[231] A few more bases might come from this space.[232]

The statuescape of Hellenistic Pergamon concentrated on the royal and monumental heart of the city, on top of the citadel hill. The shrine of Athena was the setting for dedications by the Attalid rulers, which were military in nature, but also for honorific statues, of the kings[233] and of members of the Pergamene elite families, namely priestesses of Athena Polias;[234] in 149 BC, the priestess Metris was honoured with a statue set up in this shrine, as stipulated in the decree carved on her statue base (which was found reused).[235] This practice continued after the end of the monarchy, in honour of the great civic politicians and benefactors of the city.[236] The evidence is mostly epigraphical (many of the statue bases were found reused in later fortifications), though some traces of foundations were noted; these are not sufficient to reconstruct the statuescape of the shrine.[237] There may have been honorific statues in the terrace immediately below the shrine of Athena, but the bases found there may come from the shrine. The terrace of the 'Great Altar' also served as a space for honorific statues, again of priestesses,[238] and

[227] M. Wörrle, 'Pergamon um 133 v. Chr.', *Chiron*, 30 (2000), 543–57; M. Mathys, 'Die Anfang vom Ende oder das Ende vom Anfang? Strategien visueller Repräsentation im späthellenistischen Pergamon', in A. Matthaei and M. Zimmermann, *Stadtbilder im Hellenismus* (Berlin, 2009), 227–42; and now see esp. R. Bielfeld, 'Wo nur sind die Bürger von Pergamon? Eine Phänomenologie bürgerlicher Unscheinbarkeit im städtischen Raum der Königsresidenz', *IstMitt* 60 (2010), 117–201.

[228] Radt, *Pergamon*, 89. The inscribed bases found in the Lower Agora belong to dedications (e.g. von Prott and Kolbe, '1900–1901 Inschriften', 89–90, no. 73); some of the honorific statue bases found in modern Bergama might come from the Lower Agora (e.g. the statue base for Mithradates—above, n. 167—found in the Çukurbağ Mahallesi: A. Conze and C. Schuchhardt, 'Die Arbeiten zu Pergamon 1886–1898', *AthMitt* 24 (1899), 177, no. 26).

[229] *OGIS* 266.

[230] K. Rheidt, 'Die Obere Agora: Zur Entwicklung des hellenistischen Stadtzentrums von Pergamon', *IstMitt* 42 (1992), 265.

[231] *OGIS* 332. I assume this statue did not stand on the foundation south of the temple, but closer to the altars in the middle of the agora (though there is no archaeological record of a suitable foundation).

[232] *Inschr. Pergamon* 61 (found near agora; statue of Eumenes II, set up by those who participated in the expedition against Nabis); 413 (Servilius Isauricus, in niche); perhaps 130 (priestess: more likely in the shrine of Athena or on terrace of the Great Altar).

[233] e.g. *Inschr. Pergamon* 29, 64, 181.

[234] *Inschr. Pergamon* 489, 490, 491 (early 2nd cent.), 494 (1st cent. BC); Eule, *Bürgerinnen*, 204–7; Mathys, 'Anfang vom Ende?', 232–4.

[235] *Inschr. Pergamon* 167; on date, C. P. Jones, 'Diodoros Pasparos and the Nikephoria of Pergamon', *Chiron*, 4 (1974), 183–205; Connelly, *Portrait of a Priestess*, 140–1.

[236] e.g. *Inschr. Pergamon* 453–5.

[237] Radt, *Pergamon*, 168: 'das Heiligtum muss ingesamt einem Statuenwald geglichen haben' ('the shrine must altogether have looked like a forest of statues').

[238] *Inschr. Pergamon* 129, 226, perhaps 492. Some of the female marble statues found in the area might have stood on the terrace of the Great Altar, unless they came from the terrace of the shrine of Athena (but they did not stand in the colonnade of the Altar): F. Queyrel, *L'Autel de Pergame* (Paris, 2005), 42–4. The marble

Fig. 3.8. The interior spaces of temples could also present honorific statues, in close proximity to cult-statues. Temple of Hera, Pergamon: view of the *cella* from above, podium with male statue in centre, and statue of Adobogiona on side (closest to viewer).

later of Roman officials.[239] The use of this particular space likely only started after the end of the monarchy:[240] a ceremonial and symbolical space created and exploited by the Attalids was taken over by the city of Pergamon for its own needs: commemorating the civic elite and Roman benefactors. Finally, the small Ionian temple next to the theatre may have been the setting for the marble (cult-)statue of an Attalid ruler (a fragmentary head was found in the *cella*).[241]

Further down the hill, honorific statues were found in the shrine of Hera—indeed, inside the very temple, where a statue of Attalos II may have stood, and a statue of the Galatian princess Adobogiona was added on, in the first century, to the existing statue podium in the back of the *cella* (Fig. 3.8).[242] The oblong shrine of Demeter, to the west, was also adorned with honorific statues, mostly of priestesses—first in the western half of the sacred space, in front of the portico north of the temple, later in front of the rows of seating in the eastern half.[243] Finally, the great gymnasion complex (Plan 11) was the setting for honorific statues for the Attalid rulers, for gymnasiarchs, and for benefactors such as Diodoros Pasparos. Many of these statues occupied the Upper Gymnasion, but there may have been other spots, for instance north of the temple in the Middle Gymnasion, or in the niches along the retaining wall that forms the backdrop to the narrow Lower Gymnasion.[244]

peplos-wearing 'Attalid Queen' found near the Altar (Queyrel, *Portraits des Attalides*, H1) might be the (public honorific?) portrait of a priestess (suggested, almost subliminally, in Dillon, *Female Portrait Statue*, 80–1).

[239] *Inschr. Pergamon* 404, 408, 411, 412, 416, 417, 426, and F. Queyrel, 'La Datation du Grand Autel de Pergame', *Studi Ellenistici*, 16 (2005),205 n. 19.

[240] *Inschr. Pergamon* 129 may date to the early 2nd cent. BC; 226 is certainly and 492 probably later than 133. See Queyrel, *L'Autel de Pergame*, 125, and 'La Datation du Grand Autel de Pergame'.

[241] Queyrel, *Portraits des Attalides*, 148–51, D1 (Eumenes II?).

[242] See above, n. 94.

[243] Above, n. 121.

[244] Mathys, 'Anfang vom Ende?', 234–6.

Further still came the Lower Agora; and outside of the city, the shrine of Asklepios, which was also used for statues during the Attalid period—Attalos III, in addition to his statue in the Upper Agora, had a statue set up in this shrine; later on during the Roman empire it grew in popularity.[245]

During the Hellenistic period, the distribution of honorific statues in Pergamon reflected the concentration of monumental expression on the Upper City, fostered by the Attalid dynasty: the shrine of Athena and, slightly later, the gymnasion complex were the main sites for honorific statues. Honorific monuments were largely reserved to members of the royal family, with the addition of Pergamene citizen women serving the cult of the patron deity of the dynasty. Such monuments were concentrated in the magnificent fortified heart of the Attalid state, with other monuments of the dynasty—the victory monuments, the palaces, and, indeed, the display architecture of the shrine of Athena and the Great Altar. This inflexion, determined by the function of Pergamon as the centre of the royal state, was preserved during the post-Attalid period: the shrine of Athena (with the addition of the esplanade of the Great Altar) and the gymnasia remained the favoured—most prestigious, most meaningful—spots for honorific statues. Concomitantly, both agoras seem to have remained relatively underprivileged; the theatre does not seem to have functioned as an honorific spot at all.[246] The honorific statuescape of Pergamon has a particular shape when compared to the 'normal' scheme (where the agora acts as a city's main representational space, and which I illustrated with the case of Priene); this shape reflects the city's history, but also the attachment of the post-Attalid civic elites to the monumental spaces that embodied this history—or perhaps simply their desire to exploit the prominence ensured by the Attalid monuments to grant civic monuments maximum publicity.

c. Honorific Portraits: Where in Athens?

In Hellenistic Athens,[247] honorific portraits were found across a complex townscape—in the agora (one of the main sites), on the Akropolis (the other main site), in the gymnasia, in various public buildings, in various urban shrines, in a few demes: Peiraieus, Rhamnous, Eleusis (the site of a great shrine of its own). But the case of Athens is particularly rich, and important. The city was one of the contexts where the honorific statue habit was forged, from the fourth century onwards; at the same time, it kept various particularities and idiosyncrasies. In addition, the historical record is extremely complete when compared with other Hellenistic communities, which invites us to think about statues and honours in the changing contexts of Hellenistic Athens; the historical record is replete with extremely rich evidence, epigraphical, archaeological, and literary, especially in the form of Pausanias' description of Athens town.

[245] The inscriptions are gathered and published by C. Habicht, *Inschriften des Asklepieions*.

[246] There is a statue base in the middle of the seating; this bore a bronze statue. The dating is unclear: Radt, *Pergamon*, 258.

[247] Henry, *Honours and Privileges*; R. von den Hoff, 'Tradition and Innovation: Portraits and Dedications on the Early Hellenistic Akropolis', in O. Palagia and S. V. Tracy (eds), *The Macedonians in Athens* (Oxford, 2003), 173–85; Oliver, 'Space and the Visualization of Power'; R. Krumeich, 'Ehrenstatuen als Weihgeschenke auf der Athener Akropolis: Staatliche Ehreungen in religiösen Kontext', in C. Frevel and H. vin Hesberg (eds), *Kult und Kommunikation: Medien in Heligtümern der Antike* (Wiesbaden, 2007), 308–413; R. Krumeich, 'Formen der statuarischen Repräsentation römischer Honoranden auf der Akropolis von Athen im späten Hellenismus und in der frühen Kaiserzeit', in S. Vlizos (ed.). *He Athena kata ti Romaiki epochi: prosphates anakalypseis, nees erevnes/ Athens during the Roman Period: Recent Discoveries, New Evidence* (Athens, 2008), 353–68; R. Krumeich and C. Witschel, 'Hellenistische Statuen in ihrem räumlichen Kontext: Das Beispiel der Akropolis und der Agora von Athen', in A. Matthaei and M. Zimmermann (eds), *Stadtbilder im Hellenismus* (Frankfurt am Main, 2009), 173–226, presenting their ongoing work on the statuescape of Hellenistic Athens; S. Aneziri, 'Kaiserzeitliche Ehrenmonumente auf der Akropolis: Die Identität der Geehrten und die Auswahl des Aufstellungsortes', in R. Krumeich and C. Witschel (eds), *Die Akropolis von Athen im Hellenismus und in der römischen Kaiserzeit* (Wiesbaden, 2010), 271–302. On the historical development, J. L. Shear, 'Cultural Change, Space and the Politics of Commemoration in Athens', in R. Osborne (ed.), *Debating the Athenian Cultural Revolution* (Cambridge, 2007), 91–115; on the Lykourgan honorific and dedicatory townscape, see now M. C Monaco, 'Offrandes publiques et privées sur l'Acropole et l'Agora d'Athènes à l'époque lycurguéenne (340–320 av. J.-C.)', in V. Azoulay and P. Ismard (eds), *Clisthène et Lygurgue d'Athènes* (Paris, 2012), 219–32.

A survey of the sites mentioned above, as we may imagine them at the very end of the Hellenistic period (just before the Augustan age and the subsequent impact of Julio-Claudian monarchy) might illustrate some of the specificities of the Athenian test case, as well as general principles governing the construction and use of *epiphanestatoi topoi* in the Hellenistic town-scape. Such a survey, necessarily synchronic in form, raises diachronic questions of historical evolution.

In the agora,[248] the most visible spot is occupied by the Tyrannicides, probably somewhere in the northern third of the public space; next to it, at various points in time, there have been honorific statues of exceptional importance: Antigonos and Demetrios, the 'Saviours'; at the other end of the Hellenistic period, the 'Liberators', Brutus and Cassius.[249] In both cases, the Hellenistic honorific statues exploited the meanings of the Classical monument (see below, 118). Honorific statues are to be found on the east side of the agora, near the public buildings, in a row leading up to the acute angle that forms the northern top of the agora: the statues of Lykourgos and Demosthenes (120), close to the statue of Eirene and Ploutos,[250] and the portrait of Kallias of Sphettos, are to be found here. The oldest statues are in a distinct group: those of Konon, Timotheos, and Evagoras, between the wings of the stoa of Zeus Eleutherios. A row of honorific statues also stands in front of the Stoa Poikile, to the north of the agora. There are also honorific statues along the Panathenaic Way—perhaps statues of Romans, perhaps earlier statues of Hellenistic kings.[251] The terrace wall of the Stoa of Attalos serves as a backdrop for honorific statues: a great quadriga-monument for Attalos II, statues of Romans on columnar bases.[252] The most dominant monuments are those for Attalid kings; but there is also a profusion of smaller honorific portraits, painted on wood (sometimes on gilt round panels, called 'shields': below, 254), dedicated by corporate bodies such as the ephebes (honouring their *kosmetes*) or the *prytaneis* (honouring their treasurer), in the Stoa of Attalos or in the *bouleuterion*;[253] a single statue monument, perhaps honorific, stands in the small square south of the *bouleuterion*.[254] The honorific statues are a very dominant presence; they share the space of the agora with votive offerings, cult-statues, and historical statues of past glories (Solon, Pindar); the latter have been reinterpreted by the late Hellenistic viewers as honorific statues, a good sign of the powerful presence of this genre in the agora.

The *dromos*, the stoa-lined road from the Kerameikos, is lined with statues of men and women (Paus. 1.2.4), probably late Hellenistic (as perhaps implied by the profusion of female statues, not all of which can have been priestesses; rather benefactresses or female relatives of benefactors). Just before the *dromos* joins the agora, on the south side of the road, the shrine of Demos and the Charites contains some honorific statues, along with *stelai* bearing decrees for foreign benefactors; the statue of Eumaridas of Kydonia is set up here (above, 56–7). This shrine was conceived as an honorific space for foreigners, though it did not catch on quite as much as its sponsors, the late third-century politicians Mikion and Eurykleides, had hoped; the building of a stoa has also cut off the shrine's visibility and made it something of a cul de sac.[255]

[248] Wycherley, *Literary and Epigraphical Testimonia*; Thompson and Wycherley, *Agora of Athens*; R. Krumeich in Stemmer, *Standorte*, 276–89, esp. 283–9; J. McK. Camp II, *The Athenian Agora Site Guide* (Princeton, 2010).

[249] Krumeich and Witschel, 'Hellenistische Statuen', 208–9 and n. 142: part of the base of the statue of Brutus is known (published by A. E. Raubitschek, 'The Brutus Statue in Athens', in *Atti del terzo congresso internazionale di epigrafia greca e latina* (Rome, 1959), 15–21; *SEG* 17.75, a rather banal ὁ δῆμος + accusative copula).

[250] R. von den Hoff, 'Bildnisstatue des Demosthenes'.

[251] M. Lawall, 'The Wine Jars Workroom: From Stamps to Sherds', in J. McK. Camp II and C. A. Mauzy (eds), *The Athenian Agora: New Perspectives on an Ancient Site* (Mainz am Rhein, 2009), 66–8.

[252] e.g. *SEG* 14.136 (public statue for Q. Lutatius).

[253] Pausanias 1.3.5 (mentioning a late 4th-cent. painted group of councillors); Henry, *Honours and Privileges*, 300–3, with a list of epigraphical documents (starting in the late 2nd cent.).

[254] H. A. Thompson, 'Buildings on the West Side of the Agora', *Hesperia*, 6 (1937), 169–70.

[255] M. C. Monaco, 'Contributo allo studio di alcuni santuari ateniesi I: Il *temenos* del *Demos* e delle *Charites*', *ASAtene*, 79 (2001), 103–50. There are two attested statues, one of Eumaridas, and one of the Jewish dynast John Hyrcanus (Jos. *AJ* 14.8.5). There was no statue of the philosopher Philonides of Laodikeia, as often stated: *IG* II² 1236 (also *Inscr. Eleusis* 221), a decree of the Eumolpidai and the Kerykes, does discuss earlier honours from the

The City Eleusinion, to the south of the Agora, probably contains some honorific statues, at various points within the shrine precinct, and perhaps also to the north of the precinct;[256] many of these are private honorific monuments, dating from the fourth century BC onwards; others are the ubiquitous painted portraits set up by the *prytaneis* or the ephebes.[257]

The Akropolis,[258] though a highly politicized space filled with public dedications and public epigraphy, is adorned with honorific statues for only a few great men of the early and high Hellenistic age, such as the general Olympiodoros, liberator of the city in 286 (the exact siting of these monuments is not clear; on Olympidoros, below, 273–6). Most of the monuments come from periods later than the early or even the high Hellenistic period. Like the agora, it has received spectacular monuments (probably honorific rather than agonistic) for members of the Attalid dynasty, at the immediate entrance of the shrine, and within it: pillars topped with colossal bronze equestrian statues or chariot groups.[259] Less spectacular, but much, much more numerous, are the honorific statues for lesser benefactors, Athenians or non-Athenians, and especially for Romans, or for client kings. Some of these statues are reused Classical monuments.[260] There are also many statues set up by families for daughters who have fulfilled sacred functions. Most of these statues are probably aligned along the north side of the Parthenon.

On the south slope of the Akropolis rock, the theatre of Dionysos[261] (Plan 2) and the Odeion are the site for portraits of two types: some honour dramatic poets (such as the three great tragedians, Aiskhylos, Sophokles, and Euripides (statuefied at the initiative of Lykourgos); Menander;[262] perhaps Diodoros of Sinope, Philippides;[263] some honour statesmen (such

people of Athens, but the passage usually understood as mentioning a statue (ll. 4–6, ἐστεφάνωσεν θαλλοῦ στεφάνωι καὶ πάλιν χρυσῶι | [στεφάνωι καὶ ἔστησα]εν ἐν τῶι τεμένει τοῦ Δήμου καὶ τῶν Χαρίτων βουληθέντο[ς] | [καὶ αὐτοῦ], in U. Köhler's supplement, reproduced in *Inscr. Eleusis*) is odd (one expects e.g. [καὶ εἰκόνι χαλκῆι ἣν ἀνέθηκ]εν, or [καὶ αὐτοῦ εἰκονα χαλκῆν ἀνέθηκ]εν, which would not fit the lacuna); better [οὓς ἀνέθηκ]εν, as in Bielman, *Retour à la liberté*, no. 56—Philonides dedicated the crowns in the shrine of Demos and Charites (perhaps [ὃν ἀνέθηκ]εν, merely the gold crown dedicated?).

[256] M. M. Miles, *The City Eleusinion* (Princeton, 1998): no. 22 in her epigraphical dossier is a 1st-cent. statue for an *agonothete* of the Eleusinia. The large base, flanked by two smaller bases, in the 'storage' area, might have borne honorifics. This excavated area is probably the shrine of Triptolemos, part of the City Eleusinion (but not the main shrine of Demeter and Kore): Camp, *Athenian Agora*, 144–7.

[257] *IG* II² 1039.

[258] C. Keesling, 'Early Hellenistic Portrait Statues on the Athenian Acropolis', in von den Hoff and Schultz, *Early Hellenistic Portraiture*, 141–60; Krumeich, 'Formen der statuarischen Repräsentation'; generally, Krumeich and Witschel, *Die Akropolis von Athen*.

[259] Queyrel, *Portraits des Attalides*, 299–308; Krumeich and Witschel, 'Hellenistische Statuen', 189 n. 60, 209. I am not sure that the colossal statues of Eumenes II and Attalos (II?), which a storm damaged in Athens before the battle of Actium (31 BC) at the same time as the Attalid Gigantomachy on the south side of the Akropolis (Plutarch, *Antony* 60.2), stood next to the Gigantomachy: I follow Queyrel, *Portraits des Attalides*, 305, against e.g. A. Stewart, *Attalos, Athens and the Akropolis* (Cambridge, 2004), 323 n. 2.

[260] Shear, 'Reusing Statues'.

[261] Fittschen, 'Eine Stadt für Schaulustige'.

[262] Pappastamatakis-von Moock, 'Menander und die Tragikergruppe'. Pappastamatakis-von Moock convincingly locates the statue of Menander on the only suitable foundation, the narrow foundation ('Ziller 40') in the eastern *parodos*. This identification is confirmed by Dio 31.116, who mentions the statue of a bad poet, recently set up next to Menander: this explains the presence of a narrow block immediately to the west of the Menander, bearing not a *stele* (so Pappastamatakis-von Moock: but the narrow, deep block is not suitable for this purpose), but a statue—namely that of Q. Pompeius Capito, a Pergamene poet famed for his improvisation, as attested by a base found in front of the 'right-hand *parodos*', that is, as part of the late foundation near the western *parodos*, on the spot where the base of Menander was also found (A. Rhousopoulos, *ArchEph* (1862), 177; *IG* II² 3800). Papastamatakis-von Moock identifies the long base ('Ziller 41') next to the Menander as that of the three Tragedians; but the main source, Pausanias' account (1.21), is not a sequence, but simply a description of the most noticeable statues, and hence the three tragedians could well have stood elsewhere. That Dio berates the Athenians for setting up the statue of an indifferent poet next to Menander, but does not mention the three tragedians, argues against the identification. Hence I propose placing the tragedians on 'Ziller 36', away from the long base where Pappastamatakis-von Moock places the Menander. I further expand on this matter in a forthcoming paper in *Studi Ellenistici*.

[263] *IG* II² 648, with C. Habicht, *Untersuchungen zur politischen Geschichte Athens im 3. Jahrhundert v. Chr.* (Munich, 1979), 13–15; *IG* II² 657, with Gauthier, *Bienfaiteurs*, 80; P. Thonemann, 'The Tragic King: Demetrios Poliorketes and the City of Athens', in O. Hekster and R. Fowler (eds), *Imaginary Kings: Royal Images in the Ancient Near East, Greece and Rome* (Stuttgart, 2005), 76–7.

as Eteokles),[264] or benefactors (such as king Ariobarzanes, who helped rebuild the Odeion: above, 93). In the theatre, the statues are lined, with other dedications, along the *parodoi*, and atop the *analemmata*: a seated statue of Astydamas was set up atop the west *analemma*, as the cuttings on the surviving half of the base show.[265] To the west of the theatre, immediately below the cliff face, honorific portraits, private and public (the *prytaneis* again), adorn the Asklepieion: they probably share the space to the west of the temple with other votive offerings. On the other side of the Akropolis, the gymnasion named 'Ptolemaion' is the setting for honorific statues, and painted portraits (Paus. 1.17.2).[266] The *prytaneion* (located north-east of the Akropolis, and not to be confused with the Tholos on the agora) is also adorned with honorific portraits, starting with one of the early Hellenistic general Olympiodoros (Paus. 1.26.3); many statues may have been moved there at some point, presumably in the late Hellenistic or even Roman period.[267]

Outside the town itself, there are some honorific portraits in demes, but the gradual decline in deme life means that most such images are found in a few, prosperous settings: the Peiraieus and the *emporion*;[268] Rhamnous with its soldiers;[269] Eleusis, where monuments throng the sacred court.[270] Eleusis deserves closer attention, because of the evolution in the origin of the honorific monuments. The soldiers stationed in the Attic forts set up bronze statues in the third century, and statues decreed by the people seem only to have appeared in the very late Hellenistic period (first century); this distribution must reflect the unsuitability of the shrine, open only to initiates, as a site for publicity[271]—and increased interest and activity in the shrine in the first century.

This picture is the result of a history of honorific statues in Athens; a history which mirrors its political history, with particularities due to the combination of civic pride and repeated subordination. After the fourth century, and the rising importance of statues, especially in the Agora and especially for generals, there is an important statue moment in the early Hellenistic period, followed by a period of abatement in the third century. The pace quickens again after 229, with the liberation of the city, and honorific decrees illustrate the liveliness of the honorific statue habit in the late third and especially early second century BC. The Attalids are honoured with 'super-monuments', huge in size and extraordinarily prominent; these monuments also allude to and echo each other. In the late Hellenistic period, public decrees of the Athenian *demos* attesting honorific statues are not known; but the surviving mass of statue bases clearly shows the amplification, and normalization, of the honorific statue habit. Statues for Roman officials become frequent. After the catastrophe of the city's capture in 88, a particularity is the proliferation of painted honorific portraits by civic bodies—set up in a variety of micro-sites

[264] *IG* II² 3845.

[265] *IG* II² 3775. The statue base is currently reconstructed back '*in situ*', but I daresay the *anastylosis* looks slightly odd (the reconstruction is presented in A. Samara and C. Papastamatakis-von Moock, 'Theatro tou Dionysou: Protasi timimatikis apokatastasis tis epistepsis tou analimmatos tis distikis parodou kai tou synarmozomenou se afti vathrou tou dramatikou poiiti Astydamanta', paper delivered at the First Panhellenic Conference on *Anastylosis*, Thessaloniki, 2006). More seriously, this monument's supposed date of 340 is based on unreliable sources (gathered by Snell, *TGFr* i. 198–9), and should be rejected (see below, appendix to this chapter), with the consequence that this is a retrospective statue, not set up in 340 (as the first statue in the theatre), but in the early Hellenistic period, after the Tragedians and Menander, as suggested by H. R. Goette, 'Die Basis des Astydamas im sogennanten lykugischen Dionysos-Theater zu Athen', *Antike Kunst*, 42 (1999), 21–5.

[266] On the Ptolemaion, S. G. Miller, 'Architecture as Evidence for the Identity of the Early *Polis*', in M. H. Hansen (ed.), *Sources for the Ancient Greek City-State* (Copenhagen, 1995), 201–44.

[267] Pausanias 1.18.3–4; [Plutarch], *Moralia* 847d–e (statue of Demochares moved to the *prytaneion*).

[268] *IG* II² 212 (decree for Spartokos, statues of his ancestors on Akropolis and in Peiraieus; of Spartokos on Akropolis and in *emporion*; 347/6) *SEG* 25.112, same document *ISE* 33 (decree for Kephisodoros, statues in town and in Peiraieus, 195 BC); *IG* II² 1012 (statue of an *epimeletes* of the harbour set up by association in his *archeion*, late 2nd cent.); *IG* II² 2752 (1st-cent. statue base found in Peiraieus); Pausanias 1.1.3.

[269] *Rhamnous* 10 (earlier *SEG* 41.86).

[270] Inscriptions in *Inscr. Eleusis*; for instance, for decrees of soldiers stationed in the Attic forts, *Syll.* 485 (same document *Inscr. Eleusis* 196), *Inscr. Eleusis* 200 (perhaps), 211; *Inscr. Eleusis* 275, 276, 280, 1st-cent. statue bases.

[271] Two Akarnanian youths who strayed into the shrine were executed in 200 BC: Livy 31.14.7.

within the townscape: specific shrines, bits of the agora, particular buildings. Within this history, three spots stand out: the agora, the Akropolis, the theatre of Dionysos, probably with differentiation between the three, though the exact nuances of the increase of honorific statues in the Akropolis in the late Hellenistic period, or the distribution of statues in the theatre, still escape us.

5. SPATIAL DYNAMICS: THE CIVIC SHRINE

The shrine, obviously one of the main canonical sites for honorific statues, could also function in ways that responded to specific dynamics. In the early second century BC, the citizens of Magnesia on Maeander honoured Euphemos, son of Pausanias, the *neokoros* of Artemis, with a statue in the shrine of the hero Anax.[272] The modern findspot (in what would have been in ancient times the territory of Priene or Samos) cannot be the original site of the shrine, but suggests that the shrine lay in Mt Mykale or Thorax. This was a rural shrine, on the margins of the territory—hardly an *epiphanestatos topos*, or a site to ensure maximal publicity. Why this honorific monument in the countryside, rather than in the urban centre of Magnesia? The choice was explicitly motivated by Euphemos' piety towards the 'sacred house' of the hero, and hence comparable to other examples of the relevance of statue to services, mentioned above. But it may also have had other aims, precisely because the shrine was marginal and perhaps little frequented (for instance, only during festivals): leaving a mark of Magnesian presence on the edges of the territory, in the form of a public gesture in honour of a prominent citizen. The honorific statue performs the same role as other types of public dedication or ritual gestures in the territory of a *polis*. As always, it is too simple to see this particular case merely as a reflection of elite dominance. The services by Euphemos, passing of a decree in a mass meeting, inscription of the decree, and setting up of a statue in the peripheral shrine—all of these social transactions made visible Magnesian control of the shrine, and helped Magnesians imagine and construct their territory. When they met in this rural shrine on the edge of their territory, the honorific statue, the material embodiment of the euergetical contract that held their community together, the operation of the monument in achieving publicity in the context of the civic festival—all these things acted as reminders of who they were.

Another example of specific pressures and the dynamics of statue exposition, between town, territory, and shrine is found at Eretria. The shrine of Artemis Amarysia, where some honorific statues were set up by the Eretrians (above, 86), is located some 10 km away from the urban settlement of Eretria; however, it may have acted as the centre of the large Eretrian territory, which expanded considerably from the fourth century onwards, leaving the town on the western margin. The shrine (though not in the actual, physical centre of the Eretrias) lies on the intersection of the coastal axis, between the town and the former territories of Dystos, Zarax, and Styra (taken over by Eretria), and the north–south axis, between the two coasts of Euboia.[273] In addition, the shrine was the scene of a festival, the Artemisia, which may have gathered citizens from the whole territory, and indeed from all of Euboia. Honorific statues in the shrine of Artemis can be seen as being designed for a Euboian audience generally, and specifically for the citizens of Eretria. The shrine also served for the publication of important laws and decrees, concerning the citizen body—for instance, the early Hellenistic law against tyranny, as well as documents concerning relations between Eretria and other cities of Euboia.[274]

In contrast, as discussed earlier (24–5), the Delphians, when honouring Aiskhylos son of Antandrides, a *hieromnemon* from Eretria (and local politician), set up his statue in the town,

[272] *Inschr. Magnesia* 94, with Robert, *OMS* v. 444–7, discussing notably the findspot ('Müslim Şanlı'), the provenance, and the treatment by Hiller in *Inschr. Priene*, p. xvii.

[273] See *Guide d'Érétrie* and Knoepfler, *Décrets érétriens de proxénie*; I owe my understanding of the Eretrias to several luminous, and illuminating, visits to Eretria with P. Ducrey and S. Fachard.

[274] Knoepfler, *Décrets érétriens de proxénie*, 70, 81–2, 141.

where the statue base was found on the site of the agora.[275] The choice of site may have been in response to a specific request by the Delphians, and hence reflect the Delphians' idea of appropriateness. Nonetheless, the use of the agora for a statue set up by a foreign community contrasts with the locally decreed honorific portraits in the shrine of Artemis at Amarynthos. The contrast highlights the different audiences and effects of setting up statues in different locales—the monumental civic space of the town for diplomatic gestures and relations with other communities, the shrine in the centre of the *polis* territory for honouring good citizens and members of the civic elite. Likewise, documents concerning the citizens' internal life were inscribed in the shrine of Artemis Amarysia, but proxenies, honouring foreigners, were inscribed in the shrine of Apollo Daphnephoros, in the town. A parallel can be found in the behaviour of a subdivision of the citizen body of Mylasa, in Karia. The Otorkondeis set up an honorific portrait in the shrine of Zeus Osogo, a shrine of the wider city of Mylasa, rather than their own shrine of Zeus of the Otorkondeis where they usually had their honorific decrees inscribed: the aim was not local commemoration, but the publicity of the unusual honour of the honorific portrait.[276]

One factor for the various choices between shrine and agora may be the evolution of the general historical context. At Eretria, the statue set up by the Delphians dates to the early third century; the statues in the shrine of Artemis at Amarynthos are second-century.[277] The difference may reflect changes in the political culture of Eretria, or an evolution in the relations between the different actors (town, elites, citizens across the territory), or a shift in fashion, or emulation between members of the elite, or even practicalities such as the availability of space in different venues. It is impossible to be sure, in the absence of a complete record of honorific statues from the agora: the lack of evidence is due not only to the scanty excavation, but also to the very thorough destruction of the city's monumental cover in 86 BC.

Beyond their differences, the cases of Magnesia, Eretria, and the Otorkondeis offer insight into the way in which choice of site reflects needs, and produces meanings. Meaningful choice happens among the various resources available: space is also grammar. The exact meanings are not always clear. The multiplicity of reasons and meanings may be integral to the way in which the grammar of civic space functions, and may, indeed, be part of its attraction.

6. SPATIAL DYNAMICS: THE EPIDAURIAN ASKLEPIEION

The multiple pressures on space, and the resulting impact on experience, can be seen clearly at the Asklepieion of Epidauros (Plan 4).[278] According to G. Roux and R. Tomlinson, the first honorific portrait encountered was a huge equestrian statue, visible as soon as the road heading south from the *propylaia* cleared the crest to reach the plateau where the shrine's main buildings were located. The equestrian statue would have been placed immediately against a small temple, probably that of Aphrodite: the site, the proximity of the temple, and the isolation of the statue would doubtless have made the spot an *epiphanestatos topos*.[279] The dimensions of foundations give pause: 5.94 m long, 2.50 m across. Kavvadias had identifed this as an altar, but

[275] *SEG* 32.856.

[276] *I. Mylasa* 110.

[277] Brélaz and Schmid, 'Nouvelle dédicace', 241 n. 34 (based on palaeography; note also the rare name of the honorand in *IG* 12.9.278, Techippos, probably the father of Philippos Techippou in the decree for the gymnasiarch Theopompos, *IG* 12.9.236, as noted in *IG* by Ziebarth). I thank S. Fachard for photographs of *IG* 12.9.276 and 278.

[278] There still is no complete, up-to-date study of the bases of the Asklepieion in their places and their context; neither *IG* 4² 1 nor W. Peek's revisions give indications in *Inschriften aus dem Asklepieion von Epidauros* (Berlin, 1969) and *Neue Inschriften aus Epidauros* (Berlin, 1972). P. Kavvadias, *Fouilles d'Epidaure* (Athens, 1891); *To hieron tou Asklepiou en Epidavro kai i Therapeia tou Asthenon* (Athens, 1900); F. Robert, *Épidaure* (Paris, 1935), has nothing; G. Roux, *L'Architecture de l'Argolide aux IVe et IIIe siècles avant J.-C.*, 2 vols (Paris, 1961); R. Tomlinson, *Epidauros* (St Albans and London, 1983) is the most useful; von Thüngen, *Exedra*, has located all the exedras (and only the exedras), but distributes them throughout her work according to typology.

[279] Roux, *L'Architecture de l'Argolide*, 240–3.

the location is unsuitable; hence Roux's 'colossal equestrian statue'. But the dimensions are unparalleled and unlikely to be those of an equestrian monument. The exact nature of the monument must remain unclear: a monumental (non-honorific) votive? I suggest that the foundation marks the site of a small chapel to Themis, which would explain what seems to be a mention of a 'shrine of Aphrodite and Themis' in Pausanias.

All the bases for honorific statues (securely identifiable as such) are coherently organized across the shrine. The row of six exedras, cutting across the central open space, are indubitably from honorific monuments (even though they have been reused, and hence the exact nature and original date are confused: see further Chap. 4). The exedras trace lines of circulation within this space, and specifically allow us to follow a looping path, branching off the straight north–south road from the *propylaia*, and leading to a Y-division of ways just south of the fifth exedra, where there is a gap before the next exedra. One path continued eastwards, along the esplanade of the north stoa (probably the stoa of Kotys mentioned by Pausanias), two fountains, and the shrine of the Epidotes—all facing southwards, onto the path.[280] The other path continued due south, aligned with the altar of Asklepios.

The east–west axis between the altar and the temple was lined with statues, on the north face of 'building E'; they defined the southern edge of the central space. The front of the temple itself was thickly occupied by statues, on either side of the ramp leading into the building. Further statues lined the south side of the temple, along the path which led to the Tholos; a few statues stood on the southern edge of this space. There are no statue bases on the north side of the temple, in the narrow space between the temple and the Abaton, the portico where pilgrims could spend the night in ritual and healing sleep. Nor are there statues in front of the Abaton or its addition, in the parts which extended to the west of the temple: this space, to the rear of the temple and in front of the sleeping hall, was kept uncluttered, since it was used for healing rituals. The entrance ramp of the Tholos was flanked by statues, looking east. The statue bases now located to the north of the modern path between the temple and the theatre, across from the north side of 'building E', are not *in situ* (this includes an important statue, that of Antigonos Gonatas, set up by the Epidaurians).[281] Finally, there are remains of a few bases, perhaps for statues (but in some cases clearly for dedications) by the small temple of Artemis.

The remains of honorific monuments allow us to reconstruct circulation, from the *propylaia* to the Tholos; to imagine a pilgrim, viewing the shrine, branching off to the fountains, retracing his steps to the Y-intersection and moving towards the altar, attending sacrifice, visiting the Tholos, where famous, virtuoso paintings were dedicated. Statues also constructed spaces: the inner ring-path defined by the exedras, within the broader, rectangular space of the north–south road and the stoa of Kotys; the esplanade between the temple and the altar; the piazza in front of the Tholos. Movement within the shrine might have been experienced as transition from one space to another. More generally, the statues shaped experience in this shrine (Fig. 3.3), just as honorific statues constructed the meanings of the agoras of the cities: by the late second century BC, the scale and adornment of monumental architecture were preceded, wherever the visitor looked, by the immediacy of the 'forest of statues', whose impact it is perhaps easy to under-estimate, and which should not be erased from our picture (as on the modern plans exhibited at the site of the Asklepieion). The profusion of statues, and their participation in the construction of sanctuary space, makes it difficult to identify any single *epiphanestatos topos*.

7. FROM SPATIAL GRAMMAR TO SPATIAL DISCOURSES

The case of the Epidaurian Asklepieion, or the surveys of cityscapes such as Priene—dissected, then quickly reassembled in our gaze—are exercises in mapping out statues on to landscapes;

[280] Roux, *L'Architecture de l'Argolide*, 294, on the esplanade in front of the portico, as defined by Hellenistic drains; generally, Chap. 9.

[281] *IG* 4² 1.589. The statue clearly does not lie on its original stylobate; it was reused, on its rear face, for a statue of Hadrian.

they move from the catalogue of different types or examples of *Aufstellungsort* to a realization that honorific statues are, in turn, a form of mapping of *polis* space, urban and rural. The impact of this mapping is political: the presence, in physical, monumental, undeniable form, of the outcome of civic narratives of exchange and communitarian devotion, across a whole range of spaces; the equation and subsuming of these spaces, profane and sacred, within an overarching model of public space, under the control of the community in institutionalized forms. Honorific statues recognized, but also enacted, this public control over public space.

And yet, the move from a typology of sites to a grammar and a syntax of spaces also leads to the study of social space as discourse (to continue the, perhaps increasingly unsatisfactory, linguistic metaphor that was proposed heuristically at the start of this chapter). Choices took place within the various meaningful *epiphanestatoi topoi* of the *polis* landscape; looking at lived-in test cases, or examples of dynamics of work, raises the question of agency: did those who made these choices only wish to comply with the controlled narratives imposed by the city? In the following chapter, I wish to look beyond these narratives to the possibility for competition within civic space. This will lead to an 'ecological' approach to the *epiphanestatoi topoi* and the actors within them: statues, dedicators, audiences—'ecology' is a further metaphor, developed extensively to help understand historical processes in the evolution of the post-Classical *polis*— and a revision of what we can mean by 'the civic'.

APPENDIX: THE STATUE OF ASTYDAMAS IN THE THEATRE OF DIONYSOS AT ATHENS

The attribution of this statue to 340 BC in insecure, and the sources problematic.[282] The first is a polemical anti-Athenian sentiment in Diogenes Laertius, 2.5.43; from the construction of the sentence, it is not at all clear that the information that the Athenians set up a statue of Astydamas before one of Aiskhylos should be attributed to Herakleides Pontikos (fr. 169 Wehrli; but why not Herakleides Lembos?), rather than to Diogenes Laertius himself. The second source is an anecdote concerning a boastful epigram supposedly written by Astydamas for his publicly decreed statue in the theatre voted to him, and rejected by the *boule*, whence a jeering reference in Philemon (fr. 190 Kock); the comic line is the peg for the anecdote and the epigram, as quoted, e.g. in Photius 502.21 or Suda s.v. σαυτήν—the source is the Atticist lexicographer Pausanias; H. Erbse, *Untersuchungen zu den attizistischen Lexika* (Berlin, 1950), 208 σ 6. This sort of pseudo-biographical information is notoriously unreliable, as shown by M. Lefkowitz, *The Lives of the Greek Poets* (London, 1981).

The consequence is that the statue of Astydamas cannot be dated unproblematically to 340 BC, before the statues of the three tragedians and the statue of Menander; it might have been set up after them. The question should be left open.

[282] H. R. Goette, 'Die Basis des Astydamas'; M. Sève, *BE* 00, 106. The note in *ArchRep* (2005–6), 3, on an inscribed base for Astydamas, seems confused (do they report the finding of e.g. a Roman-era epigram on Astydamas?). I thank V. Azoulay for this reference.

FOUR

Statues in their Places

Certes, la ville ne s'offre pas comme une fleur qui ignore sa beauté. Des gens, des groupes bien définis l'ont 'composée'. Pourtant, elle n'a rien d'intentionnel, comme un 'objet d'art'... En quoi consistaient les cathédrales? En actes politiques. Les statues immortalisaient un disparu et l'empêchaient de nuire aux vivants... Peut-être l'espace naquit-il à la manière des plantes et des fleurs, dans les jardins, c'est-à-dire d'œuvre de nature, uniques bien que travaillées par des gens très civilisés?...

(Henri Lefebvre.[1])

After the roster of *spaces* offered in the previous chapter, I look at statues on the ground: how they were organized (isolated, collocated, in series), and what the impact of these configurations might have been. Statues can thus be viewed in *places*, locales affected by human events, actors, and investment. The main findings are the importance of serialization as a way of controlling display (in parallel to the control exercised by public writing, analysed in Part I); but also the unmistakable importance of competitiveness between the various actors involved in spatializing; the segmentation of public space into micro-places; the necessity for the 'public actor' itself, the *polis*, to involve itself in competitive spatial processes.

I. STATUESCAPES IN PRACTICE

Where did the civic communities set up their honorific portraits? In the previous chapter, the question was met by a list of *Aufstellungsorten* (to use the convenient German term for 'setting-up-spots'): agora, urban shrine, rural shrine, theatre, gymnasion, pan-Hellenic shrine—a list that establishes a roster of possibilities, which I also proposed to call a 'grammar'. By this term, I designate the different locales, with different meanings and shapes, within which the community can choose appropriate sites. The Erythraians gave Maussollos a bronze statue in the agora, Artemisia a marble statue in the shrine of Athena.[2] In early first-century Messene, one Aristokles, having served well in his capacity as the secretary of the *sunedroi* (councillors) during the collection of a special Roman-imposed tax, was honoured with a bronze statue in front of the official rooms of the council secretary, no doubt in the agora. The statue was captioned with an inscription making the point clear: 'The city (has dedicated) Aristokles son of Kallikrates, serving as secretary to the *sunedroi*, for his goodness and the goodwill which he continuously shows towards it.'[3] In Augustan Sardeis, the benefactor Menogenes was honored with a statue in the agora, but his son Isidoros was honoured with a statue ἐν τῷ παιδικῷ, in

[1] *La Production de l'espace* (Paris, 1974), 90–1. 'For sure, the city does not offer itself like a flower which is unmindful of its own beauty. People, well defined groups have 'composed' it. Yet it is not the product of intention, like an 'art object' is.... What were the cathedrals about? Political acts. Statues immortalized a dead man and kept him from harming the living. Perhaps space was born like plants and flowers are born in gardens, in the manner of natural works, unique, albeit crafted by very civilized people?'

[2] *I. Erythrai* 8.

[3] *ISE* iii. 136. The statue was proposed by the council in its preliminary resolution; the people, in assembly, added two more painted portraits.

the school.[4] Another way to express this phenomenon is that groups set up statues in places that are available for their monumental gestures—civic subdivisions use their shrines, priestly groups use temples, *neoi* use the gymnasion, and the city uses a whole roster of spaces.

Where within these spaces? As we saw earlier, the decrees offer an immediate answer: in the *epiphanestatoi topoi*, the most visible spots. The city of Dionysopolis set up a statue of Akornion, a great benefactor, in the most visible spot of the agora, or rather allowed him to set up his own statue (decreed by the people).[5] But where, in fact, did the civic communities of the Hellenistic world set up their honorific portraits, and why? The previous chapter has offered glimpses of how complicated the notion of 'most prominent' spot actually is, a moving target—as shown by the example of the Lower Gymnasion at Pergamon in the time of Diodoros Pasparos. Where (again) were these *epiphanestatoi topoi*, on the ground? A commission of Oropians was appointed to decide on the site of the honorific statues voted in honour of two benefactors, father and son, and to be set up in the Amphiaraion: but where, exactly, in the space of the shrine?[6] The answers to such questions take us away from 'typology' (as in the previous chapter) to a political *topology* of honours involving community, individuals, memory.

The sources are epigraphical (the decrees which mention where statues are to go) and also the archaeology which I often mentioned in the previous chapter, but eschewed to examine in detail, and which will form the heart of the present chapter. The remains of statue bases, sometimes well preserved, sometimes reduced to foundations or *euthynteria*, are highly suggestive for the relations between statues, both chronological and visual, and more generally for ways of looking at statue behaviour in actual social spaces. In some cases, the answers are obvious: the density of statue bases on the ground, or on a site plan, suggests prominent spots. The western end of the agora of Priene, near the intersection of the West Gate Street and the stairway leading to the shrine of Athena, was an important *lieu de passage* (Plan 13). Likewise, the spot immediately east of the *bouleuterion* at Dodona was the point of contact between the sacred space of the esplanade and road in front of the temples, and the civic buildings (*bouleuterion*, *prytaneion*, and further on the theatre); it also lay at the intersection between the (roughly) east–west road between the sacred and the civic areas and the access way from the south-west entrance into the enclosure of the shrine (Plan 7). In Kaunos, the zone where a street from the hillside opened on to the agora and harbour was obviously a frequented and important spot in the urban layout, and hence attracted important statues, including a statue of Rome set up by the community. Another case where prominence can be seen archaeologically is the set of bases at the Amphiaraion at Oropos (Plan 3): the Oropians, in the first century BC, reused the statues by rededicating them to important Romans, and the chronological order reflects the choice of the most spectacular statue available each time a monument was rededicated. Thus the statue rededicated to Sulla (*Oropos* 443), occupying a solitary spot next to the temple, was the most prominent of the series, and the first to be rededicated; the next most prominent must have been C. Scribonius Curio (*Oropos* 444), and so on.

Yet not all statues were in such prominent spots. Where did the other honorific statues go? What decided the choice of such spots? Even if detailed answers are rarely available, these questions determine the workings of shared spaces. The following paragraphs attempt a 'topo-analysis'[7] of the spaces within which honorific statues took place, and which they contributed to shaping.

Often, modern plans of Hellenistic city centres or shrines, as drawn up by students of ancient architecture or urbanism, do not include the confusing and rich presence of honorific monuments. The panel set up in front of the remains of the temple of Asklepios near Epidauros

[4] *Sardis* 8 XI.
[5] *Syll.* 762, also *IG Bulg* I² 13.
[6] *Oropos* 294 (2nd half of the 2nd cent.). The emplacement of the two statues is not known.
[7] The term is inspired by G. Bachelard's famous essay on *La Poétique de l'espace* (Paris, 1957), but does not follow Bachelard's reliance on phenomenology and psychoanalysis.

presents modern visitors with an image of temple and shrine in their original isolation; the visitor need only lift her eyes to see the clutter of statue and dedication bases in front of the temple (Chap. 3, 108–9; Fig. 3.3). It is a mistake to consider such monuments as incidental to shared space, public and sacred: they were a crucial part of how such spaces were experienced (and hence part of the way in which they were lived as places), and their presence represented a reflection of civic history—which it is my purpose to explore in this chapter, in its concrete processes of competition and collaboration (to use an ecological metaphor, which will recur throughout this chapter), and of sedimentation (to use a geological metaphor to describe the cultural processes at work in the cityscape; the concept will be revisited in the conclusion to this chapter).

In other words, to look for the answer to 'where did cities set up honorific statues?' on the ground entails looking past civic discourse, with its assumptions of all-encompassing group narratives, ubiquitous ideological valence, and practical control—assumptions present in the decrees and the short inscriptions on statue bases. The method is archaeological—first, in the sense of relying on the record of traces left by statue behaviour, or 'statue events', in actual sites, in the form of 'horizontal stratigraphies'; secondly, in the sense of laying bare things that lie under the surface, in the search for choices by actors in specific situations. Yet this 'archaeology' of honorific statues also leads to more general points—about organizational principles, about individuals and families pursuing agendas, about the power of space itself to shape the human behaviour of individuals, groups, and communities. The consequences of this shift in gaze, and the subsequent findings and insights open up the possibility of a history of the *polis* that resembles, and draws from, recent considerations of place within urban histories; a history in which our conceptions of the civic is richer than simple reaffirmations of the strength and success of communitarian ideology.[8]

2. ON THE GROUND: PRINCIPLES OF ORGANIZATION

Epiphanestatoi topoi? Honorific statues have to go somewhere, occupy some space. Concretely, they can be seen to be organized in three ways—they can be isolated, through various strategies, and hence given extreme prominence; they can be deliberately located in significant proximity to another statue, for instance a cult-statue or another honorific monument; and they can be regrouped by clusters or in long series. Each of these ways has different impacts and meanings, and also works differently for sacred and non-sacred spaces. I propose to illustrate them with examples, drawn from the different types of sources (as always, the record is patchy and problematic), and to offer some thoughts on viewing and experience.

a. Isolation

In Hellenistic Athens, there was a prohibition on setting up honorific statues next to the famous early Classical pair of bronze statues, representing Harmodios and Aristogeiton, the tyrannicides: the original 'honorific statues', or at least amongst the earliest examples. The exact site of the Tyrannicide group is unknown, but, as mentioned earlier, it was probably located in the northern part of the Athenian Agora, within the open space defined by the convergence of the Panathenaic Way and the north–south road on the western side of the agora (Plan 1).[9] The central location in an open space of the agora created isolation, visibility, and prominence, all of which were maintained by the prohibition. These features served to emphasize (and were reinforced by) the character of the group: violent movement forward, dynamic invitation to

[8] A re-evaluation of civic ideologies in operation is offered by Gray, *Exile*.

[9] Wycherley, *Literary and Epigraphical Testimonia*, 93–8, for the evidence. The trouble is that the Augustan buildings (Odeion of Agrippa, re-erected temple of Ares) must have shifted many honorific statues from their original site.

Fig. 4.1. The earliest honorific
statues, whose movement engaged
the viewer to imitation, or warned the
viewer against despotic impulses:
the Tyrannicides in the Athenian
Agora. Roman copy, marble, of
original bronze group by Kritios and
Nesiotes (477/476 BC). National
Archaeological Museum, Naples.
Photo German Archaeological
Institute, Rome, neg. 58.1789.

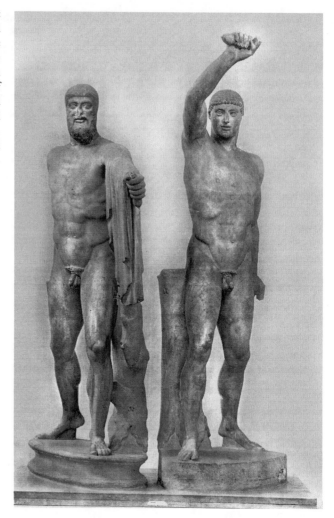

multiple angles of viewing, which created civic meanings such as anti-tyrannical reflexes, imitative urges, admiring contemplation (Fig. 4.1).[10]

These meanings emerge from isolation and centrality; this spatial strategy was much in favour. In the agora of Thasos, the statue of the famous athlete Theagenes may have occupied a prominent, isolated place, on a large, tall round base (Plan 9); rather than an original fifth- or fourth-century monument, this may be a Hellenistic relocation of an old statue, transformed into a cultic ensemble (the round base has an iron ring to hold sacrificial victims).[11] Even more impressive was the colossal statue of Augustus set up in Pergamon by the *demos* and the resident Romans, on the round base (once an Attalid votive base) in the middle of the shrine of Athena, towering above the shrine, its porticoes decked out with artworks and the Attalid victory dedications.[12] At Delos, the centre of the 'tetragonal agora' was occupied by a group of exedras bearing honorific statues—these date to the period of Delian independence, when such

[10] B. Fehr, *Les Tyrannoctones, peut-on élever un monument à la démocratie* (French tr. Paris, 1989, orig. Frankfurt, 1984).

[11] *Guide de Thasos*, 71–6, summarizing the debate about the nature of the monument. Illuminating insights about the statue of Theagenes are offered by V. Azoulay in 'The Statues of Theogenes of Thasos: Glory and Outrage' (Vernant Lecture, Oxford, 14 Feb. 2012).

[12] *Inschr. Pergamon* 383; F. Felten, 'Römische Machthaber', 119. I remain slightly dubious about the reconstruction.

monuments were extremely rare, which helps explain the highly visible spot granted to the honorands (Plan 8).[13] Later, in 126/125, the statue of the *epimeletes* (governor) Theophrastos was set up in the middle of the agora which he had built.[14] In the Oropian Amphiaraion (Plan 3), the great early Hellenistic equestrian monument, later dedicated to Agrippa, probably stood alone, at the time when it was set up, perpendicular to the route joining the theatre and the shrine, and surrounded by empty expanses.[15] All these examples illustrate how centrality structures and hierarchizes a given space, by giving it a focal point for gazes from all directions, and for movement in the space, now converted to movement *around*: modern examples are the Michaelangelo-remodelled Campidoglio in Rome, or the entrance court of the palace at Versailles; ceremonial use of space often resorts to centrality.

There were other strategies available to give honorific monuments isolation and prominence, apart from centrality. Honorific monuments could be located on the edge of spaces, for instance in front of porticoes, in centred (rather than central) positions. In the Athenian Agora, the statue of Attalos II stood in front of the stoa he offered to the Athenians;[16] similarly, equestrian statues, such as that of the Seleukid officer Larichos, occupied prominent and isolated spots in front of the stoa on the west of the agora at Priene (Plan 13),[17] and a single large honorific statue was set up, centred, in front of the northern stoa in the court of the late Hellenistic Lower Gymnasion in the same city (Plan 16).[18] In Thasos, an impressive late Hellenistic honorific monument in the form of a portrait statue atop a base in the shape of a ship prow, framed by a *pi*-shaped enclosure, held a prominent place on the north-east edge of the agora, looking down a stretch of open space (Plan 9).[19] A different strategy is adopted on Delos for the statue of Admetos, son of Bokros (Plan 8): the Delians, asked to grant the finest spot (βέλτιστον) for this monument, chose to locate it immediately against a stretch of the shrine's wall, and facing the *Neorion* (the so-called 'Monument des Taureaux'): the long bulk of this peculiar monument led the visitor to an empty space, framed by two important altars, where the statue of Admetos stood, in front of a bare wall. In these cases, the position of the statue converted a stoa, or a stretch of architecture, into the frame or the backdrop for an honorific monument, when viewed head-on, emphasizing the monument's importance.

The occupation of liminal, watershed sites represented another strategy of prominence. An honorific statue could be placed at the entrance of a temple or sacred enclosure, like the statue of Megabyxos, placed 'before the *metopion*' of the temple of Athena at Priene, between the temple and the altar,[20] or the equestrian statue (later reused for Sulla) close to the temple at the Amphiaraion (Plan 3), or the monument in honour of an Attalid at the entrance of the Athenian Akropolis (later reused for Agrippa),[21] or perhaps the statue (or the dedication?) at the entrance of the temple of Zeus Agoraios in the agora of Thasos (Plan 9).[22] Particularly

[13] *Guide de Délos*, 84, *IG* 11.4.1080–3, with C. Vial, *Délos indépendante (314–167 avant J.-C.)* (Paris, 1984), Stemma XII); von Thüngen, *Exedra*, 123.

[14] *ID* 1645; L. Mercuri, 'L'agora di Teofrasto'.

[15] This equestrian statue (one of the earliest in the series of honorific statues in the Amphiaraion) is earlier than either of its neighbours: the base of the statue of Hadeia, *c*.285, to its left, rests on the *euthynteria* of the equestrian monument (Ma, 'Oropos (and Elsewhere)'), and the proxeny decree carved on the right face of the equestrian monument shows that it is earlier than the equestrian monument on that side.

[16] H. A. Thompson, 'Excavations in the Athenian Agora: 1949', *Hesperia*, 19 (1950), 317–18; above, 104.

[17] *Inschr. Priene* 18, and the foundations of the 'western' series (above, 98–9). I suspect the equestrian base in front of the north-west stoa in the agora at Thasos belonged to an originally isolated, 'centred' monument.

[18] Krischen, 'Gymnasion von Priene'.

[19] *Guide de Thasos²*, 37.

[20] *Inschr. Priene* 3.

[21] Above, 75; also 117.

[22] *Guide de Thasos2*; also J.-Y. Marc, 'La Ville de Thasos de la basse époque hellénistique à l'époque impériale' (Ph.D. thesis, Paris-I, 1994), 36–9 (two bases in front of the temple; one small base in front of the entrance to the round enclosure next to the shrine of Zeus Agoraios). The large base in front of the temple of Dionysos near the theatre at Eretria, might also be another example (Knoepfler, *Décrets érétriens de proxénie*, no. VII); the solitary 2nd-cent. (or later) base at the south-west corner of the Athenian *bouleuterion*, in the 'square' south of the chamber, might belong to an honorific statue placed at the entrance to the porch (Thompson, 'West Side of the Agora', 169–70).

instructive is the case of the statue of Antiochos, the son of Antiochos III, whose statue was set up by a Seleukid Friend or courtier in Klaros, immediately to the south of the temple of Apollo, the last thing a person saw before actually standing in the sacred space in front of the temple (used notably for sacrifices), and the first thing he or she saw when leaving this sacred esplanade before the temple (Plan 17).[23] A later example is the large chariot group set up at the north-east angle of the Augustan-era Odeion in the Athenian Agora, at the edge of the monument, in contact with the Panathenaic Way (the impact of the monument was reinforced by the fountain in the base, which attracted attention by the contrast of movement and immobility, and perhaps made passersby stop or pause at the flowing water).[24] In these cases, the honorific monument gained its prominence from the experience of encounter, during the transition from one type of space to another, exploiting the viewer's concentration and focus, his gathering feeling of change in the nature of the space he found himself in.

Yet another strategy was the 'crowding' of space: by virtue of size or charisma, honorific portraits, sculpted or painted, could take over enclosed areas such as the *cella* of a temple, public rooms such as the *prytaneion* or the *bouleuterion*, or rooms in shared buildings such as 'one of the rooms of the tetragonal agora, in the east stoa, namely the room between the office of the *timetai* and the *agoranomion*' in Kyzikos (where the portrait of the benefactress Apollonis was set up), various rooms in the gymnasion (see previous chapter), or the meeting room of an association.[25] In the shrine on top of the Kynthos, on Delos, a small room (or perhaps esplanade) was dominated by a statue of Ptolemy X.[26] The effect might have been to overwhelm the viewer upon his entrance in a given enclosed space, at the moment, more or less prolonged, of his confrontation with the uncanny lifelike mineral or metal object, shaped through the *plus-value* of art and technique to look like a person wearing stereotypical and significant clothing and attributes, on a unlifelike pedestal—or with the intense frontal liquid gaze coming out of a flat painted board, which surviving private portraits might help us imagine (below, Chap. 8). This strategy of 'overwhelming the viewer' was also applied in rooms reserved for the imperial cult (as at Boubon, or in the recently excavated Sebasteion at Kalindoia in central Chalkidike),[27] a phenomenon which testifies to the impact which 'crowding' strategies could have.

Finally, simple Gombrichian metaphors of worth could be exploited to achieve prominence. One example is the use of gold (in the form of foil early in the Hellenistic period, and later of gold leaf), for instance on the equestrian statue, probably for an Antigonid, whose remains were found in a well in the Athenian Agora after the statue was thrown down it, or on statues of late Hellenistic benefactors (Menippos of Kolophon, Diodoros Pasparos, and many others).[28] The use of this technique, originally reserved for divine images, and deploying a material with divine connotations, gave the statue prominence amongst its architectural and sculptural environment. 'Shiny = valuable'; another such metaphor could be articulated as

[23] On Klaros, Ferrary and Verger, 'Contribution à l'histoire du sanctuaire de Claros'. The statue of Sulla placed at the entrance of a stoa on the terrace of the shrine of Apollo at Kaunos may have worked the same way, but it is hard to judge without a plan, or autopsy: *Inschr. Kaunos* 106 (with photograph of base and description of emplacement).

[24] H. A. Thompson, 'The Odeion in the Athenian Agora', *Hesperia*, 19 (1950), 70–2 ('a chariot group which would have been shown to splendid advantage rising against the front of the Odeion in clear view of those coming up the Panathenaic Way') and pl. 17.

[25] *Prytaneion*: Ptolemais in Upper Egypt, Michel 1017. *Agoranomion*: SEG 28.953, ll. 64–6; also Paros, *IG* 12.5.129. In the 1st cent. AD, three honorific statues (for a man, his wife, and her brother) may have been set up on a single big base in an 'exedra' in the agora of Thera: C. Sigalas, 'Peri tou en Thira vathrou tis Chairopoleias', *ArchDelt* 26/1 (1971) 194–200, completing *IG* 12.3.522 (whence SEG 26.943–5).

[26] *ID* 1532, with A. Plassart, *Les Sanctuaires et les cultes du Mont Cynthe* (Paris, 1928), 107–8 (the statue was privately set up by an Alexandrian Friend of the king).

[27] C. Kokkinia (ed.), *Boubon: The Inscriptions and Archaeological Remains* (Athens, 2008), 6–12; K. Sismanides and P. Adam-Veleni (eds), *Kalindoia: An Ancient City in Macedonia* (Thessaloniki, 2008), 123–31.

[28] R. Krumeich, 'Human Achievement and Divine Favour: The Religious Context of Early Hellenistic Portraiture', in von den Hoff and Schultz, *Early Hellenistic Portraiture*, 167–9; below, 149, 253.

Fig. 4.2. The Attalid monuments in Athens can be considered 'super-monuments', achieving super-visibility by their location. View of the Agora and Akropolis; the huge pillar before the entrance bore an Attalid chariot monument.

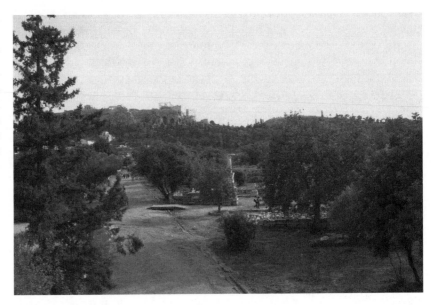

'high is mighty':[29] honorific statues could be placed on bases with an exaggerated vertical axis. The gilt statues of Menippos and Diodoros Pasparos, were set up on columns (Fig. 2.3); Attalid rulers were set up on superlatively high pilasters in Delphi and in Athens. The pilaster at the entrance of the Akropolis was probably very prominent in ancient Athens (though perhaps not always as clearly seen as it is in the modern city, Fig. 4.2); the statue it bore must have been very visible as a silhouette detached from the mass of the *propylaia* and the even greater mass of the Parthenon itself. Pilasters (basically massively heightened bases, as their details show), and columns (borrowed from, and alluding to, the architectural context, but also descended from the Archaic votive-dedicatory column) literally allowed honorific statues to stand out, above the world of viewers, who had to look up at the images of honorands.[30] A particularly striking example comes from Mylasa. In the late first century BC (or early first century AD), the city honoured one Menandros, 'benefactor of his fatherland and descendant of benefactors' with a statue on top of a column; this monument was located in the centre of a large complex, in fact an unfinished Hekatomnid monument which dominated a huge terrace. The monument hence conjugated two strategies of eminence—isolation and elevation—with a meaningful prestigious site.[31]

All these strategies differ in their details and workings, but share the common aim of achieving prominence for honorific statues, and creating true *epiphanestatoi topoi*. Space, viewing, and experience were manipulated, to create 'by-itselfness' for statues: what were the meaning and impact of metaphors for uniqueness? The first consequence was to interact with the viewer's knowledge: if he knew who the honorand on top of the central base (or the liminal base, or the dominant base, or the tall base) was, he had to acknowledge the considerable value

[29] H. Lefebvre, *La Production de l'espace* (Paris, 1974), 117, on the arrogance and violence of verticality (in the case of state architecture).

[30] Pliny, *NH* 34.27: *columnarum ratio erat attoli super ceteros mortales*, 'the point of columns was to elevate men above other mortals'. At Thermon, two 'prismatic' bases stood in front of the western stoa, one perhaps bearing the statue of a general (decorated with shields): A. K. Rhomaios, 'Anaskaphi en Thermo', *Praktika* (1931), 61–70; at Samothrake, the Macedonians honoured Philip V with a statue on a column: Kotsidu, Τιμὴ καὶ δόξα, no. 187. On columns, M. Jordan-Ruwe, *Das Säulenmonument* (Bonn 1995), to which add e.g. the monuments for Menippos and Polemaios at Klaros; Jacquemin, *Offrandes monumentales*, 131–8, on the form at Delphi.

[31] *I. Mylasa* 402 with F. Rumscheid, 'Maussollos and the "Uzun Kaya" in Mylasa', in R. van Bremen and J.-M. Carbon (eds), *Hellenistic Karia* (Bordeaux, 2010), 69–102.

and honour which was attributed to the honorand. If the viewer did not know the honorand, the prominence of the base primed his expectations, by emphasizing the honorand's 'obvious' worth. The impact could be varied. Prominence could express the honorand's exemplarity, and hence convert its setting into a representational space,[32] which symbolized civic values—this is the case of the Tyrannicides in the Athenian Agora, and perhaps of the Delians honoured in the 'tetragonal agora'. The force of prominence and isolation is paradigmatic: the statue expresses the civic ideology of goodness and recognition which was also embodied in the inscription (Chaps. 1–2). But another way prominence worked was by structuring space around the honorand, with the all too easy result of converting the idealism of the honorific monument into an expression of homage and hierarchy (the 'Versailles' effect): strategies of prominence are much used for royal honorands, and for the late Hellenistic benefactors who in many ways succeeded the kings. Civic paradigm or the homage of subjects? The distinction is of course too clear-cut, and the ambiguous balance (for instance in the case of the statue of a royal benefactor) is inseparable from the very nature of the honorific monument, and of civic honours in general.

Isolation (to focus on the most important strategy of prominence) might give the impression that it is a result, as well as an acknowledgement, of the statue's (and the honorand's) eminence, a 'forcefield' surrounding the statue: the Tyrannicides in the Athenian Agora, untouchable in their isolation, or the 'naval' monument in the agora of Thasos, facing onto an open 'aisle' from one end of the piazza to the other, a space where any passerby could see the metal statue on top of a stone prow bearing down at him. But this isolation is in fact the result of a human decision—as made clear by the decrees forbidding honorific statues to be set next to the Tyrannicides: there was no inherent physical property in the Tyrannicides group that would prevent the Athenians from setting statues next to them if they had wanted—which, indeed, happened twice (below). This occurrence reflects another phenomenon: the way in which the very isolation and prominence of certain statues made them very attractive to other statues.

b. Proximity

Statues attracted statues; honorific statues were set up next to other statues, be they honorific monuments or cult-statues. During two periods of Athenian history, honorific statues were set up next to the Tyrannicides in the Agora: between 306 and 200, statues of those other 'liberators' and 'saviours', Antigonos Monophthalmos and Demetrios Poliorketes; for a few months in 43, statues of those other tyrannicides, Brutus and Cassius.[33] In the Agora, there were other, more permanent cases of meaningful collocation. In the aftermath of the battle of Knidos (394), statues of Konon and Evagoras were set up next to the statue of Zeus Eleutherios, between the wings of the stoa of that god.[34] Perhaps in 302 (or in the 290s?), an equestrian statue of Demetrios Poliorketes was set up by an Athenian elite corps which had fought with him: the site chosen was next to a statue of Demokratia.[35]

Analogously, outside Athens, in Histria, the good citizen Dionysios, son of Strouthion, was honoured with a bronze statue in the agora, to be set up next to (the no doubt colossal statue of) Demos and the *eikones* (set up around it).[36] In Akraiphia, the posthumous equestrian statue

[32] On this concept, J. J. Czaplica, B. A. Ruble, and L. Crabtree (eds), *Composing Urban History and the Constitution of Civic Identities* (Washington, DC, 2003).

[33] Above, 104.

[34] Wycherley, *Literary and Epigraphical Testimonia*, 213; *RO* 11. Thompson, 'West Side of the Agora', 56–9, 68: large round foundation for cult-statue of Zeus, Konon, and Evagoras north of Zeus; Oliver, 'Space and the Visualization of Power'; Krumeich and Witschel, 'Hellenistische Statuen', 178.

[35] *ISE* 7; T. M. Brogan, 'Liberation Honors: Athenian Monuments from Antigonid Victories in their Immediate and Broader Contexts', in Pelagia and Tracy, *Macedonians in Athens*, 194–205 (suggesting the equestrian statue might have stood in front of the Stoa Poikile).

[36] *ISE* 128 (mid-3rd cent. BC): [στῆ]σαι δὲ αὐτοῦ καὶ εἰκόνα χαλκῆ[ν ἐν τῆι ἀγο]ρᾶι παρὰ τὸν Δῆμον καὶ τὰς εἰκόν[ας τὰς παρεστώσας αὐ]τῶ[ι], with *BE* 63, 169 and 66, 273, restoring statues surrounding the statues of Demos.

of a heroic cavalry commander, Eugnotos, was set up next to the cult-statue of Zeus Soter (named in the epigram on the base), no doubt an important focal point of the agora.[37] The locally settled Friend of the Seleukid rulers, Larichos, was meant to be honoured with a statue next to his royal masters in the shrine of Athena in Priene;[38] another Seleukid courtier Z/Menodotos was honoured, in Athens, with a statue next to his king, Antiochos VII.[39] The statue of Admetos son of Bokros, mentioned above, could also be considered a case of collocation: the statue was located close to, and in dialogue with, the *Neorion*, a spectacular votive set up by a Macedonian king (probably Demetrios Poliorketes rather than Antigonos Gonatas), and this setting was appropriate for Admetos, the Macedonian from Thessalonike.

The collocation of statues was a widespread phenomenon in the ancient landscape; ancient communities decided on it, and ancient viewers registered it. Collocation is mentioned by literary sources, such as the Hellenistic political narrative of Polybios,[40] the Roman-era biographer Plutarch,[41] or Pausanias' descriptions (for instance his account of statues at Olympia).[42] Archaeologically, it is observable in foundations and surviving lower courses of bases, placed in close proximity to others. In the Amphiaraion, the isolated early Hellenistic equestrian (reused centuries later for Agrippa) was soon joined by the statue set up by Lysimachos for his sister-in-law Hadeia: the statue stood so close to its equestrian neighbour that its own first course rested on the equestrian base's *euthynteria* (Fig. 4.3). Since this occurs very early on, it cannot be explained as the result of crowding in the row of statues that only appeared later on the Amphiaraion esplanade (see below).

In many of these cases, collocation was meaningful. Physical proximity acted as a metaphor for abstract relationship. The content of this relationship varied. It could express simple alikeness, as in the case of the honorific statues set up next to the Tyrannicides in Athens, or next to Alexander in Olympia.[43] In other cases, the relation was more complex. What was

Fig. 4.3. Statues tread on the toes of other statues, showing both the sequence in which they were set up, but also the phenomenon of jostling for place and attention. Neighbouring bases of statues of Hadeia and Agrippa (reused), Oropian Amphiaraion.

[37] *ISE* 69, with Ma, 'Eugnotos', on the site of the statue (which can be determined from an honorific decree carved on the side of the base) and the date (*c*.275?).

[38] *OGIS* 218 (*Inschr. Priene* 18).

[39] *SEG* 33.127, 38.112.

[40] Polybios 18.16: statue of Attalos I set up next to a statue of Apollo at Sikyon.

[41] Plutarch, *Kimon* 2.2 (statue of Lucullus set up next to statue of Dionysos in Chaironeia).

[42] Pausanias 6.11.1; H.-V. Herrmann, 'Die Siegerstatuen von Olympia. Schriftliche Überlieferung und archäologischer Befund', *Nikephoros*, 1 (1988), 119–83.

[43] The monument for Kallikrates, set up by Spartan exiles for the man who had returned them to their fatherland (*Inschr. Olympia* 300), was positioned close to the Philippeion, and away from the usual clusters of monuments; the spot may allude to the theme of 'freeing the Peloponnese'. On the monument, recently, P. Schultz, 'Divine Images and Royal Ideology in the Philippeion at Olympia', in J. T. Jensen, G. Hinge, P. Schultz, and B. Wickkiser (eds), *Aspects of Ancient Greek Cult* (Aarhus, 2009), 125–94.

suggested by the collocation of statues of Konon and Evagoras next to that of Zeus Soter? That god was closely linked to war, patriotic service, and freedom: indeed, the god was also called by the epithet Eleutherios. The site of the statues speaks of the freedom of the Greeks after the defeat of the Spartan effort at hegemony in the decade after the Peloponnesian War: the 'message' is linked to a very specific historical context. At Akraiphia, the statue of Eugnotos, situated near (a statue of) Zeus Soter, similarly evoked themes of freedom and warfare, with the complication that Eugnotos died, after heroic but doomed efforts, in a battle that ended with defeat and subordination for the Boiotian League. The pathos of the epigram is re-inforced by the site of the statue, which alludes, not to safety, victory, and liberty, but to the trauma of defeat, which the monument helps to transcend through grief and memory.[44] Less dramatically, but just as meaningfully, the very prominent column monument of Polemaios at Klaros drew force not only from its location at the entrance to the shrine, but also from its site next to the altar of the Charites, the personified 'Graces' which embodied values of exchange and reciprocity (above, Chap. 2; Fig. 1.7).[45]

Collocation could create new monuments, new works of art, that had to be unpacked conceptually by the viewer. The portrait of a foreign ruler or a benefactor next to Demos or Demokratia formed a fresh work, which had to be viewed as an ensemble, producing con-trolled meanings: Demetrios Poliorketes was honoured for the reasons mentioned in the decree of the Athenian volunteer *epilektoi* (above), but the place of the statue made visible the king's (ascribed) status as restorer and protector of Athenian democracy. The complexity and acrimony of the actual relationship between Demetrios and Athens is precisely elided by the monument. In Athens, the honorific statue of Lykourgos was set up next to the statues of Peace and Wealth, on the north-west side of the agora, a striking visual statement about the success of Lykourgos' administration in restoring prosperity after Chaironeia.[46]

In other cases, collocation may simply have been a case of 'appropriateness': the statue of a courtier was set up next to the king he served, or at least statues of kings belonging to the same dynasty; Attalos II, benefactor of the shrine of Apollo at Sikyon, was honoured with a statue next to the statue of Apollo: collocation amounted to a reminder of an action, a commentary. The statue of Menander may have been placed next to the statues of the three tragedians, Aiskhylos, Sophokles, and Euripides (who shared a single base): the collocation would have made a statement about the quality of Menander's poetry, and also created continuity between the restored democracy of the 280s and the Classical age. Alternatively, the tragedians may have been placed elsewhere (as I believe), and the long base next to the Menander may in fact be a later monument, placed next to the Menander, in order to compare these later poets to Menander. Later (perhaps in the first century BC), the statue of a poet (probably the Perga-mene Q. Pompeius Capito) was jammed between Menander and the long base: this statue certainly took its place next to Menander, and hence compared the Roman-era honorand with the great dramatic poet; the location made a further statement about the Roman-era honor-and, by placing him within a continuum of Attic drama constituted by Menander and the later Hellenistic poets sited next to him (Plan 2).[47] The practice is similar to the setting up of inscribed *stelai* in appropriate sites. A decree could be inscribed next to the statue which it mentioned,[48] or set up next to monuments which were related. At Miletos, a *stele* bearing a letter of Ptolemy II and an answering honorific decree was set up next to a statue of Ptolemy I; the Athenian decree honouring Eumenes II for his assistance to Antiochos IV was set up in the agora next to the statues of the latter.[49] Viewing the statue also entailed seeing and reading documents recounting stories related to the statue.

[44] Oliver, 'Space and the Visualization of Power'; Ma, 'Eugnotos'.
[45] *SEG* 39.1243.
[46] Pausanias 1.8.2; I. Worthington, 'The Siting of Demosthenes' Statue', *ABSA* 81 (1986), 389.
[47] Pappastamatakis-von Moock, 'Menander und die Tragikergruppe, and Dio 31.116; above, 105.
[48] e.g. *IG* II² 649; above, 57–9, 77; Knoepfler, *Décrets érétriens de proxénie*, 196, 326 n. 30.
[49] *Milet* 1.3.139, *OGIS* 248. Also *SEG* 24.235, 28.112, *IGBulg* I² 307 (Mesembria). Perhaps *IG* 11.4.1057?

The meaningfulness of collocation involved the viewer's knowledge: if the viewer knew (from visual cues and the inscription) the identity of the 'original' statue and the 'secondary' statue, he could understand the gesture of collocation, and the message intended by the gesture—for instance, a well-informed foreigner (or simply a citizen) in the Athenian Agora, seeing the statue of Lykourgos, the famous Athenian statesman, next to the no less famous statues of Peace and Wealth, Classical masterpieces in their own right, would grasp the point of the proximity. Collocation also produced and imposed its own knowledge—if the viewer did not know that Z/Menodotos was a Friend of the Seleukid kings (and the inscription on the base of his statue likely did not make this clear), the location of his statue next to the statue of Antiochos VII made him suspect this relation. More insidiously, the location of a statue could suggest 'facts' and 'truths'—the 'truth' that Lykourgos brought prosperity to Athens, or that Demetrios defended Athenian democracy; the 'truth' that a benefactor, perhaps unknown to the viewer (a stranger in the city, or a citizen who lived much later than the benefactor's lifetime), was a good person, public-minded and dedicated to the Demos next to whose personification his statue stood.

Yet it may be too simple to reduce collocation to simple 'messages', constructed by the addition of knowledge about one statue and another. What did it 'mean' to set up the statue of a courtier next to the statues of a king, as in the most 'appropriate' place? Did this amount to a recognition of the principles of solidarity, loyalty, and reciprocity that structured the patrimonial Hellenistic kingdoms? Was it simply a case of facilitating the legibility of statues? We must wonder what the viewers did think, when seeing the chariot group of Antigonos and Demetrios next to the Tyrannicides.

Setting up a statue next to another did not only suggest meanings about the 'secondary' statue, but also modified the way in which the 'original' statue was seen. The equestrian statue of Demetrios, on a tall base, his charismatic, youthful, individualized face, his horse, his equipment, armour, and cloak represented with all the virtuoso resources of the bronze caster,[50] stood next to Demokratia: the great king, protector of Demokratia? But how did this affect the way viewers considered the statue of Demokratia, surely much simpler, idealized, and unmistakably female next to the powerfully masculine king? The balance of power, the flow of meanings, was not easily controllable by the intentions of those who set up statues next to statues. The new statue group could also reflect Athenian dependency, Athenian subservience, Athenian attempts at making sense of the king's presence, or conflicts about what the king's presence now meant. Meanings not only varied according to the viewers (for instance, literary evidence, preserved in Plutarch's *Demetrios*, gives some sense of the unease and disagreement about honours for Antigonos and Demetrios), but also varied in time. A statue of Seleukos I next to Alexander, in Olympia, worked differently for contemporaries (as a reminder of Seleukos' proximity to Alexander and the subsequent claims to charisma and legitimacy—leaving aside the question of whoever set the statue up) and for the second-century AD visitor, Pausanias, who saw Macedonian kings remote in time.

c. Groups and Series

Dionysios, the Histrian benefactor, was honoured with a statue set up in the agora, next to the statue of the Demos—and among the other statues next to Demos. Dionysios' statue was thus not simply a case of meaningful collocation, but part of a whole cluster of statues, benefactors surrounding the personification of the People of Histria, the civic community represented in human form (be it as a heroic youth or a bearded citizen).[51] In Athens, the statue of Lykourgos,

[50] On the diversified textures of military statuary in the Hellenistic period, see my review of Katsikoudis, *Dodone*, in *BMCR* 2008.02.27; below, Chap. 8.

[51] On Demos-personifications, O. Alexandri-Tzahou, *LIMC* 3.375–82 s.v. Demos (with Roman-era numismatic examples).

near the statues of Peace and Wealth, was soon joined by a statue of Demosthenes, and perhaps later honorific statues such as Kallias of Sphettos, a grouping of Athenian statesmen.[52]

For Histria, archaeological parallels suggest arrangement as a row or series of statues. Such series constitute a very widely attested phenomenon,[53] in a variety of urban settings. They appear in the agoras of the Hellenistic cities (for instance, in Thasos, Athens,[54] and, spectacularly, in Priene: Plans 1, 9, 13),[55] in theatres, and in shrines, urban and extra-urban: Priene and Athens provide good examples of the phenomenon in urban shrines,[56] Klaros or the Samian Heraion illustrate the phenomenon as extra-urban shrines.[57] Series are also attested in the 'international' shrines, for instance at Olympia, notably with a row of equestrians on the south side of the Altis, or at the Epidaurian Asklepieion, where the phenomenon is very visible, or at the Oropian Amphiaraion, where the statues now form a long row to the north of the esplanade between the temple and the theatre;[58] at Delphi, on the 'Threshing-floor', the esplanade along the street that winds up to the temple of Apollo (Plans 3–6). Most of these assemblages are more or less visible in post-excavation settings: these might help to give an idea of the effect of series—which will be explored below.

Series are eminently practical: over time, statues accumulate, and have to go somewhere. Arrayed in pleasing, tidy rows, they allow for free circulation in public spaces, such as the agora, rather than anarchically impeding the passerby. In the sacred spaces of the shrines, groups, series, rows of honorific statues allow free circulation and access to altars and dedications, and make the monuments in the shrine easier to understand and to 'read'. This is clearly seen in the Altis at Olympia, before the *Echohalle*, and especially to the south of the first enclosure wall (Plan 5). At the Amphiaraion, the esplanade grouped honorifics, and dedications may have been located elsewhere in the shrine, near the temple, the altar, or the fountain near the temple. In Athens, the honorific monuments were to be found in the northern part of the agora, and seem totally absent from the southern part, enclosed by stoas. They may also have played the role of defining axes of circulation in clearly visible ways, for instance in the Epidaurian Asklepieion (described in the previous chapter, 108–9).

Yet, beyond the tyranny of the practical, the arraying of statues in series shaped viewing and experience in a number of important ways. Series gave an image of multiplicity, coherence, and order: this, in itself, is an affirmation of the public control of public space—not at all something to be taken for granted, and in fact a co-terminous visible manifestation of the existence of the *polis* as the institutionalized emanation of collectivity. Individual monuments (which required

[52] Worthington, 'Demosthenes' statue', perhaps far-fetched on the association of Demosthenes and Lykourgos (where he sees an allusion to Demosthenes' care for Lykourgos' children).

[53] On antecedents, C. Ioakimidou, *Die Statuenreihen griechischer Poleis und Bünde aus spätarchaischer und klassischer Zeit* (Munich, 1997); I have not seen H. Bumke, *Statuarische Gruppen in der frühen griechischen Kunst* (Berlin, 2004).

[54] T. L. Shear, 'The Campaign of 1935', *Hesperia*, 5 (1936), 15, fig. 13, for small bases on the western side of the Panathenaic Way; T. L. Shear, 'The Campaign of 1937', *Hesperia*, 7 (1938), 324, on 'small monument bases' in front of Stoa of Attalos; further Thompson, 'Agora Excavations 1949', 317–18, for 'a whole series of monuments that employed the terrace wall of the Stoa as a background, particularly toward the north where the falling terrain called for a greater height of wall' (including the columnar base for Q. Lutatius). The current display of bases is modern (H. A. Thompson, 'Activities in the Athenian Agora: 1956', *Hesperia*, 26 (1957), 105). Further H. A. Thompson, 'Excavations in the Athenian Agora: 1952', *Hesperia*, 22 (1953), 43, for 'at least a dozen' monument bases facing the Stoa of Zeus; *Hesperia*, 21 (1952), 96, for bases dating to different periods (late Archaic to Roman) around the Temple of Ares; T. L. Shear Jr., 'The Athenian Agora: Excavations of 1971', *Hesperia*, 42 (1973), 125, for the north-west corner of the agora, 'thronged with monuments . . . The foundations of some 16 monuments were found thrust cheek by jowl into the small triangular area' (not identifiable or datable, but they probably included at least some honorific statues).

[55] Other examples include Thermos: Rhomaios, 'Anaskaphi'; von Thüngen, *Exedra*, 57 (row of monuments, 38 m long)—Kassope: Hoepfner and Schwander, *Haus und Stadt im klassischen Griechenland*, 124–6 (fifty monuments); Megalepolis: Lauter and Spyropoulos, 'Megalepolis', 438–51.

[56] Above, 98–108.

[57] Above, 80–1.

[58] C. Löhr, 'Die Statuenbasen im Amphiareion von Oropos', *AthMitt* 108 (1993), 183–212.

specific items of knowledge to be interpreted) were subsumed in a multi-statue 'work', elaborated over the years by the community, in its perenniality, and experienced by the viewer, when she embraced the series from a distance as a whole, head-on or in perspective, and when she walked past statue after statue—series structured space, movement, and experience.

In terms of visual experience and artistic form, the effect of series tended towards the imposition of uniformity and homogeneity, especially because of the stereotyped, stylized appearance of most honorific statues, which reproduced types (himation-man 'Normaltypus', 'Pudicitia'-type, cuirassed men, equestrians, preferred use of bronze), and in whose workings the appearance of replication was essential.[59] Series also echoed the architectural setting, especially the relentlessly repetitive rhythms of the colonnades which series of honorific statues alluded to (in the agora of Thasos, in front of the north west stoa) or answered (in the agora of Thasos, in the case of the five southern exedras facing onto a stoa): in front of repeated columns, honorific statues themselves became repetitions. Series could bridge the gap between two projecting wings, creating a screen of statues in front of colonnades, as in the case of the 'bâtiment à paraskénia' in Thasos, or the *bouleuterion* of Mantineia.[60] Individual statues joined up in ensembles, which embedded themselves into monumental spaces, and hence claimed durability and belonging. Finally, statue series, because they presented as a monumental unity the result of a process, namely the addition and alignment of statues, also displayed time. The viewer, walking along a statue series, might read inscriptions from different periods, alluding to different events, recognize different styles in writing or in sculpture: the effect was, again, to subsume individual monuments in broader ensembles, in concrete narratives about the place where the statues were set up.

Series invited walking past, as when Pausanias walked towards the Athenian Agora, and simply noted the aligned statues of men and women, no doubt honorifics (1.2.4). Further testimony to the homogenizing power of series of honorific monuments comes from the agora itself. A series of bases in front of the Metroon almost certainly bore honorific statues, on either side of the altar of the Mother of the Gods: this is very likely, even though only the foundations survive, because of the serial arrangement, and the location. The Metroon functioned as the city archive, and the site, with its official character, was suited to the repeated honouring of good citizens. In addition, the long base of the Eponymous Heroes was located opposite the Metroon: this monument constituted another highly charged site, closely linked to Athenian civic identity, and used (at least in the Classical period, and probably later) for the display of official documents.[61] The attraction of the Heroes may explain why the series of statues was not erected immediately before the stoa fronting the Metroon, but several metres to the south, closer to the Heroes.[62] When complete, the series offered a line of honorific statues looking towards the late Classical monument of the Eponymous Heroes: the style of the honorific statues (probably himation-men) may also have echoed the appearance of the Eponymous Heroes, thus reinforcing their presentation as good citizens. If the Eponymous Heroes looked east, towards the open space of the agora, the effect for the viewer (looking towards the

[59] J. Ma, 'The Two Cultures: Connoisseurship and Civic Honours', *Art History*, 29 (2006) 325–38, on replications; also here, Chap. 2, on identity capture by public epigraphy. The issue of appearance and effect is revisited at the end of the present work (Chap. 8).

[60] Mantineia: Fougères, *Mantinée*, 174. For a later parallel, Thompson, 'Odeion', 102–3, 124–5: in the 2nd phase (2nd cent. AD) of the Odeion in the Athenian Agora, the façade was punctuated by seven seated statues, between stairs leading into the theatre, and joining a statue group on the north-western corner and a chariot-group-cum-fountain on the north-eastern corner.

[61] Wycherley, *Literary and Epigraphical Testimonia*, 93–8; T. L. Shear Jr., 'The Monument of the Eponymous Heroes in the Athenian Agora', *Hesperia*, 39 (1970), 145–222; R. Krumeich in Stemmer, *Standorte*, 276–89; most recently Papastamati-von Moock, 'Menander und die Tragikergruppe', 322 n. 193. On the Metroon, P. Valavanis 'Thoughts on the Public Archive in the Hellenistic Metroon of the Athenian Agora', *AthMitt* 117 (2002), 221–55.

[62] The identification as honorific statues may be strengthened by the fancy in Lucian, *Anacharsis* 17, that the Scythian visitor to Athens will be honoured with a bronze statue next to the Eponymous Heroes (or on the Akropolis).

Metroon from the central space, or walking between the Eponymous Heroes and the Metroon) was that of a succession of rows, the columns and façade of the Metroon, the row of honorifics, the Eponymous Heroes—all displaying alikeness, and oriented towards the Agora. If the Eponymous Heroes looked west (much less likely), the effect was to create a gallery of statues facing each other, the honorific statues facing the Eponymous Heroes.[63]

However, the homogenizing power of the series did not only work on the honorific statues: in turn, the honorific group affected the meaning of the Eponymous Heroes, which were interpreted as honorific statues (even though they were set apart by a stone fence, and by being framed by a tripod at each end of the series),[64] a development perhaps furthered by the addition of statues of royal benefactors to the Eponymous Heroes, when new tribes were created to honour these benefactors (Antigonos and Demetrios, Ptolemy, Attalos). Likewise, many of the statues set up in the great cluster of statues in the northern part of the agora, close to the Stoa of Zeus, were identified as honorific;[65] as, indeed, was the statue of Solon set up in the vicinity of the Stoa Poikile, originally a creation of the fourth century BC, but later reinterpreted as an honorific statue.[66]

The impact of serialization was, unsurprisingly, to reduce the prominence and relevance of any individual statue, and attempt to impose homogeneity and replication—a politically charged operation, which aimed at bringing under control the celebratory power of the honorific monument. In the space of 'international' shrines, the serialization of honorific statues downplayed any individual claim of eminence on the pan-Hellenic stage. Serialization worked to show control by whatever formation held authority over the shrine, resulting in a narrative of the shrine's history and continuity throughout eventful times, and hence a celebration of the shrine's importance. At Olympia, the power of serialization to structure space can be felt in the row of equestrian statues, which start opposite the Leonidaion, then, turning at right angles, constitute a series of evenly spaced monuments, succeeding each other in equal rhythm, and answering the colonnade of the temple of Zeus (Plan 5, Fig. 4.4). Because of the paucity of inscribed indications, it is difficult to date this row of equestrians, and hence the pace with which this multi-statue 'work' developed. But the recipients were almost certainly Roman officers and pro-magistrates: the effect of the row is to shift the emphasis from the importance of each individual Roman statesman, to the grand effect of the row of equestrians, and the implications for the importance of Olympia, as the place where a variety of communities honoured Romans.[67] In Klaros, the statue of Antiochos the son may have been immediately next to the temple, and the first and only honorific monument in the vicinity of the temple, when it was first set up (between 203 and 197), but, in time, it simply became one of a whole series of honorific monuments, for foreign rulers, civic benefactors, and Romans, along the 'Sacred Way' between the temple and the *propylaia* to the shrine (and, in fact, no longer the first monument next to the south-east corner of the temple, since the column monument for Menippos was squeezed between Antiochos the son and the temple: Fig. 2.3).

The same political force of serialization operated in the case of multiple honorific statues in civic spaces such as the agora. The individual honorific monument was about the dialogue

[63] There is no clear indication on the facing: the cuttings on the two surviving capping blocks are inconclusive ('20', to give it the ancient numeral carved on the bevel, one of the end blocks of the original base, bearing a tripod, and later the statue of one of the additional Eponymous Heroes; and '2', again the ancient numbering, which preserves one square cutting from the original bronze statue). Shear argues that the Hadrianic marble restoration of the balustrade on the eastern side only indicates the facing. For another view, C. Vatin, 'La base des Héros éponymes à Athènes au temps de Pausanias', *Ostraka*, 4 (1995), 33–41 (heroes arrayed all around the base).
[64] Shear Jr., 'Monument of the Eponymous Heroes'; A. Borbein, 'Die griechische Statue des 4. Jahrhunderts v. Chr.', *JDAI* 88 (1973), 101–2.
[65] Thompson, 'Agora Excavations 1952', 43, on for instance the statue of Pindar.
[66] Wycherley, *Literary and Epigraphical Testimonia*, 216.
[67] A similar row of equestrians is located on the east side of the agora of Theophrastos: Mercuri, 'L'agora di Teofrasto' (five bases, and another one to the south of, perhaps, a monument dedicated by Sulla—not an equestrian, in spite of Mommsen in *CIL* III, suppl. 1, 7234, echoed by Mercuri, 202: the inscription would be on the long side of the base, and the monument would have faced sideways onto the harbour agora).

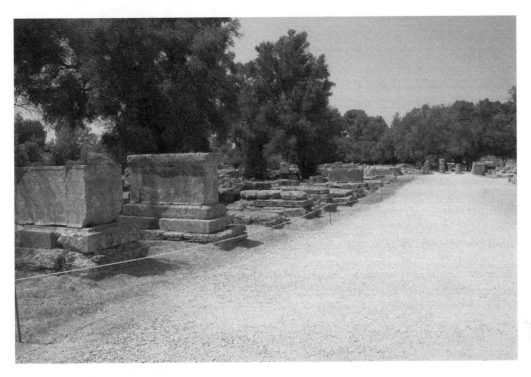

Fig. 4.4. The power of serialization: somehow, 'statue growth' in Olympia produced equidistant, ordered monuments along a main thoroughfare into the Altis. Row of equestrian bases, Olympia (south of Altis).

between community and benefactor; but individuality was lost through the integration of the single honorific moment within a series of honorific statues. In the series of inscriptions on multiple honorific bases, any individual name occurred once, but the community (*ho demos*) recurred. Through the location of any individual monument in an ordered series of similar honorific monuments, a point was made about civic control of space, status, honour, visibility, and memory. This point must have been reinforced by the appearance of the statues, notably the 'himation-man' in a pose of civic self-control and with features betraying the intent concentration of the good citizen striving for the common good, or the bland faces and stereotypical restrained poses of the female benefactresses, or even the king, portrayed though a variety of impressive, but ultimately stereotypical, tropes.[68] Serialization controlled elite claims: individual eminence was reduced by the insertion of monuments in rows of similar monuments, just as the honorand of the civic decree is praised in stereotypical terms which, in the end, lead to a blurring of identity and a reaffirmation of communal values rather than individual actions.

Serialization makes civic space into a representational space: rather than granting the individual honorand paradigmatic status, as in the case of eminence, the representational space of the agora, with its row of good citizens, is itself a paradigm of civic ideology, affirming the primacy of the communal over the individual, the value of virtuous action and the worth of requital in the form of honours—the same ideology that was expressed by the 'politics of the accusative' which I analysed in the previous section.

In some cases, the force of serialization may have been welcome. For one Doidalses, from Mysia, to have been honoured by Pergamon with a statue 'set up among great men' was a fact to be celebrated, as a sign of acceptance; more generally, the series offered the reassurance of

[68] Zanker, 'Brüche im Bürgerbild?'; Dillon, *Female Portrait Statue*; Ma, 'Le Roi en ses images'; further below, Chap. 8.

permanence and embedding within the monumental setting of any individual honorific statue.[69] Series also enabled somewhat anomalous statues to be accepted: the female statue, crammed in (as shown by the order of proxeny decrees inscribed on the bases) among the equestrians and civic heroes of the 'middle group' of the Amphiaraion esplanade (Plan 3), probably gained some appearance of normalcy by making the group into a series, and hence acceptable for the viewer's eye (see below, 139–42, for detailed thoughts on this statue in the context of the statuescape of the Amphiaraion).[70]

In other cases, strategies seem to have been deployed to counter the controlling effect of the series: the use of marble rather than bronze, multiplying portraits in different media (but the end result might have been the 'inflation of honours' and hence the reinforcement of the effect of serialization), or the setting of the base at a jauntily different, 'show-off' angle from the rest of the series. Such jaunty bases appear in highly visible spots: the south-east angle of the *bouleuterion* at Dodona (Plan 7), the parade of statues in front of the 'bâtiment à paraskénia' on Thasos (Plan 9), or in front of the Metroon in the Athenian Agora,[71] all in highly visible spots. In other cases, the angling of a base may have worked slightly differently, by suggesting that a series had come to an end, and that passersby should turn off there. At two points in the long series of monuments before the *Echohalle* at Olympia, equestrian bases angle off from the line, thus creating a point where passersby could, at last, actually enter the stoa rather than have to trudge past the statues that blocked any direct access to the portico. A position at this site was desirably prominent, as the end of the series, and the statue's position made it accompany, visually, the passerby in their curving path into the stoa, and hence dominate the experience of serialization. (That this phenomenon occurs twice seems to indicate that serialization marched on, in spite of the efforts of individual monuments to mark the end of the series in front of the *Echohalle*: Fig. 4.8.)

Moreover, serialization may have influenced the whole genre of the honorific statues: honorands may have known that many, or even most (and indeed their own), honorific portraits would end up in a series (or that a series could catch up with their initially isolated monument), and that it would have to derive meaning syntagmatically, by comparison and differentiation in relation to other statues of the same type and belonging to the same genre. Realism, individualization, stylistic diversity, variations in costume, upper-body poise, or the position of arms, may also have developed as reactions to the ubiquitous and uniformizing honorific series, especially since the series reinforced other tendencies in Hellenistic art, namely the normative force of types, and the increasing standardization of body shapes and postures.[72] I revisit these issues later; what matters here is that the very development of variation, or the development of dynamic or intensifying tropes, which were possible within the 'bespoke' model of statue making (below, Chap. 7), are themselves testimony to the tendency of the series to create a general hum of uniformity.

3. SINGULARITY AND SERIES

Isolation, collocation, series. At first sight, a historical evolution: rare honorific statues in the beginning, set up in *epiphanestatoi topoi*; other statues set up near to these pioneers; the inflation of honours leading to *Statuenwald*, the honorific series. It is true that the latter form, the series,

[69] *I. Miletupolis* 23.

[70] Reused later: *Oropos* 448; from the inscription of proxeny decrees on the statue bases on either side, it is clear that the female statue is a later addition, deliberately placed.

[71] T. L. Shear, 'The Campaign of 1934', *Hesperia*, 4 (1935), 340–70, at pl. III, facing p. 362, captioned '13'. The funerary monument for the young Athenian cavalryman Dexileos is set up, on top of a podium, at an angle to the 'Street of the Tombs' in the Kerameikos cemetery (394 BC): S. Ensoli, 'L'heróon di Dexileo nel Ceramico di Atene: Problematica architettonica e artistica attica degli inizi del IV secolo a. C', *Memorie (Accademia nazionale dei Lincei. Classe de scienze morali, storiche e filologiche)*, 8.29/2 (1987), 157–329.

[72] Dillon, *Ancient Greek Portrait Sculpture*, 76–86.

can only be the end result of a development: tipping points towards the constitution of series must have been reached easily, in that collocations tended towards the completion of rows and groups, offering 'natural' spaces for the next honorific statue, for reasons of statue coherence ('honorifics together') and visual balance ('filling out a gap', 'continuing the line'). Such pressures may have led to the constitution of the series of equestrian monuments south of the Altis at Olympia, without there being need for an explicit decision by the Eleian state or the shrine officials.

This historical sequence, ideally appealing, is difficult to document archaeologically, because of the lack of any site with a complete archaeological and epigraphical record, as opposed to mere foundations (as in the agora of Thasos or at Dodona) or reused bases (as is the case for the Epidaurian Asklepieion, or the Amphiaraion esplanade). At Klaros, the series of statues from temple to *propylaia* was the end result of several originally isolated zones of statues (the corner of the temple, the middle stretch of the 'Sacred Road', the *propylaia*) finally joining up, in the late first century BC (Plan 17). The various monuments, set up in isolation, for citizens and for Romans, were aligned on the 'Sacred Road': first the private honorific monument for Antiochos the son, then an exedra with two equestrian statues, probably in honour of Attalid rulers (Eumenes II and the future Attalos II? *c.*160?), further away (possibly facing other monuments for Attalids), then the two column monuments for Menippos (near the temple, in fact squeezing out Antiochos the son from his privileged place as first statue after the temple: Fig. 2.3) and Polemaios (near the *propylaia*, at the other end of the 'Sacred Road'), followed by a monument to M. Antonius (all these *c.*100).[73] These monuments constituted an airy series of archipelagos with gaps, which slowly filled up, with other monuments for Romans or Kolophonians. The sequence in other sites may have followed this 'droplet' or archipelago pattern of separated clusters of statues,[74] gradually joining up (rather than a relentless incremental progression of an addition of statues to make up a series). At the Amphiaraion, it seems that three groups of statues (a more 'royal' group to the west, a somewhat 'civic' group in the centre, and a 'private' group to the east) extended until they joined up, roughly, in a single sequence (with, nonetheless, gaps between the groups preserved).

Even if the series dominates in the archaeological record (because we are faced with the end product of centuries of increasingly dense 'statue growth'), even if the series corresponds to the dominant ideology of collective control over the individual monument, it is important to realize that isolation, collocation, series, do not so much constitute a historical evolution as a roster of possibilities, that largely coexisted in the public spaces of shrine and city. The agora of Thasos, or the Athenian Agora, have provided examples of all three phenomena; both also illustrate the coexistence of all three. At Thasos, series of statues were to be seen in front of the north-west stoa, the 'bâtiment à paraskénia', and in the southern alley of five exedras leading to an altar; statues were placed close to the monument for Caius and Lucius Caesar; the 'naval' base stood in solitude, prow and ram bearing down an alley clear of statues, all the way down one side of the agora until the blind side wall of the southern altar at the apex of the rhomboid agora. In Athens, the choice of tall pilasters for the Attalid monuments can be seen as a reaction to the presence of series and meaningful collocations in the normal statue sites, the agora, and the Akropolis. The architectural form chosen was itself a reflection of the need for distinction among a multitude of statues; this was also the function of the honorific column, an artefact specifically designed to produce verticality and 'super-monumentality' not in the abstract, but specifically in relation to collocation or series.

The workings of the honorific column hint at the complexity of the relation between 'isolation, collocation, series', and generally the complexity and subtleness of the workings of place. It is not just that isolated monuments in turn seem often to produce imitation,

[73] Ferrary and Verger, 'Contrbution à l'histoire du sanctuaire de Claros'; Étienne and Varène, *Sanctuaire de Claros*.

[74] On the phenomenon in modern sculpture (18th-cent. France), Jollet, 'Objet d'attention', 40.

emulation, and multiplication (the phenomenon is visible at Klaros); or that modern examples might make us wonder if the more isolated or prominent statues were not sometimes also the least looked at. More generally, since isolation and prominence are themselves determined in relation to other statues (whatever their situation), 'isolated' statues can also be read syntagmatically—as meaningful parts of wholes. The consequence is that our notion of whatever constitutes a 'series' or a group of statues should be revisited; a row of statues is not the only way in which statues relate to each other as an ensemble; such ensembles can be constituted not only by the immediate space within which a statue is placed, but also the whole roster of possibilities in a city or a shrine.

Useful as the three configurations, isolation, collocation, series, are to register and describe statue phenomena on the ground, they should be further considered dynamically: these concepts can be used typologically, but only as a heuristic device, before looking at real-life cases and events. Isolation led to series (a reflection of the 'inflation of honours' in the late Hellenistic period). Isolation also created relations with other statues, or even other monuments: architecture, dedications. Series produced strategies of prominence, surveyed above: stylistic variation, statue displacement, jaunty 'show-off' bases; series offered the possibility for variation, allusion, and meaningful variations that attracted attention and impressed the statue and its subject on the viewer's memory. Being placed in a series could also be a highly desirable position, as a mark of honour and recognition, as in the case of Doidalses, mentioned above. Conversely, collocation could act as a strategy of prominence, subordinating a statue to another; or it could prove a strategy of dominance, modifying pre-existing monumental meanings to talk about new situations: I evoked both possibilities in the case of an equestrian statue of Demetrios Poliorketes next to Demokratia. Or it could simply have been a case of convenience. That is, on occasion, it is difficult to see exactly what reasons (implicit statements, 'appropriateness') determined the collocation of statues. The statue of Lucullus set up by the Chaironeians in their agora (Plutarch, *Kimon* 2.2) was doubtless a token of their gratitude for his intervention on their behalf—but why did it stand next to a statue of Dionysos in particular? (An allusion to freedom?) Why did the Koans set up the statue of a physician next to that of Augustus?[75] At the Amphiaraion, the statue of Hadeia might have been set up next to the hitherto isolated equestrian statue for reasons of 'appropriateness'—the latter statue could have represented a friendly or related king (Lysimachos himself?), but might also have been sited at that spot to exploit the prominence and visibility of the equestrian (Plan 3). Collocation was also a question of opportunism.

To speak of opportunism and convenience perhaps evokes the workings of practical factors in managing public space: the latter was controlled by collective entities (see previous chapter), and practical decisions must have been taken by the *architekton*, the public architect, in many cities.[76] But any 'tyranny of the practical' must have been about choices and possibilities— which this chapter has tried to explore. The great Kolophonian benefactors, Polemaios and Menippos, took an active part in the location, and appearance, of their monuments.[77] To see 'series' everywhere, to find ways of seeing relations between monuments within a statuescape, to look for dynamic relations, both in space and in time—all these interpretive strategies involve trying to read groups of statues as social discourse, as a monumental text.

Another way of expressing the presence of choices and constraints within the landscape of honorific statues is to reconsider those cases where a city grants an honorand the right to choose where his portrait will be set up. The phenomenon is attested early—for the first epigraphically known honorific statue, the portrait of Konon set up by the Erythraians in a site

[75] *PH* 344.

[76] Above, 70–5; *Syll.* 284; *Inschr. Priene* 57; Perrin-Samindayar, '*Aere perennius*', 118–19.

[77] For parallels, see *IG* 12.7.231 (Minoa on Amorgos: doctor honoured with public monies to set up an honorific monument 'wherever he wants'); *IG* 5.1.1432 (Messene, for collaboration between city and honorand to set up the latter's monument).

of his choice (*c*.394),[78] as well as for the very early Hellenistic statues of high officers of the dynasts: Asandros at Athens, Timotheos and Adeimantos at Eretria.[79] In Istria, the same city where a colossal statue of Demos was surrounded by portraits of benefactors, thus constituting a meaningful collocation, another benefactor, Diogenes son of Diogenes, was granted an honorific statue in whichever spot of the agora he chose.[80] In other cases, the honorand's family decided on the site of the monument—as in the case of Nikeratos of Olbia, a statesman and general killed in battle.[81] At first sight, such cases seem to raise the alarming possibility of 'statue anarchy'—if not generalized, at least for certain individuals. The possibility is the more shocking for its taking place in a world which, at first sight, assumes the meaningful control and use of public space by the community (see previous chapter). However, the realities of a public honorific statue set up 'wherever the honorand wants' may simply have amounted to choices among the roster of possibilities in the statue landscape of town or shrine. Whatever decision the honorand made, his (or her) choice would immediately interact with other statues, in the immediate surroundings or across the whole statuescape, influencing the meaning of other statues and in turn affected by other statues: all statues existed as part of ensembles.

A final illustration of the way in which desires and intentions had to fit within a pre-existing, if evolving, set of possibilities, is the case of the equestrian statue which the Epidaurians granted to Aristoboulos, a great benefactor of the city in the first century.

It seemed good to the magistrates and the councillors and the people: to praise Aristoboulos son of Xenodokos, of Epidauros, and to give him honours, and to crown him with a golden crown, and to set up a statue of him, in bronze and on horseback, in the shrine of Apollo Maleatas and Asklepios, in the most prominent place, with the following inscription: 'The city of the Epidaurians (has set up) Aristoboulos son of Xenodokos, of Epidauros, on account of his goodness and the goodwill which he continuously shows towards it', and to proclaim the crown (etc.).[82]

The decree explicitly grants a monument in the *epiphanestatos topos*, and the type of statue chosen, a bronze equestrian, is an extremely visible, prestigious type, borrowed from idioms used to talk about kings and military honorands. The base has been found *in situ*:[83] the statue was placed in front of an earlier monument, at the south-east corner of the temple. This was as prominent as could be managed—the first statue in the row of statues on the south side of the temple, in front of another monument which earlier had occupied this spot; but the monument was only part of the whole streaming open-air sculpture gallery which wrapped around two sides of the temple (Fig. 4.5, Plan 4). Was this *the* most prominent spot in the whole shrine? The only available one? The only one at the time? Should we notice the disjuncture between the intention and the realization? It is equally possible that inclusion within the series, in this spot but also as part of the whole world of statues that lined the edge of the road from the altar to the Tholos, was indeed about inclusion in a 'most prominent spot', and that the very crowdedness of the area gave out a variety of messages which we should try to attune ourselves to: for instance, that in the context of a shrine with pan-Hellenic claims, crowded, jostling statues evoked the serried ranks of dedications, and the packed crowds of visitors during

[78] *RO* 6, with J. Ma, 'A Gilt Statue for Konon at Erythrai?', *ZPE* 157 (2006), 124–6.

[79] *IG* II² 405; Knoepfler, *Décrets érétriens de proxénie*, no. VII.

[80] *Inscr. Scythiae Minoris* 1.1. Other examples: *ISE* 41 (Argos); *IGR* 4.1703 (L. Nassius on Chios). Euphemos (see Chap. 3), portrait in the shrine of Anax (*Inschr. Magnesia* 94); Soteles of Pagai: *IG* 7.193, with A. Wilhelm, *Inschriftenkunde*, i. 261–76; *I. Iasos* 47; *SEG* 26.1817 (Aleximachos of Taucheira, honoured with a bronze statue on the agora, ἐς ὃν κα αὐτὸς ποταίρηται τόπον). Generally Veyne, *Le Pain et le cirque*, 265–6, on Apuleius, *Florida* 16.36. The formula is often found in the case of *stelai* bearing honorific decrees: e.g. *Rhamnous* 22 (contrast *Rhamnous* 46, where a commission chooses the site of the *stele*).

[81] *Syll.* 730; similarly, *TAM* 5.48, 688, or *MAMA* 6.65 (*La Carie*, no. 41) for posthumous interventions of family in choosing statue sites.

[82] *IG* 4² 1.65.

[83] *IG* 4² 1.630.

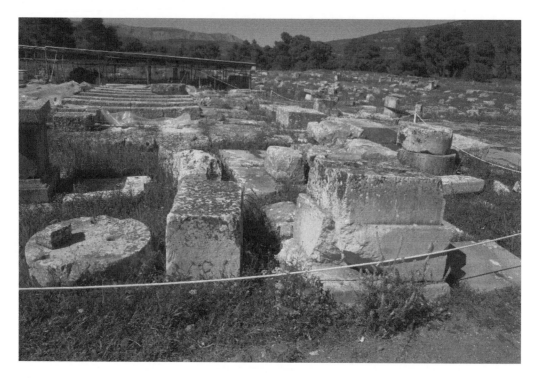

Fig. 4.5. Where, in the mass of statues, is prominence to be achieved? One of these bases is known to have borne a statue which the people of Epidauros promised to set up in the *epiphanestatos topos* (*IG* IV[2] 65). Bases south of main temple, Epidaurian Asklepieion.

processions and festivals. The point that emerges most strongly when one considers the case of the 'most prominent' statue of Aristoboulos is that it is necessary to consider statues as the interaction between intention, contexts, and history—and that the study of this interaction requires, and indeed generates, sensitivity to the monumental and the urban as *place*.[84]

4. HONORIFIC STATUES, SPACE, PLACE

On peut donc poser les questions suivantes, parfaitement recevables: 'Les espaces façonnés par l'activité practico-sociale, les paysages, les monuments et bâtiments, ont-ils des signfications? L'espace occupé par un groupe social ou par plusieurs groupes peut-il passer pour un message? Doit-on concevoir l'œuvre (architecturale ou urbaine) comme un cas remarquable des *mass-média*? Un espace social peut-il se concevoir comme un langage, comme un discours, relevant d'une pratique définie, la lecture-écriture?'[85]

We might, therefore, ask the following perfectly valid questions: Do spaces shaped by social praxis, landscapes, monuments, and buildings, have meanings? Is space, occupied by a social group or by several groups, liable to be interpreted as a message? Should one conceive of the work (architectural or urban) as a specific case among the *mass media*? Can a social space be conceived as language, as discourse, belonging to the realm of a specific practice, writing-reading?

Up to now, I have considered statues in a repertoire of possible sites—the 'grammar' reviewed in the previous chapter—and in a repertoire of possible configurations, which often achieve

[84] The inspiration is here is modern urban history: D. Hayden, *The Power of Place: Urban Landscapes as Public History* (Cambridge, Mass., 1995); Czaplica et al., *Composing Urban History*.

[85] Lefebvre, *Production*, 154. The answers are 'oui', 'oui et non. Un espace contient un message: mais se réduit-il à ce message?', and 'la réponse impliquera les plus grandes réserves'.

expression and meaning in this chapter, which gave examples of a 'discourse' of statues. An honorific monument can be placed in the agora (and not in the theatre or the shrine); it can be placed next to a statue, to say something, or to present a sight (a sign) that will be interpreted in a certain way. The focus has been on meaning, and the metaphors have been borrowed, more or less explicitly, from language and discourse: vocabulary and grammar, *topoi* and rhetoric, expression and figures, 'utterances', 'discourse', and meaning. Such tropes offer a starting point for the inventory, and the interpretation, of honorific statues within space.

This is not to take a position in the debates about the philosophical relationship between space and language, but merely to propose a way to study honorific statues, highly charged monuments set up within 'representational spaces', and their meanings. But honorific statues are also about space; the impact of what they express, and more simply of their presence, is to structure space (though not, or not exclusively, to constitute space—buildings, streets, other monuments join in that operation); indeed, the meanings expressed are achieved through the structuring of space. The point of honorific statues was to be seen: their presence, in whatever configuration, changed the process of viewing the public space (shrine, agora, . . .) where they were set up—a process which itself was a way for the viewer to 'construct' public space. The acts of viewing the space itself, other objects in the space, and humans in this space, were affected, in many possible ways: looking at (a prominent statue, a striking collocation), looking for (a particular statue lost in the shadow of a larger one), looking past (a statue at a monument or building), looking along (a row of statues). The various possible configurations also involved looking at singularity or repetition (or both, in relation to each other), engaging the viewer in different spatial ways.

Honorific statues also affected another way of 'constructing' space, namely human movement and presence within space. Statues could make pathways visible, by lining them or forming endpoints, within wider spaces, especially the empty spaces of the shrine (as at Olympia or the Epidaurian Asklepieion). Constructing space took place through constricting movement: building up a row of statues necessarily removed the possibility of free movement across space, for instance across the open space of a shrine or agora, or out of a stoa into a piazza. Even a single statue, or small group of statues, can shape movement, at a liminal site or in a narrow space (for instance on the small esplanade in front of the shrine of Demeter at Priene). The honorific statues which occupied sites in the public spaces of city and shrine necessarily represented the taking away of available space, and the restriction of possibilities for humans to move, or even simply to stand within space.

In addition, since honorific statues often had a front and a back, or a preferred orientation, they constructed viewing and movement into serial experience: moving and viewing meant seeing (for instance) backs of statues, then fronts (and inscriptions), and hence created patterns of expectation, meaning, and hierarchy within public spaces;[86] the full impact of this situation will be explored later. Honorific statues also shaped movement by inviting pause, to look at a statue, or to read an inscription, or even to sit on the stone benches (warm or cool according to time of day) which certain types of statue bases offered to passersby, at the feet of the bronze good citizens and benefactresses (Fig. 4.6).[87] Uniquely, the case of sitting allows us to get in touch with the intention of those who set up the monument: they meant for the viewer to sit at this spot—aware of the statue but turning his back to it, viewing the rest of the urban landscape from a viewpoint very close to that of the statue, with which he had to figure out his relationship (admiration, subservience, emulation, acquiescence?).

Finally, the point of honorific statues was not only visibility, but memory. Honorific statues, especially as ensembles, textured public spaces into maps of time: the ongoing construction of honorific dialogues in bronze and stone, and, especially, the presence of stories and images

[86] The notion of serial viewing was proposed by G. Cullen, *The Concise Townscape* (London, 1961), especially in his daydream-like sketches.

[87] On benches and sitting, von Thüngen, *Exedra*; von Kienlin, 'Stadtzentrum von Priene'.

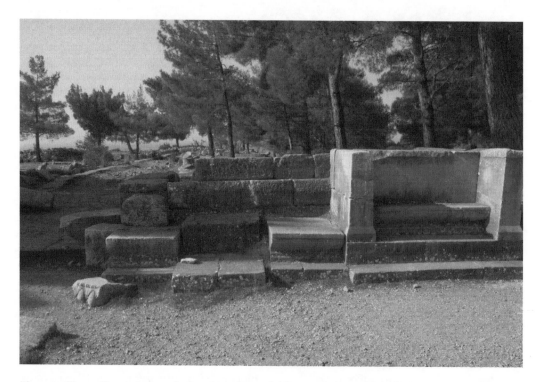

Fig. 4.6. Honorific monuments had to share the available space; some addressed the passerby directly, by offering him places to sit. Statue bases, including an exedra, western end of West Gate Street as it crosses the Agora of Priene.

from the past. In the particular case of honorific monuments, their essential nature directly politicizes their impact on public space. Honorific statues are explicitly, through the inscription on the base or stories told in inscribed decrees, about social transactions, communitarian values, social reproduction of the good citizen, and the right 'place' for eminent individuals (above, Chaps. 1–2). The issues of power relations inherent in the construction and the experience of space, the social production of space (to paraphrase Henri Lefebvre), are immediately present.[88] I wrote above that 'statues structure space/time', 'collocation of statues have meaningful effects'—but who does the structuring, and the experiencing, the interpreting? Who are the social actors involved? If statues produce 'meanings', what are these meanings, and what is the 'meaning of the meanings'? What investments, financial and ideological, are being made in the setting up of honorific statues? What historical forces are at work, at any moment and over time, in the 'spatialization of power relations'?[89]

The historical questions can first be framed, in the case of the Hellenistic *polis*, in terms of the relation between city and ruler, and of the relations between mass and elite. In certain cases, space is being structured (through the occupation or colonization of meaningful spots) to reflect domination: the dominance of foreign rulers, or the prominence of elite individuals, or of a class of notables. The actors involved might be subordinate communities, in response to

[88] Lefebvre, *Production*, esp. 136–7.
[89] On the 'spatialization of power relations', see M. Foucault, on the way architecture and urban planning allows the study of power at work (I only know this from Hayden, *Power of Place*, 254 n. 35, quoting a short introduction by G. Wright and P. Rabinow to an interview of Foucault: *Skyline* (Mar. 1982), 14–15). For an example of spatial analysis, see D. B. Small on Priene: 'Contexts, Agency and Social Change in Ancient Greece', in N. Terrenato and D. C. Haggis (eds), *State Formation in Italy and Greece* (Oxford and Oakville, Conn., 2011), 135–60.

the presence of foreign master; independent communities acknowledging the asymmetric benefactions of a foreign ruler (or powerful foreigner, such as a Roman leader); groups within communities using monument and space to make visible the power of a particular king, and hence consolidate their own position; communities responding to actions by individuals, such as statesmen or benefactors; or, finally, such elite individuals, acting solely or in collaboration with other members of their class.

But we should remain wary of any easy equation of honorific statues with domination by rulers or by oligarchies of 'notables'/*Honoratioren*. Earlier, I argued that the phrasing of the inscriptions that acted as captions for honorific statues embedded the monuments back into civic culture, by shifting the 'subject' of the work of art from the honorand to the social transaction of honouring (Chaps. 1–2); on the ground, statues could structure space in ways that expressed the power of community, by organically integrating powerful individuals, by attributing meanings and roles, and, especially, by making them part of series that expressed norms and uniformity. Just as the communitarian power of inscription is revealed by attempts to offset the 'politics of the accusative' (Chap. 2), the integrative power of series is attested precisely by elite efforts to counteract it, especially through the multiplication of statues for individuals[90] or for families. The inspiration for the multiplication and diversification of spatial niches for statues may come from the practice of honours for kings. Expressive multiplication, on a massive scale, was an essential strategy to make images display royal power: this can be seen in royal coinage, the seventeen gilt statues of Ptolemy II that are mentioned in connection with the celebration of the Ptolemaia in Alexandria, or in the disposition of dynastic monuments at Delphi.[91] *A contrario*, the importance of multiplication and presence across many spatial niches is underlined by the spatial *damnatio memoriae* carried out by the Athenians when they removed all the monuments for Antigonid rulers, and left the spaces untouched, as gaping, accursed reminders of hatred, scattered throughout the city.[92]

However, the effect of wide seeding of statues, even if it was borrowed from royal practice as a strategy to obtain effects of ubiquity and prominence, may simply have been to produce statue inflation and hence reinforce the serial effect of many statues of honorands in public space—amounting to a tragedy of the elites, tolerated and even fostered by civic communities in order to blunt any individual attempt at eminence—but at the spatial cost of the increasing collective presence of the elite through their representations, which in turn may have lessened the capacity of inscription and serialization to impose civic meaning on elite representation— or simply of the surcharge of significant spaces such as the agora or the shrine.[93]

The argument outlined above reflects my own interest in tracing civic control, rather than oligarchization, but it may be more important to realize that the issues of power and community are dialectical ones: outside domination, elite power, community power respond to each other.[94] Likewise, there is no simple way of reading the ways in which honorific statues constructed public space, where experience and history combined to multiply and diversify possible interpretations. What matters is to study how choices and vectors played out on the

[90] e.g. *SEG* 26.1817; *TAM* 5.374 (Kollyda), 468B (modern Ayazvran): crown, bronze statue, full-size painted portrait, marble statue, *Sardis* 8. See W. Raeck, 'Der mehrfache Apollodoros', on Priene, to which add *Inschr. Priene* 252–4, and compare *Inschr. Magnesia* 92a (with Holleaux, *Études*, i. 331–2) for two statues of a benefactor. For a parallel in Roman Termessos, O. van Nijf, 'Public Space and Political Culture in Roman Termessos', in O. van Nijf and R. Alston (eds), *Political Culture in the Greek City After the Classical Age* (Leuven, 2010), 215–42.

[91] Ma, 'Le Roi en ses images'; Ptolemaia: Athenaeus, 5.203b (the exact context of the gilt statues is unclear) with E. E. Rice, *The Grand Procession of Ptolemy Philadelphus* (Oxford, 1983), 126–33; Delphi: Jacquemin, *Offrandes monumentales*.

[92] Livy 31.44.4–8; H. Flower, *The Art of Forgetting: Disgrace and Oblivion in Roman Political Culture* (Chapel Hill, NC, 2006) 34–41.

[93] On surcharged/borderline insignificant spaces, Lefebvre, *Production*, 186–7.

[94] J. Ober, *Mass and Elite in Democratic Athens* (Princeton, 1989); Ma, *Antiochos III*; J. Ma, 'Paradigms and Paradoxes in the Hellenistic World', *Studi Ellenistici*, 20 (2008), 371–86.

ground, in the various configurations explored in this chapter, and what forms the production of space took in specific circumstances. To do this means looking at Hellenistic cities and shrines not simply as spaces, but also as *places*, to use the distinction developed by modern geographers: as lived contexts for human interaction and experience, that can be mapped emotionally and imaginatively, in terms of identity, experience, desire, meanings.

In the words of Y.-F. Tuan, 'cities are places, because they can organize space into centres of meaning, ... fields of care, human networks, extended to place by iteration and religion'.[95] The agora of Priene, the shrine of the Charites at Athens, the Asklepieion at Messene, are examples of meaningful places that can be studied as part of repertoires of sites, and as the result of historical forces acting on, and at work within, social space. As already discussed, the setting up of a statue, a civic gesture, could itself be the occasion for meaningful civic ritual, such as sacrifices or benefactions, as happened with the statue of Soteles of Pagai.[96] Once set up, the statue could become a focus for ritualized memorial gestures. At Erythrai, the statue of the tyrannicide Philitas was regularly polished, and wore a crown, like other citizens, on festival days, thus making the exemplary hero part of the citizen community.[97] The Hellespontine League of Dionysiac Artists honoured their benefactor Kraton with quasi-cultic gestures (the setting up of tripod and incense burner) on festival days before his statue in the theatre at Teos.[98] The statue of the benefactress Apollonis, in the agora at Kyzikos, was similarly the focus of ritual gestures.[99] Such gestures, especially in the case of the late Hellenistic super-benefactors, may derive from the honours paid to the cult-statues of rulers. But we should not focus on the aspect of homage implied by that origin: the habit of ritual gestures around honorific statues also illustrates how statues created place, and were embedded in place. In Roman Ephesos, distributions to council and *gerousia* took place in front of honorific statues (πρὸ τῶν τειμῶν, literally 'in front of the honours') representing, and set up to honour, these civic bodies: statues were part of a significant topography, which ritual reveals.[100]

Some problems arise immediately with the study of honorific statues in *place*. The first is that of sources (again): there simply are no honorific statues left, literally, in place. Generally, there rarely is enough evidence for a full history of any one place; the meshing of archaeological, epigraphical, and literary sources across time is never dense or complete enough to allow studies comparable to those of modern anthropologists or geographers. The second is that of method: if there is no evidentiary basis for the detailed investigation of individual test cases, how can 'places' be studied? A thematic approach is necessary, using those test cases where some knowledge is available: what emerges is a pattern of sedimentation and segmentation, which might prove interesting to follow and to think about. The third is that of theory: the concepts of space and place, and their relations, are highly debated within the fields of geography and urban design (the issues are the relations, oppressive or progressive, between space and power).[101] The following pages are not directly meant as a rigorous contribution to

[95] Y.-F. Tuan, 'Space and Place: Humanistic Perspective', *Progress in Geography*, 6 (1974), 239.

[96] Wilhelm, *Inschriftenkunde*, i. 272–3, with parallels; above, 129. For Roman parallels, J. Fejfer, 'Ancestral Aspects of the Roman Honorary Statue', in J. M. Højte (ed.), *Images of Ancestors* (Aarhus, 2002), 247–56; for a modern parallel (among many), A. Dumas, *Impressions de voyage en Suisse* (Paris, 1982), i. 29–30, for the re-erection in Lyons of a statue of the benefactor Jean Cleberg, in 1820, 'après avoir été promenée dans toute la ville, au son des tambours et des trompettes, par les habitants de Bourg-Neuf' (after it was paraded in the whole city, to the sound of drums and trumpets, by the inhabitants of Bourg-Neuf).

[97] Above, 60; *Syll.* 284 (also *I. Erythrai* 503), with P. Gauthier, 'Trois décrets', 215–21.

[98] Michel 1016.

[99] *SEG* 28.953.

[100] *BE* 44, 162, pp. 225–6, on *LBW* 141 (same document *I. Ephesos* 2113); τιμαί are here honorific statues, the 'honours' *par excellence*.

[101] Bachelard, *Poétique de l'espace*; D. Harvey, *Social Justice and the City* (London, 1973); Lefebvre, *Production*; Hayden, *Power of Place*; further M. Herzfeld, *A Place in History: Social and Monumental Time in a Cretan City* (Princeton, 1991); D. Massey, J. Allen, and S. Pile (eds), *City Worlds* (London, 1999); R. Cuthbert (ed.), *Designing Cities: Critical Readings in Urban Design* (Oxford, 2003). A social geography of the *polis* still remains to be written.

the theoretical debates;[102] nor can there be any question of writing as if our attention were shifting 'from space to place'. But the exercise of reading civic place, informed by the views of radical geography, is a worthwhile enterprise—and a step forward out of the old dilemmas of the post-Classical *polis*.

5. ON THE GROUND: SEDIMENTATION AND HORIZONTAL STRATIGRAPHY

Statues in series bear re-examination. In Thasos, among the several series of statues in the agora, one of the most impressive ones must have been the long row of about twenty-one honorific monuments, some perhaps bearing several statues, in front of the (no less impressive) north-west stoa (Plan 9).[103] Two things are immediately noticeable, even now, about this row of statues. The first is that its orientation is different from that of the stoa it stands in front of (Fig. 3.1). The explanation is perhaps that a few monuments were set up, along a terrace or street, on the edge of the early Hellenistic agora, and forming an angle with the shrine of Zeus Agoraios (notably the large equestrian base in the middle of the row, and the two stepped monuments to its south-west); the large north-west stoa soon followed, but the orientation of the row of statues was already determined by the earlier monuments. The second observation is that the row of statues is constituted by a terrible crowding of the bases, to the point that some bases closely adhere to others, like limpets, or even ride across the steps of two adjacent bases. Many of these bases can be shown to be 'Roman' in date (first and second centuries AD) by technical details (namely technique and texture of the surviving courses); the crowding took place over time, and was determined by the limited space available, as well as the desire to avoid placing statues in the dead-end represented by the rear of the shrine of Zeus Agoraios, and in the thoroughfare leading down to the altar. What matters is that the series is not constituted in an orderly process, but as the result of a messy process of squeezing out all the maximum utilization of space.

The exact details are irrecoverable, since not one of these bases is inscribed and the whole series has never been investigated thoroughly. The series nonetheless clearly illustrates statue growth as part of a process of urban sedimentation. By this term, a metaphor borrowed from geology or archaeology, I mean the succession of statue events and urbanistic facts that produces an observable picture of layers, each reflecting intentions, actions, happenings. At Thasos, the orientation of the row of statues preserves the trace of an earlier feature, a vanished street or terrace above (and bordering) the agora. Furthermore, the 'limpet bases' and crowding of statues, in some places constituting a solid band of bases, also illustrate sedimentation and layering (in the horizontal rather than the vertical dimension) as a result of a long history of statue events. The situation, as revealed by excavation and still visible now, might be interpreted as the result of a process of jostling and competition. Competition for space—for a physical area to occupy, within the available surface in that particular site, determined by

[102] As shown by the eclecticism (or incoherence) of the secondary literature quoted, drawing both on humanities and radical traditions of geographies of place; but the study of the Hellenistic *polis*, and indeed ancient history, has been known to survive the perils of theoretical eclecticism.

[103] On the statue bases in front of the north-west portico, *Guide de Thasos*², 65, and better Marc, *Ville de Thasos*, 96 (twenty-one bases of statues, not thirteen as the *Guide* writes), 180–1 (bases later than the stoa, probably 1st cent. AD and later). G. Daux and A. Laumonier, 'Fouilles de Thasos (1921–1922)', *BCH* 47 (1923), 323–4 (discovery), F. Chamoux, 'Chronique des fouilles et découvertes archéologiques en Grèce en 1948', *BCH* 73 (1949), 544–7, nos. 5–8 (re-excavation, proposes two groups of bases, one earlier, one later than the stoa); R. H. Martin, *L'Agora* (Paris, 1959), 51–2 (dubious about Chamoux's proposal; along with Laumonier, argues for late bases on basis of *scellements*; different orientation of statue row reflects earlier terrace, on whose fill both the stoa and the statues stand). The view proposed here is a personal hypothesis. Generally, J.-Y. Marc, 'Urbanism et espaces monumentaux à Thasos', *REG* 125 (2012), 3–18.

urbanistic constraints; competition for limited resources such as attention, visibility, memory, situation within an order of statues—in other words, competition for place.

Competition could take simpler, more visible forms than jostling in a row of bases. In Athens, the view of a statue of Chrysippos was obstructed by an equestrian statue: 'In person he was shabby, as shown by the statue in the Kerameikos, who is nearly hidden by the horseman nearby; this is why Karneades called him *Krypsippos* (horse-hidden)'. Not at all a case of meaningful collocation: the 'Krypsippos syndrome' is simply a case of competition for attention by statues in a variety of formats, the larger and more spectacular monument winning out in visibility (but not necessarily in fame or in interest: the very fact of the statue of the famous Stoic being overshadowed makes the visit to see this statue more interesting and moving).[104]

Does sedimentation reflect competition as free-for-all? The northern and southern ends of the *dromos* (at either extremity of the 'southern stoa') on Delos seems to suggest anarchy, in the accumulation of 'double-parked' statues (Fig. 4.7).[105] At Olympia, in front of the *Echohalle*, as mentioned earlier, an equestrian base was set at an angle, to achieve prominence as the 'turning point' of the series of honorific monuments; another monument was later set up, or

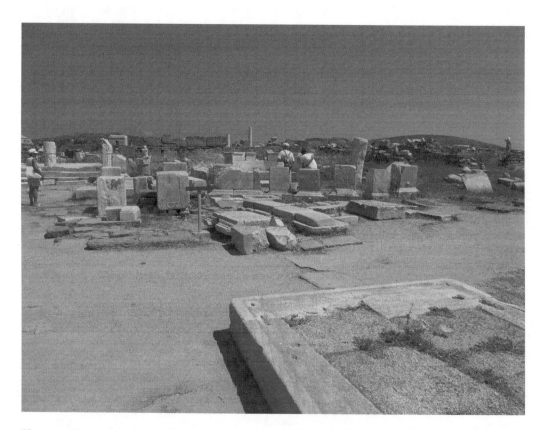

Fig. 4.7. 'Statue growth' could present very visible images of competition and 'double parking'; such phenomena must reflect specific social conditions that allow shared space to be occupied in certain ways. Northern end of the Dromos at Delos, showing complex, disordered layering of statue bases. Photogr. S. Dillon.

[104] Diogenes Laertius 7.182; probably the seated statue known from copies, and central to Zanker, *Mask of Socrates* (100–1); earlier, I have suggested that this statue was located in the gymnasion and that the equestrian statue represented a Ptolemy (above, 88 n. 148).

[105] R. Vallois, *Le Portique de Philippe* (Paris, 1923), notably 147; I am grateful to S. Dillon for discussing with me her forthcoming work on the *Dromos*.

Fig. 4.8. Monuments in series can try to 'end' the series by positioning themselves at an angle, so as to invite the passerby to turn at that point: 'statue growth' invites competitive strategies of spatial management. Bases at an angle, in front of the *Echohalle*, Olympia.

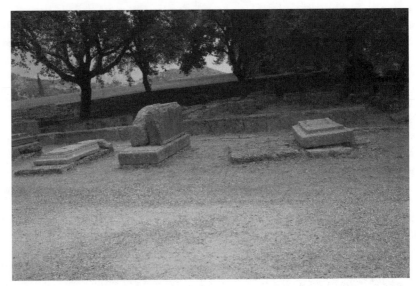

'double-parked' next to this base, to try to supplant it as the end and turning point of the series—the result, of course, was to weaken the impact of both statues (Fig. 4.8).

a. The Theatre at Magnesia on Maeander

Yet even 'double parking' can reflect deep historical processes and choices. In the theatre at Magnesia on Maeander, as mentioned in the previous chapter, the people set up a statue of the benefactor Apollophanes, another statue of (probably) a relative of Apollophanes (early second century BC?), and of the kitharode Anaxenor, a favorite of Mark Antony (who gave him administrative responsibilities and troops).[106] The two earlier statues occupied prime spots in the theatre, both *Orchestraecken*; the statue of Anaxenor was also intended to occupy such a spot—and was simply placed in front of one of the earlier statues (that of the probable relative of Apollophanes), in front of the end of the southern *parodos*. The base of Anaxenor was probably rather lower than the base of the older statue, but the new monument completely blocked out the inscription of the older (both inscriptions faced towards the orchestra).[107] The older statue, if it had survived so long, of a civic benefactor, certainly shown in *Normaltypus*-style himation and in restrained civic pose, was now second in line to the new statue of a benefactor also honoured as an artist, and perhaps represented in a venue-appropriate, attention-catching fashion, in his professional costume and with his instrument, and using the idioms fitting for artistic performance and inspiration. This is suggested by the inscribed base:

$[\dot{\eta} \ \beta o v]\lambda\dot{\eta} \ \kappa a\dot{\iota} \ \dot{o} \ \delta\hat{\eta}\mu o\varsigma$
$[\text{'}Av a]\xi\dot{\eta}v o\rho a \ \text{'}Av a\xi\iota\kappa\rho\acute{a}\tau o v\varsigma$
$[\kappa\iota\theta a]\rho\omega\delta\grave{o}v \ \delta\iota\acute{a} \ \tau\epsilon \ \tau\dot{\eta}v \ \grave{\iota}\delta\acute{\iota}a v$
$[a\grave{v}\tau]o\hat{v} \ \grave{a}\rho\epsilon\tau\dot{\eta}v \ \kappa a\dot{\iota} \ \delta\iota\grave{a} \ \tau\dot{\eta}v \ \grave{\epsilon}v \ \tau\hat{\omega}\iota$ 4
$[\grave{\epsilon}\pi\iota\tau]\eta\delta\epsilon\acute{v}\mu a\tau\iota \ \grave{v}\pi\epsilon\rho o\chi\acute{\eta}v.$

$[\hat{\eta}\tau o\iota \ \mu\grave{\epsilon}v] \ \tau\acute{o}\delta\epsilon \ \kappa a\lambda\grave{o}v \ \grave{a}\kappa o v\acute{\epsilon}\mu\epsilon v \ \grave{\epsilon}\sigma\tau\grave{\iota}v \ \grave{a}o\iota\delta o\hat{v}$
$[\tau o\iota o\hat{v}\delta' \ o[\hat{\iota}o]\varsigma \ \ddot{o}\delta' \ \grave{\epsilon}\sigma\tau\acute{\iota}, \ \theta\epsilon o\hat{\iota}\varsigma \ \grave{\epsilon}v a\lambda\acute{\iota}\gamma\kappa\iota o\varsigma \ a\grave{v}\delta\hat{\eta}.$

The council and the people (have set up) Anaxenor, son of Anaxikrates, kitharode, on account of his very own goodness, and his excellence in his art.

Forsooth this is a fine thing, to hark to a bard such as this man is, like unto the gods by his uterance (*sic*).

[106] *Inschr. Magnesia* 92 (with Holleaux, *Études*, i. 331–3), 129; Strabo 14.1.41.

[107] Hiller von Gaertringen, 'Theater von Magnesia am Maiandros', nos. 5–6, 14. The surviving heights of the earlier, 2nd-cent. bases (lower part of the *Abschlussposten* of the *parodoi*) are 83 and 81 cm; Hiller suggests that they were topped by a base of the same size. The Anaxenor base is 1 m tall, but Hiller does not indicate whether it sat directly on its foundations, or on a heightening step or block. There is no way of confirming *de visu* today, over a century and a decade after excavation (the site of the theatre is now an orchard and a scrub-covered hillside).

The inscribed base mentions Anaxenor's moral quality but also his artistic specialization, and completes the honorific caption with a pretentious quotation from the *Odyssey* (9.3–4)—complete with the widely noticed malapropism in the omission of the adscript iota in the dative in the last word, as mentioned by Strabo sarcastically (and pedantically, by the first century BC). The placing of the statue might seem a crass and heedless act of 'double parking'; but there were reasons which gave meaning to this particular instance of sedimentation in Magnesia. The two statues of Apollophanes and (probably) his relative, occupied both choice spots, and mirrored each other, since they took the same form of statue atop a base inscribed with a long decree; perhaps the position and even physiognomy of both statues created links from one post to the other on the edge of the orchestra and the retaining walls. This pair of statues reflected the importance of the financial services rendered by one family, which left its mark on the theatre they had helped build (Apollophanes' son, Demetrios, was put in charge of the second statue, that of Apollophanes, in front of the southern *parodos*). By the time of the first century, a major role was played by the 'new euergetai', local men with access to the Roman leaders and patrons (Theophanes of Mytilene and C. Iulius Zoilos of Aphrodisias are two well-known examples).[108] The Magnesians paid homage to their own 'new euergetes', but with delicacy and thought, no doubt after negotiating with Anaxenor about how best to find a place for visual representations of his status within his community. They probably did not tear down one of the pair of statues of the second-century benefactors, but set up a statue in one of the prime sites. The juxtaposition, visible from all points of the *cavea*, was a response to new conditions; but it also tried to integrate these conditions, rather than make rupture too manifest—by keeping sedimentation rather than promoting *tabula rasa* (for instance by renaming both statues of Apollophanes in Anaxenor's honour); by setting up the new statue on a lower base than the older one, so that the descending line from the *parodos* to the orchestra was preserved; by opening the possibility that yet more benefactors would complete the sequence and deserve a statue on the other side of the orchestra.

In addition to his bronze portrait, perhaps as a kitharode, in the theatre, Anaxenor was honoured with a painted portrait (no doubt full-size and *en pied*) in the agora, wearing the garment of the priest of Zeus Sosipolis, as Strabo reports. The statue in the theatre and the painted portrait in the agora are another representation of Anaxenor's importance, celebrating the diversity of his excellence (a standard strategy to manifest elite qualities in the face of the homogenizing force of the honorific portrait and its inscription); the monument for Anaxenor in the theatre constituted another 'layer', that extended to include the agora and its second monument for Anaxenor the priest. Strikingly, the inscription for the statue in the theatre mentions only moral excellence and artistic virtuosity; the portraits of Anaxenor studiously avoided mentioning the powers he wielded at the behest of the triumvir, Mark Antony. The celebration of his other qualities (perhaps including priestly piety) served as a metonymy for his anomalous situation as a 'new euergetes'; civic space was made to express the new power of the triumvir's friend—but with a margin of control and precaution for the civic community, and offering Anaxenor, the new-style 'super-euergetes', ways of integrating his status within the pre-existing civic topographies, as a promise of continuity and acceptance within civic norms, no matter what the events.

After Actium, the portraits of Anaxenor were not removed, but their meaning may have retreated to the literal qualities celebrated in them, and which had been encoded in them as insurance policy, albeit with different aims, for all the parties involved, city and benefactor: a kitharode in the theatre, a priest of the great civic deity in the agora. Yet knowledge about Anaxenor persisted, and the sight, in the theatre, of the layering of statues (great benefactor of the second century BC, 'new euergetes' of the 30s BC), suggested the layering of history—and a message about a particular place, the theatre of Magnesia, and Magnesia itself.

[108] Robert, *OMS* v. 561–83; Smith, *Monument of C. Julius Zoilos*.

Anaxenor became 'simply' a priest, a singer. Likewise, several of the statues for poets set up in the *parodoi* of the theatre of Dionysos at Athens (including the statue of Menander; below, Chap. 8) in fact honoured men close to the pro-Antigonid regime which held sway during the second period of control by Demetrios Poliorketes (295–287); after the end of Antigonid control, they were kept on, 'simply' as statues of poets, and their meaning shifted.

b. The Amphiaraion near Oropos

Sedimentation allows us to read processes of competition off the archaeological record, but also forces us to think about how the stakes of competition, and the world within which it takes place, evolve in time. Another well-known site of 'statue growth' is the terrace of the Amphiaraion at Oropos, mentioned often in this chapter and the previous one (Plan 3). The site preserves a dense array of statue bases, excavated *in situ*, and studied in a ground-breaking article by C. Löhr. The bases are inscribed with proxeny decrees, often dated by the archons of the Boiotian Federation, which have been set in a chronological sequence by R. Étienne and D. Knoepfler; in addition, the artists' signatures provides important indications on dating; finally, the place where the proxeny decrees have been inscribed provide important clues on absolute and, just as importantly, relative dating (since, in some cases, they are inscribed on those sides of bases that were rendered inaccessible by other bases, thus giving clear indication of chronological priority). All the epigraphical material has been presented anew by V. Petrakos, with careful illustration and detailed notes on the exact spot where the texts are inscribed.[109]

It may be worth signalling here that there are also considerable problems with this material. The record is not complete, in spite of the impression given by current *anastylosis* of various elements (1984)[110] and by Petrakos's map (1968) of the site, usually reproduced. This map is, inevitably, a simplified representation of what seems to lie on the ground, and hence slightly misleading: the spaces between some bases are represented as far too wide; various foundations are not represented at all. There are 'floating bases', such as that for the late fourth-century Boiotian statesman Peisis (*Oropos* 366), which is a very early honorific statue, and must have been an important part of the statue series, but which cannot be assigned to any spot. Likewise, the bases *Oropos* 375, 420, 443, 450 were found in the area of the terrace but without precise ancient location: are they to be assigned to visible foundations? Or did they come from other locations, such as the temple or the environs of the sacred fountain? In other words, were they transported when the area behind the row of statues was used for the construction of a Byzantine monastery? Nearly each one of the great equestrian bases was reused for Roman officials and generals (with one exception, a man from Andros, perhaps a friend of a Roman general), so that the loss of the original inscriptions deprives us of the possibility of the exact sequence.

Nonetheless, the following features may be outlined, at the risk of over-simplifying the complex history. The statues fall in three groups, western, middle, eastern. The western group started earliest, with at least one equestrian statue set up *c*.300, and others clearly dating to the early Hellenistic period.[111] The middle group might have started slightly later: the earliest monument is the statuary group honouring the Troizenian Diomedes for liberating his city (probably from the Spartan Kleonymos *c*.275); it was joined, at a date unknown, but before *c*.230, by two equestrians.[112] The eastern group, made up of private honorific statues set up by

[109] Löhr, 'Statuenbasen im Amphiareion von Oropos'; Étienne and Knoepfler, *Hyettos*; Petrakos, *Oropos*.

[110] Base 16 (reused for an Andrian, *Oropos* 452) is now set up on a modern concrete block.

[111] The large equestrian base reused for Agrippa is earlier than the statue set up by Lysimachos for Hadeia (*Oropos* 283), at a date generally agreed to fall between 287 and 281, since the latter statue is set up on a large step which rests on the *euthynteria* of the equestrian base (above, 119 and Fig. 4.3).

[112] The proxeny decrees on the right-hand side of one of these bases date to *c*.230 and provide the *terminus ante quem*.

Oropians, starts *c*.230, with rapid growth.[113] The character of this group is clear, because all of the original dedications are preserved. For the two other groups, however, the contrary is true: most of the original dedications were erased and the statues relabelled as Romans. Some original honorands are known (Hadeia, Diomedes). It is at least possible that the two groups had different characters: royal honorands in the west (characterized by great equestrian statues), civic in the middle, dominated by the statue group honouring a great civic fighter, flanked by equestrian statues as well (which I would hypothesize to be e.g. officers of the Boiotian League).

There are some bases which it is difficult to explain along this scheme of three differentiated groups. Within the western group, the early private statue of Megakleides, set among equestrian statues and the statue of a Hellenistic queen, seems out of place. In addition, the 'secret dedications' written on the back of bases 22 and 15 mention private citizens of Oropos, and might preserve the original dedications of the statues. Among the central group, next to equestrian statues and the statue group honouring the Troizenian hero, the statue of a woman (reused for a Roman lady, Popillia) seems anomalous (base 11). Within the eastern group, the great base for Ptolemy IV and Arsinoe IV, as well as an equestrian (reused) do not fit in with the other statues in this part of the terrace, which are private honorifics of men and women; it is clear that the equestrian (base 8) was set up next to a private monument soon after the latter was set up.[114]

What matters is that the scheme allows us to notice such anomalies, and invites us to examine such 'statue events' more closely, even if the exact motivations are irrecoverable. In the case of the western group, the presence of non-royal statues in this highly visible spot (directly across from the temple of Amphiaraos), among large equestrian statues (and the specially heightened statue of Hadeia) raises the possibility of an intended effect, aiming to prevent the colonization of this area by royal statues: both a private statue and, perhaps, public statues for Boiotian officers (if this is what monuments now bearing the inscriptions *Oropos* 446 and 444 are, one perhaps paid for privately) testify to this joint effort by a number of local actors.[115] In the middle group, the female statue, reused for Popillia, can clearly be dated after its formidable neighbours, the Anthas-Diomedes group and an equestrian, since the bases are both inscribed with proxeny decrees on the side of the female statue, and to inscribe the decrees in these places with the female statue in place would be technically arduous, and condemn the decrees to invisibility.[116] Because the female statue and its equestrian neighbour were reinscribed, we cannot know if there was any ideological connection or significant effect produced by the placement of the female statue. However, this statue exploited the location, by placing itself between two highly visible monuments, and also by bridging a slight angled gap between the two equestrians and the monument for Diomedes: this created a series, and the appearance of continuity, which may have helped compensate for any incongruity of this female statue among male statues. In the eastern group, the placement of the statues for Ptolemy IV and Arsinoe III (and the adjacent equestrian) can be dated to the 220s or later—in other words, they did not constitute an isolated group later caught up by the creep of the eastern private monuments, but were set up at a time when the eastern group was more or less constituted; indeed, they stopped any eastwards progress of the group of private statues. The reason may be practical: the western group may have been approaching its capacity. But the choice of an

[113] Monuments 5 (Ptoion, Aristonike) and 7 (Diodoros and Phanostrate) can be dated before 225 by proxeny decrees carved on their left face (*Oropos* 76–7, 173); monument 6, which bridges the two, was set up before 217, as shown by the proxeny decrees (*Oropos* 79–80). In addition, monument 7 rests on the foundation of—and hence is later than—monument 6 (both monuments are so close that their *euthynteria* courses touch).

[114] Monument 7 can be dated to before 225; its base bears the date the statue was set up, in 221 BC (*Oropos* 421: priesthood of Olympichos, who is known to have served when Potidaichos was archon of the Boiotian League).

[115] This is my interpretation of the 'hidden dedication' on the back of 446, *Oropos* 441, a family-financed public monument (like the monument for Eugnotos of Akraiphia: *ISE* 69).

[116] *Oropos* 54, 61, 62.

Fig. 4.9. Yet another actor in the 'ecology' of the shrine was public inscription—for instance of public documents—on the surfaces presented by the bases of honorific monuments: 'epigraphical pigeons'. Proxeny decrees inscribed on base of Agrippa (reused), Oropian Amphiaraion.

eastern placement also favoured the royal statue group: in quality, in site, perhaps in size, in identity, the royal monument contrasted with its private neighbours, and hence gained a prominence which it could not have retained in the crowded western group with its royal monuments (and, as I suggest, its struggle for eminence between big royal monuments and pumped-up civic monuments). Precisely because they did not fit into the series, the royal monuments remained 'big fish'—countering and overturning the workings of the statue series, in order to achieve prominence.

In addition to these instances of competition within the space of the esplanade, there is another layer to the statuescape: the proliferation of inscribed proxeny decrees, almost all passed by the *polis* of Oropos. Decrees took over all the available surfaces on the two large bases, Hadeia and (Agrippa)—to the point that the part of the equestrian base that protrudes is covered with inscriptions (Fig. 4.9) The phenomenon starts *c*.230–220, taking over the large bases of the western and middle groups; it is contemporary with the appearance of private honorific statues by and for members of the Oropian elite, in the eastern group, where a few decrees appear, as noted above, *c*.225, but the bulk of the decrees is inscribed around 200. The decrees use the bases as habitats, and exploit the visibility of the statues to achieve their own aim of publicity; they act as 'epigraphical pigeons' on the monuments, or parasites. At times, they seem to enter in competition with the statues: some statues are placed in such a way that they block off the visibility of decrees inscribed on earlier statue bases—as if trying to block the progress of the parasitical species of honorific decrees. This is visible already in the eastern group, when private honorific statues and the public inscribing of proxenies must have taken place side by side.

Yet the city of Oropos—for its activity lies behind the proliferation of decrees—had the last word. The last 'layer' in the statuescape is the pattern of reuse and reinscription of earlier bases that so thoroughly prevents us from fully understanding the earlier statue events, but that constitutes an event in its own right. The city of the Oropians, when it re-emerged from two generations or so of dormancy *c*.86 BC, perhaps having been under Eretrian control,[117] started using earlier statues as a resource of its own, rededicating earlier statues, especially equestrian, to Romans; as mentioned above, the order of dedication can be traced chronologically, and the criteria for the choice (size, visibility) can be guessed at.

Competition for space, the succession of statue events legible in their horizontal stratigraphy, and the overall presence of the *polis*, as authority managing public space, exploiting it, but also as a presence within public space, in competition with other actors: these are some of

[117] Knoepfler, 'Mummius'.

the traits that appear in the test case of the Amphiaraion. The shrine appears as a richly storied place, crammed with layers of events. What consequence does this test case have for our views of how the civic 'takes place', in practice and on the ground? The answer might lie in yet more test cases.

c. The Agora of Priene

Many other examples could be explored—for instance, the succession of bases in the small space of the Artemision at Messene; the statuescape of the Asklepieion at Epidauros, across time.[118] A particularly interesting case that shows layering of statues in place is the agora of Priene,[119] which I will revisit here, since it powerfully illustrates yet more aspects of place—in this case, elite competition and inventiveness in the face of massive intervention by public authority.

By the late third century BC, the Prienians had given their agora its definitive shape as an open space surrounded by stoas on three sides (west, south, east: early third century), defined by a broad street (West Gate Street) in its northern part; beyond this street, six steps led to a terrace in front of another stoa (the 'double stoa'), to the east of which stood the *bouleuterion* (both the double stoa and the *bouleuterion* date to the late third century). The agora was an honorific site—indeed *the* honorific site: the Prienians set up honorific monuments in various sites: in front of the west stoa, the earliest monuments, equestrian statues (such as that of Larichos, the Seleukid Friend installed in Priene) built on solid foundations which rested on bedrock; perhaps a few monuments in front of the east stoa, and the southern stoa;[120] a row of monuments on the terrace in front of the northern stoa (one foundation has been located in a sounding). Honorific inscriptions were also carved on the unfinished column drums of the southern stoa. The honorific monuments almost certainly behaved in the ways outlined above: a jostling of bases, competition for the limited resources of space and attention, crowding, opportunistic collocation by 'limpet bases'.

Two bases are still *in situ* that bore statues for the same man, Apollodoros (Fig. 4.10), one a public monument, the second a privately dedicated statue:[121]

ὁ δῆμος
Ἀπολλόδωρον Ποσειδωνίου
ἀρετῆς ἕνεκεν καὶ εὐνοίας
τῆς εἰς αὐτόν.

The people (has set up) Apollodoros son of Poseidonios, on account of his goodness and his goodwill towards it.

Βασιλείδης καὶ Καλλινίκη
τὸν αὐτῶν πατέρα
Ἀπολλόδωρον Ποσειδωνίου
ἱερητεύοντα Βασιλεῖ
καὶ Κούρησιν.

Basileides and Kallinike (have set up) their father, Apollodoros son of Poseidonios, as he was priest of Basileus and the Kouretes.

[118] Artemision: the publication by H. A. Chlepa, *Messene: To Artemisio kai hoi oikoi tes dytikes pterygas tou Asklepieiou* (Athens, 2001) is unhelpful for the questions of the construction of space and the experience of place, such as this chapter pursues. Epidauros: the full publication of the bases, completing Hiller in *IG* 4² 1 and W. Peek (*Asklepieion von Epidauros* and *Neue Inschriften aus Epidauros*) would require a monograph of its own.

[119] Above, 98–9, for bibliography. The account here is narrative, and somewhat personal. See now Bielfeld, 'Polis Made Manifest', for a parallel analysis of the politics of visibility in the agora of Priene.

[120] Traces of foundations are visible in the map in Wiegand and Schrader, *Priene*.

[121] *Inschr. Priene* 186, 236 (early 2nd cent. BC); Raeck, 'Der mehrfache Apollodoros'. Apollodoros was probably one of the envoys representing Priene before a Rhodian arbitration panel in the city's territorial dispute with Samos (*Inschr. Priene* 37, line 16), which confirms the dating.

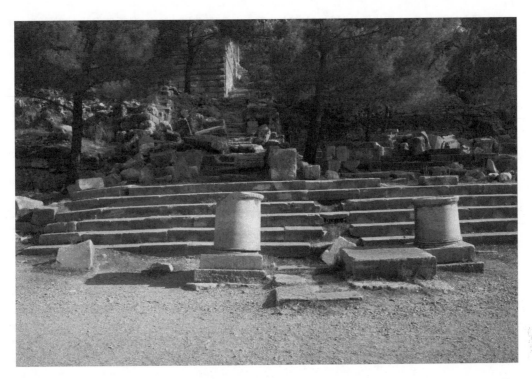

Fig. 4.10. The two statues for the same Prienian notable, at a very prominent spot in Prienian space, offer an instructive case for the phenomenon of honorific statues in action. Bases of statues for Apollorodos, Agora of Priene, *c*.200.

What the private statue is doing on the agora, and indeed what type of monument this is, will be the subject of the next two chapters. For now, what matters is to observe how the pair of statues occupies a very prominent spot, already discussed, the intersection of the stairway to the shrine of Athena and the West Gate Street. The statues stand a few metres apart, the left-hand statue not quite aligned with the edge of the stairs leading to the shrine; the pair perhaps frame a path for the Prienian stepping out from the west stoa and heading at a slight angle towards the edge of the northern terrace—or forces him to choose not to walk between the two statues. The presence of two statues, one public for Apollodoros the good citizen, one private for Apollodoros the priest, results from the desire to cement control of this particular spot, and also displays the diversity of Apollodoros' identity (rather than allow it to be captured by the role attribution represented by the public honorific statue: see above, Chap. 2); the effect is reinforced by the existence of yet a third statue of Apollodoros, in the theatre.[122] The strategic choices and the necessity to appropriate territory give a sense of the pressures that almost certainly held sway in the original main statue spaces in front of the stoas; the agora was a space of competition, and of multiple urban meanings that produced a complex, layered place.

What is particularly striking is the presence of private honorific monuments in the public space of the agora: in addition to the statue of Apollodoros son of Poseidonios, the three statues of members of one family as priests were set up as a single monument, and the statue of one Apollodoros son of Diodotos (early second century?), captioned in the bald nominative, probably came from a multi-statue family monument set up by private initiative, judging from the formulation of the inscription. The traces point to an ebullition of individual affirmation and monumental place-staking.

[122] *Inschr. Priene* 237; above, 91–3, 100.

In the late second century BC (*c*.130?), a major event modified the urban space of the agora at Priene. The northern stoa was dismantled and replaced by the 'Sacred Stoa', larger and longer (now fronting the *bouleuterion* to the east of the old agora proper); the reconstruction was paid for by a member of the Ariarathid dynasty. The Sacred Stoa was used as an honorific site—the western wall was used to carve the very long decrees for the great benefactors of late Hellenistic Priene—but the stoa was not used as a backdrop for honorific statues, as so frequently in Hellenistic agoras: the northern terrace was kept largely free of honorific monuments. Instead, the statues that once stood before the now demolished 'double stoa' were relocated to the 'main series' that lined the agora, a densely packed row of multiple-statue monuments, variations on the exedra genre (straight, *pi*-shaped, horseshoe-shaped), that started at the end of the west stoa, ran south, then across the agora, and lined the end of the east stoa. Similarity in texture, and details of construction, make it likely that this series was constituted in one go (the foundations of various bases are bonded; foundation blocks bear mason marks attesting to reassembly). This major piece of urbanism involved the displacement and re-erection of nearly thirty monuments, involving perhaps sixty statues.[123]

The result was the constitution of a gallery of statues, offset by 9 m from the line of the West Gate Street. Since all bases (and all statues, as always) are lost, we do not know how the old statues were rearranged in their new settings: how statues were grouped, which order they came in—such questions must have been settled by much negotiation and bargaining between the city and groups which still had a stake in the monuments, but also by general aesthetic and political considerations. The series offered variation—in the appearance of the bases, in the date and appearance of the statues (some isolated long bases bore equestrians or seated statues), in the nature of the bodies doing the honouring, in the identity of honorands and the backstories, more or less explicit, more or less remembered, surrounding the statues. But the series also unified, as was the effect and function of this type of spatial configuration: the 9 m space added on to the width of the street and that of the northern terrace created a powerfully structured space bordered by statues to the south and by the new stoa to the north. The royal benefaction to the north was balanced by the rows of benefactors to the south; the architecture of columns, esplanade, and stairs by the architecture of arrayed statues and exedras. These exedras were built with benches that may have served for seating during civic ceremonial (processions? meetings?) or simply during daily interaction and promenade, just like the six steps to the north of the street. The 'main series' carved, out of the old agora, a place with its particular meanings and workings: a concentrated honorific site, a ceremonial ensemble, an early and idiosyncratic version of a 'statue-street' like those found in Roman-era cities, a particular monumental vision of Prienian history as that of benefaction and response, of civic agency unfolded in bronze and marble, of good men (civic or royal, citizen or foreign) embedded within an architecture of civic meaning across time, a place where movement and repose would have taken place in a state of particular awareness of the proclaimed ideologies of the civic community. The concentration of monuments transformed the isotopic space of the agora (where daily human life balanced the idealized images of political activity and identity proposed by the honorific images) into a concrete utopian place, where the euergetic model of the good citizen was the dominant, normal model of what people should be, or even were.[124]

An honorific site as coherently constructed as the late Hellenistic agora of Priene is interesting not only for what it wants to tell us, but also for what it hides, or does not manage to say.

L'espace produit pour être lu est le plus tricheur, le plus truqué des espaces. La lisibilité dissimule. La monumentalité impose toujours une evidence lisible, elle dit ce qu'elle veut, elle cache beaucoup plus. Politique, militaire, à la limite fasciste, le monument abrite la volonté de puissance sous des signes et des

[123] The number is my own guesstimate; generally, von Kienlin, *Agora von Priene*.
[124] On the agora as complex space of daily interaction, Millett, 'Encounters in the Agora'. Isotopia and utopia: Lefebvre, *Production*, 190.

Fig. 4.11. The reorganization of space at Priene created representational spaces of high visibility, but also awkward dead ends. Gap between foundations for bases of 'main series' across Agora of Priene, and older bases lining the western side of the open square.

surfaces qui pretendent exprimer la volonté et la pensée collectives. Et qui occultent à la fois le possible et le temps.

The space produced to be read is the most mendacious, the most rigged of spaces. Legibility works to dissimulate. Monumentality always imposes a legible evidence, it says what it wishes to, and dissimulates much more. Political, military, all but fascistic, the monument shelters the will to power under signs and surfaces that claim to express collective will and collective thought, and which obscure the possible and the dimension of time.[125]

The 'main series' divided up the space of the agora: what remained of the square itself, behind the series? One effect was to create a dead angle, between the beginning of the long row of statues across the agora, and the formerly most prominent, and oldest, series of statues, the monuments for Seleukid kings and their friends set up in front of the west stoa. Several of these monuments were now blocked off by the bulging back end of a horseshoe-shaped exedra, which came as close as 1.12 m to the nearest monument—too close to allow real viewing of the older monument, and barely enough for a Prienian to brush (or to huff) past the older monument and the 'service end' of the new monument (Fig. 4.11). It is possible that some of the statues in the western row, for instance representing Prienian statesmen, were removed and integrated with the 'main series'. Looking at the older monuments further south from the 'main series' perhaps involved awareness of the gleaming row of bronze backsides and the inexpressive rear ends of bases and exedras that constituted the southern view—a view which generally characterized the rest of the agora apart from the new representational space. The older monuments were the remnants of the history of Priene in the high Hellenistic period, as a city caught in the paradoxes and problems of the relations between city and ruler, a history which the new organization of the agora left in a spatial backwater, as a result or an implicit declaration. The effect of a backwater may have been reinforced if some statues (for instance those of Prienian statesmen) were removed for inclusion in the new 'main series', and some (for instance those of kings) left behind—their isolation signifying not splendid prominence, but irrelevance, or even dereliction, in contrast to the modulated integratedness and spectacular presence of the new series.

The situation left most of the agora as a non-marked space. Some statues were set up on the eastern side, though it is difficult to understand the exact articulation and effect of what seems to have been a double row of monuments (did it act as an alley of statues leading into the agora?); the caption for one of the statues, from the large horseshoe-shaped exedra on the

easternmost row, is in the nominative ('Meniskos'), and accompanied an over-life-size bronze statue resting on a spear or staff.[126] Two large, squarish, nearly identical foundations are located immediately south of the 'main series', near its western end (21–2 Wiegand-Schrader). They are close enough, and similar enough in texture and technique (complete with the mason marks), to be considered as part of the 'main series'. They must have carried *pi*-shaped exedras with several statues—facing south, on to the square, since they would have been hidden to a spectator standing north of the 'main series'. The Prienians' intention may have been to start a second series, parallel to the north-facing series, but looking onto the square—to try to correct the situation by which the southern two-thirds of the agora were 'in the back' of the main line of statues. However, any statue in this position was necessarily in a less privileged space than those in the new honorific passage.

The 'seeding' of statues behind the main series had little effect, and the two exedras remain largely isolated in their southwards-looking position (another statue was set up immediately next to the western exedra; a private *ex testamento* base, 23 Wiegand-Schrader, south of the exedras, is almost certainly not *in situ*).[127] The impact of the new statuescape in the agora of Priene was to provoke a quest for space and attention away from the overwhelming new series. One particular niche which was probably occupied at this moment is the northern face of the west stoa, facing on to the intersection of West Gate Street. A statue base *in situ*, in front of the column that stood in the middle of the entrance of the stoa, can be dated *c*.100 (on palaeographical grounds).[128] Space, however, was limited, and quickly crowded (Fig. 4.6); a consequence was that monuments in this site had to be small—the surviving statue base, with its mini-bench, illustrates this limitation, and belongs to a monument set up not by the city (or a rich family), but by a tribe (Pandionis).

Another, much more desirable spot which was taken over lay on the other side of the West Gate Street, the site occupied by the two early second-century statues of Apollodoros discussed above. Two statues were erected between the two earlier monuments, one probably a seated statue; the foundations of the base for this latter statue incorporate a reused *Deckplatte* from an older statue base. These two new monuments were perhaps set up for descendants of Apollodoros; at any rate, they disrupted the carefully created, diversified effect of the two statues, and their grip on a particularly prominent spot in Prienian civic space. The *pi*-shaped exedra at the western extremity of the terrace in front of the Sacred Stoa deserves particular attention. It bore two private statues for men of the same family, Diokles and Athenopolis, set up towards the end of the second century. Athenopolis is celebrated in epigrams for his athletic victory at Epidauros, and the traces on the crowning block make it likely that both Athenopolis and Diokles were represented as athletes, in vigorous movement (though the statues were set up after their deaths, in the case of Diokles by his grandsons). This monument chose a particular idiom (athletic statues) and register of excellence, and occupied a uniquely prominent spot; even though it constitutes an exception, it can be viewed as a response to the new situation created by the presence of the main series.[129]

[126] *Inschr. Priene* 284; the stone, from its shape clearly belonging to the central statue of the exedra, is still on the site.

[127] *Inschr. Priene* 275: the large block comes from a larger monument, as shown by the clamps on its superior surface, and does not rest on any foundation or *euthynteria*, so that the inscription is now at shin-height, which cannot have been the ancient appearance of the monument this base once belonged to; the absence of foundation also makes it certain that this is not a block reused as an *euthynteria* course.

[128] *Inschr. Priene* 248, with dating by Hiller; I thank C. Crowther for views on this document (personal communication; dating proposed with hesitation).

[129] *Inschr. Priene* 268; the date can be determined from the stemma of the family. On the epigram, Robert, *OMS* v. 357 n. 6 with bibliography (Ebert, Moretti, earlier Robert). The family is also known, for instance, from *Inschr. Priene* 162, roughly contem,porary: a monument with three statues, for members of Athenopolis' family and commemorating their tenure as priests.

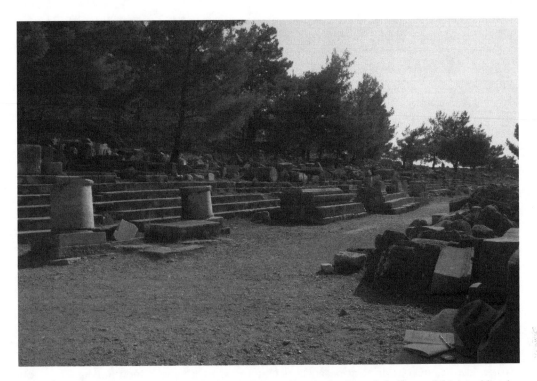

Fig. 4.12. The reorganization of space at Priene also may have had unintended effects, of driving old-style, organic statue placement in spots other than those offered by the 'main series'—the phenomenon is one of 'hydraulic pressures'. New statue growth in the Agora of Priene, at the highly prominent spot at the northern end of the West Gate Street as it nears the intersection with the stairway leading to the shrine of Athena.

Finally, four monuments (of which three were exedras) were set up along the West Gate Street, at the foot of the stairs leading to the northern terrace and Sacred Stoa (Fig. 4.12). The surviving inscriptions from one of these monuments show that it combined public statues (for a benefactor, Thrasyboulos son of Demetrios) and private statues, including a statue for a woman, Herostratis, daughter of Helikon, honoured by her son Demetrios (probably Thrasyboulos' father).[130] The monument combined genres, and statues from different generations (see below, 164–5, on such 'portfolio monuments')—it may have echoed the type of monuments erected on the other side of the street, in the 'main series'. The final base in the series carried a simple standing statue, and is placed so close to the exedra to its west that one of its courses bit into its neighbour—another example of the 'limpet base', for some reason very eager to take a place as close as possible to another monument (there can be no explanation in terms of lack of space).

These monuments started another series, facing the main series—with the result of turning their back on the northern terrace and the Sacred Stoa, which indicated the desirability of a place on the elongated space between the flight of six steps on the northern edge of the street and the 'main series'. This new series, as yet another overlay of statues in the agora, changed the dynamic of the space created by the main series, by interposing the beginning of a screen of statues between the main series and the northern monumental ensemble (two flights of stairs, Sacred Stoa). The one family that can be identified, that of Thrasyboulos, son of Thrasyboulos, was one of the leading families of the city, which gives an idea of the importance of the actors

[130] *Inschr. Priene* 99–104, *c.*100 and later.

which occupy this spot.[131] However, at this point, statue growth stopped in Priene, for whatever reasons (economic? culturally determined?): when the late Hellenistic benefactor Zosimos was honoured with portraits in 'the most prominent' spots, the sites at the Prienians' disposal were those which we can still map now, in a public space which was approaching saturation.

6. UNITY AND SEGMENTATION

Honorific statues structured public space. In many cases, statues unified: the gradual accretion (or sedimentation, to use the geological metaphor deployed earlier) took place within unitary schemes, such as the joined-up archipelagos mentioned earlier. This seems particularly true for shrines. At the Oropian Amphiaraion, the diverse areas of statue growth joined in an array of statues along the same north-east–south-west axis as the rest of the shrine area; the statues series formed an esplanade, at right angles to the temple, and facing on to the monumental fountain and the river gorge (Plan 3). At Dodona, honorific statues lined the precinct wall, as well as the street joining the temples, the *bouleuterion* and the theatre (Plan 7). In the space of the Epidaurian Asklepieion, the rows and clusters of statues constituted a whole, structuring the space of the shrine according to movement towards the important focal points, and passageways linking these focal points: the temple, the altar (united by the façade of building E and its line of honorific statues), the Tholos (see above, 108–9; Plan 4).

But honorific statues could also tend towards the segmentation of public space into smaller sub-spaces, where the meaning and impact of certain statues was effective, but limited by spatial factors, such as disposition and orientation. Most honorific monuments face in one definite direction; even if they can be viewed from different angles, they have a back. Unless statues are placed against dead space (walls, niches), and especially if they are free standing, they address certain privileged segments of the space they are placed in—and turn their backs on the rest of the world. This can even be observed in a pan-Hellenic shrine, the Altis at Olympia, where spots of particular frequentation (esplanade in front of temple of Zeus, path from Pelopion to esplanade, path along the south side of the temple) attract statues, which turn their back to the rest of the shrine. In the agora of Priene, the 'main series' divided the agora into several parts: the smaller, more intense, quasi-utopian honorific esplanade in the northern part, the less marked square of the agora, now lined with the back ends of monument after monument; the crowded north-west angle, where the urban remodelling of the agora drove later honorific statues. As argued above, the late monuments along the northern edge of the West Gate Street threatened to divide the honorific esplanade.

The agora of Thasos (Plan 9) offers a particularly interesting example of an assembly of directional spaces, created and addressed by groups of statues, but not quite cohering within the broader space of the public square. The large and impressive north-west stoa looked onto a row of honorific statues in front of it (and perhaps an honorific base at right angles to this row), but also the back of the temple of Zeus Agoraios, a dead angle where no monuments stood; further on, the monument of Theagenes (surrounded by some clear space), the statues linked to the imperial cult of the Julio-Claudian house, and a dense variety of now unidentifiable bases in the centre of the agora: the orientation of most of these is unclear, but whatever choices were made by those who set up the monuments, they always entailed orienting statues in a certain direction (towards other statues, or expected areas of frequentation), and away from others. Most strikingly, the five exedras facing the south-west stoa line the pathway towards the altar—and are situated so as to look away from the whole of the rest of the agora. An exedra linked with the cult of Livia was set up outside the agora, against the back wall of the north-west stoa; it was later surrounded by a *peribolos* of its own. The aim may have been to

[131] Fröhlich, 'Dépenses publiques', in Fröhlich and Müller, *Citoyenneté et Participation*, 225–56.

occupy a prominent space on the harbour, but the position may also have been motivated by a desire to avoid the cluttered agora proper; perhaps the very idea of finding a privileged spot, and later of enclosing it, was favoured by the segmentation of space in the Thasian agora.

Less emphatically, a large, complex space such as the Athenian Agora could be structured by groups of honorific statues into sub-spaces (western street, north-western cluster; Stoa Poikile; Stoa of Attalos; Panathenaic Way), rather than as a single unity (honorific statues probably did have that effect in the stoa-lined *dromos* leading to the Agora proper). Even apparent unities were in fact constituted by subgroups: for a viewer *c.*200, the line of statues in the Amphiaraion could easily resolve into its constituent three groups with different compositions and feels (western, central, eastern private statues). The honorific monuments in the Epidaurian Asklepieion have a different configuration and shape, according to position (and available space): the expansive, homogeneous exedras in the open space north-east of the temple made for a very different statue experience from the cramped world of jostling statue bases south of the temple (with some larger players, such as equestrians or big exedras).

Why does segmentation fostered by honorific statues deserve interest? It would be easy to minimize this phenomenon, and to consider it 'natural'. For instance, segmentation could be explained away simply as the result of practical imperatives—the desire for visible spots, concrete choices to achieve prominence. The north-west corner of the Athenian Agora was lined with a series of statues along the start of the Panathenaic Way, monuments which necessarily turned their backs on the triangular space within the acute angle that constituted the corner. But such practical choices, and their supposed necessity, are based on the privileging of certain aims, and the acceptance of certain consequences: the non-visibility of a statue from certain places, or by certain people, being viewed as unimportant; the differentiation of spaces. All of these consequences have political force, and need to be analysed in political terms. In the north-west corner of the Athenian Agora, the monuments turned their backs on what was once a sacred area, with a disused Classical-era shrine, and a well, in which were discarded the fragments of a gilt-bronze equestrian statue (perhaps representing Demetrios Poliorketes): this place of forgetfulness, of mundaneness (a late Hellenistic sewer crosses the area, cutting across the Classical shrine), occupied one of the most prominent spots of the agora, immediately behind the row of statues on the Panathenaic Way. Differentiation resulted from choices, and performed functions on the ground.

Another way to interpret, and minimize, segmentation would be to aestheticize it, in terms of 'serial vision' (Gordon Cullen): we could imagine viewers in public spaces such as the agora encountering, and delighting in, constantly shifting experiences and sights. To find oneself 'behind' a statue or an exedra could be understood as a dynamic invitation to go round and discover what the front of the monument showed through sculpture and said through inscribed text on or near the statue base. Walking in a stoa, and looking out on the backs of honorific statues, might evoke in the viewer the remembered or anticipated image of the effect of walking in front, or along the front, of the array of bronze benefactors. Or we could imagine that, in day-to-day interactions, the inhabitants of Priene or Thasos or Athens learnt to live with an unevenly distributed, multi-centred public space, broken into a variety of places and meanings; they knew when to look (when walking by the exedras in the south-west of the Thasian agora), and when not to look or to notice (when looking out onto the 'back' of statues, when squeezing past the rear end of one exedra monument and under the unviewable front of another). More simply, we should acknowledge that differing impacts and aims were part of the point of setting up monuments.[132] Yet even to try to imagine experience in terms of aesthetics and viewing acknowledges the way in which statues (isolated, grouped, serialized) could structure space into imbalanced, uneven collages.

[132] F. Queyrel, 'Réalisme et mode de représentation dans l'art du portrait hellénistique: le cas de Délos', *Ktema*, 34 (2009), 243–56.

Collage city? It is perhaps significant that segmentation is noticeable in urban public space, and less so in the case of the great shrines, where shared space is perhaps less complex, more immediately representational, and less problematically under the direct control of acknowledged authorities (though this hypothesis may have to be tested in detailed case studies—with attention to cases which do not comply, such as Olympia, Delos). What segmentation in urban public spaces might show is the complexity of civic place, its nature as potential hybridity, a set of contrasting sites—and this might emerge even from the study of the *polis*-dominated form of the honorific statue.

7. CIVIC PLACES AND/AS CIVIC AGENTS

A constant theme in this chapter's attempts to 'read' politically space and place, if not as text, at least as texture (for all the theoretical difficulties involved with the exercise) has been the presence of the 'public', in the form of authoritative control of space, and producer of collective meaning through the manipulation and management of space. Of course, this is simply to rediscover a tautology—the public control of public space, already abundantly attested in the epigraphical record (see Chap. 3). But such phenomena as meaningful collocation or homogenizing serialization, such cases as the agora of Priene, or the epigraphy of 'parasitical inscription' and reuse at the Oropian Amphiaraion, provide striking instances of some form of collective, transgenerational entity patiently at work, shaping the monumental landscape and in general the city. Across such public spaces as the agora, the theatre, the gymnasion, the urban shrine, the statuescape of honorific monuments was a self-conscious working out and performance, through public art, of the communitarian ideology, converting space into places of civic memory and meaning—in dealing with such problematic entities as the powerful ruler as master, the faraway king as benefactor, the foreign friend, the local Big Man, the rich woman benefactress. How should we name this public, collective authority? The State, the city-state, the *polis*—at least, the epigraphical and archaeological record shows how the state existed as a physical manifestation that 'took place'.

Yet 'reading' spaces and places also amounts to an archaeological *décapage* or stripping away of any simplistic view of public control over collective spaces. This is immediately obvious in the case of 'international' shrines, owned by a particular state but open to dedicatory activity by actors from outside that state: the result is a landscape of competition and jostling, for instance as in the Altis at Olympia; but competition can also be detected in urban civic spaces. Such phenomena of competition are much in evidence when 'statue sedimentation', the build-up of changing statuescapes across time, can be studied. Competition for space, for attention, for prominence: such phenomena take place in spite of public control of space, and in fact often as a reaction to public control. The hydraulic *reflux* of statue growth towards the north-west part of the agora of Priene provides one example of a response to the public pressures.

Competition, specialized niches, mimetism (between statues and the architectural environment), 'double parking', 'limpet bases', 'big fish', parasites, struggle for space within species but also between species (statues versus dedications, statues versus inscriptions), statue 'growth'—throughout this chapter, I have freely used metaphors that seem predicated on a model of the statue habit as an ecological system. Such a model is heuristically useful, as a description of phenomena, as a way out of any assumptions about a monolithic social space in the *polis*, and a thought experiment about statues as actors facing competitive pressures and responding to needs. But the experiment has its limits: the agora at Priene or the terrace of the Amphiaraion are not ecotopes, but human 'products', the result of competition, negotiation, and accommodation between public and private (see below, Chap. 6). The initial applicability of ecological metaphors, and their usefulness in showing the existence of individual actors, recedes when we realize that the agents were not the statues themselves but the community that granted or agreed to them, the honorands or families that tried to obtain

certain spots—individuals who were also, in various ways, 'the State', either as magistrates or as members of collective decision-making bodies.

The consequence is the complexity of 'civic place', which I hinted at above when discussing phenomena of segmentation. To point to competition and even segmentation in the record of sedimentation and growth in the statuescape does not quite provide, on its own, any answers to questions on the nature of complexity in the Hellenistic *polis*. A phenomenology of place cannot solve political and historical problems: whether we should view a landscape such as the Thasian agora as a sign of fragmentation and breakdown in civic culture, whether the Prienian agora shows elite capture of public space, whether such cases are instances of struggles over space, justice, the meaning of the *polis*—or whether segmentation reflects healthy diversity within complicated societies in vibrant interaction; or, again, whether segmentation and diversification are the context for elite capture of public space, carried out in spite of, and in fact with the help of, public-oriented communitarian discourses.[133] But phenomena of competition and segmentation help us sense the complexity of civic history in this period. Civic history does not have to be the description, and celebration, of collective control over space, institutions, and actions by communitarian states, but should involve the possibility of competition, of individual or group aims, of conflict, of cunning and patience by non-state actors as well as the state itself; the possibility that public space was a site of interaction, not necessarily in equilibrium, between social actors and the public entity, itself forced to behave as a competitive actor.

The record (again) is probably too patchy to allow for detailed histories of the interaction between state and individuals, and the balance of power, though some outcomes are clear, because of the way in which a break-off in statue growth has frozen the picture. What is clear is the importance of families; they will be considered in the next chapter. It is not simply a question of the familial imprint on the statuescape, but also of the presence, and operation, of a wholly separate genre, the 'private honorific statue', set up by individuals for other individuals, no doubt with public permission but without public intervention in the transaction. Such statues occupied public space in Priene: one of the two statues of Apollodoros, son of Poseidonios (above), the right-hand statue, was a privately erected monument of Apollodoros as priest. The presence of private honorific statues interferes with the workings of public honorifics, and the workings of honorific spaces. The Shrine of Demos and the Charites was meant as a privileged space for the honouring of foreign benefactors (see above, Chap. 3). The Athenian politicans Mikion and Eurykleides promoted its use; the statue of the Cretan benefactor Eumaridas was (after some delay) set up there; two centuries later, so was the statue of John Hyrcanus (in 105).[134] Yet the only known statue base from the monument is the so-called 'base of the Thriasians' (*IG* II² 3864)—a private honorific monument, of respectable size, of strikingly curved shape, occupying a prominent place in the small shrine space: it represents the extreme visibility in ancient times of the private genre, cheek by jowl with public honorifics in a space honouring foreign benefactors—and also the neglect of this genre in modern scholarship. The prominence of families, in interaction, and perhaps in competition, with the public genres, for the occupation of *polis* sites, needs consideration in the light of the previous treatment of public text and public space—as a constituent of *polis* as place, and also as an invitation to rethink the previous findings.

[133] Van Nijf, 'Roman Termessos'.
[134] Jos. *AJ* 14.8.5; Habicht, *Athens from Alexander to Antony*, 283, on the date (the decree as transmitted preserves the names of Athenians authentically known from other sources, as noted by A. Wilhelm).

III

Statues and Families

The Shape of Private Monuments

...on peut souhaiter maintenant de voir réunies et étudiées les bases de monuments honorifiques de famille, qu'il s'agisse de souverains ou de bourgeois. Leur classement chronologique serait très intéressant pour l'histoire des honneurs et pour la place tenue dans les cités par les familles de notables. [*See below for translation.*]

(L. Robert)

In parallel to (and indeed physically next to) public honorific statues, privately erected 'honorific' statues occupied spots within the shared spaces studied in the previous chapters. The present chapter gathers material to define the private phenomenon (largely familial) and to try to discern its shape: why did people set up private honorific statues? Where? The answers invite us to revisit the whole honorific phenomenon.

1. NOTICING THE PRIVATE MONUMENT

In the agora of Antiphellos, in central southern Lykia, there stood a bronze statue of a man—the caption inscribed on the base told us who he (the statue) was: ὁ δῆμος ἐτείμησεν Μηνόδοτον Δοσιθέου, 'the people has honoured Menodotos son of Dositheos'. A public honorific statue, set up by a community, in requital for services performed by an individual, in recognition of his character, with a view to proclaiming public control over honours and the exemplary importance of both communitarian investment and reciprocity in the workings of the *polis*. Next to this statue, on the same block, there stood another one, captioned as follows: Μηνόδοτος Δοσιθέου | Ἀκαμανδεὺς | τὸν αὑτοῦ υἱὸν | Θεόδοτον | θεοῖς, 'Menodotos son of Dositheos, Akamandeus, (has dedicated) his son, Theodotos, to the gods'.[1] Menodotos, the honorand of the first statue, set up another statue, of a relative of his, next to his own honorific portrait. What is the meaning of the second statue—in this particular place, the agora? What is the meaning of the juxtaposition of both statues? It is hard at least not to express some surprise at this juxtaposition—in the light of the interpretations proposed earlier for the nature of the honorific statue, even if these interpretations have started to become less sharp when confronted with phenomena of 'sedimentation' and competition on the ground studied above. The reopening of questions on the nature of the 'civic', started at the end of the previous chapter, will need to be pursued here.

Side by side with the public honorific statue, another genre developed and claimed its place in the Hellenistic cities and shrines, the 'private honorific statue'. This genre can be given an initial definition, quickly and simply (albeit at some cost in terms of the description of social realities): whereas the public honorific statue is a monument set up by a community, after a

[1] Robert, *OMS* ii. 1368–9 (correcting an earlier publication by A. Diamandaras). On Antiphellos, M. Zimmermann, 'Eine Stadt und ihr kulturelles Erbe: Vorbericht über Feldforschungen im zentrallykischen Phellos 2002–2004', *IstMitt* 55 (2005), 265–312 (with map of Antiphellos, from C. Texier). The statue base could conceivably have come from elsewhere on the site. A. S. Diamandaras, 'Epigraphai ek Lykias', *BCH* 18 (1894), 323, no. 1, also publishes another private honorific from Antiphellos (for a woman, the statue being set up by her father: late Hellenistic or imperial?).

community decision though not necessarily at community expense, especially in the late Hellenistic period, the private statue monument is set up in shared, communal, public spaces, by private individuals, out of their own monies and because of private motives, with the agreement and sanction of public authorities. Such statues can be set up by individuals for their friends or for their relatives: the latter is by far the most common. They can be the result of gestures by citizens within their cities, by individuals in cities not their own, or in 'international' shrines; notable are statues set up by members of royal dynasties for each other, or by king's men for the ruler or each other (below, and Chap. 6).

Private monuments have already been mentioned earlier in this book, especially in Part II. It is impossible to review the use of shared spaces, sacred and non-sacred, during the Hellenistic period without meeting private honorific monuments: at the Epidaurian Asklepieion, on the Athenian Akropolis, at the Oropian Amphiaraion, in the agora of Priene, where a public honorific statue and a private family monument for the same man, Apollodoros son of Poseidoneios occupied a very prominent spot (Fig. 4.10; above, 142–3). Hence an impression of ubiquity, which should in fact be examined more closely.

The genre has been identified, notably by L. Robert, who liked to designate private honorific statues with the ancient expression *syngenika*, and frequently drew attention to this genre and its interest. In a statement characteristically both throwaway and programmatic, the Roberts urged the study of the genre: 'it would be desirable to have a study gathering and going through the bases of family honorific monuments, both for rulers and for citizens. Their chronological classification would be of great interest for the history of honorific practice, and for the place held by civic elites in their communities.'[2] The programme outlined by the Roberts touches on the historical importance of the phenomenon; it must be acknowledged that there are practical difficulties with its execution.

The first (all in all fairly minor) problem is that the genre has often been misrecognized—many of the Roberts' notes on private honorific statues are corrections to studies where the genre has not been recognized, and individual documents incorrectly commented upon (for instance in *I. Erythrai*). It would be invidiously easy (and we should perhaps not fail to resist the temptation) to add to the Roberts' roster of corrections. At the end of the previous chapter, I draw attention to the 'base of the Thriasians' found *in situ* in that shrine. M. C. Monaco, the author of the recent, and exhaustive, study of the shrine describes this monument as if it were a public honorific monument, and speculates that it was accompanied by a *stele* with an honorific decree.[3] This fails to recognize a basic fact: that this monument is not a public honorific, but a private monument, erected by friends and family for two men. The date of this monument, say *c*.200, means that we cannot explain it away as a later development, for instance due to a decadence of the significance of the shrine, the devaluation of the shrine in the urbanistic fabric of this area of Athens, or a lessening of the importance of euergetical transactions.

Generally, private honorific statues are sometimes mistaken for public honours, or assumed to be funerary, or taken to represent some sort of religious dedication.[4] These interpretations

[2] The quotation is from *BE* 70, 44 (in a review of Siedentopf, *Reiterdenkmal*). See also *BE* 49, 202 (where, in commenting on a family monument from Ptolemaic Cyprus, the Roberts adduce the term *syngenikon*); *La Carie*, 326 ('mériteraient une nouvelles étude'), *BE* 67, 427 (on Telos), *BE* 73, 375, p. 141, and *BE* 74, 479, p. 274 (Erythraian examples); *Amyzon*, p. 232 n. 1 (commenting on *Amyzon* 32, the statue of Balakros set up by a relative), with examples (not all relevant: see below, n. 5). Earlier, U. Köhler, 'Attische Inschriften des fünften Jahrhunderts', *Hermes*, 31 (1896), 150–3, for Athens; Löhr, *Familienweihungen*, 223–4, recognizes the Hellenistic genre and illustrates it with examples from Rhodes, Athens, Delos, and the Oropian Amphiaraion; Dillon, *Female Portrait Statue*, 42–51, studies the epigraphy of the genre.

[3] Monaco, 'Il temeno del *Demos*', 122.

[4] *Inscr. Scythiae Minoris* I.110, where a father sets up a statue of his son, is interpreted as a homage to 'a heroic act for the common good' by the first editor, V. Pârvan, followed by D. M. Pippidi. *I. Keramos* 5B and 30 are not necessarily funerary, in spite of the editor's classification; the same applies to *Inscr. Bouthrotos* 180. *I. Perge* 2, the base a family statue of a man dedicated to Artemis, 'stand wahrscheinlich am Grabe des Verstorbenen' for S. Şahin—better to follow the original editors, Lanckoronski and Petersen, who suppose the statue stood in a shrine

contain some element of truth: private honorific portraits resemble public honours, and intersect with the public honorific practice in ways that deserve study; private honorific inscriptions can be *post mortem*, and always contain an element of commemoration that is concerned with death and family perpetuation beyond death; private dedications are very frequently dedicated to gods, in shrines (below), as religious gestures.

All the same, misrecognition of the genre, or the difficulty of classifying it, leads to it not being noticed or being dispersed in the publication of the epigraphical material, namely the inscribed bases that identified the honorific portraits and their function. In some publications, the category is not singled out;[5] in others, the definition is too narrow. Thus the published corpora of the Delian material duly group the bases of honorific statues set up by private individuals for private individuals—but other inscribed bases of statues which might be considered to fall into this category are found under a variety of other rubrics, according to the status of the honorands (rulers, officials, Roman magistrates, priests), or the site where the statues were set up (shrines of Sarapis, Kabeirion).[6] Likewise, the recent corpora for Knidos (W. Blümel) or Kaunos (C. Marek) separate 'honorific statues for individuals', and statues of individuals set up by individuals to specific deities (these are classified as dedications).

All of these classifications are perfectly defensible—to regroup all private honorific statue bases together would entail losing sight of the diversity of statuescapes within shrines, or chronological or historical information (in the case of Delos, which rulers were honoured with statues there, and when). Perhaps a rubric such as 'see also', or an index of private honorific monuments, would signal (or incite) awareness of the genre, and aid its study. The question that arises is one of definition: 'private honorific statue' and 'family honorific monument' have been introduced quickly in this chapter (and indeed mentioned often enough in earlier chapters), but in general do not seem terms that have been formally defined, and are used variously (for instance, A. Jacquemin, in her study of monumental offerings at Delphi, classifies monuments set up by non-official groups as private honorific statues, whereas I would emphasize the collective element and have treated them among public honorific portraits). In this chapter, I propose to define them as statues set up by individuals, or groups of individuals (named separately), for single individuals, though such statues can be grouped in multi-statue monuments. They very frequently retain the votive epigraphical habit of naming the deity to whom the statue is dedicated—just as public honorific statues do; hence their frequent classification as votives in modern publications.

It is in fact unclear what such statues were called by those who set them up and who saw them, in the Hellenistic world. As mentioned above, L. Robert used the term *sungenikon* with gusto, and referred approvingly to E. Preuner's study of the Daochos monument in Delphi.[7] However, Preuner's focus is on a specific genre, the representation of genealogy in visual form, slightly different from the family monuments of the Hellenistic period; in addition, Preuner followed J. Six in believing, certainly incorrectly, that the term *sungenicon*, found in Pliny, designated painted grave *stelai* of the type known from Demetrias. Pliny uses the Greek term to

of Artemis. *IG* 12, suppl. 29B, a private statue for a nurse, is called '*titulus sepulchralis*' by Hiller, but with no justification. *IG* 5.1.1189 is a private statue set up by a man of Akriai, in honour of his son, at neighbouring Gytheion, or in a shrine on its territory, but there is no need to suppose that the son died at Gytheion (W. Kolbe): the monument need not be funerary. A private family monument is classified among a list of 'funerary *stelai* found by the Ephor I. Thepsiadis . . . and brought to the museum of Thebes in the years 1961–2': E. Touloupa, *ArchDelt* 19 (1964), *Chron*. 203 (*SEG* 31.518, and now *Inscr. Thespies* 367). S. Dakaris writes of 'statues for the dead' regarding family monuments in the agora of Kassope (*Kassope: Neoteres anaskaphes 1977–1983* (Ioannina, 1984), 23), without justification.

[5] Among the inscriptions of Ephesos kept in the British Museum, the inscriptions 'for private individuals' published in *GIBM* iii. 546ff., are in fact not private honorific monuments (as the Roberts call them in *Amyzon*, 232 n. 1), but public statues for individuals not in office.

[6] On family monuments on Delos, J. Marcadé, *Au musée de Délos: Étude sur la sculpture hellénistique en ronde-bosse découverte dans l'île* (Paris, 1969), 70–2.

[7] H. E. Preuner, *Ein delphisches Weihgeschenk* (Leipzig, 1900), 47–54.

describe paintings, probably family groups;[8] the term must come from one of his Hellenistic sources, perhaps the periegete Heliodoros.[9] *Syngenika* are dedications with multiple portraits, certainly painted, perhaps sculptural (though this is unattested), but the term is not attested in the epigraphical documentation. For instance, the exedra in the agora of Kyzikos, bearing several statues of the same family, is called a προγονικὸν συνέδριον.[10] Individual statues set up privately do not seem to have been designated by any special term, apart from periphrasis: in their wills, the philosophers living in fourth-century Athens refer to *eikones* of themselves, to be set up after their deaths; a portrait of the Stoic Chrysippos was set up by his nephew.[11] In the present chapter, I will avoid the term *syngenika*, in favour of the neutral (if slightly cumbersome) 'private monuments'.

Portraits of individuals set up by other individuals, their relatives, or their friends: the absence of any special designation draws attention to the scant notice of the phenomenon in the literary evidence (whereas public honours attract regular mention); we are simply dealing with private dedications of portraits—for whatever private reasons moved individuals to go to this expensive and very conspicuous gesture. Need we call them 'honorific' at all? Many, as will be seen below, were set up in gratitude or commemoration after family events—illness, adoption, death . . . Is the notion of a 'genre' of 'private honorifics' an arbitrary imposition on a diverse practice of family statues (votive, commemorative, funerary . . .)? Even if the setting up of a permanent memorial portrait, in highly public spaces, undoubtedly grants prominence and memory to the person represented, to call private monuments 'honorific' may be begging the question of their function.

The answer to this question requires a descriptive survey of the habit of setting up private portraits of individuals. But it is immediately worth emphasizing that the practice of private portraits is not 'just' about private dedications, but has a historical context. Its forms, epigraphical, archaeological, and art-historical, are specific to the Hellenistic and post-Hellenistic periods, evolving out of, but distinct from, Archaic and Classical practice (*kouroi*, *korai*, dedications of portraits of generals, athletic victors, etc).[12] It participates in a particular dialectic transaction between the Hellenistic communities and their elites, negotiating a number of important issues: the multiplication of images, control of the terms of individual identity, the occupation of shared spaces, the place of eminent individuals and their families—these are all issues which have been raised in the previous chapters. Private statues were set up next to public honorific statues—at Antiphellos, as mentioned above, or at Priene, in the agora, or in Athens, in the shrine of Demos and the Charites. The genre of private statues, and the gesture they represented, must be viewed in connection with the genre of public statues, as a dialogue. The terms of this dialogue force us to examine the nature of the Hellenistic family, and the functioning or even the validity of such concepts as 'individual'/'state', or public/private, in the context of the post-Classical city; this is another way of considering the question of the nature of the public in Hellenistic communities, as raised by cases where the 'state' seems to be a player within shared space, interacting with other, maximizing, bodies such as families or individuals. The case of the 'ancestral exedra' in the agora of Kyzikos, in the first century BC, full of family statues but subject to public oversight, acts as a reminder of the interaction between family commemoration and civic culture and institutions.

'On peut souhaiter maintenant de voir réunies et étudiées les bases de monuments honorifiques de famille . . .' In this chapter, I obviously do not have the ambition to gather a full

[8] Pliny, *NH* 34.76, 134, 136, 143; A. Reinach, *Recueil Milliet: Textes grecs et latins relatifs à l'histoire de la peinture ancienne* (Paris, 1921), 299 n. 3: 'tableau de famille . . . sans doute également votif' (discussed in Budé edn of Pliny, *ad NH* 34.134).

[9] B. Keil, 'Der Periget Heliodoros von Athen', *Hermes*, 30 (1895), 199–240.

[10] Michel 537 with Habicht, 'Notes on Inscriptions from Cyzicus', for the date. The exedra perhaps combined private and public statues.

[11] Plutarch, *Moralia* 1033c; Zanker, *Mask of Sokrates*.

[12] Keesling, *Votive Statues*.

corpus of all known bases and monuments, but only to present a quite full overview of the 'private statue habit' in the Hellenistic age. I will try to define, formally and synchronically, the shapes private portraits take, and the places where such monuments were set up within cities and shrines; in the following chapter, I will also sketch out a history of the practice and try to map it out in space. In other words, in the present chapter and a bit of the next, I wish to do quickly the things I have tried to do, at leisure, for the public honorific genre over the previous few chapters. Finally, over both chapters, I will list, and study, the reasons why such monuments were set up; this will help define the genre—honorific?—and lead into wider historical issues about the nature of the honorific monument in general within the histories, political and cultural, of the post-Classical *polis*.

2. READING THE PRIVATE MONUMENT

Individuals set up statues of individuals, at their own expense, on their decision: the statues were appropriately captioned, by inscriptions on their stone bases, recording decision-making, relationality, and recipient. The form followed is, usually, the normal nominative-accusative copula, sometimes followed by the verb of dedication (privately dedicated portraits are never captioned with the verb τιμάω, common in certain areas of the Greek world for public honorifics: above, Chap. 1), and sometimes by the name of the divine recipient of the dedication, or simply a mention of the gods;[13] the formula is attested from the mid-fourth century onwards. As seen in Chapter 1, the syntax of dedicatory inscriptions, couched in an inflected language, poses translation problems in English; what matters is that they express relationality, for private as for public monuments. These relations fall into a number of possible cases, which can be typologized into four types, which I propose to call single, multi-generational, distributive, and multi-relational. In addition, statues can be combined in hybrid monuments that draw from the different types of monument-relations.

The *single* monument usually states a relation between the person being statuefied, and the person doing the dedicating. The forms can be very simple:[14]

Διογένης
Διογνήτου
τὸν ἀδελφὸν
Τελεσίαν

Diogenes son of Diognetos (has dedicated) his brother, Telesias. (Knidos, *c.*200)

Alternatively, such texts can be very long, as in the extensive 'CV inscriptions' from Rhodes. One Kleuthemis set up a statue of an Eupolemos—and added on a very long list of Eupolemos' achievements:[15]

[Εὐπόλεμον Εὐπολέμου]
[το]ῦ Τιμοκράτευς
καθ᾽ υοθεσίαν δὲ Τιμοκράτευς
Κλεύθεμις Κλευξένου
ταμιεύσαντα κατὰ Ἁλίεια καὶ
στραταγήσαντα κατὰ πόλεμον V καὶ
πρυτανεύσαντα V καὶ V προφατεύσαντα
καὶ ἱερατεύσαντα Ἀθάνας Λινδίας καὶ

4

[13] Guarducci, *Epigrafia*, iii. 89–96.
[14] *I. Knidos* 120. Simpler: *SEG* 30.1088 (Amorgos), where the document is called a funerary *stele*, following the editor, I. Andreou; but the photograph in *ArchDelt* 29/2/3 (1973/4), pl. 650a and pp. 872–3, makes it clear that it is a statue base (*BE* 82, 263), and fragmentary. The text does not require a patronymic for Parmenion: it is included in the name of the honorand. Even simpler: *IG* 7.2473.
[15] *SEG* 39.759.

Διὸς Πολιέως 8
καὶ ἱερατεύσαντα Ἀρτάμιτος Κεκοίας
καὶ τιμαθέντα ὑπὸ Λινδίων χρυσέωι στεφάνωι
καὶ εἰκόνι χαλκέαι καὶ στεφαναφορίαι ἐν ταῖς
παναγύρεσι, ἅς κα ζῶι, καὶ ἀναγορεύσει 12
τᾶν τιμᾶν εἰς τὸν ἀεὶ χρόνον καὶ
φυλαρχήσαντα κα[ὶ νι]κάσαντα Ποσειδάνια
καὶ ν Ἁλίεια ννν καὶ
χοραγήσαντα τραγωιδοῖς καὶ νικάσαντα 16
Ἀλεξάνδρεια καὶ Διονύσια ν καὶ
χοραγήσαντα πυρρίχαι καὶ νικάσαντα ν καὶ
γενόμενον ἐπὶ τᾶς ἐπιμελείας τῶν ἵππων
καὶ τριηραρχήσαντα ν δὶς 20
εὐνοίας ἕνεκα καὶ εὐεργεσίας
τᾶς εἰς αὐτὸν
θεοῖς.

[Eupolemos son of Eupolemos], son of Timokrates, adoptive son of Timokrates—Kleuthemis son of Kleuxenos (dedicated him)—who had been steward during the Halieia, and general in time of war, and prytanis, and prophet and priest of Athana Lindia and Zeus Polieus, and priest of Artamis Kekoia, and honoured by the Lindians with a gold crown and a bronze statue and the lifelong right to wear a crown in the festivals and the perpetual proclamation of the honours, and phylarch and victor at the Poseidania and Halieia, and *choragos* for tragedies and victor at the Alexandreia and Dionysia, and *choragos* for the pyrrhiche and victor, and official in charge of the (sacred) horses, and twice trierarch—on account to his goodwill and his benefactions towards him [*sc.* Kleuthemis], (Kleuthemis has dedicated Eupolemos) to the gods.

In the case of these 'simple', individual monuments, whether the inscription is two lines long or twenty-three, the syntactical shape is the same, expressing the one-to-one relationship, often adding indications about the dedicator, or the honorand, with family nouns—father, sons, mothers (in one unusual case, the honorands are designated as τὰς γενεάς, 'their offpring', by the dedicators).[16]

In the case of the *multi-generational* monument, a single individual is represented by a statue set up by several people, all listed, usually with indications of kinship.[17] At Tanagra, the members of a family recorded their joint collaboration to set up the statue of the daughter in the family:[18]

[Λυσί]μαχος Μενεκράτου καὶ Νικοτελὶ[ς]
[Διονυ]σοδώρου τὴν θυγατέρα καὶ Θεόπομπο[ς]
[Λυσιμάχ]ου τὴν ἀδελφὴν Λυσιμάχην τοῖς θεοῖς.

Lysimachos son of Menekrates and Nikotelis daughter of Dionysodoros (have dedicated) their daughter, and Theopompos son of [Lysimach]os (has dedicated) his sister, Lysimache, to the gods.

In such multi-generational monuments, the inscription maps out a set of relations, around a single person. Another Knidian family statue makes clear the equilibrium between the represented individual, and the group of individuals who set up the statue (*I. Knidos* 185):

Γλύκινναν ὁ πατὴρ Ἱππόκριτος
Πολυστράτου καὶ ἁ μάτηρ Φιλίτιον
Βουλακράτευς καὶ τοὶ ἀδελφοὶ

[16] *IG* 4² 1.232.

[17] *IG* 7.2837, Hyettos, terse even by Boiotian standards, omits any indication of kinship. No clear indications on date from the facsimiles in *IG* and *CIG*, which simply transcribe an edition in minuscules from Meletios, *Geographia Palaia kai Nea* (2nd edn, Venice, 1807); in fact, the presentation as a single line is perhaps unrelated to the ancient layout on the stone. If the base is still in the chapel of H. Nikolas near Dendra, this could be checked (there is no mention of it in Étienne and Knoepfler, *Hyettos*).

[18] *IG* 7.564 (1st cent. BC?). The base (but not the statue) was reused for a public statue of M. Claudius Marcellus (*IG* 7.571). Also e.g. *I. Knidos* 116, 2nd cent. (more likely a base, or an element from a family monument, than a *Wandquader*), for another configuration.

Βουλακράτης καὶ Πολύστρατος
[[τὰν ἀδελ[φὰν]] Μούσαις

Ἐπικράτης Ἀπολλων<ί>ου ἐποίησε

Glykinna—her father Hippokratos son of Polystratos, and her mother Philition daughter of Boulakrates and her brothers Boulakrates and Polystratos, dedicated her (*erased:* their sister) to the Muses. Epikrates son of Apollonios made this.

Glykinna is the object of the dedication, carried out by her relatives: the two words, 'their sister', are redundant with the indication that Boulakrates and Polystratos are her brothers, and they skew the relationality of the monument towards the brothers; these words were cut out, to leave the document to function as a serial enumeration of a set of relations of several persons towards the person (represented as a statue above the inscription). Multi-generational lists of relations can occupy a considerable amount of space, for instance on Hellenistic Rhodes,[19] especially if they combine with long 'CV' indications on achievements. Such multi-generational inscriptions on the bases of family monuments amount to stemmata, laid out 'flat' in relation to one person (Fig. 5.1):

[Εὐφράνορα Δαμαγόρα]
[Δαμαγόρας Εὐφράνορος καὶ ἁ δεῖνα Θευπρόπου]
 τὸν υἱὸν
Θεύπροπος v κα[ὶ Βουλαρί]στα Δαμαγόρα
 τὸν ἀδελφὸν
Φιλίσκος Εὐφράνορος τὸν τοῦ ἀδελφοῦ υἱὸν
Θεύπροπος Εὐκλεί[δ]α τὸν τᾶς θυγατρὸς υἱὸν
Ἀγεμάχα v καὶ v Ἀρχέστρατος Ἀρχεστράτου
 τὸν τᾶς ἀδελφᾶς υἱὸν
Μνασίας Θρασυμήδευς τὸν τᾶς γυναικὸς ἀδελφὸν
Τιμόστρατος Θευπρόπου τὸν τᾶς ἀδελφᾶς υἱὸν
Εὐφράνωρ καὶ Εὐφάνης v καὶ Δαμαγόρας v καὶ
Ἀριστοκρίτα v Φιλίσκου v τὸν ἀνεψιὸν
Ἀρχέστρατος καὶ Βουλαρίστα Θρασυμήδευς
 τὸν τᾶς τήθας υἱὸν
Νικότιμος Τιμοκράτευς τοῦ Νικοτίμου καὶ
Ἀριστώνυμος v Τιμοκράτευς τὸν τοῦ θία υἱὸν
Κρατίδας Μνασία τὸν τῶν ἀδελφῶν θίαν
Δαμαγόρας καὶ Θρασυμήδης Μνασία τὸν θίαν
στρατευσάμενον ἔν τε τοῖς ἀφράκτοις καὶ
 ταῖς καταφράκτοις ναυσὶ
καὶ νικάσαντα Ἁλίεια ἄρματι τελείωι
καὶ τιμαθέντα ὑπὸ τοῦ δάμου χρυσέωι στεφά[νωι]
[ε]ὐνοίας ἕνεκα καὶ φιλοστοργίας τᾶς εἰς αὐτο[ύς]·
 θεοῖς.

[Euphranor son of Damagoras]—[Damagoras son of Euphranor and ... daughter of Theupropos (have dedicated him), their son], Theupropos and [Boulari]sta children of Damagoras (have dedicated him), their brother, Philiskos son of Euphranor (has dedicated him), the son of his brother, Theupropos son of Eukleidas (has dedicated him), the son of his daughter, Agemacha and Archestratos children of Archestratos (have dedicated him), the son of their sister, Mnasias son of Thrasymedes (has dedicated him), the brother of his wife, Timostratos son of Theupropos (has dedicated him), the son of his sister, Euphranor and Euphanes and Damagoras and Aristokrita, children of Philiskos, (have dedicated him) their cousin, Archestratos and Boularista children of Thrasymedes (have dedicated him), the son of their aunt, Niko-

[19] E. E. Rice, 'Prosopographica Rhodiaka', *ABSA* 81 (1986), 209–50; V. Kontorini, 'La Famille de l'amiral Damagoras de Rhodes: Contribution à la prosopographie et à l'histoire rhodiennes au Ier s. av. J.-C', *Chiron*, 23 (1993), 83–99. For a similar and very rich example from Xanthos, recently published, P. Baker and G. Thériault, 'Les Lyciens, Xanthos et Rome dans la première moitié du Ier s. *a.C.*: Nouvelles inscriptions', *REG* 118 (2005), 352 (*SEG* 55.1502); *Oropos* 431 is a rather long-winded, but simple, multi-generational monument.

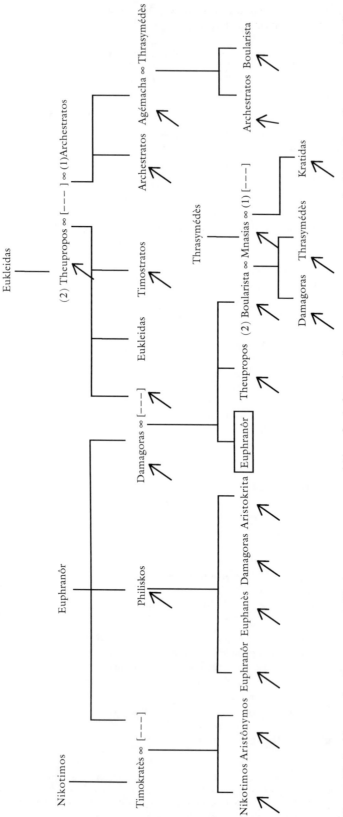

Fig. 5.1. The 'multi-generational' monuments in Rhodes amount to a stemma, laid out flat; in fact, they allow us to reconstruct stemmata, as for this prominent first-century BC Rhodian family (stemma by V. Kontorini).

timos son of Timokrates son of Nikotimos and Aristonymos son of Timokrates (have dedicated him), the son of their uncle, Kratidas son of Mnasias (has dedicated him), the uncle of his brothers, Damagoras and Thrasymedes sons of Mnasias (have dedicated him), their uncle—he had served on the undecked ships and the decked ships and won at the Halieia with the horse chariot and been honoured by the people with a golden crown—for his goodwill and love towards them, (they dedicated him) to the gods.[20]

Private individual statues, set up by single individuals or by several, could be combined in multiple-statue monuments, where statues stood side by side on long bases or exedras. In some cases, the multiple statues are due to the same dedicator (or dedicators): this is what we might call *distributive* monuments, as at the Oropian Amphiaraion[21]—



Δημοκρίτη Θεοδώρου
τὸν αὑτῆς πατέρα
Θεόδωρον Ἀρχιλόχου
Ἀμφιαράωι.

Δημοκρίτη Θεοδώρου
τὸν υἱὸν Θεόδωρον
Δημαινέτου
Ἀμφιαράωι.

Διονύσιος Ἀρίστωνος ἐπόησε.



Demokrite daughter of Theodoros (has dedicated) her own father Theodoros son of Archilochos, to Amphiaraos (Oropian Amphiaraion, third century).
Demokrite daughter of Theodoros (has dedicated) her son Theodoros son of Demainetos to Amphiaraos. Dionysios son of Ariston made this.

Such multiple-statue, single-dedicator, distributive monuments are not rare[22] (in the Oropian example above, the dedicator, Demokrite, is named first, emphasizing her importance in the transaction of making statues of her father and her son). In other monuments, the various statues are set up by different actors, thus resulting in a *multi-relational* or multi-focal interlacing of statue transactions. The base of the Thriasians, mentioned earlier, is one such monument:[23]



Διονύσιον Διονυσίου Θριάσιον
Πανδίων Ἀπολλωνίδου Θριάσιος
 ἀνέθηκεν.

Πανδίονα Ἀπολλωνίδου Θριάσιον
Βάλακρος Ἀπολλωνίδου καὶ
Ἀρισταγόρας Ἀριστοκλέους
 Θριάσιοι ἀνέθηκαν.

Καικοσθένης Δίης Θριάσιοι ἐπόησαν.



Dionysios son of Dionysios, of Thria—Pandion son of Apollonides, of Thria, dedicated him.
Pandion son of Apollonides, of Thria—Balakros son of Apollonides and Aristagoras son of Aristoles, of Thria, dedicated him.
Kaikosthenes, Dies, of Thria, made this.

The dedicator of the first statue, Pandion son of Apollonides, is in turn represented by the second statue, and, mentioned in the accusative case, the object of the statue transaction (the dedicators are two further Thriasians). Such monuments can offer complex familial groups, such as a Delian exedra, still *in situ* just north of the Portico of Antigonos Doson, which presents five statues and three generations in a web of statue transactions, to-ing and fro-ing across time:[24]

Ἀρτεμίδωρος Ἡφαιστ]ίωνος
[Μελιτεὺς Ἡφαιστί]ωνα τὸν υἱόν,
 [Ἀπόλλων]ι.

Ἀρτεμίδωρος Ἡφαιστίωνος
Μελιτεὺς τὸν πατέρα,
 Ἀπόλλωνι.

[20] Kontorini, 'Damagoras', *SEG* 43.527.
[21] *Oropos* 424–5.
[22] *IG* 11.4.1197–8 (von Thüngen, *Exedra*, no. 56); *ID* 2089; Paphos, Mitford, 'Old Paphos', no. 61 (Echetime sets up her daughter and her son); *IG* II² 3894, republished by B. D. Meritt, 'Greek Inscriptions', *Hesperia*, 29 (1960), 40–5, no. 51, with new fragments (*c*.130 BC); *Tit. Cal.* 125–7.
[23] *IG* II² 3864, 3rd cent. [24] *ID* 1962, late 2nd cent.

Fig. 5.2. The Delian monuments display family relations: a cat's cradle of relations in time, between men of the family. *IDélos* 1962.

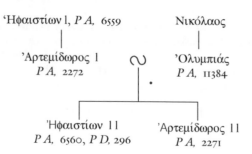

'Ηφαιστίων l, *P A,* 6559 Νικόλαος

'Αρτεμίδωρος 1 'Ολυμπιάς
P A, 2272 *P A,* 11384

'Ηφαιστίων 11 'Αρτεμίδωρος 11
P A, 6560, *P D,* 296 *P A,* 2271

['Ηφαισ]τίων [καὶ 'Αρτ]εμίδωρος
[Μελ]ιτεῖς 'Ολυμπιάδα Νικολάου
[τὴν μη]τέρα, vv 'Απόλλωνι.

'Ηφαιστίων καὶ 'Αρτεμίδωρος
Μελιτεὺς 'Αρτεμίδωρον τὸν
πατέρα, 5–6 vac. 'Απόλλωνι.

'Αρτεμίδωρος 'Ηφαιστίωνος
Μελιτεὺς 'Αρτεμίδωρον τὸν υἱόν,
'Απόλλωνι.

[Artemidoros son of Hephaist]ion [of Melita (has dedicated) Hephaist]ion his son, to [Apollo].
Artemidoros son of Hephaistion, of Melita, (has dedicated) his father to Apollo.
 [Hephais]tion [and Art]emidoros of Melita (have dedicated) Olympias, their mother, to Apollo.
Hephaistion and Artemidoros of Melita (have dedicated) Artemidoros, their father, to Apollo.
Artemidoros, son of Hephaistion, of Melita, (have dedicated) Artemidoros, their son, to Apollo.

As in the case of the single, multi-generational statue (such as the statue of Euphranor mentioned above), the multi-statue, multi-relational monument also allows a stemma to be established (Fig. 5.2).

Artemidoros I set up statues of both his sons Hephaistion II and Artemidoros II (on either wing of the rectangular exedra), and also reached back in time to statuefy his own father; reciprocally, Hephaistion II and Artemidoros II set up statues of their father, and their mother as well. What did the monument look like? Two sons flanked their father and mother, who in turn stood next to his father (her father-in-law), on top of the same *pi*-shaped base (Fig. 5.3); the inscriptions informed the viewer-reader of the identities of the persons represented, but also of the relations and the solidarity that united them (see Chap. 6).[25]

Finally, multiple-portrait ensembles very occasionally combine different types of statues, private and public, into *portfolio monuments* of statues. An early example (second half of the third century) comes from Delos:[26]

Σωτέλης Τηλεμνήστου
τὸν υἱὸν Τηλέμνηστον
τοῖς θεοῖς.
'Αριστόφιλος Εὐσθένου Κορίνθιος ἐπόησεν.

Σωτέλης Τηλεμνήστου
τὴν γυναῖκα Ξεναινὼ
τοῖς θεοῖς.
ὁ δῆμος ὁ Δηλίων

[25] Other examples of multi-relational monuments: *ID* 1963, 1965, 1968, 1969; *Inschr. Priene* 100 and 103, 162; *IG* 12.5.919–21 (Tenos, exedra with a public honorific as well as private statues). *Tit. Cal.* 125–7 (3rd cent.).

[26] *ID* 1173–4, 1086. For parallels, *ID* 1085, 1170; Thasos: Y. Béquignon and P. Devambez, 'Les Fouilles de Thasos, 1925–1931', *BCH* 56 (1932), 238–46 (1st-cent. AD exedra on street, combining private statue of Ti. Claudius Kadmos, set up by his wife Komeis, and public statue of Komeis); Robert, *Études Anatoliennes*, 366 (from Karayük plain); *GIBM* 900 (Halikarnassos); *La Carie*, no. 175 (from Sebastopolis). *IG* 12.6.1.455 might have been part of a 'portfolio' monument, as suspected by K. Hallof.

Fig. 5.3. *IDélos* 1962, second century BC: a five-statue family monument, on the left end of this series of statue monuments at the north-east end of the sacred enclosure at Delos (this is the exedra closest to the viewer; the middle exedra cannot be attributed, and the final exedra is *IDélos* 1967). Photogr. S. Dillon.

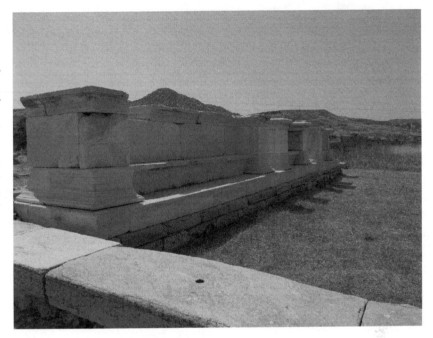

Σωτέλην Τηλεμνήστου
ἀνέθηκεν.

Soteles son of Telemnestos (has dedicated) his son Telemnestos to the gods. Aristophilos son of Eusthenes, of Corinth, made it.

Soteles son of Telemnestos (has dedicated) his wife Xenaino to the gods.

The people of the Delians has dedicated Soteles son of Telemnesos.

The first two statues constitute a multiple-statue, single-dedicator, distributive monument, concretizing the relation between Soteles son of Telemnestos (a well-known Delian notable)[27] and his son and his wife; the third statue, a public honorific, shows Soteles (the dedicator of the first two statues), in a different light, not the object of a reciprocal statue transaction from his son and wife, but honoured by his city. The whole monument offers varied pictures of identity and transactions, specified through the different nature of the inscriptions. In first-century Athens, one Diokles of Sypalettos set up statues of his relatives, but was in turn honoured after having served as navarch by the crews of the cutters (*trihemioliai*) that had served under him.[28] On Lindos, such portfolio monuments combine statues of different genres (familial, priestly auto-dedications)[29] or even different periods,[30] in complicated vertical layers of statue events and additions.

The various categories defined above (single, multi-generational, distributive, multi-relational, portfolio) apply across the Hellenistic world, and will be used throughout this chapter and the next. Within this typological scheme, there are variations in the phrasing of the inscriptions, which correspond to different pragmatic solutions to the problems of how to depict, within the resources of an inflected language, the different degrees of relation (these problems especially arise with the complex multi-generational inscriptions). Some inscriptions reduce the relation to individual names. Others ask the reader to work out relations from

[27] Vial, *Délos indépendante*, Stemma XIII.
[28] *IG* II² 3494 (with Robert, *OMS* iii. 1377–83: the crews are not Rhodians).
[29] *Inscr. Lindos* 2.300; 1.197. [30] *Inscr. Lindos* 2.244, 2.293.

the data:[31] when I read 'Artemidoros son of Hephaistion, of Melita, (has dedicated) his father to Apollo', enough information is given to deduce the honorand's name. On Rhodes, information recurs, and is multiplied—the point must precisely be the repetition and multiplication of names, the extension of genealogical coverage, in acts of familial display (see Chap. 6). In contrast, in Hellenistic Athens, names suffice, without the Rhodian-style branching back in time.[32] The order of honorands and dedicators can vary, as can the layout: on two multi-generational statues from Eretria, the honorands are mentioned in the run of the line, without particular emphasis in the layout of the stone[33]—a reminder that the captioning of statues transforms a monument into a display of a transaction and a relation (Chap. 1), in which the dedicator is as important as the honorand. Finally, family monuments are sometimes captioned with epigrams (for instance, at Kaunos, on the bases of the early Hellenistic family exedra),[34] expanding the dedicatory inscriptions with poetic texts on the motivations of the donors and the preferred experience of the viewer-reader; they constitute important documents, which deserve close attention (below, and Chap. 6).

Apart from these local variations, there exist some differences in formulation. These can be illustrated by an early example from Halikarnassos.[35]

$$Ναννίον$$
$$Καλλικλέους.$$
$$παῖδες Ἀθηνοκρίτου$$
$$Καλλικλῆς \qquad 4$$
$$Διοσκουρίδης$$
$$Μητρόδωρος$$
$$Ἀθηνόδωρος$$
$$Ἀριστοκλῆς \qquad 8$$
$$ὑπὲρ τῆς μητρὸς$$
$$Δήμητρι καὶ Κόρηι.$$

Nannion daughter of Kallikles. The children of Athenokritos, Kallikles, Dioskourides, Metrodoros, Athenodoros, Aristokles, on account of their mother, to Demeter and Kore.

Five sons dedicate an image of their mother to Demeter and Kore—a striking example of a family monument. The phrase chosen, however, is an expression in ὑπέρ, 'on account of, on behalf of, for the safety of'. The expression is found in a geographically limited area: Rhodes (where it is most amply attested) and neighbouring areas in Asia Minor, Anaphe,[36] and also on the Black Sea, at Olbia; this distribution is historically significant (and will be analysed below). A statue ὑπέρ someone is a religious offering—as an act of thanksgiving, the fulfilment of a vow, a prayer; a religious gesture. The statue set up by a woman to Eleithyia, in Knidos, [ὑπὲρ τοῦ δεῖνος] τοῦ παιδίου, had this force, whatever the circumstances behind the decision and the act;[37] the emotional use of the intimate word παιδίον rather than τέκνον perhaps hints at the stakes, and the emotions they raised. The expression makes clear the religious origin and nature of the family statues (at least in some cases: see below), and contributes to problematizing the workings (honorific or not?) of this statuary genre which the present chapter attempts to explore.

[31] *IG* 7.2795, Kopai. [32] *IG* II² 3876 (late 2nd cent. BC).
[33] *IG* 12.9.140–1. The statue of Aristonoe, priestess of Nemesis at Rhamnous, is similarly captioned: *IG* II² 3462 (with the divine recipients of the dedication, Themis and Nemesis, named first, then the dedicant, Hierokles, then, in the run of the lines, without particular emphasis, Aristonoe); also *IG* 12.5.294 (Paros), if the copy accurately reproduces the disposition of the lines.
[34] Marek and Işık, *Das Monument des Protogenes*; *Inschr. Kaunos* 49–53.
[35] *GIBM* 903 (with C. Habicht, 'Zu griechischen Inschriften aus Kleinasien', *EA* 31 (1999), 21, for dating on prosopographical grounds): early 3rd cent.
[36] *IG* 12.3.258 (the earliest: 4th or 3rd cent.), 260, 268, 269, 271.
[37] *I. Knidos* 179 (the name of the child should be restored; ὑπέρ is most probable); no indications on date, since the text is only known from a copy (A. S. Diamandaras).

Parallels make clear that, in the Halikarnassian example quoted above, the name of the person represented is in fact given in the nominative and not the accusative. For instance, the base of a multi-generational statue base from Lindos reads:

Ξενοκλῆς Ἀπολλοδότου
καθ' ὑοθεσίαν δὲ Καλλιγνώτου.
Ἐπαίνετος Ξενοκλεῦς
ὑπὲρ τοῦ πατρὸς 4
καὶ Αἰνήτα Ἐπαινέτου
ὑπὲρ τοῦ ἀνδρὸς ἱερατεύσαντος
Ἀθάνας Λινδίας καὶ Διὸς Πολιέως
καὶ Διονύσου. 8

Μνασίτιμος Τελέσωνος Ῥόδιος ἐποίησε.

Xenokles son of Apollodotos, adoptive son of Kallignotos. Epainetos son of Xenokles, on behalf of his father, and Aineta daughter of Epainetos on behalf of her husband, once he had served as priest of Athana Lindia and Zeus Polieus, and of Dionysos.
Mnasitimos son of Teleson, of Rhodes, made this.[38]

Even though the dominant epigraphical form for family monuments is the accusative construction, with its relational baggage, the nominative also occurs for the honorand,[39] juxtaposed with the name of the dedicator, and verbs of dedication, or participles in the accusative that imply the act of dedicating, and the relation between honorand and dedicator.[40]

This usage is widespread: it occurs in Athens (where it is quite common; an example is the spectacular family group set up on the Akropolis in the 330s)[41] and nearby Megara,[42] in the Peloponnese,[43] on Rhodes (plentifully), on Kalymna,[44] in Cyrene,[45] and in the Black Sea cities.[46] The epigraphical record is not dense enough across time and space to allow for a chronology and a map of the usage, but it seems more common in the fourth century (especially in Athens) and the third; at Lindos, where the record is continuous, honorands appear in the nominative into the second century BC. The exact nuance in phrasing is not clear: a multi-relational monument on Lindos includes, side by side, two statues of father and son, captioned in the two different styles, once with ὑπέρ and once in the nominative-accusative relational formula.[47] What matters is to notice the use of the nominative for the 'subject' of statues set up by individuals. The 'respectful' or 'adoring' nominative sets the honorand aside, for a moment, from the transactionality and the relationality implied in the rest of the inscription (with its dedicatory formulas, its accusative complements, its indication of divine recipients, and the names of the active dedicators, single or multiple). Similar is the old-style captioning of the honorands in the nominative, without any dedicatory formula; the name of the dedicator, and the occasion, only appear upon perusal of epigrams.

The use of the nominative by non-royal individuals, for their friends and relatives, may have been influenced by private votive, and even funerary practice; but this only raises the question

[38] *Inscr. Lindos* 1.109 (2nd half of the 3rd cent.). See e.g. *Inscr. Lindos* 1.132, 153; *IG* 12.1.104. That ὑπέρ refers to the subject of the statue is clear (in *Inscr. Lindos* 113, the three captioned names, in the nominative, under three sets of cuttings for the feet of three bronze statues, recur in the ὑπέρ formula lower down; 2nd half of the 3rd cent.). ὑπὲρ can also occur with the accusative in the name of the honorand: e.g. *Inscr. Lindos* 1.158.

[39] Kontorini, 'Damagoras', 85 n. 10, for some examples ('rare, mais pas sans exemple'). *I. Rhod. Peraia* 8, same document *Pérée rhodienne* 195, clearly starts with the name of the honorand in the nominative (before repeating it in the accusative in a nominative-accusative copula).

[40] *Inscr. Lindos* 1.148.

[41] *IG* II² 3829, 3830, 3838; *SEG* 17.84, 21.752.

[42] *IG* 7.54–5 (late 4th cent.).

[43] At the Asklepieion near Epidauros, *IG* 4² 1.241 (3rd cent.).

[44] *Tit. Cal.* 123, 124 (both *c*.300), 128, 129, 131 (3rd cent.).

[45] *SEG* 9.67, 70, 71.

[46] *IOSPE* I² 190, 191 (Olbia), 410.

[47] *Inscr. Lindos* 1.148. The preposition ὑπέρ also occurs in votive *stelai*, for instance *IG* II² 4364 (Asklepieion, mid-4th cent.).

of the function performed by naming individuals in such contexts. Every person, in her individuality, is famous and prominent to those who love or care for her; the nominative for private honorands makes claims for the importance of the persons represented in statues, and for the status of the dedicators who make such claims. The phenomenon is instructive for the nature of the private family portrait monument (see following chapter).

3. SETTING UP A PRIVATE STATUE: OCCASIONS, REASONS, MOTIVATIONS

Why do individuals and families set up statues? Whereas the public statues are motivated by reciprocity in euergetical transactions, and hence clearly honorific, private portrait monuments are set up for a variety of reasons—often clearly indicated in the monuments' captions. These avowed reasons will be surveyed here, with examples: the first step is listening to what individuals say about the statues they chose to set up. The aim is not quite to define the 'private honorific' or the nature of 'private honours'; rather to survey and typologize (as so often in this book) a whole series of possible occasions for private statue transactions. The next chapter will propose analyses and interpretations of the practice of family monuments, their motivations, and their impact.

a. Vows

As suggested above, the dedicatory inscriptions using ὑπέρ might have expressed the votive nature of certain monuments, set up after a vow for the healthy and safe existence of the person represented. Vows are expressly mentioned for some family monuments;[48] in other cases (statues of children ordered by the gods, in a dream or a vision, κατὰ συνταγήν;,[49] statues for Eilethyia, for healthy birth, or labour, or the well-being of children[50]), the circumstances are very similar to those of vows for safety or health of loved ones. Finally, individuals dedicated statues of doctors (probably after successful treatment and a return to health): these monuments also reflect private crisis and gratefulness.[51]

Safety, survival, vows, and the passage of peril: these circumstances act as reminders of the votive, substitutive function of the image, and hence of the religious origins and functions of the portrait. The workings of the statue as 'stand-in' are ancient, and basic to the nature of the Greek statuary, as was observed by J.-P. Vernant in a classic article.[52] Statues of individuals set up by relatives after a vow, illness, childbirth (or by the ill for their doctors) are not quite honorific images, and the appellation 'private honorific statues' does not suit them. They still deserve mention here for a number of important reasons. First, they show one of the functions that the dedication of private portrait statues could fulfil, as markers of religious gratitude after crisis: other types of private, family dedications, occurred against this background, which forms the general context for the private portrait monument. Second, they make explicit a type of motivation quite different from the public euergetical exchange of benefaction and honours: private anxieties, emotional investment.[53] Third, private circumstances warranted gestures in

[48] Mitford, 'Old Paphos', no. 23 (Paphos); *IG* 4² 1.208, εὐχάν at the end of the inscription (3rd cent., dated by the sculptors); the inscribed base does not give the sons' names, which perhaps appeared on a now lost crowning element; *IG* 5.2.538 (Lykosoura, 1st cent.: dedication by a couple of their son's statue, [χα]ρι[στήριον]).

[49] *Inschr. Pergamon* 123.

[50] Athens, *SEG* 18.88, 35.141, *IG* II² 4669 (statues of women, no doubt mothers, to Eilytheia); 3965 (2nd cent. AD; a woman called Ma dedicated a statue of her grandson to the Eilethuiai), perhaps 4048, *SEG* 42.173 (male statues dedicated to Eilythiai); M.-T. Couilloud, 'Nouvelle dédicace attique aux Ilithyes', *BCH* 92 (1968), 72–5. Thespiai: *IG* 7.1872, Plassart, 'Fouilles de Thespies', 410–19 for dedications to Eilytheia generally, amongst which nos. 30, 32–7 are relevant. Arkesine: *IG* 12.7.82–4.

[51] *IG* II² 3780, 3782–3, 4368 with the restoration of W. Peek, *SEG* 30.164 (statue of the doctor Phanostratos, after he cured a woman).

[52] J.-P. Vernant, *Mythe et pensée chez les Grecs* (Paris, 1985), 251–64.

[53] Xenophon, *Memorabilia* 2.2.10: mothers sacrifice and pray for their sons.

the shared public spaces of the shrine, civic or international. Side by side with public honorific dedications, family gestures made clear moments of crisis, and the family solidarity and continuity that was threatened by such moments but also existed on either side of them. The question, raised here as at many other points of this chapter, is of the impact of the juxtaposition of the public and the private.

b. Commemorating Occasions: Victories, Offices, Priesthoods

Portraits were set up privately for a number of other reasons than safety and health: victory in a contest,[54] or, especially, tenure of office, as in the case of a second-century statue from Athens:[55]

Πλείσταινον Σωκλέους Κεφαλῆθεν
ἡ γυνὴ Πλεῖστις καὶ ἡ θυγάτηρ Σωσινίκη
ἄρχοντα γενόμενον Διονύσωι ἀνέθηκαν.

Pleistainos son of Sokles, of Kephale—his wife Pleistis and his daughter Sosinike dedicated him, once he had been archon, to Dionysos.

Such statues[56] can be commissioned during office (noted by present participles, as in the example above), or upon exit of office, as a record of the limited tenure of power in the city-state. They are usually the gestures of families or friends; on Rhodes, exiting magistrates are sometimes honoured by statues set up by 'colleagues', fellow-magistrates, a practice located at the limit between public honorific statue and private gesture.[57] This particular subgenre is civic in its implications, through its choice to emphasize the holding, and, even more, the relinquishing, of legitimate authority; it is also linked to family pride, both in the visibility of the status of office-holder, and the hope of accrued familial eminence.[58] The implications of the combination of *polis* concerns within family agendas, as seen through the private statue habit, will be explored later (Chap. 6).

Closely related to the statues for magistrates, a common occasion for the dedication of portrait statues by relatives was the assumption of a priesthood or sacred office.[59] In the late second century, after occupying the most prominent priesthood at Lindos, Damokrates son of Kallikles received a multi-generational statue, set up by his immediate family:

Δαμοκράτη [Κ]αλλικλεῦς
Καλλικλῆς καὶ
᾿Αρσινόη καὶ
Ξενοκράτεια τὸν πατέρα
᾿Αρσινόη ᾿Ανδρομάχου
τὸν ἄνδρα
[ἱ]ερατεύσαντα ᾿Αθάνας Λινδίας

[54] P. de la Coste-Messelière, 'Inscriptions de Delphes', *BCH* 49 (1925), 77, no. 3 (2nd-cent. BC statue of Thrasykles, a member of a well-known Delphian family, set up by his brother after his victory in the *pankration*).

[55] *IG* II² 3479 (184/183 according to B. D. Meritt, 'Athenian Archons 347/6–48/7 BC', *Historia*, 26 (1977), 161–91). The archon, Pleistainos, is probably related to his wife Pleistis, judging by the names: they might share a grandfather named Pleistainos, and hence be cousins.

[56] For other examples after agonistic office, *IG* II² 3458 (statue of Eteokles, son of Chremonides, set up by his daughter after his service as *agonothete*; 3rd cent., set up on the Athenian Akropolis), *IG* II² 3863; *SEG* 38.3412, 41.350 (Messene); *SEG* 53.1224 (Knidos, during office as *damiorgos*); *Milet* 1.3.157 (after service as *stephanephoros*, literally as 'aisymnetes' of the *molpoi*'); *IG* 12.5.918 (Tenos, a couple set up their son's statue after his service as trierarch of the Nesiotes); *I. Keramos* 29 (a man statuefies his brother after he had been *stephanephoros*; Varınlıoğlu's 3rd-cent. dating seems late).

[57] For instance, *Inscr. Lindos* 1.172.

[58] The sentiment is made clear in *IG* 11.4.1137, the dedication of an ex-archon on Delos (3rd cent.), referring to others 'born out of this race for this share of honour'.

[59] For instance, on Rhodes: *Inscr. Lindos* 1.96, 97, 100, 104; *SEG* 39.748 might be a fragment of a priestly statue set up by relatives (ἱερῆ ᾿Αλίου). Rhodian priests also dedicated statues of themselves: *Inscr. Lindos* 1.58, 59, 61, 73, 74). For the shrine of Halios, *SEG* 39.740–7. A very impressive, multi-generational example from Kos: *SEG* 55.929.

καὶ Διὸς Πολιέως καὶ
Ἀρτάμιτος τᾶς ἐν Κεκοίαι.
θεοῖς.

Ἀγαθοκλῆς Ἀν[τ]ιοχεὺς ἐποίησε.

Damokrates son of Kallikles—Kallikles and Arsinoe and Xenokrateia (dedicated him), their father, Arsinoe daughter of Andromachos (dedicated him), her husband, once he had been priest of Athana Lindia and Zeus Polieus and Artemis in Kekoia, to the gods.[60]

Priestly statues set up by relatives are extremely well documented on Rhodes, but also in two other places. The first is Athens,[61] where the rich record allows for some sense of the shape of the phenomenon. The earliest, and grandest, examples are two statues of priestesses of Athena Polias, Lysimache I, statuefied in the first half of the fourth century already (this is in fact one of the earliest known family portraits of the type studied here, though the incomplete inscription does not indicate who dedicated it) and Lysimache II, statuefied c.300–290.[62] Painted family portraits, linked to priesthoods, are also known, such as the Eteoboutad group in the Erechtheion, representing the transmission of Poseidon's trident from Habron to Lykophron (both sons of Lykourgos the orator), but also the succession of all members of the family who had held the priesthood.[63] At Rhamnous, a statue of Aristonoe (Fig. 5.4), the priestess of Nemesis, was set up by her son in the second century: the statue is preserved (below, 281–7).[64] In addition to these statues of priests, families set up a large number of portraits of cultic personnel and individuals involved in rites or cult: for instance, daughters who had served as *arrephoroi* or *kanephoroi*,[65] or, at Eleusis, hierophants, *exegetai*, *dadouchoi*,[66] and the individuals known as 'hearth-initiates'.[67] This practice may be a development of the late Hellenistic period: the private statue habit at Eleusis is noticeably circumscribed chronologically to the second and first centuries.

To these examples in Attica should be added the rich documentation from Athenian-colonized, post-166 Delos, the third site where private priestly portraits are the best known, in enough detail that the texture and significance of the practice can sometimes be guessed at.[68] As in Athens, individuals set up statues of priests (for instance, Kynthiades of Chios set up a statue of Dionysios son of Dionysios, once he had been priest of Apollo, in the *dromos*, near the Stoa of Philip);[69] and, as in Athens, many more statues were set up for individuals who had held cultic offices, especially feminine, other than the main priesthoods of civic shrines: *huphiereia*,[70] *kanephoros* during festivals (on Delos, but also on the mainland—one Meinias,

[60] *Inscr. Lindos* 1.260.

[61] Examples are plentiful in *IG* II², part III.1, section III (pp. 116–70), studied by R. von den Hoff, 'Images and Prestige of Cult Personnel in Athens between the Sixth and 1st Cent. BCE', in B. Dignas and K. Trampedach (eds), *Practitioners of the Divine: Greek Priests and Religious Officials from Homer to Heliodorus* (Washington, DC, 2008), 107–41; also *Inscr. Eleusis* 266, 268.

[62] *IG* II² 3453, 3455, with von den Hoff, 'Images and Prestige', 126. *IG* II² 3474 contains an epigram for Philtera, priestess of Athena Polias, celebrating her Eteoboutad ancestry (but it is not clear who had set up the statue; 2nd cent.); *IG* II² 3484 is the statue of Chrysis daughter of Niketes of Pergase, priestess of Athena Polias, set up by her cousins in the late 2nd cent.

[63] [Plut]. *Mor.* 843. The wooden statues of Eteoboutadai, and the other paintings mentioned by Pausanias 1.26.5, may also be private portrait dedications at the occasion of priesthoods.

[64] *IG* II² 3462; studied extensively by Dillon, *Female Portrait Statue*.

[65] Examples are plentiful for *arrephoresasai* (*IG* II² 3564, 3470–3); 3483 is a private portrait dedication of Apollonia, *kanephoresasa* . . . , apparently found near the theatre of Dionysos.

[66] Hierophants: *Inscr. Eleusis* 242, 246. Exegetai: *Inscr. Eleusis* 275. Dadouchos: *Inscr. Eleusis* 278.

[67] *Inscr. Eleusis* 238, 244, 245, 251–3, 270, 273, 299.

[68] Examples are plentiful in the section on statues of priests in *ID* (1864–1921, section V.5); also among the dedications from the Sarapeion C, *ID* 2058, 2061, 206, 2070. The 'Egyptian' deity Sarapis also 'crowned' his priest Demetrios with a statue (probably by conveying instructions, in a dream, that the priest should set up his own statue, in the god's name): *IG* 11.4.1299.

[69] *ID* 1864, part of a multi-relational monument; 2nd cent.

[70] For instance *ID* 1867, c.125 (found in the *dromos*): Timodemos son of Pasikrates, of Melita, dedicated his daughter Diphila, once she had been *huphiereia* of Artemis, to Apollo. The 'under-priestess' of Artemis probably acted as main cult official of the goddess, who no longer had a main priestess after *ID* 1656: P. Bruneau, *Recherches sur les cultes de Délos à l'époque hellénistique et à l'époque impériale* (Paris, 1970), 196.

Fig. 5.4. The priestly genre was a privileged form for family monuments, as in the case of this portrait of a priestess, set up by her son, and exemplifying the genre of the female draped statue. Statue of Aristonoe, priestess of Nemesis at Rhamnous, mid-second century BC. H. 1.62 m. Athens, National Archaeological Museum, find inv. 232, cat. 574. Photogr. National Archaeological Museum.

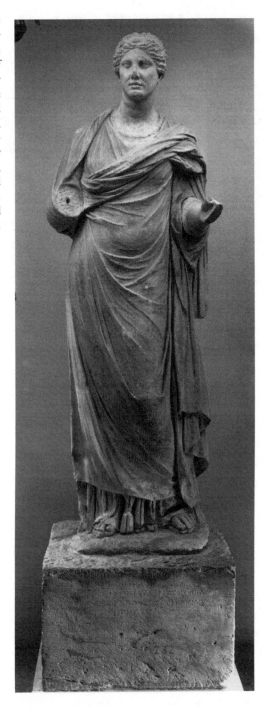

and her brother Zenon, served on the Pythais, the sacred procession, to Delphi),[71] *kleidouchoi* (Zenon also served as *kleidouchos* for the shrine on top of Kynthos, as mentioned in the inscription on the base of the multi-generational statue set up by his parents, his uncle, his two brothers, and his sister, Meinias).[72] The well-known private statues found *in situ* in a

[71] *ID* 1871 (found reused). On the participation of 'Delian' Athenians in the Pythais, P. Bruneau, *Recherches sur les cultes de Délos*, 125–6, with notes on the family of Zenon).

[72] *ID* 1891; 2070 for another *kleidouchos*, here of the Sarapeion C in III/0 BC, with P. Roussel, *Cultes égyptiens à Délos du IIIe au Ier siècles av. J.-C.* (Nancy, 1915–16), 268, on the importance of the office.

Fig. 5.5. The private monument, like the public monument, showed a relation, which could always be visualized by presenting the honourer as well as the honoured—in one case, on Delos, in a domestic context. Statues of Kleopatra and Dioskourides in their house on Delos, 137 BC (casts, erected in the original domestic location).

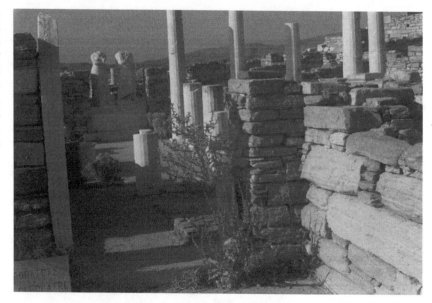

private house in Delos, though not set up at the occasion of priestly office, are nonetheless similar, in that they commemorate public piety (Fig. 5.5):

Κλεοπάτρα Ἀδράστου ἐγ Μυρρινούττης θυγάτηρ τὸν ἑαυτῆς
ἄνδρα Διοκουρίδην Θεοδώρου ἐγ Μυρρινούττης ἀνατεθεικότα
τοὺς δελφικοὺς τρίποδας τοὺς ἀργυροῦς δύο ἐν τῶι τοῦ Ἀπόλλωνος
ναῶι παρ' ἑκατέραν παραστάδα ἐπί Τιμάρχου ἄρχοντος Ἀθήνησι

Kleopatra daughter of Adrastos, of Myrrhinoutte, (has dedicated) Dioskourides son of Theodoros, of Myrrhinoutte, once he had dedicated the Delphic tripods made out of the silver, two of them, in the temple of Apollo by each *parastas*, when Timarchos was archon in Athens.[73]

Apart from the densely documented cases of Rhodes, Athens, and Delos, the habit of private priestly portraits dedicated by relatives and friends is found across the Hellenistic world—as known mostly through sporadic examples, such as the statue from the shrine of Artemis Aulideia near Tanagra:

Μνάσων καὶ Ἀθηνὼ Ζωπυρείναν
τὴν θυγατέρα ἱερατεύσασαν Ἀρτε-
μιδι Αὐλιδείᾳ.

Mnason and Atheno (have dedicated) Zopyreina their daughter, once she had been priestess, to Artemis Aulideia.[74]

Statues of priests, or ex-priests, set up by relatives and friends appear in Central Greece (for instance, from the Amphiaraion,[75] Thespiai,[76] Koroneia,[77] Elateia[78]); at Demetrias;[79] in the

[73] *ID* 1987, with P. Bruneau, *Recherches sur les cultes de Délos*, 127–8, on date and context: the year is 138/7, the 1st year the Athenians renewed the Pythais, and, as P. Bruneau suggested, Theodoros may have decided to commemorate the revival of the delegation to Delphi, with its ritual *tripodophoria*, with a dedication on Delos. On the statues, Ridgway, *Hellenistic Sculpture*, ii. 144–5.
[74] *SEG* 25.542, 1st cent. BC or later. The base is associated with a statue, but this is open to doubt (see below). Also *IG* 7.1834 (Thespiai). On the female statues from Aulis, Connelly, *Portrait of a Priestess*, 157–61.
[75] *Oropos* 405, 422 (3rd cent.), ex-priests of Amphiaraos.
[76] *SEG* 31.518 (*Thespies* 367), multi-generational monument for a woman who was priestess of Dionysos (perhaps early 2nd cent., from lettering).
[77] *SEG* 26.555 (mid-3rd cent.), dedication of statue of a woman by her father, once she had been priestess, to Artamis Orthosia.
[78] *IG* 9.1.287 (*c*.100?) and 139 (1st cent. AD?).
[79] *IG* 9.2.1122 (late Hellenistic); the base belonged to a familial exedra.

Peloponnese (Argos,[80] Messene[81]); on the islands (for instance, on Thasos among family statues set up in a specially arranged terrace in the shrine of Artemis,[82] perhaps on Samos,[83] on Kos[84]); in Asia Minor (at Pergamon,[85] Priene,[86] Miletos in the town,[87] but also in the extra-urban shrine at Didyma,[88] Halikarnassos[89]); Libya (at Cyrene and at Berenike);[90] and from the Black Sea (at Pantikapaion and Olbia).[91] The painting of an aged father, one Glaukion, and his youthful son Aristippos, described by Pliny as completed by an eagle with a snake in its claws, flying above them, might allude to the men's service as seers.[92]

More examples (and footnotes) could be given; one immediate problem is the significance of the proportional distribution of the evidence, so preponderantly attested in three places (Athens, Delos, Rhodes): what weight should we attribute to the absence or the thinness of distribution in other places? There are no private statues of priestesses at Samos (site of a great shrine of Hera), or Knidos (where a rich religious life is known by the archaeology and epigraphy). Are these accidents, or significant differences from Athens and Rhodes? At Halikarnassos, there are two known examples of family priestly statues, of which one is for a Neon son of Aristeides, known by another public statue for him (since he had served as priest of Apollo Archegetes five times). The family is presumably an important Halikarnassian one, of Theangelan origin (at least, it shows up repeatedly in the scanty evidence), providing another priest known from a decree quoted in Josephus.[93] This could reflect an accident of preservation, or the rarity, and hence significance (in terms of 'elite display' vel sim.?), of priestly family dedications in the social and political life of second-century Halikarnassos—in other words a particular choice within the competitive environment of statues which I have reconstructed in the previous chapters.

But why this choice, on the part of a particular Halikarnassian family? A more general question, at the level of the generic definition which I am attempting in this chapter, is to ask why individuals, singly or in groups, set up statues of relatives as priests. The majority of such statues are dedicated after service as a priest, as indicated by an aorist participle: the intention is to leave a monumental mark of a particular moment, usually the year of priestly office, just as individuals were sometimes represented in statue form after their service as magistrate. This is explicitly the intention behind the statue of Timanthis, priestess of Aphrodite, set up at Argos by her father, Timanthes, after a vow.[94] For cult officials (for instance the *kleidouchos* of a shrine

[80] F. Croissant, 'Note de topographie argienne (à propos d'une inscription de l'Aphrodision)', BCH 96 (1972), 137–54 (statue of Timanthis, set up by her father Timanthes, in the shrine of Aphrodite 'of the promontory'; 3rd cent.); Connelly, Portrait of a Priestess, 146.

[81] SEG 23.220 (statue of Mego set up by her parents, in the shrine of Artemis).

[82] IG 12, suppl. 383–4; on the terrace (2nd cent.), Guide de Thasos², and, importantly, Dillon, Female Portrait Statue, 135–47.

[83] IG 12.6.1.448, 452, both for neopoioi.

[84] PH 125.

[85] Inschr. Pergamon 180 (still under the Attalid monarchy).

[86] Inschr. Priene 160, 162, 180.

[87] Milet 1.3.168, Milet 6.1.250 (women represented in statues set up by relatives after performing a duty involving the supply or the handling of an allotted sacrificial ox, βουλαχέω, on which see P. Herrmann, Milet 6.1, p. 195, on no. 168); Milet 6.3.1086 (statue of man set up by his parents, once he had been priest of Athena Nikephoros; also SEG 48.1416).

[88] Inschr. Didyma 86, 87, 91.

[89] Wilhelm, Inschriftenkunde, i. 236; B. Haussoullier, 'Inscriptions d'Halicarnasse' BCH 4 (1880), 399, no. 8 (Diophantos set up a statue of his mother, Pantas, once she had been priestess of the Korybantes, as well as a statue of his wife: likely a multiple-statue, single-dedicator, 'distributive' monument).

[90] Cyrene: SEG 9.65, perhaps 66 (reading τελεσφορήσα[ντα]): familial statues of men who had been telesphoroi at festivals (3rd cent.). Berenike: SEG 28.1541, family-erected statue of man who had been priest, of Apollo (2nd cent.).

[91] CIRB 6 (Pantakapaion, with ὑπέρ, 4th cent.?); IOSPE I² 189–91 (Olbia).

[92] Pliny, NH 35.28 (the painting, by one Philochares, was set up in the Curia by Augustus; the original setting is unknown). For the soaring eagle with snake as a symbol of prophecy, the stele of Kleoboulos, son of Glaukos (Aiskhines' uncle) offers a parallel: SEG 16.193, photograph in BCH 82 (1958), 365.

[93] Wilhelm, Inschriftenkunde, i. 236–41, 306; Jos. AJ 14.233.

[94] Croissant, 'Note de topographie argienne'.

on Delos), the date can be specified by a reference to the priest in office;[95] priests, especially of civic cults, might be said to act as their own eponyms. Hence at Oropos, where the priest of Amphiaraos was the eponym, a family statue of a priest of Oropos dated itself by the honorand's year of service. Even when the priest was not the city's eponym, the succession of priests in a shrine acted as an internal, sacerdotal chronology, within which any individual family statue dedication placed itself, as the memory of a particular year within the series of priests and years: the time when Zopyreina served as priestess of Artemis Aulideia in the territory of Tanagra.

Such events may reflect *polis* history. At Miletos, the statue of a man was set up by his parents, commemorating his service as priest of Athena: the context may be the revival of interest in this cult.[96] But family-erected priestly statues mostly belong to the histories of individual families. At Halikarnassos, the service of Neon son of Aristeides as priest of Apollo for five (not necessarily consecutive) years was the occasion for his statue, set up by his uncle Menyllos, and simply describing him as ἱερητεύοντα in the present tense, capturing him in the moment of his priestly status.[97] The case of Neon, priest of Apollo at Halikarnassos, can thus be considered to belong to the category of 'honorific statue', set up privately to commemorate distinguished service and action. Such priestly statues do not so much record private motivations as the private desire to commemorate office that concerned the whole community.[98] On late Hellenistic Rhodes, two men, a *nakoros* (temple warden), along with a pipe-player, set up a statue of Aristomachos son of Aristomachos, priest of Athana Polias and Zeus Polieus, of Bybassos, priest of ἐφ' οὗ πᾶσα εἰράνα καὶ εὐωνία ἐγένετο, 'in whose time (as priest) all peace and happiness came to be'; the name of the honorand is the normal accusative, but his title, inscribed at the beginning of the inscription, stands out proudly (if ungrammatically) in the nominative.[99] Service as priest, if well accomplished, gave form to a community's piety, and was rewarded by divine favour to the whole community; this favour could be commemorated 'privately', but in a gesture that concerned the public.

But simultaneously, family-erected priestly statues also performed other functions. As had always been the function of dedications, they displayed aristocratic pride, strikingly illustrated by the case of the Eteoboutad priestly portraits.[100] In this respect, even the accounts of communally beneficial priestly service tell not only *polis* history, but also, and especially, family history, or private versions of *polis* histories. Priestly statues generally manifested family solidarity and the reciprocity uniting relatives, as made clear by the epigram under the statue of Mego at Messene,[101] set up by her parents when they served as priests and she assisted them in the ritual. Especially in the case of women fulfilling sacred office, the dedicatory portraits mark an important life-stage—not necessarily a full 'rite de passage' but an important moment of public service out of the household, in public shrines, for a limited time which it mattered to commemorate in permanent form. Transition and transformation are more obvious is statues set up by families for members who had undergone initiation, for instance at Eleusis. All these

[95] For instance *ID* 2070.

[96] *Milet* 6.3.1086 (see also *SEG* 48.1416).

[97] The participle is also used in the public statue of Neon, perhaps to mark the near-permanence implied by his repeated service.

[98] For an example of a priestess honoured publicly for happy events under her priesthood, *Inschr. Pergamon* 167: 'When Metris daughter of Artemidoros son of Theotimos was priestess of Victory-bringing Athena, the king enjoyed great successes, in consequence of which our people and all the others were left with the greatest advantages'; Connelly, *Portrait of a Priestess*, 140. Another example is the relief set up by an individual for Pausanias, priest of Apollo, at Cyrene, since Pausanias' priesthood saw the end of woes: Robert, *Hellenica*, i. 7–17; *SEG* 9.63; further bibliography *BE* 65, 468; generally, P. Ellinger, *La Fin des maux: D'un Pausanias à l'autre* (Paris, 2005).

[99] F. Jacopi, 'Nuove Epigrafi dalle Sporadi meridionali', *Clara Rhodos*, 2 (1932), 184–5, no 10. Similarly, *Inschr. Lindos* 2.347, with Rice, 'Prosopographica Rhodiaka'.

[100] *IG* II² 3474: the epigram celebrates not just her Eteoboutad ancestry (mentioned above), but specifically her descent from great Athenians, Lykourgos (the orator) and Diogenes (the liberator of 229).

[101] *SEG* 23.220.

events do not directly concern the whole community; rather, the whole community is called upon to witness moments in the life-cycle of a particular family, which assumes that it is entitled to display itself and call upon public attention.

c. Life and Death in the Family

Most frequently, 'private honorific' statues were set up to commemorate particular moments in internal family life or business, and make visible family solidarity. Such moments were points of transition which families faced and surmounted: hence family monuments can reveal, even as they try to bridge gaps and potential tension.

Such tensions are visible in the case of the practices, moments, and issues surrounding adoption (the preservation, severing, and creation of ties), and which can be an occasion for statue-making. On the Athenian Akropolis, a single base bore two statues: the first was the statue of one Lysiphanes son of Lysidemos (and adoptive son of one Kallias), and the second statue was that of Sostrate, Lysidemos' wife and Lysiphanes' mother: the adoptive father perhaps set up a statue of his new son, and his mother (upon marrying her?).[102] On Delos, a couple, Eudemos and Epaino, set up the statue of one of their sons, Demares, after he had been adopted by Theorylos son of Eudemos (clearly a relative).[103] At another social level, the practice of statues at the point (or after) adoption may underlie statues of the early Attalids: Philetairos set up a statue of Eumenes I, 'his son' (in fact his nephew), making visible the new relation, and Eumenes' status as heir to the dynast's position; the same Eumenes set up a statue of the future Attalos, also an adoptive son.[104]

Another occasion was the desire to manifest gratitude towards a guardian, perhaps at the moment of majority and in thanks for preserving property and safety, as in a private honorific statue set up at Delphi, through which one Nikandros, son of Nikandros, thanks Apollonios of Alexandria, his guardian and benefactor, for having been a good and suitable guardian (τὸν ἁτοῦ ἐπίτροπον καὶ ε[ὐ]εργέτην, ἐπιτροπεύσαντα καλῶς καὶ προσηκόντως), and having kept his property intact, and protected him in all matters.[105] In a similar, though more intimate fashion, in late third-century Dardanos, two brothers, Apelles and Metrothemis, sons of Kleanaktides, honoured their nurse (τήθη, ἐκτροφῆς ἕνεκεν καὶ φιλοστοργίας τῆς ἑαυτῶν, 'on account of her raising them, and their affection'.[106]

One particular transition that is marked by statues is the moment of death in the family. The transmission of property through inheritance can be marked by statues, set up by the heirs or the executors, upon the wishes of the deceased and as stipulated in the will. The stipulation of *ex testamento* portraits is documented in late Classical and Hellenistic Athenian wills—preserved because they happen to be the wills of famous philosophers.[107] Aristotle laid down that

[102] *IG* II² 3850 (3rd cent.); the scenario was proposed by Köhler. *IG* II² 3868 is a statue set up by Philon son of Philon, of Phlya, for Eudemos son of Sokydes, of Philaidai—his 'natural brother', [τ]ὸν ἑαυτοῦ γόνω[ι] ἀδελφὸ[ν]; the statue bridges the separation of adoption.

[103] Vial, *Délos indépendante*, 66 (mentioning *Inschr. Priene* 266 as a parallel).

[104] P. Jacobsthal, 'Die Arbeiten zu Pergamon 1906–1907. II, Die Inschriften', *AthMitt* 33 (1908), 405, no. 34, Hepding, 'Pergamon 1908–1909', 464, no. 45, with C. Habicht, 'Kronprinzen in der Monarchie der Attaliden?', in V. Alonso Troncoso (ed.), Διάδοχος τῆς βασιλείας (Madrid, 2005), 119–26.

[105] De la Coste-Messelière, 'Inscriptions de Delphes', 80, no. 6, 1st cent. Also *IG* II² 3908 (Augustan date); possibly *IG* 12.9.283 (Eretria: statue set up for a [τ]ρ[οφέα], [τ]ρ[όφιμον [ἐπίτ]ρ[όπου]); at the Epidaurian Asklepieion, Damokles and Astylaidas set up a statue of their maternal uncle, Patrokleias, 'their benefactor' (*IG* 4² 1.234): as J. Marcadé, *Recueil des signatures de sculpteurs grecs*, 2 vols (Paris, 1953–7), i. 'Xenophilos', notes, the two men's father, Thiokleidas, died in the Achaian War of 146 (*IG* 4² 1.28, l. 45), and the statue is a gesture of gratitude for the uncle's care of his orphan nephews.

[106] *IG* 12 Suppl. 29B, with Robert, *Monnaies antiques en Troade*, 30–2, and *Hellenica*, xiii. 41 (Metrothemis appears as *agonothete*, with his patronymic and his *ethnikon*, in *I. Ilion* 5, datable before 202). On nurses, Kontorini, 'Damagoras', 91–2 (τήθα means aunt in a Rhodian private honorific).

[107] These must be considered authentic. The will of Aristotle is known from two sources (below), Diogenes Laertius (perhaps drawing on Hermippos), and two Arabic translations (drawing on Andronikos of Rhodes)—the two sources concord, except that the Arabic tradition omits any mention of portraits (no doubt out of Muslim distaste for images). Theophrastus' will seems authentic, on the basis of prosopography: C. Habicht, 'Analecta Laertiana', in H. Büsing and H. Friedrich (eds), *Bathron* (Saarbrücken, 1988), 175–6. Generally, Dillon, *Ancient Greek Portrait Sculpture*, 105–6.

the executors are to see to it that portraits (*eikones*) are commissioned from Gryllion and dedicated when finished, those of Nikanor and of Proxenos, which it was my intention to commission, and that of Nikanor's mother, and they should set up the portrait of Arimnestos that has been executed, in order that there should be a memorial of him, since he died childless; and they should dedicate the portrait of our mother to Demeter in Nemea, or wherever seems good to them.

The various relatives can be identified, based on the various *Lives* of Aristotle (assuming their reliability):[108] Proxenos is the man from Atarneus who raised Aristotle after the death of the latter's father; Nikanor is Proxenos' son, very close to Aristotle (who intended his daughter to marry him); Nikanor's mother may have been Aristotle's sister, Arimneste. Childless Arimnestos is Aristotle's brother; hence, perhaps, the use of the first person plural in describing Aristotle's mother, τῆς μητρὸς τῆς ἡμετέρας.[109] Another instructive will is that of Theophrastos, who stipulated that a shrine of the Muses should be finished, with images of the Muses, but also a portrait (*eikon*) of Aristotle, and one of Nikomachos (for which the sculptor was the younger Praxiteles).[110] Finally, the early third-century head of the Peripatos, Lykon, asked for his brother to set up a statue (*andrias*) of him, the site (*topos*) to be chosen as appropriate by Lykon and two others.[111] Among all these images stipulated *ex testamento*, the portraits of Nikomachos, executed by Praxiteles, and of Lykon were certainly statues; the others could be painted portraits (the painting of Aristotle's mother by Protogenes of Kaunos might be the *ex testamento* portrait stipulated in his will).[112]

Lykon's statue, set up upon his own instructions, marks his transition from life to death with a memorial, made by the living by using the property left behind by the deceased; the transaction makes the statue a token in the interplay of transmission, exchange, absence, and reliquate that constitute the *post-mortem* event of the implementation of the will. Aristotle's will contains a more complex transaction. It is clear that he has already considered setting up a portrait of Proxenos earlier—this portrait is comparable to the statues of guardians mentioned above; likewise, Aristotle has already vowed over-life-size stone statues to Zeus Soter and Athena Soteira, in return for Nikanor's safety: these statues may be a pair of portraits of Nikanor, rather than of the deities.[113] There also already exists a portrait of Arimnestos, but this has not yet been dedicated: either it is still in the artist's workshop, or Aristotle has kept it with him, as a private memento. In either case, it is the move out of the workshop or the house, and the act of dedication in a shared space which will convert the portrait of Arimnestos into a *mnemeion*, a memorial whose force comes from being seen by all and by future generations. The other portraits, of Nikanor, his mother, and Aristotle's mother, though probably already commissioned, and certainly discussed with the testamentary executors (hence the definite articles in the will), are specifically meant to be set up after Aristotle's death. Aristotle's will specifically offers the occasion for planning (or going ahead with long-planned) family statue-fication. To literary evidence should be added, from the limits of the Hellenistic world, and the end of the period, Cicero's mention of statues set up in public spaces of first-century Sicilian cities because of testamentary dispositions.[114]

[108] I. Dürning, *Aristotle in the Ancient Biographical Tradition* (Gothenburg, 1957).

[109] H. Gottschalk, 'The Wills of the Peripatetician Philosophers', *Hermes*, 100 (1972), 314–82, less confident than A.-H. Chroust, 'Aristotle's Last Will and Testament', *Wiener Studien*, 80 (1967), 90–114, on restoring the stemma of Aristotle's relatives. If Nikanor's mother is indeed Aristotle's sister (generally, C. M. Mulvany, 'Notes on the Legend of Aristotle', *CQ* 20 (1926), 155–67), why are her name and relation to Aristotle not specified? The prosopography of Hellenistic Eresos also offers arguments to support the authenticity of Theophrastos' will, as I am informed by Aneurin Ellis-Evans.

[110] Diogenes Laertius 5.15; 5.51–2 (5.64 on Ariston of Keos as a source for Straton's will); Marcadé, *Signatures*, i. 'Praxitèle II'.

[111] Diogenes Laertius 5.71.

[112] Pliny, *NH* 35.106.

[113] I understand the text not as meaning that Nikanor, upon being saved, will set up images, but that the executors will dedicate Nikanor—in the form of two images: this is the well-known use of ἀναθεῖναι (Chap. 1).

[114] Cicero, *Verrines* 2.8.21, 2.14.36.

The practice may have been widespread, and can be traced epigraphically, if unevenly. It is well attested in some places in Asia Minor (Kyme, Aigai, Magnesia on Maeander, Priene, Miletos),[115] and sparsely attested elsewhere, for instance on Andros, Rhodes, and in Segesta[116] (and continued during the Roman empire).[117]

Many of these statues must have been set up by heirs for the deceased, in accordance with the latter's will. At Miletos, the group of men who set up the statue of Leontiskos are clearly his heirs—his son, his two grandsons, and an indeterminate friend or relative.[118]

> Λεοντίσκον Λεοντίσκου
> γυμν[α]σιαρχήσαντα Ἀπελλῆς
> Λεοντίσκου καὶ Λεοντίσκος καὶ
> Εὐθυδάμας οἱ Ἀπελλείους καὶ
> Ἀπατούριος Ἰσοκράτου κατὰ τὴν διαθήκην.
> vac. Δημήτριος Μελάνθου ἐποίησεν.

Leontiskos son of Leontiskos, who had been gymnasiarch—Apelles son of Leontiskos and Leontiskos and Eudamas sons of Apelles, and Apatourios son of Isokrates, (dedicated him), in accordance with his will. Demetrios son of Melanthos made it.

In other cases, we can see statues of the type illustrated by Aristotle's will, statues set up by executors upon the wishes of the deceased. At Rhodes, a man named Aristokleidas asked for a statue of his granddaughter Tryphera to be set up—not necessarily because she had predeceased him, as shown by the example of Aristotle having a statue of Nikanor set up.[119] The statue was set up by Aristokleidas' son, Tryphera's father, who claimed the act of dedication, but still made clear the testamentary origin of the statue event:

> Σύμμαχος Ἀριστοκλείδα
> τὰν ἑαυτοῦ θυγατέρα Τρυφέραν,
> καθ᾽ ἃν ἔθετο ὁ πατὴρ αὐτοῦ διαθήκαν.

Symmachos son of Aristokleidas, (set up) his daughter Tryphera, according to the will left by his father.

Statues of the living or the dead, left by the dead: to the category of family monuments set up *ex testamento*, another one should be associated, that of the statues set up by foundations, to be the recipient of cult and ritual honours: the intention and effect are the same as that of the statues *ex testamento*. On Thera, a couple, Epikteta and Phoinix, built a Mouseion (shrine of the Muses) in memory of their deceased son, with images (ζῷα) and statues (ἀνδριάντες) of the son and the father; upon Phoinix's death, Epikteta was required (probably by Phoinix's will) to finish the monument, 'and to place the Muses and the statues and the *heroa* (heroic images?)'. Two years later, the couple's second son died, and asked (again, probably in his will) his

[115] Kyme: *I. Kyme* 31 (the text is only known from a copy of Kontoleon, and it is not clear where the name of the honorand fits, but this is certainly a private statue set up *ex testamento*). Aigai: R. Bohn (ed.), *Altertümer von Aegae* (Berlin, 1889), 52–3, no. 3 (part of multiple-statue monument). Magnesia: *Inschr. Magnesia* 126, 128, 312. 393. Priene: *Inschr. Priene* 101, 266, 267–74. Miletos: *Milet* 1.3.168, 174; 1.7.251.

[116] Andros: *IG* 12 Suppl. 276 (1st cent. BC?). Rhodes: *Nuova Silloge* 30. Segesta: *SEG* 41.827; for G. Nenci's reading and restoration [ἔδ]ωκεν, read [ἀνέθ]ηκεν; the stone is not an architrave (Nenci), but the base of a private family statue, hence the restoration: see *BE* 00, 772 (discussing remarks by G. Manganaro).

[117] *I. Perge* 2 (the lettering makes clear that this is 2nd-cent. AD), 23 (Claudian); W. M. Ramsay, 'Inscriptions of Cilicia, Cappadocia, and Pontus', *Journal of Philology*, 11/21 (1882), 143. The Roberts, in *BE* 75, 475, on the statue of one Chrysippos, set up in the 2nd cent. AD at Kremna (*I. Central Pisidia* 57, *Steinepigramme*, iv, 18/07/01), suggest that Chrysippos stipulated this statue in his will. On Thasos, one Zotichos instructed his son Glaukippos to give 2,000 drachmas to certain parties, who responded by setting up a monument: *SEG* 27.551, 2nd cent. AD.

[118] T. Pékary, 'Inschriftenfunde aus Milet 1959', *IstMitt* 15 (1965), 118–19, no. 1.

[119] *Nuova Silloge* 30. Other examples can be given from Priene: a man inherited from his brother on the condition that he set up a statue of their father (*Inschr. Priene* 101), and the heirs of a man set up a statue of his son and the latter's wife (*Inschr. Priene* 275). Strikingly, one Achilleides left provisions to set up a statue of his son, Sosistratos, whom he had given away for adoption; earlier, they had jointly set up a multi-generational statue of another son of Achilleides, who was also given away for adoption (and probably died before his father): *Inschr. Priene* 266–7.

mother to carry out Phoinix's wishes, and 'to set up the statue and the *heroon* on his behalf, as was done on behalf of his father and his brother'. Epikteta endowed an association, charged with celebrating sacrifices to herself and her husband, and to their sons, and for feasting in their memory.[120]

On Kalaureia, one Agasikratis left 300 drachmas to the shrine of Poseidon, in order to provide for sacrifice, every two years, to Zeus Soter and Poseidon on an altar set up next to the statue of Sophanes, her husband. The *epimeletai* charged with this duty were also required to clean, and crown, the statues on the exedra, as well as a statue of Agasigratis herself, set up in the temple.[121] The statue of Agasikratis is probably a public honorific portrait; the statues in the exedra are certainly a private family monument, of the type described above. The statue of Sophanes perhaps stood in the place of honour, at one of the ends of the exedra,[122] next to which a temporary altar could be set up periodically for the sacrifices. The inscription is carved on a curved block, probably from the family exedra. The sacrifice was obviously not a sacrifice to the heroized dead, as on Thera, but it occurred next to the family statues, which inscriptions, of the familiar type, almost certainly located in a web of reciprocal familial relations: the act associated the family of statues with the religious offering to the gods—not recipients, but present and dominating throughout the ritual act, and perhaps during the feasting that followed, if the seats on the exedra were used by participants, sitting under the uncannily realistic but silent statues on top of the marble structure.

Some family-erected statues are explicitly funerary,[123] without the pretext or the occasion of the testamentary transmission of property and of instructions. Glorious death in battle is commemorated by early Hellenistic statues in Central Greece[124]—the equestrian statue of Eugnotos of Akraiphia (with a long and vigorous epigram about loss and consolation) was financed by his widow and his daughter; the statue of the Aitolian Skorpion, killed in war, was set up by his father, and also completed by an epigram where the themes of physical beauty and physical loss, bravery (*arete*), death, and memory are entwined.

Other examples are less dramatic, but the feelings behind them may have been just as poignant to those who knew the deceased and set up their portraits: a multi-generational statue set up at Xanthos, inside the town, completes the text with the formula ἥρωι—the honorand is already deceased.[125] Epigrams occasionally fill the emotional gap, and describe a sense of investment and loss. On Nisyros, a multi-generational private statue (phrased with ὑπέρ), set up by the honorand's parents, siblings, and maternal grandfather is revealed by an epigram to be both a dedication to Hermes and a funerary statue, an image of lost physicality imbued with memory and regret:[126]

[120] *IG* 12.3.330; also *RIJ* 2, 24A; B. Laum, *Stiftungen in der griechischen und römischen Antike*, 2 vols (Leipzig, 1914), no. 42; A. Wittenburg, *Il testamento di Epikteta* (Trieste, 1990), *non vidi*; A. Wittenburg. 'Grandes familles et associations culturelles à l'époque hellénistique', *Ktema*, 23 (1998), 451–6. On funerary heroization in the post-Classical world, C. P. Jones, *New Heroes in Antiquity* (Cambridge, Mass., 2010), 48–64.

[121] *IG* 4.840, 3rd cent. (better text than *RIJ* 2, 24 C in the crucial matter of the statues); P. Fröhlich, *Les Cités grecques et le contrôle des magistrats* (Geneva, 2004), 385–6.

[122] On the privileged (right) side in family groups, Wilhelm, *Beiträge*, 32, discussing Dittenberger's remarks on *Inschr. Olympia* 330 (col. 454).

[123] This is not the place for a full cultural history of the funerary statue in the Hellenistic world; for inspiration on how to study the nexus between death, image, text, ritual, and belief, see N. Llewelyn, *The Art of Death: Visual Culture in the English Death Ritual c.1500–c.1800* (London, 1991), drawing on the rich material from early modern and modern England (the Victoria and Albert Museum provides a suggestive sample of this funerary art).

[124] *ISE* 69; 85. Also *IG* 7.4247 (Thebes, epigram for Athanichos, victorious athlete, who died in battle; set up by female relative).

[125] P. Baker and G. Thériault, 'Notes sur quelques inscriptions de Lycie (Xanthos, Arykanda et Kadyanda) et deux nouvelles inscriptions xanthiennes', *REG* 122 (2009), 72–3 (1st cent. or later). One of the dedicators is known from his funerary marker (*TAM* 2.1.390).

[126] W. Peek, 'Epigramme und andere Inschriften von Nisyros', *Wissenschaftliche Zeitschrift der Martin-Luther-Universität Halle-Wittenberg*, 16 (1967), 374–6 (with Rice, 'Prosopographika Rhodiaka', 221–4, whence *SEG* 36.743); 2nd half of the 2nd cent. At l. 9, I suggest reading βίου for Peek's βαιόν (which would mean 'if Hades had not taken him for a little', or 'a little while before his time'), also on his facsimile.

Σω[σαγό]ραι μορφὰν
<ἐ>να[λί]γκιον εἰκόνα τάνδ[ε] |
μν[ᾶμ' ἀρετ]ᾶς, φθιμένο[υ]
θέντ[ο] φίλ[ο]ι γονέες, |
ἶσα φίλον [κ]ούροισιν
ὁμηλικίης ἐρατεινῆς |
σῆμα καὶ Ἑρμείει
[κλει]νὸν ἄνακτι γέρα[ς]. |
[εἰ δ'] Ἀίδης μὴ β . . . ἐνόσφισ[ε]
τόνδε πρὸ μοίρης, |
[οὐ]κ ἂν Πισαίων
ἦλθ' ἄμορος κοτίν[ων].

Like Sosagoras in shape, and a memorial of his qualities after his death, his parents have set up this portrait, to be both a loved sign for the young men of his lovely age-group, and a [fam]ed mark of honour for lord Hermes. If Hades had not taken him from life (?) before his time, he would not have gone without his share of Pisaian wild-olive.

Sosagoras' statue is a 'sign' (*sema*), a reminder, to his coevals; the word used is the same used for the grave monument, and alludes to the funerary, mourning function of the *post-mortem* statue. The epigram for an early Hellenistic family monument from Priene makes the parallels between statue and grave monument even clearer, and links the two as gestures of grief:

Αἰαντίδης Αἰσχυλῖνος Βιττάρη
Θεομνήστου Αἰαντίδεω Αἰαντίδεω

ΟΥ. ξύσθην ἐσθλοῦ πατρὸς ἤθεσι χρ[η]στοῖς
οἷς [με] ἔστεργε ἱερὸμ φῶς τόδε δερκόμενον
ἄλλοθ[ι] καὶ φθιμένου [τα]φεῖ[ο]ν θέτο, τήνδε δὲ μο[ρ]φῆς
ἔστησε εἰκόνα ἐμῆς Παλλάδος ἐν τεμένει.

Aiantides son of Theomnestos.
Aiskhylinos son of Aiantides
Bittare daughter of Aiantides
I was shaped through my noble father's character, with which he loved me when I saw this sacred light. After my death he made a grave monument elsewhere, and set up this image of my form, in the precinct of Pallas.[127]

All of these examples above were set up in public spaces: the agora, the shrine, the gymnasion. In a more direct statement about death and commemoration, statues were regularly set up on tombs. At Knidos, a γνωτὸν ἄγαλμα, 'well-known statue', was erected by a relative on the tomb of one Hyperbolos, along a road; an epigram mentions weapons, spoils, deeds of courage, no doubt alluding to service or even death in battle.[128] More prosaically, a very difficult document from Phistyon in Aitolia seems to contain the will of Leon son of Antileon, who donates money to his wife, and expects in return an *andrias* to be set up on his tomb.[129] Actual examples of funerary statues for the Hellenistic period have been preserved, for instance from Anaphe (where the statues seen by L. Ross are now in the island's archaeological museum),[130] Rheneia, Karystos, Thasos (two brothers, statuefied on their tomb by their grieving parents),[131] and

[127] S. Lambrino, 'Inscription de Priène', *BCH* 52 (1928), 399–406 (incomplete in *Inschr. Priene* 288). Lambrino reads the first letters as οὐκ ἰδίου, '(I was shaped) not by my own father's character', but the sense is not satisfactory. οὐ οὐκ followed by an adverb (e.g. 'not in vain')?

[128] *I. Knidos* 102 (2nd cent.).

[129] G. Klaffenbach, 'Neue Inschriften aus Aetolien', *Sitzungsberichte der Preussischen Akdemie der Wissenschaften* (1936), 367–70, no. 2: in case of Leon's death, the tomb (τ[ά]φον) and the *andrias* are to be finished according to a written memorandum (κατ τὰν συ[γ]γραφὰν), and the statue set up there. F. W. Schehl, 'On an Inscription from Phistyon in Aetolia (*SB Berlin* 1936, 367ff)', *AJA* 56 (1952), 9–19, argues for a statue set up in a shrine, but the arguments and restorations seem arbitrary.

[130] L. Ross, *Archäologische Aufsätze*, ii (Leipzig, 1861), 510–11.

[131] *IG* 12.8.441.

(slightly later than the Hellenistic period) the family group from Stratoni in the Chalkidike.[132] As M. Collignon noted, many draped marble statues in modern museums may well come from Hellenistic funerary monuments; the over-life-size statues among the Arundel collection in the Ashmolean Museum are a representative sample.[133] The practice continues into the Roman period: at Neokaisareia in Pontos, a late second-century AD mausoleum included statues of the deceased upon columns, an imitation of the civic idiom of honours for very great bene-factors.[134]

The usage of funerary statues, on tombs or in shrines, is older than the Hellenistic period (see below); it reflects a deep association between permanent portraits, memory, and death, and especially between loss of the physical presence of a person, and the power of the image to offer a substitute for that loss. In Athens, a man set up a statue of his brother on the Akropolis[135] in awareness that the permanence of the work of art compensated for the mortality of the body; in the epigram's striking formulation, the words 'his brother' are in apposition to 'this statue', proclaiming the illusory identity of image and subject.

Πόλυλλος Πολυλλίδου Παιανιεύς.
vac.
εἰκόνα τήνδ᾿ ἀνέθηκε Πολύστρατος αὐτοῦ ἀδελφόν,
μνημοσύνην θνητοῦ σώματος ἀθάνατον.

Polyllos son of Polyllides, of Paiania.
 Polystratos set up this statue, his brother, an immortal memory of a mortal body.[136]

Funerary statues 'fight against forgetfulness', in the Roberts' formulation;[137] the epigrams explicitly try to shape our reactions when viewing the statues, and make explicit the intentions and emotions which I have tried to tease out of the prose indication of relations between the setters and the recipients of statues. The importance of statues in mediating grief, loss, and family solidarity in funerary contexts is also made clear by Hellenistic funerary *stelai* where family members are shown around a relative who is represented in statue form, the *mise en abyme* signalling that the latter relative is already deceased, and present, in the family group, only as an image.[138] As a cultural phenomenon, the links between death, memory, family, and statues form a major part of the statue habit. What remains is to elucidate is the politics of this phenomenon: how it informs, and influences, the workings of the honorific.

d. Displaying Affection

Vows, agonistic victories, public office, priestly and sacral service, family transitions, and especially the marking of the passing away of relatives; memory, requital, exchanges, and thanks, traces left of important moments, absences compensated. All those constitute occasions for families to set up statues of their members. These statue events, we may surmise, were the occasion for negotiations, discussions, and social transactions within the families: this is clearest in the case of the *ex testamento* portraits. Epigrams give poetic texts to accompany images: they speak of reciprocity and requital (a Kalymnan calls the statue he sets up of his

[132] I. A. Papangelos, *Chalkidiki* (Ashbourne, 1987), 262 (funerary building or *heroon*). The statues are now in the archaeological museum in Polygiros.

[133] M. Collignon, *Les Statues funéraires dans l'art grec* (Paris, 1911), 280–314.

[134] *I. Arai Epitymbioi* 155. A parallel is the funerary monument with statues mentioned in an inscription from Roman Thessalonike: *IG* 10.2.608.

[135] Köhler, 'Attische Inschriften', 150–3.

[136] *IG* II² 3838. On the use of the nominative in the formula, see above, 21–3. Very similar is *IOSPE* II 9 (dated by Pairisades I, who ruled from 347 to 310); same text *CIRB* 113, Löhr, *Familienweihungen*, 145 (mistranslated: σοῦ bears on εἰκόνα not on Phanomachos, 'dein Phanomachos', Löhr).

[137] *BE* 73.538: 'une lutte contre l'oubli'.

[138] *PM* 628 (Istanbul; 1st cent.); 270 might be another case, but the fragmentary statue on a pedestal could be a statue of Artemis.

father his *threpteria*, a return for his rearing), respect for parents, the desire for memorialization, family pride, and self-advertisement.[139]

However, such epigrams are an exception. In most cases, the inscriptions under the statues are formulaic, and do not inform us explicitly about the reasons and the transactions that certainly took place. When, at Knidos, Damatria set up a statue of her daughter's son Dion to Artamis Hiakynthotrophos Epiphanes, this might well have been at the occasion of some action or service performed by Dion at the goddess' festival[140]—but the inscription tells us nothing about the occasion for the statue, only the fact of the statue transaction, and its power to make visible a relation between the generations within the same family. Private familial statues were set up in the shrine of Poseidon and Amphitrite at Tenos (perhaps because of the healing nature of Poseidon on Tenos, attested by Philochoros, but votive intention is not recorded explicitly on the rather diversely inscribed bases).[141]

The formulas occasionally give brief indication of motivation, and hence deserve attention. A statue can be set up in return for qualities such as *arete, eunoia, euergesia*—goodness, goodwill, beneficence, the same values recognized in the public honorific. A woman from Keramos, with permission from her guardian, honoured her deceased husband with a statue:[142]

Ἥδεια Μητροφάνου, κατὰ θυγα[τρο]ποΐαν
δὲ Δράκοντος, ἧς κύριος Δράκων Δράκοντος
τοῦ Λέοντος, τὸν ἑαυτῆς ἄνδρα Ἀριστοκρά-
την Δράκοντος ἀρετῆς ἕνεκεν καὶ εὐνοί-
ας τῆς εἰς ἑαυτήν· vacat θεοῖς.

Hedeia daughter of Metrophanes, adoptive daughter of Drakon, whose guardian is Drakon son of Drakon son of Leon, (dedicated) her husband Aristokrates son of Drakon, on account of his goodness and his goodwill towards her, to the gods.

The formula is exactly the same as that in a public honorific statue, and this example from Keramos illustrates, as do the other examples giving the motivation for a statue, the nature of at least some family statues as 'private honorific' monuments. It is noticeable, however, that the same Hedeia set up a statue for her daughter, without giving any justification for the statue. How are we to account for the difference? How are we to describe the second statue? At issue are the function, and workings, of the familial genre within the honorific statue habit.

A more specific term occurs to describe the motivation for private statues, φιλοστοργία—people set up portraits of their relatives out of 'tender love'. At Keramos, a man set up the statue of his brother once he had been *stephanephoros*, but out of affection.[143] Like *eunoia*, the term can be used to describe the attitude of the honorand, or the attitude of those who set up the statue: a Rhodian 'multi-generational' monument for a (now nameless) woman was dedicated εὐνοίας ἕνεκα καὶ φιλοστοργίας τᾶς εἰς αὐτάν, 'on account of the goodwill and the love (which the dedicators have) towards her'.[144] The potential bilaterality of the term reflects the ideal of a 'courant réciproque' (L. Robert) of affection in the family.[145] *Philostorgia* as a proclaimed motive for statuefication of relatives illustrates the felt need for an explicit display of intimacy in public spaces. It was publicly acknowledged: when the citizens of Metropolis in Ionia decreed honours for Apollonios, who had died in battle leading the young men during the war of Aristonikos, Apollonios' sons offered to pay for the honorific statue, by which

[139] *Tit. Cal.* 130; *Inschr. Kaunos* 49–53; *Inscr. Lindos* 1.197.

[140] *I. Knidos* 171, with W. Blümel's commentary.

[141] Family statues: *IG* 12.5.916, 918–22, 925, 879, *IG* 12, suppl. 321, discussed below.

[142] *I. Keramos* 5 (with no indications of date); van Bremen, *Limits of Participation*, 220.

[143] *I. Keramos* 29, dated by Varınlıoğlu to the early 3rd cent. AD, but this seems late, if the typeface in E. L. Hicks' diplomatic edition is reliable: 'Ceramus (Κέραμος) and its Inscriptions', *JHS* 11 (1890), 109–28, at 121.

[144] Konstantinopoulou, 'Epigraphai ek Rodou', 12–13, no. 17 (1st cent.). Also *IG* 12.1.72, *SEG* 41.1037.

[145] Robert, *Hellenica*, xiii. 39–41 (on Roman inscriptions from the Killanian Plain).

gesture they earned praise ἐπὶ τῆι πρὸς τὸν δῆμον εὐνοίαι καὶ τῆι πρὸς τὸν πατέρα φιλοστοργίαι, 'for their goodwill towards the people and their love for their father'.[146]

Philostorgia is in fact a late-comer to the vocabulary of the family monument, with its origin in royal terminology, Seleukid (in edicts)[147] and Attalid (in family statues).[148] From the display of royal family love, the term migrates to private honorific statues, from the second century onwards, in Asia Minor, the islands and especially on Rhodes.[149] The term hence has its own history[150] and its own distribution (it never appears in Athens), a good reminder of the diversity and the changeability of the private honorific habit (in conjunction with broader historical mutations, in the nature of the *polis* and of the family in the late Hellenistic period). What the term illustrates is the possibility of the public display of private affection. The same tendency, though not expressed quite so explicitly, may lie at the root of the use of familiar, often local terminology in the description of relations on statue inscriptions. At Thespiai, a man was statuefied by two generations of relatives:[151]

> Φίλιππος Λυσάνδρου τὸν ἑαυτοῦ πατέρα
> καὶ Καλλικράτης καὶ Λυσάνδρα οἱ Φιλίππου
> τὸν ἄττειν Λύσανδρον Κλεοφάνους, φύσει δὲ
> υἱὸν Σάωνος τοῦ Καλλικράτους vac θεοῖς.

Philippos son of Lysandros (dedicated) his own father, and Kallikrates and Lysandra children of Philippos their *atteis*, Lysandros son of Kleophanes, natural son of Saon son of Kallikrates, to the gods.

The term is only attested here, and must mean 'grandfather', from an Aeolic *Lallwort*;[152] similarly, the honorand in a private monument might be called *annis* (a familiar word for grandmother), as at Chaironeia, or *nennos* (maternal uncle), as Chrysippos was on the base of the statue set up by his nephew in Athens. In the latter context, the word was not usual: the relation was qualified with a term used in Anatolia, emphasizing the common origin of the two men and their bond, and displaying their shared foreign origin in Athens.[153] For the statue of Chrysippos at least, we can judge the ostentatious effect of the private term; in Thespiai or Chaironeia, it is less clear what the effect of the local terms *atteis* and *annis* could have been, but the combination of affectionate *Lallwort*, private epigraphy in a public space, and statue still remains striking.

The very frequent use of the emphatic possessive in the inscriptions of family monuments might also work to display intimacy: men and women set up (statues of) τὴν ἑαυτοῦ μητέρα, τὸν ἴδιον ἀδελφόν—literally 'her/his own mother', 'her/his own brother'.[154] Admittedly, the redundant construction is commonly used for the possessive in post-Classical Greek.[155] However, it is not

[146] *I. Metropolis* 1A 42. [147] Ma, *Antiochos III*, document no. 37.

[148] *Inschr. Pergamon* 170, 219; *I. Ilion* 41. The word is also used in a letter from Attalos II, to describe his feelings towards a relative (*RC* 65–7).

[149] Robert, *Etudes Anatoliennes*, 366; *IG* 12, suppl. 321, date tentatively proposed by P. Graindor, *Musée Belge*, 14 (1910), 29; *HTC* 56 (from Thera in the Rhodian Peraia), 1st cent. BC; *I. Mylasa* 405–7; *SEG* 39.1174 (2nd half of the 1st cent., Ephesos). Later, the term is popular in Lykia: *SEG* 53.1697 (Phellos, late Hellenistic or later), parents set up a statue of Osetes; 54.1406 (Limyra, *c*.AD 100): Pteunase sets up her husband Ermanduberis to the gods—in both cases, φιλοστοργίας καὶ μνήμης ἕνεκεν 'for love and memory'.

[150] Robert, in Holleaux, *Études*, iii. 94–5: 'L'emploi de φιλοστοργία dans les dédicaces et les décrets relatifs à un citoyen demande une étude spéciale' ('the use of φιλοστοργία in dedications and decrees in honour of citizens requires a particular study').

[151] P. Jamot, 'Fouilles de Thespies: Deux familles thespiennes pendant deux siècles', *BCH* 26 (1902), 304 no. 29; *Thespies* 388 (1st cent. BC, or AD).

[152] *LSJ* and P. Chantraine, *Dictionnaire étymologique de la langue grecque*, 4 vols (Paris, 1968–80) s.v. ἄττα (*MAMA* 3.53, in Kilikia, is an epitaph where τὸν ἄτειν appears, but the reading might be challenged, since there seems to be no name for the deceased wife whose gravestone this is).

[153] *IG* 7.3380, with L. Robert in N. Fıratlı, *Les Stèles funéraires de Byzance gréco-romaine* (Paris, 1964), 140–1; Wilhelm, *Inschriftenkunde*, ii. 13–17. On 'les termes de parenté', Robert, *Hellenica*, xiii. 33–4.

[154] The construction is to be restored in *SEG* 28.1541 (Cyrene, 2nd cent.): the honorand, Charmeidas, a priest of Apollo, is [τὸν ἑα]υτᾶς ἄνδρα; *SEG* 9.64.

[155] E. Schwyzer, *Griechische Grammatik*, 4 vols (Munich, 1980), ii. 118 n. 1, 204–5 (reflexive pronoun used for possessive in Classical Greek already); K. Meisterhans, *Grammatik der Attischen Inschriften* (3rd edn, by E. Schwyzer, Berlin, 1900), 235; *LSJ* s.v. ἴδιος, 'almost as a possessive'. It appears already in the epigram *IG* II² 3830, from Salamis (mid-4th cent.).

used uniformly across regions; most importantly, it is not used uniformly within inscriptions—the private monument from Thespiai, above, reserves the reflexive pronoun for the honorand's son, whereas his grandchildren simply use the definite article. The difference might be accounted for by more than just space on the stone: emphasis is laid on the 'main dedicator', the son. The monument set up by Demokrite for her father and her son (*Oropos* 424–5, above) uses the emphatic reflexive for the father, but a simple definite article for the son: this may be a way of inflecting slightly the monument, perhaps by lending greater importance to the eldest male on the monument. Emphasis and redundancy are more than just the 'normal' way of expressing the possessive; they show us the dedicator insisting on closeness to, and, indeed, possessiveness over the honorand—as one of the main characteristics and functions of the 'private honorific' portrait genre.

e. From Friendship to Patronage

Intimacy was not reserved for relatives: it could also be the origin of ostentatious gestures between friends. In Mylasa, the priest of Zeus Labraundeus set up a statue of the priest of Zeus Osogo.[156] This was not, or not only, a collegial gesture between priests: the statue was captioned as a gesture resulting from mutual affection, φιλοστοργίας ἕνεκεν, as in the case of statues set up by individuals for their relatives. In the gymnasion of Eretria, at some point in the late first century, a man set up a statue of a friend:

Κλεόνεικον Λυσάνδρου
Ἀμφικράτης Λυσάνδρου
τὸν ἑαυτοῦ φίλον.

Kleonikos son of Lysandros—Amphikrates son of Lysandros (dedicated him), his friend.[157]

The two men are probably relatives (rather than brothers), but choose to emphasize their friendship, commemorated by a private monument in the gymnasion, a site of male sociability and relations. In Delphi, a statue honoured the *arete* and the *eunoia* of a man for being τὸν ἀπὸ προγό[νων ξέ]νον καὶ εὐεργέτην, 'his ancestral guest-friend and benefactor',[158] thus commemorating a private relation. On Delos, at least six private honorific statues were set up for friends.[159]

However, the practice of private honorific statues among friends is rare: 'private honorific statues' are in fact dominated by the familial subgenre.[160] One explanation might be practical: the exorbitant expenditure involved in full-size marble or bronze portraiture largely limited the practice within families. But this choice, in turn, needs explanation (below, Chap. 6), with particular attention to the social function performed by the display of family relations in the community.

Outside the family, there is one type of private honorific statues that is common: it reflects not simply the availability of great wealth, but also the display of relations with (or between) the powerful: many are honorific gestures for benefactors, or patrons.[161] On Delos, the people involved are strikingly important: the sons of an *epimeletes* of the island honoured Ser. Cornelius, Ser. f., Lentulus, their guest friend—and a proconsul; L. Orbius, an important Roman, was honoured by his friends. Notably, individuals set up statues of kings:[162] the

[156] *I. Mylasa* 406, late Hellenistic. The inscription, mentioning the statue and the honorand's name in the genitive, is typical of Mylasa. (Zeus Labraundeus is a restoration by A. Laumonier.)

[157] *IG* 12.9.281, better in K. Fittschen, 'Zur Bildnisstatue des Kleonikos, des "Jünglings von Eretria" ', *Eirene*, 31 (1995), 98–108. The base was found alongside a statue, the famous 'Youth of Eretria' representing a young man swathed in a himation, standing next to a support, covered with two pairs of boxing gloves, which probably does belong with it: below, 288–9.

[158] De la Coste-Messelière, 'Inscriptions de Delphes', 80–1, no. 7. I restore [ξέ]νον for the editor's [πρόξε]νον.

[159] *ID* 1999 (late 2nd cent.); also 2000–4, perhaps also 1998.

[160] Below, chap. 6, 202–12, notably on the cases of Lindos and Delos.

[161] e.g. *Iscr. Cos* EV 150 (*PH* 126), 1st cent.

[162] W. Völcker-Janssen, *Kunst und Gesellschaft an den Höfen Alexanders d. Gr. und seiner Nachfolger* (Munich, 1995), 165–79.

enormous column monument in front of the *Echohalle* at Olympia (Fig. 6.3) is a private honorific monument set up by Kallikrates for Ptolemy II and Arsinoe II.[163]

This subgenre is well attested, for instance in the case of the Ptolemies, or in international shrines such as Delos or Olympia;[164] it performed an important role in the representation of the Hellenistic kings and their power, by the diffusion of calibrated images and texts within and without their kingdom, the display of loyalty within the royal state by the state's men,[165] and the importance, status, and connectedness of officials or local partisans of a dynasty.[166] The subgenre also allowed gestures of loyalty by governors, in the aftermath of conquest[167] or victory[168] or during dynastic conflict.[169] Such monuments seem to be honorific, rather than cultic: dedications to kings, or of altars of kings, by individuals, did not include statues.[170]

Conversely, kings set up statues of their Friends and officials.[171] On Delos, Seleukos IV set up a statue of his minister Heliodoros, with an emphatic inscription:[172]

[163] *Inschr. Olympia* 306–7; H. Hauben, *Callicrates of Samos: A Contribution to the Study of the Ptolemaic Admiralty* (Leuven, 1970); W. Hoepfner, *Zwei Ptolemaierbauten: das Ptolemaierweihgeschenk in Olympia und ein Bauvorhaben in Alexandria* (Berlin, 1971).

[164] A peculiar case is *OGIS* 121–2, where the name of the dedicant is chiselled out, no doubt after disgrace, and replaced with the name of the gods Isis and Osiris (Wilhelm, *Akademieschriften*, iii. 143–8, 150–1). Delos: *Choix Délos*, no. 37 (for Phila), 59 (Menippos for Antiochos III, his saviour and benefactor), 109 (for the future Antiochos IX), 120–1 (for Antiochos VII), 126 (for Ptolemy X); a whole monument was set up by one Helianax for Mithradates VI and his courtiers, represented in statues or, uniquely, in marble portrait medallions, *ID* 1563, 1569, 1570, 1572 1573, 1576. 1582, 1552 with P.-A. Kreuz, 'Monuments for the King: Royal Presence in the Late Hellenistic World of Mithridates VI', in J. M. Højte (ed.), *Mithridates VI and the Pontic Kingdom* (Aarhus, 2009), 131–44. At Olympia, Pausanias 6.16.2 with Stewart, *Faces of Power*, 279, S. Zoumbaki, *Prosopographie der Eleer bis zum 1. Jh. v. Chr.* (Athens, 2005), s.v. Τυδεύς, also Kruse, 'Zwei Denkmäler der Antigoniden'; Pausanias 6.17.1, statue of Ptolemy II set up by Aristolaos the Macedonian, in fact the governor of Karia (as known from a Samian decree for him, *IG* 12.6.120). At Cyrene, *SEG* 9.62 with R. Bagnall, 'Stolos the Admiral', *Phoenix*, 26 (1972) 358–68; at Paphos, Mitford, 'Old Paphos', nos. 40 (Ptolemy V, by Polykrates of Argos, governor), 51 (Ptolemy VI, by governor), 53 (Ptolemy VI by officier), 88 (Ptolemy, son of Ptolemy VIII Euergetes II, by governor), 93 (Ptolemy Alexander I, by courtier), and at Cypriot Salamis, under the Ptolemies, *Salamine de Chypre*, nos. 61 (Ptolemy II, by *oikonomos*), 64 (Ptolemy IV, by governor), 65–6 (Ptolemy V, by a gymnasiarch and by an *agonothete*), 67 (Ptolemy VI, by a Friend). Some special cases: *ISE* 56 (at Dyme, Hagemonidas, a local man in Seleukid service sets up a statue of Antiochos IV Laodike IV and Antiochos V); *SEG* 33.642 (Kilikian friend of Ariarathes VI sets up a statue of his king on Rhodes); *SEG* 30.364 (victorious athletes set up a statue of a Ptolemy—in Argos: did he act as the athletes' patron, as suggested by the Roberts, *BE* 81, 262? K. Buraselis ('Ambivalent Roles of Centre and Periphery: Remarks on the Relation of the Cities of Greece with the Ptolemies until the End of Philometor's Age', in P. Bilde (ed.), *Centre and Periphery in the Hellenistic World* (Aarhus, 1993), 260) proposes that the two athletes might have been Alexandrians.

[165] *Inscr. Alexandrie* 26 (earlier *OGIS* 731) is a statue of Ptolemy V set up by two Egyptian officers (*laarchai*). The gesture amounts to a statement of loyalty by members of a particular social class in Ptolemaic Egypt, the native warriors, which caused unrest in post-Raphia Egypt; in addition, the two officers added the names of the king's parents to the dedicatory inscription. The deep base (1.05 m) is not quite wide enough (75 cm) to have supported a group of three statues, so it is only the inscription that adds this extra dimension of dynastic loyalty.

[166] Local partisans—or simply local notables, eager to display loyalty: *MAMA* 6.173 (Apameia in Phrygia: citizen sets up *agalmata* of Eumenes II and Attalos II in the gymnasion). Generally Smith, *Hellenistic Royal Portraits*, 20–3; Ma, 'Le Roi en ses images'.

[167] *Inscr. Tyr* 18 (not long after Raphia, Polybios 5.87.6); *SEG* 20.467 (Joppa).

[168] *Inschr. Pergamon* 165 (statues of Eumenes II and Attalos set up after victory over Galatians, obtained with divine assistance).

[169] Bagnall, 'Stolos the Admiral'.

[170] e.g. *Inschr. Pergamon* 59; *OGIS* 110; *ISE* 106. Many of these dedications include the king as part of a dedicatory gesture to several deities.

[171] *RC* 45. Holleaux, *Études*, iii. 230: 'J'ignore s'il y a beaucoup d'exemples d'un tel honneur décerné à l'un de ses serviteurs par un souverain hellénistique'. See *OGIS* 39, same document Mitford, 'Old Paphos', no. 17 (Paphos, Ptolemy II sets up statue of Pyrgoteles, 'for being the master-builder of the *triakonteres* and the *eikoseres*', ἀρχιτεκτονήσ[αντα] τὴν τριακοντήρη καὶ εἰκ[ο]σ[ήρη]); *IG* 12.6.1.469 (*SEG* 1.374), with Savalli-Lestrade, *Les Philoi royaux dans l'Asie hellénistique* (Geneva, 1998), 151–2 (Attalos II sets up a statue of his general and seal-keeper Philopoimen in the Samian Heraion); *OGIS* 317, same document *IG* 12.2.639 (Attalos II sets up statue of Euakes on Tenedos); Savalli-Lestrade, *Philoi*, 153, no. 47, on B. D. Meritt, 'Greek Inscriptions', *Hesperia*, 23 (1954), 252 no. 33 (Attalos II sets up a statue of Theophilos, his foster-brother). On Delos, *Choix Délos*, no. 53 (same document *IG* 11.4.1109): Attalos I set up a statue of his general Epigenes of Teos, at the entrance to the shrine; at Pergamon, *Inschr. Pergamon* 29.

[172] *Choix Délos*, no. 71.

βασιλεὺς Σέλευκ[ος]Ἡλιόδωρον Αἰσχύλου
τὸν σύντροφον, τετ[αγμ]ένον δὲ καὶ ἐπὶ τῶν πραγμάτων,
πρὸς ὃν ἔχει τε κ[αὶ ἕξ]ει ὡς πρὸς ἑαυτὸν
διά τε τὴν φιλ[ίαν καὶ δικαιοσύν]ην 4
εἰς τὰ πράγμα[τα]
[Ἀπ]όλλ[ωνι].

King Seleukos (has dedicated) Heliodoros son of Aiskhylos, his foster-brother, and also the official appointed over the affairs, towards whom he (the king) is disposed and will be disposed as towards himself, on account of his friendship and the justice which (Heliodoros shows) towards the affairs (the state), to Apollo.

That Heliodoros then murdered his royal master (and foster-brother) only makes the declaration of closeness and gratitude in the private honorific monument more striking; the register is the same as the private statues set up by kings for their relatives, the display of harmonious personal relations as part of the successful patrimonial state.

The statue of Heliodoros set up by Seleukos IV stood next to portraits of Heliodoros and his family (συγγένειαν), set up by Artemidoros, another Friend of the king, in recognition of Heliodoros' behaviour towards the king and his affairs, and of his 'friendship and beneficence towards himself' (φιλίας δὲ καὶ εὐεργεσίας τῆς εἰς [α]ὐτὸν). The practice of private honorific statues between non-relatives is well attested in the world of royal officials: in addition to international shrines such as Delos,[173] the dedication of honorific portraits among royal officials is well attested in particular contexts such as Ptolemaic Cyrenaica[174] or Cyprus,[175] or in Seleukid and then Parthian Susa[176] or Media[177]—provincial, with weak local communal organization, and saturated with royal control and presence. The habit is attested in another world saturated with royal power: Ptolemaic Egypt itself, where statues of courtiers in favour were set up by other courtiers.[178] In Lower Egypt (perhaps Alexandria, perhaps the Eastern Delta), a courtier set up the statue of his father:[179]

[Ζηνω?]να Ἀπολλοδώρου Ἀθηναιέα τὸν
[γε]νόμενον ἐν τοῖς πρώτοις φίλοις
καὶ ἐπὶ τοῦ λογιστηρίου τῶν νομαρ-
χικῶν καὶ πρὸς τῆι ἐπιστατείαι 4
τοῦ ξενικοῦ ἐμπορίου
Θεαγένης τῶν πρώτων φίλων καὶ
τῶν ἐφημερευόντων τοῖς βασιλεῦ-
σιν εἰσαγγελέων τὸν ἑαυτοῦ πατέρα
Ἀρβαίθωι καὶ τοῖς συννάοις θεοῖς.

[173] Robert, OMS vii. 711–12 on ID 1547–8 (Choix Délos 109); Choix Délos, nos. 127–8 (also OGIS 173, ID 1533–4); Bagnall, 'Stolos the Admiral'.

[174] SEG 9.359 with Laronde, Cyrène, 418; also Laronde, Cyrène, 420: a father sets up the statue of his son, but identifies him as a Ptolemaic courtier.

[175] Mitford, 'Old Paphos', nos. 19 (among relatives of Kallikrates son of Boiskos, the admiral of Ptolemy II), 41 (statue of Zeuxo of Cyrene, wife of Polykrates, the governor, set up by Stratonike of Alexandria), 45 (statues of Hermione and Zeuxo, daughters of Polykrates, part of portfolio monument), 49 (Ptolemaic officer and wife set up statue of their son), 85–6 (statues of governor and his son, set up by courtier), 102 (statue of priest, set up by courtier). Salamis: Salamine de Chypre, nos. 81 (gymnasiarch sets up statue of governor), 89 (wife of an officer honours her father), 97 (governor sets up statue of gymnasiarch). Kition: Kition 5, 2024 (city governor, by his daughter-in-law), 2028 (officer, by his father). A fragmentary example from Rhodes probably comes from Cyprus, as I will perhaps show elsewhere.

[176] I. Estremo Oriente 183, 184–5, 204 (which I would rather date to the Seleukid period, rather than the Parthian period with Canali de Rossi), 219 (also RC 75: portrait of royal official, set up by his father, with letter of Artabanos II inscribed on the base; AD 25).

[177] I. Estremo Oriente 279 (Python son of Python sets up a statue of Menedemos, the governor of the upper satrapies—correct the slip ὑπὸ to ἐπί).

[178] OGIS 102; Polybios 14.11 (portraits of Kleino the cupbearer of Ptolemy II, set up in temples—I conjecture they belong to this category of private portraits monuments set up by other royal courtiers).

[179] I. Alexandrie 58.

Zeno (?) son of Apollodoros, of the (Alexandrine) deme of Athenaeis, who has been one of the First Friends, and the official in charge of the account-house of the nome-tax, and who served in the administration of the foreign harbour—Theagenes, one of the First Friends, one of the royal ushers on duty (has dedicated him), his father, to Harbaithos and the gods who share the temple.

The statue transaction between son and father is also the occasion for both participants to display their court status, and their services—past in the case of the father, present in the case of the son. In fact, most of the inscription is taken up by the enumeration of administrative and aulic office: the text is organized in two blocks of text, balancing and making clear the relation clear between the two men. The long enumeration of importance compensates for the relative lowliness of both officials, an impression confirmed by the small size of the base (the inscription is on a small orthostate, 34 × 30 × 7 cm).

The practice of private honorific statues for rulers or royal officials constitutes an important part of the honorific statue habit, as well as a significant phenomenon in the cultural history of the Hellenistic world. The wealth, and ostentation, of the kings and their Friends are much in evidence—as are intimacy and proximity of relations in the world of the kings and their officials. Honorand and dedicators locate their identity within the royal state, by having their court titles and offices mentioned in the dedicatory inscriptions of the private monument; this declaration of identity is also an implicit justification for the act of setting up a statue, and a pragmatic statement about the solidity of the state. Dynastic loyalty, but also cordiality, sociability, affection, were essential—the declaration of personal investment and attachment lent stability and substance to a system based on self-interest, and open to failure, as the treacherous minister Heliodoros reminds us. Finally, the relationality involved in the dedication of individual portraits by other individuals could make a point about the status of the dedicator. The crucial point, for the present chapter on private statues, is the relationship between private honorific portraits, and ostentation and power, as well as memory and mourning (which were the emphasis of the previous section).

The practice of private statues in political contexts is attested for important Romans as well as Hellenistic kings and their men, for instance Flamininus,[180] or, Q. Metellus Macedonicus, honoured by a man from Thessalonike with a statue at Olympia:[181]

> Δάμων Νικάνορος Μακεδὼν ἀπὸ
> Θεσσαλονίκης Κόϊντον Καικέλιον
> Κοΐντου Μέτελλον, στρατηγὸν ὕπατον
> Ῥωμαίων, Διὶ Ὀλυμπίωι
> ἀρετῆς ἕνεκεν καὶ εὐνοίας ἧς ἔχων διατε-
> λεῖ εἴς τε αὐτὸν καὶ τὴν πατρίδα καὶ τοὺς λοιποὺς
> Μακεδόνας καὶ τοὺς ἄλλους Ἕλληνας.

4

Damon son of Nikanor, Macedonian from Thessalonike, (has dedicated) Quintus Caecilius, son of Quintus, Metellus, consul of the Romans, to Zeus Olympios, on account of his goodness and the goodwill which he continuously has towards him (Damon) and his fatherland and the rest of the Macedonians and the other Greeks.

The private statue set up by an unknown Macedonian establishes a relation with a very important personage indeed, Q. Caecilius Metellus—the son of the consul of 206 (and envoy to Greece in 185),[182] a veteran of the Third Macedonian War (he brought the news of Pydna to Rome), praetor of 148 and victor over Andriskos, propraetor in Macedonia during

[180] *ISE* 37, 98.

[181] *Inschr. Olympia* 325, the same document is also found at *IG* 10.2.1031, and especially P. M. Nigdelis, *Epigraphika Thessalonikeia* (Thessaloniki, 2006), T14, with bibliography and discussion; also S. Lehmann, 'Der Thermenherrscher und die Fussspuren der Attaliden: Zur Olympischen Statuenbasis des Q. Caec. Metellus Macedonicus', *Nürnberger Blätter zur Archäologie*, 13 (1997), 107–30.

[182] Noted by P. S. Derow, 'Rome, the Fall of Macedon and the Sack of Corinth', in *The Cambridge Ancient History*, viii. *Rome and the Mediterranean to 133* BC (Cambridge, 1989), 321.

147–146 (before L. Mummius, the consul of 146, took over), consul in 143,[183] and a figure, unsurprisingly, honoured with public statues in Greece.[184] Damon of Thessalonike takes it upon himself to honour Metellus, in return for private services, but also for his attitude towards his city, the Macedonians, and finally all the Greeks. Damon set up the statue on the occasion of Metellus' consulate, perhaps in imitation of the familial practice of statues at the occasion of high office in the Greek cities—a sign of a personal link, however tenuous or imagined. He also boldly honours Metellus' attitude towards the Greeks as beneficial, a reflection of his disposition and goodwill—as evidenced in his restraint during the Achaian War, when he did not sack Thebes or Megara. That Metellus plundered Macedonia of artworks, slaughtered Achaian troops, and showed no interest in Greece after 146 only emphasizes the way in which the private honorific monument is very much about the association between the local friend of Rome and Roman power.

Such associations continued during the later Hellenistic period, when Greeks (and even late Hellenistic kings) honoured powerful Romans,[185] and Romans occasionally honoured Greek friends with statues.[186] Ultimately, the particular subgenre of private honorific statues for powerful Romans was largely taken over by homages to the most powerful Roman of all, the emperor (and his family);[187] such homages renew the tradition of statues for Hellenistic rulers, set up locally for local subjects. At Ilion, a priest of the imperial cult set up a statue of Augustus, 'his guest-friend and benefactor', insisting on his relation to the master of the world.[188]

4. SEEING THE PRIVATE STATUE

What did these private statues look like? A few surviving ancient statues can be identified as privately dedicated portraits, since they were found with the accompanying inscribed bases. They give a sense of the appearance of this genre, with the proviso that all of the surviving statues are made of marble, while many, perhaps most, private statues were made of bronze, as indicated by traces on the bases.[189] I examine these statues below (Chap. 8), in the context of a study of all identifiable and contextualizable honorific statues from the Hellenistic world; for now, what matters is to note that they broadly conformed to the normal, standardized types. Two early Hellenistic, slightly over-life-size statues, found together at Delphi, probably come from a private monument: a bearded middle-aged man, in a himation without a *chiton* (the 'philosopher'), and a draped woman.[190] These statues confirm the pervasiveness and acceptedness of standardized schemes, used in public and private representations

[183] *MRR* i. 430, 461, 467, 471; potted biography in J. van Ooteghem, *Les Caecilii Metelli de la république* (Namur, 1967), 51–78.

[184] *IG* 10.2.134, *IG* 7.3490, *SEG* 3.414.

[185] *ID* 1842, 1550 (Antiochos VIII is the dedicant), 1845; Jamot, 'Deux familles', 291, no. 1 (at Thespiai, Polykratidas sets up a statue of Ti. Statilius Tauros, his patron), with C. Müller, 'Les Italiens en Béotie du IIe siècle av. J.-C. au Ier siècle ap. J.-C.', in C. Müller and C. Hasenohr (eds), *Les Italiens dans le monde grec: IIe siècle av. J-C.-Ier siècle ap. J.C.* (Paris, 2002), 100 (but this is not a cult of Statilius).

[186] A. E. Raubitschek, 'Phaidros and his Roman Pupils', *Hesperia*, 18 (1949), 96–103.

[187] Examples are plentiful: I note Shear Jr., 'Excavations of 1971', 175–6, no. 2, a statue of Trajan, set up by 'his high priest' (ὁ ἀρχιερεὺς αὐτοῦ), Ti. Claudius Atticus Herodes, of Marathon, the father of the famous Herodes Atticus; V. Laurent, 'Inscriptions grecques d'époque romaine et byzantine', *Échos d'Orient*, 35 (1936), 220–33, a privately dedicated statue of Hadrian—at Hadrianoi in Mysia; J. Jannoray, 'Inscriptions delphiques d'époque tardive: Inscriptions de Lébadée', *BCH* 70 (1946), 254–9, no. 8—a statue of Matidia II, set up by Flavia Klea, a prominent Delphian woman of the 2nd cent. AD.

[188] *I. Ilion* 83 (Robert, *Monnaies antiques en Troade*, 76–7).

[189] For instance, at Delphi, Jacquemin, *Offrandes monumentales*, nos. 011, 014, 075, 094, 107, 221, 239, 249, 329; *Rhamnous* 123; *Inschr. Priene* 283, 284, 268, 275, 273; M. Feyel, 'Inscriptions inédites d'Akraiphia', *BCH* 79 (1955), 422; *Oropos* 405, 422, 424–5, 432; *Inscr. Lindos* 1.56, 60, 69, etc.

[190] M. Flashar and R. von den Hoff, 'Die Statue des sogenannten Philosophen Delphi im Kontext einer mehrfigurigen Stiftung', *BCH* 117 (1993), 408–33.

alike; the visual impact and reception of these schemes is analysed below (Chap. 6, 216–18; also 284–9).

However, the diversity of occasions for private statues also brought diversity in representations. Private monuments included such variants as dedications on columns (well before the idiom became widespread for the public honorific), or marble statuettes on pillars—both drawing on the Classical language of votive offerings.[191] The indication of priestly status must have been frequent in the private honorific statues, reflecting the importance of priestly functions as an occasion for statues. The private statues from Delphi mentioned above were found with a draped male statue, whose himation follows the usual scheme for Dionysos: this might be a priest of that deity, completing the male and the female statue in a single, multi-statue monument.[192] More frequently, male priestly statues were distinguished by the symbols of office, such as the crown, or special clothing, as can be seen on a first-century AD example from a multi-statue monument from Aphrodisias.[193]

Private monuments, like the public honorific statue, are all about relationality, as the inscriptions make clear. As in the case of public monuments, the dedicator can appear in visual form, next to the honorand who is dedicated as a statue (the practice is known as a *parastema*, a standing-aside, of the dedicator: Chap. 2, 46–8). Hence the statue of Kleopatra, next to the statue of Dioskourides, in his Delian domestic monument. On such private monuments, the inscription speaks of the relation, which is made visual and material by the statue pair; this, in turn, offers a vision of relationality, solidarity, and equilibrium. Perhaps Aristotle appeared, in statue form, as the (defunct) dedicator of family portraits on the monuments set up after his death, according to his will (above, 175–6).[194] The presence of dedicators in statue form can be deduced from many statue bases, for instance at Lindos,[195] and at Priene in the monument for Aiskhylinos, mentioned above (the deceased Aiskhylinos is flanked by his father and, for good measure, his sister).

A particularly interesting example is found in the Oropian Amphiaraion, where the crowning block survives of the 'distributive' monument Demokrite set up for her father and her son (*Oropos* 424–5, above 163, and here Fig. 5.6), both named Theodoros, as already discussed. From left to right, the viewer of the monument saw the life-size statue of her father, then the statue of her son, a boy standing next to some object (the round cutting survives—an altar?); both statues were captioned on the base under their feet, with the indication of the dedicator, Demokrite, and the names of each honorand. Then, as shown by the cuttings, came a female draped statue: this must have been Demokrite herself, whose identity was not explicitly captioned under her statue, but whose role was clear by the captions to the two other statues.[196]

[191] Löhr, *Familienweihungen*, 136 (Pausanias 1.18.8, Plutarch, *Moralia* 839b: Aphareus set up a statue of his adoptive father, the rhetor Isokrates, on a column in the Olympieion at Athens); 127 (*SEG* 43.56, also *Rhamnous* 186), bronze statuette of Antiphilos set up by Leonike, his mother, in the shrine of Nemesis at Rhamnous. The *eikonion* of Menedemos in the *stadion* of Eretria might be a private offering (Diogenes Laertius 2.132).

[192] Flashar and von der Hoff, 'Die Statue des sogennanten Philosophen', argue against this statue being a portrait of a priest, on the grounds that there are no contextual indications to impose this interpretation; however, the portrait's face, and the inscription that captioned the portrait, would suffice to make it clear if the statue represented a priest rather than a deity.

[193] C. H. Hallett, 'A Group of Portraits from the Civic Center at Aphrodisias', *AJA* 102 (1998), 59–89 (not, as first supposed by Hallett, a patrician-like dress: even in Roman Aphrodisias, there was no ranked society such as implied by this sort of distinction); Smith, *Roman Portrait Statuary from Aphrodisias*, 50. This is not necessarily a private monument.

[194] Hence it is not to be excluded that the copies of portraits of Aristotle go back to statues set up immediately after his death, as part of the testamentary dispositions. Harpalos dedicated a statue of his mistress Glykera, flanked by his own statue, at Rhosos: Athenaeus 13.586c.

[195] *Inscr. Lindos* 1.129, 145, 147, 154.

[196] V. Petrakos interprets the cuttings as the traces of two statues of small children, and a very small lone round cutting, but his drawing in fact shows the three cuttings for a draped female statue, with a centring hole (some of the traces are not the beddings for the feet of statues, but the cavities of the clamps that hold the two blocks of the *Deckplatte*; these cavities must have been damaged when the clamps were scavenged out). See already Dillon, *Female Portrait Statue*, 46. A long base at Kamiros offers a parallel (*Tit. Cam.* 81): one Panaitios son of Nikagoras

Fig. 5.6. A full family monument could show the honorands, the honourer, and even the deity who received the monument, and was shown looking on the statue group. The monument set up by Demokrite at the Oropian Amphiaraion, third century BC. Adapted from *Oropos* 424–5 (drawing M. Skouloudi).

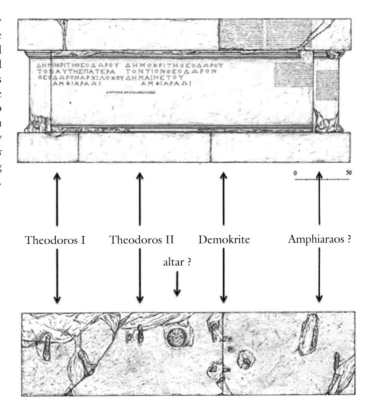

Theodoros I Theodoros II Demokrite Amphiaraos ?

altar ?

Her presence in statuary form is a sign of her assertiveness, already clear in the inscription, and, indeed, in her role as linchpin in the transmission of generations (see Chap. 6).

The same monument in the Oropian Amphiaraion bore a fourth, male, statue, at the right edge of the base, away from the busy inscribed captioning in the left-hand half of the base. Rather than another family member, unnamed, this is likely the god Amphiaraos, named as the recipient of the dedication that the family monument constitutes, and looking on benevolently.[197] Likewise, the Dionysos-like figure found with the 'philosopher' and the draped woman at Delphi might be the god himself, shown as the recipient of the dedication. A relief in Thessaloniki was dedicated to Osiris Mystis: the dedicator represented his parents next to an altar, in priestly dress: the god, youthful (and surprisingly Hellenic in dress and attitude), stands between them and above them (and the altar), gazing down at the scene (Fig. 5.8).[198] This habit, unlike the *parastema* of the dedicator, is not attested for public honorific monuments: it reminds us of the strong religious character which the family monument often had, an instructive pointer to the nature of the family monument, and to its potential difference from the public honorific genre with which it existed cheek by jowl.

set up a statue of his father, himself, the hero Kamiros, standing next to two further statues of himself and his father (judging by the cuttings—the monument includes five blocks, each bearing a male statue).

[197] The cuttings apparently fit a slightly under-life-size statue (Petrakos). I am not sure this statement is correct; if the statue were smaller, one explanation might be that it was an older statue of Amphiaraos, redeployed as part of the monument set up by Demokrite. I am grateful to R. Krumeich for discussion of this; see also Dillon, *Female Portrait Statue*, 46.

[198] G. Despinis, T. Stephanidou-Tiveriou, and E. Voutiras, *Katalogos glypton tou Archaiologikou Mouseiou Thessalonikis*, 1 (Thessaloniki, 1997), no. 67 (E. Voutiras). The divine figure, I suggest, is the god himself and not the representation of cult-statue.

5. PLACING THE PRIVATE HONORIFIC MONUMENT

Where were private honorific statues set up, among the roster of spaces offered by the cities of the Hellenistic period (Chap. 3)? The most obvious site is the shrine—already mentioned often in the roster of examples discussed above: the common statues of (ex-)priests were almost always set up in the relevant shrines, but 'simple' family monuments, for individuals, were also to be found in sacred enclosures. Statues in shrines: the category includes the great international shrine (for instance, Olympia or Delos), and the local, civic shrine. At Athens, many family statues were set up on the Akropolis, but also in the City Eleusinion;[199] in Priene, the monument for the deceased Aiskhylinos (cited above, 179) was set up in the shrine of Athena Polias, as the epigram tells us.[200] The statue of the Halikarnassian lady Nannion was set up by her five sons to Demeter and Kore, and hence almost certainly in the shrine of the two goddesses (above, 116); in Rhodes, family monuments are attested abundantly in the shrine of Athena at Lindos, and were probably just as abundant in the shrine of Helios in Rhodes town.[201]

The distinction between 'international' and 'local' shrine should not be pressed too hard. For the citizens and inhabitants of Delos, the shrine of Apollo was their local shrine where they set up a multitude of family monuments, outnumbering the private portrait dedications set up by foreigners (especially those by kings and their Friends); the same holds true for the shrine of Asklepios at Epidauros, famous in the Greek world but also the site for family dedications by the Epidaurian elite, or the Amphiaraion at Oropos, where a few private dedications by foreigners are outnumbered by the array of family monuments in the east end of the esplanade. Conversely (though more rarely), foreigners could come to a local shrine and leave a family dedication—often, but not always, great men from the major Hellenistic kingdoms.[202] In Knidos, an Alexandrian set up a statue of Sosibios, the minister of Ptolemy IV: the statue was found reused 'in the lower theatre', and comes from a shrine.[203]

As in the case of public honorific statues, the inscriptions captioning private family dedications often indicate the name of the deity that is the recipient of the dedication, and in whose shrine a particular family monument stands: on Delos, Apollo, or Apollo, Artemis, and Leto in the main shrine, Dionysos in the shrine next to the theatre,[204] Zeus Kynthios and Athena Kynthia in the mountain shrine;[205] on Lindos, to Athena Lindia and Zeus Polieus. But in the shrine at Lindos, many statue bases give a more general indication: the portrait is dedicated θεοῖς, to (the) gods.[206] The formulation can be τοῖς θεοῖς, as for a statue found in the Kabeirion at Delos,[207] private honorifics set up in the shrine of the Muses near Thespiai,[208] or a statue set up within the precinct of Apollo at Thermos.[209] But family monuments set up in shrines could

[199] Recently discovered: *SEG* 51.215 (found near Monastiraki, but certainly from the City Eleusinion); earlier e.g. *SEG* 18.85.

[200] See also *Inschr. Priene* 262, the fragmentary base of a private statue, found in the shrine of Athena near the 'treasury' (early 2nd cent.?); 272 (reused in pavement of *propylaion* of shrine).

[201] V. Kontorini, *Anekdotes Epigraphes Rhodou*, ii (Athens, 1989), gives a picture of the dedicatory landscape in the shrine of Helios that is very similar to that which emerges from *Inscr. Lindos*.

[202] *I. Knidos* 112, Milet 1.3.165 (bilingual Greek-Palmyrene), 1.7.244 (Ptolemy I: a private honorific statue set up by two Rhodians, as shown in Ma, 'History of Hellenistic Honorific Statues'). Kontorini, *Inscriptions inédites*, no. 1 (Kilikian friend of Ariarathes VI sets up statue of his king on Rhodes).

[203] C. T. Newton, *A History of Discoveries at Halicarnassus, Cnidus and Branchidae*, 2 vols (London, 1862-3), ii. 447-8 (the statue base *I. Knidos* 112, for Sosibios, found reused; Newton believed the bases of private monuments *I. Knidos* 101, 111, 172 to have come from the same shrine, and suggested a shrine of Asklepios, since this god is named in 172).

[204] *ID* 1907. [205] e.g. *ID* 1723, 1892. [206] e.g. *Inscr. Lindos* 1.147-8, 162.
[207] *ID* 1981.

[208] *IG* 7.1832 and A. Plassart, 'Fouilles de Thespies et de l'hiéron des Muses de l'Hélicon: Inscriptions. Dédicaces de caractère religieux ou honorifique, bornes de domaines sacrés', *BCH* 50 (1926), 428-9, no. 54, same document *Thespies* 350 (found in church of the Trinity near Helikon), mid-3rd cent.

[209] *IG* 9.1² 1.75 (2nd cent.?). There is no reason, in all of these cases, to suppose that the formula 'to the gods' supposes dedication in the agora, as sometimes stated. The exedra of the family and friends of Protogenes, at Kaunos, was dedicated 'to all the immortals', but set up in a precinct of Apollo.

also be dedicated to a different deity than the main one (in the vale of the Muses, a couple set up statues of their children to Demeter and Hermes)[210]—or to no deity at all.

Among the other main sites for statues, the theatre received private portrait dedications during the Hellenistic period only rarely: a statue was set up by Eumenes I for Philetairos in front of the stage building at Delos (the cuttings on the top course of the deep base show the statue was a sitting portrait, comparable to the portraits of poets such as Menander).[211] Gymnasia were the setting for private statues, of relatives and of friends, from the second century onwards, such as the multi-generational statue of Sosagoras (above, 178–9), dedicated on Nisyros by his relatives after his death to Hermes, the god of the gymnasion, or the statue of Kleonikos, set up by his friend Amphikrates (above, 183) in the gymnasion of Eretria, in the late first century BC. Similar dedications are attested at Messenia (archaeologically, through a statue base *in situ* at the entrance),[212] in Pergamon,[213] in Halikarnassos[214] and perhaps in Priene,[215] and in Athens (the material from the demolished church of Agios Demetrios Katephores probably comes from the Ptolemaion).[216]

Finally, and perhaps most remarkably in view of all that has been said in this book up to now, private statues were set up in the agora: the statue of Menodotos, evoked at the beginning of this chapter, was probably set up in the agora of Antiphellos. The most striking case, documented archaeologically, is the agora of Priene (Fig. 4.10; Chap. 3), where prime spots were occupied by private statues, whose bases are still *in situ*: the statue of Apollodoros son of Poseidonios (*c*.200) as priest of Basileus and the Kouretes (which might have represented Apollodoros as a priest—the present participle, rather than the aorist, is noticeable, and perhaps indicates a prolonged or even lifetime, rather than limited, term of priestly office), the *pi*-shaped exedra (late second century) on the west end of the terrace in front of the Sacred Stoa, bearing private statues, *ex testamento* and athletic, the portfolio exedra (*c*.100), combining public and private, on the north end of the West Gate Street.[217] The long base bearing three private priestly statues, found close to the entrance of the agora, might also have stood in the public square;[218] this is also the case with the private statues, many *ex testamento*, found in or near the area of the agora, though not *in situ*.[219]

Many other examples could be given for this habit of setting private statues in the agora.[220] On Delos, private statues were set up in the 'tetragonal agora' and, especially, in front of the *prytaneion*, a space which had constituted the 'old agora' and was separated from the 'tetragonal

[210] Plassart, 'Fouilles de Thespies', 420–1, no. 39.

[211] Fraisse and Moretti, *Le Théâtre*, 78–81 on *IG* 11.4.1106. Menander: above, 22, 105; and below, 271–2 on sitting portraits.

[212] *SEG* 46.416–17 (Augustan).

[213] Hepding, 'Pergamon 1904–1905', 338, no. 69.

[214] Haussoullier, 'Inscriptions d'Halicarnasse', 402 no. 13 (statue of hypogymnasiarch; statue of priest of Apollo, dated by hypogymnasiarch?).

[215] *Inschr. Priene* 265 (*c*.200, on palaeographical grounds), the base of the statue of Melanippos, set up by his father Nikokles son of Nikagoras, was found reused in the Roman baths on the site of the old Upper Gymnasion, and might have originally stood in the gymnasion.

[216] *IG* II² 3871, 3854, 3901, 3908 (mid-2nd cent. to Augustan period). On the Ptolemaion, Miller, 'Identity of the Early *Polis*'; E. Lippolis, 'Tra il ginnasio di Tolomeo ed il Serapeion: La riconstuzione topografica di un quartiere monumentale di Atene', *Ostraka*, 4 (1995), 43–67. The bases of statues of doctors, *IG* II² 3780, 3872–3, were found in the same church: could they come from the Asklepieion, on the other side of the Akropolis (whither some material from the Ptolemaion found its way)?

[217] *Inschr. Priene* 275, 268, 99–104.

[218] *Inschr. Priene* 162.

[219] *Inschr. Priene* 264, 266, 267, 269, 273, 277 (perhaps set up in Asklepieion), 283, 284 (part of exedra); 275 is probably not *in situ*.

[220] e.g. Kaunos (*Inschr. Kaunos* 92–6, portfolio exedra, dedicated 'to the gods and to the city'); Knidos: *I. Knidos* 115 (part of an exedra, as Newton's mistaken description of a '[reused] voussoir of an arch' makes clear), 120, 121; Akraiphia: a multi-relational base was found along with other documents which must have come from the agora, M. Feyel, 'Inscriptions inédites d'Akraiphia', 422 no. 2; Hyettos: *IG* 7.2835, with Étienne and Knoepfler, *Hyettos*, 159–60; Kassope: *SEG* 34.589 (western stoa; dated '4th-3rd cent.', which seems early); 50 (multi-relational, before north stoa), Dakaris, *Kassope*, 23–30.

agora' only by the construction of a stoa in the early second century.[221] Private statues also appear, interleaved with public statues, on the late second-century agora of Theophrastos.[222] Private monuments found in the agoras of various cities are often dedicated 'to the gods' (like the private monuments from the agora at Kassope), and many other private monuments with the same formula (especially well attested in Boiotia) might have been erected in the agora.[223]

The patchiness of the record, as always, prevents any generalization about the practice of setting up private statues in that most public of spaces, a city's agora—was it widespread, did it have a particular history? Were private statues routinely found, say *c.*100, in the agora of all, or even simply a great many, Hellenistic *poleis*? In Rhodes town, Miletos, Messene? In the case of Hellenistic Athens, there is no clear evidence for private statues in the agora, and statue bases found near the Stoa of Attalos all come from late contexts of reuse. Thus the statue base of Karneades (due to two Athenian citizens) found reused in the post-Herulian Wall, could have been set up in the agora, but might just as likely come from a nearby shrine, or the Ptolemaion,[224] and the same holds true for the statue of Theophilos, set up by Attalos II for his foster-brother;[225] the crowning course from another very large private monument for one Ischyrias (in fact an equestrian), found in the same area near the Stoa of Attalos, is likely to have been reused, and probably comes from a nearby shrine, rather than originally having stood in the agora itself.[226]

At Priene, the private statue of Apollodoros was set up in the early second century already; the practice may have started earlier, if some of the monuments in the reorganized agora were in fact private, or 'portfolio' monuments, certainly shifted and reordered by the city, but accepted as part of the statues in the agora (this is suggested by the presence of a private statue, *Inschr. Priene* 284, as part of an exedra in the main series). Furthermore, the positioning of private monuments in the north-west sector of the agora, where I suggest that Prienian notables took refuge in order to carve a new spatial niche after the large-scale reorganization (above, 146–8), shows the prominence and visibility of the private, (usually) family-dedicated portrait among the statuescape of Priene and its agora. At Delos, in front of the *prytaneion*, public and private statues mingled freely in a prime site, before an important civic building whose façade provided one of the articulating points of the public square of the Delians, next to, but not included within, the sacred space of the shrine of Apollo: this is the landscape at the end of the third century and the beginning of the second, before the Athenian takeover. The same mixture of public and private statues is suggested by the meagre remains in the agora of Kassope, and from the presence of a second-century family monument in the agora of Megalepolis, in a row of statues (many equestrian).[227]

Earlier in this work, I emphasized the role of public honorific statues, as an idealistic art form, within the civic culture and ideology of the Hellenistic *polis*: a manifestation of reciprocity between benefactor and community, a statement of community priority over the individual actors (through the relationality expressed by the formulas of statue inscriptions),

[221] Agora: *IG* 11.4.1180 (*c.*200). South of the *prytaneion*: *IG* 11.4.1086, 1170 (late 3rd cent.), 1171, 1179, (early 2nd cent.),

[222] Mercuri, 'L'agora di Teofrasto', where I note *ID* 1969, 1869, 1989, 1957, 1978, 1845, 1534, 1871–2.

[223] e.g. *IG* 7.1832 (Thespiai), 2471, 2489, (Thebes), 2795 (Kopai), 4177 (Anthedon); *IG* 12.9.1233 (Aidepsos). *SEG* 30.364, found in the agora of Argos, might be completed as a dedication (of the statue of a Ptolemy) τ[οῖς θεοῖς].

[224] *IG* II² 3781, with Thompson, 'Agora Excavations 1949', 318–19; C. Habicht, 'Athens and the Attalids in the 2nd cent. B.C.', *Hesperia*, 59 (1990), 571–2.

[225] Thompson, 'Agora Excavations 1949', 336: new fragments, found reused in the late fortifications, join with those found in 19th-cent. excavations of 'the Stoa of Attalos'; Meritt, 'Greek Inscriptions (1954)', 252, no. 33.

[226] *IG* II² 3860; K. D. Mylonas, 'Anaskaphai tis stoas tou Attalou', *Praktika* (1900), 32, describes the stone as lying on an ancient layer west of the *dromiskos* around the Stoa of Attalos, but lower than this *dromiskos*. I interpret this as a late structure, erected above the ancient level of the Panathenaic Way (which I assume Mylonas did not reach or know about). The stone, a slab 26 cm thick, 1 m wide, and 1.60 long, probably did not travel far (it must weigh over a ton).

[227] Above, 191 Lauter and Spyropoulos, 'Megalepolis', 438–51.

an affirmation of *polis* meanings rather than individual qualities (enacted through the management of space). How do private statues, produced within families, to celebrate familial occasions and relations, interact with their public neighbours? The series of statues, stretching across the agora (for instance the main series at Priene) seems to offer a powerful image of civic order—but how is this image, or our interpretation of it, affected by the interspersion of public statues for proclaimed good citizens, and portraits set up by families for relatives as priests and priestesses, as good fathers or mothers, or on the occasion of death and the transmission of property (and last wishes along with the property)?

To answer this sort of question, it matters to find out precisely the emplacement of private statues: the sites where they were most frequently set up, the international and local shrines, were also used by communities for their public statues. How did private statues participate in the shaping of space into lived places, through the various processes of control but also competition and sedimentation studied earlier? On the terrace of the Oropian Amphiaraion, private family statues are mostly limited to the eastern sector, in the last quarter of the third century (a few cases are earlier and mingle with the great, probably royal statues, of the western sector): the different genres of statue, public honorific and private familial, were kept separate, as discrete series, legible for the onlooker as a balanced presentation that itself was also a narrative of public control of the various actors that performed 'statue events' on the terrace, and participated in its shaping. The Epidaurian Asklepieion and even the crowded shrine of Apollo at Delphi may also have set aside areas for multi-statue private monuments.[228] In contrast, the *dromos* at Delos, a highly prominent space at the stoa-lined entrance to the shrine, saw early on the presence of both public and private statues: the phenomenon starts in the late third century and continues into the early second century BC, during the last decades of independent high Hellenistic Delos; it amplifies noticeably during the peculiar, 'boom-town' century or so of Athenian colonization, with much competition for space and jostling, especially near the *propylaia* (Fig. 4.7).[229]

For many important shrines, the exact layout and history of statue sedimentation on the ground escapes us: there is no clear indication for the Athenian Akropolis; the array of statues to the south of the temple of Athena at Priene is now simply a row of foundations. But it is likely that the flexible nature of the shrine, open to collective and private gestures alike, produced a diverse landscape that developed in response to a variety of factors and pressures—the presence of the 'public actor' in the form of the community, its own monumental needs and its control of space, the competition among families, the various calculations and strategies of actors in the competition for space and attention, and the interaction of these factors over time.

6. PRIVATE, PUBLIC

This chapter has surveyed a particular strand in the statue habit, and precisely the honorific statue habit, namely the practice of setting up, privately, statues for individuals, within public space. The survey has inevitably constantly drawn parallels with public practice, and thrown light on parallels as well as distinctions. In the case of the inscribed bases of private monuments, the insistence on relationality parallels public monuments, but the liking for the 'respectful' or 'adoring' nominative is a peculiarly private practice. As for occasions, the survey of the evidence shows that, in the case of private monuments, it is not just a question of individuals being honoured for a variety of reasons (as in the case of public honorific statues); what emerges is the diversity of possible functions performed by the private statue—votive,

[228] At Asklepieion, the line of exedras seems private. Delphi: Flashar and von der Hoff, 'Die Statue des sogennanten Philosophen', discuss the zone north of the temple of Apollo, where the monument of Daochos, a variety of multi-statue bases, and the three marble statues mentioned above were found.
[229] I thank Sheila Dillon for sharing her work on the Delian *dromos*.

honorific, commemorative, consolatory, emotional, familial; the central importance of families is clearly visible. Nonetheless, the frequent mention of communal service is noticeable—as a gesture towards the public sphere where the private statue was placed, but also the public statuary genre which the private statue resembled visually—with significant variants. This diversity marks difference from, but also competition with the public genre: the private genre tries to stand out from the canons and schemes of public statuary. The same competition with the 'public actor' is visible in the spatialization of private honours, where these private monuments are very present in shared spaces such as the shrine, but also, more strikingly, in the agora. This constant play of differences, allusion, challenge, and competition has been a constant feature of this examination of the nature of the private, mostly family-erected, portrait, described at some length in this chapter—a phenomenon which raises questions about the purpose of the genre, the relation of public and private in the Hellenistic *polis* (and the pertinence of these categories).

Once again: why did people put up private statues? Because they were dying and wanted to make a gesture for others, dead or alive; because someone they liked had died, or rather had done something worth commemorating—been a priest, a victorious athlete, a magistrate. But this may be an unsatisfactory way of understanding the private honorific. When the young Rhodian Euphranor son of Damagoras was honoured with a statue by his relatives, who specified that he 'had served on the undecked ships and the decked ships and won at the Halieia with the horse chariot and been honoured by the people with a golden crown', it may be misleading and over-specific to say that the victory at the Halieia provided the occasion for the statue: the young man is described with a small bundle of noteworthy actions (military service, athletic victory, public recognized services or attitudes), which the family wished to emphasize, but these do not constitute the prime reason or pretext behind the decision to set up a statue. Likewise, when a Knidian woman and her husband set up a statue of her grandfather, the occasion was not his participation in the race of the festival of Apollo Karneios, as a youth many years ago (*I. Knidos* 164); the race was a detail the dedicators considered relevant and wanted to recall, in the monument they set up in the god's shrine. So why did people put up private statues? What were the motivations, rather than the formal occasions, for private statues? The answers are easily provided—to commemorate, and comment on, a person's actions, to display piety, to achieve (to manifest) the prestige and pride of great families ('orgueil solidaire des grandes familles', in Marcadé's formulation).[230] What do these sentences actually mean?

These questions are summarized in a particular type of monument, the 'portfolio' exedra, which juxtaposes public and private honorific portraits on the same base. Should we be surprised at this juxtaposition? This whole chapter, and its survey of the private, family-centred monumental habit, has in fact been driven by a sense of unease, or even paradox. Does the family monument represent a reaction to the public honorific statue, as suggested above? Is it part of a reassertion of elite identity and dominance? The answer to these questions must affect the way we consider honorific statues, but also, more generally, the post-Classical *polis* and its political culture, the central theme of this book. At the very least, we should pause before exclaiming that 'the honorific statue was the highest honour a city could bestow on its members' (so often found in current literature about Hellenistic art and society), if such public portrait monuments had to jostle for attention with monuments set up by individuals for other individuals.

[230] *Au musée de Délos*, 72, on *IG* 11.4.1086, 1173–4.

Public Spaces, Private Statues

This chapter completes the synchronic survey, given above, of the private statue phenomenon, with a historical sketch of the practice, from its mid-fourth-century origin onwards, to the early Roman empire; this history parallels the rise of the public honorific. But how should we analyse this type of monument? The private honorific statue is a prime medium for the visibility of elite families: this phenomenon can be analysed both from an elitist and from a communitarian viewpoint. Both viewpoints are valid—which will force us to rethink the Hellenistic *polis*.

I. THE PRIVATE MONUMENT AND THE CITY

Private monuments in the shrine, private monuments in the city . . . Once we start noticing the genre of private monuments in their diverse contexts, in parallel to the public genre, it is important not to see these statues and these portraits indiscriminately, ubiquitously. The aim of the previous, chapter, apart from sketching a typology of the genre in a synchronic survey, was also to place it in specific social contexts as the starting point for questions about the functions and meanings of the genre, and about the impact it had on public spaces. The relations of private and public honorific monuments, which I broached at the beginning of the previous chapter, will be the focus of the following pages—with attempts at seeing how this relation worked out, both in time, and in various places: the running test cases, by now familiar, such as Priene, Athens, Delos, the Oropian Amphiaraion, Knidos, will be revisited, in one last promenade. The issues in this chapter are those which, implicitly, have structured the whole book: the nature of the honorific statue, the place of 'elites' in the city, and the social history of public space. These issues should not be studied as static givens, but as living phenomena, with a diversity of possible outcomes, which all shed light on, and are illuminated by, the story of 'statues and cities' in the Hellenistic period.

The *locus* of the investigation of these themes in Hellenistic history is the family, whose workings take place in public through the dedication of statuary monuments at crucial moments. The ways in which this happens deserve careful unpicking: they reveal a surprisingly complex and dynamic, even unstable, picture within family life in the Hellenistic city, where patriline matters less than the constant recreation of networks of relatives structured around individuals. The city is also the context where the workings of the other great genre of the private monument, namely the statues for or between the powerful, are also very relevant: family-like relations of intimacy and friendship also expressed social capital and agency within the varied spaces of the Hellenistic world. The workings of family dynamics will hence help us understand the problems of power in the post-Classical *polis*.

The power politics are obvious in one particular case, namely the perpetuation of the supra-local royal state through the demonstration of personal ties, or the establishment of such personal ties to buttress local eminence for members of civic elites. More intriguing is the phenomenon of the civic colouring of much of the dominant familial subgenre within the private honorific statue habit; the issue is whether to interpret this civic style in terms of communitarian norm, or take-over by a wealthy elite. I will try pushing both interpretations, but also to look beyond them, in the context of the evolutions of Hellenistic political culture.

2. A HISTORY OF THE PRIVATE HONORIFIC MONUMENT

'Private honorific statues were found from Italy to Media and Susiane, from the Black Sea to Cyrene; in the shrine, the agora, the gymnasion': that synchronic description occupies much of the previous chapter. It might describe the presence of private monuments in the Hellenistic cityscapes *c.*100 BC; but this outcome was the result of a particular historical development,[1] which should be investigated, as the framework for the study of the social life of the private honorific statue, in relation to the civic culture of the Hellenistic *polis*.

The private dedication of statues labelled as individuals is attested in the Archaic period. The clearest example is the group set up in the mid-sixth century in the Samian Heraion, by a man whose name now only survives in the fragmentary form—ilarches. The dedicant was represented at one end of the group, reclining; his wife sat at the other end of the group; both parents framed images of their children, one son and three daughters, represented as *kouros* and *korai*.[2] In Athens, there are some relevant examples, among the forest of dedications attested for the Archaic period (now vividly presented in the new Akropolis Museum). A sitting statuette of a man with writing tablets (a 'scribe' or rather an official), set up on the Akropolis, probably represents the dedicant's father.[3] There are a number of other possible Archaic examples, none conclusive. In the Samian Heraion, the *kouros* set up by Cheramyes may have belonged to a similar group dedication (perhaps it represented a son of the dedicant, named on the plinth).[4] In the Argive Heraion, a man set up a memorial of his father; the object dedicated to Zeus is designated with a deictic in the singular masculine accusative, which may imply a posthumous portrait.[5] On the Athenian Akropolis, *c.*500, one Kynarbos made a dedication to the Parthenos, with a prayer for his two daughters (the inscription is not, in spite of first appearances, a standard nominative-accusative dedicatory formula):

Ἀριστομάχεν καὶ Ἀρχεστράτ[εν - - -]
παῖδε, Φαρθενε, καὶ γενεὰν hοῖν [- - -]
[- - -] Κύναρβος παῖς ΛΙ [- - -]

Parthenos, [save] Aristomache and Archestrate, the children . . . , and their descendants (? or: as they have vowed?), Kynarbos son of Li . . . [has dedicated to you . . .].

The dedication was made up of two statuettes, as shown by the two bronze plinths still inset in the top of the base, striding figures (one smaller than the other) as the traces make clear: these are usually interpreted as two Athenas, though another possibility might be images of the two girls (portraits, in a sense—but which?), perhaps shown in *Knielauf* position.[6] Whatever they represented, they at least presented physical tokens, one per girl, which gave a physical substitute for his two daughters and his wishes for them (and their children); the principle is not far removed from that of the later family portrait group as studied in the previous chapter.

No doubt some funerary examples could be added to the small roster above: the grave *stele* of Dermys and Kitylos, with the *ronde-bosse* figures of the deceased, labelled with ἐπί + dative, was set up at Tanagra by a named third party.[7] It is clear that individual portraits, clearly

[1] B. Hintzen-Bohlen, 'Die Familiengruppe: Ein Mittel zur Selbstdarstellung hellenistischer Herrscher', *JDAI* 105 (1990), 129–54, has preliminary notes (but with too much emphasis on athletic groups); Löhr, *Familienweihungen*; van Bremen, *Limits of Participation*, 170–5; N. Himmelmann, *Die private Bildnisweihung bei den Griechen* (Wiesbaden, 2001); Keesling, *Votive Statues*.

[2] Löhr, *Familienweihungen*, 10 ('Sog. Geneleos-Gruppe').

[3] Keesling, *Votive Statues*, on *DAA* 6.

[4] M. Meyer and N. Brüggemann, *Kouros und Kore* (Vienna, 2007), no. 290 (*c.*550–540).

[5] Löhr, *Familienweihungen*, 37 (earlier *CEG* 365), early fifth cent.: Βᾶλος τὸνδ' ἀνέθηκ' Ἀργεῖος | Πρατέα hυιὸς πατρὸς μνᾶμα | Ϟρόνο παισὶ χαριζόμενος, 'Balos of Argos, son of Prateas, set this man up, a memorial of his father, in order to please the son of Kronos'.

[6] *DAA* 79, *IG* I³ 745; Himmelmann, *Private Bildnisweihung*, Löhr, *Familienweihungen*, 23, who argues against the idea of portraits on the basis that one would expect *korai* in the standard position.

[7] *IG* 7.579: Ἀμφάλκες [ἔ]στασ' ἐπὶ Κιτύλοι ἠδὲ Δέρμυι. Other examples: C. W. Clairmont, *Gravestone and Epigram: Greek Memorials from the Archaic and Classical Period* (Mainz am Rhein, 1970), nos. 1 (*IG* I³ 1241), 1bis (*IG* I³ 1251), 4 (*IG* I³ 1257), all sixth-cent. Attica.

labelled as set up privately by relatives or friends, are rare in the Archaic period; the family group at Samos is an exception. Other statue practices are preponderant, such as the auto-dedicated 'portrait' or the stand-alone image (the famous funerary *kouros* representing Kroisos, from modern Anavyssos, gives an image of his youth and his lost beauty, but does not assign the gesture to a relative or a friend).[8] There is thus no ubiquitous, clearly recognizable, Archaic forerunner to the Hellenistic practice of private monuments. Nonetheless, the principle of family visibility can be seen, in the widespread form of the family dedications: the accompanying inscriptions speak of family memory, the visibility and desirability of descendance (*genea*), within the wider context of the *polis*.[9] When Smikros set up a dedication to Athena on the Akropolis, he prayed for remembrance of himself—and his family:

$$[\ddot{\epsilon}\rho\gamma o]\nu \; \theta\alpha\lambda\acute{o}\nu\tau o\nu, \; \pi o\lambda\iota\acute{\epsilon}o\chi\epsilon \; \pi\acute{o}\tau\nu\iota' \; ' A\theta\acute{\alpha}\nu\alpha, \; / $$
$$\Sigma\mu\acute{\iota}\kappa\rho o \; \kappa\alpha\grave{\iota} \; \pi\alpha\acute{\iota}\delta o\nu \; \mu\nu\hat{\epsilon}\mu' \; \ddot{\epsilon}\chi o\iota \; h\acute{\epsilon}\delta\epsilon \; \pi\acute{o}\lambda\iota s.$$

[(This was set up) as his affairs] were flourishing, city-patron lady Athena, may this city keep memory of Smikros and his children.[10]

Some private portraits, all posthumous, are attested for the fifth century: in Athens, sons dedicated portraits of their deceased fathers on the Akropolis. A painted portrait of Themistokles and a full-size bronze portrait of Perikles (whence the famous Roman-era helmeted portrait herms) are the best known examples of this practice, which is also represented by fragments of bronze sculpture.[11] There are no epigraphical documents relative to this practice; the inscriptions that captioned this type of dedication were probably epigrams, comparable to the Archaic example beneath the seated scribe statue from the Akropolis, articulating identity and relation, but also letting the viewer-reader deduce the details.

Outside Athens, another example is the sculptural group representing a fight scene, set up at Olympia in the first half of the fifth century. According to Pausanias, Phormis, an Arkadian in the service of the Deinomenid tyrants, was shown fighting three foes; the honorand was identified by the inscription, as well as the dedicator, one Lykortas of Syracuse (doubtless a fellow Arkadian settled in Sicily). Pausanias describes the monument as 'clearly' dedicated out of friendship, perhaps a deduction rather than the paraphrase of an explicitly declared motive in the inscription.[12] The private monument was set up next to a dedication by Phormis himself, representing two horses with their grooms: if the identification of the base of Phormis' horses is correct, the monument dedicated by Lykortas in honour of Phormis, and representing him in battle, must have stood on the semi-circular base immediately to the west[13]—in other words, a 'limpet' base of the type described above in Chapter 4. The choice of site, next to the horse dedications by Phormis, emphasizes the closeness and friendship which Lykortas wished to

[8] Clairmont, *Gravestone and Epigram*, no. 2.

[9] e.g. Löhr, *Familienweihungen*, 13 (from the Ptoion), 21 (*IG* 12.5.215, Paros: prayer to Artemis for increase of the lineage).

[10] *DAA* 53.

[11] Löhr, *Familienweihungen*, 58 (Pausanias 1.1.2), for Themistokles (the portrait, seen by Pausanias in the Parthenon, might have been placed there in later times); Keesling, *Votive Statues*, chap. 7.

[12] Pausanias 5.27.6, ἔστι δὲ ἐν τοῖς ἀναθήμασι τούτοις καὶ αὐτὸς ὁ Φόρμις ἀνδρὶ ἀνθεστηκὼς πολεμίῳ, καὶ ἐφεξῆς ἑτέρῳ καὶ τρίτῳ γε αὖθις μάχεται. γέγραπται δὲ ἐπὶ τούτοις τὸν στρατιώτην μὲν τὸν μαχόμενον Φόρμιν εἶναι τὸν Μαινάλιον, τὸν δὲ ἀναθέντα Συρακόσιον Λυκόρταν· δῆλα δὲ ὡς οὗτος ὁ Λυκόρτας κατὰ φιλίαν ἀναθείη τοῦ Φόρμιδος. τὰ δὲ ἀναθήματα τοῦ Λυκόρτα καλεῖται Φόρμιδος καὶ ταῦτα ὑπὸ Ἑλλήνων· 'Among these dedications, Phormis himself is represented standing opposite an enemy, and again opposite another and a third he is shown fighting. The inscription relating to these indicates that the fighter is Phormis of Mainalia, the dedicator Lykortas of Syracuse; it is clear that this Lykortas made the dedication out of friendship for Phormis. These dedications of Lykortas, too, are called "dedications of Phormis" by the Greeks.'

[13] Pausanias clearly speaks of two monuments, one dedicated by Phormis (horses and grooms), the second by Lykortas, though sometimes referred to as Phormis' dedications, because they represented Phormis (combat scene): B. S. Ridgway, *AJA* 75 (1971), 343, reviewing F. Eckstein, *ΑΝΑΘΗΜΑΤΑ* (Berlin, 1969). Eckstein's interpretation of a single monument, 43–53, with two horses set up by Phormis framing three pairs of hoplites set up by Lykortas, is bold but probably incorrect. I hence place Lykortas' dedication on the Classical base described by Eckstein, 49 n. 40 (from stratigraphical arguments, set up soon after Phormis' horses).

make visible; the exceptional nature of both Phormis' horse monument and Lykortas' fight scene further serves to illustrate the unusual nature of private portrait dedications in the high Classical period, and their sporadic nature. In the early fourth century, the posthumous statue of Agesipolis set up at Delphi by his father (after 380), the statue of Gorgias set up by his grand-nephew in Olympia, and, less grand, an undatable family group (*c.*400?) in the Epidaurian Asklepieion, further illustrate the shared characteristics of the private monument in this phase:[14] set up in an international shrine, accompanied by an epigram, and a rare, prestigious artefact.

The genre of private, predominantly family, portrait dedications emerges fully as a socially widespread practice around the middle of the fourth century, most clearly in Athens and Attica.[15] Fourteen secure (and four doubtful) examples are known for the decades between 370 and 300, primarily on the Akropolis[16] and in the city Eleusinion,[17] with a few monuments in other shrines in the town (Asklepieion)[18] or Attica (Eleusis, the shrine of Nemesis at Rhamnous);[19] one example comes from the Amphiaraion at Oropos, under Athenian control between 366 and, probably, 336.[20] Finally, a statue of Isokrates, signed by an otherwise unknown Boutes and captioned with a lengthy epigram, was set up by multiple dedicators: this statue (known from a quotation of Philochoros preserved in Philodemos) is probably a privately dedicated monument set up during Isokrates' lifetime.[21] By the end of the fourth century, some of the examples are lavish multi-statue monuments, such as the monument, set up on the Akropolis, for members of a family from the deme of Potamos, with statues by the sculptor Sthennis. Several of the surviving bases bear Praxiteles' signature; other bases on the Akropolis, reinscribed in the Roman period but with the famous artist's signature left intact, may also have belonged to private portrait monuments.[22] In addition to portrait statues in bronze or in marble, the practice of painted portraits on wood may also have been popular: the portraits of the Eteoboutadai on the Akropolis belong to this particular, mid- to late fourth-

[14] Tod II 120 (Löhr, *Familienweihungen*, 80), *Inschr. Olympia* 293 (Löhr, *Familienweihungen*, 96, with Himmelmann), *IG* 4² 1.237 (Löhr, *Familienweihungen*, 70).

[15] Dillon, *Ancient Greek Portrait Sculpture*, 105–6. *IG* II² 4881 (with *SEG* 30.174, restorations by W. Peek), might be an early example, *c.*400, of an individual honoured with a statue on the Akropolis; but the statue, dedicated as a memorial of this individual's justice, did not necessarily represent him.

[16] Early 4th cent.: *IG* II² 3838 (Löhr, *Familienweihungen*, 89); 3912 (Löhr, *Familienweihungen*, 88). Mid-4th cent.: *IG* II² 4914 (Löhr, *Familienweihungen*, 104); 3828 (Löhr, *Familienweihungen*, 111); 4024 (not in Löhr). 2nd half of the 4th cent.: *IG* II² 3829 (Löhr, *Familienweihungen*, 161), a massive dedication by Pandaites and Pasikles of Potamos.

[17] Around the mid-4th cent.: *SEG* 51.215; 18.85 (Löhr, *Familienweihungen*, 106); perhaps a couple's auto-dedicated portraits. Also *IG* II² 4025 (Löhr, *Familienweihungen*, 151), second half of the 4th cent.; *SEG* 17.83.

[18] Asklepieion: *IG* II² 4368 (Löhr, *Familienweihungen*, 135), an *ex-voto* (portrait of a doctor) set up in the 340s. Aphareus dedicated a statue of his adoptive father Isokrates to Zeus ([Plutarch], *Moralia* 839b), *c.*340, in the shrine of Zeus Olympios (so Löhr, *Familienweihungen*, 136, on Pausanias 1.18.8). *IG* II² 3843 may be part of a 4th-cent. private honorific, seen near the temple of Zeus Olympios by Dodwell.

[19] Eleusis: [Plutarch], *Moralia* 839d (*Inscr. Eleusis* 59), statue of Isokrates, set up by Timotheos, 1st half of the 4th cent.); *IG* II² 3841 is doubtful (Löhr, *Familienweihungen*, 209 n. 22). Rhamnous: *Rhamnous* 186 (Löhr, *Familienweihungen*, 127). *IG* II² 3830 (Löhr, *Familienweihungen*, 103), mid-4th cent., from Salamis, is dedicated 'to the immortal gods', without further indication (public or sacred space?).

[20] *Oropos* 341 (Löhr, *Familienweihungen*, 126), mid-4th cent.

[21] *PHerc* 1021 col. 2, 11–16 (Philodemos' history of the Academy), whence Philochoros, *FGrHist* 328 F 59; improved by K. Gaiser, 'Philochoros über zwei Statuen in Athen', in B. von Freytag (Löringhoff), D. Mannsperger, and F. Prayon, *Praestant Interna: Festschrift für Ulrich Hausmann* (Tübingen, 1982), 91–100 (with Zanker, *Mask of Sokrates*, 356 n. 45): τό[δε] τ'[ἐστὶ περὶ αὐ]τὸν ἐ[ν] τῶι πέ[μ⟨π⟩]τωι· καὶ ἀνέθεσαν εἰκ[όνα] Ἰσ[ο]κράτους. τ . . . ποβ ν ἐφ' ὧι ἐπ[ιγ]έ[γρ]απται [Β]ούτης ἐπόησε ('This concerns him in the fifth (book): 'they set up a statue of Isokrates . . . with the inscription "Boutes made it"'). This statue is presumably not the statue set up by Aphareus: (1) the dedicators are plural; (2) the context, book 5 of the *Atthis* (covering events down to *c.*359), places the statue signed by Boutes before Isokrates' death in 338, whereas the statue set up by Aphareus was posthumous (though Jacoby rejected the restoration of book 5).

[22] Marcadé, *Signatures*, ii, 'Praxitélès I'; A. Ajootian, 'Praxiteles and Fourth-Century Athenian Portraiture', in von den Hoff and Schultz, *Early Hellenistic Portraiture*, 13–33; Keesling, 'Early Hellenistic Portrait Statues'; S. V. Tracy, 'The Statue Bases of Praxiteles Found in Athens', *ZPE* 167 (2008), 27–32. I leave aside the ample general bibliography on Praxiteles, his life, his work, his style, his genius, etc.

century context.[23] The visibility of the private portrait habit in this fourth-century Athenian context is clear—Theophrastos' Flatterer praises a man's town house for being well built, his country farm for being well kept, and his portrait for looking like him (τὴν εἰκόνα ὁμοίαν εἶναι), the last trait being the most outrageously unlikely.[24] The portrait is probably a private honorific, rather than a public honour; the town house and beautiful country estate give a sense of the socio-economic class of those who could afford privately dedicated images, namely the very wealthy. The historical significance of the private portrait phenomenon in Athens at this particular point will require more analysis later.

Outside Athens, private portrait monuments appear sparsely in other contexts—in the great shrines, such as Olympia (where a statue of Gorgias was set up by the orator's great nephew)[25] or Delphi (where Daochos of Pharsalos set up eight statues of male members of his family, including himself),[26] but also in local shrines. In Boiotia, at Thespiai, an example, signed by Praxiteles, is attested epigraphically, and a subsequently famous portrait of Phryne set up by the sculptor, may belong to the same category: the latter portrait probably stood in the shrine of the Muses.[27] Other fourth-century privately dedicated portrait statues are attested epigraphically at Corinth, Pellene, Delos, Priene, and perhaps Lindos and Knidos;[28] the statue of the courtesan Glykera that Harpalos is said to have dedicated at Rhosos, alongside his own image, presumably belongs to this category.[29] These examples illustrate the general emergence across the Greek world, in the second half of the fourth century, of the genre of private portrait dedications, with the characteristic dedicatory formula. It is unclear whether the phenomenon is due to the influence of Athens (for instance, we might suppose that proximity with Athens played a role in the appearance of private dedications at Thespiai), or a development of the earlier portrait practice in shrines (with Athens constituting simply one, particularly well documented, case). The portraits mentioned in Aristotle's will, including a portrait dedicated at Nemea (above, 175–6), might argue in favour of either interpretation.

The practice of private portrait dedications continues apace during the Hellenistic period, with increasing frequency across the Hellenistic world—for instance, by the early third century, on Rhodes,[30] on Delos,[31] in various cities and shrines in Asia Minor and in the islands,[32] in mainland Greece.[33] The female portrait statue (of one Battale) seen by the two

[23] [Plutarch], *Moralia* 843, Pausanias 1.26.5; above, 170; Wilhelm, *Inschriftenkunde*, ii. 161–7 ('Zwei griechische Inschriften') on *IG* II² 995.

[24] Theophrastus, *Characters* 2.12, with P. Millett, *Theophrastus and his World* (Cambridge, 2007), n. 216 (and 133 on Theophrastean sardonic sign-offs to his *Characters*). An *eikon* is mentioned by Demosthenes (23.130) among the local, Athenian, familial ties which Charidemos lacks: rather than a public, perhaps a private honorific statue (I thank Vincent Azoulay for this reference).

[25] *Inschr. Olympia* 293 (Löhr, *Familienweihungen*, 96). An uncaptioned statue at Olympia was interpreted, by Pausanias' time (6.4.8) as a statue of Aristotle set up by 'a pupil or a military man aware of Aristotle's influence with Antipater and earlier with Alexander', which cannot be taken as direct evidence for a late 4th-cent. private honorific at Olympia, but is historically possible.

[26] Löhr, *Familienweihungen*, 139, with bibliography (notably on date).

[27] *IG* 7.1831 (Löhr, *Familienweihungen*, 128; not from 'Leuktra' as often said, for instance by Marcadé, but from Lefka, the abandoned village on the actual site of ancient Thespiai, below modern Erimokastro; see Ajootian, 'Praxiteles', 16). The statue is dedicated 'to the gods', but this is not enough to state that the statue stood in the agora rather than a shrine: see above, 190. Phryne: Pausanias 9.27.5.

[28] Corinth: *SEG* 25.336 (Löhr, *Familienweihungen*, 170), late 4th cent.. *Inscr. Lindos* 2.645, from a site on Lindian territory, is dated by Blinkenberg to the second half of the 4th cent. on palaeographical grounds (the portrait of a man dedicated by his mother, it is captioned in verse). Knidos: *SEG* 53.1224 (a Knidian is statuefied by his sons for his service as *damiorgos*).

[29] Athenaeus 13.586c.

[30] *Inscr. Lindos* 1.56 seems to be the earliest monument; *Inscr. Lindos* 1.55, close in date, is a multiple 'auto-dedicated' portrait monument.

[31] *IG* 11.4.1166–7.

[32] Knidos: *I. Knidos* 171, *SEG* 51.1224. Anaphe: *IG* 12.3.258 (based on lettering).

[33] Megara, *IG* 7.54 (statues of a couple, set up by their son, and created by the sons of Praxiteles), also 55, 60, 61. Akraiphia, *IG* 7.4160 (in front of the temple of Apollo Ptoios). Thebes, *IG* 7.2472 (the sculptor, Daitondas, dates the monument *c*.250). Peloponnese: G. Nachtergael, *Les Galates en Grèce et les Sôtéria de Delphes* (Brussels, 1977),

women visiting a shrine of Asklepios, as portrayed by Herodas in the same chronological context as the actual examples quoted above, is probably a private dedication, set up by the family; the two women comment on the resemblance with the real Battale, their acquaintance.[34] Within the Hellenistic world, the genre takes on a diversity of forms: examples from the very early third century, chosen in close geographical proximity, are the statue of Nannion, set up by her five sons (above, 166); an exedra in the shrine of Apollo in Kaunos, with five life-size bronze statues, each captioned with an epigram, representing Protogenes, his parents, and two friends;[35] on Kalymnos[36] or Rhodes,[37] soberly captioned family exedras; in Delphi, two surviving early Hellenistic marble statues probably belonged to a multi-portrait pedestal.[38] Specific contexts for private honorifics emerge: in early third-century Central Greece, private portrait monuments are linked with death in war, such as the statue of Skorpion, set up by his father;[39] generally, the Aitolians developed a liking for family monuments, in their cities and in the shrine of Delphi which they controlled.[40]

One particular subgenre (above, Chap. 5, 184–6) is that of the private honorific portraits set up in the world of the Hellenistic kings:[41] statues set up by rulers for members of their family, and by king's men for their royal masters, and by royal officials for other royal officials, are well attested from the beginning of the Hellenistic period, at the end of the fourth century and the beginning of the third already (I suspect that it appeared under Alexander already, but none of the attested portraits for Alexander is described as a dedication by one of his officers or courtiers—or as a public honorific for that matter). Two men honoured Ptolemy I at Miletos, in the very late fourth century BC (312 or 309)—the earliest example in a long series of portraits of Ptolemaic rulers set up by their officials;[42] at Kaunos, two men honoured Philokles, king of Sidon, and Ptolemaic admiral, doubtless a gesture by pro-Ptolemaic notables or Ptolemaic officers;[43] Lysimachos set up a statue of his sister-in-law, Queen Hadeia, at the Amphiaraion of Oropos (between 287 and 281).[44] This particular subgenre developed throughout the third century, in subordinate communities, free cities, and international shrines; what matters here is that its development illustrates the spread and popularity of the private genre invented in the mid-fourth century.

Private honorific statues seem to have enjoyed particular popularity towards the end of the third century BC and the first decades of the second, say the years c.230–170 BC: at least, this is suggested by the distribution of datable inscribed statue bases known from a variety of sites: Knidos,[45]

no. 15bis (Hermione, statue of the *aoidos* Pythokles set up by his brother, with epigram; c.265–255; earlier edn: *IG* 4.682).

[34] Herodas 4.35–8; a public honorific monument for a female benefactress is not likely in the 3rd cent.

[35] *Inschr. Kaunos* 49–53.

[36] *Tit. Cal.* 121–7 for examples from the turn of the 4th or the early 3rd cents.

[37] Best exemplified in *Inscr. Lindos*.

[38] Flashar and von den Hoff, 'Die Statue des sogennanten Philosophen Delphi'.

[39] *ISE* 85 (Thermon).

[40] *FD* 3.1.154; 3.4.131, 165; A. Jacquemin, 'Aitolia et Aristainèta: Offrandes monumentales étoliennes à Delphes au IIIe s. av. J.C', *Ktèma*, 10 (1985), 27–35; below, 238.

[41] Hintzen-Bohlen, 'Familiengruppe'; E. Kosmetatou, 'Constructing Legitimacy: The Ptolemaic "Familiengruppe" as a Means of Self-Definition in Posidippus' ἱππικά"', in B. Acosta-Huges, E. Kosmetatou, and M. Baumbach (eds), *Labored in Papyrus Leaves: Perspectives on an Epigram Collection Attributed to Posidippus (P. Mil Vogl. VIII 309)* (Washington, DC, 2004), 225–46.

[42] *Milet* 1.7.244, with Ma, 'History of Hellenistic Honorific Statues'. For early Ptolemaic examples of privately dedicated ruler portraits, *OGIS* 19 (Egypt, Ptolemy I, with a bilingual Greek-Demotic inscription: the statue may have been in Egyptian style, see P. E. Stanwick, *Portraits of the Ptolemies* (Austin, Tex., 2002), 98 A2), 22 (Cyrene), 16–7 (Olympia: the monument set up by the admiral Kallikrates).

[43] W. Messerschmidt, 'Basis einer Ehrenstatue für Philokles, König der Sidonier, aus Kaunos', *IstMitt* 58 (2008), 419–23, dating *Inschr. Kaunos* 82 to the early 3rd cent. rather than 309.

[44] *Oropos* 283.

[45] From Knidos, at least *I. Knidos* 111–15, 120, 164–5 (which are private honorifics from a *pi*-shaped exedra, and not the dedication from the altar of the shrine of Apollo Karneios: Ma, 'Notes on the History of Hellenistic Honorific Statues'), 171.

Lindos,[46] Delos (where private monuments start to appear in the *dromos*),[47] the Epidaurian Asklepieion,[48] and, most distinctly, the Oropian Amphiaraion, where, after a few examples from the first half of the third century, a whole series of private monuments were set up, in quick succession (perhaps over a decade or two), in the western third of the terrace.[49] In Athens, after the explosion in the late fourth century, and some examples in the first half of the third century (which may have been a time of abatement for the genre of private honorifics, and in general for sculpture), private honorifics likewise seem to pick up in the first half of the second century (mostly concentrated on the Akropolis).

This pattern is not observable universally. On Athenian-controlled Delos, a spectacular increase occurs after 167 (and particularly towards the end of the second century), where the private honorific statues proliferate in all public spaces of the shrine and the town, in ways that dwarf even the upsurge in private statues in the last decades of independent Delos, in the late third and early second centuries. Privately dedicated statues of initiates and religious officials appear only in the second century in Athens and in Attica (in Eleusis).[50] On Anaphe, the private honorific habit is best attested in the late second and first centuries;[51] likewise, private honorific statues in Lykia seem to emerge in the second and first centuries BC.[52] Such patterns emerge from the preserved statue bases; it is almost certain, though not directly attested, that painted portraits of individuals, singly or in family groups, continued to be dedicated in shrines and in gymnasia, in ways which the loss of any evidence prevents us from perceiving.[53]

Finally, private honorific statues are widespread throughout the 'Greek East' under the Roman empire—though, just as during the Hellenistic period, unevenly distributed in time and in space (and unevenly documented). Private honorifics continued in Athens, on the Akropolis; a statue of Regilla was set up, perhaps in the vicinity of the Agora, by Fl. Suplicianus Dorion, the archon of the Panhellenion, εἰς [πα]ρηγορίαν φ[ί]λου, 'for the consolation of a friend', namely Herodes Atticus after the death of his wife in AD 160/1.[54] In Lindos, the practice, once so richly attested, drops off during the Roman empire (perhaps because the shrine was saturated with private offerings of the Hellenistic period),[55] whereas it continues in neighbouring Asia Minor.[56] In Chaironeia, a series of private honorifics from the first to the third centuries AD reflects the presence of local elites, enjoying Roman citizenship, and performing roles at the provincial level—the milieu of Plutarch (who indeed appears as an honorand, and is once named as an ancestor).[57] In Macedonia, private honorifics appear under the Roman empire (from c.AD 100 onwards, with a noticeable increase in the third century), whereas the genre is totally absent from Hellenistic Macedonia.[58]

[46] The point is not affected by the redating of the epigraphical material from Lindos (proposed by N. Badoud, whose findings were presented at the 13th International Congress of Greek and Latin Epigraphy in Oxford (2007); I have not seen his *Le Temps de Rhodes*), and I assume that the banding offered by Blinkenberg is still correct enough to support the statement offered here.

[47] *ID* 1168, 1175, 1176, 1184.

[48] Private monuments around 180 BC and later: the material is scattered in *IG* 4² 1 and needs serious reconsideration; for examples, nos. 211–34 (under the heading of dedications).

[49] Above, 139–42.

[50] Above, 170.

[51] ὑπέρ-captioned private statues: *IG* 12.3.258 (*c*.300), 268, 271, 290 (all likely 1st cent.); the dates are based on the palaeography.

[52] e.g. *TAM* 2.283, 309, 310.

[53] I suspect the shields with portraits known in the Delian gymnasion (Moretti, 'Inventaires') are not public honorifics but privately dedicated images.

[54] A. E. Raubitschek, 'Greek Inscriptions', *Hesperia*, 12 (1943), 74, no. 22, completing *IG* II² 4076.

[55] The last private honorific is *Inscr. Lindos* 2.344 (tacked on to a public honorific).

[56] *I. Kibyra* 67–74, well commented on by T. Corsten; examples in *TAM* 3 (Termessos).

[57] *IG* 7.3422–7.

[58] The shape of the private honorific statue habit is visible in *IG* 10.2 (Thessalonike), the epigraphical corpus of Beroia (*EKM*), and the collection of 'Macedonian bases', P. Adam-Veleni, *Makedonikoi bomoi: Timetikoi kai taphikoi vomoi autokratorikon chronon sti Thessaloniki, protevousa tis eparchias Makedonias kai sti Veroia, proteuousa tou koinou ton Makedonon* (Athens, 2002). Apuleius, *Florida* 15, claims that a statue on Samos was a private honorific set up by Polykrates for Pythagoras, which has no historical value for the development of the private genre, but indicates its prevalence in Roman times (as well as literary constructs on the relations of tyrants).

The phenomenon of private honorific statues can be thus traced, in its fully developed form, from around the mid-fourth century BC to the third century AD (when it disappears), with some obvious clusters of examples in time and space: Athens in the fourth century, Rhodes in the late third and early second centuries, Delos in the late second century. Within this broad pattern, as shown above, individual timelines can be sketched (for instance, the story of Athens, or of Delos, where the third-century bulge, and the late second-century explosion, are remarkable); local bodies of material reveal different rhythms (for instance in island *poleis*), with the *caveat* that the evidence is not plentiful enough for sustained analysis. The appearance of private honorifics may be interpreted as the spread of a fashion among elites, because of the 'influence' of centres of the practice: private honorifics in Boiotia, Euboia, and Megara were perhaps 'influenced' by the presence of Athenian family monuments; likewise, Rhodes probably 'inspired' the emergence of the practice in Lykia and Karia (politically occupied by Rhodes between 188 and 167), and certain islands (Tenos, which was politically linked with Rhodes in the second century).[59] The use of the ὑπέρ formula in cities of the Black Sea hints at Rhodian cultural influence. The importance of the private statue habit on Rhodes in the decades 220–170 BC, then its abatement (with a slight resurgence in the early first century), and the explosion of family statues on Delos in the second half of the second century, both reflect the political and economic fortunes of these two places. Finally, the practice of setting up statues among members of royal dynasties, generally in the world of the Hellenistic kingdoms (by royal officials for their rulers, or by officers for other officials) has a history of its own, with specific shapes according to dynasties (the Ptolemaic officials practise the private statue habit with gusto; the Attalid dynasty sees the practice of statues set up among members of the dynasty; private statues are rare among the Seleukids, and non-existent among the Antigonids). The 'royal' fashion may have influenced the private statue habit among civic elites, notably by offering models in the international shrines, for instance at Delos or Delphi.

These phenomena pose sharply the problem of the workings, function, and meaning of private monuments. The genre is not quite an Archaic survival or even a revival, but, within a continuous development from the Archaic *kouroi* and *korai*,[60] a creation of the late Classical and early Hellenistic period, like the public honorific statue, whose story and development it echoes and mimics (with a time lag of slightly over a generation, from the 390s for the emergence of the public genre to the 360s for the establishment of the private genre). The contexts of the private honorific genre, surveyed at length in the previous pages, need examining in some detail, to try to reconstruct function and impact in the context of Hellenistic honorific culture, which I have studied throughout this book as inscribed words, works of art, and the management of public space. The shapes of family self-expression, beyond any possible family history, also have implications for the workings of the genre; these workings, in turn, are instructive for the understanding of the position of these objects—between individualism, elitism, and collectivism.

3. MAKING FAMILIES (VISIBLE)

Beyond any specific 'occasion' to be commemorated (a doubtful notion, I argue above), the private honorific monument displayed relations between individuals, most frequently relatives. As mentioned earlier in the case of the Archaic predecessors to the private honorific

[59] *Amyzon* 34; for Tenos, *IG* 12.5.918, 919–21 (one a private honorific for the 'trierarch of the Nesiotes', Chrysogonos, set up by his parents, the others part of a multi-relational statue monument for members of Chrysogonos' family, including his mother Nausion; also R. Étienne, *Ténos I: Le Sanctuaire de Poséidon et d'Amphitrite* (Paris, 1986), 141–2), 922, 923; on the Rhodian presence on Tenos, R. Étienne, *Ténos II: Ténos et les Cyclades du milieu du IVe siècle a. J.-C. au milieu du IIIe siècle ap. J.-C.* (Paris, 1990), 115–17 on documents, and generally 101–24.

[60] Dillon, *Female Portrait Statue*, 3, on continuity from *korai* to late Classical and Hellenistic female votive statues.

monument, the act of dedication itself, as a visible, permanent gesture, often made visible family in time, rather than simply individual prominence: an Akarnanian man's dedication of a statue to Herakles 'preserved the deathless memory of his father and of himself'.[61] The epigrams that very occasionally accompany private monuments make clear the intentions of the genre: the celebration (or creation) of the dedicator's prominence, the dedicator's gratitude towards his or her relatives.[62]

τάνδε θεοῖς Διότιμος Ἀρίστου εἰκόνα μορφᾶς
στᾶσεν Ἀπόλλωνος Δαλίου ἐν τεμένει·
πατρὶ δὲ πρᾶτος ἑῶι θρεπτήρια καὶ χάριν ἥβας
ὤπασε, ἀφ᾽ οὗ πατέρων ναίομεν ἄστυ τόδε·
οὐδεὶς γάρ πω τῶν πρίν, ὅσοι ναίουσι Κάλυμναν,
τῆσδε ἔτυχεν τιμῆς παιδὸς ὑπὸ σφετέρου.

Diotimos son of Aristos set up the image of Aristos' bodily shape in the shrine of Delian Apollo; he was the first since the time we live in this town of our fathers, to render to his father a return for rearing, a token of gratitude for having raised him to manly youth; for none of the previous men who inhabited Kalymna received this honour from his child.

More concisely, private honorific monuments occasionally declare their motivations—the requital of gratitude for benefactions, or the display of *philostorgia*, family love (above, 181–2). However, such explicit declarations of reciprocity or sentiment, in their very explicitness, are of limited help for the study of the display of family relations in the genre of private monuments; it matters not simply to repeat what is already articulated in epigram or *titulus*, but to look at the shape of the phenomenon. What sort of family is being displayed? What kind of family dynamics emerges?

Without attempting to write a history of the Hellenistic family as visible through its private statuary monuments, a few characteristics are immediately clear, especially from ensembles of material such as Delos, Athens, Oropos, or Lindos, but also from the genre as a whole. The first is the importance of the nuclear family. On Delos, statues of a woman and her daughter were set up in the 'Sarapeion C' by the male members of the family, the father and the brothers—thus making the nuclear family visible, in statuary or inscribed form:[63]

Διοδώραν Ἡφαιστίωνος Ἀθηναίου θυγατέρα Λυσίας Μηνοδότου Ἀθηναῖος
τὴν ἑαυτοῦ γυναῖκα καὶ τὴν θυγατέρα Ἀρίστιον, καὶ Μηνόδοτος καὶ Ἡφαιστίων
οἱ Λυσίου Ἀθηναῖοι τὴν μητέρα καὶ τὴν ἀδελφήν, Σαράπιδι, Ἴσιδι, Ἀνούβιδι, Ἁρποχράτει.

Diodora, daughter of Hephaistion of Athens—Lysias son of Menodotos, of Athens, (set up) his wife, and also his daugther, Aristion, and Menodotos and Hephastion sons of Lysias, Athenians, (set up) their mother and their sister—to Sarapis, Isis, Anoubis, Harpokrates.

Indeed, at first sight, the majority of statue transactions happen within the immediate, 'simple', nuclear family (married couple and children);[64] for instance, all the few private honorifics known from Megara fall in this category.[65] Single statues for uncles,[66] cousins, or grandparents

[61] *IG* 9.1² 2.238; the dedicant's father (Lasthenes) is named before the dedicant, Laphanes, who appears only in the last line; Herakles likewise is called 'descendant of Zeus and Alkmene'.

[62] *Tit. Cal.* 130B (early 3rd cent.). A similar sentiment in the epigram accompanying the statue of Mego, set up at Messene by her parents (*SEG* 23.220).

[63] *ID* 2095 (inscription on lintel rather than base; date unclear). The mother was also honoured with a standalone statue by her sons (*ID* 2096). *IG* II² 4031, *Oropos* 431 are similar examples.

[64] On the nuclear family in Greek history, C. Patterson, *The Family in Greek History* (Cambridge, Mass., 1998), S. B. Pomeroy, *Families in Classical and Hellenistic Greece: Representations and Realities* (Oxford, 1997); S. Lape, 'Solon and the Institution of the "Democratic" Family Form', *CJ* 98 (2002–3), 117–39 (on the 'conjugal family'). On the history of the family, see generally P. Laslett (ed.), *Household and Family in Past Time* (Cambridge, 1972), then E. Todd, *L'Origine des systèmes familiaux*, i. *L'Eurasie* (Paris, 2011); Todd argues that the ancient Greek family was probably nuclear, with temporary patrilocal residence (or patrilocal proximity residence), 334–6 (a pattern which the pattern of honorific statues might confirm).

[65] *IG* 7.54, 55, 60, 61.

[66] See below, 206, on Echedemos and Isandros of Kydathenaion.

(grandchildren) occur,[67] but are much rarer. As already noted in the previous chapter, statues for (apparently unrelated) friends are rarer still: on Lindos, this type of transaction occurs four times out of nearly sixty monuments (including multi-statue monuments) over three centuries.[68] This pattern is of course influenced by specific conditions: statues for friends are well attested on post-167 Delos.[69] The Delian case reflects the particularities of its social life, namely the presence of merchants and international contacts; another area where the non-familial relations dominate is the subgenre of private honorifics among the world of royal officials and partisans, who use statues to manifest power and status (above, 185–6). Nonetheless, allowing for exceptions such as the Delian case, the predominance of family transactions is the overarching characteristic of the private genre, and some of statues between individuals where family relations cannot be detected by explicit declaration or onomastics might be 'hidden', implicit, familial monuments.

The familial transactions are of course potentially varied: husbands and wives honour each other with statues;[70] on Rhodes, Chairemon and his daughter Atheno jointly set up, probably in the shrine of Artemis, the statue of Sumacha (sic), his wife and her mother, the senior female partner in the nuclear family;[71] siblings are statuefied, sometimes on their own (Chairippe, priestess of Demeter and Kore, was statuefied by her two brothers in Athens c.360), sometimes as part of multi-generational transactions.[72] The point is the display of harmony within the family, notably the solidarity between husband and wife at the heart of the household.[73] However, the most frequent relation that is displayed in family statues is that between parents and children: parents set up statues of their children (a special case is that of the commemoration of sacred duties or status held by these children),[74] and, especially, men set up statues of their fathers—a relation already apparent in late Archaic and early Classical Athens (above), but widely noticeable (for instance in the closed body of material from Lindos). This relation is characteristic and instructive for the workings of the genre of private honorific statues in the context of dynamic family relations.

The first consequence of the importance of son–father statue transactions is to show the presence of male lineage, or at least continuity in time, beyond the immediate boundaries of the 'nuclear family'. On Rhodes, a familial monument referred to three generations of men: a grandfather, a father, a son, represented by two statue transactions (the father for the grandfather, the son for the father).[75]

Ἡράκλειτος Παυσανία.
 vacat
Ἀπολλόδοτος Ἡρακλείτου
Νεττίδας ματρὸς δὲ ξένας
 τὸμ πατέρα
 φυλαρχήσαντα
 φυλᾶι Ἰαλυσία[ι]
 καὶ νικάσαντα εὐα[νδ]ρίαι
 καὶ λαμπάδι Διοσωτήρια
 Ἀσκλαπίεια Ἁλίεια
 θεοῖς.

Ἀπολλόδοτος Ἡρακλείτου
Νεττίδας ματρὸς δὲ ξένας.
Ἡράκλειτος Ἀπολλοδότου Σάμιος
ὧι ἁ ἐπιδαμία δέδοται τὸμ πατέρα
θεοῖς.

[67] For instance Inscr. Lindos 2.284, 299; I. Knidos 165.

[68] Inscr. Lindos 1.104, 138, 153, 155. As noted earlier, I consider the statues set up by colleges of magistrates for individuals upon exit of office as public monuments, because they are collective, and indeed involve public officers.

[69] ID 1999–2016.

[70] Inscr. Lindos 1.78 (couple) ID 1987; IG 12.3.491–2, mutual exchange of statues between husband and wife on Thera; Nuova Silloge 31 (woman honours her husband, Rhodes, 2nd cent.).

[71] Nuova Silloge 29 (1st cent. BC), dedicated to Artamis.

[72] Chairippe: SEG 51.215. Also e.g. Oropos 404, 415; IG 7.2795 (Kopai, 1st cent.).

[73] Van Bremen, Limits of Participation, emphasizes this factor.

[74] As in the case of Mego (above, n. 62, on SEG 23.220) or of the Athenian girls (in Athens or post-167 Delos) who served as kanephoroi (e.g. SEG 33.197: a couple dedicates to Demeter and Kore a statue of their daughter, initiate and kanephoros in the Pythaios of 138 or 96 BC); generally, above, Chap. 5, 170.

[75] Nuova Silloge 19.

(*Left column*) Herakleitos son of Pausanias—Apollodotos son of Herakleitos, of the deme of Nettidai but of foreign mother, (dedicated him), his father, who had served as phylarch for the tribe Ialysia, and won in the contest of manly beauty (*euandria*) and the torch race at the Dios Soteria, the Asklapieia, and the Halieia, to the gods.

Apollodotos son of Herakleitos, of the deme of Nettidai but of foreign mother—Herakleitos son of Apollodotos, of Samos, enjoying residency rights, (dedicated) him, his father, to the gods.

The monument includes an epigram, under the right-hand dedication, which makes clear the investment in family continuity, and hoped-for prosperity and growth.

ἀτθρήσας, ὦ ξεῖνε, τὸν ἔμπνοον ἐγγύθι χαλκὸν
μνᾶσαι τᾶς ὁσίας τοῦδε δικαιοσύνας·
τρὶς δέκα γὰρ λυκάβαντας ὁμοῦ ξείνοις τε καὶ ἀστοῖς
χρυσὸν σὺν καθαρᾶι πάντ' ἐφύλαξε δίκαι·
οὕνεκ' Ἀπολλοδότωι μίμνει κλέος, ἅδε δὲ μορφὰ
ἐξ Ἡρακλείτου παιδὸς ἀναγράφεται.
ἀλλὰ γένος τελέθοι καὶ ἐς ὕστερον ὡς ὅδε πατρὸς
φέρτερος, ὡς παίδων παῖδες ἀρειότεροι.

Stranger, gaze close up on the living bronze and remember the holy justice of this man: during thirty years, for foreigners and citizens alike, he kept watch over gold, with constant pure justice. Hence glory remains with Apollodotos, and this image is inscribed by his son Herakleitos. May the race continue in future times, and just as this man was better than his father, thus may the children of their children be yet stronger.

More tersely, a father set up a statue of his son, in Athens, in the early third century:[76]

Ἰσχυρίαν Ἀριστίωνος Ἀγγελῆθεν
ὁ πατὴρ ἀνέθηκεν.

Ischyrias son of Ariston, from Angele—his father set him up.

Remarkably, the son is named first, in the fronted accusative that is often reserved for kings, whereas the father is content to stay anonymous, his name and demotic to be deduced only from his son's patronym. The statue was part of an equestrian monument, as can be seen from the traces on top of the inscribed block (Fig. 6.1): Ischyrias was represented on a grandly rearing horse, a trope taken over (just like the fronted accusative) from the register of royal celebration.[77] The effect is for the father to insist on the son's glory, in happy self-effacement at seeing the succession of generations take place as increase, thus resolving the culturally inbuilt tensions between father and son in the son's favour,[78] as part of the constitution of lineage.

Fig. 6.1. A private monument could also take on public forms, or at least visual forms that were publicly significant. Crowning block of privately erected monument of Ischyrias—an equestrian statue. *IG* II² 3860, Athenian Agora, *c*.300?

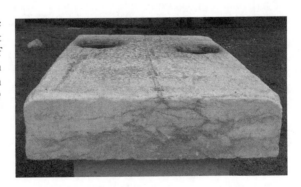

[76] *IG* II² 3860.

[77] On the visual idioms of the equestrian, Siedentopf, *Reiterdenkmal*. Dimensions of the block: 1 m front, 1.60 m long, i.e. a small equestrian.

[78] B. S. Strauss, *Fathers and Sons in Athens: Ideology and Society in the Era of the Peloponnesian War* (London, 1993).

Fig. 6.2. Echedemos, his uncle, and their relatives: the private honorific is also a stemma.

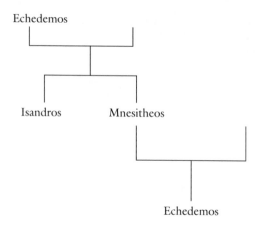

The monumental inscription on the crowning course might have been completed by an epigram on the shaft of the base, making clear the exploits of Ischyrias (I suspect that he died in war, which would justify his being celebrated in these terms).

Familial continuity is already implied in the music of proper names, from father to son, in the inscriptions accompanying simple honorific statues: the pattern of naming manifests the alternate rhythm from grandfather to grandson, transmitted by the father,[79] and hence conveys generational depth beyond the immediate statue transaction. Mnason son of Eubolos sets up Eubolos, his son; Menekrates son of Agathon sets up his father Agathon son of Menekrates; Pollis and Apelles set up their father Apelles son of Pollis.[80] Such jingle effects also work in statues transactions between relatives beyond the father–son relation, and equally reveal families: the statue set up by Echedemos of Kydathenaion for his uncle Isandros, of the same deme, allows us to reconstruct a small stemma (Fig. 6.2).[81]

'Εχέδημος Μνησιθέου Κυδαθηναιεὺς
τὸν θεῖον
'Ίσανδρον 'Εχεδήμου Κυδαθηναιέα
ἀνέθηκεν.

Echedemos son of Mnesitheos, of Kydathenaion, has dedicated his uncle, Isandros son of Echedemos, of Kydathenaion.

When an Epidaurian couple set up the statues of their children, and described them as τὰς γενεάς, the word, meaning 'offspring', also expressed the hope for more general descendance and continuity.[82] In the case of funerary statues, set up (in the private context of the funerary enclosure or family-funded shrine, or in public spaces such as the agora) for deceased relatives, especially children, the same attention to lineage is paid—in the form of pathos and grief at the interruption of family continuity, even as the public qualities of the deceased are celebrated. This is the case for the funerary statue set up by Drakon for his son Skorpion, after his death in

[79] e.g. [Demosthenes] 43.74. Not a rigid rule: E. Fraenkel, *PW* 16, 1616–26, s.v. Namenwesen, §3 Die griechischen Vollnamen, at col. 1624.

[80] *IG* 7.528 (Tanagra), *I. Erythrai* 341, *IG* II² 3841 (Athens, reused in church of H. Demetrios Katephores, so perhaps from gymnasion). In late Hellenistic Knidos, a son set up a statue of his (admittedly adoptive) father—both named Euphranor, as, indeed, were the dedicator's grandfather and great-grandfather: *I. Knidos* 115. The names in *IG* II² 3479 (mentioned above, 169), knit the family together (elements in *Pleist-* and in *So-* recur from generation to generation).

[81] *IG* II² 3854, Akropolis, mid-3rd cent. Isandros and Mnesitheos were *epimeletai* of the procession of Dionysos (*IG* II² 668, 266/5). On the family, C. Habicht, *Studien zur Geschichte Athens in hellenistischer Zeit* (Göttingen, 1982), 189–93. I return to this document elsewhere.

[82] *IG* 4² 1.210.

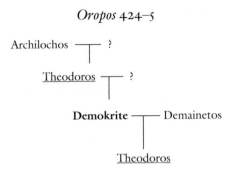

Fig. 6.3. The 'kindred' of
Demokrite of Oropos, in
stemma representation.

Oropos 424–5

battle, or of the statue recording the *morpha* of the youthful, Olympic-calibre Sosagoras, and set up by his parents after he had died (above, 178–9).

Yet family statues do not exclusively illustrate 'patrilines', lineages structured around the succession of fathers and sons as male heads of households:[83] it is immediately obvious that women are recipients of statues, and that women also set up 'private honorifics', often on their own. At the Oropian Amphiaraion, as already discussed in the previous chapter, Demokrite set up a 'distributive' monument with a statue of her father and one of her sons (and, indeed, of herself and probably of Amphiaraos looking on), in the last quarter of the third century.[84] The family network mentioned in the monument and the text can easily be summarized in stemmatic form (Fig. 6.3).

The stemma clearly shows that the inscription is readable: Demokrite, the dedicator, is the centre of gravity of the monument, the fulcrum in the statue transaction that produced the four statues on the long marble base in the shrine. Demokrite is indubitably related to the two honorands, but the monument does not represent 'her family', in the sense of a clearly defined, co-residential household, structured around male kinship relations. Instead, as schematized on the stemma above, Demokrite belongs to a 'family', constituted by herself, her son (and other children?), and husband (for some reason absent from the monument), but also to the remnants of another nuclear family, that constituted by her parents and herself.[85]

Demokrite's autonomy in the matter may be caused by particular circumstances: if her husband has died, she may be living with a young son (Theodoros, whose youth is shown by the smaller traces on the statue base), and an aged, widower father—a familial unit constructed by the specific evolution of demography and time. The statues may be a way of cementing this relation within a delicate situation (involving property between generations), and perhaps of expressing gratitude for the elder Theodoros' financial support; the issue may be Demokrite's dowry, returning to her father's house but promised to her son. But without any need for such a scenario, the passage of the male name, from Demokrite's father to her son, also tightens the web of kinship around her, rather than keeping a patrilineal lineage clear. Specifically, the monument might present a 'secondary lineage', which perpetuates the mother's father's name (and perhaps marks the transmission of property from the mother's side), rather than the father–son succession (the monument eschews any mention of a husband, but also raises the possibility of the existence of an elder son, bearing the husband's name): the grandson has the 'right name', his grandfather's, which bridges the generations across the patrilinear boundaries.

[83] Contrast Archaic Attica, where this relation is predominant in funerary and votive material: A. D'Onofrio, 'Oikoi, généalogies et monuments: Réflexion sur le système des dédicaces dans l'Attique archaïque', *Ktema*, 23 (1998), 103–21.

[84] *Oropos* 424–5.

[85] On the position of women between families, at the point of contact between nuclear families, van Bremen, *Limits of Participation*, 204, adducing J. Goody; S. C. Humphreys, review of Pomeroy, *Families*, in *American Historical Review*, 104 (1999), 1358–9.

The broader point emerges that familial monuments do not in fact necessarily, or even usually, take place within 'nuclear families' (defined as co-residential units made up of parents and children). It is true that in some cases, children, associated as dedicators to statue transactions, must be present in symbolical terms, as participants in the honorific gesture rather than financial *Stifter* of the expensive portrait statue (this may be the case for the monument of Diodora, quoted above).[86] Nonetheless, in others, dedicators, though identified as the honorand's children or siblings, must be adults in possession of property (disposable income or available collateral), able to disburse the necessary sums to commission honorific portraits, and legally recognized as interlocutors by the authorities in control of public space. This seems the case for Echedemos of Kydathenaion, honouring his uncle (without the intermediary of his father), or Chairippe's brothers, who set up a statue of her as priestess of Demeter and Kore, but, probably at this stage, no longer living with her under their parents' roof (though the absence in the inscription of a named husband or parents gives pause as to whose household she resides in). The monument set up by Diotimos of Kalymna for his father Aristos (quoted above) explicitly commemorates the former's accession to adulthood; statues *ex testamento* are, by their nature, about the transmission of property, and hence moments when the personal relations rooted in old 'nuclear families' are dissolved by time and death, leaving the memorial traces in the form of family statues that often represent in visual form the last wishes of the deceased.[87] The issues of property are clear in the case of testamentary statues; in other cases, family monuments might represent such moments as the coming of age of children, or their marriage, or arrangements between sons and fathers about maintaining the latter in old age even as the former take over the main property and its management.[88] Sons enter their estates and commemorate this moment with expensive gestures which reaffirm their filiation as well as their personal relation to their father—both displaying, and dissimulating, the break that this moment represents; lineage continuity takes place at the price of constant dissolution of nuclear units.

The presence of property issues (in implied or sublimated forms) in the context of the often emotional family gestures represented by private honorific monuments is linked to the nature of the family as a *locus* of social reproduction and the transmission of material goods within time.[89] What matters here is that family statue transactions, even though the majority take place between close kin, rather than focus on making nuclear families visible, represent moments within generational cycles, where individuals have relations that cross the boundaries of nuclear families, and establish ties based on kinship, often rooted in nuclear families that have evolved. A son who has the wherewithal to set up a statue of a parent both makes manifest his familial independence (he likely has a nuclear family of his own) and commemorates his family links; he gestures towards the family which raised him to this status of independent social and economic actor. An individual who sets up the portrait of a living spouse, especially a woman presumably drawing on dowry money, makes visible a commitment to the familial unit—but also implies her ability to decide to dispose her agency and her choice in the matter.

[86] Also e.g. *IG* II² 4031; *Oropos* 431.

[87] On the constant movement of construction and break-up of 'elementary' families, A. Burguière and P. Beillevaire (eds), *Histoire de la famille*, i. (Paris, 1986); E. Avezzù and O. Longo (eds), *Koinon aima: Antropologia e lessico della parentela greca* (Bari, 1991).

[88] Such arrangements are attested in modern anthropological material, but can be detected in ancient sources, notably at the end of the Odyssey: O. Longo, 'I figli e i padri: Forme di riproduzione e controllo sociale in Grecia antica', in Avezzù and Longo, *Koinon Aima*, 77–108. Ajootian, 'Praxiteles', 26, suggests that the display of solidarity visible in the statue of Chairippe set up by her two brothers may concern responsibility at some important familial moment.

[89] For a parallel, B. Vernier, *La Génèse sociale des sentiments: Aînés et cadets dans l'île grecque de Karpathos* (Paris, 1991); B. Vernier, 'Quelques remarques méthodologiques sur l'étude comparative des systèmes de parenté', in A. Bresson, with M.-P. Masson, S. Perentidis, and J. Wilgaux (eds), *Parenté et société dans le monde grec de l'Antiquité à l'âge moderne* (Bordeaux, 2006), 12–27.

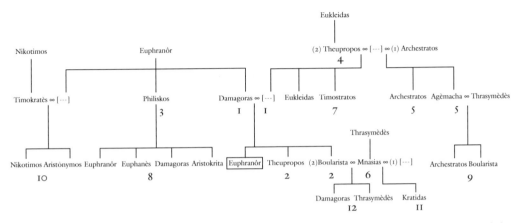

Fig. 6.4. My big fat Rhodian family: the kindred of young Euphranor of Rhodes (from V. Kontorini). The numbers correspond to the order of appearance in list of dedicants.

Thus what family statues make visible is not so much nuclear families as kindreds—relations, or networks of relations centred around one individual (or several individuals in the case of multi-relational statue monuments),[90] a web of kin that moves and changes with the individual.[91] The monument set up by Demokrite reveals, not quite her family or families, but a particular, fragmentary kindred, monumentalized by her choice and for her reasons. The kindred can be extended, as seen in the multi-generational monuments attested with increasing frequency in the late Hellenistic period, and especially on first-century Rhodes: the statue of Euphranor son of Damagoras, discussed in the previous chapter, illustrates this category. As mentioned above, the block of names that appears on the statue base can be clarified as a stemma (Fig. 6.4).

We might look at the stemma, and see it as a document giving evidence for 'the family of the admiral Damagoras', as V. Kontorini writes (no less than thirty individuals are named). However, as a monument, the statue and its base commemorate the relations between young Euphranor and a network of twenty-one relatives, presented in a specific order (numbered in the stemma above): first his parents; then his siblings; a paternal uncle; a maternal grandfather; a 'maternal aunt' and a 'maternal uncle' (in fact the half-siblings of Euphranor's mother); Euphranor's brother-in-law (the husband of his sister); a maternal uncle; four cousins (on Euphranor's father's side), the children of the 'maternal aunt' (who call Euphranor's mother *tetha*), two more cousins (probably children of a sister of Euphranor's father Damagoras); one Kratidas, the son of Mnasias (Euphranor's brother-in-law, named earlier), who must be the paternal half-brother of Euphranor's nephews (the children of Boularista, Euphranor's sister); and finally the said nephews.

It is certain that the block of names is not structured haphazardly, and the order must represent some form of family priorities, or the 'importance' of the various individuals in relation to Euphranor and each other, or the magnitude of contributions to the statue (Mnasias, Euphranor's half-brother, is named eight lines above his son Kratidas, who appears as honouring 'the uncle of his sister and brother'; the presence of children, in the form of various nephews and cousins, may be purely honorific, rather than the result of any financial contribution), the greater or lesser investment (emotional and financial) in the statue. But it is

[90] This central individual is the 'I' or the '*ego*' in anthropological literature on kinship networks; the expression is not quite suited for the Hellenistic private monuments, where the individual is the 'him' / 'her' caught in a web of honorific relations (see Chap. 2).

[91] Patterson, *Family in Greek History*. The same phenomenon is visible on Classical Attic grave *stelai*: J. Bergemann, *Demos und Thanatos* (Munich, 1997).

equally obvious that the order is not a fixed structure comparable to the Athenian *anchisteia* which determined the order of proximity, and property rights, surrounding any adult male citizen.[92] The honorific monument mobilizes an *ad hoc* extended kindred—around Euphranor, the '*ILLE*' (to coin an expression, rather than the anthropologists' '*EGO*')[93] at the centre of the web: individuals are not named with a specialized terminology or lexicon, but in terms of relations and connection.[94] This kindred connects, around a single individual, a number of 'simple' families (five 'active' families, one 'composite', themselves the product of two earlier families, that of old Euphranor on Damagoras' side, and the 'composite' family of Theupropos on young Euphranor's mother's side), at different points in the generational cycle, as shown by the different places where the stemma sprouts offspring (such as Boularista's two sons), or gathers still childless individuals (assuming all potential participants in the statue transaction are represented on the long inscription). This type of extended kindred, where the jingle of repeated generational names is lost among the jungle of relatives close and less close, must reflect the conditions of elite competition (drawing on extensively pooled resources across individual descent lines) and 'cognatic' solidarity on late Hellenistic Rhodes—rather than any survival of 'clan' or 'genos'.[95] It nonetheless vividly illustrates the general point that family honorific monuments make visible *ad hoc* kindreds: for all their implicit claims about continuity and solidarity, they illuminate relations—at a particular moment.

The same point may be made concerning the category of 'multi-relational' family monuments, where a cat's cradle of relations is displayed by plural, interlocking statue transactions. It is true that some such monuments occur within the 'nuclear' family, and commemorate patrilines. On Delos, the five statues atop one of the exedras at the north-east angle of the shrine commemorate the relations between a couple, Artemidoros I and Olympias, their two sons (Hephaistion II and Artemidoros II), and Hephaistion I, father to Artemidoros I, grandfather to the latter's sons (above, 203). The music of the names emphasizes family continuity, as does the reaching back a generation, to present three generations of Hephaistions and Artemidoroses; the statue transactions display reciprocity between these generations—the father sets up separate portraits of his sons, who in turn set up his portrait. However, even in this case, it is clear that there is a 'centre of gravity' to the web of relations in the statue, Artemidoros I, initiator or recipient of four out of five statues on the monument, and the person around whom the kindred is structured and presented—just as Demokrite is the structuring principle of the monument she set up at the Amphiaraion, or Diodora is the focal point of the monument her nuclear family set up for her. The multi-relational monument is thus a way of presenting a group of individuals (including nuclear families) as kindred, networks of kin around one person—or, occasionally, as interlocked kindreds, in the case of multi-relational monuments with multiple focal points.

The effect of the private monument is to present the 'generation game'—a snapshot of relations, within time, in a kindred-centred effect underlying complex transactions but also the simple statues within the nuclear family. Monuments construct relations between generations, forwards (when parents set up statues of children, young or grown) or backwards (when individuals set up statues of parents or even grandparents). At Knidos, on the terrace of the shrine of Apollo Karneios, as part of a multi-relational monument, a couple set up a statue of the woman's grandfather;[96] they chose to mention his participation in the ritual race of the

[92] On the *anchisteia*, see now Patterson, *Family in Greek History*.

[93] On this terminology, and a primer on how to describe kinship groups, F. Zonabend, 'De la famille: Regard ethnologique sur la parenté et la famille', in Burguière and Beillevaire (eds), *Histoire de la famille*, i. 15–75.

[94] This appears from the contrast between the designation of individuals in the block of names on the base of Euphranor's monument, and the abstract scheme of terms given, for the bilateral genealogy of an ideal Athenian family, by M. Miller, 'Greek Kinship Terminology', *JHS* 73 (1953), 46–9. On ideological charge in the familial lexicon, E. Avezzù, 'Antropologia e lessico della parentela greca', in Avezzù and Oddone, *Koinon Aima*, 25–40.

[95] A. Bresson, 'Règles de nomination dans la Rhodes antique', *DHA* 7 (1981), 345–62.

[96] *I. Knidos* 165.

Karneia; this event took place not in the grandfather's old age, but in earlier times, probably during his young adulthood, and the statue, set up by his grand-daughter when she was already married, looks back in time, and bridges generational presents into presence.[97] The grandfather is perhaps still alive; even if deceased, he is part of a recent familial past: generally, family monuments remain within a shallow generational depth, presenting known relatives, living or recently deceased, such as parents who bequeath property, or prematurely deceased offspring or siblings. The exceptions constituted by the dynastic monument of Antigonos Gonatas at Delos, or the genealogical table of the Eteoboutadai, are very different in nature from the 'normal' private honorific among citizens and royal families alike, attested with such regularity by the epigraphical material.[98]

In spite of the general absence of genealogical depth as a means for familial self-expression, it is clear that the visual scenography of kindreds in the form of private portrait monuments is also a form of time management, in two ways. The 'snapshots' are about relations, often between generations (especially between sons and fathers), and hence inscribed in time. First, a punctual relation between individuals is monumentalized and projected forward in time. The representation of kindred is a choice, and represents an unstable relation: this will inevitably disappear because of the pressures of generational change and, simply put, time and death; but this relation is memorialized, using the available resources of figurative art (in imposing, massive sculptural or uncannily lifelike and intense painted form), architectural display, and public space to create the 'deathless memory' which familial epigrams mention.

Secondly, and conversely, monumental permanence, as a choice and an intention, applies pressure on the family relations between honorand and dedicator. The function of this pressure is located within familial strategies, and linked to familial events, dramas, or states: a fourth-century Athenian private portrait group of a couple (Kleiokrateia and her husband) was probably set up by her family after conflict, attested by a complicated lawsuit (one of the speeches is preserved in the Demosthenic corpus)—the statue transaction reaffirms family solidarity, displays it in permanent form, and packages it in the form of a relation, punctual but worth memorializing. The majority of private monuments do not allow the precise reconstruction of circumstances; but, as the epigram from Kalymna quoted above suggests, they were certainly part of familial transactions involving exchanges, property, and obligations, and helping to reproduce individual families as well as general social structures.

The genre of private honorific monuments provides the material for studies in the history of the Hellenistic family, in the form of the examination of test cases such as the shape of filiation, the importance, already alluded to, of extended kindreds on Rhodes, or adoption (prevalence, function, persistence of previous family links), or the margin of action for women, or the marriage and friendship strategies of royal officials in 'provincial' contexts. The general point is that such test cases allow us to see the simultaneous workings of descent and extended kindred. In addition, private honorific monuments amount to a discourse on kinship and relationality, within the social history of the Hellenistic world. These topics, however, lie outside the scope of the present study.[99] What remains is that the private honorific monuments make such observations possible, by the display of relations between individuals in the form of monuments that memorialize relations which allude to continuities, but also achieve specific effects within familial relations in the present. The workings of the private monument also amount to narratives about place (as Lucy Lippard has observed about modern family snapshots)—the community where family transactions and reproduction take place, and whose public spaces are occupied by family monuments, or whose presence is alluded to when families set up

[97] On the rituals of the Karneia, W. Burkert, *Greek Religion: Archaic and Classical* (Oxford, 1985), 234–6.

[98] Antigonid monument: below, 226. Eteoboutadai: 198–9.

[99] Bresson, 'Règles de nomination' (inspired by Vernier); van Bremen, *Limits of Participation*; A. Bresson, 'La Parenté grecque en palindrome' in A. Bresson, M.-P. Masson, S. Perentidis, and J. Wilgaux (eds), *Parenté et société dans le monde grec de l'Antiquité à l'âge moderne* (Bordeaux, 2006), 13–22.

monuments in international shrines. These private narratives about place coexist with other narratives—the stories embodied in public honorific statues (Chaps. 1–2), whose workings are different. The coexistence of these two narratives, or discourses, illustrated with the juxtaposition of the two statues of Apollorodos at Priene (Fig. 4.10), raises the issue of the relation between public and private.

4. PRIVATE AND PUBLIC

It may be time to re-examine what I have meant all along during this chapter and the previous one, and the ones before that, by 'public' and 'private'.[100] In simple terms, the definitions I have kept before me are the following: public—which concerns, is owned by, managed by the whole political community; private—which concerns individuals and their lives, their family relations rather than their political activities. It is immediately obvious that the definition is too crude, and neglects the ways in which public and private imbricate, as well as the contradictions and philosophical problems involved in the construction of separate public and private realms—especially in view of the previous section, whose main finding was the segmentation of public space, very visible in shared civic places such as the agora of Thasos or Priene. Nonetheless, the concepts, even crudely sketched, apply to the two types of honorific monuments which are the concern of the present work.

A public honorific monument is granted by a community, as a collective gesture, directed towards an individual, but displaying, as its 'subject' a relation between incommensurate entities. I have argued (Chaps. 1–2) that in this transaction, the community is primary and permanent, the individual dependent, determined, and limited in time, and the balance of symbolical power celebrates civic ideology and agency. The individual honoured might be a Hellenistic king, a mid-Hellenistic civic statesman or general, or a late Hellenistic 'super-benefactor'; the monument, at least, is not a simple act of homage, but provides a narrative that speaks of community, and shared common goods, or indeed the common good; the viewer-reader might be a member of this community, or a similar community, and feel affected by the monument.

The family monument manages time and relationality in very different ways, and to different aims. This type of monument does not concern the whole community, but specific individuals, who initiate, or benefit from, the private gestures that constitute it. The reflexive possessive, which appears so often in the captions to the family monuments, makes clear the private nature of these gestures: τὸν ἑαυτοῦ πατέρα, or τὸν ἴδιον πατέρα—the latter adjective is etymologically related to reflexive pronouns, and also the word ἑταῖρος, used by Protogenes, at Kaunos, to describe the close friends whom he statuefies alongside his relatives.[101] The statue transaction takes place between similar entities, individuals who are related biologically, through bonds that are socially recognized as creating boundaries between a group and the rest of mankind. The private honorific monument speaks of the continuity and the reproduction of these boundaries; it alludes to family institutions (such as the transmission and disposal of property, funerary commemoration). Furthermore, this type of monument commemorates relations between individuals defined as members of nuclear families often at the moment when generational cycles must have taken these individuals out of the household, and processes of succession are more or less explicitly thought about: the display of relations is about the state of kinship at a precise moment in time, but also about familial pasts and futures. All these concerns, at the heart of the family honorific monument, are inherently private: the monument

[100] S. C. Humphreys, 'Public and Private Interests in Classical Athens', *CJ* 73 (1977–8), 97–104 (repr. in *The Family, Women and Death* (London, 1983), chap. 2); van Bremen, *Limits of Participation*, 173; also *Ktema*, 23 (1998). On the topic, and the relation of public and private in different systems of political thought, R. Geuss, *Public Goods, Private Goods* (Princeton, 2001).

[101] M. Casevitz, 'Notes sur le vocabulaire du privé et du public', *Ktema*, 23 (1998), 39–45; *Inschr. Kaunos* 49–53.

is produced by, and relates to, specific individuals, and does not directly involve the collectivity, but stays within the realm of family and kin.

Yet the private family monument, and the relations it presents, take place in public—in the shared spaces of the shrine, the gymnasion, the agora; the theme of such monuments is personal, but the setting and the effect is not intimate. Are its values and impact somehow 'public'? One answer would be to state that the *polis* was made up of individuals, organized in households, whose reproduction was essential to the continuity of the *polis*. Should we speak of (e.g.) the 'interconnectedness of *polis* and *oikos*' as eroding the distinction between public and private?[102] Before going so far, it might matter to examine the political and ideological stakes of the public display of private relations—and its impact on the public sphere and on civic culture.

a. Individuals, Families, Civic Place

Individuals and their families: is there a society, let alone a city-state, on the implied horizon of the family monument? One interpretation of this genre has been to see it as the sign of the rise of privatization and individualism in the post-Classical age, or even the late Classical city already: A. Borbein, for instance, in his survey of fourth-century sculpture, speaks of the rise of individualism (in the fifth century already), and the fourth-century rise of the family (indeed, dynastic) monument as a sign of increased independence of families in relationship to the community; the monument, on this view, celebrates family continuity per se, without any sense of exemplarity or obligation.[103] Some arguments might be adduced in favour of an 'individualist' reading. First, the focus on family and friends is of course inherent to the genre. As argued above, the transactions construct *ad hoc* kindreds, centred on individuals, *EGO*-dedicators, or *ILLE*-dedicated parties: such networks are unstable and transitory, and could be interpreted as signs of individuals in a world of kin, rather than of constitutive social relations within communities. Second, the genre of private honorifics enjoyed favour among the non-*polis* circles of king and king's men: this predilection is a major feature of private statue practice, and indeed may have contributed to propagating the genre (above, 184–6). The genre was thus adopted enthusiastically by the 'free-floating elements' which constitute an essential part of the power structure of the Hellenistic supra-local state formations. Thirdly, the tone of the epigrams that accompany some of the more lavish dedications is decidedly ostentatious, as in the lines where Diotimos boasts of being the first ever on Kalymna to requite his father's care with a statue monument (quoted above).[104] The act of dedicating a statue is itself highly visible, and speaks of the social confidence and assertiveness of the dedicator, as well as presenting permanent, obviously expensive, monumental images of the dedicator's relatives, or even the dedicator himself, as on the monuments where the dedicator appears as a statue next to the honorand.

Yet there is nothing inherently and inevitably 'individualist' about relations in the nuclear family.[105] In particular, during the Hellenistic period, it is a mistake to interpret the family monuments in terms of a paradigm of decline of the city-state and its values—a paradigm whose validity has generally been challenged,[106] and which specifically does not help us to understand the relations between the family and the *polis* in this period (for instance, there is no evidence for the mobility of individuals eroding the importance of citizenship, and family

[102] Patterson, *Family in Greek History*; F. de Polignac and P. Schmitt-Pantel (eds), *Public et privé en Grèce ancienne, Ktema*, 23 (1998), 6.

[103] Borbein, 'Die griechische Statue des 4. Jahrhunderts v. Chr', 85–90 ('die Eigenständigkeit eines einzelnen Geschlechtes gegenüber der Gemeinschaft'); Stewart, *Exploration*, 22, sees both private and public statues as a sign of 'increasing individual self-assertion as the polis declines'; Löhr, *Familienweihungen*, 154, 221–6, discusses other views on 'individualism' in late Classical art and society.

[104] *Tit. Cal.* 130B; also e.g. *Inscr. Lindos* 1.197.

[105] Laslett, *Household and Family* (against views that large extended families give way to nuclear families and individuals).

[106] See Chaps. 1–2 of the present work.

reproduction within the citizen body).[107] The public dimension is not lost in the world of private statues. In many cases, statue transactions between individuals show an explicit interest in public identity. At Priene, Apollodoros' statue, set up by his children in the agora, mentions his priesthood, and hence an activity for the whole community, which provides the occasion for the statue, or determines the identity assumed by the honorand, and the way the viewer looks at him and thinks of him; this example is only one of many where the private transaction is also 'about' religious office.[108] More generally, private monuments can commemorate public powers and responsibilities—at Knidos, a man is statuefied by his sons while he was *damiorgos* (*c*.300?); in the late Hellenistic period (probably), one Euphranor set up a statue of his father, Euphranor son of Euphranor son of Euphranor, for supplying grain to the [sacr]ed tables for six [months].[109] One of the statues in the early Hellenistic family exedra in the shrine of Apollo at Kaunos records how one Lysias, son of Artemes, was chosen as *prytanis* (and crowned himself with ivy at this occasion).[110] Such public roles are commemorated lavishly on the 'CV' inscriptions from Rhodes, where an honorand, statuefied by an extensive kindred, is described with a list of offices held and honours received.[111] Even the statue of Dioskourides, set up by his wife Kleopatra in 138 BC in their house on Delos, which seems a very private gesture (M. Kreeb has spoken of 'apotheosis'), in fact referred to a public act of piety (Fig. 5.5).[112] *ID* 1979 and 1980, are other examples of private family monuments parading public service; the spirit of these monuments is close to the 'CV' inscriptions on Rhodes.

More concisely, on Pholegandros, Times dedicated (a statue of) his mother, Praxiopo daughter of Times, whom the *demos* also honoured;[113] at Halikarnassos, Drakon was set up, in statue form, by his parents, who took care to mention that he had been 'honoured by the people' ($\tau\epsilon\tau\epsilon\iota\mu\eta\mu\acute{\epsilon}\nu\upsilon\nu$ $\acute{\upsilon}\pi\grave{\upsilon}$ $\tau\upsilon\hat{\upsilon}$ $\delta\acute{\eta}\mu\upsilon\upsilon$).[114] All these examples (which could be multiplied) show private monuments entwined with the desire for public recognition; the mention of public service is felt to be relevant and pragmatically effective in the 'speech-act' constituted by the setting up of the monument, and by the monument (statue + inscription) addressing the reader-viewer.

b. Consensualism

Even in the Athenian dominion of Delos, a private statue inside a house referred to public action. Another way, then, to consider the private honorific monument would be 'communitarian'—to see it as deeply embedded within the political communities where it was produced, and moved by desire for, and acceptance of, a civic culture that posited service to the community as the basis for individual worth, and indeed allowed the community to define worth in these terms. The Rhodian monument (mentioned above) recording three generations of fathers and sons takes care to mention the services of Herakleitos, the grandfather, and the public repute of Apollodotos, the father (as banker, his justice has gained him *kleos*).[115]

[107] R. van Bremen, 'Family Structures', in A. Erskine (ed.), *A Companion to the Hellenistic World* (Oxford, 2003), 313–30 (correcting views in Pomeroy, *Families*).

[108] Above, 169–75.

[109] *SEG* 53.1224; *I. Knidos* 115 ($\sigma\iota\tau\epsilon\acute{\upsilon}\sigma\alpha\nu\tau\alpha$ $\tau\grave{\alpha}\varsigma$ $[\iota\epsilon\rho\grave{\alpha}]\varsigma$ $\tau\rho\alpha\pi\acute{\epsilon}\zeta\alpha\varsigma$ $\kappa\alpha\grave{\iota}$ $\tau\iota\mu\alpha\theta\acute{\epsilon}\nu[\tau\alpha$ $\upsilon]\pi\grave{\upsilon}$ $\tau\upsilon\hat{\upsilon}$ $\delta\acute{\alpha}\mu\upsilon\upsilon$).

[110] *Inschr. Kaunos* 53 (I do not think that the inscription refers to a public honorific statue of Lysias, set up by the people of Kaunos to Dionysos, but to Dionysos-related sacred service carried out by the *prytanis*).

[111] See above, 159–60, on *SEG* 39.759.

[112] *ID* 1978, with F. Queyrel, review of M. Kreeb, *Untersuchungen zur figürlichen Ausstattung delischer Privathaüser* (Chicago, 1988), in *Topoi*, 1 (1991), 101–4: 'dans le détail des analyses, K[reeb] me paraît avoir sous-estimé la force d'attraction exercée par les modèles publics' ('in the detail of his analyses, Kreeb, it seems to me, has underplayed the attractive power of public models'); also F. Queyrel, 'Réalisme et mode de représentation dans l'art du portrait hellénistique: Le Case de Délos', *Ktema*, 34 (2009), 254. On the statues, Ridgway, *Hellenistic Sculpture*, ii. 144–5; the group is powerfully analysed in a forthcoming paper by J. Griesbach.

[113] *BE* 82, 251 (Pholegandros).

[114] D. H. French, 'A Sinopean Sculptor at Halicarnassus', *EA* 4 (1984), 82, no. 4 (reproducing the earlier text by Cousin and Diehl, and dating this text, and a complex of documents relating to this family, to the 1st cent.).

[115] *Nuova Silloge* 19, quoted above, 204–5.

Strikingly, two honorific statues from the Rhodian deme of Kedreai, one public, one private, for the same man, present different images. The first is a standard ἐτίμασε civic formulation, giving less emphasis to the honorand than to the routine expressions that frame him (the politics of this type of expression are analysed above, Chap. 2). The statue was probably set up in the agora of the deme.[116]

ὁ δᾶμος ὁ Κεδρεατᾶν
ἐτίμασε Τεισίαν Θευδάμου
χρυσέωι στεφάνωι, εἰκόνι
χαλκέαι, προεδρίαι ἐν τοῖς
ἀγῶσι οἷς τίθεντι Κεδρεᾶται
ἀρετᾶς ἕνεκα καὶ εὐνοίας
ἂν ἔχων διατελεῖ εἰς τὸν
[δᾶ]μον τὸν Κεδρεατᾶν.

The people of the Kedreatai has honoured Teisias son of Theudamos, with a gold crown, a bronze statue, front seating in the contests which the Kedreatai hold, on account of the excellence and the goodwill which he continuously shows towards the people of the Kedreatai.

The second, set up in the early second century by relatives (the honorand's brother and the honorand's nuclear family) in a 'multi-generational' statue transaction, gives a full record of Teisias' public actions, and the honours he received:[117]

[Τει]σίαν Θευδάμ[ου]
Καλλιάναξ Θευδάμου τὸν ἀδελφόν,
Ἁγησαγάθα Αἰσχίνα τὸν ἄνδρα,
Ἀγανωρὶς καὶ Ἁγησαγάθα Τεισία τὸν πατέρα,
στραταγήσαντα ἐν τῶι πέραν κατὰ πόλεμον
καὶ πρυτανεύσαντα καὶ στεφανωθέντα χρυσέωι στεφάνωι
ὑπὸ φυλετᾶν Δυμά[ν]ων καὶ πρωρατεύ-
σαντα κατὰ πόλεμον καὶ ἱερατεύσαντα
ἐν Κεδρέαις Ἀπό[λλω]ν[ο]ς Πυθίου καὶ Κεδριέως
καὶ ἁγεμόνα γενό[μεν]ον τετρήρευς κατὰ
[π]όλεμον καὶ [στεφανω]θέντα χρυσέωι στε-
[φά]νωι ὑπὸ τῶν παρ[οίκ]ων τῶν ἐν Κεδρέαις [καὶ ὑπὸ]
[τῶ]ν συμπολεμη[σά]ν[τ]ων [——] καὶ ἁγέμονα [γε]
[νόμ]ενον ἐμ Μεγίστ[αι] κατὰ πόλεμον
[καὶ νικ]άσαντα Ἡράκλεια πάλαν καὶ παγκ[ράτιον]
[καὶ Διοσκ]ούρια καὶ Ποσειδάνια, καὶ τιμαθέντ[α]
[καὶ στεφ]ανωθέντα θαλλοῦ στεφάνωι ὑπὸ Τ[——]
[——κ]αὶ ὑ[π]ὸ Κ[α]λλιπολιτᾶν καὶ ὑπὸ Τριπολιτᾶν,
[καὶ ἀγ]ωνοθετήσαντα ἐν τῶι ἄστει·
θεοῖς. Πυθόκρι[τος ἐποίησε].

Teisias son of Theudamos—Kallianax son of Theudamos (has dedicated him), his brother, Hagesagatha daughter of Aiskhinas (has dedicated him), her husband, Aganoris and Hagesagatha children of Teisias (have dedicated him), their father—after he had served as general on the continent in wartime, and served as a *prytanis*, and been crowned with a gold crown by the members of the tribe of the Dymanes, and served as ship-lookout in wartime, and served as priest of Pythian and Kedrian Apollo in Kedreai, and acted as commander on a *tetreres* in wartime, and been crowned with a gold crown by the *paroikoi* (resident foreigners) in Kedreai and by those who fought with him [*x* number of times] . . . and acted as commander at Megiste in wartime, and been victorious at the Herakleia in wrestling and *pankration*, and at the Dioskouria and the Poseidania, and been honoured and crowned with a crown of leaf by the . . . and by the Kallipolitans and the Tripolitans, and served as *agonothete* in the city—

(They dedicated him) to the gods. Pythokritos made this.

116 *Pérée rhodienne* 4, with commentary; *I. Rhod. Peraia* 552.
117 *Pérée rhodienne* 3, with commentary; *I. Rhod. Peraia* 553.

The 'CV' inscription captioning the family monument does not mention the honours (especially the statue) granted by the honorand's home deme: the consequence must be that these public honours, and the honorific statue, granted by the Kedreates came later. The public ἐτίμασεν inscription could have detailed all the great things (military, naval, administrative, athletic, religious) performed by Teisias; it merely mentions his attitude towards the Kedreates, and none of his actions in Rhodes, or the honours he received from other bodies than the Kedreates. In communitarian-public fashion, the values honoured are not general and foundational, but virtues as specifically manifested towards a community and its welfare; in institutional-civic style, much space is given to the routine honours granted by the community, which embed individual action and eminence into the framework of civic time and practice. In contrast, the family statue (did it act as a 'nudge' to the deme of Kedreai?) lists in great detail services and honours, organized thematically: the enumeration insists on the diversity of areas of distinction achieved by Teisias, in a way that illustrates the moves of civic elites to escape the constraining limits of civic honours (above, 49–54). Yet what is being displayed and celebrated by the monument is not personhood or family, but public service and collective recognition by various communities in the form of civic honours. The comparison between the public and the private honorific statue shows the difference between the form of the genres, but also the grip of civic ideology, and the ways in which 'individuals' are presented by other individuals as part of a wider world. The competitive desire for distinction took the form of the enumeration of public service.

The two statues of Teisias raise the question of the publicness of the honorific statue, publicly decreed or privately erected. Was there something inherently public about the private honorific monument? Why else did private, *ex testamento* statues mention public service?[118] At the very least, the fact of public locale and exposure exercised pressure on the private genre, determining the range of what was appropriate to mention in this context. A trace of this pressure may be seen in the appearance of mentions of service and status in the private statues set up in a different world, namely the statues erected for royal officials by their colleagues or relatives. In Kition, the statue of Melankomas, once city governor, is captioned with an inscription mentioning other offices held (military and within the ruler cult); the monument was set up by Aristo, wife of his son (also named Melankomas), the current governor of Kition, and their children (in other words, by Melankomas' daughter-in-law and grandchildren);[119] likewise, court titles and offices are regularly named in such monuments.[120] Naturally, this service is to the king and his interests, within the world of the king's men; what matters is that this practice shows the sense, shared between 'civic' and 'royal' private honorific monuments, that such monuments are not simply about kindreds and relationality, but that the 'public' service is a relevant feature to mention.

Confirmation of the publicness of the private monument might be found in the 'portfolio' monuments combining public and private statues side by side—such as the base from Antiphellos discussed in Chapter 5, alongside other such monuments (155, 164–5); the juxtaposition of statues, public and familial, of Apollodoros in the agora at Priene might be considered as constituting a kind of portfolio monument. Portfolio monuments also show the importance of the public roles, prominent even in familial ensembles. The constitution of such monuments needs to be considered. The late Hellenistic exedra in the agora of Kaunos presented two private statues (for priests of Rome, an important public function), framing three public statues (with no mention of any specific office or service), for different members of the

[118] At Miletos: Pékary, 'Milet 1959', 118–19, no. 1; *Milet* 1.3.168, *ex testamento* statue for a woman who 'drew an ox by lot' (βουλαχήσασα: above, Chap. 5 n. 87), set up by her biological son (who had been given away for adoption).

[119] *Kition* 5, 2024.

[120] e.g. *I. Estremo Oriente* 204, 279.

same family:[121] was this the result of a single decision? This would entail the Kaunian community honouring three members of the same family at one go (including a father and a son), and the private statues being set up on the same occasion, as a single monumental unit. Another possibility is that the monument regroups disparate statues, set up at different occasions, perhaps in different sites, into the 'portfolio' decided on by the family, on some occasion.[122] In both cases, the private statues complement the public, by offering a priestly image that harmonizes with the implied public service acknowledged by the public statues (and the concomitant honours of crown, and, in one case, of *sitesis* and *proedria*, mentioned in the statue captions). If the Kedreate multi-generational private portrait monument perhaps acted as a nudge to the community, in the case of the Kaunian exedra the private gestures amplify the public honours, and acknowledge their force and legitimacy as a model for 'private honours': the private statue transactions mirror and collaborate with the public gestures.

The placing of private statues alongside public images, on the same base, as part of the same statue group atop an exedra, as part of a mixed row, as in the Prienian agora, or generally in the same public space, may also have contributed to 'serialize' the private statues, by assimilating them visually to the canonical forms of the public honorific statue, and within the normative and integrative force of spatial serialization. As suggested earlier, the genre of the private statue was couched in a strongly normative visual vocabulary (himation man, draped woman, civic fighter), drawing on an accepted register of styles, poses, and attitudes. The civic meanings of this visual language were determined in two ways: by the captioning of the highly privileged form of the honorific statue, they were explicitly designed to serve the purpose of showing the good citizen; the details of pose, clothing, facial expression, and stylistic treatment, also combined to present civic meanings of restraint and public-mindedness.

This currency of 'public' visual language in private monuments is also to be seen in Hellenistic grave-*stelai* of the 'Smyrnian' type, analysed by P. Zanker (Fig. 2.2), but also, in different guises, across the Hellenistic world.[123] These *stelai* often show the name of the deceased in the accusative, dependent on the *demos*, appearing in the nominative, within a crown, which refers to the act of crowning, as on the pediment *stele* now in the Ashmolean Museum, of Archippos son of Dion. Archippos brings his right hand to his crowned head, in the ancient gesture of self-crowning; however, he is dressed in chiton and himation (a roll of which falls across his poised left arm, the 'Kos-style'), in civic style, and, above him, a crown frames the name of the *demos* in the nominative, as the agent doing the honouring; Archippos duly appears lower, on the *sima*—in the accusative of being honoured.[124] This phenomenon may confirm the public aspect of the private honorific statues set up by citizens in sacred and public spaces. A similar phenomenon is the public values and *polis*-mindedness expressed by the privately erected and commissioned grave *stelai* in Classical Attica, which present individuals in acceptable gender, age, and public roles: even if individuals are shown in interactional ensembles, and in a greater variety of roles and poses than the static, frontal, Hellenistic *stelai* and statue groups, the importance and relevance of public personas in images produced by private initiative are very clear.[125] The parallel can be pursued further: just as private honorific statues

[121] *Inschr. Kaunos* 92–6.

[122] An imperial-era (2nd-cent. AD?) decree from Akmoneia in Phrygia for a benefactor decides to 'honour with an exedra of all his family' portrait statues (τετειμῆσθαι δὲ καὶ ἐξέδρᾳ τοῦ γένους αὐτοῦ παντὸς ἀγάλματα καὶ εἰκόνας καὶ ἀνδρειάντας δυναμένους ἐν τῷ ἐπιφανεστάτῳ τόπῳ τῆς πόλεως) might designate the gathering of pre-existing statues of the benefactor's ancestors upon a single, 'portfolio' monument (but the meaning of the whole phrase is unclear: *SEG* 56.1490).

[123] Zanker, 'Hellenistic Grave Stelai'; 'Brüche im Bürgerbild?'; the apparition of symbols of public life (weapons, crowns) on the 'Totenmahlrelief' is also a significant example, of the presence of the public in private images (J. Ma, 'Une culture militaire en Asie mineure hellénistique?', in J.-C. Couvenhes and H. L. Fernoux (eds), *Les Cités grecques et la guerre en Asie Mineure à l'époque hellénistique* (Paris, 2004), 199–220).

[124] *PM* 149, cf. 156, 158; on self-crowning. Above, chap. 2, 49–55, on the accusative of being-honoured in private contexts, with further examples.

[125] Bergemann, *Demos und Thanatos*.

reflect the attraction and influence of public honorific statues, private grave monuments in Classical Athens respond to the presence of public burial.[126] The influence of the public monument on private imaginations can be seen, later, in Roman Aphrodisias, where sarcophagi show himation-wearing men resembling the statuary types of public honorific imagery.[127]

Most family honorific portrait monuments did not mention public service in their captions (as on the long 'CV' monuments from Rhodes). Nonetheless, they can be considered as a public form—because of their place 'in public', but also because the themes they air affect the community: the good (albeit unequal) relations between husband and wife,[128] and more generally the moving relationships between family, time, reproduction, property, horizontal links, are also community issues. The display of webs of relationality on family monuments marks moments of desired or actual transition and transmission, within the ticking away of generational cycles; these moments concern the city, because successful familial transitions are essential to the continuity of the *polis*. Ideally, the city-state took an interest in such private, familial matters as the preservation and transmission of property 'within the family' to legitimate citizen heirs, the care of children for their parents, and the negotiation of these matters involving both vertical and horizontal partners;[129] the success of such transactions is vital to the success of the *polis*, and private family honorific statues might be considered as a form of public accountability and exemplarity. Some private statue habits should be interpreted in this light, such as stipulating in wills that statues of certain individuals should be set up out of the inheritance, as tokens of the smooth transmission of property in the form of memorial gestures. Another example is the explicit designation of statues as *threpteria*, signs of gratitude returned to parents in requital for raising children to adulthood. The epigrams for the statue of Aristos at Kalymna, or of Protogenes at Kaunos, illustrate the accomplishment of familial obligations, and emphasize the exemplary force of such family statues; they confirm the relationship between family statues and the successful negotiation of family transitions in time. All of these statue transactions commemorate relationality and transmission: the structural tensions and rivalries within kinship relations, starting with the relation between fathers and sons which was so crucial as a homology for the *polis*,[130] are downplayed by the monumental celebration of family solidarity.

Reproduction and solidarity mattered for the *polis*. For smaller *poleis*, the transmission of patrimony, the conservation of the jingle of familiar names within legitimate citizen families, the good equilibrium between various households sprouting out of an outgrown nuclear family, were signs of stable demographic success and the promise of the perpetuation of the community, in simultaneously biological and social terms. Even for larger *poleis*, the perpetuation of the citizen body was a matter of concern, because of the nature of citizenship as a defined descent group enjoying both privileged status and egalitarian political rights,[131] whose renewal could not be taken for granted. When the statue of Nannion was set up at Halikarnassos by her five sons in the shrine of Demeter and Kore,[132] the plentifulness of this mother's offspring bore promise for citizen numbers; furthermore, one might surmise that the father is deceased, and that the sons have entered their inheritance—harmoniously, as shown by their joint dedication, and in conditions of prosperity, equality, and fairness, which claim that any

[126] I owe this point to unpublished, ongoing work by Sally Humphreys.

[127] C. H. Hallett in Smith, *Roman Portrait Statuary from Aphrodisias*, 157.

[128] Van Bremen, *Limits of Participation*, 117–18, on marital harmony and devotion in the public sphere; 136–41, 273, on the image of the couple as *civic* complementarity.

[129] Patterson, *Family in Greek History*; Lape, 'Solon'; S. Lape, *Reproducing Athens: Menander's Comedy, Democratic Culture, and the Hellenistic City* (Princeton, 2004), on the importance of the conjugal family in maintaining *polis*, and even democratic, continuity.

[130] Strauss, *Fathers and Sons*; J. K. Davies, review in *JHS* 119 (1999), 210–11 (on structural features).

[131] J. K. Davies, 'Athenian Citizenship: The Descent Group and the Alternatives', *CJ* 73 (1977–8), 105–21.

[132] *GIBM* 903; above, 167.

tensions have been overcome, and which reflect on the city at large.[133] This especially matters, because the city, imagined as a brotherly community (as well as a world of fathers and sons), in fact rested on the potentially fraught relation between real brothers, where consanguinity and proximity might give rise to particularly violent conflict.[134] In fact, we do not know how the five brothers, Nannion's sons, got on: the monument might reflect the aftermath of conflict settlement, just as the portraits of Kleokrateia and her husband mark resolution after a lawsuit.[135] Even so, in these cases, the public sphere is used performatively, to create family harmony, as an essential part of civic life.

To accept the relevance of family statues in public space is to enter a statement about the *polis*—not only as a political community institutionalized in state forms, but also as a society, as the existence of a civic realm which is in the public arena but not directly 'under' the state. Recent work has insisted on the ways in which the *polis* is also explicitly made up of the addition of 'private' groupings and even individuals, amongst whom shared goods are distributed.[136] In this sense, the *polis* is made up of individuals and families. For instance, private display and luxury might be viewed not as opposed to the common interest, but a sign of the prosperity of the community considered as the sum of individual fortunes, and hence a public good.[137] The statues, marble and bronze, dedicated on the Athenian Akropolis by the ancestors of the speakers in a late Classical Athenian forensic speech (Isaios 5), might have included private honorific statues; at any rate, such private gestures are mentioned as benefitting the public (in this specific case by adorning the shrine) in parallel with liturgies and military service.[138] The genre of private honorific statues starts early on, emerging thirty years or so after the public genre (above), in the context of the democratic culture of fourth-century Athens: the precocity of the private genre suggests how closely linked it is with the essential workings of *polis* culture. The statue of Apollodoros, standing in the agora of Priene next to his public portrait, and set up privately by his children, showing him in the guise of a minor priest—we should try to imagine a framework in which this might not be a cause for alarm, but rather for rejoicing by the community: the workings of the monument might be easy-going and 'folkloric', in allowing social practice and relations a presence in public space.

Polis and/as families. The public workings of the family statue point to ways in which the genre could have functioned as communal expression, especially in small cities (or in civic subsettlements, such as the Attic deme Rhamnous),[139] where many of the citizens will have been distantly related to the participants in family statue transactions, and hence taken an interest in circumstances and individuals as well as in values and images. Family memory might seem part of a broader collective memory, which it both reflected and helped constitute.[140] In the agora of Priene, the 'main series', which stretched across the whole front of the space and grouped relocated statues (above, 145–6; Plan 13), almost certainly mingled public honorifics and family portrait statues. This was a decision taken by the city: the 'representational space' thus created was lined with, in effect, a single, multi-family large-scale 'portfolio' monument, which gave an image of community constituted by both public and private gestures, where families were participants in the creation of the public sphere, to which they fully and openly

[133] Hellenistic society, like ancient Greek society in general, did not know the tension-generating 'archontic' or 'kanakaric' system of inegalitarian distribution of inheritance present in parts of modern Greece (Bresson, 'Parenté', 21), so that the Halikarnassian monument is not a Vernier-style dissimulation or sublimation of familial inequalities. On tensions between brothers: C. A. Cox, *Household Interests: Property, Marriage Strategies and Family Dynamics in Ancient Athens* (Princeton, 1998).

[134] I owe this point to Gray, *Exile*.

[135] Ajootian, 'Praxiteles', and above, 211.

[136] *Ktema*, 23 (1998) gathers a numbers of essays, unified in this view.

[137] The idea is found in Xenophon, *Poroi*, 4.8–9, with P. Gauthier, *Un commentaire historique des Poroi de Xénophon* (Geneva, 1976), *ad loc.*; Ma, 'Paradoxes'.

[138] Isaios 5.41–2, with R. Thomas, *Oral Tradition and Written Record in Classical Athens* (Cambridge, 1989), 101.

[139] Private honorifics at Rhamnous: *IG* II² 3839 and 3462 (*Rhamnous* 123, 133), private statues of the boy, Antiphilos, and the priestess, Aristonoe.

[140] Longo, 'I figli e i padri', 81 (using Fustel de Coulanges).

belonged.[141] Family statues, on this interpretation, are a symptom of the *polis* as a macro-kinship structure, fictive but made up of real families joined up in a civic family.

On Thera, the numbers of honorific statues between *c*.200 and *c*. 100 AD are more or less evenly distributed between public and private monuments, and often concern the same honorands[142]—as if public and private monuments were two different ways for the same individuals to appear within civic space. This way of making the city visible, through the monumentalization of family relations, notably in the agora, may have worked to affirm Theran presence in the particular circumstances of its history during the Hellenistic period. The island was held, and garrisoned, by the Ptolemies for over a century, from the time of the Chremonidean War to the mid-second century;[143] this presence impacted on the social and religious space, the daily life and the economic activities of the city-state, which was caught in the extractive and controlling network of the Ptolemaic state.[144] The island was governed by a Ptolemaic officer; a Ptolemaic garrison occupied part of the town, with its own social spaces such as a reserved gymnasion, and its own social life; the epigraphical documents of this social life is marked as belonging to the Ptolemaic world (royal correspondence, regnal years, Macedonian and Egyptian months). A foreigner, Artemidoros of Perge, remodelled the approach to the town with a shrine that reflected his own, idiosyncratic, religious preferences; he may have been a retired member of the garrison. Various traces of ruler-cult are attested, from the time of Arsinoe II to Ptolemy VI.[145] Artemidoros set up a monument, probably a statue, to Ptolemy III, in a small but highly visible precinct located near the shrine of Apollo Karneios, on the main street leading to the agora; the epigram on the base, carved in the living rock, records the participation of the Therans in the dedication.[146]

The occupation of the agora by the monuments of citizen families may have acted as a response to this long-lasting, multiform foreign presence. Such monuments manifested publicly the rhythms and shapes of citizen reproduction, the solidarity of citizen families, and the density of kinship networks. They did not leave any major *epiphanestatos* space for family or friendly monuments by members of the Ptolemaic garrison or administration; they opposed images of locally rooted individuals, perpetuating the *polis* in the form of their families, to the presence of the free-floating elements in the power structure of the supra-local state. The town can be seen as organized around two poles, the old sacred and civic centre at one end (with the temple of Apollo Karneios, and the civic gymnasion) and the Ptolemaic quarter at the other (with the gymnasion of the garrison, barracks, and perhaps the 'Kommandantur' of the governor). The old centre received a mark of the Ptolemaic presence, in the form of the ruler-shrine founded by Artemidoros; the main civic centre in the middle of the town, constituted by the agora, was not left free, but defended by public honorific statues set up by the Therans, and private honorific statues set up by individual Therans. In this civic space, as well as throughout the town, there are no private statues of garrison members; nor was the prolific Artemidoros honoured with a statue—at the end of his life, he was made a citizen, and

[141] Von Kienlin, 'Stadtzentrum von Priene', 118–19.

[142] I count twenty-seven public monuments to twenty-two private monuments in *IG* 12.3 (including 444, two parents dedicating the statue of their son in the shrine of the Egyptian gods). For family links: e.g. 485, 487 and 486, 487 as public and private monuments for members of the same family; 514 and 1407.

[143] Bagnall, *Administration of the Ptolemaic Possessions*, 123–34, 120–3; *IG* 12.3.330.

[144] *IG* 12.3.327; M. I. Rostovtzeff, *The Social and Economic History of the Hellenistic World* (Oxford, 1941), ii. 694–5; Chaniotis, *War in the Hellenistic World*, 152–4.

[145] C. Witschel, in W. Hoepfner (ed.), *Das dorische Thera V: Stadtgeschichte und Kultstätten am nördlichen Stadtrand* (Berlin, 1997), at 42–5.

[146] *IG* 12.3.464 (Artemidoros set up temples to the first three Ptolemies). I do not think the Therans are said to be 'raising' or 'nurturing', τρέφοντ[ε]s, Ptolemy III, 'son of Ptolemy born of Ptolemy'—better to read στέφοντ[ε]s, crowning? ('Nurturing' baffles F. Hiller von Gaertringen, 'Der Verein der Bakchisten und die Ptolemäerherrschaft in Thera', *Festschrift zu Otto Hirschfelds sechzigstem Geburtstage* (Berlin, 1903), 91). Also *IG* 12.3, suppl. 1388.

the *stele* recording these honours was embedded in the midst of his peculiar dedications.[147] These manifestations mattered, because of the fragility of filiation-created families: without pronouncing ourselves on the impact of migration fluxes on Hellenistic Thera, this fragility can be recognized in the 'dearth of kinsmen' in evidence in the documentation concerning the foundation of a group to commemorate the deceased members of a Theran woman, Epikteta, around the time when private honorific statues start appearing on Thera.[148] This foundation, with its exclusive privileging of Therans, can be interpreted in the same way as the profusion of private statues: as a way for the *polis* of Thera, as society, to express itself in the face of outside pressure.[149]

The same analysis can be offered for the Amphiaraion near Oropos (above, 139–42). The terrace east of the temple was early on occupied by widely spaced, but aligned statues of foreign rulers, foreign civic heroes, and (probably) Boiotian grandees; the statues gradually joined up in a long series, even though a rough distribution of the space available according to type of honorand probably still held sway. As mentioned earlier, the last quarter of the third century saw the quick emergence of a whole series of family honorific statues, concentrated in the eastern third of the esplanade, and developing westwards. These were all set up by Oropians, and ensured that the open representational space of the shrine was not monopolized by outsiders: they represented an Oropian presence, albeit one carried out by the efforts of individual Oropians. The monument set up by Demokrite, as argued above, represented not only herself, her father, and her son, but probably also Amphiaraos himself, standing to the side of the kinship group and probably attending offerings being made on an altar. The Demokrite-Theodoroi group thus made a grand statement about this particular kinship group's piety, and tried to dominate the nascent series of family statues. But serialization carried on, with another long base (representing another Oropian couple, Diodoros and Phanostrate):[150] the effect was to embed the Demokrite monument into a long series of bases, with the god in the middle of Oropian individuals represented around him. The competitive display by Oropians was also a collaborative venture, to create an Oropian place within the shrine. The presence of individual Oropians acted as a reminder of the community that controlled the shrine, even though the shrine was inland and at a certain uphill distance from the urban centre of Oropos. The foreign statues represented grand personages, kings and their kin, great men of the Boiotian League; with these, the Oropian private statues entered into a locally controlled dialogue, offering portraits of men and women appreciated by their kinsmen, successful family transactions and relations, names and faces that were meaningful to the Oropian audience, and this meaningfulness was perceived, if not understood, by foreign visitors. Private statues affirmed communal worth for the Oropian community.

Yet this series was put to an end by an equestrian statue (the original honorand is unknown) and a statue group for Ptolemy IV and Arsinoe III, probably set up by the Oropian *polis* itself. The reason for the intervention within this statue space is unclear: as argued in Chapter 4, the Oropian private families allowed the royal statues to stand out (instead of being crowded with the big equestrian statues at the western end of the esplanade). The situation might be the result of pressure from supra-*polis* actors, or local partisans of these actors, in search of visibility in the shrine (the ecological model I explored in Chap. 4). Another explanation is that the Oropian authorities themselves placed the royal statues in this series, to limit the expansion of family statues on the esplanade. The block of family monuments made the point of Oropian presence and visibility in the Oropian shrine, but private statues were not allowed to dominate

[147] *IG* 12.3, suppl. 1343–4.

[148] Above, pp. 177–8, on *IG* 12.3.330 (also *RIJ* ii. 24A and Laum, *Stiftungen*, no. 42); Pomeroy, *Families*, 109–13 (also on the foundation of Diomedon of Kos).

[149] F. von Hiller, *PW* 5A, 2277–2302, s.v. Thera (Geschichte), at col. 2299; A. Wittenburg, 'Grandes familles et associations cultuelles à l'époque hellénistique', 451–6 (though the analysis in terms of decline might be qualified).

[150] *Oropos* 422–3. The order of the bases, from east to west, is indicated by the shape and order of the foundation blocks on which the bases rest.

the representational space of the shrine. The intervention of the *polis* makes clear the public impact of the statement made by private monuments—within limits set by the *polis*, and under its control: the monumentalization of individual Oropians and their family relations was not allowed runaway growth. This interpretation shows the *polis* as a player within the 'ecotope' constituted by competing statues—but the dominant one. This is finally shown by its leaving a mark in the form of the long continuous band of proxeny decrees carved across statue bases, and its ability to manage statues, Oropian and foreign, public and private, in order to create messages. In the first century BC, when the Oropians regained control of their *polis* after a period of Eretrian control, they reused most of the statues on the esplanade of the Amphiaraion to honour great Roman benefactors and statesmen; however, they left untouched the private statues in the western part of the esplanade. Perhaps the subject matter and the style of these statues made them unsuitable for rededication to powerful Romans; but the Oropians might have welcomed, after a period of abeyance, the image of past prosperity and continuity which the family statues offered.

Similar forces can be seen at work in the Epidaurian Asklepieion (above, 108–10). In this case, the Epidaurians did rededicate many of the private monuments from the first century BC onwards; however, it still seems likely that many of the exedras that form a great arc across the open space of the shrine were set up as Epidaurian private family monuments, or 'portfolios' combining public and private honorific statues; a large base south of the temple carried an Epidaurian family honorific monument.[151] Many more such monuments are attested by inscribed bases which cannot now be located. These monuments were set up from the second century BC onwards at the same time as the use of the shrine for 'foreign' honorific statues intensified. Noticeably, the private monuments are carefully captioned to give the dedicators and the honorands their *ethnikon*: they are Epidaurians, honouring Epidaurians. This information could have been implied pragmatically, by the omission of the *ethnikon*; the Epidaurians' choice had a different, insistent effect:

> Ἀρχὼ Ἀστυλάϊδα Ἐπιδαυρία
> Ἐχεκράτειαν Δαμοκλέος
> Ἐπιδαυρίαν τὰν αὐτᾶς ματέρα
> Ἀπόλλωνι, Ἀσκλαπιῶι.

Archo, daughter of Astylaidas, of Epidauros (has dedicated) Echekrateia, daughter of Damokles, of Epidauros, her own mother, to Apollo, Asklepios.

The spatial strategy adopted is ambitious, if diffuse: whereas the Oropian family monuments created a single block in the eastern third of the esplanade, Epidaurian monuments shaped the whole experience of the visitor to the shrine by occupying crucial points in the shrine's space, in the form of the curved line of exedras that structured the main open space, but also at the central point where the access road from the north, the altar, and the temple intersected, and next to the Tholos. In the 'international' shrine, the consistent labelling of private honorific monuments acted cumulatively, to create a collective presence of Epidaurians, whose private gestures for local citizens are put on a par with the monuments set up by Peloponnesian states to honour prominent non-Epidaurians; the effect is to mark Epidaurian ownership of the shrine.

Most private honorific statues were set up 'at home', in public spaces or in shrines, and acted to make family processes visible in the community, as well as to an ideal outside visitor. Many

[151] Von Thüngen, *Exedra*, no. 33, carried private honorific statues (*IG* 4² 1.247); von Thüngen, *Exedra*, no. 17, preserves the original dedication of a public honorific statue, perhaps part of a portfolio (*IG* 4² 1.635); von Thüngen, *Exedra*, no. 31, preserves the original dedications of a multi-relational family monument; the large von Thüngen, *Exedra*, no. 48, north-east of the Tholos, is a 1st-cent. BC reuse of an older exedra, in order to set up a private family monument (*IG* 4² 1.232). The 'altar-shaped', pinkish base south of the temple bears *IG* 4² 1.210, discussed and completed by Peek, *Asklepieion von Epidauros*, no. 95, with two or perhaps three private statues. (Von Thüngen, *Exedra*, no. 7, much reused, preserves part of the original dedications of a portfolio—*IG* 4² 1.336, 620, with *Asklepieion von Epidauros*, no. 145—of a Phliasian family.)

examples illustrate the political force of such processes of display. In Lindos, almost all of the private statues are of Lindians, alongside Lindian public honorifics, statues set up by colleges of Lindian magistrates and officials, and auto-dedicated statues of Lindians; especially prominent are statues of priests of Athana Lindia and Zeus Polieus. The effect is to insist on the local identity of Lindos, one of the three towns in the Rhodian state (just as the Kameirans retained control of the traditional office of the *mastroi*),[152] and Lindian monopoly of priestly office and sacred space. The local function of family dedications is brought out by the contrast between the first-century BC family statue of Eupolemos son of Eupolemos (and adoptive son of Timokrates), named as priest of Athana Lindia, Zeus Polieus, and Artemis Kekoia, and the contemporary statue of Eupolemos set up by a friend in the shrine of Halios in Rhodes town, and naming a whole series of offices held in the centre.[153] When Eupolemos served as eponymous priest in Lindos, he was probably mature in years, and hence had already held offices in Rhodes; these were not relevant in the Lindian family monument, which regrouped statues of Eupolemos (set up by his wife, his sons, and his sister), his son Timokrates (set up by his fellow priests), and the statue of Eupolemos' great-grandfather, Timokrates son of Eupolemos, a century older than the two other statues, and removed from an older monument to stand with the two more recent statues (this statue is captioned in a mere nominative, with no indication of dedicator: an auto-dedicated statue?). The 'jingle' effect of names brings out family continuity; all three men are described as having served as priests of Athana Lindia and Zeus Polieus. Filiation gives an image of Lindian control of the great shrine, and acts as a metaphor for the continuity of Lindian agency and identity.

Finally, the setting up of family statues could stake out the claims of a state over a particular place, making it 'home'. The Aitolian family groups, set up on astonishing column monuments (Fig. 6.5),[154] made a splash in Aitolian-controlled Delphi:[155] the very fact of Aitolian private monuments, treating the monumental space in this ostentatious way, was a statement of ownership (in contrast, there is a single known private honorific set up by a Delphian during the period of Aitolian contol).[156] Likewise, the proliferation of private statues on Athenian-held Delos, in contrast with the regulated spaces of Athens proper, made clear Athenian presence, and also the peculiar status of Delos as a 'colony' open to Athenian exploitation, and no longer a sovereign, *polis* space.

Family stories are caught within larger stories, and can act as synecdoches of these larger stories. The equestrian statue of an Athenian, Ischyrias, was set up by his father, probably in a shrine not far from the agora, sometime *c.*300 (judging by the letter forms);[157] I have discussed it above, in the context of the display of family continuity, and hypothesized that it may have commemorated death in war, like other private honorific statues (above, 205–6). At any rate, this martial image of a citizen may have answered other equestrian monuments, set up publicly, for powerful outsiders, the Macedonian Asandros (publicly decreed but privately erected), or Demetrios Poliorketes, set up in the agora, notably close to the statue of Demokratia.[158] In response, the private monument may have conveyed patriotic meanings, such as the value of the participation of citizens in fighting for the city, at a time when public honours were used to mediate between the community and Macedonians, and to find ways to express subordination in acceptable cultural and material forms; the private use of the grand, royally

[152] *Tit. Cam.* 109 (also *Syll.* 339, *IG* 12.1.694).

[153] *Inscr. Lindos* 2.293B; *SEG* 39.759, with Kontorini, *Anekdotes Epigraphes*, 73 for commentary.

[154] Van Bremen, *Limits of Participation*, 175; Jacquemin, *Offrandes monumentales*, 334–5, listing five monuments; Dillon, *Female Portrait Statue*, 37 and 193 n. 194.

[155] 'Making a splash' is inspired by R. Osborne, 'Island Towers: The Case of Thasos', ABSA 81 (1986), 167–78.

[156] Jacquemin, *Offrandes monumentales*, 327–31, for full list of privately dedicated monuments; no. 263 is the lone 3rd-cent. example. But 242, 250bis, 261, 262, 269 are early 2nd-cent. family monuments due to Delphians, followed by 240–2, 249, 264 in the late 2nd or 1st cent.): Delphians put their mark on the shrine after the end of Aitolian domination.

[157] *IG* II² 3860; on the original site, above, 192.

[158] Above, 118–21.

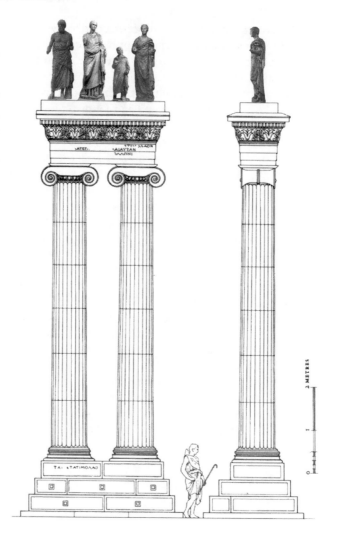

Fig. 6.5. Making a splash: in Aitolian-dominated Delphi, private family monuments took on extraordinarily conspicuous forms. Reconstruction of Aitolian family monument at Delphi, mid-third century BC (*FD* 3.4.129–31). Reconstruction and composition from S. Dillon after F. Courby.

inflected equestrian trope reinforced the comparison. The Athenian state, or Athenian official bodies, might set up equestrian statues of Demetrios Poliorketes in public space, but an individual Athenian could make a private gesture using the same sculptural form, to speak of civic agency and liberty (as well as the existence of individual wealthy and patriotic Athenians).

Another example of a private statue alluding to public circumstances is the statue set up in the Epidaurian Asklepieion by Damokles and Astylaidas, in commemoration of the care they received from their benefactor Patrokleidas, their maternal uncle (*IG* 4² 1.234). This monument is the product of particular historical circumstances, the death of their father, Thiokleidas, in the Achaian War;[159] family solidarity was brought to bear, legible in the pattern of names, since Astylaidas is named after his maternal grandfather, Patrokleidas' father; family solidarity kept reproduction going in the *polis*, by ensuring that war orphans grew up and entered their estates—a service sometimes rendered by the community, but in this case, perhaps in the straitened conditions after 146, by a relative stepping in. Equally instructive as examples of privately erected monuments as illustrations of, and even responses to, very public events, are the statue of one Timagoras, set up in the very early Hellenistic period on Astypalaia

[159] Marcadé, *Signatures*, i, 'Xenophilos'; above, Chap. 5 n. 106.

as an ornament for his fatherland, because he had led ships to a naval victory,[160] and the relief set up at Mantineia, in the very late Hellenistic period, by one Damatrios, for Charmiadas, who had led a local contingent at Actium (the relief also shows a personified Nikopolis).[161]

Less dramatically or poignantly, the occupation of local sacred space allowed the community to manifest its particular relationship with a deity through the multiplication of the individual acts of piety represented by family dedications. The mention of religious office and the detailed listing of public services implied community and institutions at work within historical time, reflected in private lives: Rhodian 'CV' inscriptions list service during the wars of the Rhodian state. Private family monuments also made clear citizen reproduction, both biological and social; the generational pact is seen fulfilled, the community lives in the succession of individuals—the effect is at its strongest when the private statues are plentiful, for instance in Thera, or in Hellenistic Thespiai.[162] In examining such phenomena as the block of family statues at the Amphiaraion, the two statues of Apollodoros at Priene, or the three statues of priests at Lindos (great-grandfather, father, son), I have aimed at the possibility that these things were viewed with recognition, or even pleasure, by the community at large, as a mode that expressed public identity through private gestures. Similar analyses might be offered for the dedication of family monuments in pan-Hellenic shrines, for instance at Olympia, Delphi, or Delos, where they served as ways to make present, through family relations, a particular city before an international audience, and hence broadcast this city's wealth (as reflected in private dedications) and continuity (as made clear by family continuities). The workings of such dedications is comparable to the glory that private athletic victory brings to the victor's home city.[163]

This recognition of the pleasure and pride a citizen would feel upon seeing a family monument at home or abroad, would result from the fruitful dialectic between public and private: one Apemon, setting up the statue of his father (captioned with an 'adoring' nominative) in a shrine, declared that he was 'adorning holy Salamis'.[164] But this dialectic might come at a price, rather than operate as an inevitable and benign result of *polis* ideology or 'mentality': recent claims about the co-terminous extension of family and city, the near-meaninglessness of the notion of state, the incompleteness of the distinction between public and private, underplay the political force of the distinction between public and private, and the implications of the various phenomena that appear on the ground (literally) during the Hellenistic period. The communitarian interpretation offered above was written within the 'vitalist' paradigm which sees the continued strength of *polis* ideology and institutions in the Hellenistic period, and seeks to explain (away?) phenomena in terms of this position;[165] earlier parts of this work have used the test case of honorific statues to study *polis* ideology at work. Without returning to a 'declinist' paradigm, it might be necessary to examine the possibility of elitist behaviour and strategies, notably in reaction to the constraining parameters and norms posed by civic ideology and *polis* political culture (above, Chap. 2). Another way of putting this point is to return to the agora of Priene—did the choice of lining the main thoroughfare with a row of mixed monuments and family statues improve the public space and its workings? Or did it ruin the centrepiece of the civic townscape? In other words: what did family statues negate?

c. Elitism

Family monuments also display power. A subgenre that makes clear this relation with power is that of royal monuments (above, 184–6), which somewhat dropped out of sight in the previous section on the communitarian workings of 'bourgeois' statues. As studied earlier,

[160] *IG* 12.3.211 (the statue is set up by Ares, whom I suppose to be an individual rather than the god).

[161] *IG* 5.2.297.

[162] The numbers can be surveyed in the material gathered in *Thespies* (ed. P. Roesch): the private statues are more numerous than the public honorifics.

[163] Robert, *OMS* v. 354–72, on 'la force du lien entre victoire et patrie' ('the powerful link between victory and fatherland') in agonistic texts; L. Kurke, *The Traffic in Praise: Pindar and the Poetics of Social Economy* (Ithaca, N.Y, 1991).

[164] *IG* II² 3830 (*c*.350). [165] Ma, *Antiochos III*; Ma, 'Paradoxes'.

this subgenre insists on continuity and solidarity in the context of transmission of dynastic power: the family principle is writ large in the case of the reproduction of the patrimonial state. Such statues display the dynastic principle: they show who is most wealthy and powerful, who is here to stay, as they transfer wealth and power from generation to generation. This is already true of the early monument set up by the Thessalian dynast Daochos, and is the essence of the dynastic family groups.[166]

The Attalids showed a particular liking for family monuments, which might be considered to reflect the nature of the dynasty, as more 'civic' in style than the great Macedonian dynasties.[167] Even so, the workings and meaning are worth considering closely. In Pergamon, the family monuments set up by members of the dynasty in the shrine of Athena[168] make visible the solidarity of the ruling group, and the transmission of rule: the heir to the diadem is usually singled out this way.[169] Such monuments express the local attachment of the dynasty; they also manifest their power over the city, which belongs to, and is the centre of, the Attalids' 'family business'; they use the local context of the city and its sacred space to broadcast the dynasty's power, a move which is a further expression of domination. The statue of Antiochis set up by her royal husband, Attalos I, in the mountain shrine of the Mother of the Gods, at Mamurt Kale in the Yünt Dağ, also broadcast dynastic relations to a particular audience, the festival-goers and pilgrims of this particular area (the cities and settlements of Eastern Aiolis, north-western Lydia),[170] closely subject to the Attalids. The dynastic monument set up by Antigonos Gonatas at Delos[171] in conjunction with the dedication of a stoa, and of his admiralship after his victory over Ptolemaic forces in the Aegean, acted as a manifestation of power. The monument showed twenty of Antigonos' 'own ancestors', named with the normal reflexive possessive, and represented with full-size bronze statues: though the names of these ancestors are lost, it is likely that the monument presented continuity, from mythical times down to Antigonos Monophthalmos and Demetrios Poliorketes, whose power in the Cyclades was renewed by Gonatas' victory—a genealogical continuity which was a claim to power after three decades of struggle, both as an act of denial of Ptolemaic presence, and a promise in the future.[172] Another example of such dynastic dedications is the set of statues dedicated by Attalos I, also on Delos, and associated with the dynasts (Eumenes I and Attalos I) with Mysian heroes.[173]

Furthermore, the effect of power is deployed when family statues are dedicated in local contexts by outsiders—the free-floating power-holders of the royal state, who display their prosperity and family stability, as products, props, and tokens of the authority of the supra-local state formation in operation: Ptolemaic Cyprus offers a striking example of this phenomenon.[174] The dedication of portraits of royal masters by power-holders in local contexts also demonstrates royal power—and makes clear the *ad hoc*, unconstrained relation between king

[166] Hintzen-Bohlen, 'Familiengruppe'.

[167] Polybios 20.1–8, 32.8.1–7 (obituaries of Apollonis, Eumenes II).

[168] *Inschr. Pergamon* 170, 219.

[169] W. Leschhorn, 'Die Königsfamilie in der Politik: Zur Mitwirkung der Attalidenfamilie an der Regierung des pergamensichen Reiches', in W. Lechhorn, A. V. B. Miron, and A. Miron, *Hellas und der griechische osten: Studien zur Geschichte und Numismatik der griechischen Welt* (Saarbücken, 1996), 79–98; R. Étienne, 'La Politique culturelle des Attalides', in F. Prost (ed.), *L'Orient méditerranéen de la mort d'Alexandre aux campagnes de Pompée: Cités et royaumes. Pallas*, 62 (2003), 357–77; Habicht, 'Kronprinzen in der Monarchie der Attaliden?'

[170] A. Conze and P. Schazmann, *Mamurt-Kaleh: Ein Tempel der Göttermutter unweit Pergamon* (Berlin, 1911), 38–9; on the geography of the area, P. Herrmann, *Neue Inschriften zur historischen Landeskunde von Lydien und angrenzenden Gebieten* (Vienna, 1959) and H. Müller, 'Ein Kultverein von Asklepiasten bei einem attalidischem Phrourion im Yüntdağ', *Chiron*, 40 (2010), 427–57.

[171] F. Courby, *Le Portique d'Antigone ou du nord-est* (Paris, 1912), 74–83; *Choix Délos*, no. 36; *Guide de Délos*, 196, no. 31

[172] K. Buraselis, *Das hellenistische Makedonien und die Agäis* (Munich, 1982).

[173] *IG* II.4.1107. 1108, 1206–8; H.-J. Schalles, *Untersuchungen zur Kulturpolitik der pergamenischen Herrscher im dritten Jahrhundert vor Christus* (Tübingen, 1985), 127–36, with earlier bibliography (by Wilhelm and Robert).

[174] Above, 185.

Fig. 6.6. The 'private monument' form was also used by royal officials, to make statues about their loyalty and the greatness of the dynasty they served. Reconstruction of the monument honouring Ptolemy II and Arsinoe II, set up by Kallikrates son of Boiskos at Olympia, before 270 BC. H. 10 m up to top of capitals. Drawing by W. Hoepfner.

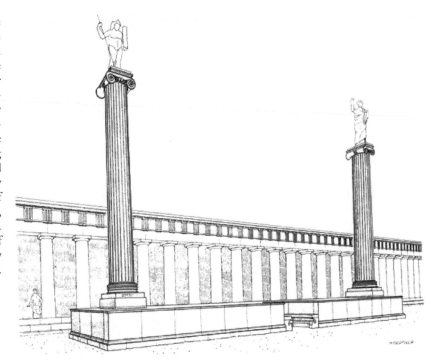

and king's man; the standing statue of Ptolemy IV dedicated in Tyre by the governor Thraseas of Aspendos is a case in point.[175] Finally, 'royal' private honorifics—by members of the dynasties and royal officers—were set up in international shrines. An early example is the statue of Philetairos, dedicated by Eumenes I at the Amphiaraion of Oropos;[176] the most spectacular example is perhaps the monument for Ptolemy II and Arsinoe II, set up by their navarch, Kallikrates son of Boiskos, of Samos, at Olympia (Fig. 6.6).[177] Such monuments do not speak of local pride manifested before an international audience, but of the visibility and confidence of the free-floating power-holders who constituted the Hellenistic supra-local state: the king, his relatives, his officers.

Private honorific monuments, as used in the world of the kingdoms, are both familial and disembedded, to an extreme degree, and in order to express domination (at home) and power (abroad). Their workings seem very different from the embedded, *polis*-centred analysis I offered above for family monuments set up, at home (and abroad) by citizens. The kings and their men took a form that was created before the emergence of monarchies, and applied it to their own needs. Yet in doing so, they created highly visible examples of the family genre: the spread of the concept of *philostorgia* from Attalid family monuments to the statues set up by citizens for their relatives shows the influence of royal monuments on the private genre at large.[178] The royal subgenre revealed potential meanings in the family monument: it spoke of confidence, dominance, display, wealth, continuity, and legitimacy. Were these meanings also present in the family monument when deployed by citizens? Were they also part of the civic landscape? To what effect?

To start with Olympia, Delos, Delphi: family dedications in international shrines[179] were a gesture of social confidence on a world scene. Both the dedicant, and the honorand, 'must be

[175] *Inscr. Tyr* 18; above, 184. [176] *Oropos* 388.

[177] Above, 183–4. [178] Above, 181–2.

[179] *Oropos* 415 (Herakleitos of Halikarnassos, statuefied by his brother: doubtless an important man, known from proxeny decrees from Histiaia and Chios, but not necessarily the friend of Kallimachos as proposed by W. Swinnen, 'Herakleitos of Halikarnassos, an Alexandrian Poet and Diplomat?', *AncSoc* 1 (1970), 39–52); *IG* 11.4 1193–9 for private, familial, statues set up at Delos by foreigners in the 3rd and early 2nd centuries.

someone' in their home communities—the social capital thus created was probably important back in these communities, just as the glory gained by the athletic victor redounded to his city's repute, but also to that enjoyed by his family, and himself, in a delicate, tense dialectic.[180] A much later example illustrating the importance implied by family dedications in a great shrine is the Nymphaion of Herodes Atticus in Olympia, adorned with family sculptures.[181] Likewise, family statues dedicated in local dominions, such as Aitolian-controlled Delphi, or Athenian-held Delos, though they reflected public domination, also showed the wealth[182] and prestige of particular families who benefitted from control and had the confidence to make a display in such venues, especially since they were also international shrines: by making a point about the power of their communities, the individuals and families who set up such monuments are also making a point about their ability to represent this power, and hence about their own standing.

Most frequently, it was in the social space of their own *poleis* that families and individuals cut a figure through the dedication of private honorific monuments. Instead of a form of collective expression, could they amount to the elite capture of space? Even in Priene, it was perhaps not everyone who could happily point to the statue of a relative in the 'main series' across the agora. In Athens, in Lindos, the families commemorating transmission and relationality within generational cycles, through statue transactions, were certainly part of a wealthy social elite. To state the most obvious factor, that of money, full-size marble or bronze statuary, in single examples or in groups, was extremely expensive—even if the development of statue habits, public or private, led to such phenomena as artists with regional clienteles (especially around the statue-intensive environment of Rhodes), the pooling of resources to produce statues, 'statue inflation' in the form of multiple honours, rationalization of production (below, Chap. 7). Even painted portraits on wood, cheaper and used by associations as well as families, were a costly medium.[183]

Portraiture, with its uncanny deployment of art to produce life, or the lifelike, at the bidding of the living, was a luxury good, and the preserve of elite clienteles: this is a basic fact of the social context of Hellenistic art. In using wealth to display family relations and stability, of interest to the cities, wealthy individuals and households were also using family relations to display wealth[184]—a gesture which is not power-neutral. The possibility I wish to examine here is that the 'communitarian' function of the private honorific monument—the display of the continuity of families, as part of the prosperity and self-expression of the *polis*—could allow individuals to carry out a number of strategic operations in their communities, operations that can be considered 'elitist', in that they constituted a civic elite, and raise the problem of the place of elitist discourse within the Hellenistic *polis*.[185]

Of course, in the crudest sense, private honorific statues made 'wealth' visible: they advertised the fact that certain families or individuals had enough cash, or the means to raise enough cash, to set up a statue (at the price of say 1,500–2,000 drachmas) or a whole series of statues (at the price of perhaps around a talent for a multi-statue monument)—affordable enough for whole communities, but the sign of significant private wealth when executed at the behest of individuals. They also enabled individuals, in a private capacity, to exploit the availability of artists to carry out the spectacular image-making enterprise, deployed over time in public spaces, to their own glory, a powerful statement of their economic power, their claims to social

[180] Kurke, *Traffic in Praise*.

[181] *Inschr. Olympia* 614–18 (along with members of the imperial house, with whom Herodes shows his familiarity).

[182] On the wealth and luxuriousness (*poluteleia*) of Aitolian elites, Polybios 13.1.1 with F. W. Walbank, *A Historical Commentary on Polybius* (Oxford, 1957–79), *ad loc.*, adducing Agatharchides of Knidos, *FGrHist* 86 F 6 (on the fearlessness of Aitolians being commensurate to their luxurious living).

[183] Above, 198–9, on paintings on wood.

[184] For a parallel, van Bremen, *Limits of Participation*, 142–4, on female finery, especially while holding office, as elite display of wealth.

[185] For an elitist interpretation of honorific statues for women, Eule, *Bürgerinnen*, esp. 153–61.

distinction, and the acceptability of their presence within their communities.[186] But advertising wealth was not the only way in which private statues worked to elitist effect: what matters is the way in which they constructed an elitist discourse around families, through a number of operations.

The first such operation is simply to make wealthy individuals, and their families, highly visible, and hence to emphasize the existence, and the continuity of elite families.[187] In Thera, members of the same family, and often the same individuals, were honoured with portrait statues, public and private;[188] the effect was to multiply not just generic images of good citizens (as argued above), but images of specific people, organized according to families, just as the two portraits of Apollodoros at Priene offered a diverse image of the identities of a particular citizen. At Delos, at the very end of the fourth century, Stesileos set up statues of his parents on either side of the entrance to the shrine of Aphrodite—in which he also dedicated (and probably built) the temple itself.[189] This particular area of the shrine was saturated with the presence of Stesileos, in the form of his pious dedication, and the aged parents he chose to honour out of the fortune they had passed on to him. An equally striking claim was staked out at the entrance of the gymnasion of Messene, in the early first century BC: Damonikos, after having served as gymnasiarch, dedicated a statue (a herm?) on one side of the *propylaion*, and, on the other side, a statue of his brother Telestas (to Hermes).[190] The visibilization of elite families is matched by funerary practices: family tombs celebrated wealthy families, giving an image of the perpetuation of the family group and its material fortunes, the two concepts being equated.[191] On Lindos, a particular family is attested both by a large multi-relational exedra, and a lavish tomb with funerary altars within monumental architecture.[192]

The particular visibility of female portraiture within the family genre also takes a form which conveys, through perlocutionary allusions, the eliteness of those families who can afford to set up private honorific monuments. In visual terms, the lavish amounts of clothing, in different textures (thick or translucid), the variations among different registers of dress and pose (priestly and traditional, or playfully sexualized in the more modern style of thick chiton and semi-transparent silk mantle), the poise needed to carry off, and simply carry, this sort of dress—these elements all amount to a *habitus* which displays wealth but further sublimates it into elegance, desirability, and social superiority.[193] More implicitly, the presence of women, pervasive both within the individual cities, and across cities and shrines in the whole Hellenistic world, conveys a whole package of elitist messages. The dedication of expensive monuments makes clear the availability of disposable income in the hands of women and also, beyond the women, within the families in whose reproductive and social strategies women played crucial roles. The insistence on the harmony between husband and wife shows the successful management of household relations by male members of the elite, and hence legitimizes their claim to continuous civic rule. Likewise, elite conjugal harmony offers an image of the stability of

[186] On the economic and practical aspects of image-making, see below, Chap. 7.
[187] *IG* 12.9.1233 (1st cent. BC, Histiaia), with Wilhelm, *Beiträge*, 125–6, adducing the subscription list *IG* 12.9.1189: 'Sicherlich ist das Haus der Atheno und ihrer Kinder eines der reichsten jener Zeit im nördlichen Euboia gewesen' ('for sure, the house of Atheno and her children will have been one of the richest of northern Euboia in this period'); the multi-generational statue monument set up at Delphi by Xenon son of Boulon, and his sons, for Xenon's wife Pasichon, reflected the wealth and confidence of a great Delphian family (*Syll.* 602, same document in *FD* 3.4.242, early 2nd cent.).
[188] *IG* 12.5.485–8; 514, 1408.
[189] *IG* 11.4.1166–7 with Vial, *Délos Indépendante*, Stemma XI; C. Durvye, 'Aphrodite à Délos: Culte privé et public à l'époque hellénistique', *REG* 119 (2006), 83–113.
[190] *SEG* 46.416–17.
[191] J. Fedak, *Monumental Tombs of the Hellenistic Age* (Toronto, 1990), M.-T. Le Dinahet-Couilloud, 'Les Rituels funéraires en Asie Mineure et en Syrie à l'époque hellénistique (jusqu'au milieu du Ier siècle av. J.-C.)', in F. Prost (ed.), *L'Orient méditerranéen de la mort d'Alexandre aux campagnes de Pompée* (Rennes, 2003), 65–95. The archaeology of death and of the funerary in the Hellenistic period remains an understudied topic.
[192] *Inscr. Lindos* 2.622–3.
[193] Dillon, *Female Portrait Statue*, 101–2.

families, but also of social class, both as a metaphor and as the site of biological and social reproduction.[194]

The family prominence of Stesileos on Delos illustrates a second operation carried out by private honorific monuments: the familial colonization of public space and of public forms. Private monuments in the space of the agora or the shrine were often grouped in ways that made families visible: this is the effect of the two statues of Apollodoros at Priene. In the agora of Theophrastos on Delos, one Dionysios son of Nikon (who fulfilled the function of *epimeletes* of the island) set up a statue of the proconsul Servius Cornelius Lentulus at one end of the space and, at the edge of the 'Salle Hypostyle' where a street led out from the agora, a large exedra with a statue of his son and daughter (Plan 8). The open space was framed with two images, showing his eminence and his connection to a powerful Roman, and the wealth and continuity of his family.[195]

The multi-statue base and the exedra, familial or 'portfolio', though descended from the Archaic family group, may be a response to such pressures in Hellenistic shared 'places', developed with the intention of taming the homogenizing effect of multiplicity, studied in the previous chapter. As spatial strategy, the familial exedra allowed the creation, and control, of micro-segmentation:[196] monuments for members of the same family—the 'ancestral *sunedrion*' mentioned by a decree of Kyzikos[197]—where serialization was inflected to talk about a single family, and modulated to describe the variety of its members' achievements, and its continuity through time, by the representation of different generations and the solidarity between them. The portfolio monument, which I interpreted as giving a public colour to private honorific transactions, could be read quite differently, as allowing families to contextualize and even tame public honours, by juxtaposing them with private honorific statues—a move which it is tempting to see as a response to the constraining, identity-ascribing force of the public honorific statue (above, Chap. 2). Embedded within privately dedicated statues, the public portrait became integrated in the cat's cradle of the multi-relational monument that made kindreds visible; the *polis* became an actor among other actors in the statue transaction, in a process which reproduced, artificially, the process of competition which is legible in complex civic places (Chap. 5). An actual example of statuary preserved from a multi-statue monument in first-century Aphrodisias[198] illustrates the expressive diversity of elite personhood as displayed in the family exedras, of whatever nature (multi-relational or portfolio).

Another symptom of this diversifying function of the private statue is the occasional presence of relief adornment on the statue base. The base of the statue of an Amyzonian, set up by his nephew, bore the emblem of the head of a hunting spear: this image took over a practice reserved for public monuments (the use of *episema* to describe communities, in visual short-hand of common identity) to add information about a rich man and his *passe-temps*, the hunting of big game in the neighbouring granite highlands of the Latmos.[199] The statue of an athlete, Menodoros son of Cnaios, set up by a friend on the agora of Theophrastos on Delos, rested on a spectacular base representing the whole series of crowns which Menodoros won (Fig. 6.7)—thirty-two victories—and, in addition, three crowns granted by the cities of Athens, Rhodes, and Thebes, and one crown granted, privately, by a king of Kappadokia. The private honorific monument takes over forms from another genre, the victory monument;

[194] On the place of women within elite strategies by civic families (rather than as part of a history of female 'emancipation'), van Bremen, *Limits of Participation*.

[195] *ID* 1845, 1969; on this space, Mercuri, 'L'agora di Teofrasto'.

[196] Marcadé, *Au Musée de Délos*, 72.

[197] Michel 537, discussed above, 72–3, 158. Other examples of family 'real estate': *IG* 12.7.82–3 (family statues to Eilethyia on Arkesine); *Inscr. Lindos* 1.42.

[198] Hallett, 'Portraits from the Civic Center at Aphrodisias' Fig. 8.3.

[199] *Amyzon* 34. On the spear, J. Ma, 'Autour des balles de fronde "camiréennes"', *Chiron*, 40 (2010), 171 n. 76. The same message perhaps appears in a funerary *stele* from Kyzikos (2nd cent.), combining a banquet, a hunt scene, and a 'Demosthenic' figure in himation: the point is the multiplication of images, where the civic appears as one of several facets of personhood (*PM* III).

Fig. 6.7. For some, crowns were crowns, public or private, and could be displayed as such. Front orthostate of private honorific monument set by by Demetrios of Antiocheia for the victorious athlete Menodoros son of Cnaios, at Delos (probably agora of Theophrastos). H. 0.91 m; l. 1.83 m. *I. Délos* 1957, later second century BC.

furthermore, in its list, the monument assimilates civic honours, and crowns, to the impressive list of personal achievement in the field of athletics: yet another way in which to deal with the constraining, identity-assigning force of civic culture.[200]

The colonization of public space, sacred and non-sacred, by family statues, effected a third operation: the legitimation of social inequality and difference, through the discourse of civic synecdoche, by which the display of kinship and transmission within a particular social group of the extremely wealthy was made to stand in for the reproduction of the whole community and the expression of its collective will. This operation is facilitated through the use of morally valorized terms (reciprocity), emotional descriptors (memory and grief, *philostorgia*), religious forms (dedications to an expressly named divine recipient; commemoration of priesthoods), and local patriotism (as in the case of families resisting Ptolemaic reshaping of Theran spaces). Private honorific statues, in occupying public space, offer a contract to the viewer-reader. Namely, he is asked to agree that the reproduction of the *polis* passes by the social reproduction, from nuclear household to nuclear household, of particular families, which stand for the community and, to a certain extent, are the community; on occasion, he is further asked to consent to these statues, and these families, standing for his *polis* resisting foreign pressure or expressing the power and agency of his *polis*. The way in which family monuments enunciate transitions and transmission, representing kindreds as points of continuity, is not simply a form of elite accountability (as argued above): it also supposes the relevance of the family affairs of the wealthy to the whole community, the acceptability of their family solidarity and desired continuity as topics for community sanction, as in the case of the fourth-century Athenian monuments, commissioned by wealthy families from the fashionable sculptor Praxiteles, as signs of post-dispute reconciliation, or displays of solidarity and pride at a family member achieving the priesthood of Demeter and Kore.[201]

A simple visual statement of the politics of familial synecdoche is given by a monument set up in Kameiros. Five statues stood on a base, in two groups: the first was a father–son couple, set up by the son, Panaitios, for his (natural) father, Nikagoras; the second was captioned Κάμιρον | Παναίτιος θεοῖς πᾶσι, and probably showed Panaitios (and perhaps one of his fathers,

[200] *ID* 1957 (second half of the 2nd cent.). The roster of crowns is in fact incomplete.
[201] *SEG* 17.83; *SEG* 51.215; Ajootian, 'Praxiteles'.

natural or adoptive) next to 'Kameiros', probably the hero who founded the town. The whole monument linked family, individual, and the identity of the community in the form of its prestigious mythical past.[202] The monument probably occupied a very visible site in the esplanade before the temple of Apollo Pythios.[203]

The crackle of clean family laundry being aired publicly contains the claims not just of specific families, but of a whole social class; this is the process R. van Bremen has studied as the 'familiarization of public life', combined with social distance between elite and community, ongoing during the late Hellenistic and the Roman period.[204] Wealth is acceptable; more importantly, just as acceptable is the non-euergetical, non-altruistic expenditure of wealth to commemorate the familial bounds, biologically and socially created, within which wealth is transmitted. This message, contained in the captions that identified the statues, may have been reinforced by the visual medium, if the portraits on the lavish multi-statue monuments displayed 'family faces', artificially selected and emphasized physical traits that embodied continuity beyond the tensions implied by the generational cycle: such tropes were possible, at least for men, within the naturalistic idiom adopted, and beyond the choices made to represent age.[205] The reproduction of (wealthy) families is good, as is the public commemoration of members of such families; certain people, through wealth, have access to memory and to the permanent articulation, explicit or implicit, of high emotions (grief, pride, familial or conjugal love), for instance visible in the public monumentalization of vows that is an important part of the genre (above, 168–9). The emotional charge, and the claim to distinction and exemplarity, are obvious in the set of epigrams that accompanied the family monument set up by Protogenes at Kaunos.[206] Even the civic style of certain family monuments, with the mention (brief or prolix) of public service, works to legitimize a social class: the same families who display wealth and use wealth to display their solidarity and their qualities, are also publicly disposed, pious,[207] liturgically minded, richly diverse and successful in their undertakings, and socially useful. The impact of these ideological claims can be measured by the persistence of family honorific statues on Thera after the disappearance of Ptolemaic control, and hence of the risk of foreign encroachment on public spaces; or, more succinctly, in the yearning of the labourer whom Theokritos imagines singing about his beloved—'If only I had as much wealth as they say Kroisos owned: we would both be dedicated in gold to Aphrodite, you holding the pipes or a rose or an apple, I wearing new clothes and new Amykla-boots on both feet.'[208]

The reading offered here is of the civic family honorific monument as an elitist genre, with aristocratic tones; it tries to reintroduce social class and inequality into the equation, and especially to discern them behind any attempt at blurring the distinction between public and private. Communitarian discourse, predicated on the identity between private reproduction

[202] *Tit. Cam.* 81; the founding hero is mentioned in Pindar, *Olympian* 7.135; Diod. 4.58. 'Kameiros' might also have been a personification of the town; the same point about the association of family and community is made.

[203] It is of course difficult to tell from the publication, since it gives no indication on location; but it seems that this is the large base that is located at the end of the main entrance into the esplanade (visible on e.g. C. Bernardini, *I bronzi della stipe di Kamiros* (Athens, 2006), pl. 3).

[204] Van Bremen, *Limits of Participation*, 163–4.

[205] A parallel is offered by the 'family groups' on Roman (3rd-cent. AD) funerary *stelai* in Northern Greece, a genre well represented in the Archaeological Museum of Thessaloniki (e.g. Despinis *et al.*, *Katalogos glypton* 1, no. 128; also Kaltsas, *Ethniko Archaiologiko Mouseio*, no. 767, reinterpreted in the 19th cent. as an image of the saints Kosmas and Damianos); the family resemblance in the painted group of seers later set up in the Curia in Rome was commented on by Pliny (*NH* 35.28; above 173). On face and family, B. Vernier, *Le Visage et le nom: Contribution à l'étude des systèmes de parenté* (Paris, 1999), notably on socially determined beliefs on family resemblances on modern Karpathos; originally, B. Malinowski, *The Sexual Life of Savages in North-Western Melanesia* (London, 1929), 173–7.

[206] Above, 212, on *Inschr. Kaunos* 49–53.

[207] On piety as a factor mitigating self-promotion, van Bremen, *Limits of Participation*, 175–9.

[208] Theokritos 10.32–5.

and *polis* community, comes at the price of allowing implicit aristocratic discourses about the importance of filiation being maintained, from kindred to kindred, in the generation game of statue transactions;[209] the diverse monuments about the eminence of individuals and the wealth of the families that commemorate them would seem to add up to an implicit discourse about heredity and power as enjoyed by a social class. The term 'aristocratizing' is perhaps not too strong[210] to describe the tendency towards the elaboration of a class identity predicated on inherited qualitative distinctions, whose transmission is celebrated publicly, with the consent of the whole community,[211] resulting in a strong claim to shape public space and the perception of time (through the display of recurrent names or the mapping out of generations horizontally and vertically, rather than the historical celebration of individual action and community which characterizes the public honorific statue). I earlier hinted at the possibility that the subgenre of royal family monuments influenced the local family monuments; conversely, the 'aristocratic' workings of the genre—focused on heredity, distinction, and stability in time and space—made it appropriate for exploitation by the kings and their men.

5. FAMILY MONUMENT, PUBLIC MONUMENT

Is this 'elitist' (or even 'aristocratizing', 'aristocratic') analysis correct? At the very least, it shows how the genre of family monuments embody an 'anthropological' universe, centred on kinship, display, wealth, property—that coexisted with the political and moral realm of citizen institutions and discourse predicated on communitarian values. The coexistence should not be analysed as the result of historical evolutions (let alone decline) in the Hellenistic or late Hellenistic *polis*: public honorific statues and private statues coexist in late Classical Athens and early Hellenistic *poleis*, and the dialectic between aristocratic and communal is at the heart of the Archaic and Classical *polis*.[212] The emergence of the private honorific genre, a generation after the public honorific, is itself to be considered a reaction to, and a comment on, the public statue habit: a development which shows the existence of elite families, with expressive needs and claims. In itself, this development is revealing of the workings of the *polis* as a space for competition between different individual actors, but also different classes and visions of what community is, and what it is for: hence the phenomena of segmentation and 'ecological' pressures detailed in Chapter 5, and which the problem of family statues in public space shows very clearly.

The question is what place within the social fabric of the Hellenistic *polis* was taken by elitist discourse and artefacts. The monuments set up by Stesileos on Delos—two family statues, and a temple—sound like a grand statement, but it is important to realize that they were set up in an isolated site on the edge of the main area of the shrine: segmented off from the *epiphanestatoi topoi* reserved for dedications and the very rare public honorific statues, and excentric. During the period of Delian independence, most private honorific families in the late third and early second centuries BC crowded within the *dromos* (Fig. 4.7), in a series that hinted at a form of organization, public control, and family consent to collaborate with the public. The case of Stesileos suggests that the elitist analysis cannot be pushed too far, because of the diversity and fragmentation of social space in the Hellenistic cities: what was the audience of family monuments? Could the habit of family statues have been an elite *passetemps*, part of an incoherent social landscape which combined signs of political institutions and discourses as

[209] On the importance of filiation in aristocratic ideology, Longo, 'I figli e i padri', 78.
[210] The relevance of the notion of aristocracy is debated by P. Hamon, 'Élites dirigeantes'; generally, L. Capdetrey and Y. Lafond (eds), *La Cité et ses élites* (Bordeaux, 2010).
[211] D'Onofrio, '*Oikoi*, généalogies et monuments: Réflexion sur le système des dédicaces dans l'Attique archaïque', *Ktema*, 23 (1998), 118.
[212] O. Murray, *Early Greece* (London, 1993); A. Duplouy, *Le Prestige des élites: Recherches sur les modes de reconnaissance sociale en Grèce entre les Xe et Ve siècles avant J.-C.* (Paris, 2006); Capdetrey and Lafond, *La Cité et ses élites*. I hope to return to this topic at greater length.

well as private, 'anthropological' values and interests?[213] Could the practice have been part of a complex and evolving dialectical relationship between the community and the elite which it helped constitute?

Such issues worked themselves out in detail at the local level, shaped by a multitude of factors. In Priene, the reordering of the agora, the constitution of the 'main series' combining public and private, can be interpreted in several ways. The measure imposed control on what was probably a proliferation of private statues in the public, representational space of the agora—and ordered them into a meaningful series. However, serialization was carried out through a series of (probably) portfolio monuments, where public and private monuments stood side by side, in an equivalence which both embedded the private within the public, but also reduced the public honours to a facet of elite identities and relations. Furthermore, the reshaping of the agora also legitimized and even privileged the practice of family honours, centred around the synecdoche of eminent families as *polis*: the same elite individuals may have been responsible for the reorganization of the agora (as members of the Prienian political class, and its officials), and the honorands and beneficiaries of the family monuments on their multi-statue bases across the face of the agora, as members of elite families.

Yet the series, even with its potentially aristocratic meanings, was perceived as constraining by some: as analysed in Chapter 5, some family monuments escaped the scheme laid down by the 'main series', and attempted to colonize another highly visible site, the foot of the stairs across the northern side of the West Gate Street—offering the organic image of spaced, non-integrated exedras, rather than the tightly knit and obviously integrated series of monuments in the 'main series'. In the first century, this process faltered—which points to pressures on the elite, namely the fragility of family continuity, the dispersability of mobilizable wealth, the impact of competitive display in the form of full-size portrait statue dedications. It might be tempting to interpret the 'statue race' between households as amounting to a 'tragedy of the elite', preventing the accumulation of wealth by enforcing patterns of display and competition, and constantly raising the threshold for visibility by the use of serialization, which dampened any attempt at creating distinction through multiple statues. The genre of family statues in public space may have carried aristocratic meanings, and performatively defined an elite; but conversely, demographic and economic pressures, under which pre-industrial elites are well known to have laboured,[214] may have made it difficult to maintain the continuity of individual families, as each monument also makes clear, by showing the processes of sprouting and running to seed that inevitably occurred in the developmental cycle from nuclear family to nuclear family. The 'main series' at Priene speaks of the presence of a group of eminent families, honoured publicly and privately—but does not necessarily speak of the continuity, let alone the dominance of this group: merely of the existence of an elite, as an abstract category, which in itself is not surprising, nor offensive or indigestible, for an egalitarian-minded community. The 'main series', and the few monuments that escaped its model, represents a particular moment in Prienian history—a trace of the aspirations and strategies of a particular group in the second half of the second century, but also a record of the way these aspirations were integrated and tamed by historical processes.

Similar interpretative exercises—around the limits of elitism both as a modern concept and an ancient reality—might be proposed for the series of family monuments on the terrace of the Oropian Amphiaraion, as analysed above, or even Thera, where the funerary foundation for Epikteta shows a 'dearth of kinsmen' (Pomeroy) rather than strong, dominant elite families.[215] On Rhodes, the tri-generational monument with a statue of Herakleitos son of Pausanias set up by his son, Apollodotos, and a statue of Apollodotos set up by *his* son, Herakleitos, is less

[213] On social incoherence, P. Veyne, *Les Grecs ont-ils cru à leurs mythes?* (Paris, 1983).

[214] Demographic fragility is one of the structural factors underlining the picture of intra-elite tensions given by Zuiderhoek, *Politics of Munificence*.

[215] Pomeroy, *Families*, 109–13.

straightforwardly a celebration of aristocratic lineage than suggested by the portraits of the two men standing side-by-side, slightly back to back, and especially the eight-line epigram (quoted above, 205), celebrating continuity and ever-increasing eminence.[216] The elder Herakleitos fulfilled civic office and competed successfully in Rhodian contests (as a young man, since he not only ran victoriously in the torch race, but was also crowned for *euandria*);[217] not a long 'CV' of public achievements, but clear markers of citizen status, which root the family in a past of growing up within the closed institutions of the Rhodian *polis*, serving in the Rhodian state. But Herakleitos' son, Apollodotos, is born of a 'foreign mother', which must mean he is not a full citizen, even though he puzzlingly claims membership of the Lindian deme of the Nettidai (whereas his father was phylarch in the 'Ialysian tribe', which must be the former city of Ialysos, now a constituent tribe of the Rhodian state). Apollodotos' son, the younger Herakleitos, who set up the second statue and perhaps was responsible for the aristocratic-sounding epigram, is named as a Samian—not a citizen of Rhodes at all, but, in spite of his Rhodian grandfather and *matroxenos* father, a foreigner with residence rights (*epidamia*). The exact details of status and citizenship are unclear (what the difference is between a *matroxenos* and a citizen born of two Rhodian parents is mysterious; how Herakleitos received his Samian citizenship is baffling).[218] Wherever this monument was set up (in one of the shrines of Rhodes town), it did not cement the position of an elite family: it reveals shifts in position—the continuity of 'lineage' comes at the price of gradable loss in citizen status—even as it tries to claim eliteness. The tri-generational monument thus shows not a pre-existing elite celebrating its position, but attempts at creating position, within an open social field. This conclusion is another instance of segmentation and competition, just as can be read in the archaeology of civic place, and as is revealed by the nature of the family monument as a snapshot of kindred rather than as what it claims to be, the affirmation of pre-existing, natural continuity.

Other cases, such as Rhamnous (with its family statues *c*.350, but not, it seems, later), Lindos (with a good record of statues during the Hellenistic period), Miletos, and Kaunos, might have to be worked out in detail, as well as cases where there does not seem to be a phenomenon of private family statues struggling to occupy public space—Athens, for instance, never seems to allow private statues in the agora; the Thriasian multi-relational monument in the shrine of Demos and the Charites, or the statues in the City Eleusinion, hover on the edges of a space highly structured by public honorifics.

The dialectic between public and private, the diversity of situations, the constant attraction and hegemony of public models of acceptable behaviour, even for elite identity—these are familiar topics in the history of the post-Classical *polis*, and it matters to keep the fluidity of the social and political landscape in mind. Nonetheless, it is important to focus on a few broad developments, of importance for the interpretation of honorific statues both public and private, and generally for political culture in the Hellenistic period.[219] A widespread phenomenon is the inclusion of family members of honorands in public honorific monuments.[220] Excepting the possible case of a late fourth-century monument set up by Pella in honour of Archon, and including statues of his parents and brothers,[221] the practice starts in the third century BC with the dynasties of the Hellenistic kings,[222] and the families of high royal officials

[216] *Nuova Silloge* 19, referring to H. van Gelder, *Geschichte der alten Rhodier* (The Hague, 1900), 229.

[217] The contest for *euandria*, male beauty, memorably appears in a sacred law from Bargylia: *SEG* 45.1508; generally, N. B. Crowther, 'Male "Beauty" Contests in Greece: The Euandria and Euexia', *Antiquité Classique*, 54 (1985), 285–91.

[218] D. Ogden, *Greek Bastardy in the Classical and Hellenistic Periods* (Oxford, 1996), 300–4.

[219] Van Bremen, *Limits of Participation*, 96–7, 183–4.

[220] J.-C. Balty, 'Groupes statuaires impériaux et privés de l'époque julio-claudienne', in N. Boncasa and G. Rizza, *Ritratto ufficiale e ritratto privato* (Rome, 1988), 31–46, provides some notes on the practice, but pays insufficient attention to who sets the statues up; van Bremen, *Limits of Participation*, 183–6, on public take-over of private statues.

[221] *SEG* 18.222; *RO* 92—where the dedicatory epigram is understood as referring to statues set up by Archon.

[222] Dynastic group of Ptolemy III set up by Aitolians at Thermon: *ISE* 86, with C. Bennett, 'The Children of Ptolemy III and the Date of the Exedra of Thermos', *ZPE* 138 (2002), 141–5, and E. Kosmetatou, 'Remarks on a

(on early second-century Cyprus).[223] The practice is also attested in the case of the relatives of important Romans, in the first century BC (for instance the Cicero brothers at Samos).[224] In the second century BC, this form of honour, by which the civic community embraced the honorand's family, and the dynastic principle, in the same homage, extended to citizen benefactors. As discussed earlier (Chap. 2, 46–8), the city of Kyme, in honouring the benefactress Archippe (*c*.150), set up statues of her, notably one showing Archippe being crowned by a colossal image of the Demos. The same monument also included her father Dikaiogenes 'on the same base' (as mentioned in two of the decrees for Archippe).[225] At Oropos, a priest of Amphiaraos was honoured with a statue, along with his son (who had fulfilled the sacred office of *spondophoros* in the same year as his father's priesthood);[226] in Eretria, the city set up public honorific statues of the benefactor Theopompos—and also of his sons and of his daughter (perhaps as a separate group rather than on the same base as the statue of Theopompos), thus adding at least three statues to that of Theopompos.[227] In AD 1, the Macedonian city of Kalindoia honoured the local benefactor Apollonios for his services as priest of Rome and Augustus, and 'for the brilliance of his soul and his love of glory directed towards his fatherland' (ἐπὶ τῇ λαμπρότητι τῆς ψυχῆς καὶ τῆς εἰς τὴν πατρίδα φιλοδοξίας): in addition to praise and a crown, the decree included a marble statue for Apollonios, his father, and his mother, to be set up in the most prominent spot of the agora as chosen by the *agonothete*.[228]

The practice of family groups, set up publicly but to honour a single individual by including his or her kinsmen, is reserved for very important benefactors, such as the Roman L. Nassius, on Chios,[229] or C. Iulius Theopompos at Knidos[230]—and constitutes yet another 'royal' feature taken over by the local elites;[231] it continued during the Roman empire.[232] In addition, individuals may have been honoured with statues singly rather than as part of statue groups, as an acknowledgement of the services and character of a relative of theirs—this is suggested by finds of stand-alone bases with inscriptions such as 'The people (has set up) Herais daughter of Glaukon, on account of the benefactions carried out by her father for the fatherland'.[233]

Delphic Ptolemaic Dynastic Group Monument', *Tyche*, 17 (2002), 103–11; *Syll.* 629 (*FD* 3.3.240, Kotsidu, Τιμὴ, καὶ Δόξα, no. 105), Aitolians for Eumenes II and family.

[223] On Cyprus: Mitford, 'Old Paphos', nos. 43–5 (earlier *BE* 49, 202); C. Habicht, 'Ein thesprotischer Adliger im Dienste Ptolemaios' V', *Archaeologia Classica*, 25–6 (1973–4), 313–18, on *Kourion* 42 (noted in *BE* 77, 551).

[224] P. Herrmann, 'Samos', 128–34; U. Weidemann, 'Drei Inschriften aus Kyme', *ArchAnz* (1965), 446–66 (late 1st cent.); Tuchelt, *Frühe Denkmäler*, 51–4, 64–5, and Ephesos 02, Magnesia 02–05, Pergamon 023 (all 1st cent.); Eule, *Bürgerinnen*, 200, no. 14 (Euromos), 19; H. J. Kienast and K. Hallof, 'Ein Ehrenmonument für samische Scribonii aus dem Heraion', *Chiron*, 29 (1999), 205–23 (Scribonii honoured in Samian Heraion); *Inschr. Kaunos* 107–8 (C. Scribonius and wife); *ID* 1613, 1622, part of an exedra, with a statue of Q. Hortensius set up by the people of the Athenians and the inhabitants of the island, not in honour of his own considerable status and achievements, but as 'the uncle of Caepio, on account of the benefactions carried out by Caepio himself towards the city'—Caepio being, in all probability, none other than the tyrannicide Brutus, installed in Athens (A. E. Raubitschek, 'The Brutus Statue in Athens', 17–18). A statue group with a specifically chosen kindred of Brutus?

[225] *SEG* 33.1041, van Bremen, 'Archippe'.

[226] *Oropos* 294 (late 2nd cent.?).

[227] *IG* 12.9.236 (and suppl.), *c*.100 BC.

[228] M. V. Hatzopoulos and L. D. Loukopoulou, *Recherches sur les marches orientales des Temenides* (Athens, 1992), K2 (*SEG* 42.579).

[229] *IGR* 4.1793, with Wilhelm, 'Beschlüsse der Chier', and Keil, 'Volksbeschlüsse der Chier'.

[230] *I. Knidos* 51–5.

[231] Gauthier, *Bienfaiteurs*; Robert and Robert, *Claros*.

[232] e.g. *TAM* 5.48, 688; L. Robert, in A. Dupont-Sommer and L. Robert, *La Déesse de Hierapolis-Castabala, Cilicie* (Paris, 1964), 50 (five statues set up on a terrace wall; copied by A. Wilhelm).

[233] *I. Ephesos* 3431, from Metropolis in Ionia. Such inscriptions, if they come from blocks that originally belonged to multi-statue bases, obviously attest publicly erected family groups; if from stand-alone bases, they might still have belonged to family groups constituted of separate statues erected in close proximity. This is the case for the equestrian monument of L. Licinius Murena at Kaunos, framed by two standing statues (*Inschr. Kaunos* 103–4). Of these latter statues, only one base survives, inscribed for Murena's elder son, L. Licinius Murena; it is likely that the other statue, now only attested by the first course of the base, represented Murena's other son, C. Licinius Murena, rather than Murena's colleague, Aulus Terentius Varro (Marek). Examples of

At Kyme, the statues of Archippe and her father were paid for by Archippe's brother, Olympios; at Kalindoia, the statues of Apollonios' parents, as well as his own, were paid for by Apollonios. Families and individuals stepped in to meet the considerable financial costs of public involvement in family statuefying; the development marks the increasing normality of the practice of having families and individuals paying for public honorific statues in general (below, 247). In the early third century, the *post-mortem* equestrian statue of the heroic cavalry commander Eugnotos was set up at Akraiphia by the community, but with the widow and the daughter meeting the costs,[234] though this remains exceptional at such an early date; at Halikarnassos, the participation of a group, perhaps familial, in the financing of the honorific statue for Diodotos, is specifically described as the result of the temporary lack of available public monies.[235] The phenomenon is best attested in the later Hellenistic period. On second-century Paros, the marble statue of the *agoranomos* (and good man) Killos was financed by his son, Dexiochos, who 'came before (the assembly) and said he thanked the people for the honours voted to his father, but that he would give the money for the portrait and the dedication of the portrait'.[236] This type of gesture perhaps never lost the element of drama in the assembly (in AD 1, at Kalindoia, Apollonios took on the costs of the statues in the same assembly that voted the honorific decree for him), but the practice of having public honorific statues financed by families (and occasionally friends) grew increasingly common, during the first century BC and the first century AD. It is well attested at Magnesia on Maeander[237] or Thera, where the publicly decreed honorific statues for Mnasikritos and Chairopoleia, a couple, and Ti. Claudius Medon, her brother, were set up by Chairopoleia on a very large base, 'out of her funds'.[238] The latter is said to have set up her statue 'while she was still living', a curious feature which probably is a contamination from funerary epigraphy (where it matters to insist on the continuing life of the monument's originator, to ward off bad luck), as if the public statues were part of a private funerary monument. Finally, the practice is widespread during the Roman empire, across all of the eastern provinces:[239] the honorific *titulus* remains the same as the old formula which emerged during the early Hellenistic period, with all of its political implications, but with the mention, at the end, of the intervention of family to care for the setting of the statue, out of private funds (ἐκ τῶν ἰδίων).

The honorific monument set up at Kyme represents the Demos, towering over Archippe, and crowning her—the balance of power, at least symbolical, is made clear (above, Chap. 2). Yet on the same base, Dikaiogenes, an older man, Archippe's father, looks on at the honorific transaction; and the whole monument is paid for by Archippe's brother. The additional statue and the private financing interfere with the clear civic meanings of the monument. Public family groups, public statues of individuals to honour their relatives, family financing of public statues—these developments make clear the importance of the phenomenon of private honorific statues that has been investigated in the present chapter and the previous one, and the impact that this phenomenon had on the civic genre of the public honorific statue. Family statues, and multi-statue groups, were a means of self-expression for rich families, and could be inflected to constitute an elite: the involvement of the community in this genre may amount to an acknowledgement of the elitist principles (relationality converted into lineage, display of

individuals honoured publicly on account of their relatives were noted at Pergamon by A. Wilhelm, *Beiträge*, 190–1 (on *Inschr. Pergamon* 482, 492, 501, 516, and *ID* 1622), and 317 (on Hepding, 'Pergamon 1904–1905', 333–5). See also *Nuova Silloge* 458, *PH* 116 (both Kos, 1st cent. AD?); *SEG* 45.1499 (Alabanda).

[234] *ISE* 69 with Ma, 'Eugnotos'.

[235] Wilhelm, *Inschriftenkunde*, i. 287, on Michel 456 (same document Migeotte, *Emprunt*, 102).

[236] *IG* 12.5.1.129.

[237] *Inschr. Magnesia* 131, 153, 160–3, 166, 188.

[238] *IG* 12.3.522 (Chairopoleia carried out the *anastasis* of all three portraits), with Sigalas, 'Chairopoleia' (*SEG* 36.943–5; *BE* 73, 321; I am not sure the husband and the brother were deceased); the base was 2.76 m long, and may have occupied one of the 'exedras' in the agora of Thera (Sigalas).

[239] For instance *I. Erythrai* 43 (with *BE* 73, 375, p. 141); *TAM* 3.56, 67, 125, 132.

inequality and permanence under civic forms, acceptance of the public relevance of domestic qualities)[240] as well as an attempt to control these principles. The increased expense, combined with social phenomena such as the rise of the super-rich elite of the late Hellenistic period and its willingness to bear the cost of this last round of statue inflation, may have constituted the process by which the normal practice of the Roman empire (public honorifics explicitly paid for by families) came to arise.

The embedding of 'family thinking' within the visual medium of self-expression available for civic communities is an extension of the domestication of public space to public discourse itself; it further illustrates how mechanisms that emerged in response to royal power were applied to the expression of elite distinction. This, then, may be the outcome of the complex equilibria between private and public, elite and community, that I have focused on reading in the sedimented stratigraphy of place, the record of segmentation of place, and in the epigraphical record, throughout this work: we witness, by the end of the late Hellenistic period and into the Roman empire, the take-over of the public genre and the appropriation of its meanings into the private sphere. Whether or not this amounts to seeing the Greek city in the Roman era as dominated by elites, devoid of politics and characterized by the death of egalitarian-communitarian culture remains to be seen, and is in any case a different question.[241] But the presence of social, economic, political, and cultural change in the late Hellenistic *polis* is a clear historical phenomenon,[242] of which the developments and outcomes traced above are a symptom.

The ultimate uniformity of these apparently elitist outcomes, in spite of the diversity of situations illustrated by the various Hellenistic test cases visited in this chapter, forces us to look back on the various social processes investigated throughout the present work. The *polis* needed to maintain equilibria between competitive pressures, between the affirmation of the public sphere and the constitution of an elite, between community ideology and family expression:[243] the recognition of family principles and family thinking (for instance by allowing families to colonize micro-segments of public space)[244] may have been part of this balancing act. The equilibria may have been difficult to sustain, in the face of macro-historical change, resulting in the fragility and tensions which I have tried to listen to. Nonetheless, it is not enough merely to qualify the private honorific monument (which has provided a way into these tensions, under the surface of civic ideology and political culture) as an elitist artefact, the result of competitive aristocratic display. The power of honorific culture, and the normative force of the honorific statue, make up the heart of the symbolical system of the publicly displayed statue. The Eretrians considered it a particular honour for Theopompos that they converted his family monument into a public monument: they did not pay for the statues, but granted the right to inscribe this as dedicated by the people—affirming the value of public recognition. At Kalindoia, a late second-century BC funerary epigram commemorates a 12-year-old boy by recalling the grandfather whose name he bore: 'his fellow citizens set up a bronze

[240] *PH* 115: at Kos, one Anaxikleia is publicly honoured with a statue for her attitude towards her husband.

[241] For the beginnings of an answer, Nijf, 'Roman Termessos'; earlier J. Ma, 'Public Speech and Community in Dio Chrysostom's *Euboikos*', in S. Swain (ed.), *Dio Chrysostom: Politics, Letters, and Philosophy* (Oxford, 2000), 108–24; A. Zuiderhock. 'On the Political Sociology of the Imperial Greek City', *GRBS* 48 (2008), 417–45; C. T. Kuhn, 'Public Political Discourse in Roman Asia Minor' (D.Phil. thesis, University of Oxford, 2008); A.-V. Pont, *Orner la cité: Enjeux culturels et politiques du paysage urbain dans l'Asie gréco-romaine* (Pessac, 2010). I will return to the question elsewhere.

[242] Gauthier, 'Bienfaiteurs'; Chankowski, 'Diodoros Pasparos'; Müller and Frölich, *Citoyenneté et participation*; Hamon, 'Élites dirigeantes'.

[243] For a parallel, see J. Bergemann's analysis of funerary iconography and practice in 4th-cent. Athens as potentially subversive, yet successfully integrated within the dynamics of Athenian political culture, in *Demos und Thanatos*, also 'Attic Grave Reliefs and Portrait Sculpture in Fourth-Century Athens', in von den Hoff and Schultz, *Early Hellenistic Portraiture*, 34–46.

[244] In addition to the examples discussed above, note *Amyzon*, no. 15B: the *stele* bearing an honorific decree passed by Xanthos for the rhetor Themistokles of Ilion was to be set up in Ilion, 'next to the statues of his father, Aiskhylos'.

portrait of him for the sake of memory, and in doing so they strode in orderliness (βάντες ἐν εὐνομίαι): sitting, he holds one hand on his knee, and with the other, he grasps the crown of the people and the council'.[245] The private statue group, in the house of Kleopatra and Dioskourides on Delos, acted as a quasi-public dedication, by referring to his public service and his piety.

Most strikingly, at Lindos, a lavish multi-relational family monument, grouping the four statues of three brothers and their father, who had all served as priests of Athena Lindia and Zeus Polieus, ends with an epigram which reaffirms the desire for the public, rather than simply celebrating lineage:[246]

πρὶμ μέν τοι γενέτας ἐπιβώμια θ[ύ]ματα, Παλλάς,
 ὡς θέμις, εὐιέρων ἐντὸς ἔλαμψ[ε δ]όμων,
τρισσοὶ δ' ἁμὲς ἔπειτα συναίμον[ες] οἷς τόδε μούνοις
 ὤπασας ἃ Λίνδου σεμνὸν ἔχεις σ[κ]όπελον.
Βάκχου δ' ἁβροκίτωνος Ἀλεξάν[δρ]ου τ' ἐν ἀέθλοις
 δισσὰ χοραγεσίας ἐκφερόμα[ν σ]τέφεα
πατρὸς Πυθαγόρα Λυσίστρατος· ἄ[φθο]να δ' ἀστοῖς
 μοῦνος πανδάμου δαιτὸς ἔνε[ιμ]α γέρα.
στᾶσε δέ με κλεινὰ πρύτανιν Ῥό[δος] ἠδ' ἐπὶ βουλᾶς
 γράμμασι καὶ τιμὰν ἔσχον ἀγωνο[θετε]ῖν.
τοὔνεκα κυδαίνοι τις ἑὰν πόλιν· ο[ἵ]δε γὰρ ἐσθλοῖς
 πατρὶς ἀειμνάστους ἀντινέμειν χάριτας.

Previously, our father performed shining sacrifices for you, Pallas, as is the custom, within your sacred dwelling; and later, we three brothers did so, to whom alone you granted this, you who rule over the august rock of Lindos. And I, Lysistratos, son of Pythagoras, twice carried off the crown of the *choregia* (organizing and financing a chorus) in the contests of soft-robed Bakchos and of Alexander; and alone I distributed to the townsmen countless shares of honour in the feast for the whole people. Famous Rhodes made me a *prytanis* (president of the Council) and the official in charge of the letters of the Council, and I had the honour to be *agonothete* (to preside over a contest). For these reasons, let one bring glory to his city; for the fatherland knows how to give back ever-remembered tokens of gratitude.

The portrait of the father, Pythagoras, does not name a dedicator, and is probably an older, auto-dedicated statue, moved to the exedra by the three brothers, in order to constitute a family monument with father and sons (later, the statue of yet another priest of Athena and Zeus was added, probably a relative). Filiation is displayed, even though two of the brothers were later adopted by other Rhodians. The monument groups the three sons of Pythagoras, and the epigram celebrates filiation and achievement. It particularly insists on the services of Lysistratos, as magistrate and benefactor. Most importantly, it ends with a versified version of the hortative clause so frequent in honorific decrees (above, Chap. 2), promising the reciprocal return of *charis* in exchange for public service, thus recognizing excellence. But what are the everlasting *charites* granted by the fatherland? They might be interpreted as the very offices which Lysistratos has filled: service and requital are co-terminously bound. But a hasty reader of the epigram, who is also the viewer of the multi-statue monument, might also think of the statues he sees, as if these statues, set up privately and lavishly to commemorate priesthoods, were substitutes for the desired public honorific statues which gave memory and *charis* in forms that rewarded and constrained the political imagination of citizens.[247]

[245] *SEG* 42.596, from Hatzopoulos and Loukopoulou, *Marches Orientales*, K 18. See further below, Chap. 6, 271–2.

[246] *Inscr. Lindos* I.197 (mid-2nd cent. BC).

[247] For another Rhodian parallel, *BE* 66, 291, on a private statue described, in an epigram, as celebrating public glory.

IV

Statues as Images

Making an Honorific Portrait

A fifteenth-century painting is the deposit of a social relationship. On one side there was a painter who made the picture, or at least supervised its making. On the other side there was somebody else who asked him to make it, reckoned on using it in some way or other. Both parties worked within institutions and conventions—commercial, religious, perceptual, in the widest sense social—that were different from ours and influenced the forms of what they together made.

(M. Baxandall, *Painting and Experience in Fifteenth-Century Italy* (Oxford, 1988))

When Baxandall offered a slightly unconventional class on Renaissance sculpture at the Courtauld Institute where he went into details of workshop practices such as accounting and the technicalities of bronze casting, he was not asked back again.

(Obituary for Michael Baxandall, *The Times*, 27 August 2008)

In this chapter, I examine two ways of looking at the processes involved in making an honorific portrait (primarily the bronze honorific statue). The first way is to focus on political processes (commissioning, control, financing); the second way is to imagine the artistic processes, notably the very complex sequence that produced a bronze statue. These two approaches are combined in a third section on the 'art worlds' involved in the honorific statue transaction: in practice, this was a local, communitarian art happening. The main findings are the (relative) affordability of the honorific portrait, and the bespoke nature of the processes. An appendix gathers the evidence for the economics involved; the frequently quoted 'price' of 3,000 drachmas needs qualifying (the sum is not for the statue, but the total honorific package; the sum seems to have decreased in the second century).

I. POLITICAL WORK

The honorific monument was the artefact of a particular political culture; it was designed to express communitarian values, statements, and relations; it stood in for an individual, but also a whole community, and a whole world. These are the meanings that can be read off the monument, especially the inscribed stories that created and inflected meaning around the portrait. Yet the latter had to be made, as a physical object. It was the outcome of a political process, as implied by the display of political relationality on the short *tituli* on statue bases, and as made explicit by the long standardized texts of the honorific decrees. In many decrees, the actual production and erection of the honorific statue is taken for granted: the statue, and its base, will simply happen, and the decree concentrates mention on grand issues of memorial publicity through inscription, or diplomatic communication.[1] Other decrees simply mention the allocation of public funds for the 'setting up' of the honorific portrait.[2] However, on occasion, communities took care to specify, and inscribe, at least some of the processes and institutions involved in materializing its honorific intention.[3]

[1] Ellipse of the actual statue-making processes: *IG* II² 983, 1223; *SEG* 33.127; *OGIS* 129, 339; *Syll.* 630.
[2] Bare mention of the origin of funds, *IG* II² 654; 657; *Inschr. Magnesia* 94.
[3] See already Smith, *Hellenistic Royal Portraits*, 16–90; Stewart, *Greek Sculpture*, 59–60; *Faces of Power*, 168; and esp. Perrin-Saminadayar, 'Aere Perennius'.

An honorific statue was a special gesture; it might require special officials, chosen for the purpose of getting the monument made: statue, base, inscription, and dedication. At Theangela in Karia, such a procedure was initiated when the city decided to honour an important benefactor (probably a royal official), with a statue set up in the agora.

$$\text{ὅπως δ' ἂν ἡ εἰκὼν συν[τελεσθῆι]}$$
$$\text{ἐν τάχει ἐλέσθαι τῶν πολιτῶ[ν ἐπιμελη]-}$$
$$\text{τὰς δύο οἵτινες ἐγδώσονται τὴν [ποίησιν]}$$
$$\text{καὶ ἐπιμελήσονται ὅπως συντελ[εσθῆι·]}$$

...in order that the portrait be completed rapidly, let there be chosen out of the citizens two commissioners who will contract out the making and make sure that it is completed.[4]

Such commissioners (*epimeletai, epistatai, archontes*, or, in Boiotia, members of an *arche* or body of magistrates)[5] are well attested from the late fourth century to the second century;[6] from the late second century onwards, the rise of direct elite financing of public honorific statues[7] probably crowded out the civic institution of the specially appointed statue commission. They usually formed a small board (two to five strong), with local variation: the association of the Dionysian Artists of the Isthmos selected a single man, whereas the soldiers stationed in the Attic forts appointed eleven men, representing the various garrisons.[8] The decree from Theangela, quoted above, illuminates the rationale: to handle the matters involved in the successful making (συντέλεια)[9] of a statue, with a sense of purpose and timeliness, and hence to avoid the statue getting lost among the routine of year-to-year civic administration and (at times alarmingly haphazard) civic finances. Care, supervision, administration: the statue commissioners were elected officials, and as such answerable to the *polis,* before whom they presented detailed proposals, and rendered account of monies spent.[10]

The commission supervised the making of a statue: specifically, it carried out the contracting (*egdosis*) of this particular type of public work, by drawing up written specifications and an agreement.[11] In the absence of surviving public contracts for honorific statues, we may recognize the operation of similar documents as implied in building accounts,[12] and, in a rather different way, in euergetical transactions between communities and sculptors who waived part or all of their fees in the execution of their obligations.[13] The exact modalities

[4] Robert, *Coll. Froehner*, no. 54 (first half of the 3rd cent.?).

[5] On Boiotian *archai*, P. Roesch, *Thespies et la confédération béotienne* (Paris, 1965), 181; M. Holleaux, 'Inscriptions du temple d'Apollon Ptoios', *BCH* 14 (1890), 2 and 184.

[6] *IG* 12.9.196 and 198: Eretria, late 4th-cent.; equally early are the commissioners attested in decrees for Nikomedes of Kos, a Friend of Antigonos Monopthalmos (*IG* 12.4.1 129, ll. 48, 74–5). At Athens: *IG* II² 672, 682, 1304, 1330; *SEG* 28.60 with Shear Jr., *Kallias of Sphettos*, 56 (noting that in the case of *IG* II² 682, the decree of Phaidros of Sphettos, the commission included his son and a fellow demesman). Also *IG* 12.1.6 (Rhodes); *ISE* 41 (Argos); *OGIS* 213, *Milet* 6.3.1026 (Miletos); *Syll.* 368; *Pérée rhodienne* 45 (same document *I. Rhod. Peraia* 402); *I. Erythrai* 52. Decree for Eirenias: *SEG* 36.1046; *Oropos* 294, *IG* 12.9.236; *IG* 9.2.66A, from Lamia (these four examples date to the 2nd cent.). A statue commissioner is attested at Knidos in the 1st or 2nd cent. AD: *I. Knidos* 74.

[7] R. O. Hubbe, 'Public Service in Miletus and Priene in Hellenistic and Roman Imperial Times' (Ph.D. thesis, Princeton University, 1951); Chankowksi, 'Pergame', 178–80; P. Gauthier, 'Le Décret de Thessalonique pour Parnassos: L'Évergète et la dépense pour sa statue à la basse époque hellénistique', *Tekmeria*, 5 (2000), 39–63; above, 237.

[8] *IG* 4.1.588; *Syll.* 485. In another decree of a military corps, *IG* II² 1304, the commission collaborates with magistrates.

[9] P. Herrmann, 'Neue Urkunden zur Geschichte von Milet im 2. Jahrhundert v. Chr.', *IstMitt* 15 (1965), 71, l. 19.

[10] *IG* 12.9.196 and 236 (Eretria), 899 (Chalkis, where the commissioners will receive public funds καθότι ἂν γράφωσιν). In Boiotia, special commissions are well attested for various public works (above). Generally, Fröhlich, *Contrôle des magistrats*, 401.

[11] Demosthenes 18.122 compares Aiskhines to a man who has contracted a statue according to a draft, and complains about the finished product.

[12] On this material, see now C. Feyel, *Les artisans dans les sanctuaires grecs aux époques classiques et hellénistiques à travers la documentation financière en Grèce* (Paris, 2006).

[13] *IG* 11.4.514 (Delos, decree for Telesinos, early 3rd cent.); M. Sève, 'Le Dossier épigraphique du sculpteur Damophon de Messène', *Ktema*, 33 (2008), 117–28 (notably *SEG* 41.332; 49.423; 51.466, same document *IG* 9.1² 4.1475); *SEG* 43.451 (the city of Pydna honours two men from Demetrias for repairing the cult-statue of Apollo Dekadrys, 'of the Ten Oaks': *c*.169 or earlier?).

remain unclear: whether the contract was tendered competitively, how the financial and practical details were negotiated.

Public financing meant the involvement of officials. In many decrees, a financial clause stipulates the administrative route for the disbursement of the funds, often in brief, routine terms:[14] the equestrian statue, certainly an expensive artifact (below), set up by the Milesians in honour of Antiochos I was to be funded by monies set aside by the *anataktai*.[15] The matter-of-fact tone embeds the making of the honorific monument into the functioning of civic institutions.[16] But such honorific transactions were something special, outside the routine of administrative expenditure, and the sources of the funding for this special item of expenditure sometimes required inventiveness, or at least had to be specified explicitly: special contributions of a more or less voluntary sort,[17] the designation of particular streams of revenue within the civic budget (for instance the harbour tax at Epidauros Limera, whose income over two years was assigned for a pair of honorific statues),[18] the sale of membership in the gymnasion and hence citizenship (attested in a city in Egypt, probably Ptolemais),[19] the offering of civic taxes as guarantees of future payment,[20] loans from various sources.[21]

The reason for special measures is that honorific monuments, especially those involving statues, were costly: the scanty evidence suggests routine costs around 2,000–3,000 drachmas (3,000 drachmas is clearly attested in the late fourth and early third centuries, a lower price, around 2,000 drachmas or below, is clearly attested in the second century BC, especially in centres of artistic activity and concentrated statuary production—the evidence is laid out in the appendix to this chapter).[22] The figure of (say) 1,900–3,000 drachmas is not quite 'the price of an honorific statue' (in spite of Diogenes Laertius 6.2.35, where the philosopher Diogenes contrasts the 3,000 drachmas for which a statue is sold, πιπράσκεται, and the price of food), but the amount communities are willing to spend for the honorific monument, which comprises portrait statue, base with inscription, and occasionally inscribed *stele*. This figure applies to monuments with 'simple', life-size or over-life-size bronze statues; but there must have been considerable variation. Honorific painted portraits were certainly much cheaper;[23] there is no

[14] *IG* II² 646 and 648 (*exetastes* and trittyarchs will provide funds); *IG* 12.1.6 (Rhodes: whatever expenditure occurs for statue, base, and *stele*, the generals will provide); 12.2.527 (with Wilhelm, *Neue Beitrae*, v. 11–19, also in *Akademieschriften*, i. 253–61); Michel 544 with Wilhelm, *Neue Beitrae*, vi. 45–6, also in *Akademieschriften*, i. 336–7).

[15] *OGIS* 213; likewise, in *IG* 12.9.196 (Eretria), public funds for the equestrian statue of Timotheos appear only in the mention of the accounting for expenditure by the commissioners, and in a decree of the Thessalian League, the granting of two equestrian statues is followed by the matter-of-fact stipulation γενομένου τοῦ ἀνηλώματος εἰς τὰς εἰκόνας καὶ τὰς βάσεις ὑπὸ τῶν συνέδρων ('the expenditure for the statues and the bases having been carried out by the *sunedroi*').

[16] Bertrand, 'Formes de discours politiques'.

[17] *IG* 9.2.489 (Phayttos), γενομένης τῆς εἰσφορᾶς ἐξ ἐπαγ[γελίας] ('the *eisphora* haveing taken place after promises'); *Syll.* 485.

[18] Budget: Robert, *Coll. Froehner* 54, with Gauthier, *Poroi*, 17–18. Harbour tax (τὸ θαλάσσ[ιον τέλος]): A. Wilhelm, *Griechische Inschriften rechtlichen Inhalts* (Athens, 1951), 60–7 (also in *Akademieschriften*, iii. 454–61), on *IG* 5.1.931 (the Roberts announce a study in *BE* 53, 76). On Delos in 179 BC, a special fund, among sacred monies, was set aside 'for the images' (εἰς τὰς εἰκόνας; *ID* 442 A, ll. 87 and 114; also in *Nouveau Choix de Délos*, with comment p. 188): the fund received two payments of 400 drachmas, one a reimbursement of monies advanced to finance a gift to the Aitolians. But it is not clear what these images are (a 'sinking fund' set up to provide for future honorific statues?).

[19] *SEG* 8.641, same document Bernand, *Prose*, no. 27 (104 BC), decree of the *Koinon* of the gymnasion.

[20] *OGIS* 46, with Migeotte, *Emprunt*, no. 103. *IG* 12.9.1234C, 1235A, *SEG* 29.802, are public honorific statues set up c.200 by the city of the Hestiaians, ἐκ τῶν αὐτῆς πόρων—the need to specify probably attests to the take-over of statue financing by civic elites as normal practice, since civic funding is remarkable enough to be mentioned on a short base inscription.

[21] *ID* 290, l. 130; F. Costabile, *Polis ed Olimpieion a Locri Epizefiri* (1992), tab. 8 (Epizephyrian Lokroi).

[22] On costs of statues, Wilhelm, *Inschriftenkunde*, i. 287; *Neue Beitrae*, vi. 27–9 (reproduced *Akademieschriften*, i. 318–20), Gauthier, 'Parnassas'. I have not seen L. B. Stenersen, *De historia variisque generibus statuarum iconicarum apud Athenienses* (Christiania, 1877), 127. For the cost of statues of the Roman emperor, Højte, *Roman Imperial Statue Bases*, 52–6 ('most fall within the range of 2000 to 8000 sesterces').

[23] Wilhelm, echoing Holleaux, proposed to see the 200 drachmas mentioned in a decree from Abdera (*Inscr. Thrac. Aeg.* E 9) as the price of a gilt painted portrait, Ἀλεξανδρείων δια[κοσίων], but the text is perhaps Ἀλεξανδρείων δρα[χμῶν] *figure* for a gilt-bronze statue.

information for marble statues (which were no doubt cheaper than bronze in places with a good local supply of marble and local sculptors, such as Paros or Aphrodisias).[24] At the other end of the spectrum, the costs involved in such variants as gilt-bronze statues, equestrian statues, honorific columns or pilasters, colossal statues, or multi-statue groups, were certainly much higher than the 1,900–3,000 drachmas range adumbrated above. The sums involved are undoubtedly important in light of what we know of salaries in the Hellenistic period;[25] they are still dwarfed by the figures known for large benefactions and foundations, and important building work such as fortifications.[26] It is true that, in straitened conditions, communities would find it difficult to fund honorific portraits: elite financing became increasingly attractive in the late Hellenistic period, with the financial struggles on the part of the *polis* and the rise of super-rich benefactors (the two factors may be linked). Another solution is the reuse of previously dedicated honorific monuments, as was carried out by the Oropians in the first century BC, when they re-emerged after a period of Eretrian domination, and no doubt their fledgling, renascent public finances were too weak to finance new honorific statues to match the Oropians' perceived need, practical or symbolical, to grant statue honours to powerful figures in their world, namely Roman officers in Greece;[27] no doubt the gesture also marked a break with the high Hellenistic past, embodied by the public honorific statues set up by the Boiotian League.

The dedication of the statue may have offered the occasion for further civic ritual: this is suggested by the euergetical gestures (sacrifices, offerings of sweet wine) accomplished by benefactors such as Soteles of Pagai, or Archippe of Kyme, when their own statues were set up.[28] Soteles admittedly had paid for his own statue, and his benefactions have an air of auto-celebration; Archippe, however, had not paid for her statue (and those of her relatives, which the city set up at the same time); her benefactions involved and displayed civic institutions such as the boule, the tribes, and the metics, all three bodies receiving gifts for sacrifices and feasting. The style of event is typical of the late Hellenistic period[29] (and continues into the Roman imperial period with distributions of cash),[30] but might be an evolution of earlier practices of marking the 'dedication' (if not quite the modern-style 'inauguration' or 'unveiling') of an honorific monument. Similarly, ritual gestures such as cleaning or crowning surrounded the statue of a tyrannicide, Philitas, at Erythrai,[31] and may be implied by the groove surrounding

[24] O. Rubensohn, 'Parische Künstler', *JDAI* 50 (1935), 49–69; Smith, *Roman Portrait Statuary form Aphrodisias*, iv. 29.

[25] The oft-quoted figure is the range of yearly salaries for educators in early 2nd-cent. Teos (*Syll.* 578) of between 500 and 600 drachmas, comparable to the 30 or 40 drachmas per month paid at Miletos at the end of the 3rd cent. (*Syll.* 577); see J. D. Sosin, 'Accounting and Endowments', *Tyche*, 16 (2001), 161–75. The accounts from Delos, studied by Feyel, *Artisans*, further give a sense of costs and casual salaries on Delos. This is not the place to go into the details of Delian economic history, on which see still G. Reger, *Regionalism and Change in the Economy of Independent Delos, 314–167 BC* (Berkeley, Calif., 1994).

[26] F. G. Maier, *Griechische Mauerbauinschriften* (Heidelberg, 1959–61), ii. 66–8 (for instance a single tower might cost up to 9,000 drachmas, one and a half talents). At Miletos, the foundation that provided the income for the teachers (previous note) was based on a donation of 10 T—enough to pay for the installation of perhaps thirty full-size bronze statues with their bases.

[27] *Oropos* 433–51; Brélaz and Schmid, 'Nouvelle dédicace', 250–1, write as if the Oropians merely reused the shafts of the bases of the numerous equestrian monuments, to install new statues (and new crowning blocks, which matters for their attempt at typological dating by moulding shape). This is incorrect, since reuse of the statue involved reinscription, and at the most changing the features of the statue: Blanck, *Wiederverwendung*, and Perrin-Saminadayar, '*Aere Perennius*'. Hence the unsettling effect of reuse: Platt, 'Honour Takes Wing'.

[28] *IG* 7.190 with Wilhelm, *Abhandlungen*, i. 272–3; *I. Kyme* 13.

[29] For similar late Hellenistic feasts, and the relations they construct between elite and community, see *Inschr. Priene* 108, 109, 112, 113, with P. Hamon, 'Le Conseil et la participation des citoyens: Les mutations de la basse époque hellénistique', in P. Fröhlich and C. Müller (eds), *Citoyenneté et participation à la basse époque hellénistique* (Geneva, 2005), 127–9, Fröhlich, 'Dépenses publiques', 238–45.

[30] *Inschr.* Magnesia 179, 193 (distribution of oil); *SEG* 54.724 (Rhodes, 3rd cent. AD). Examples are gathered in Wilhelm, *Abhandlungen*, iii. 635–6.

[31] *Syll.* 284.

the late Hellenistic portrait head found at Pergamon (the so-called 'Diodoros Pasparos').[32] Such gestures acted to confirm the embedding of the honorific portrait monument within the 'cold city' of ritual and repeated time, and its function as the visible mobilization of civic institutions at work.

Even if the cost of statues was clearly significant,[33] it is excessive to state that honorific portraits were granted by communities lightly, in the expectancy that the honorands would invariably pick up the cost, or without serious thought about financing.[34] Admittedly, in a first-century decree from Messene, it is only the phrasing that implies that a bronze statue decreed by the council and the people, and inscribed in completely normal style ('The city (has set up) Aristokles . . .') was in fact set up, and hence paid for, by the honorand himself: ἐξέστω αὐτῶι στᾶσαι τὰν εἰκόνα πρὸ τοῦ ἀρχείου κτλ., 'let it be possible for him to set up the statue in front of the office'.[35] However, the way in which, in the second century, honorands are seen to pay the cost of their public statue as an explicitly noteworthy service (after public pressure or negotiation)[36] argues against undisclosed routine private financing by honorands earlier in the Hellenistic period. The practice of financing honorific monuments by friends (possibly attested as early as the third century),[37] or by 'promises' in the assembly, in the style of public subscriptions, might be interpreted as a step towards private financing:[38] presumably the honorand could 'promise' to provide funds for the statue. Even so, the process embedded the possibility of self-financed public honorific monuments back within civic institution and ritual. Honorands are attested, in the second century, intervening in the process of public commissioning, as collaborators with the commission[39] or as the actual recipient of public monies for the execution of the statue and the monument—monies which they probably could complete out of their own funds.[40] This practice has earlier parallels in fourth-century Athens, where civic bodies could honour individuals with small sums (say 30 drachmas) towards dedications and sacrifices: the individual takes on the practical aspects of these gestures.[41] The involvement of honorands can thus have civic meanings; nonetheless, it allowed private actors to shape the meanings and the forms of public monuments. At Klaros, the Kolophonian notable Polemaios, while topping up public funds, may have decided on the strikingly assertive form of the monument—a statue on top of a column (Fig. 1.7), imitated by his contemporary Menippos (Fig. 2.3). In first-century Messene, one Aristokles, honoured by a publicly decreed statue which he paid for himself, asked for a meaningful location (in front of the office of the secretary of the council), which he duly obtained.[42] These processes hint at the significance of the evolution, namely at the gradual emergence of the practice of direct elite financing in the later Hellenistic period; they also explain the continued public financing earlier in the period, as a way of keeping control of monumentality and public space in the city.

[32] Stewart, *Greek Sculpture*, 232 and fig. 872; regular crowning of a statue figures in Michel 1065 (Technitai of Dionysos), discussed with parallels in Wilhelm, *Abhandlungen*, i. 659.

[33] The orator Dio Chrysostom imagines the Rhodians protesting about the expense involved in having new honorific statues made (31.41), in response to his reproaches about their practice of rededicating old honorific statues to new honorands.

[34] Thus Perrin-Saminadayar, '*Aere Perennius*'.

[35] *ISE* 136 (in the preliminary resolution by the council). The Macedonian Asandros had likewise been granted permission to set up his equestrian statue wherever he wished in Athens (but not next to the Tyrannicides), *IG* II². 450: this event is exceptional, and reflects the exceptional pressures on Diadoch-era Athens (314/3 BC).

[36] Above, n. 7.

[37] Wilhelm, *Inschriftenkunde*, i. 287, perhaps in the Halikarnassian decree for Diodotos.

[38] *I. Stratonikeia* 7 (decree of the *Koinon* of the Panamareis, early 2nd cent.): the *telesma* for a statue of Leon, son of Chrysaor, is to be provided *ex epangelias*.

[39] *IG* 9.2.66A: the commission of three men is joined by Philon, one of the honorands (in fact the son of the main honorand, Polyxenos).

[40] At Kolophon, public monies were given to Polemaios for him to take care of the erection and the dedication of his monument: *SEG* 39.1243, col. V, ll. 48–53.

[41] Wilhelm, *Inschriftenkunde*, ii. 42; *Urkunden dramatischer Aufführungen in Athen* (Vienna, 1906), 233, quoting S. B. Franklin, 'Public Appropriations for Individual Offerings and Sacrifices in Greece', *TAPA* 32 (1901), 72–82.

[42] *ISE* 136.

The frequent silence about the details of the public financing of honorific monuments might be a choice on the part of certain city-states or political entities, conveying implied messages: a shift away from economic relation to symbolical balance, but also the city's insouciance about financial matters and hence its own wealth—which is also a way of re-establishing the symbolical balance in dealing with elite individuals. In the case of larger *poleis*, such as Athens, Rhodes, or Miletos, especially with a local artistic tradition and a population of artists, coming up with the few thousand drachmas necessary may in fact not have been a grievous item of expenditure, and the voting of honorific portrait monuments by the assembly may have been a financially realistic gesture. The 153 youths frequenting the gymnasion of Kolophon at the end of the third century BC could come up with the funds to pay for a statue for their gymasiarch: if the statue cost 2,000 drachmas, the cost would have been 13 drachmas each, a moderate sum which gives a sense of the affordability of the statue as an artefact.[43]

Sometimes honorific statues could be set up with surprising swiftness. The Boiotian Confederation voted a statue for Antiochos III, in winter 192/1 when the king spoke before the Boiotians at Thebes; the statue was set up in time to provoke Acilius Glabrio's anger when he saw it at Koroneia, in the aftermath of the defeat of Antiochos at Thermopylai in spring 191—in other words, this particular statue was set up in six months or less.[44] But generally, honorific statues could take time, even for big cities. The citizens of Byzantion voted honorific portraits for Prousias I, king of Bithynia—but took their time to set them up, which the king held against them as a *casus belli*.[45] The citizens of Byzantion almost certainly did not intend to slight Prousias: the honorific decisions took a stately pace of implementation, which was nothing unusual for a Hellenistic city-state. Byzantion was honouring a foreign ruler; the citizens of Ptolemais in Upper Egypt, on the other hand, decreed a statue for their own ruler to be set up in their gymnasion—and failed to set it up, which prevented them later from setting up the statue of a gymnasiarch before settling the matter of the statue of the king (the sale of citizenship, mentioned above as a financial expedient, was decreed in response to this situation).[46] The Prienians voted a statue for the Seleukid Friend Larichos—the process of setting this up took enough time for them to change their mind about the site for the statue.[47] At Theangela, the appointment of a commission and the decision to free funds for an immediate down payment (below) may have been meant to demonstrate the city's serious intent to get the statue done—to an important figure, namely a local representative of (probably) the Ptolemaic state.

Even slower than the Prienians in making up their mind about Larichos' statue was the process involved in honouring the Kydoniate Eumaridas (discussed above). The decree in his honour stipulated a bronze statue on the Akropolis, and was passed in 227 BC (in the archonship of Heliodoros, in Thargelion); in 221 (Anthesterion, in the archonship of Arche-laos), the Athenians decided 'to grant Eumaridas the setting up of the statue, that the people decreed earlier, (now to be set up) in the shrine of the Demos and the Charites, as Eurykleides and Mikion request in his favour'. This does not mean that the statue had been set up on the Akropolis, and then was moved down to the new shrine near the Agora, but that the statue, six years later, had not yet been put up: the delay allowed the Athenian politicians Eurykleides and Mikion to develop the idea of moving the statue to what they considered a more suitable spot, the new shrine where foreign benefactors could be meaningfully honoured.[48] The specification of legal delays for officials of second-century Megalepolis to put a statue and its base out to

[43] *SEG* 55.1251.
[44] Liv. 36.6; 36.20.
[45] Polybios 4.49.
[46] *SEG* 8.641; above. n. 19.
[47] *Inschr. Priene* 18, Gauthier, 'Larichos'.
[48] *Syll.* 535 (from *IG* II² 844), also in Bielman, *Retour à la liberté*, no. 31; the dates from Meritt, 'Archons', and Osborne, 'Archons'; but see now N. Papazarkadas and P. J. Thonemann, 'Athens and Kydonia: Agora I 7602', *Hesperia*, 77 (2008), 73–87. On the site of the statue, above, Chap. 3. Generally, see Perrin-Saminadayar, 'Aere Perennius'.

contract presumably aimed at avoiding the implementation of the honorific decision getting lost in the leisurely and syncopated processes of civic administration (with its principles of rotation and collegiality).⁴⁹ These leisurely rhythms show the long-term nature of the honorific monument, but should not be exaggerated: there seems to be nothing to parallel the extreme example of delays encountered by a colossal bronze equestrian statue of Louis XIV, decreed by the États-Généraux of Burgundy in 1686 and set up sixty-two years later.⁵⁰

Cities sometimes owned up to the difficulties of producing the honorific monument, by distinguishing between the honorific gestures which could be accomplished 'at present' (ἐπὶ τοῦ παρόντος) and the deferred dedication of a statue, to be carried out when finances allowed. This can be seen in a third-century decree from Istros for a benefactor, Dionysios, honoured with praise, inscription as a benefactor, and a bronze statue; 'for now', the decree will be inscribed on a *stele*, and later, 'once the statue is set up' (σταθέντος δὲ τοῦ ἀνδριάντος).⁵¹ As discussed above (61), in 95 BC, the *neoi* of Thessalonike honoured their gymnasiarch, Paramonos, with a crown of foliage, a bronze statue, and a full-size painted portrait; however, their treasurers paid out κατὰ τὸ παρὸν, 'for the time being', the sum for the painted portrait and the *stele* on which the decree was inscribed.

A cynical interpretation would be to see such moments as admissions of financial shortfall, and silent pleas for the honorands to step in; which, indeed, was a possible, and increasingly frequent, outcome. But the record of cities taking their time to set up honorific statues hints at a different interpretation. The point of the honorific monument is not, or not just, the satisfaction of the honorand. Its first goal, as the ultimate form of the honorific gesture, is to display collective agency, in the interplay of benefaction and reciprocity, and in the working of institutions within civic ideology; its second goal is to create monumental reminders of recompense, and hence feelings of emulation, in the viewer. In this respect, timeliness is perhaps not the most important concern: it may matter to the individual honorand (hence the anger of Prousias I at not seeing his honorific statues spring up in Byzantion), but the community and its monuments exist in a different sense of time, where taking years to set up a monument decided on collectively, and already satisfyingly celebrated through proclamation and inscription, is not a pressing problem. The intention of the monument is to set out community-creating and community-reinforcing political parameters for the interaction with powerful outsiders, especially rulers and later governors, and with members of the community. The statue is part of a whole honorific transaction which lies in the realm of political work: in that respect, deliberating, then deciding, on an honorific statue, proclaiming it, inscribing the narrative of good behaviour framed in terms of collective norms, then of purposeful decision-making and the working-out of the decision within the rule of law and the play of institutions—all these mattered as much as the actual bronze, marble, or wooden artefact.

2. ARTWORK

But of course, the honorific portrait existed, after various more or less long drawn out processes, as a material object. The decrees sometimes gave brief indications about the statue—starting with the simple stipulation that it should be ὡς καλλίστη, as fine or as beautiful as possible. The citizens of Sestos, when honouring the benefactor (and gymnasiarch) Menas, in the late second century, accepted that he would pay for his statue, but punctiliously enjoined that he should take care that the statue should be as fine as possible. Other examples of such

⁴⁹ IG 5.2.437 (restored in 436) with Robert, OMS i. 243: rather than an honorific column ([κι]όνα), restore στᾶσαι δὲ (αὐτοῦ) εἰκ]όνα).

⁵⁰ S. A. Callisen, 'The Equestrian Statue of Louis XIV in Dijon and Related Monuments', Art Bulletin, 23 (1941), 131–40. The monument, nearly 30 tons in weight, was finished in 1692 and transported from Paris to Burgundy, where it languished in a village barn until 1720, when it was carted to Dijon; after some years spent in storage, then more years on a temporary base, it was erected on its permanent base in 1748 (only to be knocked off in 1792).

⁵¹ ISE 128.

indications are the early Hellenistic Prienian decree for Megabyxos, the priest of Artemis at Ephesos, and the Parian decree, passed *c*.150, for the Ptolemaic courtier Aglaos of Kos.[52]

The Parians also specified the size of the statue: 4 cubits, slightly over life-size, of a type known archaeologically: the 'Terme Ruler' now in Rome, the male bronze statue in the sea off Adana, the bronze 'Lady of Kalymna', or the marble 'Arundel Homer' now in the Ashmolean Museum are examples; this may have been the normal size of honorific statues.[53] This type of practical note is occasionally found in honorific decrees; it is mostly concentrated in the second century, and in the 4–5-cubit range[54] (an exception is the pair of statues of the Demos of Alabanda/Antiocheia and of Antiochos III, set up by the Delphic Amphiktiony in 201: each was 8 cubits tall).[55] These give a quick practical indication of a specific kind of statue desired by the community as they chose what practical form to give the concrete portrait, among a range of possibilities. The specification of size probably reflected the choice for an unusually large statue (ranging from slightly above the *c*.2 m norm to the colossal, say around 3 or 4 m tall); more usually, decrees do not specify size, only the material (bronze or marble), and in the absence of indication, the statue can be supposed to have been a 'life-size', or slightly over-life-size, image. In the case of painted portraits, the indication of a full-size image (as in the case of the gymnasiarch Paramonos, honoured at Thessalonike: above)[56] implies that the honorific *eikon grapte* was customarily a small-size bust portrait, to fit within the frame, often said to be a round 'shield' (*hoplon*).

Equally unusual, and uninformative, are indications on the type and appearance of the statue: the statue of Attalos III standing on top of spoils, indications of the wearing of armour or the holding of a sceptre, the description of cult-statues of Antiochos III and Laodike as ἱεροπρεπέστατα, 'most suitable for their sacred nature', are very rare and mostly concern royal portraits, important tokens in the transaction between city and ruler, and hence the object of care and thought; or else they represent fighting heroes of the Hellenistic cities.[57] Another example of a brief note on type comes from Didyma, where the people of the Milesians honoured one Autophon with a gold statue and an εἰκόνι χαλκῆι προφητικῆι, 'a bronze statue showing him as the prophet (of Apollo of Didyma)'—no doubt wearing his priestly costume and crown.[58] A second-century decree from Kos mentions the attitude (σχῆμα) and the dress (στολά) of the statue—but probably leaves these matters to be decided by the *prostatai* in charge of the statue.[59] Later, in the Roman imperial period, short indications of type appear: men and women are honoured with 'the statue of education' or 'the statue of excellence' or

[52] *OGIS* 336; *Inschr. Priene* 3, l. 9; *SEG* 33.682, l. 22. And also *SEG* 50.1195 (early: akrolithic statue of Philetairos at Kyme); *SEG* 41.1003 I, l. 44 (of cult-statues of Antiochos III and Laodike III at Teos); *Inschr. Priene* 108, l. 317 (bronze and marble statues) and 132, l. 11 (bronze statue), for late Hellenistic benefactors; *Inschr. Magnesia* 101, l. 22 (bronze statue of the demos of Magnesia, decree by the Larbenoi in gratitude for sending foreign judge); *ID* 1518 (bronze statues of Ptolemy VI, set up by soldiers).

[53] Smith, *Roman Portrait Statues from Aphrodisias*, 29–30: the 'normal' size for statues at Aphrodisias falls between 2 and 2.20 m.

[54] Wilhelm, *Beiträge*, 140–1, with examples; Holleaux, *Études*, i. 367 (6-cubit statue in *IG* 4.558B. Le Guen, *Les Associations de Technites dionysiaques à l'époque hellénistique* (Nancy, 2001), no. 36); G. Roux, 'Qu'est-ce qu'un κολοσσός?', *REA* 62 (1960), 39; Jacobsthal, 'Pergamon 1906–1907', 375, no. 1. and 379 n. 2 (Pergamon, gilt 5-cubit statues of Attalos III set up by gymnasiarchs); Höghammar, *Sculpture and Society*, no. 7. Generally, D. Kreikenbom, *Griechische und römische Kolossalporträts bis zum späten ersten Jahrhundert nach Christus* (Berlin, 1992).

[55] *OGIS* 234, l. 26.

[56] εἰκόνι γραπτῇ τελείαι in *IG* 10.2.4; the expression also occurs in *CIG* 3068 and 3085 (Teos), *TAM* 5.468B (Mysia Abbacitis), *I. Kios* 22, with R. Vallois, 'Les Pinakes déliens', in *Mélanges Holleaux* (Paris, 1913), 292, and Blanck, 'Porträt-Gemälde als Ehrendenkmäler', *BJb* 168 (1968), 3. *SEG* 6.814 (Le Guen, *Technites*, no. 66), a late 2nd-cent. decree of the Dionysiac Artists on Cyprus, mentions an εἰκόνα γραπτὴν ὁλοσώματον: a full-size, head-to-toe portrait, but was it full-size? A *bon mot* by Cicero implies the existence of over-life-size painted bust portraits (Macrobius, *Sat.* 2.5, with Blanck, above). I am not sure how to interpret the expression τε[λείοις ἀν]δριᾶσιν on an early imperial statue base from Didyma (*Inschr. Didyma* 261, with Robert, *Hellenica*, xi/xii. 454–6).

[57] *OGIS* 332; *IG* 11.4.566; *I. Tralleis* 18 (cf. *RC* 69). Also for statues in arms: *IGBulg* I² 315, 388bis, *IOSPE* I² 315.

[58] *Inschr. Didyma* 131, with Robert, *Hellenica*, xi/xii. 456–9.

[59] *IG* 12.4.1.65.

'a virginal statue'.[60] Such indications are lacking in the Hellenistic period, in spite of honorific statues following canonical types, for both male and female statues (see below, Chap. 8): type was taken for granted, or not considered part of the matters which needed discussing or recording. The gilt 'colossic' portraits attested five times in late Hellenistic documents are probably not 'types' of statues, as sometimes claimed, but oversize images like those discussed above.[61]

Very rarely, the world of the concrete making of a statue appears in the epigraphical evidence. The decree from Theangela, already discussed above, for a nameless benefactor (probably a royal official) mentions a sum of 400 drachmas to be paid out by the treasurer [εἰς] δὲ τὴν πλᾶσιν τῆς εἰκόνος, 'for the shaping of the portrait'. This is to take place after the contracting out of the ποίησις (if this is the correct supplement) of the statue, as an immediate down payment, before the source of income for the rest of the expense is determined by the next *prostatai* in office, who will hand over the monies to the treasurer to hold and pay over as necessary when the statue is completed. This 'shaping' of the statue must designate some form of preliminary modelling, in clay or wax. The same process appears in a Delian account (mentioned above), where 300 drachmas are seen to be lent from the temple treasury to the city, εἰς τὴν κήρωσιν τοῦ ἀνδριάντος οὗ ἀνατίθησιν [ὁ δῆμος βασιλέως Π]τολεμαίου, 'for the *kerosis* (*modelling in wax?*) of the statue [which the people] is setting up [of King P]tolemy';[62] the sum is too important for the mere maintenance (*ganosis*) of a statue (in addition, bronze statues do not need a protective coat of wax, but regular oiling alongside the removal of patina):[63] it must correspond to one of the preliminary operations in the lost-wax process. The next stage appears in a third-century decree from Miletos, where separate financial arrangements are made for the casting of the statue, probably after the first phases of modelling and moulding.[64] Similar arrangements might underlie the separate mention, on Rhodian statue bases, of the caster (his activity described with ἐχαλκούργησε, 'X worked the bronze'), singling out as a particularly important phase the complex and skilled process of casting the bronze parts that would make the finished product.[65]

[60] Robert, *OMS* vi. 22–3; *I. Kyme* 25 (in private honorific).

[61] *SEG* 33.1035, ll. 2–5 (Archippe); *SEG* 55.1503 (Xanthos), *IGR* 4.292, l. 24 (Diodoros Pasparos at Pergamon); *Sardis* 27 (Iollas of Sardeis); Bresson, 'Painted Portrait, Statues and Honors for Polystratos' (Apameia in Phrygia). Roux, 'Qu'est-ce qu'un κολοσσός', holds that the adjective describes a type, with legs joined together, and interprets the Pergamene and Sardian examples as 'honorific herms' of the hip-herm type (surprisingly followed by P. Baker and G. Thériault, 'Les Lyciens', 336; generally defended and elaborated, for the archaic and Classical periods, in N. Badoud, 'Les Colosses de Rhodes', *CRAI* (2011), 110–50, with the correct observation that the meaning 'big' for 'kolossic' is only clearly attested in the late Hellenistic period). Roux's argument is that the expression χρυσῇ κολοσσικῇ in the Sardian decree for Iollas designates a statue of solid gold, and hence a small-scale, herm-like image; likewise, he held that the portraits of Diodoros Pasparos set up on στυλίδες must have been small-scale solid gold. These interpretations cannot hold: the portraits were large-scale gilt statues (as in the case of the 5-cubit gilt statues set up in the gymnasion of Pergamon: above, n. 53), which there is no reason to interpret as huge archaizing 100% gold 'honorific herms'. The statue of the Demos of Mylasa crowning Olympichos was 5 cubits tall, and is a colossal statue in a *parastema* (Isager and Karlsson, 'Labraunda'). The 'colossal' image of the Demos crowning Archippe was not a herm-like image of the People, but a statue larger than the statue of Archippe. See already, and still, M. Dickie, 'What is a Kolossos and How were Kolossoi Made in the Hellenistic Period?', *GRBS* 37 (1996), 237–57; and now Bresson, 'Painted Portrait, Statues and Honors for Polystratos'.

[62] *ID* 290, l. 130, with Marcadé, *Au Musée de Délos*, 85.

[63] *Syll.* 284 is clear on the need to remove ἰός. T. Homolle, 'Comptes et inventaires des temples déliens en l'année 279', *BCH* 14 (1890), 496–9: *ganosis* involved scouring with natron, then spongeing on oil, rose perfume (for marble), and (admittedly) wax, before a final buffing with cloth.

[64] *Milet* 6.3.1026, ll. 87–10: τὸ δὲ ἀργ[ύριον τὸ μὲν εἰς τ[ὴν εἰκόνα ἐ]ξελ[εῖ]ν τοὺς ἀνατάκτας, [το δὲ] εἰς το[ῦ ἀνδριάντο]ς τ[ὴν] χαλκουργίαν τοὺς [ταμίας ὑπερετῆσαι, μερισθέντων] τῶ[ν] ἄλλων ἀ<να>λωμάτων, ('as for the monies, let the *anataktai* set aside the monies for the [likeness], and let the [treasurers] take care of the expenditure for the bronze-working of the [statue] once the other items of expenditure [have been assigned]'). The restorations, by P. Herrmann, are very attractive, notably in the distinction between the 'likeness' and the concrete statue.

[65] V. C. Goodlett, 'Rhodian Sculpture Workshops', *AJA* 95 (1991), 676; G. Zimmer and K. Bairami, *Rhodiaka ergasteria chalkoplastikis* (Athens, 2008).

Makers of images did appear: if not casters, at least sculptors, whose signatures occasionally complete the inscribed statue bases. In spite of the absence of specific attention or information on the part of the inscribed decrees, archaeology and comparative evidence from the modern period gives some idea of what they did, when contracted by cities to give materiality to civic purpose and social text. Most frequent will have been the complex processes involving bronze statues, made with the indirect lost-wax technique, which we can reconstruct from archaeo-logical evidence, technological probability, and modern parallels (Fig. 7.1).[66] In this process, a model was built up in clay over an armature, and probably fired. Next, a series of separate, multi-parted piece moulds was taken of this clay model's parts. These intermediate moulds were lined with a fine layer of wax, brushed on molten, or pressed in as thin sheets,[67] in order for each to leave the artist with a hollow wax positive (reproducing the clay model) which would be packed with, or fitted over, a core made of earth mixed with organic matter (horsehair, straw, wool, pistachio shells),[68] touched up,[69] and finally surrounded with a network of wax rods whose imprint would serve as pour channels and air vents.

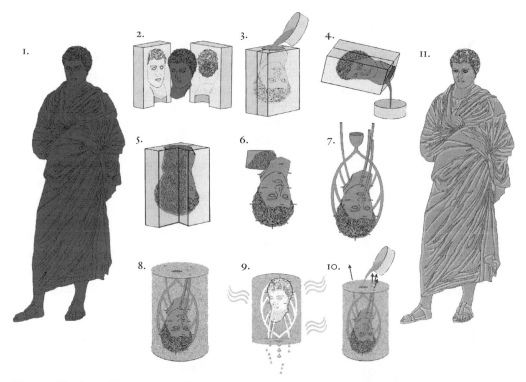

Fig. 7.1. The honorific statue was the result of a painstaking process of modelling and moulding, the 'indirect lost-wax' process. Original reconstruction by J. Masséglia.

[66] J. V. Noble, 'The Wax of the Lost Wax Process', *AJA* 79 (1975), 368–9; C. Mattusch, *Greek Bronze Statuary: From the Beginnings through the Fifth Century B.C.* (Ithaca, N.Y, 1988); G. Zimmer, *Griechische Bronzegusswerk-stätten* (Mainz, 1990); D. Haynes, *The Technique of Greek Bronze Statuary* (Mainz, 1992); B. Janietz Schwarz and D. Rouiller, *Ein Depot zerschlagener Grossbronzen aus Augusta Raurica* (Augst, 1996), 43–108; G. Zimmer and N. Hackländer (eds), *Der betende Knabe* (Frankfurt am Main, 1997); E. Formigli (ed.), *I grandi bronzi antichi* (Siena, 1999); Zimmer and Bayrami, *Rhodiaka ergasteria*. The yearly surveys of research by C. Rolley in *Revue Archéologique* (1983–2006) are invaluable.

[67] G. Lahusen and E. Formigli, *Römische Bildnisse aus Bronze* (Munich, 2001), 497–8. The imprint of wax sheets ('lasagne' in the parlance of Italian Renaissance artists) is visible in the inside of a bronze male torso in the Ludwig Collection, displayed in the Basel Antikenmuseum (no inventory number; I saw this in summer 2010).

[68] Lahusen and Formigli, *Römische Bildnisse aus Bronze*, 484–5.

[69] Modelling in wax in mentioned among the interests of the recluse Attalos III, along with casting (and hammering) bronze figurings: Justin 36.4.4.

Contrary to what is often written, I do not think that the wax positives were assembled into a full working model, further shaped by the sculptor, then taken apart again to be invested with clay (as argued by some):[70] if this model had been packed with a core (and supported by an armature), slicing through the thin (*c.*3–6 mm) wax layer and the coarse core (with its iron armature) would easily have damaged the modelling and posed serious technical difficulties; if this model had been left hollow, it would hardly have stood up, in Mediterranean conditions, and cutting it apart, even with heated tools, might have altered the shape, size, and proportions of precisely those parts that had to fit perfectly after casting.

The positives were invested with clay; each positive was coated with its clay shell, the latter being secured to the core by metal spacing pins (or 'chaplets') driven through the clay coating and the wax layer. All of these clay shells were fired in order to melt out the wax inside; the metal pins held the outer clay of the shell off the inner clay core. Molten bronze was poured through the network of channels into the thin cavities and empty layers left by the wax. The work of modelling, investing, and casting probably took place within large, specially dug casting pits.[71]

When cold,[72] the finished bronze parts would be broken free from the clay shells, rid of the casting channels and chaplets, checked for casting defects (which would be patched), and further reworked with punch and chisel. The various parts would be welded up with molten bronze directly poured on shallow cavities along the joins, together with other parts cast with the direct wax technique (for instance, complex drapery, fringes, or various parts of armour: *pteruges*, shoulder guards).[73] Special parts would be inset or inlaid: eyes with lashes (perhaps silvered), silver teeth, copper nipples, edging on clothes or weapons.[74] The bronze statue of Augustus/Octavian, found in the Euboian channel and now exhibited in the National Arch-aeological Museum in Athens, wears a tunic with two *clavi* inlaid in copper.[75] If desired, the statue might be gilded:[76] in the early Hellenistic period,[77] with gold foil anchored in grooves cut in the bronze surfaces, and in the late Hellenistic period, with gold leaf; the ease of the

[70] Thus Mattusch, *Greek Bronze Statuary, passim*; whence S. Hemingway, *The Horse and Jockey from Artemision* (Berkeley, Calif., 2004); *contra* Haynes, *Technique*. See also Zimmer and Hackländer, *Knabe*, 60–1.

[71] Zimmer, *Bronzegusswerkstätten*.

[72] On post-casting work, Lahusen and Formigli, *Römische Bildnisse aus Bronze*, 460–70, 481, 487–8, 500.

[73] On such parts, Ma, review of Katsikoudis, *Dodone*, in *BMCR* 2008.02.27.

[74] C. Houser, 'Silver Teeth: Documentation and Significance', *AJA* 91 (1987), 300–1. The sheathed sword found in the well in the northern part of the Athenian Agora (C. Houser, 'Alexander's Influence on Greek Sculpture as Seen in a Portrait in Athens', in B. Barr-Sharrar and E. N. Borza (eds), *Macedonia and Greece in Late Classical and Early Hellenistic Times* (Washington, DC, 1982), 230–4), with other debris from an equestrian, is adorned with gold strip—as, indeed, a real sword might have been (the sword from the tomb of Philip at Vergina is thus decorated: M. Andronikos, 'The Royal Tombs at Aigai (Vergina)', in M. V. Hatzopoulos and L. D. Loukopoulou (eds), *Philip of Macedon* (London, 1981), 224. Bronze lashes are well attested at Dodone (the finds are exhibited in the National Archaeological Museum in Athens, and noted in Katsikoudis, *Dodone*). The 'bronze sheets' exhibited in the Mycenae Museum among the finds from the (mostly unpublished) shrine of Enyalios at Asprochomata are bronze lashes from statues.

[75] Kaltsas, *Ethniko Archaiologiko Mouseio*, no. 664; Lahusen and Formigli, *Römische Bildnisse aus Bronze*, no. 24.

[76] On 'golden' (i.e. gilt) statues, see the Roberts, *BE* 76, 551, p. 530; 78, 40, p. 461; 82, 391, on an epigram from Kibyra, now *Steinepigramme*, iv, 17/01/01, where the sentiment is expressed that the honorand deserved a gilt statue (the same trope of drawing attention to the inadequacy of the actually offered honorific portrait appears in *Anth. Pal.* 16.36, with Mango, 'Epigrammes honorifiques', 24); Robert, *OMS* iv. 123–5; A. Cameron, *Porphyrius the Charioteer* (Oxford, 1973), 214–22; W. A. Oddy, M. R. Cowell, P. T. Craddock, and D. R. Hook, 'The Gilding of Bronze Sculpture in the Classical World', in *Small Bronze Sculpture from the Ancient World* (Malibu, Calif., 1990), 103–24; C. Ampolo, 'Onori per Artemidoro di Efeso: La statua di bronzo "dorata"', *Parola del Passato*, 63 (2008), 361–70. Lahusen and Formigli, *Römische Bildnisse aus Bronze*, 505–21, correctly note that the 'golden likeness' cannot have designated solid-gold images. They further argue that *eikon chryse* exclusively means a foil-gilt rather than a leaf-gilt image, but this is too restrictive. The solid-gold statue in Plautus, *Curculio* 439–41, must be a comic exaggeration.

[77] The leg of the equestrian statue, perhaps of Demetrios Poliorketes, found in a well in the north sector of the Athenian Agora and now displayed in the Agora Museum, illustrates the technique (above, n. 74): Camp, *Athenian Agora*, 138. The gold was stripped before the statue fragments were discarded, yet the grooves retain some of the foil. The statue of a king Antiochos decreed by the city of Ilion, if dated to Antiochos I, is another early example (*c.*275?).

latter technique may have contributed to the increasing frequent grant of gilt-bronze statues.[78] This work probably took place on temporary bases set up next to the casting pits.[79]

The honorific statues in marble (purely honorific, or set up in the context of cultic honours) were produced by the age-old techniques of stone working,[80] namely the use of a variety of specialized steel tools (roughly in order of intervention upon the stone): the point, the claw chisel, the flat chisel, the drill, the rasp. The statues were often made of several pieces of marble, pieced together (the sculpting of full-size or over-life-size marble statues out of single blocks only becomes the rule in the Roman imperial period).[81] The final product would be worked over with the rasp, and perhaps polished and finished with protective coats; the hair and the facial features would be painted, as well as drapery (in vivid colours in the case of female dress), often with the indication of motifs such as borders; highlights might be gilded.[82] The treatment of clothing offered scope for virtuoso effects, especially in the case of female dress, with the representation of thick folds seen underneath thinner mantels pulled coquettishly tight over the hip.[83] Marble honorific statues, like other marble sculpture, could be produced by the use of full-scale clay or plaster models in clay, whose proportions, stance, and features were transferred to the marble block with a system of measuring and pointing. In other cases, the marble honorific statue might be a reworking and finishing of a prefabricated figure roughed out in the round but in the merest outline (male, female) in the quarry already (as is attested for Archaic sculpture and for Roman sarcophagi).[84] Both paths are compatible: blocks could have been quarried and roughed out specifically for later finishing in relation to a clay model; or a clay model could be used to finish a pre-made 'rough' by scaling measures up or down, according to the available proportions.

Both bronze and marble statues would be fitted on a stone base, an architectural construction resting on a foundation course and an *euthynteria* course—the base itself could be monolithic, or an assemblage comprising the body of the base (a single block, or several orthostates clamped together), and the crowning course on which the statue stood.[85] As discussed above (Chap. 1, 38–45), the base was slightly adorned, with mouldings and crisp lines, sometimes contrasting with planes left stippled by the claw chisel. The base's multilayeredness literally heightened the statue, and marked it out from its surroundings; its surface bore the writing which gave meaning to the statue; the base thus united the image and the text

[78] The bronze statue found near Adana (Fig. 8.1) probably preserves traces of gilding (C. Brüns-Özgan and R. Özgan, 'Eine bronzene Bildnisstatue aus Kilikien', *Antike Plastik*, 23 (1994), 81–9; B. S. Ridgway, *Hellenistic Sculpture*, iii. *The Styles of ca. 100–31 BC* (Madison, Wis., 2002), 123–4; it is the earliest preserved leaf-gilt statue (whatever its date), earlier than the group found at Cartoceto (late republican or Julio-Claudian? R. R. R. Smith, review in *JRS* 82 (1992), 273; J. Pollini, 'The Cartoceto Bronzes: Portraits of a Roman Aristocratic Family of the Late First Century BC', *AJA* 97 (1993), 423–46; Lahusen and Formigli, *Römische Bildnisse aus Bronze*, no. 17).

[79] Zimmer and Hackländer, *Knabe*, 56–7, 59 (examples from Rhodes and Demetrias).

[80] S. Adam, *The Technique of Greek Sculpture in the Archaic and Classical Periods* (London, 1966); O. Palagia, 'Marble Carving Techniques', in O. Palagia (ed.), *Greek Sculpture: Function, Materials, and Techniques in the Archaic and Classical Periods* (Cambridge, 2006), 243–79; for the Hellenistic period and local 'schools', A. Linfert, *Kunstzentren hellenistischer Zeit* (Wiesbaden, 1976); A. Stewart, *Attika: Studies in Athenian Sculpture of the Hellenistic Age* (London, 1979), e.g. 104–5.

[81] Adam, *Technique*, 104–5, for an early 1st-cent. example from Rheneia; R. Jacob, 'Les Pièces rapportées dans la statuaire attique en marbre du IVe siècle avant J.-C.', *Bulletin Archéologique*, 30 (2003), 41–54; Dillon, *Female Portrait Statue*, 17–18, with striking examples: the privately dedicated statue of Aristonoe, priestess of Nemesis at Rhamnous, had its arms and head carved and added on separately; in the case of the head, a swell on the neck joined with drapery on the trunk, thus contributing to camouflaging the join.

[82] Queyrel, 'Ofellius Rufus', 409–10 (lines and border picked out in colour on late 2nd-cent. marble statue on Delos); B. Bourgeois and P. Jockey, 'Le Geste et la couleur: Stratégies et mises en couleurs de la sculpture hellénistique de Délos', *Bulletin Archéologique*, 30 (2003), 65–77. On female costume and polychromy, and its social meanings, Dillon, *Female Portrait Statue*, 6 and n. 288.

[83] Dillon, *Female Portrait Statue*, ch. 2.

[84] D. Boschung and M. Pfanner, 'Les Méthodes de travail des sculpteurs antiques et leur signification dans l'histoire de la culture', in M. Waelkens (ed.), *Pierre éternelle: Du Nil au Rhin* (Brussels, 1990), 128–42.

[85] Jacob-Felsch, *Statuenbasen*, and Schmidt, *Hellenistische Statuenbasen*, with close attention to ornament and typology; Dillon, *Female Portrait Statue*, 27–38; also Gerstein (ed.), *Display and Displacement*.

into a single monument. The actual height of the base varied, according to the size and nature of the statue. The surviving element is usually the main shaft of the base, of modest size and hence misleading as to the full effect of the original base; all the same, the complete bases, with bottom and crowning courses, reached a height around 1.5–1.8 m—enough to emphasize the statue, but not to create the kind of extravagant, ornate, tall confections such as became current in Western Europe from the modern period onwards,[86] though occasionally more elaborate bases were used: columns, pillars, ship-shaped constructions, and the multi-statue base with a bench, which modern archaeologists call 'exedra'.[87]

The construction of the base needed specific attention, as a piece of architectural work.[88] It is sometimes explicitly mentioned in decrees, after the grant of a statue; at Athens, the commission in charge of honours for Antigonos Doson were told to take care of 'the statue and the base' ([τῆς εἰκόνος] καὶ τοῦ βήματος).[89] In practice, the presence of a well developed statue habit, and its paraphernalia, helped. At Kaunos, the two sons of a Roman official were honoured with statues, standing on either side of their father's equestrian statue;[90] the cylindrical bases for these two statues, set up at the same time, are slightly different in mode of construction: one was put together with the usual separate elements (base shaft clamped to block), the other, more unusually, was monolithically carved out of a single block, shaped to look like the cylindrical shaft and its parallelepipedal plinth. This suggests that the bases were perhaps not made specifically for these statues, but put together from pre-existing, prefabricated elements. Such elements might be exemplified by the profusion of uninscribed mouldings and crowning blocks found in the excavation of the shrine of Halios at Rhodes.[91] Once the base was built up, the statue would be fixed to the crowning course with lead, under the soles of standing bronze males, around the edges of draped bronze females;[92] a foot (literally the sole remnant of a male statue) in the museum on Delos, or the two feet of the Antikythera 'philosopher', illustrate the practice.[93] Marble statues would also be fixed with lead, to bond the plinth on which the statue stood, to a cavity in the base: the statue of the priestess Aristonoe set up in the temple of Nemesis at Rhamnous, or the statue of a young man, Kleonikos, set up in the gymnasion of Eretria, were fixed in this way.[94] At some point during the process, perhaps at the end, the statue base would be inscribed—with the short or long texts that have been studied in the preceding chapters.

No honorific painted portrait survives from the Hellenistic period, though they were plentiful:[95] the numerous painted shields attested in the inventory of the Delian gymnasion might be (private?) honorific portraits.[96] Later funerary portraits from Roman Egypt give a sense of technique—encaustic (pigments mixed with hot wax), tempera (pigments in egg yolk), or a combination of both. A scene on a painted sarcophagus (first century AD?)[97] from Pantikapaion (Kerch) shows a painter working at his easel (he is heating a metal instrument for encaustic work), surrounded by portraits (Fig. 7.2), including some on round supports which

[86] Hall, *World as Sculpture*.

[87] Jacob-Felsch, *Statuenbasen*; von Thüngen, *Exedra*. Ships: *IGBulg* I² 388bis, *Inscr. Lindos* 1.169; *Guide de Thasos2*, 37.

[88] Schmidt, *Statuenbasen*, 206–7, on the principles of construction involved; Courby, *Portique d'Antigone*, 90.

[89] *IG* II² 793; also *IG* 5.2.437.

[90] *Inschr. Kaunos* 103–4.

[91] Kontorini, 'Damagoras', 85 n. 6, referring to G. Konstantinopoulou, 'Anaskaphai eis Rodon', *Praktika* (1975), 238–48, with fig. 219a, 220b, 221a.

[92] Many examples illustrated in *Inscr. Lindos*; 1.132, 142B, and 2.347 for the edge-fixing of the bottom of bronze female statues (further examples in Dillon, *Female Portrait Statue*, 186 n. 89). See Haynes, *Technique*; F. Willer, 'Beobachtungen zur Sockelung von bronzenen Statuen und Statuetten', *BJb* 196 (1996), 337–70.

[93] Antikythera feet: Kaltsas, *Ethniko Archaiologiko Mouseio*, no. 575 (X 15090–1).

[94] Below, Chap. 8.

[95] Blanck, 'Porträt-Gemälde'.

[96] See Moretti, 'Gymnase'. Could these be painted shields for athletic contests?

[97] M. I. Rostovtzeff, *La Peinture décorative antique en Russie méridionale: Saint-Petersbourg 1913–1914* (Paris, 2003–4), 474–90, with commentaries by A. Barbet (491).

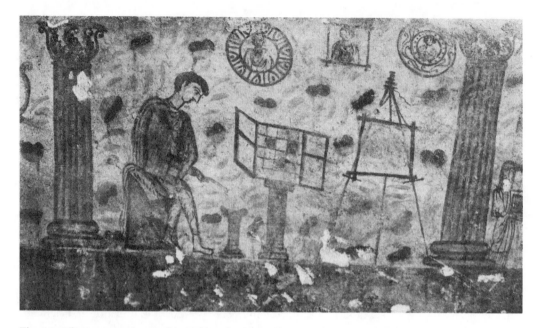

Fig. 7.2. The processes involved in making the painted honorific portrait are less well known than those of bronze and marble statuary; a rare image of a painter at work shows him making the painted portrait panels that were used for honorific portraits, public and private. Kertch, 'sarcophagus found in 1900', with interior painting; first century AD? (from M. Rostovtzeff).

clearly have the ornamentation typical of the Macedonian shield; however, it is unclear whether such 'portraits on shields' (*eikon enoplos, eikon en aspidio, eikon enaspidios*) were painted on actual bronze-faced shields (of traditional hoplitic type, or of Macedonian type), or wooden panels shaped like shields and preserving shield-like decorative features (I favour the latter, on grounds of practicality and expense). Two other paintings, or rather a painting and a blank on the painter's easel, on the same fresco, are contained within rectangular frames with the mortised rods crossed and protruding, of the 'Oxford type' known from the Fayoum.[98] The 'Fayoum portraits' further suggest that the support, if wooden, would be thin panels of fine wood, for instance limewood. Some painted portraits were 'gilt', *epichrysos*:[99] the adjective designates the leaf gilding, or the blocking out with gold pigments, of the background surrounding and delineating the figure, a practice which Orthodox icons might help us imagine. Other portraits probably had a unified dark or blue background (also attested in Byzantine portraiture, and perhaps descending from the Hellenistic painted portrait).[100]

The practical art processes led to outcomes on the ground: bases, dedications in sacred or civic buildings (see next section). These outcomes involved a particular official, the *architekton*, or public architect. The architect certainly played a role in placing the statue, and perhaps with the processes of building up the base on top of foundations dug within public sites. He also may have taken an interest in the actual processes of statue making: at Bargylia, the *architekton* was involved in the casting of a silver fawn (costing 1,200 drachmas) in honour of Artemis,[101] and even though there is no direct testimony, such public officials, alongside statue commissions, may have supervised or helped the casting of bronze honorific portrait statues.

[98] J. Fenton, *Leonardo's Nephew: Essays on Art and Artists* (London, 1998), 37 (on surprisingly elaborate frames, perhaps fronted with glass); Barbet (above, n. 97).

[99] *IG* II² 1048, *IG* 5.2.269; *I. Iasos* 98.

[100] D. V. Ainalov, *The Hellenistic Origins of Byzantine Art*, tr. E. and S. Sobolevitch, ed. C. A. Mango (New Brunswick, NJ, 1961), 210–14.

[101] *SEG* 45.1508.

3. THE ART WORLDS OF THE HELLENISTIC HONORIFIC STATUE

Processes of making, under the eye of the commissioners and the supervision of the public architect, were carried out locally: here is the dimension where the political work of institutions in action and the art work of technology and making come together, illustrating how the commission of honorific statues, as a major source of artistic patronage in the Hellenistic period, operated in practice.

The local nature of the process is indicated by the evidence of casting pits (Fig. 7.3): archaeologically excavated examples are located close to the sites where statues were eventually set up, no doubt to minimize transport costs and facilitate work; they were dug out and used for a specific statue, probably as a one-off, and filled in after use.[102] If such casting pits reflect normal practice (and their number on Rhodes, a statue-rich island, suggests this was the case), the archaeological evidence (admittedly incomplete) suggests that normally commissioning a bronze statue was not a matter of finding an artist in his workshop-studio or foundry and ordering a work of art to be delivered, but of inviting an artist to come to the community that commissioned the statue, and to work the latter up on the spot, in a temporary workshop. At Kassope, a casting pit was dug close to the agora (in fact under the shelter of the *propylon*); in Demetrias, casting installations were set up in the disused palace (after 167), in order to produce an equestrian monument that might have been destined for the nearby agora.[103]

The local nature of work and workshop has implications for the economics of the bronze honorific statue. As mentioned above, the figures of *c.*2,000–3,000 drachmas do not corres-

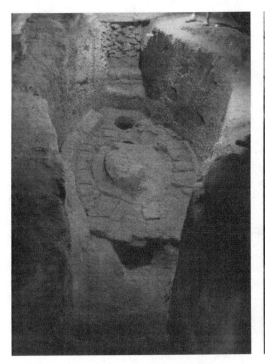 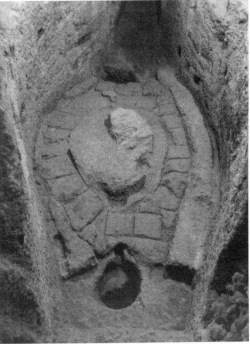

Fig. 7.3. The casting pit was the scene of the spectacular process of making the various metal parts that would be assembled to produce the bronze honorific statue. Excavated casting pit, Rhodes (Mylonas plot), third century BC. Length of the pit: 11 m preserved (original was longer); w. 3.5 m at widest point. Photogr. G. Zimmer.

[102] Zimmer, *Bronzegusswerkstätte*; Zimmer and Hackländer, *Knabe*.
[103] Zimmer, *Bronzegusswerkstätte*, 100–6.

pond to the artist's fee, but a lump sum covering the whole process of setting up a monument, whether the artist received a large part of the sum and contracted out all the sub-processes, or (as mentioned earlier, and as I feel more likely)[104] the statue commissioners or civic officials (and later, the benefactors themselves) managed the funds, out of which the artist's fee was only one, perhaps negotiable, element. A very important expenditure was no doubt the bronze itself, whose price probably varied, but may well have reached or exceeded 500 drachmas.[105] In addition, the manufacture of the statue required clay, wax, possibly plaster, iron; the installations included the casting pit(s), lined with hundreds of bricks and hosting a secondary firing and casting precinct made of brick walls, temporary stone bases for working on models, moulds of the final product—and sheds or roofs to shelter all of these installations from the weather.[106]

All of these temporary structures needed labour, and materials. In third-century Delos, the necessary bricks for a casting-pit might have cost around 30 drachmas (including labour for manufacture, but excluding labour for the laying of the pit);[107] such costs may have added up to a significant expenditure. The firing of the clay moulds, over days and days, and the casting of the bronze, demanded enormous amounts of fuel—brush, charcoal, and firewood, a valuable commodity whose transport was not cheap (and which, on an island, might have to be imported).[108] Finally, the construction of the permanent base, the fixing of the statue with lead, the inscription on the base, and the inscription of an honorific decree, on the base or a separate decree, were all paid out of the funds allocated by the city. Without real data on the contract, or even on local costs and their variations, it is vain to try to determine exactly the artist's net profit at the end of the economic transaction between him and the city: a fee around 1,000 drachmas seems possible, not a 'tidy sum' with minor subtractions for materials (A. Stewart, in any case probably supposing that the artist managed the whole sum), but a respectable payment after a major, long-drawn-out venture. An artist might be holding several commissions simultaneously, executing the delicate modelling work himself but leaving other stages of the work to skilled assistants (who would have to be paid or maintained, according to status, by the artist).

What matters here is not quite the question of 'the social status of the artist',[109] or whether economics reflects distinction and artistic value, and hence the question of the invention of art.

[104] In first-cent. AD Knidos, the sum for an honorific statue is handed over to an elected commissioner, for him 'swiftly (ἐν τάχει) to take care of the setting up of the portrait'.

[105] Stewart, *Attika*, 113 and n. 31, proposes 273 dr. for 5 T (about 300 pounds, 136 kg) of bronze, but this low figure is reached with figures from 420 BC, which cannot be helpful to study costs in the Hellenistic period, two centuries later. If one uses W. M. Murray's figures for late 4th-cent. Athens—60 dr. 1.5 obols per T: 'The Weight of Trireme Rams and the Price of Bronze in Fourth-Century Athens', *GRBS* 26 (1985), 141–50—the price reaches 315 dr; with the figure of 11.5 obols per mna of bronze in 4th-cent. Epidauros (*IG* 4² 1.110A, ll. 16–18 with Feyel, *Artisans*, 169–70), the price reaches 575 dr. A. de Ridder, 'Grandes statues de bronze', *RA* (1915), ii. 97–113, assumes a weight of 120 kg (about 270 pounds), but doubles the data from 420 BC to account for hypothetical inflation during the Hellenistic period (probably excessive, and in fact meaningless) to reach a figure of 500 dr.

[106] Zimmer, *Bronzegusswerkstätten*, and Zimmer and Hackländer, *Knabe*, give a sense of these installations. An experimental reconstruction of a large Rhodian casting pit needed 300 bricks for lining, and an unspecified number for the chamber; the ancient installation in fact was made up to two, simultaneously working pits.

[107] Feyel, *Artisans*, 208, on *IG* II.2.287A ll. 98–100: 6 drachmas 2 obols per hundred bricks; we might estimate the necessary number to fit out a casting-pit at 500 bricks.

[108] On duration of firing, Zimmer and Hackländer, *Knabe*, 97, with experimental data for a single mould: 8 hours to melt out the wax, 72 hours to fire the mould; G. Zimmer, *per epist.*, estimates the quantity of wood burnt at approximately 0.5 m³. On fuel, its transport, and its price, Demosthenes 42.7, Strabo 14.2.24; de Ridder, 'Grandes statues de Bronze'; S. D. Olson, 'Firewood and Charcoal in Classical Athens', *Hesperia*, 60 (1991), 411–20, with notes on price at 417 n. 27, 418 n. 33 (summarizing the Delian evidence, as studied by G. Glotz and W. K. Pritchett: slightly over a dr. per talent of firewood, but Delos probably imported; 8–9.5 dr. per 'basket' of charcoal). A. Bresson, *L'Économie de la Grèce des cités*, i. *Les Structures et la production* (Paris, 2007), 78–82, explores the economics, and simply the costliness, of ancient fuel. Zimmer and Hackländer, *Knabe*, 63, speculates that the charcoal left over by the firing and casting (as shown by experimental archaeology) was sold off by the sculptor, to recoup costs (why not by the city?).

[109] On which see Günther in Filges, *Skulpturen und Statuenbasen*, 151–2, on Dionysokles son of Attinas, known from signatures but also from a Milesian subscription list (*Milet* 1.3.151, l. 27) of the 180s, where he is seen paying

The examination of local context and economics implies that the statue habit created niche behaviours of its own that resulted in complex artistic processes being broken down into manageability, through proximity, supervision, and the involvement of civic payments for a myriad of specific tasks within the artistic project. The contrast with the statue of Louis XIV ordered by the Estates of Burgundy from a prestigious but remote workshop (above) is very striking. This is the context in which the named sculptors known for honorific statues through signatures must be viewed: at Lindos, and generally on Rhodes, many are only known once, and most are known only on Rhodes, or in a very regional context, such as Theon of Antiocheia, who appears on Rhodes but also at Knidos and Kaunos.[110] Sculptors on Rhodes might be foreigners (as is common from the late fourth to the early second centuries), or Rhodian citizens (as is very visible during the resurgence of Rhodian honorific statuary, public and private, in the first century);[111] it is clear that most, or even all, resided on Rhodes (as shown by the foreign sculptors with privileged residence rights, *epidamia*). The Rhodian case is probably exceptional, because of the force of the statue habit on the island; it is important that the sculptors on Rhodes also worked in neighbouring *poleis* (on the mainland and in the islands),[112] and perhaps also contributed to the creation of centres of sculptural self-expression, for instance at Kos. This phenomenon may have contributed to the economics of the honorific statue, namely the lack of inflation in price (and indeed the possible dip in price), at least as suggested by evidence from the second century (below).

Signed statue bases in Boiotia also suggest a strong local element, with occasional resort to foreign sculptors, largely drawn from Athens: this can still be considered a regional context. This is even the case for the great Praxiteles's work in Boiotia.[113] There were exceptions to the localism of the honorific artefact: Lysippos made honorific statues (public and private) for the Boiotians, the Thessalians, as well as a princely family in Thessaly—in addition to his portraits of Alexander.[114] This particular exception, however, may reflect the conditions of mid- to late fourth century Greece, notably with the competitive claims of potential hegemonic powers, and more generally the openness of artistic horizons at the moment when the honorific statue habit is still being formed. But by the third century BC, the honorific statue seems to be a firmly local genre—defined, and confirmed, by the economics and economies which I have examined above.

Cessavit deinde ars? The Elder Pliny's famous, and mysterious, description (*NH* 34.52) of a lull in art between the 121st Olympiad (296–293 BC) and the 156th (156–153 BC)—a period which coincides with the rise of the honorific statue as a major form of *polis* art. I have argued above that the art world of the Hellenistic honorific statue operates at a non-*Meister*, non-masterpiece level, because of forms of political supervision and answerability, and because of the economies involved (locality or regionalism, tight civic budget); the stereotypicality of the representations, their non-heroic, resolutely pragmatic focus (local good citizens, or rulers seen through

500 dr., like nearly all the other subscribers (in any case this may reflect communitarian restraint; in contrast, Sève, 'Damophon de Messène', on the seeming wealth and dominant social position of a mid-Hellenistic Peloponnesian sculptor, an impression which might be confirmed by *IG* 12.2.497, a fragmentary funerary epigram for a Mytilenian sculptor who was also an athlete, and honoured by 'kings and peoples' (I thank P. Martzavou for this reference).

[110] *I. Knidos* 165 with further references; *Inschr. Kaunos* 58 (dedication by *tamiai*). Theon also worked in marble, as the reliefs from the altar of Apollo Karneios at Knidos show, *I. Knidos* 168 (*I. Knidos* 165 is not the dedicatory inscription from that altar: J. Ma, 'Private Statues, Public Spaces', in J. Greisbach (ed.), *Polis und Porträt: Standbilder als Medien öffentlicher Repräsentation im hellenistischen Osten* (forthcoming)).

[111] Goodlett, 'Rhodian Sculpture Workshops'.

[112] For instance Phyles of Halikarnassos, Marcadé, *Signatures*, ii. 89–96; Zimmer and Bairami, *Rhodiaka ergasteria*, 81, no. 34.

[113] *IG* 7.1831; above, Chap. 6, pp. 198–9.

[114] *IG* 7.2553 (private honorific, Thebes); Ducrey and Calame, 'Signature de Lysippe', with *BE* 09, 259 (statue base of Theban leader, probably Pelopidas, set up at Thebes by one Hippias). Bousquet, 'Inscriptions de Delphes' (1963), 206–8 (statue of Pelopidas set up by Thessalians at Delphi), *IG* 9.2.249 (athletic dedication, Pharsalos).

the prism of local euergetical transactions) also made honorific statues unsuitable for any narrative of art focused on artists and titled masterpieces: there is no place for any 'Phyles of Halikarnassos, and his *Men in Himation*' in such a story.[115] This phrase is, of course, a pastiche of the way Pliny describes artists and artworks: it is very striking to read through Pliny, *NH* 34, with an eye to possible honorific statues, and to constantly feel that one is located in a different world from the art world of the civic honorific monument: the world of Pliny is one of connoisseurship, famous artists, and works classified by genre, not by civic function.

The local mode of production, with artists travelling and setting up temporary workshops, was used for any large bronze sculpture. But it was particularly appropriate, as a way to embed art within communitarian contexts, to the honorific statue. We might wish to speculate further about these communitarian social contexts. The making of a bronze honorific statue, drawn out over time, taking place next to the final site, starting with a hole in the ground and ending with a finished shiny statue atop a crisp, sharply lettered marble base, might have resembled a public art performance in its own right.[116] This sort of artistic happening within the community might have involved dramatic moments—such as the casting or the breaking of the moulds after casting, or the setting up of an equestrian statue, complete with rearing horse, on the top course of a base—or disturbing, absurd sights, such as half-formed clay models, or a heap of unpolished body parts. These moments of drama would have underlined the risk and uncertainty involved in the production of the work of art—and hence rendered all the more necessary the political supervision that ensured that the honorific monument was about demonstrating in practical terms the capacity of political will and character to summon up artistic works: like the decree or the workings of civic institutions, artistic process may have acted to draw attention away from the honorand to the community. The processes of taking casts of originals might have been of interest to the citizens acting as statue commissioners, in that they offered striking visual metaphors of the social reproduction and emulation that was at the heart of the euergetical transaction. The carving of marble statues by pointing off full-size clay models may have offered the occasion for similar metaphors. Civic embedding may thus have operated in the case of marble statues, and even painted portraits, though in the case of these two forms the artist may have done more of their work in their own workshops; if the artist was local, as in the case of the Parian or Aphrodisian honorific marbles, the same communitarian processes will have been at work.

Communitarian pressures: during the long-drawn-out and very varied artistic processes— noisily knocking off or gouging out layers of marble, then patiently rasping and polishing, or multiple processes of digging, building, modelling, leading to the final drama of fire and molten metal—the civic community could be involved, in supervising or instructing the artist and his workforce, and discussing with the artist what the honorand should look like, to fit the stories that would surround the portrait. This goes beyond the problem of physiognomic resemblance, and the question of whether the honorand posed for his statue or his painted portrait—in the case of female portraits, the style and cultural canons imposed a bland, unified look which conveyed desired values rather than individuality.[117] The formal and informal presence of the community, and in many cases the local origin of the artist himself, might have helped frame the terms of the image, the stylistic and typological choices about face, clothing, pose, and gesture, that had to be made in order to make the image speak of political culture and equilibria. The processes would fall into different categories, according to the situation. For instance, a community might be honouring a local good citizen, who would not stop coming and going among his fellow citizens during the making of the statue within the

[115] Marcadé, *Signatures*, ii. 82–96; *IG* 12.1.85.

[116] Zimmer's imaginative reconstruction (in *Bronzegusswerkstätten* and *Knabe*) of the social life surrounding the casting pit, complete with local gawkers and children, points in this direction.

[117] Dillon, *Female Portrait Statue*, sensitively explores these cultural canons, with close attention to the final product.

city, not far from the site where it would ultimately be set up; the benefactor, or members of his family, might be actively involved in telling the artist what they wanted. Or a community might be honouring a ruler, be it a faraway benefactor or a political master, with a statue set up locally: the end result would reflect available types (perhaps even coins), the artist's choices, and the community's sense of what the ruler might want, but also of how it should position itself. Or, again, a community might be honouring a citizen from another city: if Megabyxos might visit Priene to make points about what finery he should be wearing in his statue, a visit from Antileon of Chalkis to tell the Samians, or the artist retained by the Samians, how he should look, might be more difficult; similarly, it is unlikely that the men honoured with statues in many cities (as recorded in the *Ehrentafel* type of documents) could each time intervene actively in the local processes of image-making.

Yet another situation occurred (frequently) when a community decided to set up a statue in an international shrine: since the artist would be working in the shrine, and not in the city doing the honouring, he would not have to negotiate pressure from civic officials or the community; he might be left with instructions, and perhaps enough funds, to carry out the project. Such a process probably occurred when the city of Kos decided to honour a man with a statue set up in Ephesos: the statue commissioners travelled to Ephesos to contract out the work there.[118] The artist would have to remember and interpret the collective will of strangers, but also deal with the locality where the statue would be set up: multiple, overlapping pressures. For instance, Xenokrates of Athens (perhaps an artist known by Pliny, a rarity in the case of the artists making honorific statues) was commissioned to make, at the Oropian Amphiaraion, the complex statue group by which Troizen honoured a good citizen who had helped free the city, as well as this citizen's ancestor from heroic times;[119] in addition to following instructions from the Troizenians, Xenokrates had to locate his work within the emergent row of statues on the esplanade of the shrine.

Xenokrates signed his work; the dynamic here might be the desire of the Troizenians to show to the visitors of the shrine that they had hired a well-known sculptor. The same dynamic may explain the frequency of signatures recorded on the bases of the equestrian monuments in the same shrine.[120] Another example of a 'signature-rich' epigraphy is provided by the community of Lindos, which often indicated the sculptors when setting up honorific statues (a rare occurrence), perhaps because sculptors were named for the plethora of private dedications in the shrine (signatures grow rarer in the first century BC, but this holds true for private dedications as well).[121] In contrast, signatures are mostly absent from public honorific statues at the Asklepieion near Epidauros, even if it was an internationally renowned shrine. Local factors created variety in practice; I would hazard that, in many cases, public honorific monuments were not signed by artists, fittingly for works which expressed collective will in action rather than exalting the status of the artist.[122]

The precise processes might be reflected in the epigraphical material. In two documents, discussed above, modelling is mentioned, and paid for in advance. In the first of these, a civic decree, the citizens of Theangela freed 400 drachmas for the *plasis* of the portrait: rather than a general 'shaping', the word might designate the modelling of the full-size clay model that would serve as a base for the indirect lost-wax process. This is a stage at which negotiation and explanation by the statue commissioners could influence the appearance of the statue, within

[118] *IG* 12.4.1.65 (I do not think the commissioners would have needed to travel to Ephesos specifically to find an artist to execute a statue on Kos).

[119] *Oropos* 389; Ma, 'Oropos (and Elsewhere)'.

[120] *Oropos* 385, 387, 390, 416.

[121] *Inscr. Lindos* 1.123, 125, 169, 234, 281, 2.297, 305, 333. No signature in *Inscr. Lindos* 2.243 (which is complete), 244H (part of a big, complex family monument), 273 (broken, but lower edge intact), 309? (fragmentary), 330, 345.

[122] Generally, D. Viviers, 'Signer une œuvre en Grèce ancienne: Pourquoi? Pour qui?', in J. de la Genière (ed.), *Les Clients de la céramique grecque* (Paris, 2006), 241–53. The rule seems to be that most public honorific statue bases are not signed; most signed bases are not public honorific statues: but this is purely impressionistic.

types and stylistic choices favoured both by the public patron (for reasons of collective expectation) and the artist.

The second document is the record, in public accounts of Delos, of a payment, in 246, of 300 drachmas for the *kerosis*, the 'waxing', of the statue of King Ptolemy III. The word might designate the stage following the *plasis* attested at Theangela (if my interpretation is correct), namely the application of wax inside the moulds taken off the clay model, to produce the wax positives, later to be invested within clay. This process was not purely mechanical: apart from the care needed to produce, then smooth off the wax imprints, this is a stage at which the artist worked in, or even added on, most of the details and ornament, such as fingernails, locks and strands of hair, or (in the case of a cuirassed statue) the realistic features on armour or equipment, perhaps to be cast separately by the direct-wax process. In particular, the artist might concentrate on the face, to work on physiognomic details according to what was known on Delos of what a Ptolemy should look like—a delicate question in 246, the year of the accession of Ptolemy III: apart from echoing known Ptolemaic canons, the artist responded to the needs of the community which commissioned the portrait, for its particular aims. The *kerosis* was carried out according to a *sungraphe*: this document was perhaps a financial schedule, but might also have contained indications on how the Delians wanted their Ptolemy to look.

In the indirect lost-wax technique, the full-size clay model, and the moulds taken off this model, are not destroyed by the manufacturing processes; this offers a guarantee against casting accidents or defects, but could also allow an artist to reproduce this statue indefinitely. The availability of the moulds helps to explain the practice of multiple honorific statues: the same moulds could produce several sets of wax positives, and hence several statues—which could be set up in different locales (or even different cities), or of which one might be gilt.[123] But were the moulds reused, from statue to statue? This was not the case for the statue commissioned by the Theangelans: if *plasis* means the modelling of an original clay model, the Theangelan statue was an one-off. However, we must ask if other honorific statues were knock-offs, produced from moulds taken once and for all from a generic clay model and reused repeatedly.[124] Such a process, especially since there was no intermediate stage of modelling on a full-wax model (as argued above) would have resulted in a series of uniform, identically posed and sized statues. The same questions could be asked of the other forms of honorific portrait, namely the marble statues or painted panels set up or hung up by cities to honour benefactors: were they bespoke or ready-made, produced *en masse* in workshops with only the face left blank for finishing? Uniformity of course might have been desirable: it facilitated production, kept the economics under control, maintained the work within a small range of types.

Yet within these types, there clearly was much space, and indeed desire, for individual variation. From Dodona, two honorific statues for military men, father and son, were set side by side: the only surviving fragments are the sword scabbards, which are similar (highly ornate, with animal motifs) but also very different (one figures a lioness head, the other an eagle)[125]—an indication of the sort of individualization that was offered even within the indirect lost-wax technique. The example of the *kerosis* of the statue of Ptolemy III at Delos, involving a significant payment and a written proposal, shows the care that went into shaping

[123] *CID* 4.86. On multiple statues, *Inschr. Priene* 186, 236, 237; Raeck, 'Der mehrfache Apollodoros'; *Inschr. Kaunos* 92–3; *I. Rhod. Peraia* 552–3 (same inscriptions in *Pérée rhodienne* 3–4), the statues of Teisias of Kedreai; *Inschr. Priene* 109, 117; *I Assos* 18; *I. Iasos* 85; *Sardis* 27 (Augustan, for the benefactor Iollas); Chankowski, 'Diodoros Pasparos'; in the present work, 7, 126, 133, 229. On mass production and rationalization in the Roman empire, M. Pfanner, 'Über das Herstellen von Porträts: Ein Beitrag zu Rationalisierungsmassnahmen und Productionsmechansimen von Massenware im späten Hellenismus und in der römische Kaizerzeit', *JDAI* 104 (1989), 157–257.

[124] C. C. Mattusch, e.g. 'Lost-Wax Casting and the Question of Originals and Copies', in Formigli, *I grandi bronzi antichi*, 75–82.

[125] Katsikoudis, *Dodone*, with Ma, *BMCR* 2008.02.27.

the wax positives (whether they were taken off pre-existing or specially made piece moulds). Marble statuary probably involved similar processes, involving preliminary, generalized roughing out, the transfer of pre-established proportions and measures, and the focus on individual traits in the face. In the case of female honorific statues, both bronze and marble portraits eschewed physiognomic realism, in favour of youthful idealized traits. These parameters were set by the deep cultural constant of men choosing the images, and the meanings conveyed by the images, of women for public display. In this way, these images reflect the way in which female euergetism was not about female emancipation or agency, but strategies of elite family display, determined by men; in other cases, women were honoured not for their own actions, but qua relatives of male benefactors.[126] But even for female portraits, so different from the physiognomically individualized portraits of men, subtle choices and variations were possible, in hairstyle, modelling of neck and facial features and volumes, pose, with different allusions and registers:[127] these, too, could have been determined in negotiations between artist and community, at the various stages of the production of the statue, as outlined above. Finally, in the case of the painted honorific portrait, the processes are more difficult to reconstruct, and the occasions for communitarian osmosis more difficult to imagine. The parameters are simply unknown (commission from faraway masters or local artists? execution in a studio or visit by the artist?);[128] nonetheless, it is tempting to envisage processes of negotiation and supervision analogous to those at work with bronze and marble, within the constraints and history of the genre (the question is whether the 'Fayoum portraits' are more of a help or a hindrance in trying to see a forever-lost second-century honorific painted portrait). Without direct evidence, the exact modalities of the production of honorific portraits are lost, but I suspect that most were in fact completely bespoke, involving the initial modelling of clay models (rather than the reuse of such models from portrait to portrait)—thus giving great scope for specific response to the patron's specifications.

A marble head was found in an architectural complex that served for cultic and collective activities in late Hellenistic Pergamon; there is no real reason to identify this portrait with Diodoros Pasparos—whose honours, in any case, do not show a world of 'hubris gone mad', as A. Stewart writes.[129] But it is not impossible that Diodoros Pasparos' portrait showed mildness and restraint of expression like those on the Pergamon marble head. Such traits are the result of the processes outlined in the pages above—political work, negotiation between community, artists, and honorand, and hence the sensitivity of sculpture to the political culture that produced it. The outcomes will have to be sought in the stylistic instantiation of the statues, and the material forms of the political force of the honorific portrait, at the intersection of ethical norms and physical individualization.

[126] Van Bremen, *Limits of Participation*.

[127] Dillon, *Female Portrait Statue*, esp. ch. 3.

[128] In mid-3rd-cent. Egypt, the Alexandrine painter Theuphilos, after completing work for Zenon (the well-known agent of the high-official Apollonios) in the Fayoum, asked if he might be commissioned to do some *pinakes* (private painted portraits?): *PSI* 4.407.

[129] Stewart, *Greek Sculpture*, 232.

APPENDIX: THE COST OF HONORIFIC MONUMENTS

Diogenes Laertius (6.2.35) speaks of 3,000 drachmas as the price for a statue in the late fourth century (the context is a pronouncement of Diogenes of Sinope). The well-known epigraphical evidence, as summarized below, does not contradict this piece of evidence, but nuances it.

1	Athens, early fourth century	Statue?	1,550 dr. for the setting up [of the portrait]	*SEG* 39.63, Agora 16, no. 31	ἐς δὲ τὴν ἀνα[.10] ς δ[ὸ]ναιΧ𐅅𐅅 δραχμὰς
2	Athens, 307	Statue	3,000 dr.	*IG* II² 555	στῆσ[αι τὸν δ]ῆμον εἰκόνα χαλκῆν ἐν Βυζαντίωι Ἀσ[κληπι]άδου ἀπὸ τρισχιλίων δραχμῶν καὶ στ[εφανῶ]σαι αὐτὸν χρυσῶι στεφάνωι ἀπὸ χιλ[ίων δρα]χμῶν
3	Halikarnassos, first half of third century	Crown and statue	4,000 dr. (for crown and statue?)	Migeotte *Emprunt* 102	στεφανῶσαι Διόδοτον Φιλονίκου χρυσῶι στεφάνωι καὶ εἰκόνι χαλκῆι ἀπὸ δραχμῶν τετρακισχιλίων
4	Delos, 195 BC	Statue of Philippos, statue of Attalos I	3,000 dr. for both	*ID* 399	(3000 dr.) [ἔθ]εσαν ταμίαι οἱ ἐπ' ἄρχοντος Ἀπολλοδώρου Ἡγέας καὶ Ἀπολλόδωρος εἰς τὴν εἰκόνα τοῦ βασιλέως Ἀττάλου <καὶ> εἰς τὴν [ε]ἰκόνα τοῦ ἰατροῦ Φιλίππου
5	Delos 194 BC	Statue of Attalos, Statue of Antiochos III and Laodike III	4,000 dr. for three statues	*ID* 399	(4000 dr) ἔθεσαν ταμίαι Διάκριτος καὶ Νίκων εἰς τὴν εἰκόνα τοῦ βασιλέως Ἀττάλου καὶ εἰς τὴν [εἰκό]να τοῦ βασιλέως Ἀντιόχου καὶ τῆς βασιλίσσης Λαοδίκης
6	Bybassos, 175–150 BC	Statue and crown	Not more than 2,100 dr.	*Pérée rhodienne* 45 (44 is same).	εἰς δὲ [τὰν κατασκευὰν] τοῦ στεφάνου καὶ τοῦ ἀνδριάντος [καὶ τᾶς στάλας κ]αὶ τὰν ἀνάθεσιν καὶ τὰν ἀναγραφὰ[ν τοῦ ψαφίσματο]ς τελεσάντω τοὶ ἱερομνάμονες το[ῖς αἱρεθεῖσιν ἀνδ]ράσι τὸ ταχθὲν ὑπὸ τοῦ δάμου· ταξάτω [μὴ πλεῖον δρα]χμᾶν δισχιλιᾶν καὶ ἑκατόν
7	Lamia, *c.* 170 BC	Two 5-cubit statues	40 mnai (from honorands?) = 4,000 dr.	*IG* 9.2.66A; Bielman, *Retour à la liberté*, no. 48	ἐνευπορεῖ ἀργυρίου μνᾶς τεσσαράκοντα
8	Priene, 150 BC	Statue of Demos	3,000 dr. as additional contribution	*RC* 63	
9	Kos, second century	Statue	2,000 dr. for the statue	*IG* 12.4.65	(drachmas) 'β
10	Knidos, first or second century AD		3,500 denarii	*I. Knidos* 74	

1 is dubious: the mention of the statue is restored (the portrait of Konon has been suggested), and the sum is the lowest attested. 2 explicitly attests 3,000 drachmas as the value (ἀπό + sum, derived from the meaning of 'material out of which something is made'—LSJ s.v. III.2) of the portrait, in Athens in 307 BC. It is likely that the early third-century portrait-monument of Diodotos, at Halikarnassos (3), also cost 3,000 drachmas, if the indication of 4,000 drachmas covers both the portrait and the crown.[130]

At Delos, in 195 (4) and 194 (5), the sums of 3,000 and 4,000 drachmas, cover four statues. In 195, 3,000 drachmas allowed for the completion of one statue (that of the Koan doctor Philippos, son of Philippos),[131] and the inception of work on the second, that of Attalos I: for instance, the Delians might have spent 1,500 drachmas on the statue of Philippos, and the same sum on starting the (more elaborate?) statue of Attalos I. In 194, 4,000 drachmas enabled the Delians to set up three statues, that of Attalos I, and two new statues, of Antiochos III and Laodike III: for instance, a few hundred drachmas might have allowed the completion of work on the statue of Attalos I, leaving (say) 1,800 drachmas for each of the statues of the Seleukid royal couple. These figures are speculative, but the Delian evidence clearly suggests a cost of slightly under 2,000 drachmas for honorific portrait monuments. The same is true for Bybassos, in the Rhodian Peraia, in the early second century (6): the Rhodian deme specifies that the whole honorific package (crown, statue, inscription) must not cost more than 2,100 drachmas (it is not necessary to suppose that this breaks down as 100 drachmas for the crown and 2,000 drachmas for the statue). Both Delos and the Rhodian Peraia, as centres of sculptural production, may have been able to lower costs for honorific monuments from the 3,000 drachma price attested earlier. In Lamia, in the same period, a benefactor pays 4,000 drachmas towards two over-life-size bronze statues (7)—though, of course, this may only be a contribution, rather than the total cost, and cannot prove a general lowering of the price of honorific monuments in the early second century. However, the price of 2,000 drachmas is explicitly attested on the fragment of a Koan honorific decree, of second-century date (9).

The statue of the Demos set up at Priene by a second-century ruler, probably Orophernes, cost at least 3,000 drachmas (8): these were contributed by two of the ruler's Friends, sent on embassy to Priene. Wilhelm has argued that the terminology used, designating an additional contribution, implies that the monument was a group, showing the ruler crowning the Demos of Priene, but I do not think this necessary. The text of the letters does not mention a statuary group, but merely a statue of the Demos, set up by the ruler: this might have been a particularly lavish statue, and the contribution of the Friends might simply have been to pay for the cost of the monument, in the ruler's name. The Roman-era example from Knidos (10), putting the cost at 3,500 denarii, indicates a rise in the price of an honorific statue, perhaps linked to a general rise in prices since the Hellenistic period.

[130] De Ridder, 'Grandes statues de bronze'; Wilhelm, *Neue Beiträge*, vi. 29.
[131] The base is extant: *IG* 11.4.1078.

EIGHT

Looking at an Honorific Portrait

Finally, I look at statues. Do we know what the honorific portraits looked like? Typological analysis gives us some idea—but the limits of this approach are also worth underlining: the genre may have been diverse and played with the resources offered by types. I examine seventeen cases of honorific portrait where we can say something about appearance and context. The bespoke nature of the artistic processes involved (previous chapter) allowed for precise calibration of effect and appearance, in spite of the general context of homogenizing pressures within the urban monumental context.

I. TYPES AND DIVERSITY

The previous chapter reconstructed and imagined the processes by which honorific portraits came into being. Produced by communal forces or private initiatives, displayed in shared spaces, shoehorned into sequences, involved in competitive sedimentative sequences—what did the Hellenistic honorific portraits look like? Throughout this book, I have assumed that we know the answer to this question: honorific statues fell in three main groups, well defined visually, easily recognizable, and hence providing answers to another, equally interesting question—what did the Hellenistic honorific portraits signify?

The first category was constituted by male figures of a particular type, the standing man wearing the heavy woollen himation and usually the chiton. This standardized 'normal type' was widespread, and closely linked to a sense of appropriateness;[1] its popularity is reflected in its very high frequency in Hellenistic and post-Hellenistic funerary imagery.[2] The bronze statue, found in the sea off the Kilikian coast, and now preserved in the Adana museum, provides one example (Fig. 8.1).[3] The second category is the Hellenistic royal portraits, the group of statues of the kings. These were produced according to fixed types (with a small range of variants): equestrian (calm or charging), on foot naked, on foot armoured. These types

[1] Theophrastus, *Characters* 19.7 shows an unpleasant character wandering out to the agora with a thick chiton and thin, dirty himation—the direct opposite of the normal, pleasant combination of thin chiton and thick, clean, well pressed himation, as worn by the male exemplars of the honorific statue genre. The himation-wearing statue of Alexander (?) from Magnesia under Sipylos (Stewart, *Faces of Power*, 334–6), presumably projects civic style onto a retrospective ruler portrait.

[2] The 'normal type' is defined in *PM* i. 61–3. Its meanings are studied in classic articles by Zanker, 'Hellenistic Grave Stelai', 'Brüche im Bürgerbild', and *Mask of Sokrates*, with important qualifications and refinements in Smith, 'Kings and Philosophers' and his review of *Mask of Sokrates*, *Gnomon*, 71 (1999), 448–57; Dillon, *Ancient Greek Portrait Statue*, 73–6, 77, on standardization in the Hellenistic period after late Classical diversity; Smith, *Roman Portrait Statuary from Aphrodisias*, 35–8, and C. H. Hallett in Smith, *Roman Portrait Statuary from Aphrodisias*, 150–2. 'Philosopher' portraits are a subgenre of the civic; the visual signs of thinking are not intrinsically 'philosophical', but spring from civic norms or are readapted by them; the meaning is not culture and thought, but concern for the common good: Wörrle, 'Überlegungen zum Bürgerbild'.

[3] Brüns-Özgan and Özgan, 'Bildnisstatue'; Ridgway, *Hellenistic Sculpture*, iii. 123–4. Another example of this genre is provided by a slightly over-life-size (h. 1.85 m), unprovenanced bronze statue representing a himation-wearing male, long in a private collection in Manhattan and now exhibited in the Metropolitan Museum (inv. 2001.443: C. A. Picón et al, *Art of the Classical World in the Metropolitan Museum of Art* (New Haven, 2007), 185, 447).

Fig. 8.1. The civic 'normal type' of the male honorific statue showed a man in himation, with or without the chiton, in a range of poses. Bronze statue preserving traces of gilding, found at sea off Adana, first century BC (not a Roman governor). Public or private statue? H. 1.8 m (preserved). Adana Museum 1.13.1984, photogr. W. Schiele, 1991 (German Archaeological Institute, Istanbul, R 26.976).

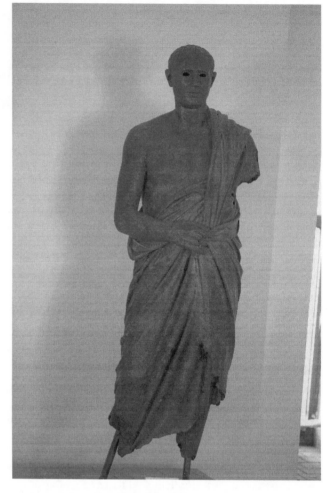

borrowed from the registers of divine and athletic imagery, combined with physiognomic portraiture (idealized or realistic).[4] The statue of a naked man with an idealized, muscular body and physiognomically represented facial traits, found in Rome and now displayed in the Museo Nazionale, probably represents a Hellenistic prince (Fig. 8.2).[5] The third category is the Hellenistic female portrait. Women were represented according to a restricted number of bodily and vestimentary schemes, which have been well studied and catalogued. The figures could be dressed with the old styles inherited from the Classical period, or, typically, with the Hellenistic combination of chiton covered with a thin, tightly draped overgarment; the faces present an idealized image of beauty and full-blown youth. The female portrait offered a striking, vivid presence, different from its male counterparts but in no way overpowered by them.[6] The over-life-size bronze statue of a woman, recently found at sea near Kalymnos, exemplifies the genre.[7]

[4] See for instance Smith, *Hellenistic Royal Portraits*, 'Kings and Philosophers'; Stewart, *Faces of Power*; Queyrel, *Portraits des Attalides*; Ma, 'Le Roi en ses images'.

[5] Queyrel, *Portraits des Attalides*, 200–34. Another example of this genre is provided by a large (h. 2.20 m), unprovenanced bronze statue representing a naked male, once holding a spear with the raised right hand, long in a private collection in Manhattan and now exhibited in the Metropolitan Museum (inv. 2006.50; Smith, *Hellenistic Royal Portraits*, Cat. no. 45).

[6] Smith, *Hellenistic Sculpture*, 83–6; Eule, *Bürgerinnen*; S. Dillon and J. Lenaghan in Smith, *Roman Portrait Statuary from Aphrodisias*, 194–6; Dillon, *Female Portrait Statue*. On female costume, L. Llewelyn-Jones, *Aphrodite's Tortoise: The Veiled Woman of Ancient Greece* (Swansea, 2003).

[7] Dillon, *Female Portrait Statue*, 110–11, 246. This important statue is yet unpublished, hence the impossibility of reproducing a photograph; but photographs have been published in the press (for instance *To Vima*, 4 Sept. 2009) and are available online.

Fig. 8.2. The Hellenistic ruler-portrait showed power, using a number of visual idioms—for instance hyper-masculine nudity. Bronze portrait of a Hellenistic prince, mid-second century BC. H. 2.20 m. Museo Nazionale (Palazzo Massimo alle Terme), inv. 1049. Rome, Museo Nazionale Romano (Palazzo Massimo alle Terme). å 2012. Photo Scala, Florence, courtesy of the Ministero Beni e Att. Culturali.

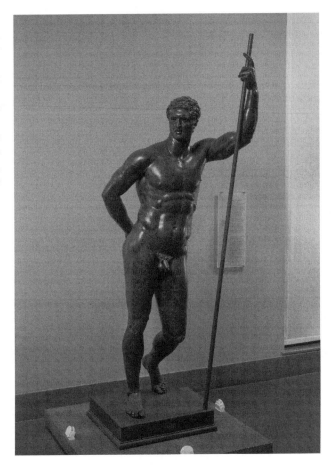

The three categories sketched out above have served throughout this book, especially in framing arguments about the role of honorific portraits as role assignment in the euergetical transaction, the political force of spatialization, and the workings of the privately dedicated honorific statue. However, within each of the three categories, considerable variety occurred. The 'himation-men' could come in vestimentary variants (notably the 'Kos' style, with the himation-end not thrown over the shoulder, but dramatically draped over the left arm in a near-horizontal roll: Fig. 8.3); the body posture and weight could be distributed dynamically between back and front legs, or in a 'four-square' position where the statue stood artlessly and faced forwards full-on;[8] the face might be bearded, or clean-shaven. This diversity is suggested by surviving male draped statues in marble, but also by the male figures on the funerary *stelai* of the Hellenistic period, which exhibit considerable variation;[9] the same diversity appears for female draped statues.[10]

Within the limited range of royal portraiture, the actual statues probably showed considerable and deliberate variation, in the treatment of the face, or in body posture (for instance, the arms of an equestrian statue could be arranged in various gestures).[11] In Athens, statues of

[8] Von den Hoff, 'Bildnisstatue des Demosthenes'; among the statue bases which preserve evidence of male standing figures (excluding athletes), four out of fifteen stood in the 'four-square' position: Filges, *Skulpturen und Statuenbasen*, 107.

[9] R. Kabus-Preisshofen, *Die Hellenistische Plastik der Insel Kos* (Berlin, 1989); Dillon, *Ancient Greek Portrait Sculpture*, 76–98 (esp. for late Classical and early Hellenistic Athens).

[10] Smith, *Hellenistic Sculpture*, 85.

[11] The equestrian statue attested by fragments found near Kalymnos, raised his right arm and kept his left arm folded across his body: *ArchRep* (2006–7), 91 and (2008–9), 77.

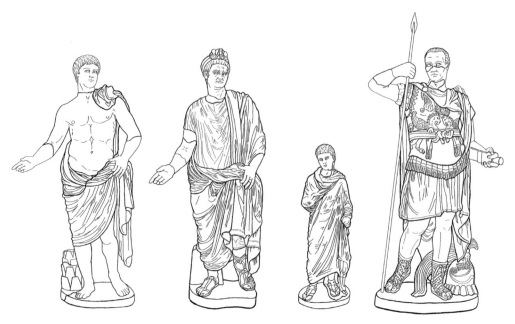

Fig. 8.3. The diversity of types appeared clearly on family 'portfolio' monuments, regrouping statues from different genres on the same base. Reconstruction of family group from Aphrodisias, first century AD? Drawing by C. Hallett.

Antigonos Monophthalmos and Demetrios Poliorketes were set up next to the Tyrannicides—in a chariot,[12] a rare honour, attested also in the case of at least three chariot-monuments (in fact whole statuary groups, with chariot, honorands, attendants) of the Attalids at Athens, on the agora, at the entrance to the Akropolis and at the north-east angle of the Parthenon itself; in addition, an 'Attalid' pillar at Delphi may have supported a monument with a two-horse chariot.[13] The origins and connotations of this rare type might be agonistic (the Attalid statues are perhaps linked to victories at the Panathenaia), but also heroizing, ostentatious, and royal—one of Apelles' paintings of Alexander represented the king in a chariot.[14]

Other finds are suggestive of the diversity of royal portraits, beyond what we think of as the habitual types. The bronze head recently found at sea, near Kalymnos, shows an aged male figure with an intent face, a short beard, Macedonian hat (*kausia*), and some form of textured headband worn under the *kausia*: this does not fit any of the known 'types' of royal portraiture, and could represent a Hellenistic ruler in a particular role, or a member of a royal dynasty, or perhaps even a royal friend, if the headband is not a royal diadem (it seems to lack the floating ends).[15]

The diversity of royal images should alert us to a broad range of statues that do not fit the three groups defined above. Honorific statues of men and women of citizen status could take

[12] Diod. 20.46.2; Habicht, *Athens from Alexander to Antony*, 68; Krumeich, 'Human Achievement and Divine Favor', 168.

[13] M. Korres, 'Anathimatika kai timitika tethrippa stin Athina kai tous Delphous', in A. Jacquemin (ed.), *Delphes cent ans après la grande fouille* (Athens, 2000), 314–29; Queyrel, *Portraits des Attalides*, 299–312.

[14] Pliny, *NH* 35.93 with F. Jünger, 'Das Gemälde des Apelles von Alexander auf dem Wagen', in J. Gebauer, E. Grabow, F. Jünger, and D. Metzler, (eds), *Bildergeschichte: Festschrift Klaus Stähler* (Möhnesee, 2004), 255–63.

[15] *ArchRep* (2003–4), 72, quoting D. Kazianis, *ArchDelt* 52 (1997), *Chron.* 1201 and pl. 444β; it is difficult to determine the nature of the headband from the photographs. On the *kausia*, C. Saatsoglou-Paliadeli, 'Aspects of Ancient Macedonian Costume', *JHS* 113 (1993), 122–42; E. Janssen, *Die Kausia: Symbolik und Funktion der makedonischen Kleidung* (Diss. Göttingen 2007). I wonder if the 'diadem' is a woollen sweatband attached to the leather cap: Plautus, *Miles Gloriosus*, 1178, mentions a woollen 'roll' (*scutulum*) which may be part of the *kausia* (Janssen, *Kausia*, 40–1, is dubitative), and a late Hellenistic epigram (Antipater, *Garland of Philip* 41 Gow-Page) describes the *kausia* as 'thirsting to drink the sweat' of the epigram's honorand (Saatsoglou-Paliadeli, 'Macedonian Costume', 123–4, thinks this a metaphor).

on the appearance of priests and priestesses, especially in the context of private honorific monuments, wearing priestly dress and a crown: this is how the second statue of Apollodoros, at Priene, next to his public statue, must have appeared.[16] Four bases from Lindos suggest a minority of priestly statues showing male figures holding sceptres or staffs—a type different from the 'normal' himation wearers, and unknown from other sources.[17] Male citizens could appear as armed men, on foot or on horseback; we do not really know what these looked like. Fragments from Dodona suggest they could be really quite ornate;[18] the leg of an equestrian statue found in the agora, and a similar leg found off the island of Kalymnos, show the detailed and realistic representation of footwear, complete with spur.[19] A man in armour, part of an early imperial family group found at Aphrodisias, might be the portrait of a civic leader of the previous generation, the troubled first century BC, and show what a very late Hellenistic civic fighter looked like (Fig. 8.3).[20]

Civic benefactors could appear seated, without necessarily being 'thinkers' or 'poets' (such as Menander, represented seated in his statue in the theatre of Dionysos at Athens): this is shown by a late Hellenistic funerary epigram from the Macedonian city of Kalindoia (discussed above, 238–9), where a boy is made to mention the honours of his homonymous grandfather:

[Εἰ γνῶναι ποθέε]ις τὸ ἐμὸν γένος, ἅδε [πέτρα σοι]
 [λέξει, ὅστις] κεῖμαι τᾷδε λιπὼν βιοτόν.
[δωδεκέτης ἔ]θανον, βαίνω δ' ὑπὸ τύμβον ἄφη[μος]
 [ἐνδόξου π]άππου τὰτὸ λαχὸν ὄνομα· 4
[κέκλητ' οὖν κ]ἀκεῖνος Ἀριστομένοιο Φιλώτας,
 ὃς πάτραι γνώμαν ἔσχεν ἰσουράνιον·
δὴ τοῦ χαλκείαν μὲν ἀνέστασαν πολιᾶται
 ἰκόναν εἰς μνάμναν {μνάμαν}, βάντες ἐν εὐνομίαι· 8
ἑζόμενος γὰρ ἔχει χέρα γούνατι, τᾶι δέ τευ ἄλλα
 δάμου καὶ βουλᾶς τόνδε κρατεῖ στέφανον·
[κα]ρύσσει δ' ἀρετὰν δαῖ ἁ ΣΤΑ . Ι . . . πολύγραπτος
 στάλα {ι} καὶ πύργων ὡς ἐφάνη πρόμαχος 12

[If you wish to know] my race, this [stone will tell you who I am] as I lie here, having left life. I died [at 12 years old], and go under the tomb with no repute of my own, having received the same name as [a glorious] grandfather: he too [was called] Philotas son of Aristomenos, who held in his fatherland a purpose equal to the heavens: for this reason, his fellow citizens, walking in lawfulness, set up his image in bronze, for the sake of memory: indeed, sitting, he holds a hand on his knee, and with the other he holds this the crown of the people and the council; and the [upright] *stele* with much writing proclaims his goodness, and how he appeared fighting before the towers. (*The poem goes on for eight more lines.*)[21]

The statue of Philotas (the grandfather) might have been set up in the second half of the second century BC, during the tumultuous post-Antigonid period; there is no evidence in the Anti-

[16] Apollodoros: *Inschr. Priene* 186, 236 (early 2nd cent. BC), with W. Raeck, 'Der mehrfache Apollodoros. Zur Präsenz des Bürgers im hellenistischen Stadtbild am Beispiel von Priene', in Zanker and Wörrle (eds), *Stadtbild und Bürgerbild*, 231–8. On private priestly monuments, above, 169–75. On female priestly statues, Connolly, *Portrait of a Priestess*; Dillon, *Female Portait Statue*. C. H. Hallett in Smith, *Roman Portrait Statuary from Aphrodisias*, 155–6, considers priestly costumes in the post-Hellenistic city (though it is excessive to describe it as 'an honorific costume in its own right').

[17] *Inscr. Lindos* 1.83, 109 are 3rd-cent. private honorifics, set up by men for their fathers after the latter were priests of Athana Lindia and Zeus Polieus; 93 and 101 are auto-dedicated statues set up by men after their priesthoods. An early Hellenistic (?) marble male statue from Kos might have shown a man holding a stick in his loosely hanging right arm, but the arm is lost (Kabus-Preisshofen, *Hellenistische Plastik der Insel Kos*, no. 19).

[18] *ISE* 69 with Ma, 'Eugnotos'; Ma, 'Oropos (and Elsewhere)', on *Oropos* 389; Ma, review of Katsikoudis, *Dodone*, BMCR 2008.02.27.

[19] Houser, 'Portrait in Athens'; Kazianis, *ArchDelt* 52 (1997), *Chron.* 1201 and pl. 444β (perhaps to be associated with the *kausia* wearer discussed earlier).

[20] Smith, *Roman Portrait Statuary*, 50–1.

[21] Hatzopoulos and Loukopoulou, *Marches orientales*, K 18 (*SEG* 28.541 with 42.596). The various published readings for line 11 are not satisfactory (for starters the line should scan), though the meaning must be clear (I saw the stone in the Archaeological Museum of Thessaloniki in Nov. 2008, as part of an exhibition on Kalindoia, without being able to read anything more).

gonid cities for civic honorific statues for local benefactors, of the type well-known in the rest of the Hellenistic world. The seated posture did not refer to images of thinkers and poets (such as Poseidippos),[22] but evoked the sitting magistrate, perhaps even Roman models in post-Antigonid Macedonia. In addition, the majestically relaxed pose (this is how I interpret the hand on knee, as godlike and befitting the 'heavenly' mind of the honorand) conveyed confidence and eminence, as materialized in the uplifted crown: the gesture might have been one of display, but perhaps also one of self-crowning. The decree carved next to the statue spelt out the story of civic-mindedness and political deeds, probably in the form of military prowess.

Other civic images fell within a range of naked males: athletes were represented naked, and youths, for instance in private honorific monuments, may have been represented naked or nearly naked: this solution appears in the early-imperial family monument from Aphrodisias already mentioned above.[23] More surprisingly, a late third-century gymnasiarch, Sosilos, on Delos, was represented naked (holding a rod which rested on an object or mass emerging from the base).[24] Children might be represented, especially in family groups. The Aphrodisias family monument, once again, gives an idea of the possibilities, in showing a boy demurely swathed in a himation, and contrasting with the swaggering figures around him (semi-naked youth, priest, armoured leader).

The appearance of statues was determined by their social and spatial contexts. Attalos I choose to honour Philetairos, the founder of the Attalid dynasty, with a seated statue, perhaps because the appearance of the statue (the 'type') was well suited to the theatre, by evoking theatre seating (especially the honorific seats, *prohedria*, among the front-seating in the auditorium), and perhaps also poetry: these connotations of the seated position would have operated in this particular context.[25] The problem of context, and more precisely the absence of secure context, is the third factor that must be borne in mind when trying to reconstruct the appearance and effect of Hellenistic honorific statues. The examples given above—Terme ruler, Adana youth, Lady of Kalymnos—were found bereft of any original context. Dating and identification remain speculative: there is no reason to suppose the Adana youth is a Roman official on the grounds of traces of gilding, which in fact is not restricted to Romans as argued by the scholars who published this remarkable statue.[26] The same observations apply to countless other original statues from the Hellenistic period, bronze or (mostly) marble, complete or fragmentary—the 'Delphi philosopher', the 'Antikythera philosopher', the 'Worried Man' from Delos. Such modern, art-historical monikers betray our ignorance of how they fitted within the city of images of the Hellenistic period.

The absence of text, place, and history prevents us from fully interpreting most ancient portraits.[27] We do not know the context and full meanings of the famous portrait of Aiskhines, known from ancient copies. We do not know how to imagine the honorific statue of a Roman governor set up in a Hellenistic city.[28] We do not know what the significance of the variations

[22] Zanker, *Mask of Sokrates*.

[23] Smith, *Roman Portrait Statuary from Aphrodisias*, 50–1; Zanker, 'Hellenistic Grave Stelai', notably on the implications of a 3rd-cent. Hellenistic Koan funerary relief, Kabus-Preisshofen, *Hellenistische Plastik der Insel Kos*, no. 20.

[24] *IG* 11.4.1087 (statue base), *ID* 1417A, ll. 133–4 (description of a 'dedication of the Delians'); Knoepfler, 'Sôsilos'; A. Jacquemin, 'Gymnase de Délos', 155–7; Moretti, 'Inventaires'; von den Hoff, 'Ornamenta γυμνασιώδη?'; S. Skaltsa, 'Sosilos' Statue Base and Nudity in Public Honorific Portrait Statues in the Hellenistic Period', in D. Kurtz with H.-C. Meyer, D. Saunders, A. Tsingarida, and N. Harris (eds), *Essays in Classical Archaeology for Eleni Hatzivassiliou 1977–2007* (Oxford, 2008), 239–47.

[25] *IG* 11.4.1106 with Fraisse and Moretti, *Le Théâtre*, 78–81; above, 191. Seated statues are absent from Smith, *Hellenistic Royal Portraits*.

[26] Brüns-Özgan and Özgan, 'Bildnisstatue'.

[27] Dillon, *Ancient Greek Portrait Sculpture*, esp. 99–126, sensitively explores the possibility of matching the many unnamed portrait heads known essentially from Roman-era copies to various statue genres and types in Hellenistic Athens (generals, politicians, etc.).

[28] On Hellenistic portraits of Roman officials, Tuchelt, *Frühe Denkmäler*; Trümper, *Agora des Italiens*, 209–10. An inscribed statue base of a Roman official (*quaestor* or *pro quaestore pro praetore*), perhaps L. Antonius (the triumvir's brother) was found at Magnesia under Sipylos (*TAM* 5.1365, with P. J. Thonemann, 'The Date of

between various forms of himation men were (how to interpret, for instance, the 'Kos-style' draping); nor whether the schemes shifted alongside with the position of the civic benefactor during the Hellenistic period, just as the prose of the honorific decree started to change noticeably *c.*150. It would be interesting to know if the portraits of the late Hellenistic civic benefactors took on some of the visual traits of the royal portraits, once the kings waned as a political force in the Hellenistic world, and the civic elites found themselves both assuming royal roles and receiving royal-style honours. All these questions show the difficulty of matching existing statuary material with the contexts which epigraphy and the archaeology of sites records. This mismatch is illustrated by the lack of correspondence between the corpus of surviving Hellenistic statuary from Kos, and an epigraphically centred study of the social history of honorific statues on the same island.[29]

2. HONORIFIC PORTRAITS IN CONTEXT: ATHENS IN THE 280S

It is worth reviewing the honorific portraits for which we have at least some concrete evidence concerning both appearance and context. For public honorific monuments, I would like to examine six significant cases: three statues (famous, but known only from copies) from early Hellenistic Athens, an unusual honorific relief from the Peloponnese, a marble late Hellenistic himation-wearer from Priene, and a large late Hellenistic male nude from a particular context, the 'Agora des Italiens' on Delos. (To these should be added the three statues of the female relatives of a Roman governor, set up at Magnesia on Maeander, very briefly discussed below.)

The earliest example is particularly interesting. It groups three honorific statues from early Hellenistic Athens: the statues of Menander, Olympiodoros, and Demosthenes. The earliest may have been the statue of Menander, set up in the Theatre of Dionysos.[30] The bronze statue, as we can reconstruct it from Roman copies, represented Menander sitting on a massive chair with a cushion, his head slightly turned to his right. He was clean-shaven, his hair short, quite close to the skull but arranged in a dramatic architecture of flowing locks. The forehead was marked by long transversal lines, as well as two high wrinkles at the root of the nose; the eyes sunken. Menander wore the chiton and the himation, the latter falling loosely about his body (Fig. 8.4). The statue, with its plinth, rested directly atop the base (a modern reconstruction which added an intercalary heightening block is mistaken), and the base probably rested on two steps; it was inscribed with Menander's name in the nominative (and the artists' signatures). The monument was almost certainly located in the east *parodos*, and may have been set up not far from the statues of the three tragedians erected at the time of Lykourgos.[31] The exact context and date are unknown. The statue shows an aged Menander, and the statue presumably dates near or after his death, aged 52, in 292/1. We cannot associate the statue with the 'oligarchical' regime between 292 and 287, during the second period of control by Demetrios Poliorketes, on the baseless grounds that Menander was 'pro-Macedonian' or politically withdrawn.[32] The monument could equally well date to (e.g.) 294 or after the liberation of

Lucullus' Quaestorship', *ZPE* 149 (2004), 80–2, at 81 n. 8) alongside a fragmentary *capite velato* togate statue (G. Mendel, *Catalogue des sculptures grecques, romaines et byzantines* (Constantinople, 1912), ii. ii, no. 591) but the association of statue and base is uncertain.

[29] Kabus-Preisshofen, *Hellenistische Plastik der Insel Kos*; Höghammar, *Sculpture and Society*.

[30] Fittschen, 'Statue des Menander'; Papastamati-von Moock, 'Menander und die Tragikergruppe'. The treatment here is indebted to Zanker, *Mask of Sokrates*, though I propose different analyses and conclusions.

[31] Thus Papastamati-von Moock; above, I have suggested that the Tragedians might have been located on the other *parodos*, or on another base (Ch. 3 n. 262).

[32] The conventional picture of Menander should be dispelled. His drama has been shown to be engaged with the issues of democratic politics in early Hellenistic Athens: Lape, *Reproducing Athens: Menander's Comedy, Democratic Culture, and the Hellenistic City* (Princeton, 2004). Menander's politics cannot be reconstructed easily: closeness to Demetrios of Phaleron (supported by Kassandros, the enemy of Demetrios Poliorketes) does not represent a long-standing 'pro-Macedonian' stance. It is true that he may have been close to Theophrastos (if the biographical tradition is reliable), who in turn was responsible for the recall of the oligarchs by Demetrios in 292. Later descriptions of Menander's lifestyle are unreliable (A. Körte, *PW* xv. 707–62, s.v. Menandros (9), at coll.

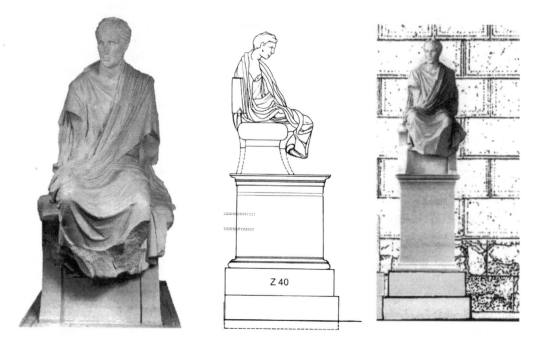

Fig. 8.4. The face of the 280s (1): the honorific portrait of Menander showed him seated, dressed in himation and chiton, and with a deeply lined face. Reconstructions by C. Papastamati-von Moock, based on statue type by K. Fittschen: reconstruction of Menander on seat; reconstruction of statue, seat, and base; the Menander monument in its site in the theatre of Dionysos.

Athens in 287. Two other statues of poets were set up in the theatre of Dionysos at this time, one for (probably) Diodoros of Sinope *c*.295, the other for Philippides of Kephale in 281/0; it is clear that the latter, and likely that the former, were honoured for political services, though their status as poets determined the place where their statues were erected.[33]

The second statue is that of Olympiodoros, an Athenian statesman and general.[34] Pausanias mentions his statue on the south side of the Akropolis; his account gives a sense of the context of Athens in the 290s and 280s, and is worth quoting extensively.

ἔστηκε δὲ καὶ Ὀλυμπιόδωρος, μεγέθει τε ὧν ἔπραξε λαβὼν δόξαν καὶ οὐχ ἥκιστα τῷ καιρῷ, φρόνημα ἐν ἀνθρώποις παρασχόμενος συνεχῶς ἐπταικόσι καὶ δι᾿ αὐτὸ οὐδὲ ἕν χρηστὸν οὐδὲ ἐς τὰ μέλλοντα ἐλπίζουσι ... χρόνῳ δὲ ὕστερον ἄνδρας ἐσῆλθεν οὐ πολλοὺς μνήμη τε προγόνων καὶ ἐς οἵαν μεταβολὴν τὸ ἀξίωμα ἥκοι τῶν Ἀθηναίων, αὐτίκα τε ὡς εἶχον αἱροῦνται στρατηγὸν Ὀλυμπιόδωρον. ὁ δὲ σφᾶς ἐπὶ τοὺς Μακεδόνας ἦγε καὶ γέροντας καὶ μειράκια ὁμοίως, προθυμίᾳ πλέον ἢ ῥώμῃ κατορθοῦσθαι τὰ ἐς πόλεμον ἐλπίζων· ἐπεξελθόντας δὲ τοὺς Μακεδόνας μάχῃ τε ἐκράτησε καὶ φυγόντων ἐς τὸ Μουσεῖον τὸ χωρίον εἷλεν ... Ὀλυμπιοδώρῳ δὲ τόδε μέν ἐστιν ἔργον μέγιστον χωρὶς τούτων ὧν ἔπραξε Πειραιᾶ καὶ Μουνυχίαν ἀνασωσάμενος· ποιουμένων δὲ Μακεδόνων καταδρομὴν ἐς Ἐλευσῖνα Ἐλευσινίους συντάξας ἐνίκα τοὺς Μακεδόνας. πρότερον δὲ ἔτι τούτων ἐσβαλόντος ἐς τὴν Ἀττικὴν Κασσάνδρου πλεύσας Ὀλυμπιόδωρος ἐς Αἰτωλίαν βοηθεῖν Αἰτωλοὺς ἔπεισε, καὶ τὸ συμμαχικὸν τοῦτο ἐγένετο Ἀθηναίοις αἴτιον μάλιστα διαφυγεῖν τὸν Κασσάνδρου πόλεμον. Ὀλυμπιοδώρῳ δὲ τοῦτο μὲν ἐν Ἀθήναις εἰσὶν ἔν τε ἀκροπόλει

709–11, dismissing a description in the Latin fabulist Phaedrus), and should not be used as the basis for estimations of Menander's supposed anti-democratic, anti-*polis* attitude. An anti-democratic reading is proposed by W. M. Owens, 'The Political Topicality of Menander's *Dyskolos*', *AJP* 132 (2011), 349–78, within a sense of the extreme complexity of the politics of early Hellenistic Athens as developed by P. Iversen, 'Was Menander a Democrat?' (paper delivered at the APA Annual Meeting in 2012).

[33] *IG* II² 648, 657; Oliver, 'Space and the Visualization of Power', 285; above, 94, 105–6.

[34] Pausanias 1.26.1–2; Diogenes Laertius 6.23; Habicht, *Athens from Alexander to Antony*, 75, 90–6; Habicht, *Pausanias' Guide to Ancient Greece*, 90–2, 100–1; B. Dreyer, *Untersuchungen zur Geschichte des spätklassischen Athen (322–ca. 230 v. Chr.)* (Stuttgart, 1999), 259–73; Grieb, *Hellenistische Demokratie*, 77–85; G. J. Oliver, *War, Food, and Politics in Early Hellenistic Athens* (Oxford, 2007), 54–63; P. Paschidis, *Between City and King: Prosopographical Studies on the Intermediaries between the Cities of the Greek Mainland and the Aegean and the Royal Courts in the Hellenistic Period, 322–190 BC* (Athens and Paris, 2008), 132–9, with sources and discussion.

καὶ ἐν πρυτανείῳ τιμαί, τοῦτο δὲ ἐν Ἐλευσῖνι γραφῆ· καὶ Φωκέων οἱ Ἐλάτειαν ἔχοντες χαλκοῦν Ὀλυμπιόδωρον ἐν Δελφοῖς ἀνέθεσαν, ὅτι καὶ τούτοις ἤμυνεν ἀποστᾶσι Κασσάνδρου.

There stands Olympiodoros, who received fame on account of the greatness of the deeds which he accomplished, and not least because of the time when he accomplished them, for he gave resolution to men who had known continuous defeat and who could conceive of no hope at all for the future . . . (*There follows an account of Athens under Macedonian control.*) Later, a few men recalled their ancestors, and considered to what state had fallen the glory of the Athenians, and straightaway elected Olympiodoros as their general. He led them against the Macedonians, and the old and young too, hoping to gain success in war by enthusiasm rather than might; when the Macedonians sallied out he defeated them and, as they fled to the Mouseion, he captured the fort . . . This is the greatest deed of Olympiodoros', apart from those he accomplished when he recovered Peiraieus and Mounychia; and when the Macedonians mounted an incursion against Eleusis, he ranged the Eleusinians and defeated the Macedonians. Earlier, when Kassandros invaded Attica, Olympiodoros sailed to Aitolia and convinced the Aitolians to send troops to the Athenians' aid, and this alliance was chiefly responsible for the Athenians escaping the war with Kassandros. So Olympiodoros has honours on the Akropolis and in the *prytaneion*, and also a painting in Eleusis; and the Phokians who hold Elateia set up a bronze (statue of) Olympiodoros in Delphi, for he helped them too, when they revolted from Kassandros.

Olympiodoros' most famous deed was the capture of the Mouseion, which had been held by a garrison of Demetrios Poliorketes. The Aitolian-aided fight against Kassandros dates to 306; the defence of Eleusis might date to this context, or to the liberation of Athens in 287; the recapture of Peiraieus might also have taken place in the aftermath of 287 (but the exact context is disputed). What Pausanias does not tell us is that this active and successful democratic general had precisely been favoured by Demetrios before the revolt of 287: when Demetrios seized the city in 295, he appointed Olympiodoros archon for 294/3, and Olympiodoros stayed in office, unconstitutionally, the following year; he may have been supplanted by the oligarchs recalled in 292. Olympiodoros' behaviour in these eventful years reminds us how facile and unhelpful the labelling of individuals as 'collaborators' or 'nationalists' can be.[35]

Olympiodoros was honoured with a statue (almost certainly bronze) on the south side of the Akropolis,[36] and a painted portrait at Eleusis; the statue in the *prytaneion* was perhaps placed there at a later time.[37] The portrait at Eleusis might date to Olympiodoros' defence of the deme, whenever this happened. The two bronze statues were public honours, one set on the Akropolis, and the second probably in the agora; a possible dating solution is that one was decreed after the capture of the Mouseion, and the second at the end of Olympiodoros' life.[38] The head of one of the portraits (perhaps the Akropolis statue) is probably reproduced in a Roman-era herm labelled 'Olympiodoros' with suitable features. It shows a serious-looking man of mature years, with a high forehead, receding hairline but flowing locks, a short beard, and an intent face characterized by a concentrated gaze and a firm-set mouth (Fig. 8.5); there are enough similarities with a securely dated statue (below) to place the original portrait in Athens in the early Hellenistic period, and hence to support an identification with Olympiodoros the general. The herm gives no indication of the original clothing or armour, but this

[35] Likewise, the *bouleutai* honoured in 290/289, under the 'oligarchy', played prominent roles in the democratic restoration after 287/286: *ISE* 12. Again, the Boiotian statesman Peisis of Thespiai, who led the Boiotians against Kassandros and also in revolt against Demetrios, but was appointed polemarch of his city by Demetrios: Plutarch, *Demetrius* 39, Paschidis, *Between City and King*, 312–15.

[36] Stewart, *Attalos, Athens, and the Akropolis*, 182: the statue was located by the south-west corner of the Parthenon, an unusual spot. The statue faced the Mouseion, the site of Olympiodoros' 'greatest feat'.

[37] Paus 1.25.2, 26.3 (where the word τιμαί designates honorific statues; Gauthier, *Bienfaiteurs*, 79, writes as if the 'honours' in the *prytaneion* were abstract rewards, but they would not be still visible to Pausanias). Pausanias 1.18.3 mentions other statues in the *prytaneion*: a 5th-cent. athlete, Miltiades, and Themistokles (reused for Roman-era honorands); the disparate nature of the assemblage hints at a later collection of statues shifted to this site. The statue of Demochares was transported from the Agora to the *prytaneion*, at some (unspecified) time: [Plutarch], *Moralia* 847c.

[38] Dreyer (above, n. 34), believes that one of the statues was set up at the end of Olympiodoros' career, the latest event in this career being the recapture of Peiraieus in 280; this interpretation has not been generally followed, but the dating may well be correct (see below).

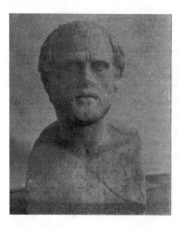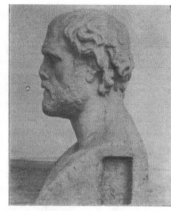

Fig. 8.5. The face of the 280s (2): the general and politician Olympiodoros, with intent, firm features. Roman-era marble herm, labelled with the name of Olympiodoros, found in Palestine. Now in National Museum, Oslo.

would not normally figure on a herm: in all likelihood, Olympiodoros did not stand naked, but rather in arms; his head seems to have been carried dynamically (an impression reinforced by the flowing hairstyle), with an outwards gaze slightly turned to the figure's left.

 This parallels the statue of Demosthenes, the orator, who was honoured with a posthumous bronze statue, set up in 280/79, on the proposal of his nephew Demochares, forty-two years after his death, as is known by the decree preserved in the literary tradition.[39] The statue stood on the western side of the agora, between the monument of the Eponymous Heroes and the statues near the Stoa of Zeus. Near the statues of Demosthenes, other famous statues were located: Eirene and Ploutos, and the statue of Lykourgos.[40] The portrait of Demosthenes can be reconstructed from Roman copies (Fig. 8.6) and a detail in Plutarch: in the normal slightly over-life-size format, it stood in a 'four-square' position (albeit with one leg slightly forward), arms lowered and hands clasped, the himation worn without a chiton jammed in place by the left arm, head slightly lowered and with a very furrowed brow and intent gaze.[41] The statue was executed in a strikingly naturalistic style, which gave visible presence to the absent orator. The same effect of presence is continued in the epigram, carved on or next to the base; which addresses Demosthenes directly:[42]

εἴπερ ἴσην ῥώμην γνώμῃ, Δημόσθενες, ἔσχες,
οὔποτ' ἂν Ἑλλήνων ἦρξεν Ἄρης Μακεδών

If only you had had force equal to resolve, Demosthenes, Macedonian Ares would not have ruled over the Greeks.

The three statues belong to the years around 280. The statue of Demosthenes is firmly dated to 280; the statues of Olympiodoros belong to the years after 287, without it being clear if they came before or after Demosthenes (and hence whether it influenced it, or was influenced by it). Problematically, the sitting portrait of Menander is impossible to pin within the 290s and 280s; the meaning of the statue would be different according to whether it was set up by the still democratic regime of 295–292, the oligarchy of 292–287, or the restored free democracy of 287 onwards. Other statues were set up in the theatre around this time: the undatable statue of

[39] [Plutarch], *Moralia* 850 F (decree quoted in annex to the Lives of the Ten Attic Orators).
[40] Worthington, 'Demosthenes' Statue'; von den Hoff, 'Bildnisstatue des Demosthenes'; above, 104, 120–2.
[41] Plutarch, *Demosthenes* 31.1–2. The Roman-era marble copy currently in the Ny Carlsberg Glyptotek, Copenhagen, shows clasped hands (rather than the clutched scroll of 18th-cent. reconstructions), but these are a 1950s reconstruction (using the hands of a conservator as a model): M. Moltesen, 'De-restoring and Re-restoring: Fifty Years of Restoration Work in the Ny Carlsberg Glyptotek', in J. Burnett Grossman, J. Podany, and M. True, *History of Restoration of Ancient Stone Sculptures* (Los Angeles, 2003), 209–10.
[42] Plutarch, *Demosthenes* 30.5; [Plutarch], *Moralia* 847a.

Fig. 8.6. The face of the 280s (3): the posthumous statue of the orator Demosthenes, a monument showing civic-mindedness and also civic pathos. H. 2.02 m. Cast of Roman copy, Braccio Nuovo, Vatican (now in Cast Gallery, Ashmolean; by courtesy of the Ashmolean Museum).

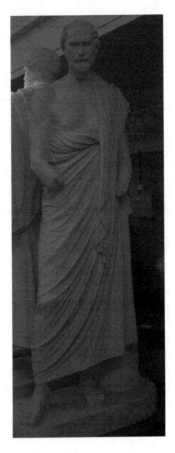

Eteokles son of Chremonides, an eminent Athenian (and father of the politican Chremonides); the statue of (probably) the poet Diodoros of Sinope, datable to 294; the statue of Philippides of Kephale, set up in 281/280. Without any pretence at proof, we might propose dating the Menander, along with the other statues in the theatre, to the post-287 restoration: the Menander, the Olympiodoros, and the Demosthenes would thus form a chronologically and politically coherent group, where we could see some visual details of a broader statuescape at a precise historical moment.

To use the terminology of a Koan decree, the attitude ($\sigma\chi\hat{\eta}\mu\alpha$) and the dress ($\sigma\tauo\lambda\acute{\alpha}$) of all three statues differed profoundly,[43] as well as the sites where they were set up. The impression of diversity might have been reinforced by the statue set up for one Herodoros, a (non-Athenian) Friend of Antigonos and Demetrios who was honoured with a grant of citizenship and a portrait in the agora (anywhere except next to the Tyrannicides). The document relief associated with the tall *stele* bearing the honorific decree shows Athena crowning a standing man in armour, reflecting the military identity of a royal Friend: this might have been the mode chosen for his bronze statue.[44]

Nonetheless, the three monuments are also characterized by the unity of their civic ideology. The epigram for Demosthenes speaks of regret and lost possibilities, but also of the righteousness of the good citizen's exemplary resolve, and its direct relevance to the citizen viewer in its valorizing of Athenian and generally Greek freedom. The monument for Olympiodoros might have been captioned with verse: Pausanias draws on a narrative source (probably a decree, or a historian dependent on a decree), for the story of Olympiodoros' exploits, but the judgement

[43] *IG* 12.4.1.65; above, 250, 261.
[44] *IG* II² 646; the document relief is reproduced in Dillon, *Ancient Greek Portrait Sculpture*, 109, fig. 145.

on the greatness of his deeds and the *phronema* (literally 'mind'—resolution) which they inspired in the Athenians at a moment of despair sounds like the paraphrase of an epigram, which could have been meant to be read alongside the epigram for Demosthenes. In Pausanias' narrative of the victorious assault on the Mouseion, Olympiodoros places his hopes in the capacity of his fellow citizens' enthusiasm (*prothumia*), a cardinal civic virtue of communitarian devotion, to overcome the Macedonians' might—the word used (*rhome*) is the same as in the Demosthenes epigram. If Pausanias echoes the original decree for Olympiodoros, or a contemporary literary source, this account of victory picked up the themes of the Demosthenes epigram and placed them in a positive account; this relation suggests that the statue and decree for Olympiodoros came after the Demosthenes. The statue of Menander also fits within a civic context: we should view Menander not as the disengaged poet of private life, but as the author of civic texts engaged with democratic issues and problems of participation, status, and citizenship—whatever the exact details of his political stance within the complicated politics of the period. The statue for Menander commemorates his contribution to a sense of civic purpose; if it dates to the democratic restoration of the 280s, it may also have a reconciliatory force, acknowledging the worth of politically oriented and thoughtful comedy centred on the city, throughout the vicissitudes of regime change and conflict.

This ideological unity was reinforced by formal, visual features. Rather than insist on the difference between a supposedly luxurious and private Menander, a pathetic Demosthenes, and an energetic Olympiodoros, the three faces might be compared in terms of their ethos, as faces of the 280s, inasmuch as we can reconstruct them from the Roman copies. They are characterized by naturalistic insistence on age, as seen in the volumes of the face and the wrinkles in the best copies (Demosthenes' crowfeet; the 'Venus ring' wrinkles on Menander's neck, betraying age rather than softness or effeminacy), and by the furrowed foreheads and wrinkles between the eyebrows. Demosthenes' wrinkles were represented plastically, with deep dramatic masses, and asymmetrical; Menander's wrinkles made a deep and extended network, overlaying the still handsome features. Olympiodoros' face, which may have been treated in a slightly more 'Classicizing' or idealizing style, was also marked by a frown and the deep pair of wrinkles at the root of the nose. Of course, these elements are very widespread (notably in 'philosopher portraits' and the portraits of poets, as studied by P. Zanker, or in the representations of maturity in late Classical Attic grave *stelai*). The interest of the 'face of the 280s' is that we have a precise context to interpret its ideological meaning rather than looking for the inherent, generalized semiotics of (e.g.) the furrowed brow. The statues strive to show individuals whose physique reflects concern for the *polis* in various forms, obligation towards the community, and investment in the community's continuity and freedom—in different ways, and with different effects. They also show civic attitudes as embodied, literally, over a lifetime. The same exploration of the relationship between time, lifespan, and civic behaviour is at work in the honorific decrees of early Hellenistic Athens, which reward actions at the end of a political career.[45]

The statues of Menander, Demosthenes, and Olympiodoros, whatever their exact chronological relation, belonged to a moment in the history of the honorific statue, at Athens, but also generally the generation between 295 and 270 BC, book-ended by the statues set up *c*.295, in the immediate aftermath of the second take-over by Demetrios Poliorketes (for two foreigners, Herodoros and, probably, Diodoros of Sinope), and by the statues of Demochares of Leukonoe and Kallias of Sphettos, set up in 271/0 and 270/69, shortly before the great patriotic war declared by Athens, leading a coalition of Greek states, against Antigonid Macedonia. These years were marked by a profusion of honorific statues, most for good citizens or for outsiders who helped the democracy.[46] Such statues came after the multiplication of statues under (and

[45] Gauthier, *Bienfaiteurs*, 79–92 ('honneurs tardifs'); K. Rosen, 'Ehrendekrete, Biographie und Geschichtsschreibung: Zum Wandel der griechischen Polis im frühen Hellenismus', *Chiron*, 17 (1987), 277–92.

[46] The evidence is gathered by Oliver, 'Space and the Visualization of Power', 184–5, notably *IG* II² 646 (Herodoros), 648 (unnamed poet), [Plutarch], *Moralia* 851d–f (Demochares), *SEG* 28.60 (Kallias).

for) Demetrios of Phaleron (soon removed, but which had still introduced a new phase in the history of statues in Athens),[47] and the placing of spectacular statues of Antigonos Mono-phthalmos and Demetrios Poliorketes in prominent sites of Athenian political topography—such as the chariot group next to the Tyrannicides. It is tempting to suppose that the '280s face' was widely used for the other statues of civic benefactors in the early third century.

It is also likely that the choices made in the 280s were very influential; the question is what influence they exercised in Athens during the period of Macedonian domination (262–229) and the newly freed, and rapidly changing, Athens of the late third and early second centuries. It is excessive to suppose that this moment determined the visual appearance of the honorific statue across the Hellenistic world. The genre had been evolving for a long time, in many places: in consequence, similar contexts of political developments between subordination and freedom, and of local intermonumentality, should be imagined elsewhere, determining local visual choices more than any Athenian model.

3. HONORIFIC PORTRAITS IN CONTEXT: POLYBIOS IN THE PELOPONNESE

A striking number of honorific portraits of the respected statesman and great historian Polybios son of Lykortas, of Megalepolis, are known from the Peloponnese; most were noted by Pausanias, 300-odd years after Polybios' mid-Hellenistic career. One was set up in Megalepolis, in the agora, near the shrine of Zeus Lykaiaos: it took the form of an honorific relief *stele*, with an epigram paraphrased by Pausanias, and which celebrated Polybios' travels, his friendship with Rome, and his action in putting an end to their anger against the Greeks.[48] Another honorific relief is mentioned by Pausanias in the shrine of Despoina, belonging to the city of Lykosoura: the epigram (again paraphrased by Pausanias) declares mournfully that had Greece followed Polybios' advice, it would not have fallen, and that after its error, only Polybios had provided it with help.[49] Two more *stelai* in honour of Polybios are noted briefly by Pausanias: one at Mantineia and one at Tegea.[50] In addition, an honorific statue (*andrias*) was set up by the city of Pallantion, and another by the Eleians, at Olympia.[51]

What is the context for these portraits? After the catastrophe of 146, which saw the tragic defeat and dissolution of the Achaian League at the hands of Rome, Polybios performed many services, when he notably drew up the constitutions for the cities; for which services he was awarded 'the highest honours'—the expression designates, inter alia, honorific portraits.[52] The honorific reliefs from Megalepolis and Lykosoura clearly date to this context, as indicated by the epigrams, with their different tones (the Megalopolitan is Odysseian, with emphasis on Polybios' journeys and resourceful achievements,[53] the Lykosouran is 'Demosthenic' in its insistence on what-may-have-been). The honorific statues set up at Pallantion and Olympia could date to any chronological context, but here too, the years after 146 are likely: in the case of Olympia, because an honour by the Eleians (never very friendly to the Achaians) would fit well in the new pan-Hellenic mood after 146; in the case of Pallantion, because of the general

[47] Azoulay, 'La Gloire et l'outrage'.

[48] Pausanias 8.30.8.

[49] *IG* 5.2.537, a fragment of a relief found in the shrine, was tentatively identified as belonging to the stele for Polybios by Hiller von Gaertringen, but the identification must remain speculative (the restored mention of Prienians, Antiocheians on the Maeander, and Paroreatai, as the bodies doing the honouring, inscribed directly in the field of the *stele*, is perplexing).

[50] Pausanias 8.9.1; 8.48.8.

[51] Pausanias 8.44.4; *Inschr. Olympia* 302.

[52] Pausanias 8.30.9; Polybios 39.5.4 (Loeb). On the settlement of Greece, R. M. Kallet-Marx, *Hegemony to Empire: The Development of the Roman* Imperium *in the East from 148 to 62* BC (Berkeley, Calif., 1995), 76–84.

[53] The theme echoes Polybios' own self-presentation: Polybios 12.28.1, 35.6.4 (jibe by Cato); F. W. Walbank, *Polybius* (Berkeley, Calif., 1972), 11, 25, 50–4, on 'this grand, if slightly humorless comparison', and the echo in the Megalopolitan epigram.

desire of most, or perhaps all, of the former member cities of the Achaian League to set up honorific portraits of Polybios at this precise juncture. Though reliefs were chosen at Megalepolis and Tegea, Polybios was honoured with a marble statue around 145, for his formal defence of Philopoimen against a proposal to remove the latter's statues.[54]

The Mantineian *stele* is mentioned by Pausanias; an inscribed fragment, found reused on the site, comes from this monument. The incomplete inscription contains parts of an elegiac couplet, which clearly refers to an image honouring the son of Lykortas. This is certainly Polybios, since the same couplet was reused, in an antiquarian gesture of homage, for the two honorific statues of a descendant, T. Flavius Polybios of Messene, set up by the Messenians and the Achaians respectively, in the second century AD,[55] and the couplet can be reconstructed securely at Mantineia:[56]

τοῦτο Λυκόρτ[α παιδὶ πόλις]
περικαλλ[ὲς ἄγαλμα | ἀντὶ καλῶν]
[ἔργων εἴσατο Πουλυβίωι]

The city has set up this fine image to the son of Lykortas, in return for fine deeds—to Polybios.

Furthermore, the last line of the couplet was read inscribed across the top of a *stele* found reused near the ancient site of Kleitor; the name was apparently later confirmed on a plaster cast of the *stele*.[57]

[τοῦτο Λυκόρτα παιδὶ πόλις περικαλλὲς ἄγαλμα]
ἀντὶ καλῶν ἔργων εἴσατο Πο[υ]λύ[βίωι].

It is likely that this honorific *stele* also belongs to the post-146 context where the Megalopolitan and the Lykosouran *stelai* are securely located. In sum, three honorific portraits are securely dated after 146 (the two aforementioned *stelai*, and the marble statue set up when Polybios saved the honorific statues of Philopoimen); four more honorific portraits probably date to the same context (the honorific *stelai* at Mantineia, Tegea, and Kleitor, and the statue at Pallantion). Of these seven portraits, four are *stelai* (Mantineia, Tegea, Lykosoura, Kleitor), which also supports the chronological coherence of the whole ensemble.

If this reconstruction is correct,[58] the granting of portrait honours for Polybios across the Peloponnese was not simply a response to the benefactions and services he offered to the several communities during the settlement of Greece, but a way of displaying a capacity for collective action, even in the aftermath of the destruction of the federal state of the Achaian League, and even without formal decision mechanisms (assuming that these portraits date before the problematic 'reformation' of the Achaian League sometime after 146).[59] The

[54] Polybios 39.3.11 (Loeb). Polybios' brother Thearidas and father Lykortas were honoured with statues (by the Epidaurians and the Spartans respectively) at the Asklepieion (*IG* 4² 1.623–4).

[55] *Inschr. Olympia* 449–450; A. Heller, 'D'un Polybe à l'autre: Statuaire honorifique et mémoire des ancêtres dans le monde grec d'époque impériale', *Chiron*, 41 (2011), 287–312 (wondering if a Hellenistic *statue* of Polybios was not reused for his descendant).

[56] *IG* 5.2.304. The disposition of the lines (which I here correct slightly) gives the size of the *stele*: since the preserved eleven letters of line 1 occupy 27 cm, the full twenty-two letters took up 54 cm, which is the measurement of the slab at the top—a smallish *stele*, unless this was the left-hand pilaster framing a very large one.

[57] *IG* 5.2.370. The *stele* is published fully by Bol and Eckstein, 'Polybios-Stele'.

[58] The attribution of the Kleitor *stele* has been doubted, for instance by Richter, *Portraits*, 248, followed by Ridgway, *Hellenistic Sculpture*, ii. 210–12, but their arguments cannot hold. See already Walbank, *Commentary*, i, pp. ix–x.

[59] Pausanias 7.16.9–10; *Syll.* 684, *Inschr. Olympia* 328; S. Accame, *Il dominio romano in Grecia dalla guerra acaica ad Augusto* (Rome, 1946), 147–8; J. A. O. Larsen, *Greek Federal States: Their Institutions and History* (Oxford, 1968), 500–1; Kallet-Marx, *Hegemony to Empire*, 76–82. The problem is whether the 'reconstituted' League comprised all of the cities which had belonged to the Achaian League at the time of its might, or only original Achaia. *ISE* 60, an honorific inscription for an Achaian commander, set up by Achaian contingents who fought against Galatians under one Cn. Domitius, has been dated to 122 (Kunze), 192 (Moretti), and 190 (Canali de Rossi in *ISE* iii (2nd edn), 244–56, with summary of earlier arguments; the attribution to the battle of Magnesia is open to objection. I personally favour Moretti's dating of 192, and hence believe that the text cannot be used to show that the reconstituted Achaian League of the late 2nd-cent. BC included cities beyond Achaia proper.

Fig. 8.7. The honorific reliefs for the Achaian statesman Polybios were a highly original form of monument, expressing the local identity of the Peloponnese even after the catastrophe of 146 BC; the example from Kleitor is the only one preserved, but it is richly instructive in its details. Cast of relief, formerly in Berlin. H. 2.18 m (*stele*), 1.96 m (figure), w. 1.11 m (*stele*).

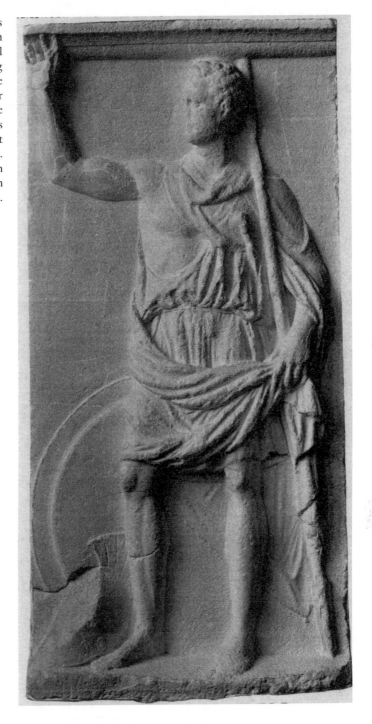

ubiquity of the portraits (a form of pan-Peloponnesian serialization) and the unity of purpose they implied, recalled the uniformity of federal institutions, across local member *poleis*, that had been the peculiarity and the strength of the League. The multiple portraits, across the Peloponnese, also recalled the portraits of Philopoimen, set up in the cities of the Achaian League after his death.[60] This was indeed a fitting echo to honour Polybios. His father had

[60] Plutarch, *Philopoimen* 21.5.

been an associate of Philopoimen, and Polybios himself, as a youth, had carried Philopoimen's ashes in the latter's grand funeral. In addition, as mentioned above, it was thanks to Polybios' intervention that Philopoimen's statues were saved from Roman rancour and from destruction after the end of the League in 146. The reference to Philopoimen also worked more generally, as an evocation of the past, in the form of Achaian military might and political institutions.

This particular context for the production of portraits of Polybios explains several features. First, the shared choice of the unusual form of an honorific relief *stele* (which seems unparalleled to me, and certainly unlike the reference to public honours in east Greek funerary *stelai*) was a way of showing a common culture and purpose. Second, the sharing of epigrams between Mantineia and Kleitor suggests there was a 'standard' formula available for at least some cities to use; which did not prevent other cities from finding their own epigrams—this pattern of uniformity and deliberate local variation is typical of networked systems, and does not diminish the political force of the multiple portraits of Polybios.

Of these multiple portraits, one survives, the *stele* from Kleitor—a very rare example of a securely contextualizable original honorific portrait from the Hellenistic world (Fig. 8.7).[61] The relief *stele* was very large; the relief form was not chosen for reasons of economy, and the full monument must have been impressive: we should imagine the *stele* on top of its own stepped base, crowned with a finial or pediment, and vividly painted. The relief is carved with carefully varying degrees of depth. Polybios himself is shown slightly over-life-size (1.96 m), looking to the viewer's left. The hair is left in rough masses, representing tightly curled hair; painted, it would have given the fair illusion of a close-cropped hairstyle. The face is physiognomically individualized through the hairline, the shape of the forehead, and especially the slightly bulbous eyes. The brow is slightly furrowed, wrinkles mark the root and the labionasal corner: this is not an idealized heroic young face, but a realistically represented mature figure. His body faces the viewer, his right arm raised and his right hand open in a salutatory gesture. He wears an *exomis*, a light tunic with one sleeve undone so as to expose the right arm and part of the chest. Over the *exomis*, Polybios wears a cloak (*chlamys*), pinned on his left shoulder, the left edge hanging (and pulled down by a small corner weight), the right edge drawn around the right thigh and held, in a roll, by the lowered left hand at waist height. The last two fingers of the left hand bore a ring each (too worn to allow the modern viewer to determine what they were). Boots were probably painted on the featureless feet; the figure holds a spear which ends in a massive spike (the point is out of the picture field), and wears, on a baldric, a sword, adorned with a horseman (or perhaps an Eros on a panther).[62] A round hoplitic shield, partly obscured by the standing figure, and a crested helmet, a late Hellenistic hybrid model, with a visor marked by a spiral motif, rest on the ground.

The relief of Polybios represents him as a civic fighter—but with some significant specificities. The weapons cast him in a military role, and such military images may have been part of a Central Greek and Peloponnesian tradition.[63] In the case of the Kleitor relief, the exact allusions escape us: the spear, with its massive point, is perhaps an infantry spear, just as the big hoplite shield might be the 'Argive' shield which Pausanias says was reintroduced by Philopoimen;[64] the horseman (?) on the sword might allude to Polybios' hipparchy (the spear could conceivably be a cavalry lance). The rings on Polybios' left hand might be insignia

[61] Ridgway, *Hellenistic Sculpture*, ii. 228 n. 61. Generally, Bol and Eckstein, 'Polybios-Stele', from the *stele* and earlier observations by L. Gurlitt ('Ein Kriegerrelief aus Kleitor', *AthMitt* 6 (1881), 154–66) and A. Milchhöfer ('Polybios', *ArchZeit* 39 (1881), 153–8). The *stele*, now severely worn and damaged (it is apparently kept in the village of Kato Kleitoria), is best known from photographs, photographs of a now lost cast (Berlin) made from the original, and a cast of this cast (Freiburg).

[62] From the description, it is not entirely clear where this relief decoration was located: on the guard? across the scabbard mouth?

[63] Ma, 'Eugnotos'; Ma, *BMCR* 2008.02.27, notably on Plutarch, *Aratos* 23.3 for a description of Aratos, whose pose resembles that of a statue in armour.

[64] Pausanias 8.50.1; Plutarch, *Philopoimen* 9.2 speaks of *aspidas*, along with the sarissa (which cannot be wielded with the traditional hoplitic shield).

of office, for instance signet rings bearing public seals. Polybios is not represented realistically in the full heavy armour of the battle combatant; the *exomis* he wears, with the right shoulder exposed, is a simple, almost rustic piece of clothing, appropriate for manual workers but in fact also for soldiers, who must show a taste for hard physical exercise. The body revealed by the *exomis* is duly muscular and powerful, the trained body of an Achaian fighter, on the model of the redoubtable Philopoimen, as revealed by Plutarch's *Life* of this Achaian general. Polybios, at the time the relief was carved, was in his late fifties; though it is not impossible that he had remained active, vigorous, and muscular, the body on the Kleitor relief is also a physical imagining of the Philopoimen-like Achaian soldier—a social body of shared Achaian person-hood, at the precise moment when this body was now a sign of past military agency.

The massive upper body, seen frontally, occupies the full field of the *stele*, in an assertive, dynamic pose whose drama is reinforced by the movement of the *chlamys* pulled back by the left hand; at the same time, this gesture of retaining drapery rather than letting it float or flutter charismatically, recalls the various attitudes by which the himation-men involve their limbs in their drapery, showing restraint. Such a civic interpretation fits the Polybios *stele* well: the muscular body is not allowed to expand too assertively, as royal portraits do, but is restrained by the pose of the left arm, and thus locates military activity within the self-control and law-abiding concerns of the good politician and citizen. The face, individualized and aged, marked with the 'worried' traits of the good citizen, reinforces this civic ethos.

Other elements of the portrait *stele* may point away from the context of Achaian political culture. The rings on Polybios' hands might not be official signet rings, but gifts—for instance from the dynasties which Polybios was close to, the Ptolemies and one of the two warring branches of the Seleukids. The rings would thus allude to Polybios' involvement in the very grandest of international politics. Another possibility is that one of these rings is a gold ring worn in virtue of a grant by a Roman magistrate—just as a benefactor in Messene was awarded this right by a consul (the Messenians felt the need to confirm the grant).[65] The ring might act as a reminder of Polybios' status within the Roman world, and the exceptional favour he enjoyed with Roman senatorial circles.

If the ring(s) should be viewed as signs of Roman favour, this must influence the way we should interpret Polybios' hair. Of course, the short hairstyle and shaved chin is not an innovation by the late Hellenistic period, but part of the normal self-presentation of a Hellenistic gentleman such as Polybios. Yet it might also suggest proximity and loyalty to the new hegemonical power in the Greek world, namely the Romans, as represented by shaven, short-haired commanders and officers, the *hegoumenoi* which would loom so large on the horizons of the Hellenistic cities in the second and first centuries. Polybios' head can be viewed as a very early example (the earliest attested) of the Greek *philorhomaios*, the pro-Roman local notable whose face and styling show his political attitude and capacity for local patronage through his contacts at the centre of power.[66] The portrait *stele* combines reference to trad-itional Achaian values with an allusion to Polybios' role in the new, post-146 world.

Finally, the portrait may also draw on religious registers. The image itself is described (in what I have argued is a standard epigram, used across the Peloponnese) as a 'fine image', περικαλλὲς ἄγαλμα—the expression is a cliché, of great antiquity, to describe works of art in the context of religious dedication, pleasing to the gods.[67] The genre of the *stele*, and its massive proportions, evokes votive reliefs; the massive, muscular body, revealed by the *exomis*, evokes the representation of heroes. The classicizing style furthers these religious associations. From

[65] *IG* 5.1.1432; Wilhelm, *Inschriftenkunde*, i. 502–8. I thank Paraskevi Martzavou for these references. In the first cent. AD, the citizens of Pantikapaion granted a gold ring to a benefactor (*IOSPE* II 5, now *CIRB* 432; *BE* 69, 287).

[66] R. R. R. Smith, 'Cultural Choice and Political Identity in Honorific Portrait Statues in the Greek East in the Second Century AD', *JRS* 88 (1998), 83–6.

[67] e.g. *SEG* 19.568 (on an Archaic dedication from Samos, the famous statue set up by Cheramyes, now in the Louvre); *CEG* 335 (dedication at the Ptoion). The expression is the subject of a meditation by C. Karouzos, *Perikalles agalma exepoies ouk adaes* (Athens, 1940) (with the Roberts, *BE* 46/7, 19).

Pausanias' description, we know that reliefs of Polybios were set up next to gods or heroes. At Lykosoura, the relief portrait of Polybios came last, after three reliefs showing the Fates and Zeus, Herakles and Apollo wrestling over the Delphic Tripod, and the Nymphs and Pan. At Tegea, the portrait *stele* of Polybios stood next to the altar of Ge (Earth) and another portrait of Elatos, one of the sons of Arkas, an important figure in the links between Arkadia and Phokis.[68] It is possible that the *stele* at Kleitor was also set up in sacred space, near images or reliefs of heroes and gods. The raised right arm and open hand on this *stele* would thus work as a gesture of adoration or homage, addressed to the sacred personages in this space. However, the location of this image—with all of its references to the political culture and past military achievements of the Achaian League—within sacred space in proximity to heroes, also has the bitter-sweet, ambiguous effect of assimilating the Achaian past to the heroic realm. The full force of this gesture, in the post-146 world, needs appreciating in the context of the late Hellenistic and early Roman Peloponnese.

4. HONORIFIC STATUES IN CONTEXT: PRIENE AND DELOS *c*.120

In Priene, an over-life-size headless himation-wearing marble statue was found in the lower gymnasion, and was probably set up on the base in front of one of the stoas (Fig. 8.8).[69] The statue may have represented a gymnasiarch, or a benefactor, and was almost certainly a publicly dedicated statue—set up by the city or by an association linked to the gymnasion; the material hints at a date in the second century or later (for instance, it might have been part of a group of several statues in different materials for the same benefactor, as is well attested at Priene). The statue corresponds to a version of the 'normal type', though the loss of the head does not allow us to see how the Prienians chose to represent the benefactor's face. The pose is four-square, with the weight equally distributed and no swing in the hips, even though the right foot is pushed slightly forward. The himation is worn without a chiton, and the arms may have been placed in the 'Demosthenes' position, hands clasped in front of the body; there is no trace of the flamboyant drapery favoured in the Kos-style. The feet are bare. The Priene statue illustrates the currency of the traditional forms, along basic, deliberately plain schemes (served by extreme care in the execution of the complex drapery),[70] even in the late Hellenistic period; the absence of chiton and the bare feet may be appropriate for the gymnasion (see further below). The old Greek style fitted the function of the gymnasion as a site of Hellenic culture; the absence of full dress (chiton, himation, shoes) may have signified greater informality, or the readiness of the honorand to participate in physical activities.

On Delos, the Italian *negotiatores* set up an honorific marble statue in the porticoed complex which served as their social and corporate space, the so-called 'Agora des Italiens':[71] this was the portrait statue of one C. Ofellius Ferus, erected 'on account of his justice and the love of good which he displays towards them', δικαιοσύνης ἕνεκα καὶ φιλαγαθίας τῆς εἰς ἑαυτούς (Fig. 8.9).[72] The large statue represents Ofellius naked, standing with his weight on his back right leg, and the left leg forward; a fringed cloak is draped over the left shoulder and arm. Ofellius holds a sheathed sword, point upwards, with his left hand in the crook of his left arm; the raised right arm (now lost) held a spear. The whole composition is a reworking and combining of Classical models and styles; it takes over the royal, Alexander-generated tropes of youthfulness, military dynamism, and heroic masculinity, but combined them with a head (now lost) which probably

[68] The well-known decree of the Elateians for the citizens of Stymphalos bears witness to the vitality of these links (*ISE* 55, with commentary and further references).

[69] Wiegand, in Wiegand and Schrader, *Priene*, 268–9, with Krischen, 'Gymnasion von Priene', 143–4 (the statue did not stand in a niche in the 'Ephebensaal'); Linfert, *Kunstzentren*, 37, Rumscheid, *Priene*, 210 (the upper part seems lost; the lower part was once in the Basmane depot in Izmir, inv. 3037).

[70] Linfert, *Kunstzentren*, 37–8.

[71] Trümpy, *Agora des Italiens*, 207–13.

[72] Queyrel, 'Ofellius Ferus'; C. H. Hallett, *The Roman Nude: Heroic Portrait Statuary*, 200 BC–AD 300 (Oxford, 2005), 103–7; on which see the review by B. S. Ridgway, *BMCR* 2006.03.19.

Fig. 8.8. A statue from the Lower
Gymnasion in Priene gives us
a contextualized example of the
'normal type', in stone. Fragmentary
marble statue, once over-life-size.

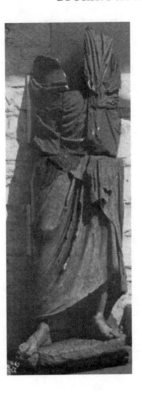

presented Ofellius' face in a realistic manner, perhaps toned down to fit with the classicizing style of the body.

We know precisely who this portrait is supposed to represent. C. Ofellius Ferus dedicated one of the stoas in the 'Agora des Italiens': he was honoured as a benefactor and important member of the community of Italian traders, within their special semi-private space which he contributed to building. He does not seem to have held office as a magistrate or pro-magistrate of the Roman Republic, and hence could not be represented with official insignia of military *imperium*. Why the choice of heroic nudity, arms, and cloak? The problem is to decide whether these refer to something specific (for instance, some form of official service or military activity), or whether these features have an *expressive* function. I favour the second solution. The absence of any specific mention in the inscription preclude any allusion to military activity or office that would complete the inscription by visual reference. The ethical qualities praised, justice and 'love of good', suggest some informal, though very present, role within the community of Italians, and the willingness to show goodness in the very material forms of euergetism. Hence the 'royal' forms are adopted as expressive: they provide a striking, and original, way of attributing distinction to the benefactor. In addition, they also allow the Italian traders to variously appropriate the pre-existing cultural forms of Classical art in its fluency and technical skill, and royal imagery in its impressiveness and heroic presence. This appropriation itself was an act of assertion and power on the island of Delos in which they played an important, but not quite official, role.

The two marble statues—Priene himation-man as civic benefactor honoured in the gymnasion, Italian trader as heroic armed nude in the Italians' 'clubhouse'—are roughly contemporary, but come from very different contexts. The Prienian statue can be considered typical of the norm of public civic honorific statues in Hellenistic *poleis*. It gives a documented example of this norm in existence (thus confirming the generalized picture given in the preceding chapters). Furthermore, its late Hellenistic date illustrates the vitality of this norm, which continued into the period of the Roman empire (see the concluding chapter to this book). The three first-century marble statues of the female relatives of a Roman governor, set up in Magnesia on

Fig. 8.9. The Italians on Delos developed their own statuary language, often highly original, out of pre-existing idioms. Marble statue of C. Ofellius Ferus, Delos, 'Agora des Italiens'. H. 2.28 m (orig. *c*.2.8 m), now Museum of Delos, A 4340. Photogr. Ph. Collet, courtesy of the French School of Archaeology, Athens.

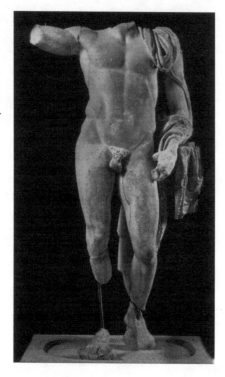

Maeander, reinforce this image of the continuity of stereotypical norms: the statues follow fixed patterns, and have completely idealized, non-individual faces.[73]

In contrast, Ofellius' statue is set up by a particular group, Roman and Italian immigrants in a Greek land, with a loose social organization. The unusual choices embodied in this statue, as analysed above, reflect the Italians' taste and identity. Just as the Priene statue, and the three women of Magnesia, lie squarely in the mainstream of the honorific genre, the statue of Ofellius lies on the margins of the possible, and illustrates the wide diversity of choices available, especially by the late Hellenistic period.

5. PRIVATE HONORIFIC PORTRAITS

Those private honorific statues which survive reflect the diversity of the genre (above, Chap. 5). The philosopher portraits, known from Roman copies, were set up as private honorifics, by relatives or friends: two Athenians set up a statue of Karneades, and (I hypothesize) there was a single statue of Chrysippos in Athens, set up by his nephew in the Ptolemaion (the gymnasion where the statue of Karneades may have also been set up). Both statues represented the philosophers as seated; the statue of Chrysippos, at least, was strikingly original in its choices, as vividly described by P. Zanker: the philosopher, sitting on a simple stone block, wore a himation without chiton about his frail body, and held his open right hand across his lap, a gesture of argumentation.[74] The philosopher portraits represent a very particular, and limited, segment of the private honorific genre, responding to the expressive needs of individuals wishing to commemorate their relations within the circle of philosophers and their pupils.

Other identifiable private honorific portraits are more conventional, especially in the case of statues of women—albeit with subtle variations and inflexions. At Rhamnous, the portrait of

[73] D. Pinkwart, 'Weibliche Gewandstatuen aus Magnesia am Mäander', *Antike Plastik*, 12 (1973), 149–59; Smith, *Hellenistic Sculpture*, 86 and fig. 116; Eule, *Bürgerinnen*, 204.
[74] Zanker, *Mask of Sokrates*, 97–102 (and *passim*); above, 88, 136.

Aristonoe, set up by her son around the middle of the second century (Fig. 5.4), is executed according to conventional schemes, as can be seen in the body pose and the drapery, as well as the idealized, beautiful face and elegant hairstyle. At the same time, the portrait is characterized in two ways. First, Aristonoe is presented with priestly attributes, as is fitting for this statue set up to commemorate her service to Nemesis and Themis, the deities of Rhamnous. Second, in addition, her face, though idealized, presents traces of ageing, such as bags under the eyes, a double chin, and wrinkles on the neck, as is fitting for a woman of mature years honoured by a grown son (who has enough resources to pay for a 2,000-drachma statue).[75] We cannot be sure where the statue originally stood. It was found inside the 'small temple' at Rhamnous, which served as a treasury in the shrine, next to the larger temple. However, there is no certitude that this was the original site where it was set up, since it could have been moved there later, or displaced there during the subsequent history of the site.[76] Nonetheless, the statue of Aristonoe is the best preserved, and most instructive, example of female private honorifics. It helps us imagine what the full effect might have been for fragmentary examples such as the statue of Zopyreina, set up by her parents at the shrine of Artemis Aulideia after her service as priestess,[77] or the statue set up by Lysias, an Athenian on Delos, and his two sons (probably in the late second century), for one of their female relatives (either Diodora, Lysias' wife, or Athenion, Lysias' daughter), as part of a multi-statue, multi-relational monument in a niche on the terrace of the Serapeion C.[78] The statue of Aristonoe also sharpens our perception of other well-preserved female private honorific statues, such as the late Hellenistic marble statue of Kodis from a whole row of such statues, set up in a stoa on a specially built terrace at the top of the shrine of Artemis Polo.[79] This particular statue, like the others surrounding it, seems bland and conventional; the serializing force of the arrangement seems to have encouraged uniformity, in contrast with the more individualized, stand-alone statue of Aristonoe.

There are three well-preserved (or representative) private honorific statues of men, all in marble. One is the statue of Dioskourides, an Athenian on Delos, honoured by his wife Kleopatra with a statue set up in their house: Dioskourides' statue survives, as does that of Kleopatra, both found near the base in its site, but without their heads (Fig. 5.5). The pose of both seems highly conventional (Pudicitia for her, arm-sling for him).[80] The similarity of postures and drapery patterns is completed by the symmetry of weight distribution (right leg for her, left leg for him), and the composition shows conjugal harmony. Kleopatra's posture perhaps shows a more pronounced swing of the hips, which brings out, by contrast, the solidity of the posture adopted by Dioskourides: the difference is deliberate, and gendered, showing the male's dominant position in the couple and in the community. This is part of the politics of the himation-wearing 'normal type', which we should imagine as very widely used for private honorific statues, especially as part of multiple-statue monuments: the male himation wearers probably dominated, by their poses and faces, the female statues with their less individualized faces, closed and 'modest' body language, and more pronounced imbalance in body posture.

Another male private honorific statue is that of a Roman official, C. Billienus, praetorian commander *pro consule*, honoured by Midas son of Zenon, of Herakleia, with a statue set up in the stoa of Antigonos on Delos, in the last years of the second century.[81] Billienus must have

[75] Dillon, *Female Portrait Statue*, 106–10. On the cost of statues, above, 264–5.

[76] Petrakos, *Rhamnous* I, 288.

[77] Above, Chap. 5 n. 74; *SEG* 25.542, first cent. BC or later. On the female statues from Aulis, Connelly, *Portrait of a Priestess*, 157–61. I examined the statue and its base in the museum at Thebes, and do wonder if they are correctly associated: the cavity in the base seems much larger, and differently shaped, from the statue plinth.

[78] *ID* 2095–6 with notes by P. Roussel; Marcadé, *Au musée de Délos*, 134–5; Dillon, *Female Portrait Statue*, 87–9, 173.

[79] *IG* 12 Suppl. 382; *Guide de Thasos*,[2] 90–1; very careful treatment in Dillon, *Female Portrait Statue*, 136–47.

[80] Dillon, *Female Portrait Statue*, 88–90.

[81] *ID* 1854; T. C. Brennan, *The Praetorship in the Roman Republic* (Oxford, 2000), 523, 548; Courby, *Portique d'Antigone*, 41–5. Marcadé, *Musée de Délos*, 134, Hallett, *Roman Nude*, 132, on Billienus' costume.

Fig. 8.10. The gymnasion was the site for public but also private honorific monuments, recording friendship: an early first-century AD example from Eretria preserves the statue and the base (alas, the original emplacement cannot be determined): it shows a young man, barefoot but wearing a tightly wrapped himation. Marble statue of Kleonikos, set up by his friend Amphikrates. H. 1.95 m, height of monument with base 2.95 m—but the total monument was taller, since the surviving elements of the base sat on another moulded course, and probably another block (hence original height of monument *c*.3.5 m). Athens, National Archaeological Museum, find inv. 244, cat. 655; photogr. National Archaeological Museum.

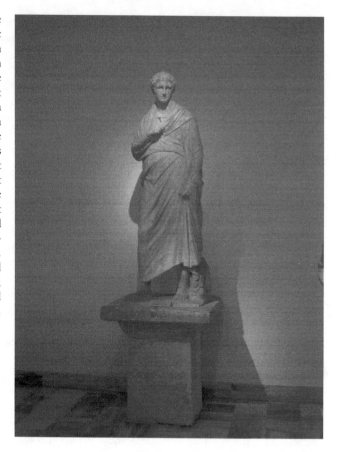

been important—governor in Macedonia or Asia—and his status is reflected by the size as well as the site of the monument: the large statue stood on a base 2.59 m long, big enough to support several statues; it represented Billienus in full armour, with a fringed cloak, spear, and shield; a ship's ram was represented next to his right foot, as an allusion to command at sea or naval victory. The location of the statue is very prominent: it is placed, unusually, inside the stoa, at the northern end, thus dominating the whole vista down the long covered space. The choice of location distinguishes the statue of Billienus from the very crowded statue environment in front of the stoa. The statue of Billienus may represent a particular subgenre of the private honorific statue: the setting up of statues of very 'public' figures, namely kings or Roman officials, by 'private' individuals, acting in their own capacity, to make gestures that make visible the honorand's power, but also associate the dedicator with the stature and importance of the honorand.[82] The visual language, not surprisingly, must have largely been borrowed from the public register, specifically the genre of the royal statue.

A final example of a male private honorific statue comes from a gymnasial context. A marble statue found in the gymnasion in Eretria was found close to its inscribed statue base, which identifies the statue as the portrait of one Kleonikos son of Lysandros, set up by one Amphikrates son of Lysandros, for 'his friend' (Fig. 8.10).[83] In spite of the identical patronymics, the two men are not brothers, as conveyed by the information that they were

[82] Above, 183–7.

[83] *IG* 12.9.281; above, 183. The association between the base and the statue was challenged in S. Lehmann, 'Der bekleidete Gymnasiast: Eine neue Deutung zum Jüngling von Eretria', *Antike Kunst*, 44 (2001), 18–23, but convincingly reaffirmed by Knoepfler ('Débris', 238–40): the cavity on top of the base, in its actual state, is larger than the plinth of the marble statue, but it is likely that this actual state reflects systematic damage inflicted on

friends. Kleonikos' full face is idealized in its treatment of eyes, nose, mouth, and brow, and inspired by Classical models. The hair is worn in short curls, and descends slightly on either side in the shape of sideburns. Kleonikos wears a himation, in the classic 'arm-sling' pose, his right hand appearing out of the drapery in the middle of his chest, his left arm straight at his side, with his loosely clenched fist appearing under the drapery: the pattern of the drapery across the body resembles that on the statue of Aiskhines known from a Roman copy,[84] the pose with the straight arm is close to that of Dioskourides on Delos. Beneath the tight swathing described by the himation, the edge of a chiton appears (as on the Aiskhines type). His feet are bare; his left foot rests on a support covered with a pair of boxing gloves, of the type used for practice in the gymnasion.

Kleonikos' statue is the only known private honorific statue from a gymnasion; even if its exact site is not known, it provides us with a secure context to try to interpret what we see—the record, in statue form, of one of the friendships that characterized the world of the young men of the gymnasion, and that left material traces in many forms, such as graffiti on the walls and benches of the gymnasion.[85] The boxing gloves refer to physical activity in the gymnasion—not competition, but practice and training with a partner, in preparation for eventual competition in the gymnasion's contests or in more prestigious arenas. The bare feet are very noticeable, and the reason for this feature may also lie in the gymnasial context: the fine sandals of the normal himation-wearers would not have been worn around the gymnasion environment, full as it was with the dust and the sand of the running-track and the wrestling-pit, and the oil and water of bodily ablutions. Yet Kleonikos is not represented naked, as an athlete in training, but fully clothed, with chiton as well as himation. The clothing carries connotations of restraint, fitting for a youth (precisely because of fears of youthful unruliness and violence)—but also of culture, which alludes to the cultural function of the gymnasion, a place where lectures (*akroaseis*) in philosophy, history, or literature took place.[86] The bare feet might connote old-fashioned Greekness, in keeping with the cultural nature of the gymnasion.

The face is a reworking of a Classical model used for religious sculpture, known from a Roman version (the 'Hermes Richelieu'), which is perhaps appropriate since Hermes is one of the presiding deities of the gymnasion. The idealized features also lend Kleonikos the shining, assertive physical beauty which was so prized in the gymnasion—but any sexual anxiety is stifled by the image of restraint and self-control, shown by the full dress of himation and chiton.[87] Finally, Kleonikos' frame is noticeably slender: the narrow swathed shoulders are shaped in a triangular form, unlike the square broad frame of most himation-men; the whole body is elongated in relation to the small head (the relation is 1/10). In spite of the training gloves next to Kleonikos' left foot, his body is not the muscular, packed frame of the heavy athlete, but, hinted at under the himation, the long sihouette of a youth, appropriate for the age-group that frequented the gymnasion.

6. CONTEXTS FOR SEEING

I have here surveyed seventeen honorific portraits: four public (three known through copies; three more female statues are also relevant), ten private (two known through copies). The

both sides in order to scavenge the lead bedding of the statue. On the date, E. Mango, *Das Gymnasium* (Gollion, 2003), 114; Brélaz and Schmid, 'Une nouvelle dédicace', 239; generally, Skaltsa, *Hellenistic Gymnasia*, 105–6, 120–4.

[84] Richter, *Portraits*, 213, no. 6.

[85] Couilloud, 'Les Graffites du Gymnase'.

[86] *OGIS* 339; *IG* 12.9.234; *FD* 3.1.273; A. Tziafalas and B. Helly, 'Décrets inédits de Larissa (3)', *BCH* 131 (2007), 423–5; L. Robert, *Études épigraphiques et philologiques* (Paris, 1938), 14; P. Scholz, 'Elementarunterricht und intellektuelle Bildung im hellenistischen Gymnasion', in D. Kah and P. Scholz (eds), *Das hellenistische Gymnasion* (Berlin, 2004), 103–28; M. Haake, 'Der Philosoph Alexander, Sohn des Alexander, aus Athen: Zu einem neuen hellenistischen Ehrendekret aus Larisa für einen bislang unbekannten Philosophen', *Tyche*, 25 (2010), 39–48.

[87] On physical beauty in the gymnasion, Robert, *Hellenica*, i. 127–31; on restraint, Gauthier and Hatzopoulos, *Loi gymnasiarchique*, notably lines B 1–10, with pp. 57–68.

majority of the evidence lies in the later Hellenistic period, from *c*.150 onwards; no doubt there are more examples to be included, from the first centuries BC and AD, which deserve analysis. In spite of the diversity which I adduced earlier as a probable component of the appearance of the honorific statue (seated men, armed citizens, etc.), it is still likely that the 'normal types' enjoyed wide currency: the portraits of Kleopatra and Dioskourides look as conventional as possible, precisely because the private statue monument inside the house also refers to public actions, and more generally because it was in the interest of the genre to look 'public'. Other private statues may have decided deliberately, and flamboyantly, to present images that were not easily reducible to the normal types of public statuary.

Earlier, I developed the hypothesis that the placing of honorific statues in rows tended towards 'serialization', an effect of visual uniformity which reduced any individual claim at eminence as well as any artistic stand-out quality. I would maintain that the point of the general effect of 'forests of statues' was to reduce individual eminence, as a deliberate political ploy; to see a long row of honorific statues, even if each one showed variations, did not necessarily encourage lingering over each one. Across a whole shrine or agora, variations in size, shape, type, rather than necessarily making any one statue stand out, may again have reinforced the overall effect of ornamentation and history-heavy presentation. But what this section has shown is that every statue was the rich product of a multitude of choices and forces: the bespoke nature of the statue production process made it responsive to the pressures that existed within every context, each time. Produced in response to these contexts, the statue was, in turn, a participant member in creating this context, because it also embodied a gesture or an intention.

Conclusion

In concluding, I attempt two things. First, I summarize the main arguments in the previous three parts of the present book, and try to locate the different findings within a broad narrative of the post-Classical city, down to late Antiquity. Even though there seem to be oligarchizing evolutions, such a narrative should not be the story of elite take-over of political culture, but of the continued dialectical relationship between community and elite, within a complicated, conflictual history of the civic; in the Greek cities of the Roman empire, elite affirmation had to take place within constraints inherited from the Classical and Hellenistic polis, and which the honorific statue embodied. Second, I take the honorific statue, as studied throughout the present work, as a starting point to visit the issues of the 'Greek portrait' within an anthropology of Greek art; in view of the functions and the politics of the portrait (as defined explicitly in the epigraphical material), I take a position on the nature of this artistic genre (naturalistic; between realism and idealism; not purely defined and viewed in terms of iconographical conventions). In a final, short coda, I show that the two approaches (political and artistic) can be mapped onto one another, to discover what honorific portraits did, and why they were desirable.

I. DISCOURSE, SPACE AND PLACE, FRIENDS AND FAMILIES

Honorific statues and the Hellenistic cities: this book has gone about showing that there are three ways of telling the story of their relation, over the three or four centuries of the Hellenistic period (*c.*350 BC–AD 50); three sets of phenomena, and their implications that need to be unpacked within the larger themes which have undergirded this book. It may be worth summarizing them, once more, to try to see where the interpretive balance lies between these three possible views; the following summaries gather themes that have appeared across all three parts (and six chapters) that constitute the bulk of this work.

The first story, based on the institutionalized epigraphical phenomena (the inscribed bases as a trace of the whole monument), is that of the civic culture overwhelmingly in control of the symbolical balance of power; a constructivist interpretation, confident in the power of value enactment. Examining 'obvious' formulas, and their semiotic problems—'the demos has dedicated (a statue of) X', 'the demos has honoured X with a (this) statue', 'the demos (has dedicated (a statue of)/honoured (with this statue)) X'—allows the politicized, or at least civically informed, reading of monuments. The main finding is that normatized captioning, within a small range of local variations and semiotic choices, shifted the 'subject', and hence the meaning, of the honorific monument: not homage, not representation of a Great Man, but the enacting of relationality. Monument stands for community, in an act of self-representation, self-affirmation, and role-assignment, in relations with powerful outsiders or eminent citizens. The implications are the primacy of community over individual, no matter what his or her status; the honorific statue is hence not an elitist artefact, but a communitarian one, and this view of a cardinal artefact of Hellenistic political culture has major implications for our understanding of the post-Classical *polis*, in reinforcing, or simply giving expression to, the 'vitalist' paradigm within which 'elite capture' means 'the capture of the elite by the community'. This interpretation of the honorific statue as carrying out communitarian identity capture

is partly shaped by the nature of the surviving evidence: the 'grammar' of inscriptions, and the cultural practice of captioning portraits in relational terms. To look beyond the 'paper statue' entails thinking about the actual, physical, bronze or marble object and the whole monument, as a visual statement, rather than as a linguistic discourse.

Many statues reinforced civic meanings: the potential presence of the community in statuary (often colossal) form, shown as the entity doing the honouring and hence deciding on recognition and status; the strongly constrained *Normaltypus* statue of the good citizen, the stereotypical images of women, even, perhaps, certain royal portraits, inflected to fit civic meanings. In this story, the use of space, controlled by the civic community, reinforced these meanings. Statues were placed in a variety of places, according to appropriateness: the agora and the civic shrine, the gymnasion and the theatre. Collocation of statues of honorands next to gods, personifications of city or democracy, or meaningful places, reinforced the ideological messages of communitarian primacy, explicit and implicit, contained in the honorific monuments set up by the cities for local benefactors and foreign rulers. The placing of honorific statues in series of uniform monuments made the point that no one monument was unique, any more than any benefactor was unique; by processes of local embedding, the honorific transaction ensured social reproduction within a political culture, but also of that political culture. Writing, monument, and space interlocked, to visualize, reinforce, and produce a strong civic ideology, of communitarian subsuming of service and character within the *polis*.

Yet was it so simple? Looking at 'statue events' on the ground, in the archaeological record, shows that civic history is not simply the story of the hegemonical control of the community over (the terms of) its members' behaviour in relation to it; this applies even to the artefacts that were meant to express this ideology, the figurative, inscribed, emplaced honorific monument. Such monuments had to 'take place', in the sense that they embodied events and transactions within a civic culture, but also in the sense that they represent concrete, materialized claims upon the scarce resources of time, memory, and space. Hence a second story, developed from the archaeology of the Hellenistic cityscapes and shrine settings, a story which also amounts to an 'archaeology' of civic discourse and ideology. The emblem of this story is the landscape of statue bases jostling, on the ground, to avoid dead ends and occupy prime spaces: this can be exemplified in the great international shrines (Delos, Olympia, Delphi), but also in such eminently civic spaces as the agora (at Priene or Thasos). I explored the landscapes of competition through metaphors, mainly ecological—'limpet' bases, 'parasites', 'big fish', 'growth' towards the rare resources of space, memory, attention—within an overarching (if not terribly consistent) metaphor of the Hellenistic cityscape as an ecotope, a competitive ecology of self-interested actors.

Ecology rather than ideology? At least, the realization that more is going on than simply the enactment, emplotment, emplacement of civic ideology; on the ground, 'emplacement' means complex processes of negotiation between individual actors, the previous 'actors' in the form of earlier statues or the general built environment, and finally the human, living community that uses shared spaces, and what I called 'the public actor'—the State, the civic, authoritative entity which controls public space, even though it has to interact with individual, private actors, and sometimes appears in the guise of one among many competing actors within public space. Competition and interaction, in other words, takes place between elite individuals, but also between elite individuals and the political community that attempts to control them on the ground. This picture is far more unstable than the image of control implied by discourse and ideology, though it may be overdramatic: the presence of competing actors in public space is precisely what the presence of the public is there to balance and control, within living patterns of development.

Competitive processes lead to spatial outcomes, in the form of civic 'place', shaped by historical pressures. The nature of these outcomes is not predetermined—'elite capture' in the sense of the take-over of a public good (shared space) by the elite is a possibility, but it is hampered by other factors, such as the patience of the 'public actor', or the processes of

competition themselves, which might neutralize any attempt at elite capture by enforcing a 'tragedy of the elites' in the form of honour inflation and generalized serialization, or by changes in the wider historical context. Particular test cases, such as the theatre at Magnesia on Maeander, the terrace of the Amphiaraion at Oropos, or the agora at Priene, if read in detail, show competitive, collaborative, 'environmental', and 'governmental' processes at work, combining to produce complex outcomes. However, a more general outcome that can be read is the segmentation of civic space—particularly visible in the agora of Thasos, but also at Priene or Athens: at the very least, this forces pause before vaunting the power of the honorific statue to impose communitarian ideology on elites. The 'archaeology' of civic space and civic discourse hence leads to a redefinition of 'civic'—the civic does not need to be the history of the successful hegemony of *polis* over individual (let alone the never-ending triumph of 'democratic' ideology), but should be able to accommodate the presence of competition, manipulation, and pressures; this vision of the civic is close to, and inspired by, the work of modern urban historians and geographers.

Apart from the 'public actor', the archaeological record shows the traces of private actors, as participants in the competitive processes of 'taking place'; the third story that can be told about honorific statues is that of the private honorific statue, set up by a variety of powerful private actors—kings and their men; the local friends of kings and Romans; and especially wealthy families—in the same spaces, and often as part of the same monument (portfolio bases), and starting very soon after the emergence of the public honorific statue. Even though wealthy families and individuals had set up portrait statues (dedicatory and funerary) in the Archaic and Classical periods, the specific form of the private honorific statue is less a survival than an invention of the late Classical period, almost certainly in reaction to the public statuary genre. Private honorific statues are well attested in shrines, but also, more surprisingly, in public spaces such as the agoras of various Hellenistic cities. Whereas the public genre celebrated service or benevolence, by rulers or citizens, towards whole communities, the private genre marked individual relations of friendship or familial affiliation, often during privately signifi-cant moments—the fulfilment of office or priestly duties, athletic victory, and in particular moments of transition within family life, such as death, reconciliation, entering into one's estate. Such moments might be imagined even when there is no explicit occasion for a private, familial, statue; at any rate, the setting up of a statue is itself an occasion, an event, which does not so much guarantee continuity of pre-existing lineage as construct and make visible 'kindreds', networks of kin who participate in the statue transaction.

Three questions emerge, of great importance for understanding the social history of power in the Hellenistic world: why this private genre emerged, what social functions it fulfilled, what social trends it reflected and accelerated. In the case of the Hellenistic kingdoms, the answers seem obvious: statues set up within the dynasty made clear patterns of succession and emotional commitments between members of a ruling house (especially in the case of the Attalids); statues set up by royal officials for their master, or occasionally by kings for royal officials, made clear ties of loyalty and the solidity of the patrimonial state (for instance in post-Raphia Koile-Syria, or when Seleukos IV dedicated a statue of his minister Heliodoros on Delos); statues set up for one another by power-holders in royal states created personal ties of cordiality and commitments between the free-floating elements within the administration and army (as is visible in Seleukid Susa or Ptolemaic Cyprus).

Within the Hellenistic cities, the private genre allowed wealthy individuals and families to achieve visibility, and commemorate their relations through the form of permanent monu-ments set up in public spaces such as the agora. The publicness of the private monument meant that it was often couched in communally normed terms, for instance through the commem-oration of public service (in short notations, or in long, Rhodian-style 'CV' inscriptions), or the adoption of the same visual idioms as the public honorific inscription. This same public character also allowed the private genre to express communal values. Private statues set up by members of a community could give that community visibility and presence in the face of

outsiders (as probably took place on Thera, or such famous shrines as the Asklepieion at Epidauros or the Amphiaraion near Oropos). More generally, the portrayal of such family values as conjugal harmony, brotherly *entente*, and the transmission of property, were relevant to the political imagination of the *polis* as a human community not unlike a family. At the same time, a consensual interpretation should not dissimulate the elitist potential of family-dedicated statues. The genre displays wealth, and does so on the assumption of the validity of the power of a social elite to act as the synecdoche for *polis* reproduction. Furthermore, it allows families to vary the terms of their public representation, thus escaping the communal constraints of the public honorific. In addition, the practice of private monumentalization integrates public statues within 'portfolios' which try to assimilate public honours to only one of the facets of elite identity. Finally, the private honorific statue habit constitutes the background against which private financing of public honours tends towards the norm, an evolution which starts during the late Hellenistic period and gains full force during the Roman empire.

This book opens with civic discourse, and ends with 'family thinking' (R. van Bremen); it starts with a particular paradigm, the 'vitalist' view, developed notably by P. Gauthier, but confronts a variety of dynamic phenomena, spatial and human, that hint at a complex civic history of competition, interaction, and evolution. The physical objects, the actual honorific statues, have to be viewed in the context of this complex civic history—as embodiments of civic ideological control in the euergetical transaction, as tokens in a struggle for power within and over the cities, as moments in archaeologies of social relations. The multiple viewpoints on the honorific statue show that all three story-lines or interpretive angles I have developed above coexist; the challenge may be to find ways to understand their relation with each other. This relation is first heuristic. It is the definition of communitarian ideology, sketched out in Part I of this book, that forces us to puzzle over the traces of competition in the archaeological record and the presence of familial actors in the *polis* as social space. Conversely, reading the archaeological record or unpacking family thinking casts a new light on the workings and the reach of communitarian *polis* ideology. Secondly, the relation between these potential interpretive lines itself says something about the complexity, and synchronic multivalence, of an artefact and a social transaction such as the honorific statue. In other words, might a 'unified statue theory' tell us the story of the honorific statue—but also, through a particular test case, the story of the post-Classical *polis* itself?

2. 'UNIFIED STATUE THEORY' FROM PRIENE TO APHRODISIAS

The immediate temptation is to give, anew, a single narrative of the honorific statue habit as a 'total' social phenomenon—but also as the story of a shift, from a predominantly public and communitarian to an private elitist culture. The story goes something like this. The honorific statue appears, in the early fourth century, as an exceptional honour (located within the still evolving practice of honours for benefactors); this honour allowed communities to reward powerful outsiders (Konon, Evagoras, the Hekatomnids) as well as pre-eminent citizens, for their services as military commanders, politicians or statesmen, and later as financial benefactors. As outlined above, during the high Hellenistic period, the honorific statue thus performed important functions in the political *praxis* and the political culture of the Hellenistic cities: relating to the Hellenistic kings within the terms of *polis* discourse, and hence with a chance of constraining them in stereotypical roles, as well as recasting power relations as symbolical transactions where the city enjoyed an active part; relating to local 'Big Men' in formulaic terms that did not emphasize the Big Man and his qualities as recipient of homage, but cast the community as the dominant partner in the reciprocal transaction between benefactor and city. The statue converted the benefactor into an exemplar, whose image created emulation among other individuals, outsiders, or citizens, or even other rulers. Honorific portraits literally put Big Men in their place (inoffensively placed next to statues of gods, or embedded within series of others like them). This genre of public art manifested the city's

capacity to reward amply and permanently: when the citizens of Magnesia on Maeander set up a statue for a benefactor who had lent money for construction work on the theatre, they meant to show *their* generosity (*megalopsuchia*, literally 'great-souledness'), a clear indication of the function of honours in wresting status back to the benefit of the community.[1]

The development of the private, and especially familial, portrait statue, dedicated in public spaces, must show elite awareness of the constraining potential of the public honorific statue. It is not a late phenomenon, but appears in the late Classical period (*c.*350), where it allowed for the multiplication of familial images in Athens, in competition with still parsimoniously granted public statuary honours; it is also particularly prominent at various points in Hellenistic history, in the early third century (for instance on Delos), or in the late third century (on Delos, on Rhodes, at Kaunos, at Oropos). The phenomenon represents a reaction to the public honorific: private statues allowed private transactions to claim memorial perenniality in space, but on different terms from the public honorifics. Because the private genre embodied particular values (private emotions, loyalty, and reciprocity; fenced-off micro-communities in the form of friendships or kindreds; the importance of patrimony and patrimonial politics), it was favoured by elite members of the Hellenistic cities, and the supra-*polis* players in the Hellenistic kingdoms, from the level of the rulers and their relatives down to the level of the officers and soldiers in the provinces.

In the cities, as explored above (Chap. 8), the private honorific statuary genre was mostly expressed in a visual language undistinguishable from the public honorifics (*himation*-man, various stereotypical female schemes), and, though captioned in very distinct ways (ὑπέρ-inscriptions, 'adoring' nominatives), often referred to public achievement in monumental writing ('CV' inscriptions, or mention of public duties or sacred office). The publicness of the private genre is testimony to the powerful grip of the public honorific statue (and generally the discourse of public honours and recognition as an essential part of self-realization) on the imagination of the social elite in the Hellenistic cities—as shown by the prevalence of the accusative of 'being honoured', 'being crowned' in non-public forms such as the Smyrnian-style funerary relief or the private dedication. Furthermore, the family honorific statue, as suggested above, could perform the public function of making the *polis* visible in the face of outside pressure or in the form of family continuities. Yet at the same time, the publicly acceptable forms of the private honorific allowed the emergence of practices and discourses which must have affected the force of the public honorific monument: the setting up of private honorific in the very public space of the agora; the assimilation of public and private statues in family 'portfolio' monuments; the assumption of the ability of the wealthy to represent the city in processes of synecdoche, by which elite familial processes stand in for the social reproduction of the whole city; the conspicuous take-over and parading of family emotions (*philostorgia*) and patrimonial continuity which had earlier been the *apanage* of Hellenistic dynasties but now expressed the eminence and permanence of elite families in their local communities.

Private statues in the agora appear in the late third century; the years 225–180 BC saw the affirmation of elite families through this particular genre, and hence mark an important moment in the history of the honorific statue habit, and in the shift of the balance of symbolical power that this habit represented in the Hellenistic cities. Further developments occur in the late Hellenistic period, from *c.*150 onwards: the increasing importance of private financing of public honorific statues; the increasing power and wealth of a small number of benefactors (this phenomenon in itself represents a major historical shift in the Hellenistic world, and still awaits explanation). This eminence is reflected in the availability of royal-style honours for citizen benefactors, and generally in the proliferation of statue honours for benefactors, who can receive a multitude of portraits in different media, in a shift of the meaning of the honorific

[1] *Inschr. Magnesia* 92B, early 2nd cent.; above, 137; the same sentiment in Demosthenes 20.64; decrees of the *Koinon* of the Magnetes declare that the point of honours is to incite emulation among men who see the *megalomereia* (magnificence) of the Magnetes—*IG* 9.2.1103, *SEG* 23.447 (with *BE* 64, 229).

statue from the one-off monumentalization of relationality towards gestures of homage to local Big Men.[2] The outcome is the statuescape of the Roman *polis*,[3] with its own evolutions and characteristics: the emergence of the statue-lined avenue, the statue-bedecked monument; the lengthening of the statue captions and the routine financing by relatives or by the honorands themselves, in what constitutes a significant shift in the balance of economical and symbolical power involved in the statue transaction;[4] the heightening (and thinning) of the statue base, as a technology for the expression of distinction. All these phenomena can be studied in detailed test cases, especially that of Roman (and, to a lesser extent, late Roman) Aphrodisias;[5] this is the city of elitist outcomes, as postulated by Quass and van Nijf,[6] where 'unified statue theory' seems indeed to have occurred—the two branches of the honorific statue habit, family and public, have conflated, but with the result that public processes seem to be in the hands of private actors.

From Priene to Aphrodisias: shifts did happen, and the starting point in the vitalist Hellenistic city of the 'long fourth century', namely one where political culture and political issues are the same as those of the (late) Classical city, only makes the contrast with the final outcomes of the Roman *polis* the more striking, raising the question of how the evolution took place. Yet even in the Roman *polis*, just as in the late Hellenistic *polis*, the political culture of the *polis* and of publicness did not cease to operate, as shown precisely by the nexus of image, place, and text that constituted the Roman-era honorific statue, for all the changes and evolutions that had taken place in the late Hellenistic period and under the Roman empire, into late antiquity. A third-century AD statue base from the *bouleuterion* at Priene spends more time describing the public bodies that voted the honour 'in frequent meetings of council and assembly (*boulekklesiai*) and in decrees', than the soberly mentioned services (financial expenditure during office) of the honorand.[7] The calm, moderate visual language of the statues for benefactors at Roman Aphrodisias belong to a civic culture; and so do late antique statues voted to governors, and captioned with epigrams that combine civic concern, antiquarian language, and Christian concepts.[8] The shape and evolution of the balance of symbolical power between community, wealthy individuals, self-interest, and communitarian ideology needs investigating through detailed test cases, and perhaps even more through an examination of (e.g.) the honorific statue habit in the Roman and late Roman Greek East,[9] in other words through a book comparable to the present one, but prolonging the story of the honorific statue

[2] One instance among many of the proliferation of statue honours: at Herakleia under Salbake, a gymnasiarch left money for contests; and was honoured with a statue, in perpetuity, each time the contest was celebrated (van Bremen, *Limits of Participation*, 190 n. 173 on *La Carie*, nos. 79–82).

[3] For instance, B. Burrell, 'Reading, Hearing, and Looking at Ephesos', in W. A. Johnson and H. N. Parker (eds), *Ancient Literacies: The Culture of Reading in Greece and Rome* (Oxford, 2009), 69–95; F. D'Andria and I. Romeo (eds), *Roman Sculpture in Asia Minor* (Portsmouth, RI, 2011).

[4] Above, 237–47. The situation is best expressed in Roman legislation which imposes the burden of the financing for erecting honorific statues on the honorand and not tax revenues: *Cod. Just.* 1.24.4, rescript of Thedosius II: *eius, cuius ad honorem petitur, expensis propriis statuam colocari praecipimus* ('we order that the statue be set up at the own expenses of the person, concerning the honouring of whom petition is being made').

[5] Smith, *Roman Portrait Sculpture of Aphrodisias* (emphasizing that 'the massive deployment of busts and statue honors for emperors and local gentry was over by *c.* AD 250', 5; 74); I owe my understanding of the social landscape of Roman Aphrodisias to seminars in Oxford by A. Chaniotis, where forthcoming work was expounded.

[6] Quass, *Honoratiorenschicht*; van Nijf, 'Roman Termessos'.

[7] *Inschr. Priene* 246 (the statue base is still *in situ*).

[8] Generally, Robert, *Hellenica*, iv; Cameron, *Porphyrius*, 254–5; Mango, 'Epigrammes honorifiques'; R. R. R. Smith, 'Late Antique Portraits in a Public Context: Honorific Statuary at Aphrodisias in Caria, A.D. 300–600', *JRS* 89 (1999), 155–89, with bibliography; U. Gehn, *Ehrenstatuen in der Spätantike: Chlamydati und Togati* (Weisbaden, 2012); A. R. Brown, 'Last Man Standing: Chlamydatus Portraits and Public Life in Late Antique Corinth', *Hesperia*, 81 (2012), 141–76. For another sixth-cent. AD example (among many), the statue set up by the city of Aphrodisias for a benefactor (Ioannes) frames the transaction in terms of reciprocity and requital (*ALA*, no. 73): what is the meaning of this nicety at this date?

[9] For Roman Asia Minor, van Bremen's study of female benefactors and wealthy families (*Limits of Participation*) and Pont's survey of the politics of building (*Orner la cité*) offer instructive test cases.

in the Hellenistic period (and affecting our interpretation of the phenomenon in the Hellen-
istic period).

What matters is that, even in the Roman and late Roman periods, in spite of deep
oligarchizing changes (and the possibility that much of the constitutional regulation of the
elites turned into self-regulation), public communitarian culture did not turn into a sham, but
remained a vital element of civic history (even if we take 'civic' in the redefined sense offered
above, namely as a history of conflict, competition, and pressures, rather than simply the
enactment of civic ideology). The 'curial' culture of the elitist Roman *polis* was itself the product
of the need to accommodate civic norms that place the city-state at the centre of the moral
universe of the individual, and assumed its primacy and its role as the site of recognition and
honour within contexts of political speech and communitarian discourse.[10]

Two consequences ensue, for the present purpose, in the context of a study of the honorific
statue in the Hellenistic world. First, 'unified statue theory' should not be about a narrative of
elite take-over, but of constant give-and-take between community control and elite affirmation
(with a particular and complicating niche occupied by the need to relate to powerful outsiders:
kings, Romans); not so much linear narrative, but rather the 'ecology' which I tried to read on
the ground. A picture of competition does not quite square with any facile views about civic
control and public primacy; but nor does it necessarily equal the gradual and irreversible
destruction of *polis* institutions and ideology by the elite. It rather enforces a picture of elitism
as being constantly performed, against a background of very real and effective communal
gestures and texts with which elitism had a complicated relationship of dependency and rivalry,
that defined it and gave it sense. In other words, this is what the public sphere was supposed to
do: not to exercise untrammelled hegemony over individuals and elite (as modern descriptions
of ancient civic ideology or Athenian democracy sometimes seem to idealize it), but to offer
spaces of interaction and competition and coexistence over time.

Second, the evolutions that did take place were slow, in a context of constant pressure and
competition (and with a very broad watershed, initiated in the decades 225–180, but at its most
visible in the late second century). Each statue transaction, instead of being studied diachron-
ically as part of an aggregate march towards the elitist *telos* of the Roman-era *polis*, might be
more fruitfully considered in its own context, as the product of interaction and bargaining in
specific worlds with its particular niches: Hellenistic Priene and its sites of statues; the
Epidaurian Asklepieion; pre- or post-167 Delos. The elitist city (often beloved of archaeolo-
gists) and the 'moderately democratic' city (beloved of epigraphists) were of course the same
city, or to be found in the same cities across the Hellenistic world; the 'hot' city of history,
evolving because of pressures both external and internal, and the 'cold' city of stereotypical
discourse, monumental time, and ritual performance, are ways of looking at the same warm,
living city of choices constantly made and remade.

3. THE HONORIFIC STATUE BETWEEN AGENCY AND EXPRESSION

Throughout this book, I have focused on a number of recurrent questions: who set up
honorific statues, where, within what political culture... But the first question asked may be
worth asking again—once again, one last time: why say thank you with a statue? Another
way of putting the question would be to ask: what were Hellenistic citizens, or men and
women, thinking about when they set up honorific statues? Perhaps not about the struggle
between *polis* ideology and elite families and their affirmation; this struggle 'took place' within a
rich civic history, but constantly and progressively over decades and centuries, and not in
explicit terms; all the pressures, outlined above, were at work simultaneously, as parameters
within which choice and action took place. The actors were (also) thinking about, or in terms

[10] This is the argument of Ma, '*Euboikos*'.

of, other things: the production and the impact of images, the processes of looking, a sense of aesthetics in time. What were the functions of the honorific statue for the different constituencies involved in the statue transaction?[11]

The honorific statue (and painting) took its place among a world of other statues (and paintings)—dedications, architectural sculpture, cult-statues—in a variety of spaces: the shrine, the gymnasion, even the agora. It is not the purpose of this book (especially at this late stage) to explore the world of images in Hellenistic society, within which the honorific statue took place and meaning, by processes of collaboration, competition, and contrast;[12] a world both physical and mental, which it would be crucial to know to understand the honorific statue, public and private. But it is worth trying to see how honorific portraits functioned as images—as part of the Hellenistic *cité des images*, and as a contribution to a historical anthropology of/in Hellenistic images, which, in turn, should help us to appreciate the honorific statue.

What was the effect, or 'agency', of a Hellenistic honorific statue? It is worth recalling the actors involved in the transaction: the benefactor-honorand, the honourer targeted by the benefaction and responding to it, the artist, the artwork, the audience. A first approach might be to cast these actors in the conceptual tools of the theory developed by A. Gell to study agency in art, around four basic concepts—the artist, the index (a material indication that allows viewers to 'abduct', infer intention), the prototype (the entity represented in an image and in a causal relation with it), the recipient—which exist in relations of agency or passivity.[13] Hence schematic, algebraic representation or modelling of relation in agency in 'art situations', such as:

$$[[[\text{Artist-A}] \longrightarrow \text{Prototype A}] \longrightarrow \text{Index-A}] \longrightarrow \text{Recipient-P}$$

where A denotes an 'agent', P a 'patient' in relation to the agent; the direction of the arrows, the relation of agency; the smaller arrows, the secondary relations, and the longer arrow the main relation, between the 'index' and the recipient. For instance, the artist (e.g. Leonardo da Vinci) determines the representation of the subject (Mona Lisa), which in turn determines the shape taken by the index (the painting), which finally affects the audience. The position of the artist and the prototype would be reversed in cases where the agency of the prototype came first, and it determined the agency of the artist. This is certainly the relation involved in the making of an honorific statue, as suggested by my earlier examination of the interlacing of political work and artistic work, and the constant involvement of the community in the process of commissioning and executing (above, appendix 1).

More generally, the relations in the honorific statue are complex to unpack and represent.[14] To start, the 'prototype' is in fact double, the benefactor-honorand, and the community or the individual who has received the benefaction and responds with honours. One of these honours is in fact the portrait (in statuary or painted form), so that the 'index' is a representation of the honorand, a representation of the relationship between the honorand and the honourer, and part of the honours themselves; in turn the effect of the index is exercised on the honorand, the honourer, and any other audience. The nature of the action exercised by the honourer on the honorand, and the image on the honourer and the honorand, and an ideal audience, has been the subject of the previous treatment of the honorific portrait in its political and civic context:

[11] On artistic genres, T. Hölscher, 'Architectural Sculpture: Messages? Programs? Towards Rehabilitating the Notion of "Decoration" ', in R. von den Hoff and P. Schultz (eds), *Structure, Image, Ornament: Architectural Sculpture in the Greek World* (Oxford, 2009), 54–67.

[12] A model is offered by Stewart, *Statues in Roman Society*.

[13] A. Gell, *Art and Agency: An Anthropological Theory* (Oxford, 1998); R. Osborne and J. Tanner (eds), *Art's Agency and Art History* (Malden, Mass., 2007), with an indispensable final essay by Whitney Davis ('Abducting the Agency of Art', 199–219).

[14] As, in fact, the relations of agency are in any art situation; the point is developed by Davis (previous note) on problems of the 'depth of abduction'.

the negotiation between individual eminence and civic embedding, according to the nature of the parties involved and the balance of power, intention, and agency in each situation.

To say as much is to highlight the function of the honorific portrait as image—but also to raise the question of how the honorific statue achieved this effect, in formal, iconographical, semiotic, and even aesthetic terms: in other words, what more did the honorific portrait do than the awarding of a crown, the proclamation of honours, the inscribing of a decree? These were the gestures which constituted 'normal' honours and indeed the context within which the honorific portrait fitted. The question partly concerns the history and the workings of the Greek portrait, a much-debated topic;[15] to which the notes below offer a sketched, selective contribution.

In the case of the honorific portrait, public and private, the 'abducting' (inferring) of intention was channelled by the inscriptions which constituted the monument, and specifically by those formulas which described the intended impact and effect of the image. In prose, statues are described in the hortative clauses of the honorific decrees, studied earlier: 'in order that the people be seen to return marks of gratitude to worthy men, and that others strive for such matters'; likewise, the epigram accompanying the bronze statue for the Phokian leader Xanthippos imagines the viewer's reaction: 'Let a man, seeing Xanthipppos, son of Amphar-etos, say: "see how great signs of gratitude (*charites*) are for the good"'.[16]

> ἀλλά τ[ις αὖ] Ξάν[θ]ιππον ἰδὼ[ν] Ἀμφα[ρέ]του υἱὸν
> φάσθω·ἀΐδ'[ὣς] μεγάλαι [τ]οῖς ἀγαθοῖς [χ]άριτες.

The intention is to make abstract things visible (*eucharistia*, namely the honourer's attitude and readiness to requite benefactions; the relationality inherent in honorific formula, sometimes developed in the form of statuary groups), to leave memorials of good men, and to create emulation among other men: exemplarity leads to social reproduction. The statue achieves visibility, as proclaimed by the epigram accompanying a fourth-century private honorific on Lindos: the statue itself bursts into first-person speech, whose vivacity matches the powerful presence of the image, εἰκὼν δ' εἰμι σαφὴς ἐσορᾶν, 'Polyaina, his mother, set up Stasagoras, son of Damokrates: and I am the image, clear to see'.[17] But private statues could also declare the same aim of social reproduction as the public monuments, as in the case of the private statues set up by Protogenes at Kaunos, in the early Hellenistic period: seeing the statue of Proto-genes' mother, suckling her infant, would inspire other mothers to the same disposition and feelings.[18]

Memorialization contained the second function of portraits, made explicit in epigrams: making the body visible in spite of time and death, and hence providing consolation and compensation. In one of the early examples of private, familial statues, set up in fourth-century Athens, one Polystratos 'set up this statue, his brother, an immortal memory of a mortal body'.[19] A funerary epigram from Kos presents the deceased thanking his deme (Isthmos), even in death, for the gift of memory through civic honours—public burial, crowns, and a statue:

[15] Recently, R. R. R. Smith, 'The Use of Images: Visual History and Ancient History', in T. P. Wiseman (ed.), *Classics in Progress: Essays on Ancient Greece and Rome* (Oxford, 2002), 59–102; Dillon, *Ancient Greek Portrait Sculpture*; Tanner, *Invention of Art History*, and 'Portraits and Agency: A Comparative View', in Tanner and Osborne, *Art's Agency and Art History*, 70–94; O. Jaeggi, *Die griechischen Porträts: Antike Repräsentation, moderne Projektion* (Berlin, 2008), especially on the German historiography of the problem of the Greek portrait. Generally, e.g. S. Nodelman, 'How to Read a Roman Portrait', *Art in America*, 63 (1975), 26–33; P. Bruneau, 'Le Portrait', *Ramage*, 1 (1982), 71–93; L. Giuliani, *Bildnis und Botschaft* (Frankfurt, 1986); Stewart, *Faces of Power*, 64–7; R. Brilliant, *Portraiture* (London, 1991); C. Freeland, *Portraits and Persons: A Philosophical Inquiry* (Oxford, 2010).

[16] *Syll.* 361, with Bousquet, 'Inscriptions de Delphes' (1960).

[17] *Inscr. Lindos* 2.645.

[18] *Inschr. Kaunos* 51.

[19] *IG* II² 3838; above, 198; the herm *IG* II² 3754 for a dead youth is a *paramythion*, a consolation; also *BE* 73, 458 on statues for the youthful dead.

Ἰσθ<μ>ὲ παλαι<γ>ενέος νήσσ<ο>υ πέδον, ἄφθιτε δῆμε,
σοὶ μεγάλων δώρων καὶ νέκυς οἶδα χάριν.
εἰκόνι καὶ στεφάνοισιν ἀειμνήστω[ι τε]
σήματι τοῦ πικροῦ ῥῦσιν ἔχω θανάτου.

Isthmos, plain of the ancient-born island, wealthy deme, though dead, I owe you gratitude for great gifts: [(rewarded?)] with a statue and crowns and an eternally remembered grave-marker, I have defence against bitter death.[20]

Both these functions (visibility leading to social reproduction, and visibility leading to memory in the absence caused by death) are visible in the long, powerful epigram for the dead Akraiphian cavalry commander, Eugnotos, which I have discussed on several occasions earlier, but never quoted fully, in all its force:

Τοῖος ἐὼν Εὔγνωτος ἐνάντιος εἰς βασιλῆος
 χεῖρας ἀνηρίθμους ἦλθε βοαδρομέων
θηξάμενος Βοιωτὸν ἐπὶ πλεόνεσσιν Ἄρηα.
 οὐ δ' ὑπὲρ Ὀγχηστοῦ χάλκεον ὦσε νέφος· 4
ἤδη γὰρ δοράτεσσιν ἐλείπετο θραυομένοισιν,
 Ζεῦ πάτερ, ἄρ<ρ>ηκτον λῆμα παρασχόμενος·
ὀκτάκι γὰρ δεκάκις τε συνήλασεν ἰλαδὸν ἵππω[ι],
 ἥσσονι δὲ ζώειν οὐ καλὸν ὡρίσατο 8
ἀλλ' ὅγ' ἀνεὶς θώρακα παρὰ ξίφος ἄρσενι θυμῶι
 π[λή]ξατο, γενναίων ὡς ἔθος ἀγεμόνων
τὸμ μὲν ἄρ' ἀσκύλευτον ἐλεύθερον αἷμα χέοντα
 δῶκαν ἐπὶ προγόνων ἠρία δυσμενέες 12
νῦν δέ νιν ἔκ τε θυγατρὸς ἐοικότα κἀπὸ συνεύνου
 χάλκεον [τύπ]ον ἔχει π[έ]τρος Ἀκραιφιέων
ἀλλά, νέοι, γί[ν]εσθε κατὰ κλέος ὧδε μαχηταί,
 ὧδ' ἀγαθοί, πατέρων ἄ{ι}στεα [ῥ]υόμενοι. 16

This is what Eugnotos was like when he came to the rescue, facing the numberless troops of the king, having whetted the Boiotian Ares against greater numbers, but he did not drive the bronze cloud above Onchestos. For indeed he was defeated, alone among snapping spears, father Zeus, presenting an unbroken courage, for eight times and ten he drove forth by squadron with cavalry, and he did not think it right for one defeated to live, but, removing his breastplate, he struck with male heart against his sword (?), as is the custom for noble leaders. In fact, the enemies gave him back unstripped, pouring free blood, for the mounds of his ancestors; and now, the rock of the Akraiphians has him, from his daughter and his wife, as a bronze image in his likeness. But, young men, thus in glory become fighters, thus become brave men, defending the city of your fathers.[21]

What did honorific portraits do? How did they achieve their effects? My earlier survey of what the statues might have looked like suggests great diversity: honorific portraits could take the form of male royal figures (on foot and naked or armoured; or on horseback and armed) with open, swaggering stances and supercilious faces, or that of male civic figures (as good generic citizens on foot, as priests, as civic fighters in arms, either standing or on horseback), with rather different, more controlled postures and faces, or yet that of female figures, within a range of possibilities offered by costume and social role (priestly, 'conservative' and 'modern'), endowed with smooth beautiful facial features, and ample bodily forms under their clothes—within the same genre, perhaps ten different schemes. Within this diversity, however, several common functional features emerge which should be put in connection with the actions which statues are explicitly said to fulfil.

[20] *PH* 418 (date unclear; public burial points to the late Hellenistic or early Roman period, though the indication of straight barred alphas prevents too late a dating—e.g. 2nd cent.?).

[21] *ISE* 69 with Ma, 'Eugnotos'; on the shape of memory, community, and time in Hellenistic and post-Hellenistic Akraiphia, see P. Martzavou, 'Recherches sur les communautés festives dans la "vieille Grèce" (IIème siècle a. C.-IIIème siècle p. C.)' (Ph.D. thesis, EPHE-IVème section, 2008), 48–133.

The first function is establishing presence—as the epigram for Eugnotos puts it, Akraiphia 'has him', and the people of Erythrai crowned the bronze statue of Philetas, the tyrannicide, on festival days, as if he were one of the members of the crowd of citizens[22]—but in a way that is also an alluding to absence: this is the complex content of the 'making visible' that statues do. Presence was not just a question of the physicality, the 'thereness' of the metal or stone object, on a specially designed stone platform; it was achieved by the artist's virtuoso skill at representing with wondrous accuracy diverse textures, in their materiality. This can be seen most clearly in the treatment of cloth, for instance the diverse patterning of folds caused by the wearing of draped garments, or the effect of folds on a chiton worn under a tightly draped, thin mantle: the overgarment was shown pulled and stretched over the underlying, thicker folds—this is now illustrated, in bronze, by the unpublished over-life-size female statue found near Kalymnos.[23] Shoes were represented realistically, in their intricate lacing and strapping; the sandals worn by the 'Antikythera philosopher' (now in fragments in the National Archaeological Museum in Athens) illustrate the level of detail.[24] Surfaces free of folds often showed pressmarks, as if the figure were wearing a real, clean piece of clothing, specially treated and recently unfolded.[25] Equally painstakingly executed was the representation of military dress, with a riot of different textures and materials, represented in stone or bronze: the fragments from Dodona show stiff linen breastplates, the twisted threads that made up the terminal fringes on the *pteruges* of metal cuirasses, leather baldrics, thick woollen cloaks with stitched edges.[26] The cumulative effect of this representation of materiality was to emphasize the lifelike presence of a person; the same effect may have been achieved for honorific painted portraits, notably through the treatment of the gaze. Simultaneously, the effect was to underline the unrealness of this presence, as evidenced by soft materials represented with deceptive accuracy in hard media.[27]

Many honorific statues showed clothed or armoured bodies, where the effects of the real were at work; but the same paradox of the real-seeming presence of the image and of its unreality, denouncing the absence of the real person, is at work in the showing of the human, using the resources of naturalism.[28] Naturalism was present in the positioning of the body, in various schemes of distribution of body weight, limbs, and head-neck complex, which placed the statue in the same space as the viewer and engaged him or her. Naturalism was also present in the texture of flesh, represented with particular attention to volume, modulation, texture. This took varied forms, such as the powerful musculature of the Terme Ruler or the slightly sagging chests of the bronze 'Adana youth' or the marble 'Arundel Homer', or the meaty forearm (and noticeable paunch) of the latter male statue, or the subtle anatomical variations in muscle masses and veins on the fragment of a bronze arm, from a very high-quality equestrian statue found in the agora at Pella (another fragment illustrates the careful treatment of

[22] *Syll.* 284. Likewise, the marble statue of a benefactor on Anaphe was to be crowned at the start of every month (*IG* 12.3.249, 1st cent.); I wonder how long such provisions remained in force.

[23] Dillon, *Female Portrait Statue*, 110–11, 246.

[24] K. D. Morrow, *Greek Footwear and the Dating of Sculpture* (Madison, Wis., 1985); Kaltsas, *Ethniko Archaiologiko Mouseio*, no. 575 (X 15090–1).

[25] H. Granger-Taylor, 'The Emperor's Clothes: The Fold Lines', *Bulletin of the Cleveland Museum of Art*, 74 (1987), 114–23; for instance, the fold marks are visible on the marble statue of Dioskourides of Myrrhinous, at Delos (Ridgway, *Hellenistic Sculpture*, ii. 145) or on the bronze statue of a boy (perhaps Lucius Caesar) now in the Metropolitan Museum: Lahusen and Formigli, *Römische Bildnisse aus Bronze*, no. 35. The himation quickly lost these fold marks if it was used as a coverlet as well as a piece of clothing, as in Classical Athens (Aristophanes, *Ekklesiazousai*, 334).

[26] Katsikoudis, *Dodone*, with review by Ma, *BMCR* 2008.02.27.

[27] The mention of 'wearing bronze clothes' in a statue-related fragmentary epigram in the Poseidippos collection (C. Austin and G. Bastianini, *Posidippi Pellaei quae supersunt omnia* (Milan, 2002), no. 60) may be playing on awareness of real-looking clothes, falling in swathes and folds, in fact being fashioned out of stiff and heavy metal.

[28] On which, Tanner, *Invention of Art History*; J. Elsner, 'Reflections on the "Greek Revolution" in Art'; R. von den Hoff, 'Naturalism and Classicism: Style and Perception of Early Hellenistic Portraits', in Schultz and von den Hoff, *Early Hellenistic Portraiture*, 49–62.

horseflesh, which is paralleled in the marble equestrian from Melos).[29] Variations in poses, even within certain types (himation-man, 'Pudicitia', ...), especially if monuments were seen in series, gave the illusion that a specific statue, differentiated from the others, represented a real individual. Finally, naturalism was present in the faces of the statues, with fine detail paid to anatomical correctness, individual variation, and physiognomic expressiveness, a phenomenon which emerges with force in the fourth century, precisely at the time of the development of the public honorific.[30] All these elements, and their 'presentifying' force, were at work in the bronze statue of Demosthenes at Athens, as we can reconstruct it from copies;[31] the face, but also the realistic details of muscle tension in the arms, made 'Demosthenes' present.

All these features collaborated to make the statue as lifelike as possible, but also reminded the viewer of the unreality of the lifelike simulacrum presented, and the absence of the 'subject' of the statue: the *topos* of the lifelikeness of the statue, so intense that it seems about to speak, only emphasizes the absence of voice and of the possibility of living conversation with the image—a gap which the metaphor of 'voiced statues' or 'oggetti parlanti' also betrays.[32] As lifelike as the statue appeared, it was, at the point of encounter, removed from the direct physical contact of the viewer, by the effect of an ornate pedestal, whose specific function was to heighten, elevate, and distantiate (above, 38–43, 254–5), by physical dimensions, by materiality and texture (the eye was drawn both up to the lifelike metal object, and down to the inscribed and meaningful, yet inanimate, stone, whose qualities were brought out by polishing and drafting), and by the crafted, arbitrary modulations proffered by mouldings and courses. There was no possibility of looking an honorific statue in the eye, or only at arbitrary distances fixed by the lowered gazes coming down from elevated immobile human figures; likewise, the subtle drama of the body positions took place slightly above the level of the viewer. Demosthenes did not look at the viewer; Eugnotos, on his charger, was involved in his own story of battle and defeat, implied by the statue, but in another world than the viewer's. The painted portrait did engage the viewer's gaze directly—this was the main technical trick to establish the illusion of presence; but two-dimensionality was sufficient to maintain the same paradox of an awareness of absence commensurate with the success of the artwork to achieve presence.

The honorific statue was a thing that looked like a person—a specific, real person, a referent named and narrated; that was the function of naturalism in the particular case of this statuary genre, in combination with the stories on the inscribed base. Naturalism, in the case of the honorific statue, had a precise force; beyond iconographical conventions, it mattered that the image looked like someone, a real person. Whether it actually looked like the 'sitter' or the 'prototype' is not determinable, and beside the point; the techniques and stylistic traits used were shared with genre statues ('pseudo-Seneca', fishermen) or imaginary portraits ('Homer'),[33] but deployed for a very specific, politically determined purpose. It may seem that naturalism worked in diverse forms, according to the particular kind of honorific statue, along a spectrum between the 'idealized' and the 'realistic'. In their different practical ways, the packed, hypermasculine musculature of the Terme Ruler, the highly ornate armour worn on the statue of Demetrios (?) at Athens,[34] the blankly beautiful face of the typical female honorific statue (public or private) fall into the category of the idealized, in their naturalistic representation in perfect forms of things that actually exist in reality (naked men, draped women). In contrast, the very loose body tone and wrinkled, intent faces of civic benefactors seem realistic representations of citizen men as they might appear in reality. The distinction certainly has

[29] Akamatis, 'Agora Pellas', 28, with fig. 12; Kaltsas, *Ethniko Archaiologiko Mouseio*, no. 575.

[30] Dillon, *Ancient Greek Portrait Sculpture*.

[31] On the impact of heightened naturalism in this case, von den Hoff, 'Bildnisstatue des Demosthenes'.

[32] 'About to speak': e.g. Austin and Bastianini, *Posidippi*, no. 63; Tanner, *Invention of Art History*, 231–2. Voiced statues: above, Chap. 1; *IG* 4² 1.619; Konstantinopoulou, 'Epigraphai ek Rodou', 8–11, no. 13.

[33] Jaeggi, *Die griechischen Porträts*, 92–5.

[34] Houser, 'Alexander's Influence', 230–4: the helmet crest was held by a figure of Pegasos, alluding to the crest on the chryselephantine statue of Athena in the Parthenon.

force, and the two categories draw upon each other for their definition and their workings: this is brought home by the coexistence of the perfect musculature and the sagging aged body, or the youthful face and the wrinkled face, within the same public genre as defined by social practice and epigraphy, within the same social spaces (the city, the shrine), and sometimes within the same series. In the Hellenistic period, at a precise point in the development of Greek art, the dichotomy between idealizing and realistic is defined by the visual opposition, within the diverse register of possibilities and in the actual spectacle of statues.[35]

The dichotomy operates by reflecting the very diverse social functions and contexts of the honorific statue. The portrait of a Hellenistic ruler draws on particular registers (athletic, godlike); it may act as a visualization, on the part of a courtier or a body of troops, of the superhuman status of the ruler, fulfilling various functions within the Hellenistic royal state. Or it could act as a balanced piece of 'role assignment' on the part of a city, which recognizes the ruler's military and political superiority, tries to sublimate it with divine tropes, and finally aims to constrain it within norms of exchange and beneficence.[36] In contrast, the portrait of a civic benefactor is shaped by the norms of civic culture, with emphasis on restraint and communitarian identity defined through bodily and mental devotion to serving public interests,[37] and the 'realistic', or at least non-idealized, features refer to this particular political regimen. The idealized female face, in the heightened, stereotypical beauty and timeless youthfulness of the features, may be the product of social forces—the prevalence of the male gaze (reflecting both the male viewer as the ideal, normal recipient of female statues, and the way in which women, even in the public sphere, were caught in familial strategies and interests determined by men);[38] idealized female beauty is the product of male social power.

Yet what matters for the nature of the honorific statue is that the dichotomy between idealizing and realistic can be broken down easily. The king and the clothed woman correspond perfectly, in accepted and expected ways, to types: this is the force of the idealized physical traits. The good citizen, with his somatic and vestimentary characteristics, is also a type—ubiquitously talked about, projected, and imposed, in civic discourse; the mature body and intent, aged face, seem realistic rather than 'perfect', but in fact express adequation with a type, and hence work as a form of idealism: his face, his freshly pressed clothes, and elaborately tied shoes, are just right for his role as a member of the political class of the Hellenistic *polis*. Likewise, the civic fighters may have been presented with highly ornate equipment, showing an aesthetic excess that took these portraits into the realm of the ideal rather than the strictly realistic: this is suggested by the surviving fragments from Dodona, two extremely beautiful sword-grips (representing a panther and an eagle), a fluted spear-butt decorated with silver inlaid ivy tendrils.[39] This assimilation may have been facilitated by the effect of serialization, distributed across social space or within actual statue series constituted within specific places. The comment by Theophrastus, that the Flatterer tells one that he looks like his *eikon*, shows awareness that the image is meant to seem *better*, in some way, than the model.[40] In a simple

[35] In the Classical period, the anatomically correct representation of male musculature is realistic rather than idealizing: Smith, 'Use of Images', 78–9 ('In its day this was a brash new hard-hitting realism'); Jaeggi, *Die griechischen Porträts*, 46–59 (on the high Classical portraits of Themistokles and Perikles, conventional rather than heightened in their specific contexts). The spectrum also accommodates representations which are naturalistic, but grotesque; on which see J. E. A. Anderson, 'Gesture, Postures and Body Actions in Hellenistic Art' (D.Phil. thesis, University of Oxford, 2010).

[36] On ruler statues in different contexts, Smith, *Hellenistic Royal Portraits*; Ma, 'Roi en ses images'. The (cult) statues of Antiochos III and Laodike III at Teos were meant to be as *hieroprepes* as possible (fitting to the sacred): *SEG* 41.1003 I, ll. 44–5.

[37] Zanker, 'Brüche im Bürgerbild?'; Wörrle, 'Überlegungen zum Bürgerbild'; Tanner, *Invention of Art History*, 116–40; on the royal–civic dichotomy, Smith, 'Kings and Philosophers'.

[38] Jaeggi, *Die griechischen Porträts*, 92–115; Dillon, *Female Portrait Statue* (with modern comparisons, for instance on the 'typical', presentable face of aspiring models); van Bremen, *Limits of Participation*.

[39] Above, n. 23.

[40] Theophrastus, *Characters* 2.12.

way, the standardized size of honorific statutes had an idealizing effect: they showed people, of bronze or stone, a little bit bigger than real people. The increasing use of gold, applied directly to statues or as a background to portraits painted on panels, also had an idealizing effect on 'normal' civic images of himation-wearing men (such as, for instance, the 'Adana youth', which was leaf-gilt even as it has the expected intent expression of a naturalistically represented face).

Conversely, the effect of serialization may also have been to ground the 'idealized' portraits within the parameters of the possible, and hence allow them to be considered as a kind of realism. Royal portraits, and even the stereotypical female faces, show physiognomically personalized traits (admittedly as subtle variations in proportions, volumes, and relations, in the case of the women) that suggest to the viewer that she is looking at the representation of a real individual, that existed: this is how the face of the Terme Ruler works, or the finely modelled face and hair of Aristonoe of Rhamnous. Earlier, I evoked the impact of variations in the pose of statues, suggesting real presences rather than copies and replicas; within series, the effect was to suggest the realness of all of the represented subjects of the statues, whatever their stylistic register. Juxtaposition of the 'idealized' with more intensely realistic statues such as the citizen benefactors also may have permitted mental homogenization, reinforcing those elements in the usually 'idealized' portraits that produced an effect of the real, and tipping those portraits into the same camp as the 'normal' citizen benefactors—the realm of the actual.

The honorific statue does more than the *stele* or the carved representation of a crown, which act as symbols and indices of the honorific relation. In the case of the honorific statue, the tension between idealized and realistic made this artefact, whatever the exact choices made and the subgenre adopted, into a claim that individual instances of types had existed, fulfilling all the requirements of the type, both physical and abstract. The statue of Eugnotos of Akraiphia was ἐοικότα—the participle means both 'seeming like' and 'fitting'. Resemblance, appropriateness, and moral qualities are all expressed by the word, and the programmatic claim is that the statue looks real because it looks right. This claim to the instantiation of the moral can best be understood by contrasting the honorific statue with the images of the gods. Such images act as a technology that 'presentifies' the invisible, namely ubiquitous divine powers, in physical forms, that range from the conceptually aniconic to full-blown, 'naturalistic' masterpieces.[41] In contrast, the aesthetically pleasing adequation (ἐοικότα) of the statue with stereotypical formal expectations,[42] which invited the viewer's assent, had political force. It publicized the existence of specific individuals which art 'presentified', but on the specific condition that they be monumentally framed and seen as exemplars: this is the function of the inscription, which captures the individual and his personhood within certain stories, in both private and public contexts. The crown carved on the base of a benefactor honoured with a statue in the gymnasion at Amphipolis makes the same point, in visual form.[43]

One operation carried out by the honorific statue between the actual and the ideal was double: it captured individual identity within *polis* norms, and affirmed the efficacy or simply the existence of these abstract norms. 'This is what a good man looks like', 'These are the good things which this particular man did'—these are the propositions articulated in the monument for Eugnotos, discussed above: τοῖος ἐών ...[44] Furthermore, the honorific statue suggests that the instantiation of ethical values is what individual identity is about; the statue presents the real person. In late Hellenistic Argos, a benefactor, Augis son of Aristomedes,

[41] P. Veyne, 'Propagande expression roi, image idole oracle', *L'Homme*, 114 (1990), 7–26 (republished e.g. in *La société romaine* (Paris, 1991), 311–42), drawing on Vernant, *Mythe et pensée*, 339–51; also Robert, *Hellenica*, iv. 8–9, on the theme of (for instance) gods leaving their abode to settle in a place, as a statue.

[42] On the importance of adequation with values as part of the 'decorative', and hence the aesthetically acceptable, Hölscher, 'Decoration', close to Veyne, 'Propagande expression roi'; Tanner, *Invention of Art History*, 140, on the honorific statue's power to 'enculture' its viewer.

[43] Lazaridi, 'Gymnasio', 254 and pl. 17.

[44] The adjective also appears in *IG* 9.2.59, the honorific epigram accompanying an honorific statue: the city of Hypata is glorious in that it has 'such men', τοιούσδ' ἄνδρας.

presented himself before the council and renewed all the services which he had performed for the people's common and pressing needs, and when asked by the council, he performed various and very great services, in the past year as in the previous ones, and, now, when there was a need for the sum of ten thousand drachmas, he furnished them, without interest, to the *hieromnamones* and the treasurer, for the contest of the Titeia, thus conforming to his very self (ἀκόλουθος γινόμενος αὐτο[σαυ]τῶι) and his earlier actions for the people.[45]

Augis was duly rewarded with praise, a crown, and a bronze statue set up in the most prominent spot. The honorific statue was an image of conformity and coherence within personhood. A dictum, attributed (impossibly) to Sokrates compared (somewhat laboriously) the unmoving nature of the lifelike statue with the constancy of the good man: ἀνδριὰς μὲν ἐπὶ βάσεως, σπουδαῖος δὲ ἀνὴρ ἐπὶ καλῆς προαιρέσεως ἑστώς, ἀμετακίνητος ὀφείλειε ἶναι, literally 'a statue standing on its base, and a good man standing on an excellent attitude, must remain unmoved'.[46]

If the divine image 'presentifies' the gods, the honorific statue has the effect of 'absentifying' its human subject, by its multiple nature as image of an actual person, and as symbol of an ideal person, and for a nexus of relations within a whole political culture. Akraiphia 'has' Eugnotos—but only as a bronze image. By its durability as thing, the honorific statue clearly will remain once the individual mortal honorand is gone; the origins of the image as substitute for the person, especially in death,[47] reassert themselves, in a process aided by the currency of honorific statues, or statues like honorific statues, in funerary contexts. The honorific statue gravitates towards the funerary and consolatory substitute; in turn, this relation explains why the funerary genre is deeply inspired by public honorific imagery, both in the statuesque way in which the deceased are presented, and the frequent allusion, in text and image, to civic honours.[48] The use of past participles in honorific inscriptions indicate how the honorific monument refers to a past, when it is gone, and tries to capture a pause in time, for future consumption.[49] The inscription on the statue for Antigonos Gonatas at the Epidarian Asklepieion is instructive in the ways it constructs its actors and the viewers, in time:[50]

ἁ πόλις τῶν Ἐ[πιδαυρί]ων ἀνέθ[ηκεν βασιλέα]
Ἀντίγονον β[ασιλέω]ς Δημητρ[ίο]υ Μακεδόνα
ἀρετᾶς ἕνεκε[ν καὶ εὐ]νοίας, [ᾶς ἔ]χων διετέλει
εἰς τὰν πόλιν [τὰν Ἐπι]δαυρί[ων].

The city of the Epidaurians has set up King Antigonos, son of King Demetrios, Macedonian, on account of his goodness and the goodwill which he used to show to the city of the Epidaurians.

The verb describing Antigonos' attitude is in the imperfect, a past tense; this should not be interpreted as an indication that Antigonos was dead at the time the statue was set up (nor, of course, that Antigonos had ceased to be benevolent at the time of the honour). The tense agrees with the past tense of the verb of setting up; the whole sentence is conscious of the future viewer, and the monument shows awareness of its function as message to its future, the present time of the viewer. Hence the past tense is meant for our benefit, rather than the performed present tense more frequently found on such inscriptions. The tense on this particular inscription makes clear the nature of the honorific monument as *project*, from one temporality to another: the monument is directed by the present at the future. This intention may explain why one of the tendencies for the spatialization of honorific statues, in parallel and

[45] *SEG* 22.266 (originally published by G. Daux).

[46] Stewart, *Statues in Roman Society*, 42. The allusion might be to the unmoving statue, but also to the often flaunted desirability of not moving statues, because of the deleterious effect on good men who might want to perform services for their community (the theme of Dio 31).

[47] Vernant, *Mythe et pensée*, 325–38 (classic study on the *kolossos*).

[48] Zanker, 'Hellenistic Grave Stelai'; *I. Prusa* 27, 30, 31. The adoption of the honorific formula (ἐτίμησεν) in Roman Asia Minor reflects the same attraction of the funerary towards the honorific.

[49] The deployment of text thus parallels the workings of the image: Bruneau, 'Le Portrait', on poses as pauses.

[50] *ISE* 46.

in competition with serialization, is segmentation: each monument can function as an autonomous operation creating a 'time capsule' addressed not to the present viewers but to possible, hoped-for viewers drawn from posterity. In acting as a packaging of the present for the eyes of future viewers, the 'absentifying' effect has political force, in allowing the sublimation of relations with a foreign ruler, or the displacement of a local Big Man's eminence into the world of monumental time rather than actual interaction.

In turn, the honorific monument as time capsule is read by its ideal readers, situated at some point in time when the original subject is indeed no longer living, in *their* present, his or her absence palliated and materialized by the image and the framing text and monument. The monument allows the future to imagine its past. In this context, another effect of absentifying is to facilitate identification. In the absence of the actual person, in the presence of the actual-looking image, the viewer can see that the 'ideal' ruler, benefactor, priest, friend, mother, was a person like himself or herself; this realization invites identification with the (subject of the) image. The physical appearance, stylistic choices, and general 'expressive symbolism' (J. Tanner) involved in the honorific portrait thus are directly linked to the processes of social reproduction, which is one of the honorific genre's avowed aims. An exchange between Aiskhines and Demosthenes implies that good citizens should imitate Solon, as visualized in his statue, both morally and physically.[51] The statue of Eugnotos is framed as an invitation to Akraiphian young men to be civic fighters 'in this way', ὧδε, in the same way as the statue showed and the text explained; the invitation was realized in the lists of conscript citizen soldiers inscribed on the side of the base.[52] Likewise, at Erythrai, the statue of the tyrannicide Philitas was so potent that an oligarchy tried to neutralize it by removing its characteristic attribute, the avenging sword, in the hope that the statue would simply become another artwork. The restored democracy made a point of mobilizing public institutions such as magistrates and civic finance to restore the statue; officials conducted a public inquest concerning the 'pose' of the sword, to start conversations and embodied remembrance, and make citizens remember, in their physical posture, the appearance of the statue—of course I remember, Philitas swung his sword just *so*—thus actualizing the power of the statue to reproduce itself as paradigm of the good citizen.[53]

Social reproduction through images (that 'reproduce' their model): the profusion of honorific statues, public and private, amounted to an example of the phenomenon described by A. Gell as 'distributed personhood'. Stereotypical, normed images showed good people that had existed and invited people to relate their own existence to these images, across space and time, in a dynamic interplay of presence and absence; the population of statues multiplied itself and produced other statues, both through the processes of 'statue growth', serialization and competition, and through the multiplication of statues for the same person: this is why, in Priene, one saw statues of Apollodoros, Apollodoros, Apollodoros.[54]

4. CITY OF IMAGES

Honorific statues as the story of the power interaction between communities, families, and, individuals in space; honorific statues as the story of art phenomena, the body, personhood,

[51] Aiskhines 1.24–6; Demosthenes 19.251–4; Ma, 'Two Cultures'.

[52] Ma, 'Eugnotos'.

[53] *Syll.* 284, with J. Ma, 'The City as Memory', in G. Boys-Stones, B. Graziosi, and P. Vasunia (eds), *The Oxford Handbook of Hellenic Studies* (Oxford, 2009), 248–59.

[54] *Inschr. Priene* 186, 236, 237; Raeck, 'Der mehrfache Apollodoros'. Other examples of multiple statues: *Inschr. Kaunos* 92–3; *I. Rhod. Peraia* 552–3 (same inscriptions in *Pérée rhodienne* 3–4), the statues of Teisias of Kedreai; *Inschr. Priene* 109, 117; *I Assos* 18; *I. Iasos* 85; *Sardis* 27 (Augustan, for the benefactor Iollas). The *Ehrentafel* listing multiple honours, almost always including statues, also give an image of one person distributed over many locales, and generally of distributed personhood: above, 33, with references. On the inherent power of images to generate copies and reproductions, Foucault, *Ceci n'est pas une pipe*.

time, death, memory—both stories can be mapped onto each other; indeed, the result should be mapped on the story of Hellenistic art and Greek culture generally (for instance, reading Pausanias should be part of that operation). At least, the city of materiality and memory might offer a way out of the 'two cities' dichotomy, between the 'hot' city of eventness and the 'cold' city of ritual, that has posed a problem throughout this book.

The political force (and moral instantiations) of the art operations, as mapped onto political situations, varied, just as the 'embedding' effected by inscriptions took a variety of forms—seeing the *eikon* at the intersection of naturalism, idealism, and realism, meant different things if the statue were that of a king set up by his officers, a woman set up by her relatives, or a man set up by his city, in terms of the ethical meanings of the image, and the effect on the viewer and the dedicator. The portrait of a benefactor from the Cyrenaican city of Arsinoe responded to a citizen's benefactions, through which 'he made visible the excellence (*kalokagathian*) of his race (*genous*)' (and not 'of his character', *ethous*, as was first read): the institution of recognizing a man's character, as visible in his actions, through a physical image of him is here located within an oligarchical variant on *polis* culture.[55]

Honorific statues mattered—and were desirable. The kinsmen of the Kedreate Teisias wanted to leave a physical trace of Teisias, with a long narrative of all the things which he had done, and which showed what sort of man he was; the private statue was also a hint to the community that Teisias deserved a public statue. The Athenian statesman Kephisodoros, at the end of his career, yearned for a statue.[56] In spite of the ethical, communitarian constraints on identity, the honorific statue offered a benefactor a lasting, monumental image, endowed with individualized physical plausibility but also with idealized aspects, exciting admiration as an artistic work (sometimes signed by the artist), and promising to create presence in various forms: the material statue, but also reputation, and reproduction through imitation by others and by posterity. It is no wonder the Epicureans expressed disdain for statues, alongside the crowns which gave statues their context in honorific culture: they belonged to pleasures that were neither natural nor necessary. Likewise, it is no wonder that members of the civic elites felt alarm or unease at the practice of renaming or moving statues, which showed the fragility and lability of the honorific practices that were meant to project present relations into the future.[57]

This, then, is why communities, individuals, and families said thank you with a statue. The honorific portrait was attractive to the honorand for the multiple reasons outlined above, and which amount to the possibility of self-recognition through other people's gaze. Who would not welcome the chance of seeing oneself as other people see him (or her), if the outcome is guaranteed to be aesthetically pleasing, and a mixture of the entrancingly realistic and the exhilaratingly positive to the point of idealism? But this attractiveness was also a trap. For those doing the honouring, saying thank you with an image was, like uttering 'I love you', a way of saying it, after all, beyond all the constraints of formula and syntax, *to* an image.[58]

[55] *SEG* 28.1817 ('character' restored by J. Reynolds, 'race' read by L. Moretti); the decree was passed by the *gerousia* and the council, a reflection of the restricted, oligarchical nature of this Cyrenaican *polis*.

[56] Teisias: above, 215, on *I. Rhod. Peraia* 552–3 (same inscriptions in *Pérée rhodienne* 3–4); Kephisodoros: *ISE* 33.

[57] Dio 31; Platt, 'Honour Takes Wing'.

[58] On the role of the image in erotic relations, desire, and the erotic gaze, M. Bettini, *Il ritratto dell'amante* (Turin, 1992). The Hellenistic honorific portrait, in its painted form (which has been treated glancingly in this work), may be one of the ancestors of the Orthodox icon (on which see H. Belting, *Likeness and Presence* (Chicago, 1994)): the play between presence and absence, the role of the frontal gaze, and the importance of idealization and type, are important features in both genres. This final remark does not reduce the operativeness of the findings in Chaps. 1–2 (that inscription embeds statues in relations)—but explains their meaning.

PLANS

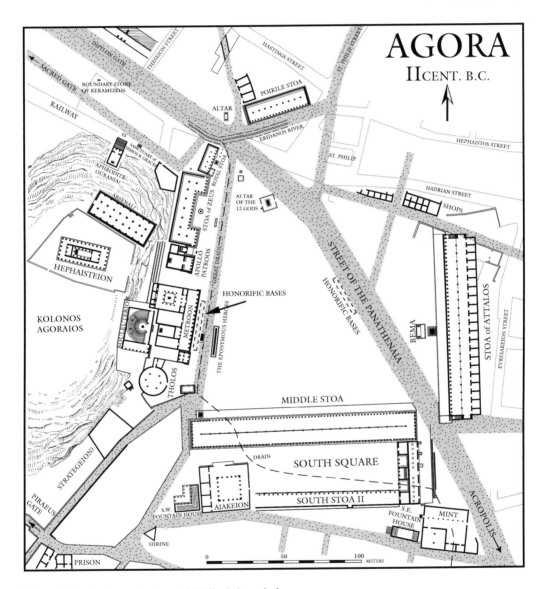

Plan 1. Athenian Agora in the mid-Hellenistic period.

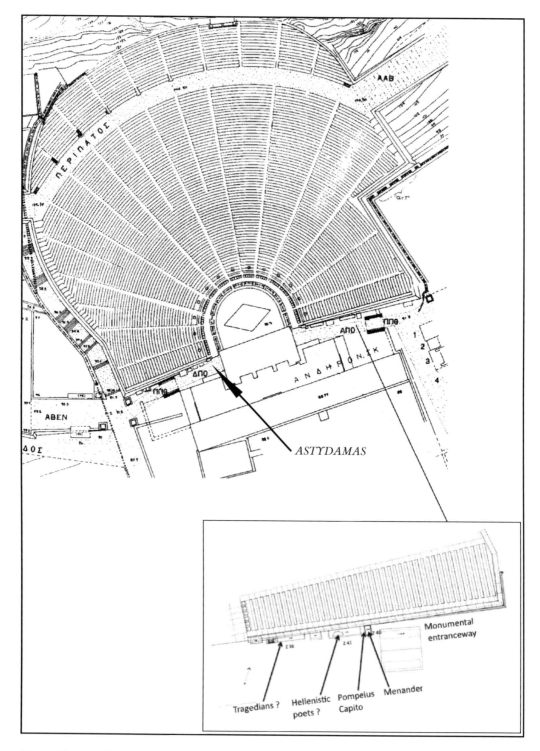

Plan 2. Theatre of Dionysos, Athens, with known honorific statue bases, from the fourth century BC to the first century AD.

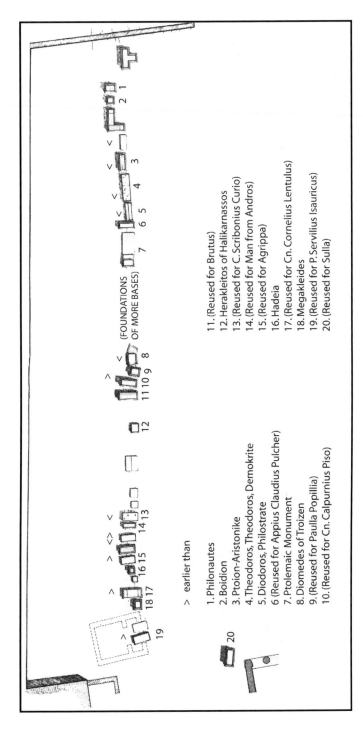

1. Philonautes
2. Boidion
3. Ptoion-Aristonike
4. Theodoros, Theodoros, Demokrite
5. Diodoros, Philostrate
6. (Reused for Appius Claudius Pulcher)
7. Ptolemaic Monument
8. Diomedes of Troizen
9. (Reused for Paulla Popillia)
10. (Reused for Cn. Calpurnius Piso)

11. (Reused for Brutus)
12. Herakleitos of Halikarnassos
13. (Reused for C. Scribonius Curio)
14. (Reused for Man from Andros)
15. (Reused for Agrippa)
16. Hadeia
17. (Reused for Cn. Cornelius Lentulus)
18. Megakleides
19. (Reused for P. Servilius Isauricus)
20. (Reused for Sulla)

> earlier than

(FOUNDATIONS OF MORE BASES)

Plan 3. Esplanade before the Amphiaraion near Oropos: honorific statues near the temple. The statue growth took place between c.285 and c.200 BC; the majority of the public honorific monuments were reused by the Oropians in the first century BC. Based on V. Petrakos' plan of the esplanade.

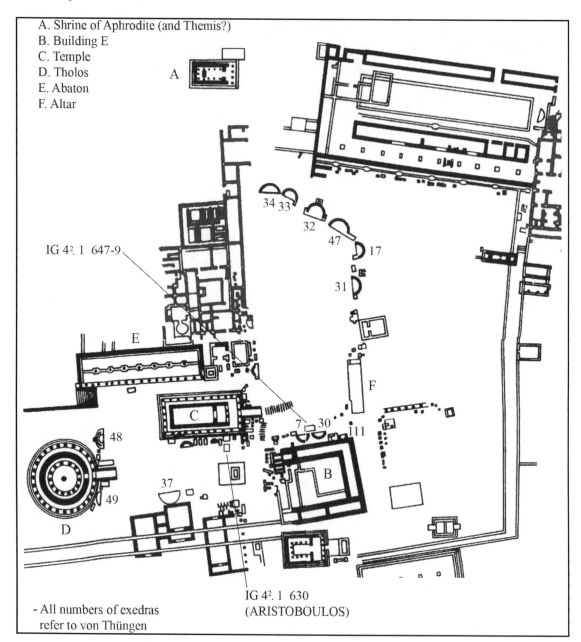

A. Shrine of Aphrodite (and Themis?)
B. Building E
C. Temple
D. Tholos
E. Abaton
F. Altar

IG 4². 1 647-9

- All numbers of exedras
 refer to von Thüngen

IG 4². 1 630
(ARISTOBOULOS)

Plan 4. Asklepieion near Epidauros. The statuescape was 'full' by the first century BC; many of the exedras were reused around that time. After a plan by M. Melfi.

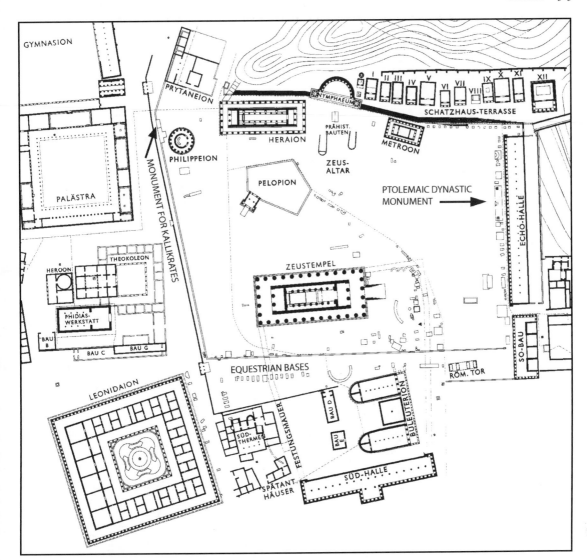

Plan 5. Olympia, Altis. The state of the shrine by the time of the Roman empire still preserved the structuring trace left by dedications and honorific monuments of the earlier periods.

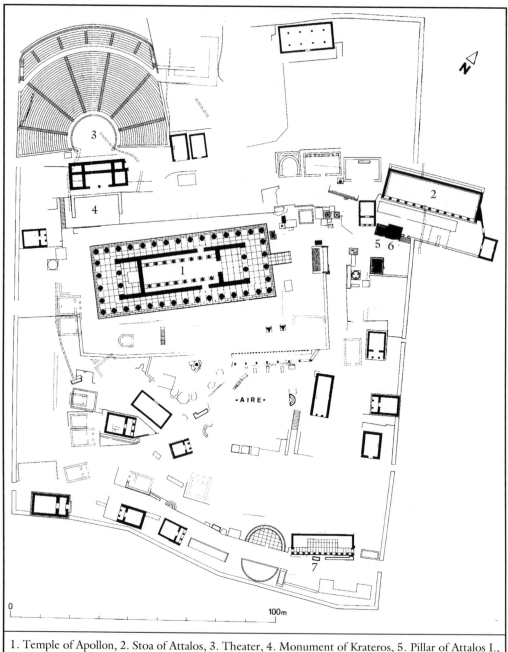

1. Temple of Apollon, 2. Stoa of Attalos, 3. Theater, 4. Monument of Krateros, 5. Pillar of Attalos I.,
6. Pillar of Eumenes II. , 7. Statue of Philopoimen

Plan 6. Delphi, shrine of Apollo: the plan shows some of the many honorific monuments set up in the Hellenistic period.

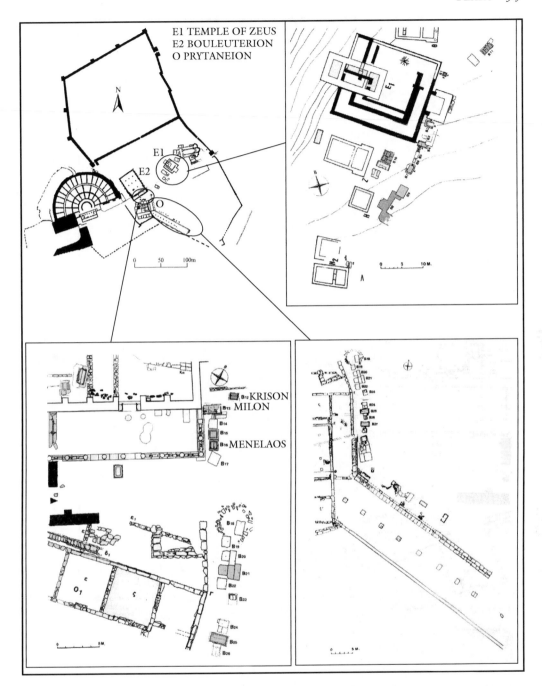

Plan 7. Dodona, with close-ups on three zones of statue growth: near the temples, at the intersection of two roads and at the entrance to the civic zone, and along the southern stoa. The plan probably shows the prosperous shrine of the years before 167 BC, when it was sacked.

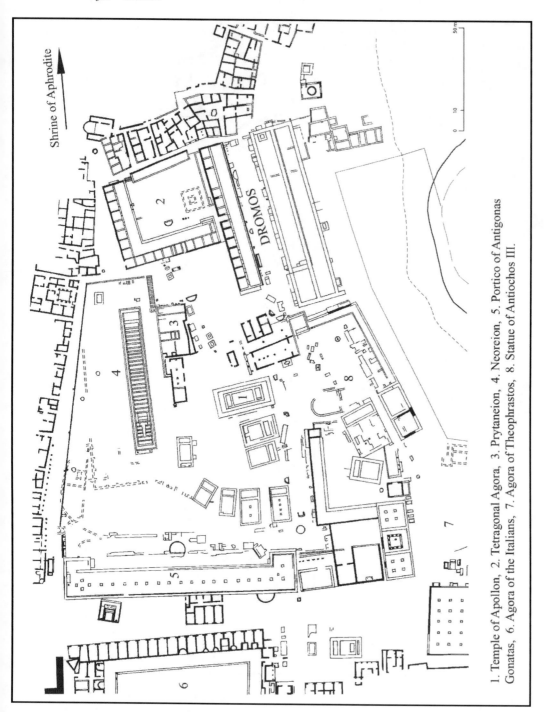

1. Temple of Apollon, 2. Tetragonal Agora, 3. Prytaneion, 4. Neoreion, 5. Portico of Antigonas Gonatas, 6. Agora of the Italians, 7. Agora of Theophrastos, 8. Statue of Antiochos III.

Plan 8. Delos: the final state of statue growth, by the early first century BC, developed across many zones, away from the former areas of display (the Tetragonal Agora, the prytaneion, the zone east of the Neorion). The Dromos was a particularly favoured area for public and private honorific monuments, starting in the late third century BC.

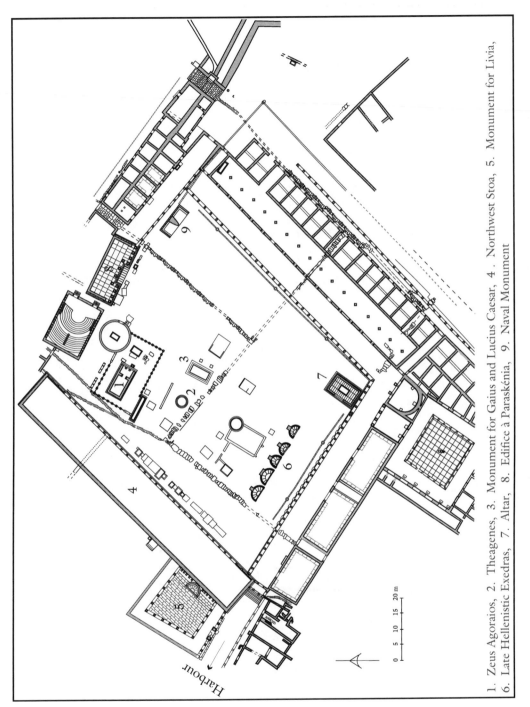

Plan 9. The Agora at Thasos, by the first century AD, showed segmentation into mini-spaces, according to multiple dynamics. After a plan drawn up by J.-Y. Marc and realized by S. Blin, based on M. Wurch-Kozelj.

1. Zeus Agoraios, 2. Theagenes, 3. Monument for Gaius and Lucius Caesar, 4. Northwest Stoa, 5. Monument for Livia, 6. Late Hellenistic Exedras, 7. Altar, 8. Edifice à Paraskénia, 9. Naval Monument

Harbour

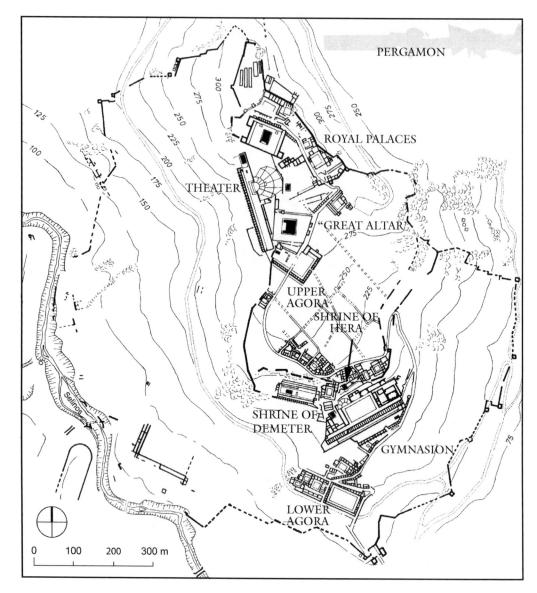

Plan 10. The main urban zone of Pergamon, with different contexts for honorific statues in the Hellenistic (Attalid and post-Attalid) period.

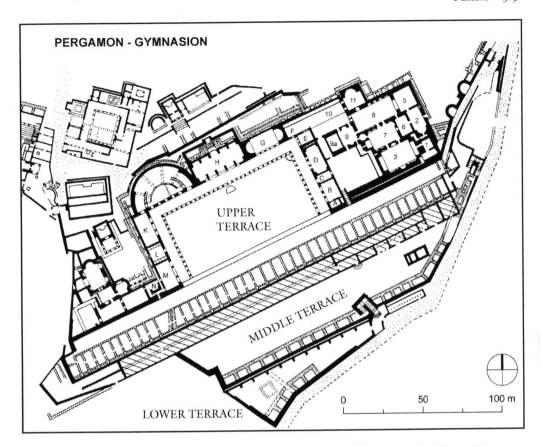

Plan 11. The gymnasia in Pergamon occupy three terraces; the Upper Terrace contained honorific statues both on the edges of the palaistra, and in specially arranged rooms (such as H, and B where the statue of Diodoros Pasparos was set up).

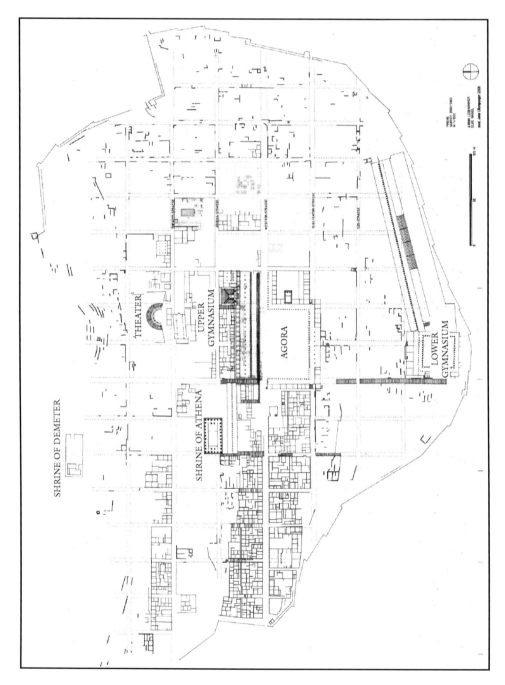

Plan 12. General view of the city Priene *c.*100 BC, with several monumental contexts for honorific statues.

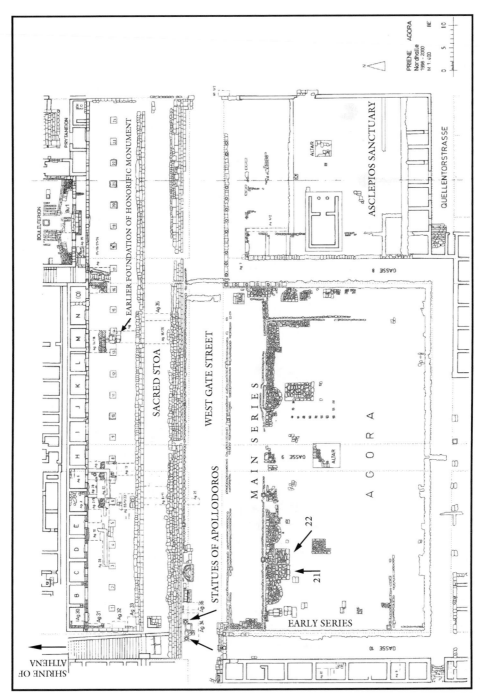

Plan 13. Agora of Priene *c.*100 BC, showing a trace of the older, organic statue growth, the reorganization of the civic space, and the reactions on the ground.

322 PLANS

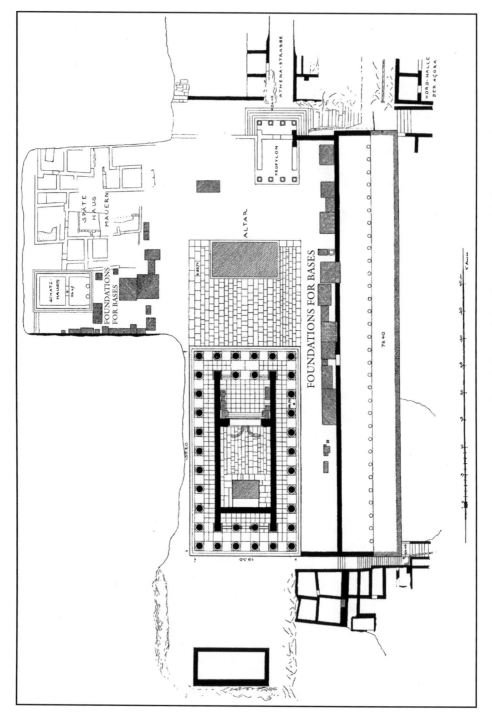

Plan 14. Shrine of Athena, Priene, *c.*100 BC, showing the temple and altar, and also the two zones with foundations for bases, some of which almost certainly bore honorific monuments (including honorific pilasters).

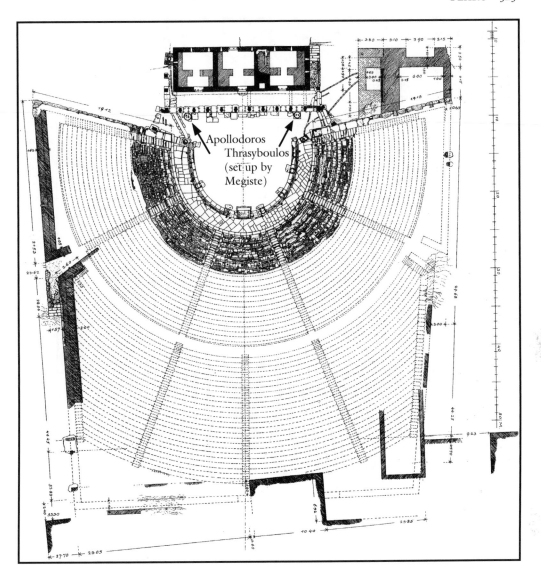

Plan 15. Theatre, Priene, *c*.100 BC, with statue bases along the stage building.

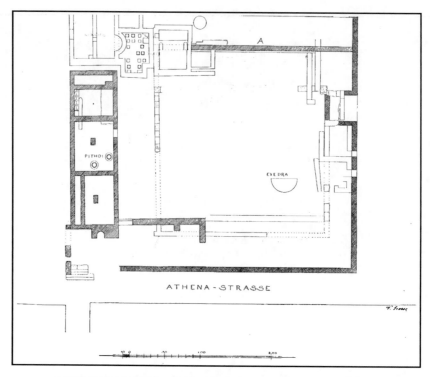

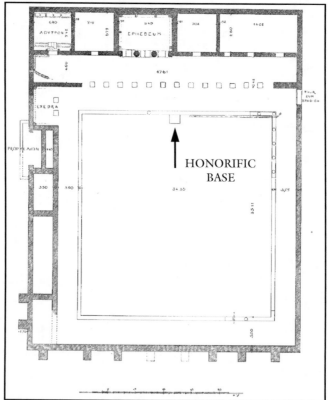

Plan 16. Upper and Lower Gymnasion at Priene, *c.*100 BC.

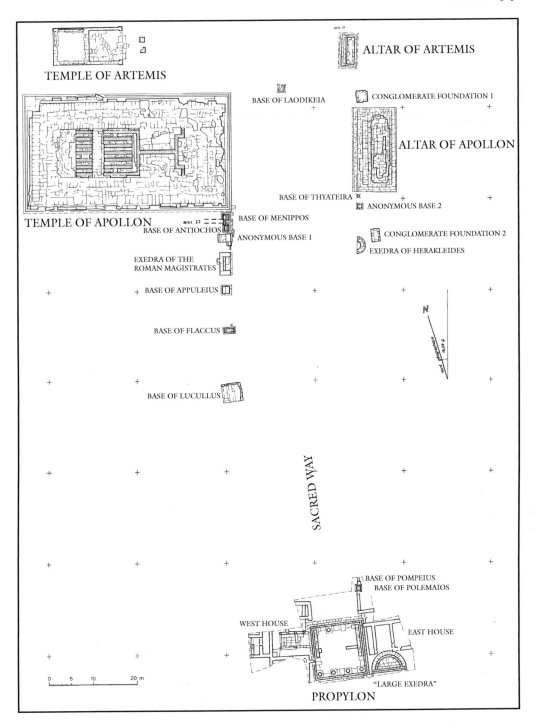

TEMPLE OF ARTEMIS

ALTAR OF ARTEMIS

BASE OF LAODIKEIA

CONGLOMERATE FOUNDATION 1

ALTAR OF APOLLON

TEMPLE OF APOLLON

BASE OF THYATEIRA

ANONYMOUS BASE 2

BASE OF MENIPPOS

BASE OF ANTIOCHOS

ANONYMOUS BASE 1

CONGLOMERATE FOUNDATION 2

EXEDRA OF HERAKLEIDES

EXEDRA OF THE
ROMAN MAGISTRATES

BASE OF APPULEIUS

BASE OF FLACCUS

BASE OF LUCULLUS

SACRED WAY

BASE OF POMPEIUS

BASE OF POLEMAIOS

WEST HOUSE

EAST HOUSE

0 5 10 20 m

"LARGE EXEDRA"

PROPYLON

Plan 17. Klaros, with some of the monuments visible on the 'Sacred Way' between the entrance to the shrine and the temple of Apollo.

BIBLIOGRAPHY

ACCAME, S., *Il dominio romano in Grecia dalla guerra acaica ad Augusto* (Rome, 1946).

ADAM, S., *The Technique of Greek Sculpture in the Archaic and Classical Periods* (London, 1966).

ADAM-VELENI, P., *Makedonikoi bomoi: timetikoi kai taphikoi vomoi autokratorikon chronon sti Thessaloniki, protevousa tis eparchias Makedonias kai sti Veroia, protevousa tou koinou ton Makedonon* (Athens, 2002).

—— (ed.), *Kalindoia: An Ancient City in Macedonia* (Thessaloniki, 2008).

AINALOV, D. V., *The Hellenistic Origins of Byzantine Art*, tr. E. and S. Sobolevitch, ed. C. A. Mango (New Brunswick, NJ, 1961).

AKAMATIS, I. M., 'Agora Pellas: 15 chronia archaiologikis erevnas', *Archaia Makedonia*, 6 (Thessaloniki, 1999), 23–44.

AKAMATIS, I. M., *LIMC* 8.922, s.v. Olganos.

ALEXANDRI-TZAHOU, O., *LIMC* 3.375–82, s.v. Demos.

AMANDRY, P., 'Chronique des fouilles et découvertes archéologiques en Grèce en 1947', *BCH* 71–2 (1947–8), 423–71.

AMPOLO, C., 'Onori per Artemidoro di Efeso: la statua di bronzo "dorata"', *Parola del Passato*, 63 (2008), 361–70.

ANDRONIKOS, M., 'The Royal Tombs at Aigai (Vergina)', in M. V. Hatzopoulos and L. D. Loukopoulou (eds), *Philip of Macedon* (London, 1981), 188–231.

ANEZIRI, S., 'Kaiserzeitliche Ehrenmonumente auf der Akropolis: Die Identität der Geehrten und die Auswahl des Aufteilungsortes', in R. Krumeich and C. Witschel (eds), *Die Akropolis von Athen im Hellenismus und in der römischen Kaiserzeit* (Wiesbaden, 2010), 271–302.

ARENA, E., '*L'eikon* delfica di Filippo II e la dedica degli Anfissei a Delfi', *Ancient Macedonia*, 7 (Thessaloniki, 2007), 293–326.

AUDIAT, J., *Le Gymnase*. Exploration Archéologique de Délos, 28 (Paris, 1970).

AUSTIN, C. and BASTIANINI, G., *Posidippi Pellaei quae supersunt omnia* (Milan, 2002).

AVEZZÙ, E., 'Antropologia e lessico della parentela greca', in E. Avezzù and O. Longo (eds), *Koinon aima: Antropologia e lessico della parentela greca* (Bari, 1991), 25–40.

—— LONGO, O. (eds), *Koinon aima: Antropologia e lessico della parentela greca* (Bari, 1991).

AZOULAY, V., 'La Gloire et l'outrage: Heurs et malheurs des statues honorifiques de Démétrios de Phalère', *Annales*, 64 (2009), 303–40.

BCHELARD, G., *La Poétique de l'espace* (Paris, 1957).

BADOUD, N., 'Les Colosses de Rhodes', *CRAI* (2011), 110–50.

BAGNALL, R., 'Stolos the Admiral', *Phoenix*, 26 (1972), 358–68.

—— *The Administration of the Ptolemaic Possessions Outside Egypt* (Leiden, 1976).

BAKER, M., 'Playing with Plinths in Eighteenth-Century Sculpture', in A. Gerstein (ed.), *Display and Displacement: Sculpture and the Pedestal from Renaissance to Post-Modern* (London, 2007), 62–71.

BAKER, P. and THÉRIAULT, G., 'Les Lyciens, Xanthos et Rome dans la première moitié du Ier s. *a.C.*: Nouvelles inscriptions', *REG* 118 (2005), 329–66.

—— —— 'Notes sur quelques inscriptions de Lycie (Xanthos, Arykanda et Kadyanda) et deux nouvelles inscriptions xanthiennes', *REG* 122 (2009), 63–83.

BALTY, J.-C., 'Groupes Statuaires impériaux et privés de l'époque julio-claudienne', in N. Boncasa and G. Rizza (eds), *Ritratto ufficiale e ritratto privato* (Rome, 1988), 31–46.

BRBANTANI, S., 'The Glory of the Spear: A Powerful Symbol in Hellenistic Poetry and Art. The Case of Neoptolemus "of Tlos" (and Other Ptolemaic Epigrams)', *Studi Classici e Orientali*, 53 (2007) [2010], 67–138.

BAXANDALL, M., *Painting and Experience in Fifteenth-Century Italy: A Primer in the Social History of Pictorial Style* (2nd edn, Oxford, 1988).

BELTING, H., *Likeness and Presence* (Chicago, 1994).

BENNETT, C., 'The Children of Ptolemy III and the Date of the Exedra of Thermos', *ZPE* 138 (2002), 141–5.

BÉQUIGNON, Y. and DEVAMBEZ, P., 'Les Fouilles de Thasos, 1925–1931', *BCH* 56 (1932), 232–86.

BÉRARD, C., *L'Héróon à la porte de l'Ouest*, Eretria, 3 (Berne, 1970).

BERGEMANN, J., *Demos und Thanatos: Untersuchungen zum Wertsystem der Polis im Spiegel der attischen Grabreliefs des 4. Jahrhunderts v. Chr. und zur Funktion der gleichzeitigen Grabbauten* (Munich, 1997).

—— 'Attic Grave Reliefs and Portrait Sculpture in Fourth-Century Athens', in R. von den Hoff and P. Schultz, *Early Hellenistic Portraiture: Image, Style, Context* (Cambridge, 2007), 34–46.

—— HALLOF, K., 'Hieron und Lysippe: Inschriften, Ikonographie und Interpretation eines bekannten attischen Grabreliefs', *AthMitt* 112 (1997), 269–80.

BERNAND, A., *La Prose sur pierre dans l'Égypte hellénistique et romaine* (Paris, 1992).

BERNARD, P., 'Vicissitudes au gré de l'histoire d'une statue en bronze d'Héraclès entre Séleucie du Tigre et la Mésène', *JSav* (1990), 3–68.

BERNARDINI, C., *I bronzi della stipe di Kamiros* (Athens, 2006).

BERTINETTI, S., *La statua di culto nella pratica rituale greca* (Bari, 2001).

BERTRAND, J.-M., 'Formes de discours politiques: Décrets des cités grecques et correspondance des rois hellénistiques', in C. Nicolet (ed.), *Du pouvoir dans l'antiquité: Mots et réalités*. Cahiers du Centre Glotz, 1 (Paris and Geneva, 1990), 101–15.

—— *Cités et royaumes du monde grec: Espace et politique* (Paris, 1992).

BERTI, F., FABIANI, R., ZIZILTAN, Z., and NAFISSI, M. (eds), *Marmi erranti: I marmi di Iasos presso i musei archeologici di Istanbul* (Istanbul, 2010).

BESCHI, L., 'I "disiecta membra" di un santuario di Myrina (Lemno)', *ASAtene*, 79 (2001), 191–251.

BETTINI, M., *Il ritratto dell'amante* (Turin, 1992).

BIELFELD, R., 'Wo nur sind die Bürger von Pergamon? Eine Phänomenologie bürgerlicher Unscheinbarkeit im städtischen Raum der Königsresidenz', *Ist. Mitt* 60 (2010), 117–201.

—— 'Polis Made Manifest: The Physiognomy of the Public in the Hellenistic City with a Case Study on the Agora in Priene', in C. Kuhn (ed.), *Politische Kommunikation und öffentliche Meinung in der antiken Welt* (Stuttgart, 2012), 87–122.

BIELMAN, A., *Retour à la liberté: Libération et sauvetage des prisonniers en Grèce ancienne* (Lausanne, 1994).

BLANCK, H., 'Porträt-Gemälde als Ehrendenkmäler', *BJb* 168 (1968), 1–12.

—— *Wiederverwendung alter Statuen bei Griechen und Römern als Ehrendenkmäler* (Rome, 1969).

BLINKENBERG, C., *Lindos: Fouilles et recherches, 1902–1914*, ii. *Inscriptions*, 2 fasc. (Berlin, 1941).

BLUMENTAL, R., 'Many Months Away, El Paso's Giant Horseman Stirs Passions', *New York Times*, 10 Jan. 2004.

BODEL, J., '"Sacred Dedications": A Problem of Definitions', in J. Bodel and M. Kajava (eds), *Dediche sacre nel mondo greco-romano: Diffusione, funzioni, tipologie* (Rome, 2009), 17–30.

—— KAJAVA, M. (eds), *Dediche sacre nel mondo greco-romano: Diffusione, funzioni, tipologie* (Rome, 2009).

BOHN, R. (ed.), *Altertümer von Aegae* (Berlin, 1889).

BOL, P. C. and ECKSTEIN, F., 'Die Polybios-Stele in Kleitor/Arkadien', *Antike Plastik*, 15 (1975), 83–93.

BOMMELAER, J.-F., *Lysandre de Sparte: Histoire et traditions* (Athens, 1981).

—— *Guide de Delphes: Le Site* (Athens, 1991).

—— 'Observations sur le théâtre de Delphes', in J.-F. Bommelaer (ed.), *Delphes: Centenaire de la 'grande fouille' realisée par l'École française d'Athènes, 1892–1903* (Leiden, 1992), 277–300.

BORBEIN, A., 'Die griechische Statue des 4. Jahrhunderts v. Chr.', *JDAI* 88 (1973), 43–212.

BOSCHUNG, D. and PFANNER, M., 'Les Méthodes de travail des sculpteurs antiques et leur signification dans l'histoire de la culture', in M. Waelkens (ed.), *Pierre éternelle: Du Nil au Rhin. Carrières et préfabrication* (Brussels, 1990), 128–42.

BOURGEOIS, B. and JOCKEY, P., 'Le Geste et la couleur: Stratégies et mises en couleurs de la sculpture hellénistique de Délos', *Bulletin Archéologique*, 30 (2003), 65–77.

BOUSQUET, J., 'Une statue de Pélopidas à Delphes signée de Lysippe', *RA* 14 (Oct.–Dec. 1939), 125–32.

—— 'Inscriptions de Delphes', *BCH* 83 (1959), 146–92.

—— 'Inscriptions de Delphes', *BCH* 84 (1960), 161–75.

—— 'Inscriptions de Delphes', *BCH* 87 (1963), 188–208.

BRÉLAZ, C. and SCHMID, S., 'Une nouvelle dédicace à la triade artémisiaque provenant d'Érétrie', *RA* (2004), 227–58.

BRENNAN, T. C., *The Praetorship in the Roman Republic*, 2 vols (Oxford 2000).

BRESSON, A., 'Règles de nomination dans la Rhodes antique', *Dialogues d'Histoire Ancienne*, 7 (1981), 345–62.

—— *Recueil des inscriptions de la Pérée rhodienne* (Paris, 1991).

—— 'La Parenté grecque en palindrome', in A. Bresson, M.-P. Masson, S. Perentidis, and J. Wilgaux (eds), *Parenté et société dans le monde grec de l'Antiquité à l'âge moderne* (Bordeaux, 2006), 13–22.

—— *L'Économie de la Grèce des cités*, i. *Les Structures et la production* (Paris, 2007).

—— 'Painted Portrait, Statues and Honors for Polystratos at Phrygian Apameia', in K. Konuk (ed.), *Stephanephoros* (Bordeaux, 2012), 203–20.

—— MASSON, M.-P., PERENTIDIS, S. and WILGAUX, J. (eds), *Parenté et société dans le monde grec de l'Antiquité à l'âge moderne* (Bordeaux, 2006).

BRILLIANT, R., *Portraiture* (London, 1991).

BRINGMANN, K. and von Steuben, H. (eds), *Schenkungen Hellenisticher Herrescher an griechische Städte und Heiligtümer* (Berlin, 1995).

BROGAN, T. M., 'Liberation Honors: Athenian Monuments from Antigonid Victories in their Immediate and Broader Contexts', in O. Pelagia and S. V. Tracy (eds), *The Macedonians in Athens* (Oxford, 2003), 194–205.

BROWN, A. R., 'Last Men Standing: Chlamydatus Portraits and Public Life in Late Antique Corinth', *Hesperia*, 81 (2012), 141–76.

BRUNEAU, Ph., *Recherches sur les cultes de Délos à l'époque hellénistique et à l'époque impériale* (Paris, 1970).

—— 'Le Portrait', *Ramage*, 1 (1982), 71–93.

—— and Ducat, J., *Guide de Délos* (4th edn, Paris, 2005).

BRÜNS-ÖZGAN, C. and ÖZGAN, R., 'Eine bronzene Bildnisstatue aus Kilikien', *Antike Plastik*, 23 (1994), 81–9.

BULLE, H., *Griechische Statuenbasen: Skizze zu einer Entwickelungsgeschichte der antiken Postamentformen* (Munich, 1898).

BULLOCH, A., GRUEN, E. S., LONG, A. A. and STEWART, A. (eds), *Images and Ideologies: Self-Definition in the Hellenistic World* (Berkeley, Calif., 1993).

BUMKE, H., *Statuarische Gruppen in der frühen griechischen Kunst* (Berlin, 2004).

BURGUIÈRE, A. and BEILLEVAIRE, P. (eds), *Histoire de la famille*, i. (Paris, 1986).

BURKERT, W., *Greek Religion: Archaic and Classical* (Oxford, 1985).

BURASELIS, K., *Das hellenistische Makedonien und die Ägäis: Forschungen zur Politik des Kassandros und der drei ersten Antigoniden (Antigonos Monophthalmos, Demetrios Poliorketes und Antigonos Gonatas) im ägäischen Meer und in Westkleinasien* (Munich, 1982).

—— 'Ambivalent Roles of Centre and Periphery: Remarks on the Relation of the Cities of Greece with the Ptolemies until the End of Philometor's Age', in P. Bilde (ed.), *Centre and Periphery in the Hellenistic World* (Aarhus, 1993), 251–70.

BURRELL, B., 'Reading, Hearing, and Looking at Ephesos', in W. A. Johnson and H. N. Parker (eds), *Ancient Literacies: The Culture of Reading in Greece and Rome* (Oxford, 2009), 69–95.

BURZACHECHI, M., 'Oggetti parlanti nelle epigrafi greche', *Epigraphica*, 24 (1962), 3–54.

CABANES, P., *L'Épire de la mort de Pyrrhos à la conquête romaine (272–167 av. J.C.)* (Paris, 1976).

CALLISEN, S. A., 'The Equestrian Statue of Louis XIV in Dijon and Related Monuments', *Art Bulletin*, 23 (1941), 131–40.

CAMERON, A., *Porphyrius the Charioteer* (Oxford, 1973).

CAMP II, J. M., *The Athenian Agora Site Guide* (5th edn, Princeton, 2010).

CAPDETREY, L. and LAFOND, Y. (eds), *La Cité et ses élites: Pratiques et représentation des formes de domination et de contrôle social dans les cités grecques* (Bordeaux, 2010).

CARROLL, K., *The Parthenon Inscription* (Durham, 1982).

CARTER, J., *The Sculpture of the Sanctuary of Athena Polias at Priene* (London, 1983).

CASEVITZ, M., 'Notes sur le vocabulaire du privé et du public', *Ktema*, 23 (1998), 39–45.

CHAMOUX, F., 'Chronique des fouilles et découvertes archéologiques en Grèce en 1948', *BCH* 73 (1949), 516–74.

CHANIOTIS, A., *War in the Hellenistic World: A Social and Cultural History* (Malden, Mass., 2005).

—— 'Theatre Rituals', in P. Wilson (ed.), *The Greek Theatre and Festivals: Documentary Studies* (Oxford, 2007), 48–66.

CHANKOWSKI, A., 'La Procédure législative à Pergame au Ier siècle au J.-C.: A propos de la chronologie relative des décrets en l'honneur de Diodoros Pasparos', *BCH* 122 (1998), 159–99.

CHANTRAINE, P., *Dictionnaire étymologique de la langue grecque: Histoire des mots*, 4 vols (Paris, 1968–80).

CHARITONIDIS, S. I., *Ai epigraphai tis Lesvou: Sympleroma* (Athens, 1968).

CHARNEUX, P., 'Chronique des fouilles et découvertes archéologiques en Grèce en 1956: Argos VIII, Inscriptions', *BCH* 81 (1957), 684–6.

CHAVIARAS, M. D., 'Nisirou epigraphai', *ArchEph* (1913), 6–16.

CHLEPA, H. A., *Messene: to Artemisio kai hoi oikoi tes dytikes pterygas tou Asklepieiou* (Athens, 2001).

CHRISTOL, M. and MASSON, O. (eds), *Actes du Xe Congrès International d'Épigraphie Grecque et Latine, Nîmes, 4–9 octobre 1992* (Paris, 1997).

CHROUST, A.-H., 'Aristotle's Last Will and Testament', *Wiener Studien*, 80 (1967), 90–114.

CLAIRMONT, C. W., *Gravestone and Epigram: Greek Memorials from the Archaic and Classical Period* (Mainz am Rhein, 1970).

COLLIGNON, M., *Les Statues funéraires dans l'art grec* (Paris, 1911).

CONNELLY, J. B., *Portrait of a Priestess: Women and Ritual in Ancient Greece* (Princeton, 2007).

CONNOR, W. R., 'Charinus' Megarean Decree', *AJP* 83 (1962), 225–46.

CONZE, A. and SCHUCHHARDT, C., 'Die Arbeiten zu Pergamon 1886–1898', *AthMitt* 24 (1899), 97–240.

—— SCHAZMANN, P., *Mamurt-Kaleh: ein Tempel der Göttermutter unweit Pergamon*. Jahrbuch des Kaiserlich Deutschen Archäologischen Instituts, Ergänzungsheft, 9 (Berlin, 1911).

COSTABILE, F., *Polis ed Olimpieion a Locri Epizefiri* (Soveria Mannelli, 1992).

COUILLOUD, M.-Th., 'Nouvelle dédicace attique aux Ilithyes', *BCH* 92 (1968), 72–5.

—— 'Les Graffites du Gymnase', in J. Audiat, *Le Gymnase*. Exploration Archéologique de Délos, 28 (Paris, 1970), 101–34.

COULTON, J. J., 'Pedestals as "altars" in Roman Asia Minor', *Anatolian Studies*, 55 (2005), 127–57.

COURBY, F., *Le Portique d'Antigone ou du nord-est: Et les constructions voisines*. Exploration Archéologique de Délos, 5 (Paris, 1912).

COUSIN, G., 'Note sur une inscription d'Alabanda', *BCH* 32 (1908), 203–4.

—— DIEHL, C., 'Inscriptions d'Alabanda en Carie', *BCH* 10 (1886), 299–314.

COX, C. A., *Household Interests: Property, Marriage Strategies and Family Dynamics in Ancient Athens* (Princeton, 1998).

CROISSANT, F., 'Note de Topographie argienne (à propos d'une inscription de l'Aphrodision)', *BCH* 96 (1972), 137–54.

CROWTHER, C. V., 'I. Priene 8 and the History of Priene in the Early Hellenistic Period', *Chiron*, 26 (1996), 195–250.

CROWTHER, N. B., 'Male "Beauty" Contests in Greece: The Euandria and Euexia', *Antiquité Classique*, 54 (1985), 285–91.

CULLEN, G., *The Concise Townscape* (London, 1961).

CUTHBERT, A. R. (ed.), *Designing Cities: Critical Readings in Urban Design* (Oxford, 2003).

CZAPLICA, J. J., RUBLE, B. A. and CRABTREE, L. (eds), *Composing Urban History and the Constitution of Civic Identities* (Washington, DC, 2003).

DAKARIS, S., *Kassope neoteres anaskaphes 1977–1983* (Ioannina, 1984).

D'ANDRIA, F., and ROMEO, I. (eds), *Roman Sculpture in Asia Minor* (Portsmouth, RI, 2011).

DAREMBERG, C., and SAGLIO, E. (eds), *Dictionnaire des Antiquités grecques et romaines*, 5 vols (Paris, 1877–1919).

DARESTE, R., HAUSSOULLIER, B. and REINACH, T., *Recueil des Inscriptions juridiques grecques*, 2 vols (2nd edn, Paris 1898–1904).

DAUX, G. and LAUMONIER, A., 'Fouilles de Thasos (1921–1922)', *BCH* 47 (1923), 315–52.

DAVIES, J. K., 'Athenian Citizenship: The Descent Group and the Alternatives', *CJ* 73 (1977–8), 105–21.

—— review of B. S. Strauss, *Fathers and Sons in Athens* (London 1993), in *JHS* 119 (1999), 210–11.

DAVIS, W., 'Abducting the Agency of Art', in R. Osborne and J. Tanner (eds), *Art's Agency and Art History* (Oxford, 2007), 199–219.

DEBORD, P. and VARINLIOĞLU, E. (eds), *Les Hautes terres de Carie* (Pessac, 2001).

DE LA COSTE-MESSELIÈRE, P., 'Inscriptions de Delphes', *BCH* 49 (1925), 61–103.

DELORME, J., *Gymnasion: Étude sur les monuments consacrés à l'éducation en Grèce (des origines à l'Empire Romain)* (Paris, 1960).

DE POLIGNAC, F., 'Analyses de l'espace et urbanisations en Grèce archaïque: Quelques pistes de recherche récentes', *REA* 108 (2006), 203–23.

—— SCHMITT-PANTEL P. (eds), *Public et privé en Grèce ancienne: Lieux, conduites, pratiques*. Ktema, 23 (1998).

DE RIDDER A., 'Grandes Statues de bronze', *RA* (1915), ii. 97–113.

DEROW, P. S., 'Rome, the Fall of Macedon and the Sack of Corinth', in *The Cambridge Ancient History*, viii. *Rome and the Mediterranean to 133 BC* (2nd edn, Cambridge, 1989), 290–323.

DES GAGNIERS, J. (ed.), *Laodicée du Lycos* (Quebec, 1969).

DESPINIS, G., 'Timetikon psephisma ek Parou', *ArchDelt* 20/1 (1965), 119–32.

—— Stephanidou-Tiveriou, T. and Voutiras, E. (eds), *Katalogos glypton tou Archaiologikou Mouseiou Thessalonikis*, 1 (Thessaloniki, 1997).

DICKIE, M., 'What is a Kolossos and How Were Kolossoi Made in the Hellenistic Period?', *GRBS* 37 (1996), 237–57.

DIAMANDARAS, A. S., 'Epigraphai ek Lykias', *BCH* 18 (1894), 323–33.

DILLON, S., *Ancient Greek Portrait Sculpture* (Cambridge, 2006).

—— *The Female Portrait Statue in the Greek World* (Cambridge, 2010).

DONALD, W. A., *The Political Meeting Places of the Greeks* (Baltimore, Md., 1943).

D'ONOFRIO, A., '*Oikoi*, Généalogies et monuments: Réflexsion sur le système des dédicaces dans l'Attique archaïque', *Ktema*, 23 (1998), 103–21.

DÖRNER, F. K. and GRUBEN, G., 'Die Exedra der Ciceronen', *AthMitt* 68 (1953), 63–76.

DOVER, K. J., 'Anthemocritus and the Megarians', *AJP* 87 (1966), 203–9.

DREYER, B., *Untersuchungen zur Geschichte des spätklassischen Athen (322–ca. 230 v. Chr.).* Historia Einzelschrift, 137 (Stuttgart, 1999).

DUCREY, P. and CALAME, C., 'Notes de sculpture et d'épigraphie en Béotie, II: Une base de statue portant la signature de Lysippe de Sicyone à Thèbes', *BCH* 120 (2006), 63–91.

—— FACHARD, S. and KNOEPFLER, D., *Érétrie: Guide de la cité antique* (Fribourg, 2004).

DUMAS, A., *Impressions de voyage en Suisse*, 2 vols (Paris, 1982).

DUNANT, C. and POUILLOUX, J., *Recherches sur l'histoire et les cultes de Thasos*, ii.(Paris, 1958).

DUPLOUY, A., *Le Prestige des élites: Recherches sur les modes de reconnaissance sociale en Grèce entre les Xe et Ve siècles avant J.-C.* (Paris, 2006).

DUPONT-SOMMER, A. and ROBERT, L., *La Déesse de Hierapolis-Castabala, Cilicie* (Paris, 1964).

DÜRNING, I., *Aristotle in the Ancient Biographical Tradition* (Gothenburg, 1957).

DÜRRBACH, F., *Choix d'inscriptions de Délos* (Paris, 1921–2).

DURVYE, C., 'Aphrodite à Délos: Culte privé et public à l'époque hellénistique', *REG* 119 (2006), 83–113.

ECK, W., 'Statuendedikanten und Selbstdarstellung in römischen Städten', in Y. Le Bohec (ed.), *L'Afrique, la Gaule, la religion à l'époque romaine: Mélanges à la mémoire de Marcel Le Glay* (Brussels, 1994), 650–62.

ECKSTEIN, F., *ANAΘHMATA: Studien zu den Weihgeschenken strengen Stils im Heiligtum von Olympia* (Berlin, 1969).

EBERT, J., *Griechische Epigramme auf Sieger an gymnischen und hippischen Agonen* (Berlin, 1972).

EILERS, C. F., *Roman Patrons of Greek Cities* (Oxford, 2002).

EKROTH, G., 'Theseus and the Stone: The Iconographic and Ritual Contexts of a Greek Votive in the Louvre', in J. Mylonopoulos (ed.), *Divine Images and Human Imaginations in Ancient Greece and Rome* (Leiden, 2010), 143–69.

ELLINGER, P., *La Fin des maux: D'un Pausanias à l'autre. Essai de mythologie et d'histoire* (Paris, 2005).

—— 'Plutarque et Damon de Chéronée: Une histoire, un mythe, un texte ou autre chose encore?', *Kernos*, 18 (2005), 291–310.

ELSNER, J. (ed.), *Art and Text in Roman Culture* (Cambridge, 1996).

—— 'Reflections on the "Greek Revolution" in Art: From Changes in Viewing to the Transformation of Subjectivity', in S. Goldhill and R. Osborne (eds), *Rethinking Revolutions through Ancient Greece* (Cambridge, 2007), 68–95.

—— *Roman Eyes: Visuality and Subjectivity in Art and Text* (Cambridge, 2007).

ENSOLI, S., 'L'heroôn di Dexileo nel Ceramico di Atene: Problematica architettonica e arstistica attica degli inizi del IV secolo a. C', *Memorie (Accademia nazionale dei Lincei. Classe di scienze morali, storiche e filologiche)* 8.29/2 (1987), 157–329.

ERBSE, H., *Untersuchungen zu den attizistischen Lexika* (Berlin, 1950).

ERTUĞRUL, F. and MALAY, H., 'An Honorary Decree from Nysa', *EA* 43 (2010), 31–42.

ÉTIENNE, R. *Ténos I: le sanctuaire de Poséidon et d'Amphitrite*, (Paris 1986).

—— *Ténos II: Ténos et les Cyclades du milieu du IVe siècle a. J.-C. au milieu du IIIe siècle ap. J.-C.* (Paris 1990).

—— 'La Politique culturelle des Attalides', in F. Prost (ed.), *L'Orient méditerranéen de la mort d'Alexandre aux campagnes de Pompée: cités et royaumes. Pallas*, 62 (2003), 357–77.

—— KNOEPFLER, D., *Hyettos de Béotie et la chronologie des archontes fédéraux entre 250 et 171 avant J.-C. BCH* Supplément, 3 (Paris, 1976).

—— VARÈNE, P., *Sanctuaire de Claros, l'architecture: Les Propylées et les monuments de la voie sacrée. Fouilles de Louis et Jeanne Robert et Roland Martin, 1950–1961* (Paris, 2004).

EULE, J. C., *Hellenistische Bürgerinnen aus Kleinasien: Weibliche Gewandstatuen in ihrem antiken Kontext* (Istanbul, 2001).

FEDAK, J., *Monumental Tombs of the Hellenistic Age: A Study of Selected Tombs from the Pre-Classical to the Early Imperial Era* (Toronto, 1990).

FEHR, B., 'Kosmos und Chreia: Der Sieg der reinen über die praktische Vernunft in der griechischen Stadtarchitektur des 4. Jhs. v. Chr.', *Hephaistos*, 1 (1979), 155–85.

FEHR, B., *Les Tyrannoctones, peut-on élever un monument à la démocratie* (French tr. Paris, 1989, orig. Frankfurt, 1984).

FEJFER, J., 'Ancestral Aspects of the Roman Honorary Statue', in J. M. Højte (ed.), *Images of Ancestors* (Aarhus, 2002), 247–56.

FELTEN, F., 'Römische Machthaber und hellenistische Herrscher: Berührungen und Umdeutungen', *JOAI* 56 (1985), Beiblatt, 109–54.

FENTON, J., *Leonardo's Nephew: Essays on Art and Artists* (London, 1998).

FERRARY, J.-L., *Philhellénisme et impérialisme* (Paris, 1988).

—— 'Les Inscriptions du sanctuaire de Claros en l'honneur de Romains', *BCH* 124 (2000), 331–76.

—— VERGER, S., 'Contrbution à l'histoire du sanctuaire de Claros à la fin du IIe et au Ier siècle av. J.-C.: L'Apport des inscriptions en l'honneur des Romains et des fouilles de 1994–1997', *CRAI* (1999), 811–50.

FEYEL, C., *Les Artisans dans les sanctuaires grecs aux époques classiques et hellénistiques à travers la documentation financière en Grèce* (Paris, 2006).

FEYEL, M., 'Inscriptions inédites d'Akraiphia', *BCH* 79 (1955), 419–23.

FILGES, A., *Skulpturen und Statuenbasen: Von der klassischen Epoche bis in der Kaiserzeit* (Mainz am Rhein, 2007).

FILGIS, M. N. and RADT, W., *Die Stadtgrabung. i. Das Heroon*. Altertümer von Pergamon, 15/1 (Berlin, 1986).

FIRATLI, N. *Les Stèles funéraires de Byzance gréco-romaine* (Paris, 1964).

FISCHER-HANSEN, T., 'The Earliest Town-Planning of the Western Greek Colonies, with Special Regard to Sicily', in M. H. Hansen (ed.), *Introduction to an Inventory of Poleis* (Copenhagen, 1996), 317–73.

FITTSCHEN, K., 'Zur Rekonstruktion griechischer Dichterstatuen, 1. Teil: Die Statue des Menander', *AM* 106 (1991), 243–79.

—— 'Eine Stadt für Schaulustige und Müßiggänger. Athen im 3. und 2. Jh. v. Chr.', in M. Wörrle and P. Zanker (eds), *Stadtbild und Bürgerbild im Hellenismus* (Munich, 1995), 55–77.

—— 'Zur Bildnisstatue des Kleonikos, des "Jünglings von Eretria"', *Eirene*, 31 (1995), 98–108.

—— 'Von Einsatzbüsten und freistehenden Büsten: Zum angeblichen Bildnis der "Keltenfürstin Adobogiona" aus Pergamon', in C. Evers and A. Tsingarida (eds), *Rome et ses provinces: Genèse et diffusion d'une image du pouvoir. Hommages à Jean-Charles Balty* (Brussels, 2001), 109–17.

FLASHAR, M. and VON DEN HOFF, R., 'Die Statue des sogennanten Philosophen Delphi im Kontext einer mehrfigurigen Stiftung', *BCH* 117 (1993), 408–33.

FLOWER, H., *The Art of Forgetting: Disgrace and Oblivion in Roman Political Culture* (Chapel Hill, NC, 2006).

FORMIGLI, E. (ed.), *I grandi bronzi antichi: Le fonderie e le techiche di lavorazione dell' età arcaica al Rinascimento* (Siena, 1999).

FOUCAULT, M., *Ceci n'est pas une pipe: Deux lettres et quatre dessins de René Magritte* (Montpellier, 1973).

FOUGÈRES, G., *Mantinée et l'Arcadie orientale* (Paris, 1898).

FRAISSE, P., 'Analyse d'espaces urbains: Les "Places" à Délos', *BCH* 107 (1983), 301–13.

—— MORETTI, J.-C., *Le Théâtre*. Exploration Archéologique de Délos, 42 (Paris, 2007).

FRANKLIN, S. B., 'Public Appropriations for Individual Offerings and Sacrifices in Greece', *TAPA* 32 (1901), 72–82.

FRANZIUS, I. (FRANZ, J.), *Elementa Epigraphices Graecae* (Berlin, 1840).

FREELAND, C., *Portraits and Persons: A Philosophical Inquiry* (Oxford, 2010).

FREITAG, K., 'Olympia as "Erinnerungsort" in hellenistischer Zeit', in M. Haake and M. Jung (eds), *Griechische Heiligtümer als Erinnerungsorte von der Archaik bis in den Hellenismus* (Stuttgart, 2011), 69–94.

FRENCH, D. H., 'A Sinopean Sculptor at Halicarnassus', *EA* 4 (1984), 75–83.

FRÖHLICH, P., *Les Cités grecques et le contrôle des magistrats (IVe–Ier siècle avant J.-C.)* (Geneva, 2004).

—— 'Dépenses publiques et évergétisme des citoyens dans l'exercice des charges publiques à Priène à la basse époque hellénistique', in P. Fröhlich and C. Müller (eds), *Citoyenneté et Participation à la basse époque hellénistique* (Geneva, 2005), 225–56.

—— MÜLLER, C. (eds), *Citoyenneté et participation à la basse époque hellénistique* (Geneva, 2005).

GAISER, K., 'Philochoros über zwei Statuen in Athen', in B. von Freytag (Löringhoff), D. Mannsperger, and F. Prayon, *Praestant Interna: Festschrift für Ulrich Hausmann* (Tübingen, 1982), 91–100.

GAUTHIER, P., *Un commentaire historique des Poroi de Xénophon* (Geneva, 1976).

—— 'Les Honneurs de l'officier séleucide Larichos à Priène', *JSav* (1980), 35–50.

—— 'Notes sur trois décrets honorant des citoyens bienfaiteurs', *RevPhil* 56 (1982), 215–31.

—— *Les Cités grecques et leurs bienfaiteurs* (Paris, 1985).

—— 'Notes sur le rôle du gymnase dans les cités hellénistiques', in P. Zanker and M. Wörrle (eds), *Stadtbild und Bürgerbild im Hellenismus* (Munich, 1995), 1–11.

—— 'Le Décret de Thessalonique pour Parnassos: L'Évergète et la dépense pour sa statue à la basse époque hellénistique', *Tekmeria*, 5 (2000), 39–63.

—— 'Le Décret de Colophon l'Ancienne en l'honneur du Thessalien Asandros et la sympolitie entre les deux Colophon', *JSav* (2003), 61–100.

—— 'Un gymnasiarque honoré à Colophon', *Chiron*, 35 (2005), 101–12.

—— HATZOPOULOS, M. V., *La Loi gymnasiarchique de Beroia* (Athens, 1993).

GEHN, U., *Ehrenstatuen in der Spätantike: Chlamydati und Togati* (Wiesbaden, 2012).

GELL, A., *Art and Agency: An Anthropological Theory* (Oxford, 1998).

GERLACH, E., *Griechische Ehreninschriften* (Halle, 1908).

GERSTEIN, A. (ed.), *Display and Displacement: Sculpture and the Pedestal from Renaissance to Post-Modern* (London, 2007).

GEUSS, R., *Public Goods, Private Goods* (Princeton, 2001).

GIULIANI, L., *Bildnis und Botschaft* (Frankfurt, 1986).

GOETTE, H. R., 'Die Basis des Astydamas im sogennanten lykugischen Dionysos-Theater zu Athen', *Antike Kunst*, 42 (1999), 21–5.

GOLDHILL, S., 'The Great Dionysia and Civic Ideology', *JHS* 107 (1987), 58–76.

—— OSBORNE, R. (eds), *Art and Text in Ancient Greek Culture* (Cambridge, 1994).

GOODLETT, V. C., 'Rhodian Sculpture Workshops', *AJA* 95 (1991), 669–81.

GOTTSCHALK, H., 'The Wills of the Peripatetician Philosophers', *Hermes*, 100 (1972), 314–82.

GOUNAROPOULOU, L. and HATZOPOULOS, M. V., *Epigraphes Kato Makedonias* (Athens, 1998).

GRANDJEAN, Y. and SALVIAT, F., *Guide de Thasos* (Athens, 2000, 2nd edn).

GRANGER-TAYLOR, H., 'The Emperor's Clothes: The Fold Lines', *Bulletin of the Cleveland Museum of Art*, 74 (1987), 114–23.

GRANINGER, D., *Cult and Koinon in Hellenistic Thessaly* (Leiden, 2011), 43–86.

GRAY, B., 'Exile and the Political Cultures of the Greek Polis, c.404–146 BC' (D.Phil. thesis, University of Oxford 2011).

GREISBACH, J. (ed.), *Polis und Porträt: Standbilder als Medien öffentlicher Repräsentation im hellenistischen Osten* (forthcoming).

GRIEB, V., *Hellenistische Demokratie: Politische Organisation und Struktur in freien griechischen Poleis nach Alexander dem Grossen.* Historia Einzelschrift, 199 (Stuttgart, 2008).

GRUBEN, G., 'Naxos und Paros: Vierter vorläufiger Bericht über die Forschungskampagnen 1972–1980. II. Klassische und hellenistische Bauten auf Paros', *ArchAnz* (1982), 621–89.

GUARDUCCI, M., *Epigrafia greca*, 4 vols (Rome, 1967–78).

GURLITT, L., 'Ein Kriegerrelief aus Kleitor', *AthMitt* 6 (1881), 154–66.

HAAKE, M., 'Der Philosoph Alexander, Sohn des Alexander, aus Athen: Zu einem neuen hellenistischen Ehrendekret aus Larisa für einen bislang unbekannten Philosophen', *Tyche*, 25 (2010), 39–48.

HABICHT, C., *Die Inschriften des Asklepieions.* Altertümer von Pergamon, 8/3 (Berlin, 1969).

—— *Gottmenschentum und griechische Städte* (2nd edn, Munich, 1970).

—— 'Ein thesprotischer Adliger im Dienste Ptolemaios' V', *Archaeologia Classica*, 25–6 (1973–4), 313–18.

—— *Untersuchungen zur politischen Geschichte Athens im 3. Jahrhundert v. Chr.* (Munich, 1979).

—— *Pausanias' Guide to Ancient Greece* (Berkeley, Calif., 1985).

—— 'Neue Inschriften aus Thessalien', *Demetrias*, 5 (Bonn, 1987), 307–17.

—— 'Analecta Laertiana', in H. Büsing and H. Friedrich (eds), *Bathron: Beiträge zur Architektur und verwandten Künsten für Heinrich Drerup zu seinem 80. Geburtstag von seinen Schülern und Freunden* (Saarbrücken, 1988), 173–8.

—— 'Athens and the Attalids in the Second Century BC', *Hesperia*, 59 (1990), 561–77.

—— 'Samos weiht eine Statue des *populus Romanus*', *AthMitt* 105 (1990), 259–68.

—— 'Ist ein 'Honoratiorenregime' das Kennzeichen der Stadt im späteren Hellenismus?', in M. Wörrle and P. Zanker (eds), *Stadtbild und Bürgerbild im Hellenismus* (Munich, 1995), 87–92.

—— *Athens from Alexander to Antony* (Cambridge, Mass., 1997).

—— 'Zu griechischen Inschriften aus Kleinasien', *EA* 31 (1999), 19–29.

—— 'Beiträge zu koischen Inschriften des 2. Jahrhunders v. Chr', in N. Ehrhardt and L.-M. Günther (eds), *Widerstand, Anpassung, Integration: Die griechische Staatenwelt und Rom: Festschift für Jürgen Deininger zum 65. Geburtstag* (Stuttgart, 2002), 103–7.

—— 'Die Ehren der Proxenoi: Ein Vergleich', *Museum Helveticum*, 59 (2002), 13–30.

—— 'Notes on Inscriptions from Cyzicus', *EA* 38 (2005), 93–100.

HABICHT, C., 'Kronprinzen in der Monarchie der Attaliden?', in V. Alonso Troncoso (ed.), Διάδοχος τῆς βασιλείας: La figura del sucesor en la realeza helenística, suppl. 9 to Gerion (Madrid, 2005), 119–26.

—— 'Neues zur hellenistischen Geschichte von Kos', Chiron, 37 (2007), 123–52.

HAHLAND, W., 'Bildnis der Keltenfürsten Adobogiona', in G. Moro (ed.), Festschrift für Rudolf Egger: Beiträge zur älteren europäischen Kulturgeschichte (Klagenfurt, 1953), ii. 135–57.

HALL, J., The World as Sculpture: The Changing Status of Sculpture from the Renaissance to the Present Day (London, 2000).

HALLETT, C. H., 'A Group of Portraits from the Civic Center at Aphrodisias', AJA 102 (1998), 59–89.

—— The Roman Nude: Heroic Portrait Statuary, 200 BC–AD 300 (Oxford, 2005).

HAMON, P., 'Les Prêtres du culte royal dans la capitale des Attalides: Note sur le décret de Pergame en l'honneur du roi Attale III (OGIS 332)', Chiron, 34 (2004), 169–85.

—— 'Le Conseil et la participation des citoyens: Les Mutations de la basse époque hellénistique', in P. Fröhlich and C. Müller (eds), Citoyenneté et participation à la basse époque hellénistique (Geneva, 2005), 121–44.

—— 'Élites dirigeantes et processus d'aristocratisation à l'époque hellénistique', in H.-L. Fernoux and C. Stein (eds), Aristocratie antique: Modèles et exemplarité sociale (Dijon, 2007), 77–98.

HANSEN, M. H., The Athenian Democracy in the Age of Demosthenes (Oxford, 1991).

—— 'The Polis as an Urban Centre: The Literary and Epigraphical Evidence', in M. H. Hansen (ed.), The Polis as an Urban Centre and as a Political Community (Copenhagen, 1997), 9–86.

—— FISCHER-HANSEN, T., 'Monumental Political Architecture in Archaic and Classical Greek Poleis: Evidence and Historical Significance', in D. Whitehead (ed.), From Political Architecture to Stephanus Byzantius: Sources for the Ancient Greek Polis. Historia Einzelschrift, 87 (Stuttgart, 1994), 23–90.

HARVEY, D., Social Justice and the City (London, 1973).

HATZOPOULOS, M. V. and LOUKOPOULOU, L. D., Recherches sur les marches orientales des Temenides: Anthemonte-Kalindoia, 2 vols (Athens, 1992).

HAUBEN, H., Callicrates of Samos: A Contribution to the Study of the Ptolemaic Admiralty (Leuven, 1970).

HAUSSOULLIER, B., 'Inscriptions d'Halicarnasse', BCH 4 (1880), 395–408.

—— 'Inscriptions d'Héraclée du Latmos', RevPhil 23 (1899), 274–92.

HAYDEN, D., The Power of Place: Urban Landscapes as Public History (Cambridge, Mass., 1995).

HELLER, A., 'D'un Polybe à l'autre: Statuaire honorifique et mémoire des ancêtres dans le monde grec d'époque impériale', Chiron, 41 (2011), 287–312.

HELLY, B., 'Décrets de Démétrias pour les juges étrangers', BCH 95 (1971), 543–59.

HEMINGWAY, S., The Horse and Jockey from Artemision: A Bronze Equestrian Monument from the Hellenistic Period (Berkeley, Calif., 2004).

HENNIG, D., 'Staatliche Ansprüche an privaten Immobilienbesitz', Chiron, 25 (1995), 235–82.

HENRY, A. S., Honours and Privileges in Athenian Decrees: The Principal Formulae of Athenian Honorary Decrees (Hildesheim, 1983).

HEPDING, H., 'Die Arbeiten zu Pergamon 1904-1905. II. Die Inschriften', AthMitt 32 (1907), 241–377.

—— 'Mithradates von Pergamon', AthMitt 34 (1909), 329–40.

—— 'Die Arbeiten zu Pergamon 1908–1909. II. Die Inschriften', AthMitt 35 (1910), 401–93.

HERDA, A., 'Panionion-Melia, Mykalessos-Mykale, Perseus und Medusa: Überlegungen zur Besiedlungsgeschichte der Mykale in der frühen Eisenzeit', IstMitt 56 (2006), 43–102.

HEREWARD, D., 'Inscriptions from Pamphylia and Isauria', JHS 78 (1958), 57–77.

HERMARY, A., 'Les Noms de la statue chez Hérodote', in M.-Cl. Amouretti and P. Villard (eds), EUKRATA: Mélanges offerts à Claude Vatin (Aix-en-Provence 1994), 21–9.

HERRMANN, H.-V., 'Die Siegerstatuen von Olympia: Schriftliche Überlieferung und archäologischer Befund', Nikephoros, 1 (1988), 119–83.

HERRMANN, P., Neue Inschriften zur historischen Landeskunde von Lydien und angrenzenden Gebieten (Vienna, 1959).

—— 'Die Inschriften römischer Zeit aus dem Heraion von Samos', AthMitt 75 (1960), 68–183.

—— 'Neue Urkunden zur Geschichte von Milet im 2. Jahrhundert v. Chr.', IstMitt 15 (1965), 71–117.

—— and Malay, H., New Documents from Lydia (Vienna, 2007).

HERZFELD, M., A Place in History: Social and Monumental Time in a Cretan Town (Princeton, 1991).

HERZOG, R., 'Symbolae Calymniae et Coae', RivFil NS 20 (1942), 1–20.

HICKS, E. L., 'Ceramus (Κέραμος) and its Inscriptions', JHS 11 (1890), 109–28.

HILLER VON GAERTRINGEN, F., 'Ausgrabungen im Theater von Magnesia am Maiandros. I. Inschriften', AthMitt 19 (1894), 1–53.

—— 'Der Verein der Bakchisten und die Ptolemäerherrschaft in Thera', *Festschrift zu Otto Hirschfelds sechzigstem Geburtstage* (Berlin 1903), 87–99.

HIMMELMANN, N., *Die private Bildnisweihung bei den Griechen: zu den Ursprüngen des abendländischen Porträts* (Wiesbaden, 2001).

HINTZEN-BOHLEN, B., 'Die Familiengruppe: ein Mittel zur Selbstdarstellung hellenistischer Herrscher', *JDAI* 105 (1990), 129–54.

HÖGHAMMAR, K., *Sculpture and Society: A Study of the Connection between the Free-standing Sculpture and Society on Kos in the Hellenistic and Augustan Periods* (Uppsala, 1993).

HØJTE, J. M., 'Cultural Interchange? The Case of Honorary Statues in Greece', in E. N. Ostenfeld, K. Blomqvist, and L. C. Nevett (eds), *Greek Romans or Roman Greeks? Studies in Cultural Interaction* (Aarhus, 2002), 55–63.

HØJTE, J. M., *Roman Imperial Statue Bases: From Augustus to Commodus* (Aarhus, 2005).

HÖLBL, G., *Geschichte des Ptolemäerreiches: Politik, Ideologie und religiöse Kultur von Alexander dem Grossen bis zur römischen Eroberung* (Darmstadt, 1994).

HÖLSCHER, T., *Öffentliche Räume in frühen griechischen Städten* (Heidelberg, 1998).

—— 'Rituelle Räume und politische Denkmaler', in H. Kyrieleis (ed.), *Olympia 1875–2000: 125 Jahre Deutsche Ausgrabungen* (Mainz, 2002), 331–43.

—— 'Architectural Sculpture: Messages? Programs? Towards Rehabilitating the Notion of "Decoration" ', in R. von den Hoff and P. Schultz (eds), *Structure, Image, Ornament: Architectural Sculpture in the Greek World* (Oxford, 2009), 54–67.

HOEPFNER, W., *Zwei Ptolemaierbauten: Das Ptolemaierweihgeschenk in Olympia und ein Bauvorhaben in Alexandria* (Berlin, 1971).

—— (ed.), *Das dorische Thera V: Stadtgeschichte und Kultstätten am nördlichen Stadtrand* (Berlin, 1997).

—— LEHMANN, L. (eds), *Die Griechische Agora* (Mainz, 2006).

—— SCHWANDER, E.-L. *Haus und Stadt im klassischen Griechenland* (2nd edn, Munich, 1994).

HOLLEAUX, M., 'Inscriptions du temple d'Apollon Ptoios', *BCH* 14 (1890), 1–64, 181–203.

—— 'L'Inscription de la tiare de Saïtaphernès', *RA* 29 (1896), 159–71.

—— *Études d'épigraphie et d'histoire grecques*, 6 vols (Paris, 1938–68).

HOMOLLE, T., 'Comptes et inventaires des temples déliens en l'année 279', *BCH* 14 (1890), 389–511.

HOUSER, C., 'Alexander's Influence on Greek Sculpture as Seen in a Portrait in Athens', in B. Barr-Sharrar and E. N. Borza (eds) *Macedonia and Greece in Late Classical and Early Hellenistic Times* (Washington, DC, 1982), 229–38.

—— 'Silver Teeth: Documentation and Significance', *AJA* 91 (1987), 300–1.

HUBBE, R. O., 'Public Service in Miletus and Priene in Hellenistic and Roman Imperial Times' (Ph.D. thesis, Princeton University, 1950).

HUMANN, C., *Magnesia am Maeander: Bericht über Ergebnisse der Ausgrabungen der Jahre 1891–1893* (Berlin, 1904).

HUMPHREYS, S. C., 'Public and Private Interests in Classical Athens', *CJ* 73 (1977–8), 97–104.

—— *The Family, Women and Death: Comparative Studies* (London, 1983).

—— review of S. B. Pomeroy, *Families in Classical and Hellenistic Greece* (Oxford 1997), in *American Historical Review*, 104 (1999), 1358–9.

INTZESILOGLOU, B., 'I Itonia Athina kai to Thessaliko omospondiako iero tis sti Philia Karditzas', *Archaiologiko Ergo Thessalias kai Stereas Elladas*, 1/2003 (Volos, 2006), 221–37.

IOAKIMIDOU, C., *Die Statuenreihen griechischer Poleis und Bünde aus spätarchaischer und klassischer Zeit* (Munich, 1997).

IPPEL, A., 'Die Arbeiten zu Pergamon 1910–1911. II, Die Inschriften', *AthMitt* 37 (1912), 277–330.

ISAGER, S. and KARLSSON, L., 'A New Inscription from Labraunda: An Honorary Decree for Olympichos. Labraunda no. 134 (and no. 49)', *EA* 41 (2008), 39–52.

JACOB, R., 'Les Pièces rapportées dans la statuaire attique en marbre du IVe siècle avant J.-C.', *Bulletin Archéologique*, 30 (2003), 41–54.

JACOB-FELSCH, M., *Die Entwicklung griechischer Statuenbasen und die Aufstellung der Statuen* (Waldsassen, 1969).

JACOBSTAHL, P., 'Die Arbeiten zu Pergamon 1906–1907. II, Die Inschriften', *AthMitt* 33 (1908), 375–420.

JAMOT, P., 'Fouilles de Thespies: Deux familles thespiennes pendant deux siècles', *BCH* 26 (1902), 291–321.

JANIETZ SCHWARZ, B. and ROUILLER, D., *Ein Depot zerschlagener Grossbronzen aus Augusta Raurica: die Rekonstruktion der beiden Pferdestatuen und Untersuchungen zur Herstellungstechnik* (Augst, 1996).

JACOPI, G., 'Nuove epigrafi dalle Sporadi meridionali', *Clara Rhodos*, 2 (1932), 165–255.

JACQUEMIN, A., 'Notes sur quelques offrandes du Gymnase de Délos', *BCH* 105 (1981), 155–69.

JACQUEMIN, A., 'Aitolia et Aristaineta. Offrandes monumentales étoliennes à Delphes au IIIe s. av. J.-C.', *Ktèma*, 10 (1985), 27–35.

—— 'Ordre des Termes des dédicaces delphiques', *AION* NS 2 (1995), 141–57.

—— *Offrandes monumentales à Delphes* (Athens, 1999).

JAEGGI, O., *Die griechischen Porträts: Antike Repräsentation, moderne Projektion* (Berlin, 2008).

JANNORAY, J., 'Inscriptions delphiques d'époque tardive: Inscriptions de Lébadée', *BCH* 70 (1946), 247–62.

JANSSEN, E., *Die Kausia: Symbolik und Funktion der makedonischen Kleidung* (Diss. Göttingen, 2007).

JOLLET, E., 'Objet d'attention: L'Intérêt pour le support en France à l'époque moderne', in A. Gerstein (ed.), *Display and Displacement: Sculpture and the Pedestal from Renaissance to Post-Modern* (London, 2007), 33–61.

JONES, C. P., 'Diodoros Pasparos and the Nikephoria of Pergamon', *Chiron*, 4 (1974), 183–205.

—— 'Events Surrounding the Bequest of Pergamon to Rome and the Revolt of Aristonicos: New Inscriptions from Metropolis', *JRA* 17 (2004), 469–86.

—— *New Heroes in Antiquity: From Achilles to Antinoos* (Cambridge, Mass., 2010).

JORDAN-RUWE, M., *Das Säulenmonument: Zur Geschichte der erhöhten Aufstellung antiker Porträtstatuen*. Asia Minor Studien, 19 (Bonn, 1995).

JUDEICH, W., *Topographie von Athen* (2nd edn, Munich, 1931).

JÜNGER, F., 'Das Gemälde des Apelles von Alexander auf dem Wagen', in J. Gebauer, E. Grabow, F. Jünger, and D. Metzler, (eds), *Bildergeschichte: Festschrift Klaus Stähler* (Möhnesee, 2004), 255–63.

KABUS-PREISOFEN, R., *Die Hellenistische Plastik der Insel Kos* (Berlin, 1989).

KAH, D. and SCHOLZ, P. (eds), *Das hellenistische Gymnasion* (Berlin, 2004).

KALLET-MARX, R. M., *Hegemony to Empire: The Development of the Roman Imperium in the East from 148 to 62 BC* (Berkeley, Calif., 1995).

KALTSAS, N. E., *Ethniko Archaiologiko Mouseio: ta glypta. Katalogos* (Athens, 2001).

KATSIKOUDIS, N. T., *Dodone: Oi Timetikoi Andriantes* (Ioannina, 2006).

KAVVADIAS, P., *Fouilles d'Epidaure* (Athens, 1891).

—— *To hieron tou Asklepiou en Epidavro kai i Therapeia tou Asthenon* (Athens, 1900).

KEESLING, C., *The Votive Statues of the Athenian Acropolis* (Cambridge, 2003).

—— 'Early Hellenistic Portrait Statues on the Athenian Acropolis', in R. von den Hoff and P. Schultz, *Early Hellenistic Portraiture: Image, Style, Context* (Cambridge, 2007), 141–60.

KEIL, B., 'Der Perieget Heliodoros von Athen', *Hermes*, 30 (1895), 199–240.

KEIL, J., 'Die Volksbeschlüsse der Chier für Lucius Nassius', *JOAI* 35 (1943), *Beibl.* 121–6.

KENNEDY, H., 'From *Polis* to Madina: Urban Change in Late Antique and Early Islamic Syria', *Past and Present*, 106 (1985), 3–27.

KIENAST, H. J. and HALLOF, K., 'Ein Ehrenmonument für samische Scribonii aus dem Heraion', *Chiron*, 29 (1999), 205–23.

KLAFFENBACH, G., *Bemerkungen zum griechischen Urkundenwesen* (Berlin, 1960).

—— *Griechische Epigraphik* (2nd edn, Göttingen, 1966).

—— 'Neue Inschriften aus Aetolien', *Sitzungsberichte der Preussischen Akdemie der Wissenschaften* (1936), 358–88.

KNOEPFLER, D., 'La Base de Sôsilos à la synagogue de Délos', in A. Plassart (ed.), *Études Déliennes publiées à l'occasion du centième anniversaire du début des fouilles de l'École française d'Athènes à Délos. BCH* Supplément, 1 (Paris, 1973), 233–7.

—— 'Contributions à l'épigraphie de Chalcis', *BCH* 101 (1977), 297–312.

—— 'L. Mummius Achaicus et les cités du golfe euboïque méridional: A propos d'une nouvelle inscription d'Érétrie', *Museum Helveticum*, 48 (1991), 252–80.

—— *Décrets érétriens de proxénie et de citoyenneté* (Lausanne, 2001).

—— 'Débris d'évergésie au gymnase d'Érétrie', in O. Curty with S. Piccan and S. Codourey, *L'Huile et l'argent: Gymnasiarchie et évergétisme dans la Grèce hellénistique* (Fribourg, 2009), 203–41.

—— *La Patrie de Narcisse* (Paris, 2010).

KÖHLER, H. K. E., 'Geschichte der Ehre der Bildsäule bei den Griechen', in L. Stephani (ed.), *Gesammelte Schriften*, vi (St Petersburg, 1853), 243–366.

KÖHLER, U., 'Attische Inschriften des Fünften Jahrhunderts', *Hermes*, 31 (1896), 137–54.

KOKKINIA C. (ed.), *Boubon: The Inscriptions and Archaeological Remains: A Survey 2004–2006* (Athens, 2008).

KONSTANTINOPOULOU, G., 'Epigraphai ek Rhodou', *ArchDelt* 18/1 (1963), 1–36.

—— 'Anaskaphai eis Rhodon', *Praktika* (1975), 238–48.

KONTORINI, V., *Inscriptions inédites relatives à l'histoire et aux cultes de Rhodes au IIe et au Ier S. av. J.-C.: Rhodiaka I* (Louvain-la-Neuve, 1983).

—— *Anekdotes Epigraphes Rhodou*, ii (Athens, 1989).

—— 'La Famille de l'amiral Damagoras de Rhodes: Contribution à la prosopographie et à l'histoire rhodiennes au Ier s. av. J.-C', *Chiron*, 23 (1993), 83–99.

KORRES, M., 'Anathimatika kai timitika tethrippa stin Athina kai stous Delphous', in A. Jacquemin (ed.), *Delphes cent ans après la grande fouille: Essai de bilan. BCH* Supplément, 46 (Athens, 2000), 293–329.

KOSMETATOU, E., 'Remarks on a Delphic Ptolemaic Dynastic Group Monument', *Tyche*, 17 (2002), 103–11.

—— 'Constructing Legitimacy: The Ptolemaic "Familiengruppe" as a Means of Self-Definition in Posidippus' ἱππικά, in B. Acosta-Huges, E. Kosmetatou, and M. Baumbach (eds), *Labored in Papyrus Leaves: Perspectives on an Epigram Collection Attributed to Posidippus (P. Mil Vogl. VIII 309)* (Washington, DC, 2004), 225–46.

KOSMOPOULOU, A., *The Iconography of Sculptured Statue Bases in the Archaic and Classical Periods* (Madison, Wis., 2002).

KOTSIDU, H., *Τιμὴ καὶ δόξα: Ehrungen für Hellenistische Herrscher im griechischen Mutterland und in Kleinasien unter besonderer Berücksichtigung der archäologischen Denkmäler* (Berlin, 2000).

KOUSSER, R., 'Creating the Past: The Vénus de Milo and the Hellenistic Reception of Classical Greece', *AJA* 109 (2005), 227–50.

KREIKENBOM, D., *Griechische und römische Kolossalporträts bis zum späten ersten Jahrhundert nach Christus* (Berlin, 1992).

KREUZ, P.-A., 'Monuments for the King: Royal Presence in the Late Hellenistic World of Mithridates VI', in J. M. Højte (ed.), *Mithridates VI and the Pontic Kingdom* (Aarhus, 2009), 131–44.

KRISCHEN, F. 'Das hellenistische Gymnasion von Priene', *JDAI* 38–9 (1923–4), 133–50.

KRUMEICH, R., *Bildnisse griechischer Herrscher und Staatsmänner im 5. Jahrhunder v. Chr.* (Munich, 1997).

—— 'Ehrenstatuen als Weihgeschenke auf der Athener Akropolis. Staatliche Ehreungen in religiösen Kontext', in C. Frevel and H. von Hesberg (eds), *Kult und Kommunikation: Medien in Heiligtümern der Antike* (Wiesbaden, 2007), 380–413.

—— 'Human Achievement and Divine Favor: The Religious Context of Early Hellenistic Portraiture', in R. von den Hoff and P. Schultz (eds), *Early Hellenistic Portraiture: Image, Style, Context* (Cambridge, 2007), 161–80.

—— 'Vom Haus der Gottheit zum Museum? Zu Ausstattung und Funktion des Heraion von Olympia und des Athenatempels von Lindos', *Antike Kunst*, 51 (2008), 73–95.

—— 'Formen der statuarischen Repräsentation römischer Honoranden auf der Akropolis von Athen im späten Hellenismus und in der frühen Kaiserzeit', in S. Vlizos (ed.), *I Athena kata ti Romaiki epochi: prosphates anakalypseis, nees erevnes / Athens during the Roman Period: Recent Discoveries, New Evidence* (Athens, 2008), 353–68.

—— WITSCHEL, C., 'Hellenistische Statuen in ihrem räumlichen Kontext: Das Beispiel der Akropolis und der Agora von Athen', in A. Matthaei and M. Zimmermann (eds), *Stadtbilder im Hellenismus* (Frankfurt am Main, 2009), 173–226.

—— —— (eds) *Die Akropolis von Athen im Hellenismus un in der römischen Kaiserzeit* (Wiesbaden, 2010).

KRUSE, T., 'Zwei Denkmäler der Antigoniden in Olympia: Eine Untersuchung zu Pausanias 6.16.3', *AthMitt* 107 (1992), 273–93.

KUHN, C. T., 'Public Political Discourse in Roman Asia Minor' (D.Phil. thesis, University of Oxford, 2008).

KUHNERT, E., 'Statue und Ort in ihrem Verhältnis bei den Griechen', *Jahrbücher für classische Philologie*, suppl. 14 (1885), 245–338.

KURKE, L., *The Traffic in Praise: Pindar and the Poetics of Social Economy* (Ithaca, N.Y, 1991).

KYRIELEIS, H., *Führer durch das Heraion von Samos* (Athens, 1981).

LAHUSEN, G. and FORMIGLI, E., *Römische Bildnisse aus Bronze: Kunst und Technik* (Munich, 2001).

LAMBERT, S. D., 'What Was the Point of Inscribed Honorific Decrees in Classical Athens?', in S. D. Lambert (ed.), *A Sociable Man: Essays in Ancient Greek Social Behaviour in Honour of Nick Fisher* (Swansea, 2011), 193–214.

LAMBRINO, S., 'Inscription de Priène', *BCH* 52 (1928), 399–406.

LAMBRINOUDAKIS, V. 'The Emergence of the City-State of Naxos in the Aegean', in M. C. Lentini, *Le due città di Naxos* (Giardini Naxos, 2004), 61–74.

—— WÖRRLE, M., 'Ein hellenistisches Reformgesetz über das öffentliche Urkundenwesen von Paros', *Chiron*, 13 (1983), 283–368.

LAPE, S., 'Solon and the Institution of the "Democratic" Family Form', *CJ* 98 (2002–3), 117–39.

—— *Reproducing Athens: Menanders Comedy, Democratic Culture, and the Hellenistic City* (Princeton, 2004).

LARFELD, W., *Griechische Epigraphik* (3rd edn, Munich, 1914).

LARSEN, J. A. O., *Greek Federal States: Their Institutions and History* (Oxford, 1968).

LASLETT, P. (ed.), *Household and Family in Past Time* (Cambridge, 1972).

LAUM, B., *Stiftungen in der griechischen und römischen Antike: Ein Beitrag zur antiken Kulturgeschichte*, 2 vols (Leipzig, 1914).

LAURENT, V., 'Inscriptions Grecques d'époque romaine et byzantine', *Échos d'Orient*, 35 (1936), 220–33.

LAUTER, H., 'Megalopolis: Ausgrabungen aus der Agora 1991–2002', in E. Østby (ed.), *Ancient Arcadia* (Athens, 2005), 235–48.

—— SPYROPOULOS, T., 'Megalopolis: 3, Vorbericht 1996–1997', *ArchAnz* (1998), 415–51.

LAWALL, M., 'The Wine Jars Workroom: From Stamps to Sherds', in J. McK. Camp II and C. A. Mauzy (eds), *The Athenian Agora: New Perspectives on an Ancient Site* (Mainz am Rhein, 2009), 63–8.

LAWTON, C. L., *Attic Document Reliefs: Art and Politics in Ancient Athens* (Oxford, 1995).

LAZARIDI, K., 'To gymnasio tis Amphipolis', in *Mneme D. Lazaridi: Polis kai chora stin archaia Makedonia kai Thraki* (Thessaloniki, 1990), 241–73.

LAZZARINI, M. L., *Le formule delle dediche votive nella Grecia arcaica* (Rome, 1976).

—— 'Epigrafia e statua ritratto: Alcuni problemi', *AAPat* 97 (1984–5), 83–103.

LE DINAHET-COUILLOUD, M.-T., 'Les Rituels funéraires en Asie Mineure et en Syrie à l'époque hellénistique (jusqu'au milieu du Ier siècle av. J.-C.)', in F. Prost (ed.), *L'Orient méditerranéen de la mort d'Alexandre aux campagnes de Pompée: Cités et royaumes à l'époque hellénistique* (Rennes, 2003), 65–95.

LE GUEN, B., *Les Associations de Technites dionysiaques à l'époque hellénistique* (Nancy, 2001).

LEFEBVRE, H., *La Production de l'espace* (Paris, 1974).

LEFÈVRE, F., *L'Amphictionie pyléo-delphique: Histoire et institutions* (Athens, 1998).

LEFKOWITZ, M., *The Lives of the Greek Poets* (London, 1981).

LEHMANN, S., 'Der Thermenherrscher und die Fussspuren der Attaliden: Zur Olympischen Statuenbasis des Q. Caec. Metellus Macedonicus', *Nürnberger Blätter zur Archäologie*, 13 (1997), 107–30.

—— 'Der bekleidete Gymnasiast – eine neue Deutung zum Jüngling von Eretria', *Antike Kunst*, 44 (2001), 18–23.

LESCHHORN, W., 'Die Königsfamilie in der Politik: Zur Mitwirking der Attalidenfamilie an der Regierung des pergamensichen Reiches', in W. Lechhorn, A. V. B. Miron, and A. Miron (eds), *Hellas und der griechische osten: Studien zur Geschichte und Numismatik der griechischen Welt. Festschrift für Peter Robert Franke zum 70. Geburtstag* (Saarbücken, 1996), 79–98.

LEVENSOHN, M. and LEVENSOHN, E., 'Inscriptions on the South Slope of the Acropolis', *Hesperia*, 16 (1947), 63–74.

LEWIS, D. M., 'Public Property in the City', in O. Murray and S. R. F. Price (eds), *The Greek City from Homer to Alexander* (Oxford, 1990), 245–64.

LINFERT, A., *Kunstzentren hellenistischer Zeit: Studien an weiblichen Gewandfiguren* (Wiesbaden, 1976).

LIPPARD, L., *The Lure of the Local: Senses of Place in a Multicentred Society* (New York, 1997).

LIPPOLIS, E., 'Tra il ginnasio di Tolomeo ed il Serapeion: La riconstuzione topograpfica di un quartiere monumentale di Atene', *Ostraka*, 4 (1995), 43–67.

LLEWELYN, N., *The Art of Death: Visual Culture in the English Death Ritual c.1500–c.1800* (London, 1991).

LLEWELYN-JONES, L., *Aphrodite's Tortoise: The Veiled Woman of Ancient Greece* (Swansea, 2003).

LOHMANN, H., 'Forschungen und Ausgrabungen in der Mykale 2001-2006', *IstMitt* 57 (2007), 59–178.

LÖHR, C., 'Die Statuenbasen im Amphiareion von Oropos', *AthMitt* 108 (1993), 183–212.

—— *Griechische Familienweihungen: Untersuchungen einer Repräsentationsform von ihren Anfängen bis zum Ende des 4. Jhs. v. Chr* (Rahden, 2000).

LONG, A. A. and SEDLEY, D. N., *The Hellenistic Philosophers*, 2 vols (Cambridge, 1987).

LONGO, O., 'I figli e i padri: forme di riproduzione e controllo sociale in Grecia antica', in E. Avezzù and O. Longo (eds), *Koinon aima: Antropologia e lessico della parentela greca* (Bari, 1991), 77–108.

LURAGHI, N., 'The Demos as Narrator: Public Honours and the Construction of Future and Past', in L. Foxhall, H.-J. Gehrke, and N. Luraghi (eds), *Intentional History: Spinning Time in Ancient Greece* (Stuttgart, 2010), 247–63.

MA, J., 'Fighting *Poleis* of the Hellenistic World', in H. van Wees (ed.), *War and Violence in Ancient Greece* (London, 2000), 337–76.

—— 'The Epigraphy of Hellenistic Asia Minor: A Survey of Recent Research (1992–1999)', *AJA* 104 (2000), 95–121, at 107–11.

—— 'Public Speech and Community in Dio Chrysostom's *Euboikos*', in S. Swain (ed.), *Dio Chrysostom: Politics, Letters, and Philosophy* (Oxford, 2000), 108–24.

—— *Antiochos III and the Cities of Western Asia Minor* (rev. edn, Oxford, 2002).

—— *Antiochos III et les cités d'Asie Mineure* (Paris, 2004).

—— 'Une culture militaire en Asie mineure hellénistique?', in J.-C. Couvenhes and H. L. Fernoux (eds), *Les Cités grecques et la guerre en Asie Mineure à l'époque hellénistique* (Paris, 2004), 199–220.

—— 'The Many Lives of Eugnotos of Akraiphia', *Studi ellenistici*, 16 (2005), 141–91.

—— 'A Gilt Statue for Konon at Erythrai?', *ZPE* 157 (2006), 124–6.

—— 'Hellenistic Honorific Statues and their Inscriptions', in Z. Newby and R. E. Newby-Leader (eds), *Art and Inscriptions in the Ancient World* (Cambridge, 2007), 203–20.

—— 'Notes on Honorific Statues at Oropos (and Elsewhere)', *ZPE* 160 (2007), 89–96.

—— 'Paradigms and Paradoxes in the Hellenistic World', *Studi Ellenistici*, 20 (Rome, 2008), 371–86.

—— 'The Two Cultures: Connoisseurship and Civic Honours', *Art History*, 29 (2006), 325–38.

—— Review of N. Katsikoudis, *Dodone: Oi Timetikoi Andriantes* (Ioannina, 2006), *BMCR* 2008.02.27.

—— 'The Inventory *SEG* 26.139 and the Athenian Asklepieion', *Tekmeria*, 9 (2008), 7–16.

—— 'The City as Memory', in G. Boys-Stones, B. Graziosi, and P. Vasunia (eds), *The Oxford Handbook of Hellenic Studies* (Oxford, 2009), 248–59.

—— 'Autour des balles de fronde "camiréennes" ', *Chiron*, 40 (2010), 154–73.

—— 'Le Roi en ses images: Essai sur les représentations du pouvoir monarchique dans le monde hellénistique', in I. Savalli-Lestrade and I. Cogitore (eds), *Des Rois au prince: Pratiques du pouvoir monarchique dans l'orient hellénistique et romain (IVe siècle avant J.-C.–IIe siècle après J.-C.* (Grenoble, 2010), 147–64.

—— 'Notes on the History of Honorific Statues in the Hellenistic Period', in P. Martzavou and N. Papazarkadas (eds), *New Documents, New Approaches: The Epigraphy of the Post-Classical Polis* (Oxford, 2012), 165–79.

—— 'Honorific Statues and Hellenistic History', in L. Yarrow and C. Smith (eds), *Imperialism, Cultural Politics and Polybius: Essays in Memory of P. S. Derow* (Oxford, 2011), 230–51.

—— 'Private Statues, Public Spaces', in J. Greisbach (ed.), *Polis und Porträt: Standbilder als Medien öffentlicher Repräsentation im hellenistischen Osten* (forthcoming).

MacDOWELL, D. M., *Andocides: On the Mysteries* (Oxford, 1962).

MADDOLI, G., *Epigrafi di Iasos: Nuovi Supplementi*, i. *Parola del Passato*, 62 (2007).

—— 'Du Nouveau sur les Hékatomnides d'après les inscriptions de Iasos', in R. van Bremen and J.-M. Carbon (eds), *Hellenistic Karia*. Ausonius Études, 28 (Talence, 2010), 123–31.

MAGNELLI, A., 'Kleobis e Biton a Delfi: Realtà o leggenda', in A. Martínez Fernández (ed.), *Estudios de Epigrafía Griega* (Santa Cruz de Tenerife, 2009), 81–91.

MAIER, F. G., *Griechische Mauerbauinschriften*, 2 vols (Heidelberg, 1959–61).

MAIURI, A., 'Viaggio di esplorazione in Caria: Parte III. Inscrizioni: Nuove iscrizioni dalla Caria', *ASAtene*, 4–5 (1921–2), 461–88.

MALINOWSKI, B., *The Sexual Life of Savages in North-Western Melanesia: An Ethnographic Account of Courtship, Marriage and Family Life aAmong the Natives of the Trobriand Islands, British New Guinea* (London, 1929).

MALLWITZ, A., *Olympia und seine Bauten* (Munich, 1972).

MANGO, C. A., 'Epigrammes honorifiques, statues et portraits à Byzance', republished in *Studies in Constantinople* (Aldershot, 1993), 23–35.

MANGO, E., *Das Gymnasium*. Eretria, 13 (Gollion, 2003).

MARC, J.-Y., 'La Ville de Thasos de la basse époque hellénistique à l'époque impériale: Les Constructions publiques d'une cité grecque du IIème siècle avant J.-C. au IIIème siècle après J.-C.' (Ph.D. thesis, Paris-I, 1994).

—— 'L'Agora de Thasos du IIe siècle av. J.-C. au Ier siècle ap. J.-C.: État des recherches', in J.-Y. Marc and J.-C. Moretti (eds), *Constructions publiques et programmes édilitaires en Grèce entre le IIe siècle av. J.-C. et le Ier siècle ap. J.-C. BCH* suppl. 39 (Athens, 2001), 495–516.

MARC, J.-Y., 'Urbanisme et espaces monumentaux à Thasos', *REG* 125 (2012), 3–18.

MARCADÉ, J., *Recueil des signatures de sculpteurs grecs*, 2 vols (Paris 1953–7).

—— *Au Musée de Délos: Étude sur la sculpture hellénistique en ronde-bosse découverte dans l'île* (Paris, 1969).

MAREK, C. and IŞIK, C., *Das Monument des Protogenes in Kaunos* (Bonn, 1997).

MARI, M., 'The Ruler Cult in Macedonia', *Studi Ellenistici*, 20 (2008), 219–68.

MARTIN, R., *L'Agora*. Études Thasiennes, 6 (Paris, 1959).

MARTZAVOU, P., 'Recherches sur les communautés festives dans la "vieille Grèce" (IIème siècle a. C–IIIème siècle p. C.)' (Ph.D. thesis, EPHE-IVème section, 2008).

—— ' "Isis" et "Athènes": Épigraphie, espace et pouvoir à la basse époque hellénistique', in M.-J. Versluys L. BRICAULT (eds), *Les Cultes isiaques et le pouvoir* (Leiden, forthcoming).

—— PAPAZARKADAS, N. (eds), *The Epigraphy of the Post-Classical Polis: Papers from the Oxford Epigraphy Workshop* (Oxford, 2012).

MASSEY, D., ALLEN, J. and PILE, S. (eds), *City Worlds* (London, 1999).

MATHYS, M., 'Der Anfang vom Ende oder das Ende vom Anfang? Strategien visueller Repräsentation im späthellenistischen Pergamon', in A. Matthaei and M. Zimmermann (eds), *Stadtbilder im Hellenismus* (Berlin, 2009), 227–42.

MATTHAEI, A. and ZIMMERMANN, M. (eds), *Stadtbilder im Hellenismus* (Berlin, 2009).

MATTUSCH, C. C., *Greek Bronze Statuary: From the Beginnings through the Fifth Century B.C.* (Ithaca, N.Y, 1988).

—— 'Lost-Wax Casting and the Question of Originals and Copies', in E. Formigli (ed.), *I grandi bronzi antichi: Le fonderie e le tecniche di lavorazione dall'età arcaica al Rinascimento* (Siena, 1999), 75–82.

MAU, A., 'Die Statuen des Forums von Pompeji', *RömMitt* 11 (1896), 150–6.

MEISTERHANS, K., *Grammatik der Attischen Inschriften* (3rd edn by E. Schwyzer, Berlin, 1900).

MELETIOSI, *Geographia Palaia kai Nea* (2nd edn, Venice, 1807).

MENDEL, G., *Catalogue des sculptures grecques, romaines et byzantines*, 3 vols (Constantinople, 1912).

MERCURI, L., 'Contributi allo studio degli spazi pubblici delii: L'Agora di Teofrasto', *ASAtene*, 86 (2008), 193–214.

MERKELBACH, R. and STAUBER, J., *Steinepigramme aus dem griechischen Osten*, 5 vols (Stuttgart, 1998–2004).

MERITT, B. D., 'Athenian Archons 347/6–48/7 BC', *Historia*, 26 (1977), 161–91.

—— 'Greek Inscriptions', *Hesperia*, 23 (1954), 233–83.

—— 'Greek Inscriptions', *Hesperia*, 29 (1960), 1–77.

MERKER, I. L., 'The Ptolemaic Officials and the League of the Islanders', *Historia*, 19 (1970), 141–60.

MESSERSCHMIDT, W., 'Basis einer Ehrenstatue für Philokles, König der Sidonier, aus Kaunos', *IstMitt* 58 (2008), 419–23.

MEYER-SCHLICHTMANN, C., 'Neue Erkenntnisse zum Heroon des Diodorus Pasparos in Pergamon: Keramik aus datierenden Befunden', *IstMitt* 42 (1992), 287–306.

MIGEOTTE, L., *L'Économie des cités grecques: De l'archaïsme au Haut-Empire* (Paris, 2002).

—— *L'Emprunt public dans les cités grecques: Recueil des documents et analyse critique* (Quebec, 1984).

MILCHHÖFER, A., 'Polybios', *ArchZeit* 39 (1881), 153–8.

MILES, M. M., *The City Eleusinion*. Athenian Agora, 31 (Princeton, 1998).

MILLER, M., 'Greek Kinship Terminology', *JHS* 73 (1953), 46–52.

MILLER, S. G., 'Architecture as Evidence for the Identity of the Early *Polis*', in M. H. Hansen (ed.), *Sources for the Ancient Greek City-State* (Copenhagen, 1995), 201–44.

MILLETT, P., 'Encounters in the Agora', in P. Cartledge, P. Millett, and S. von Reden (eds), *Kosmos: Essays in Order, Conflict and Community in Classical Athens* (Cambridge, 1998), 203–28.

—— *Theophrastus and his World*. CCJ suppl. vol 33 (Cambridge, 2007).

MILNER, N. P., 'A Hellenistic Statue Base in the Upper Agora at Oinoanda', *Anatolian Studies*, 48 (1998), 113–16.

MITFORD, T. B., 'The Hellenistic Inscriptions of Old Paphos', *ABSA* 56 (1961), 1–41.

MOLTESEN, M., 'De-restoring and Re-restoring: Fifty Years of Restoration Work in the Ny Carlsberg Glyptotek', in J. Burnett Grossman, J. Podany, and M. True (eds), *History of Restoration of Ancient Stone Sculptures* (Los Angeles, 2003), 207–22.

MONACO, M. C., 'Contributo allo studio di alcuni santuari ateniesi I: Il *temenos* del *Demos* e delle *Charites*', *ASAtene*, 79 (2001), 103–50.

—— 'Offrandes publiques et privées sur l'Acropole et l'Agora d'Athènes à l'époque lycurguéenne (340–320 av. J.-C.)', in V. Azoulay and P. Ismard (eds), *Clisthène et Lycurgue d'Athènes: Autour du politique dans la cité classique* (Paris, 2012), 219–32.

MORETTI, L., *Inscriptiones Graecae Urbis Romae*, 4 vols (Rome, 1968–90).

MORETTI, J.-C., 'Le Gymnase de Délos', *BCH* 120 (1996), 617–38.

—— 'Les Inventaires du gymnase de Délos', *BCH* 121 (1997), 125–52.

MORROW, K. D., *Greek Footwear and the Dating of Sculpture* (Madison, Wis., 1985).

MÜLLER, C., 'Les Italiens en Béotie du IIe siècle av. J.-C. au Ier siècle ap. J.-C.', in C. Müller and C. Hasenohr (eds), *Les Italiens dans le monde grec: IIe siècle av. J-C.-Ier siècle ap. J.C. Circulation, activités, intégration*, *BCH* suppl. 41 (Paris, 2002), 89–100.

MÜLLER, H., 'Königin Stratonike, Tochter des Königes Ariarathes', *Chiron*, 21 (1991), 393–424.

—— 'Ein Kultverein von Asklepiasten bei einem attalidischem Phrourion im Yüntda', *Chiron*, 40 (2010), 427–57.

MÜLLER, K., *Hellenistische Architektur auf Paros* (Berlin, 2003).

MÜLLER-WIENER, W., 'Neue Weihgeschenke aus dem Athena-Heiligtum in Priene', in *ArchAnz* (1982), 691–702.

MULVANY, C. M., 'Notes on the Legend of Aristotle', *CQ* 20 (1926), 155–67.

MURRAY, O., *Early Greece* (2nd edn, London, 1993).

MURRAY, W. M., 'The Weight of Trireme Rams and the Price of Bronze in Fourth-Century Athens', *GRBS* 26 (1985), 141–50.

MYLONAS, K. D., 'Anaskaphai tis stoas tou Attalou', *Praktika* (1900), 31–6.

MYLONOPOULOS, J. (ed.), *Divine Images and Human Imaginations in Ancient Greece and Rome* (Leiden, 2010).

NACHMANSON, E., 'Zu den Motivformeln der griechischen Ehreninschriften', *Eranos*, 11 (1911), 180–96, republished by E. Pfohl, *Inschriften der Griechen: Grab-, Weih- und Ehreninschriften* (Darmstadt, 1972), 153–72.

NACHTERGAEL, G., *Les Galates en Grèce et les Sôtéria de Delphes: Recherches d'histoire et d'épigraphie hellénistiques* (Brussels, 1977).

NEWBY, Z. and NEWBY-LEADER, R. (eds), *Art and Inscription in the Ancient World* (Cambridge, 2007).

NEWTON, C. T., *A History of Discoveries at Halicarnassus, Cnidus and Branchidae*, 2 vols (London, 1862–3).

NIGDELIS, P. M., *Epigraphika Thessalonikeia* (Thessaloniki, 2006).

NOBLE, J. V., 'The Wax of the Lost Wax Process', *AJA* 79 (1975), 368–9.

NODELMAN, S., 'How to Read a Roman Portrait', *Art in America*, 63 (1975), 26–33.

NORWOOD, G., 'A Greek Inscription Copied from Gallipoli', *CQ* os 11 (1917), 1–2.

NOWICKA, M., *Le Portrait dans la peinture antique* (Warsaw, 1993).

OBER, J., *Mass and Elite in Democratic Athens* (Princeton, 1989).

ODDY, W. A., COWELL, M. R., CRADDOCK, P. T. and HOOK, D. R., 'The Gilding of Bronze Sculpture in the Classical World', in *Small Bronze Sculpture from the Ancient World* (Malibu, Calif., 1990), 103–24.

OGDEN, D., *Greek Bastardy in the Classical and Hellenistic Periods* (Oxford, 1996).

OIKONOMOS, G. P., 'Anaskaphai en Messini', *Praktika* (1925–6), 55–66.

OLIVER, G. J., *War, Food, and Politics in Early Hellenistic Athens* (Oxford, 2007).

—— 'Space and the Visualization of Power in the Greek *Polis*: The Award of Portrait Statues in Decrees from Athens', in P. Schultz and R. von den Hoff (eds), *Early Hellenistic Portraiture: Image, Style, Context* (Cambridge, 2007), 181–204.

OLSON, S. D., 'Firewood and Charcoal in Classical Athens', *Hesperia*, 60 (1991), 411–20.

OSBORNE, M. J., 'The Archons of Athens 300/299–228/7', *ZPE* 171 (2009), 83–99.

OSBORNE, R., 'Island Towers: The Case of Thasos', *ABSA* 81 (1986), 167–78.

—— TANNER, J. (eds), *Art's Agency and Art History* (Malden, Mass., 2007).

OSTERMAN, C., *De praeconibus graecis* (Marburg, 1845).

OWENS, W. M., 'The Political Topicality of Menander's *Dyskolos*', *AJP* 132 (2011), 349–78.

PAGE, D. L., *Further Greek Epigrams* (Cambridge, 1981).

PALAGIA, O., 'Marble Carving Techniques', in O. Palagia (ed.), *Greek Sculpture: Function, Materials, and Techniques in the Archaic and Classical Periods* (Cambridge, 2006), 243–79.

PAPANGELOS, I. A., *Chalkidiki* (3rd edn, Ashbourne, 1987).

PAPASTAMATI-VON MOOCK, C., 'Menander und die Tragikergruppe: Neue Forschungen zu den Ehrenmonumenten im Dionysostheater von Athen', *AthMitt* 122 (2007), 273–327.

PAPAZARKADAS, N. and THONEMANN, P. J., 'Athens and Kydonia: Agora I 7602', *Hesperia*, 77 (2008), 73–87.

PASCHIDIS, P.. *Between City and King: Prosopographical Studies on the Intermediaries between the Cities of the Greek Mainland and the Aegean and the Royal Courts in the Hellenistic Period, 322–190 BC* (Athens and Paris, 2008).

PATON, W. R. and HICKS, E. L., *The Inscriptions of Cos* (Oxford, 1891).

PATTERSON, C., *The Family in Greek History* (Cambridge, Mass., 1998).

PEEK, W., 'Epigramme und andere Inschriften von Nisyros', *Wissenschaftliche Zeitschrift der Martin-Luther-Universität Halle-Wittenberg*, 16 (1967), 369–87.

—— *Inschriften aus dem Asklepieion von Epidauros*. Abhandlungen der Sächsischen Akademie der Wissenschaften zu Leipzig, Philologisch-Historische Klasse, 60/2 (Berlin, 1969).

—— *Neue Inschriften aus Epidauros*. Abhandlungen der Sächsischen Akademie der Wissenschaften zu Leipzig, Philologisch-Historische Klasse, 63/5 (Berlin, 1972).

PÉKARY, T., 'Inschriftenfunde aus Milet 1959', *IstMitt* 15 (1965), 118–34.

PERRIN-SAMINADAYAR, E., '*Aere perennius*: Remarques sur les commandes publiques de portraits en l'honneur des grands hommes à Athènes à l'époque hellénistique: modalités, statut, réception', in Y. Perrin with T. Petit (eds), *Iconographie impériale, icogographie royale, iconographie des élites dans le monde gréco-romain* (St.-Etienne 2004), 109–37.

PETRAKOS, V. C., *Hoi epigraphes tou Oropou* (Athens, 1997).

PFANNER, M., 'Über das Herstellen von Porträts: ein Beitrag zu Rationalisierungsmassnahmen und Productionsmechansimen von Massenware im späten Hellenismus und in der römische Kaizerzeit', *JDAI* 104 (1989), 157–257.

PHARAKLAS, N., 'Enepigraphon vathron ex Akraiphniou', *ArchDelt* 23/1 (1968), 293–4.

PICÓN, C. A., MERTENS, J. R., MILLEKER, E. J., LIGHTFOOT, C. S., HEMINGWAY, S. and PUMA, R. DE, *Art of the Classical World in the Metropolitan Museum of Art*: *Greece, Cyprus, Etruria, Rome* (New Haven, 2007).

PINKWART, D., 'Weibliche Gewandstatuen aus Magnesia am Mäander', *Antike Plastik*, 12 (1973), 149–59.

PLASSART, A., 'Fouilles de Thespies et de l'hiéron des Muses de l'Hélicon: Inscriptions. Dédicaces de caractère religieux ou honorifique, bornes de domaines sacrés', *BCH* 50 (1926), 383–462.

—— *Les Sanctuaires et les cultes du Mont Cynthe*. Exploration archéologique de Délos, 11 (Paris, 1928).

PLATT, V., 'Honour Takes Wing: Unstable Images and Anxious Orators in the Greek Tradition', in Z. Newby and R. Leader-Newby (eds), *Art and Inscriptions in the Ancient World* (Cambridge, 2007), 247–71.

POLLINI, J., 'The Cartoceto Bronzes: Portraits of a Roman Aristocratic Family of the Late First Century BC', *AJA* 97 (1993), 423–46.

POMEROY, S. B., *Families in Classical and Hellenistic Greece: Representations and Realities* (Oxford, 1997).

PONT, A.-V., *Orner la cité: Enjeux culturels et politiques du paysage urbain dans l'Asie gréco-romaine*. Scripta Antiqua, 24 (Pessac, 2010).

PRÊTRE, C., and BRUNET, M., *Nouveau choix d'inscriptions de Délos: Lois, comptes et inventaires* (Athens, 2002).

PREUNER, H. E., *Ein delphisches Weihgeschenk* (Leipzig, 1900).

PRICE, S. R. F., *Rituals and Power: The Roman Imperial Cult in Asia Minor* (Cambridge, 1984).

PRITCHETT, W. K., *Pausanias Periegetes*, 2 vols (Amsterdam, 1998–9).

PUCCI, P., 'Inscriptions Archaïques sur les statues des dieux', in M. Detienne (ed.), *Les Savoirs de l'écriture en Grèce ancienne* (Lille, 1988), 480–97.

PUGLIESE-CARRATELLI, G., 'Supplemento epigrafico rodio', *ASAtene*, 30–2 (1952–4), 247–316.

QUASS, F., *Die Honoratiorenschicht in den Städten des griechischen Ostens: Untersuchungen zur politischen und sozialen Entwicklung in hellenistischer und römischer Zeit* (Stuttgart, 1993).

QUEYREL, F., 'C. Ofellius Ferus', *BCH* 115 (1991), 389–464.

—— review of M. Kreeb, *Untersuchungen zur figürlichen Ausstattung delischer Privathäuser* (Chicago, 1988), in *Topoi*, 1 (1991), 101–4.

—— *Les Portraits des Attalides: Fonction et représentation* (Athens, 2003).

—— *L'Autel de Pergame: Images et pouvoir en Grèce d'Asie* (Paris, 2005).

—— 'La Datation du Grand Autel de Pergame', *Studi Ellenistici*, 16 (2005), 201–11.

—— 'Réalisme et mode de représentation dans l'art du portrait hellénistique: Le Cas de Délos', *Ktema*, 34 (2009), 243–56.

RADT, W., *Pergamon: Geschichte und Bauten einer antiken Metropole* (2nd edn, Darmstadt, 1999).

RAECK, W., 'Der mehrfache Apollodoros: Zur Präsenz des Bürgers im hellenistischen Stadtbild am Beispiel von Priene', in M. Wörrle and P. Zanker (eds), *Stadtbild und Bürgerbild im Hellenismus* (Munich, 1995), 231–38.

—— 'Priene: Neue Forschungen an einem alten Grabungsort', *IstMitt* 53 (2003), 313–423.

RAINBIRD, P., 'Representing Nation, Dividing Community: The Broken Hill War Memorial, New South Wales, Australia', *World Archaeology*, 35/1 (June 2003): *The Social Commemoration of Warfare*, 22–34.

RAMSAY, W. M., 'Inscriptions of Cilicia, Cappadocia, and Pontus', *Journal of Philology*, 11/21 (1882), 142–60.

RAUBITSCHEK, A. E., 'Greek Inscriptions', *Hesperia*, 12 (1943), 12–96.

—— 'Phaidros and his Roman Pupils', *Hesperia*, 18 (1949), 96–103.

—— 'Epigraphical Notes on Julius Caesar', *JRS* 44 (1954), 65–75.

—— 'The Brutus Statue in Athens', in *Atti del terzo congresso internationale di epigrafia greca e latina* (Rome, 1959), 15–21.

RAUSA, F., 'Due donari agonistici dall' Acropoli', *AthMitt* 113 (1998), 191–234.

RAYMOND, A., 'Islamic City, Arab City: Orientalist Myths and Recent Views', *British Journal of Middle Eastern Studies*, 21 (1994), 3–18.

REGER, G., *Regionalism and Change in the Economy of Independent Delos, 314–167 BC* (Berkeley, Calif., 1994).

REINACH, A., *Recueil Milliet: Textes grecs et latins relatifs à l'histoire de la peinture ancienne* (Paris, 1921).

REINACH, S. H., *Traité d'Epigraphie grecque: Précédé d'un essai sur les inscriptions grecques* (Paris, 1885).

REINACH, T., 'Une Inscription grecque d'Eléonte', *CRAI* (1917), 29–30.

REUSSER, C., *Der Fidestempel auf dem Kapitol in Rom und seine Ausstattung: Ein Beitrag zu den Ausgrabungen an der Via del Mare und um das Kapitol 1926–1943* (Rome, 1993).

RHEIDT, K., 'Die Obere Agora: Zur Entwicklung des hellenistischen Stadtzentrums von Pergamon', *IstMitt* 42 (1992), 235–82.

RHODES, P. J. and OSBORNE, R., *Greek Historical Inscriptions, 404–323 BC* (Oxford, 2003).

RHOMAIOS, A. K., 'Anaskaphi en Thermo', *Praktika* (1931), 61–70.

RICE, E. E., *The Grand Procession of Ptolemy Philadelphus* (Oxford, 1983).

—— 'Prosopographica Rhodiaka', *ABSA* 81 (1986), 209–50.

RICHTER, G. M. A., 'New Signatures of Greek Sculptors', *AJA* 75 (1971), 434–5.

—— *The Portraits of the Greeks*, abriged and revised by R. R. R. Smith (Oxford, 1984).

RIDGWAY, B. S., Review of F. Eckstein, *ΑΝΑΘΗΜΑΤΑ* (Berlin, 1969), in *AJA* 75 (1971), 342–3.

—— 'The Setting of Greek Sculpture', *Hesperia*, 40 (1971), 336–56.

—— *Hellenistic Sculpture*, ii. *The Styles of ca.200–100 BC* (Madison, Wis., 2000).

—— *Hellenistic Sculpture*, iii. *The Styles of ca.100–31 BC* (Madison, Wis., 2002).

—— Review of C. H. Hallett, *The Roman Nude* (Oxford, 2000), in *BMCR* 2006.03.19.

RIGSBY, K., *Asylia: Territorial Inviolability in the Hellenistic World* (Berkeley, Calif., 1996).

ROBERT, F., *Épidaure* (Paris, 1935).

ROBERT, J. and ROBERTS, L., *Hellenica: Recueil d'épigraphie de numismatique et d'antiquités grecques*, 13 vols (Paris, 1940–65).

—— —— *La Carie: Histoire et géographie historique avec le recueil des inscriptions antiques*, ii. *Le Plateau de Tabai et ses environs* (Paris, 1954).

—— —— *Fouilles d'Amyzon en Carie* (Paris, 1983).

—— —— *Claros I: Décrets hellénistiques* (Paris, 1989).

ROBERT, L., *Collection Froehner* (Paris, 1936).

—— *Études Anatoliennes: Recherches sur les inscriptions grecques de l'Asie Mineure* (Paris, 1937).

—— *Études épigraphiques et philologiques* (Paris, 1938).

—— *Le Sanctuaire de Sinuri près de Mylasa*, i. *Les Inscriptions grecques* (Paris, 1945).

—— *Opera Minora Selecta: Épigraphie et antiquités grecques*, 7 vols (Amsterdam, 1969–90).

—— 'Sur des inscriptions de Délos', in A. Plassart (ed.), *Études déliennes: Publiées à l'occasion du centième anniversaire du début des fouilles de l'École française d'Athènes à Délos. BCH* suppl. 1 (Athens, 1973), 435–89.

—— *Nouvelles Inscriptions de Sardes: Ier fascicule* (Paris, 1964).

—— *Monnaies antiques en Troade* (Paris and Geneva, 1966).

—— *A travers l'Asie Mineure: Poètes et prosateurs, monnaies grecques, voyageurs et géographie* (Athens and Paris, 1980).

—— *Documents d'Asie Mineure* (Athens and Paris, 1987).

ROESCH, P., *Thespies et la confédération béotienne* (Paris, 1965).

ROSEN, K., 'Ehrendekrete, Biographie und Geschichtsschreibung: Zum Wandel der griechischen *Polis* im frühen Hellenismus', *Chiron*, 17 (1987), 277–92.

ROSS, L., *Archäologische Aufsätze*, ii (Leizpig, 1861).

ROSSO, E., 'Le Message religieux des statues impériales et divines dans les théâtres romains: Approche contextuelle et typologique', in J.-C. Moretti (ed.), *Fronts de scène et lieux de culte dans le théâtre antique* (Lyon, 2009), 89–126.

ROSTOVTZEFF, M. I., *The Social and Economic History of the Hellenistic World*, 3 vols (Oxford, 1941).

—— *La Peinture décorative antique en Russie méridionale: Saint-Petersbourg 1913–1914*, 2 vols (Paris, 2003–4).

ROUECHÉ, C. and REYNOLDS, J. M., *Aphrodisias in Late Antiquity: The Late Roman and Byzantine Inscriptions Including Texts from the Excavations at Aphrodisias Conducted by Kenan T. Erim* (London, 1989).

ROUSE, W. H. D., *Greek Votive Offerings: An Essay in the History of Greek Religion* (Cambridge, 1902).

ROUSSEL, P., *Cultes égyptiens à Délos du IIIe au Ier siècles av. J.-C.* (Nancy, 1915–16).

ROUX, G., 'Qu'est-ce qu'un κολοσσός?', *REA* 62 (1960), 5–40.

—— *L'Architecture de l'Argolide aux IVe et IIIe siècles avant J.-C.*, 2 vols (Paris, 1961).

—— 'Les Comptes du IVe siècle et la reconstruction du temple d'Apollon à Delphes', *RA* (1966), 245–96.

RUBENSOHN, O., 'Parische Künstler', *JDAI* 50 (1935), 49–69.

RUMSCHEID, F., *Priene: A Guide to the 'Pompeii of Asia Minor'* (Istanbul, 1998).

—— 'Maussollos and the "Uzun Kaya" in Mylasa', in R. van Bremen and J.-M. Carbon (eds), *Hellenistic Karia* (Bordeaux, 2010), 69–102.

RUSCU, L., 'Eine Episode der Beziehungen der westpontischen Griechenstädte zu Mithradates VI: Eupator, König von Pontos', *Tyche*, 15 (2000), 119–35.

SAATSOGLOU-PALIADELI, C., 'Aspects of Ancient Macedonian Costume', *JHS* 113 (1993), 122–47.

ŞAHIN, M. Ç., 'Recent Excavations at Stratonikeia and New Inscriptions from Stratonikeia and its Territory', *EA* 41 (2008), 53–81.

SANSONE, D., 'Cleobis and Biton at Delphi', *Nikephoros*, 4 (1991), 121–32.

SAVALLI-LESTRADE, I., *Les Philoi royaux dans l'Asie hellénistique* (Geneva, 1998).

SCHALLES, H.-J., *Untersuchungen zur Kulturpolitik der pergamenischen Herrscher im dritten Jahrhundert vor Christus* (Tübingen, 1985).

SCHAZMANN, P., *Das Gymnasion: Der Templebezirk der Hera Basileia*. Altertümer von Pergamon, 6 (Berlin, 1923).

SCHEDE, M., *Die Ruinen von Priene: Kurze Beschreibung* (2nd edn, Berlin, 1964).

SCHEHL, F. W., 'On an Inscription from Phistyon in Aetolia (*SB* Berlin 1936, 367ff)', *AJA* 56 (1952), 9–19.

SCHMIDT, I., *Hellenistische Statuenbasen* (Frankfurt am Main, 1995).

SCHOLZ, P., 'Elementarunterricht und intellektuelle Bildung im hellenistischen Gymnasion', in D. Kah and P. Scholz (eds), *Das hellenistische Gymnasion* (Berlin, 2004), 103–28.

SCHULLER, W. W., HOEPFNER, W. and SCHWANDER, E.-L. (eds), *Demokratie und Architektur: Der hippodamische Städtebau und die Entstehung der Demokratie* (Munich, 1989).

SCHULTZ, P., 'Divine Images and Royal Ideology in the Philippeion at Olympia', in J. T. Jensen, G. Hinge, P. Schultz, and B. Wickkiser (eds), *Aspects of Ancient Greek Cult: Context, Ritual and Iconography* (Aarhus, 2009), 125–94.

—— VON DEN HOFF, R. (eds) *Early Hellenistic Portraiture: Image, Style, Context* (Cambridge, 2007).

SCHWINGENSTEIN, C., *Die Figurenausstattung des griechischen Theatergebäudes* (Munich, 1977).

SCHWYZER, E., *Griechische Grammatik*, 4 vols (5th edn, Munich, 1980).

SCOTT, M., *Delphi and Olympia: The Spatial Politics of Panhellenism in the Archaic and Classical Periods* (Cambridge, 2010).

SÈVE, M., 'Le Dossier épigraphique du sculpteur Damophon de Messène', *Ktema*, 33 (2008), 117–28.

SHEAR, J. L., 'Reusing Statues, Rewriting Inscriptions, and Bestowing Honours in Roman Athens', in R. Leader-Newby and Z. Newby (eds), *Art and Inscriptions in the Ancient World* (Cambridge, 2007), 221–46.

—— 'Cultural Change, Space and the Politics of Commemoration in Athens', in R. Osborne (ed.), *Debating the Athenian Cultural Revolution: Art Literature, Philosophy and Politics 430–380 BC* (Cambridge, 2007), 91–115.

—— *Polis and Revolution: Responding to Oligarchy in Classical Athens* (Cambridge, 2011).

SHEAR, T. L., 'The Campaign of 1934', *Hesperia*, 4 (1935), 340–70.

—— 'The Campaign of 1935', *Hesperia*, 5 (1936), 1–42.

—— 'The Campaign of 1937', *Hesperia*, 7 (1938), 311–62.

SHEAR Jr., T. L., 'The Monument of the Eponymous Heroes in the Athenian Agora', *Hesperia*, 39 (1970), 145–222.

—— 'The Athenian Agora: Excavations of 1971', *Hesperia*, 42 (1973), 121–79.

—— *Kallias of Sphettos and the Revolt of Athens in 286 BC* (Princeton, 1978).

SHIPLEY, G., 'Little Boxes on the Hillside: Greek Town Planning, Hippodamos, and *Polis* Ideology', in M. H. Hansen (ed.), *The Imaginary Polis* (Copenhagen, 2005), 335–403.

SIEDENTOPF, H. B., *Das hellenistische Reiterdenkmal* (Waldsassen, 1968).

SIGALAS, C., 'Peri tou en Thira vathrou tis Chairopoleias', *ArchDelt* 26/1 (1971), 194–200.

SKALTSA, S., 'Hellenistic Gymnasia: The Built Space and Social Dynamics of a Polis Institution' (D.Phil. thesis, University of Oxford, 2008).

—— 'Sosilos' Statue Base and Nudity in Public Honorific Portrait Statues in the Hellenistic Period', in D. Kurtz with H.-C. Meyer, D. Saunders, A. Tsingarida, and N. Harris (eds), *Essays in Classical Archaeology for Eleni Hatzivassiliou 1977–2007* (Oxford, 2008), 239–47.

SMALL, D. B., 'Contexts, Agency and Social Change in Ancient Greece', in N. Terrenato and D. C. Haggis (eds), *State Formation in Italy and Greece: Questioning the Neo-Evolutionaist Paradigm* (Oxford and Oakville, Conn., 2011), 135–60.

SMITH, R. R. R., *Hellenistic Royal Portraits* (Oxford, 1988).

—— *Hellenistic Sculpture: A Handbook* (London, 1991).

—— 'Kings and Philosophers', in A. Bulloch, E. S. Gruen, A. A. Long, and A. Stewart (eds) *Images and Ideologies: Self-Definition in the Hellenistic World* (Berkeley, Calif., 1993), 202–12.

—— *The Monument of C. Julius Zoilos* (Mainz am Rhein, 1993).

—— Review of P. Zanker, *Die Maske des Sokrates: Das Bild des Intellektuellen in der antiken Kunst* (Munich, 1995), *Gnomon*, 71 (1999), 448–57.

—— 'Cultural Choice and Political Identity in Honorific Portrait Statues in the Greek East in the Second Century AD', *JRS* 88 (1998), 56–93.

—— 'Late Antique Portraits in a Public Context: Honorific Statuary at Aphrodisias in Caria, AD 300–600', *JRS* 89 (1999), 155–89.

—— 'The Use of Images: Visual History and Ancient History', in T. P. Wiseman (ed.), *Classics in Progress: Essays on Ancient Greece and Rome* (Oxford, 2002), 59–102.

—— with J. LENAGHAN, *Aphrodisias: City and Sculpture in Roman Asia* (Istanbul, 2008).

—— with S. DILLON, C. H. HALLETT, J. LENAGHAN, and J. VAN VOORHIS (eds), *Roman Portrait Statuary from Aphrodisias* (Mainz am Rhein, 2006).

SOSIN, J. D., 'Accounting and Endowments', *Tyche*, 16 (2001), 161–75.

—— 'Unwelcome Dedications: Public Law and Private Religion in Hellenistic Laodicea by the Sea', *CQ* 55 (2005), 130–9.

STANWICK, P. E., *Portraits of the Ptolemies: Greek Kings as Egyptian Pharaohs* (Austin, Tex., 2002).

STEMMER, K. (ed.), *Standorte: Kontext und Funktion antiker Skulptur* (Berlin, 1995).

STENERSEN, L. B., *De historia variisque generibus statuarum iconicarum apud Athenienses* (Christiania, 1877).

STEPHANIS, I. E., *Dionysiakoi technitai: Symvoles stin prosopographia tou theatrou kai tis mousikis ton archaion Hellinon* (Iraklio, 1988).

STEWART, A., *Attika: Studies in Athenian Sculpture of the Hellenistic Age* (London, 1979).

—— *Greek Sculpture: An Exploration* (New Haven, 1990).

—— *Faces of Power: Alexander's Image and Hellenistic Politics* (Berkeley, Calif., 1994).

—— *Attalos, Athens and the Akropolis: The Pergamene 'Little Barbarians' and their Roman and Renaissance Legacy* (Cambridge, 2004).

STEWART, P., *Statues in Roman Society: Representation and Response* (Oxford, 2003).

STILLWELL, R. (ed.), *Antioch on the Orontes*, iii. *The Excavations 1937–1939* (Princeton, 1941).

STRAUSS, B. S., *Fathers and Sons in Athens: Ideology and Society in the Era of the Peloponnesian War* (London, 1993).

STRUBBE, J., 'Epigrams and Consolation Decrees for Deceased Youths', *Antiquité Classique*, 67 (1998), 45–75.

—— 'Cultic Honours for Benefactors in the Cities of Asia Minor', in L. de Ligt, E. A. Hemelrijk, and H. W. Singor, *Roman Rule and Civic Life: Local and Regional Perspectives* (Amsterdam, 2004), 315–30.

SVENBRO, J., *Phrasikleia: Anthropologie de la lecture en Grèce ancienne* (Paris, 1988).

SWINNEN, W., 'Herakleitos of Halikarnassos, an Alexandrian Poet and Diplomat?', *AncSoc* 1 (1970), 39–52.

TANNER, J., *The Invention of Art History in Ancient Greece: Religion, Society and Artistic Rationalisation* (Cambridge, 2006).

—— 'Portraits and Agency: A Comparative View', in J. Tanner and R. Osborne (eds), *Art's Agency and Art History* (Malden, Mass., 2007), 70–94.

TARN, W. W., 'The Political Standing of Delos', *JHS* 44 (1924), 141–57.

THEMELIS, P. G., 'Die Statuenfunde aus dem Gymnasion von Messene', *Nürnberger Blätter zur Archäologie*, 15 (1998–9), 59–84.

—— *Heroes at Ancient Messene* (Athens, 2003).

—— 'Die Ägora von Messene', in H. Frielinghaus and J. Stroszeck (eds), *Neue Forschungen zu griechischen Städten und Heiligtümern* (Möhneberg, 2011), 105–25.

THOMAS, R., *Oral Tradition and Written Record in Classical Athens* (Cambridge, 1989).

THOMPSON, H. A., 'Buildings on the West Side of the Agora', *Hesperia*, 6 (1937), 1–226.

—— 'The Odeion in the Athenian Agora', *Hesperia*, 19 (1950), 31–141.

—— 'Excavations in the Athenian Agora: 1949', *Hesperia*, 19 (1950), 313–37.

—— 'Excavations in the Athenian Agora: 1951', *Hesperia*, 21 (1952), 83–113.

—— 'Excavations in the Athenian Agora: 1952', *Hesperia*, 22 (1953), 25–56.

—— 'Excavations in the Athenian Agora: 1956', *Hesperia*, 26 (1957), 99–107.

—— and WYCHERLEY, R. E., *The Agora of Athens: The History, Shape, and Uses of an Ancient City Center*. Athenian Agora, 14 (Princeton, 1972).

THONEMANN, P. J., 'The Date of Lucullus' Quaestorship', *ZPE* 149 (2004), 80–2.

—— 'The Tragic King: Demetrios Poliorketes and the City of Athens', in O. Hekster and R. Fowler (eds), *Imaginary Kings: Royal Images in the Ancient Near East, Greece and Rome* (Stuttgart, 2005), 63–86.

TODD, E., *L'Origine des systèmes familiaux*, i. *L'Eurasie* (Paris, 2011).

TOO, Y. L., 'Statues, Mirrors, Gods: Controlling Images in Apuleius', in J. Elsner (ed.), *Art and Text in Roman Culture* (Cambridge, 1996), 133–50.

TRACY, S. V., 'The Statue Bases of Praxiteles Found in Athens', *ZPE* 167 (2008), 27–32.

TRÜMPY, M., *Die 'Agora des Italiens' in Delos: Baugeschichte, Ausstattung und Funktion einer späthellenistischen Porticus-Anlage* (Rahden, 2008).

TSCHERIKOWER, V., *Die hellenistischen Stadtgründungen von Alexander dem Grossen bis auf die Römerzeit* (Leipzig, 1927).

TUCHELT, K., *Frühe Denkmäler Roms in Kleinasien: Beiträge zur archäologischen Überlieferung aus der Zeit der Republik und des Augustus* (Tübingen, 1979).

TUAN, Y.-F., 'Space and Place: Humanistic Perspective', *Progress in Geography*, 6 (1974), 211–52.

TZIAFALAS, A. and HELLY, B., 'Décrets inédits de Larissa (3)' *BCH* 131 (2007), 421–74.

VALAVANIS, P., 'Thoughts on the Public Archive in the Hellenistic Metroon of the Athenian Agora', *AthMitt* 117 (2002), 221–55.

VALLOIS, R., 'Les *Pinakes* déliens', in *Mélanges Holleaux: Recueil de mémoires concernant l'antiquité grecque offert à Maurice Holleaux en souvenir de ses années de direction à l'École française d'Athènes (1904–1912)* (Paris, 1913), 289–98.

—— *Le Portique de Philippe*. Exploration archéologique de Délos, 7/1 (Paris, 1923).

VAN BREMEN, R., *The Limits of Participation: Women and Civic Life in the Greek East in the Hellenistic and Roman Periods* (Amsterdam, 1996).

—— 'Family Structures', in A. Erskine (ed.), *A Companion to the Hellenistic World* (Oxford, 2003), 313–30.

—— 'The Date and Context of the Kymaian Decrees for Archippe (*SEG* 33, 1035–1041)', *REA* 110 (2008), 357–82.

—— CARBON, J.-M. (eds), *Hellenistic Karia*. Ausonius Études, 28 (Talence, 2010).

VAN EFFENTERRE, H. and TIRÉ, C., *Guide des Fouilles françaises en Crète* (2nd edn, Paris, 1978).

VAN GELDER, H., *Geschichte der alten Rhodier* (The Hague, 1900).

VAN NIJF, O., 'Public Space and Political Culture in Roman Termessos', in O. van Nijf and R. Alston (eds), *Political Culture in the Greek City after the Classical Age* (Leuven, 2010), 215–42.

VAN OOTEGHEM, J., *Les Caecilii Metelli de la République* (Namur, 1967).

VON PROTT, H. and Kolbe, W., 'Die 1900–1901 in Pergamon gefundenen Inschriften', *AthMitt* 27 (1902), 44–151.

VATIN, C., 'La Base des Héros éponymes à Athènes au temps de Pausanias', *Ostraka*, 4 (1995), 33–41.

VERNANT, J.-P., *Mythe et pensée chez les Grecs: Études de psychologie historique* (rev. edn, Paris, 1985).

VERNIER, B., *La Génèse sociale des sentiments: Aînés et cadets dans l'île grecque de Karpathos* (Paris, 1991).

—— *Le Visage et le nom: Contribution à l'étude des systèmes de parenté* (Paris, 1999).

—— 'Quelques remarques méthodologiques sur l'étude comparative des systèmes de parenté', in A. Bresson, with M.-P. Masson, S. Perentidis, and J. Wilgaux (eds), *Parenté et société dans le monde grec de l'Antiquité à l'âge moderne*. Ausonius Études, 12 (Bordeaux, 2006), 12–27.

VEYNE, P., 'Les Honneurs posthumes de Flavia Domitilla et les dedicaces grecques et latines', *Latomus*, 21 (1962), 49–98.

—— *Le Pain et le cirque: Sociologie historique d'un pluralisme politique* (Paris, 1976).

—— 'Le Folklore à Rome et les droits de la conscience publique sur la conduite individuelle', *Latomus*, 42 (1983), 3–30.

—— *Les Grecs ont-ils cru à leurs mythes? Essai sur l'imagination constituante* (Paris, 1983).

—— 'Propagande expression roi, image idole oracle', *L'Homme*, 114 (1990), 7–26.

—— *La Société romaine* (Paris, 1991).

VIAL, C., *Délos indépendante (314–167 avant J.-C.): Étude d'une communauté civique et de ses institutions* (Athens, 1984).

VIDAL-NAQUET, P., and LÉVÊQUE, P., *Clisthène l'Athénien: Essai sur la représentation de l'espace et du temps dans la pensée grecque de la fin du VIe siècle à la mort de Platon* (Paris, 1964).

VIVIERS, D., 'Signer une œuvre en Grèce ancienne: Pourquoi? Pour qui?', in J. de la Genière (ed.), *Les Clients de la céramique grecque*. Cahiers du Corpus Vasorum Antiquorum France, 1 (Paris, 2006), 241–53.

VLASSOPOULOS, K., 'Free Spaces: Identity, Experience and Democracy in Classical Athens', *CQ* 57 (2007), 33–52.

VÖLCKER-JANSSEN, W., *Kunst und Gesellschaft an den Höfen Alexanders d. Gr. und seiner Nachfolger* (Munich, 1995).

VON DEN HOFF, R., 'Tradition and Innovation: Portraits and Dedications on the Early Hellenistic Akropolis', in O. Palagia and S. V. Tracy (eds), *The Macedonians in Athens* (Oxford, 2003), 173–85.

—— 'Ornamenta γυμνασιώδη? Delos und Pergamon als Beispielfälle der Skulpturenausstattung hellenistischer Gymnasien', in D. Kah and P. Scholz (eds), *Das hellenistische Gymnasion* (Berlin, 2004), 373–405.

—— 'Naturalism and Classicism: Style and Perception of Early Hellenistic Portraits', in P. Schultz and R. von den Hoff (eds), *Early Hellenistic Portraiture: Image, Style, Context* (Cambridge, 2007), 49–62.

—— 'Images and Prestige of Cult Personnel in Athens between the Sixth and First Century BCE', in B. Dignas and K. Trampedach (eds), *Practitioners of the Divine: Greek Priests and Religious Officials from Homer to Heliodorus* (Washington, DC, 2008), 107–41.

—— 'Hellenistische Gymnasia: Raumgestaltung und Raumfunktionen', in A. Matthaei and M. Zimmermann (eds), *Stadtbilder im Hellenismus* (Berlin, 2009), 245–75.

—— 'Die Bildnisstatue des Demosthenes als öffentliche Ehrung eines Bürgers in Athen', in M. Haake, C. Mann, and R. von den Hoff (eds), *Rollenbilder in der Athenischen Demokratie: Medien, Gruppen, Räume im politischen und sozialen System* (Wiesbaden, 2009), 193–220.

VON GERKAN, A., *Das Theater von Priene, als Einzelanlage und in seiner Bedeutung für das hellenistische Bühnenwesen* (Munich, 1921).

—— MÜLLER-WIENER, W., *Das Theater von Epidauros* (Stuttgart, 1961).

VON HESBERG, H., 'Das griechische Gymnasion im 2 Jh. v. Chr.', in M. Wörrle and P. Zanker (eds), *Stadtbild und Bürgerbild im Hellenismus* (Munich, 1995), 13–27.

—— 'Hellenistische Theater: Zur Funktionalität der Räume und ihrer Bedeutung für die *Polis*', in A. Matthaei and M. Zimmermann (eds), *Polisbilder im Hellenismus* (Berlin, 2009), 277–303.

VON KIENLIN, A., *Die Agora von Priene* (Ph.D. thesis, Universität München, 2004).

—— 'Das Stadtzentrum von Priene als Monument bürgerlicher Selbstdarstellung', in E.-L. Schwadner and K. Rheidt (eds), *Macht der Architektur: Architektur der Macht* (Mainz am Rhein, 2004), 114–20.

VON REDEN, S., 'The Well-Ordered *Polis*: Topographies of Civic Space', in P. Cartledge, P. Millett, and S. von Reden (eds), *Kosmos: Essays in Order, Conflict and Community in Classical Athens* (Cambridge, 1998), 170–90.

VON THÜNGEN, S., *Die freistehende griechische Exedra* (Mainz, 1994).

WACKER, C., *Das Gymnasion in Olympia: Geschichte und Funktion* (Würzburg, 1996).

WALBANK, F. W., *A Historical Commentary on Polybius*, 3 vols (Oxford, 1957–79).

—— *Polybius* (Berkeley, Calif., 1972).

WALLENSTEN, J. and PAKKANEN, J., 'A New Inscribed Statue Base from the Sanctuary of Poseidon at Kalaureia', *OpAth* 35 (2010), 156–65.

WEIDEMANN, U., 'Drei Inschriften aus Kyme', *ArchAnz* (1965), 446–66.

WELSH, M. K., 'Honorary Statues in Ancient Greece', *ABSA* 11 (1904–5), 32–49.

WIEGAND, T. and SCHRADER, H. (eds), *Priene: Ergebnisse der Ausgrabungen und Untersuchungen in den Jahren 1895–1898* (Berlin, 1904).

WILHELM, A., *Urkunden dramatischer Aufführungen in Athen* (Vienna, 1906).

—— *Beiträge zur griechischen Inschriftenkunde mit einem Anhange über die öffentliche Aufzeichung von Urkunden* (Vienna, 1909).

—— *Neue Beiträge zur griechischen Inschriftenkunde*, 6 vols (Vienna, 1911–32).

—— 'Die Beschlüsse der Chier zu Ehren des Leukios Nassios', *Wiener Studien*, 59 (1941), 89–109.

—— *Griechische Inschriften rechtlichen Inhalts* (Athens, 1951).

—— *Akademieschriften zur griechischen Inschriftenkunde*, 3 vols (Leipzig, 1974).

—— *Abhandlungen und Beiträge zur griechischen Inschriftenkunde*, 4 vols (Leipzig and Vienna, 1984–2002).

WILLER, F., 'Beobachtungen zur Sockelung von bronzenen Statuen und Statuetten', *BJb* 196 (1996), 337–70.

WILSON, J., 'Elite Commemoration in Early Modern England: Reading Funerary Monuments', *Antiquity*, 74 (2000), 413–23.

WITTENBURG, A., *Il testamento di Epikteta* (Trieste, 1990).

—— 'Grandes Familles et associations cultuelles à l'époque hellénistique', *Ktema*, 23 (1998), 451–6.

WÖRRLE, M., 'Vom tugendsamen Jüngling zum "gestreßten" Euergeten: Überlegungen zum Bürgerbild hellenistischer Ehrendekrete', in M. Wörrle and P. Zanker, *Stadtbild und Bürgerbild im Hellenismus* (Munich, 1995), 241–50.

—— 'Pergamon um 133 v. Chr.', *Chiron*, 30 (2000), 543–57.

WORTHINGTON, I., 'The Siting of Demosthenes' Statue', *ABSA* 81 (1986), 389.

WÜST, F. R., *Philipp II. von Makedonien und Griechenland in den Jahren von 346 bis 338* (Munich, 1938).

WYCHERLEY, R. E., *Literary and Epigraphical Testimonia*. Athenian Agora, 3 (Princeton, 1957).

—— *The Agora of Pericles* (Princeton, 1968).

ZANKER, P., 'The Hellenistic Grave *Stelai* from Smyrna: Identity and Self-Image in the *Polis*', in A. Bulloch, E. S. Gruen, A. A. Long, and A. Stewart (eds), *Images and Ideologies: Self-Definition in the Hellenistic World* (Berkeley, Calif., 1993), 212–30.

—— 'Brüche im Bürgerbild? Zur bürgerlichen Selbstdarstellung in den hellenistischen Städten', in P. Zanker and M. Wörrle (eds), *Stadtbild und Bürgerbild im Hellenismus* (Munich, 1995), 251–73.

—— *The Mask of Socrates: The Image of the Intellectual in Antiquity*, English tr. by A. Shapiro (Berkeley, Calif., 1995).

ZIMMER, G., *Griechische Bronzegusswerkstätten: Zur Technologieentwicklung eines antiken Kunsthandwerks* (Mainz, 1990).

—— *Locus Datus Decreto Decurionum: Zur Statuenaufstellung zweier Forumsanlagen im römischen Afrika* (Munich, 1989).

—— BAIRAMI, K., *Rhodiaka ergasteria chalkoplastikis*. Rhodos, 2 (Athens, 2008).

—— HACKLÄNDER, N. (eds), *Der Betende Knabe: Original und Experiment* (Frankfurt am Main, 1997).

ZIMMERMANN, M., 'Eine Stadt und ihr kulturelles Erbe: Vorbericht über Feldforschungen im zentrally-kischen Phellos 2002–2004', *IstMitt* 55 (2005), 265–312.

ZONABEND, F., 'De la famille: Regard ethnologique sur la parenté et la famille', in A. Burguière and P. Beillevaire (eds), *Histoire de la famille* (Paris, 1986), i. 15–75.

ZOUMBAKI, S., *Prosopographie der Eleer bis zum 1. Jh. v. Chr.* (Athens, 2005).

ZUIDERHOEK, A., 'On the Political Sociology of the Imperial Greek City', *GRBS* 48 (2008), 417–45.

—— *The Politics of Munificence in the Roman Empire: Citizens, Elites and Benefactors in Asia Minor* (Cambridge, 2009).

INDEX LOCORUM

Coins
RPC
 i.2364: 47
Papyri
PHerc 1021 col. 2 11–16 (*History of the Academy*)
 98
PSI
 4.407: 263
Inscriptions
Agora 16
 31: 264
Amandry 'Fouilles et découvertes archéologiques
 en Grèce', *BCH* 71–2 (1947–8), 423–71
438, no. 4
 16
Amyzon
 15B: 238
 24: 31
 32: 156
 34: 202, 230
 70: 26
Arvanitipoulos, *Polemon*, 1 (1929), 201–6, 424
 53
Baker and Thériault 'Les Lyciens, Xanthos et Rome'
 REG 118 (2005) 352
 161
Baker and Thériault 'Notes sur quelques
 inscriptions de Lycie' *REG* 122 (2009) 72-3
 178
Bernand *Prose sur pierre dans l'Egypte* (1992)
 15: 87
 27: 87, 245
 40: 87
Bielman *Retour à la liberté* (1994)
 31: 56–7, 248
 48: 264
 56: 105
Bohn *Altertümer von Aegae* (1889)
 52–3 no. 3: 177
Bousquet, 'Inscriptions de Delphes', *BCH* 83
 (1959), 174–5
 6
Bousquet, 'Inscriptions de Delphes' *BCH* 87 (1963),
 206–8
 5, 27, 259

Brélaz and Schmid, S., 'Une nouvelle dédicace à la
 triade artémisiaque', *RA* (2004), 227–58
 80
CEG
 344: 46
 335: 283
 365: 196
Chankowski 'Diodoros Pasparos' *BCH* 122 (1998),
 159–99
 7, 17, 87
Charitonidis *Ai epigraphai tis Lesvou* (1968)
 6: 81
Chaviaras 'Nisirou epigraphai', *ArchEph* (1913)
 6–16, no.
 1: 79
Choix
 13: 48
 17: 56
 18: 56
Choix Délos
 16: 19
 36: 226
 37: 184
 49: 72, 73
 53: 184
 59: 184
 71: 184–5
 109: 184, 185
 120: 184
 121: 184
 123: 97
 126: 184
 127: 185
 128: 185
CID 4
 85: 71
 86: 17, 95, 262
 87: 95
 88: 17, 95
 89: 95
 136: 26
CIG
 2657: 20
 3065: 7
 3068: 250
 3085: 250

CIRB
 6: 173
 113: 180
 432: 283

Clairmont *Gravestone and Epigram* (1970)
 1: 196
 2: 197
 4: 196

Cousin and Diehl 'Inscriptions d'Alabanda en
 Carie' *BCH* 10 (1886) 308-10, 311–14
 33

DAA
 6: 196
 53: 197
 79: 196

De la Coste-Messelière 'Inscriptions de Delphes'
 BCH 49 (1925), 61–103:
 no. 6: 175
 no. 7: 183

Despinis 'Timitikon psephisma ek Parou', *ArchDelt*
 20/1 (1965), 119–32
 80

Diamandaras, 'Epigraphai ek Lykias', *BCH* 18
 (1894), 323, no. 1
 155

Downey, in Stillwell *Antioch on the Orontes* (1941)
 98, no. 179
 62

Ducrey and Calame, 'Signature de Lysippe', *BCH*
 120 (2006), 63–91
 5

Dunant and Pouilloux, *Recherches sur l'histoire et les
 cultes de Thasos*, ii (1958), no. 405
 20

Ebert, *Griechische Epigramme auf Sieger* (1972)
 40: 23
 64: 39

Erturul and Malay, 'An Honorary Decree from
 Nysa', *EA* 43 (2010), 31–42
 72

DGE
 316: 46

FD
 3.1.154: 200
 3.1.273: 289
 3.2.135: 6
 3.3.128: 23
 3.3.240: 236
 3.4.63: 80
 3.4.129: 224
 3.4.130: 224
 3.4.131: 200, 224
 3.4.165: 200

 3.4.176: 5, 22, 27
 3.4.218-22: 6
 3.4.239: 3
 3.4.242: 229
 3.6.7: 91
 3.6.47: 91
 3.6.56: 91

Feyel 'Inscriptions inédites d'Akraiphia', *BCH* 79
 (1955), 422 no. 2
 187, 191

French, 'A Sinopean Sculpture at Halicarnassus',
 EA 4 (1984), 82, no. 4
 214

Gauthier, 'Un gymnasiarque honoré à Colophon',
 Chiron 35 (2005), 101–12
 35

Gauthier and Hatzopoulos, *Loi gymnasiarchique*
 (1993)
 B 1-10: 289
 B 48–72: 85

GIBM
 546ff: 157
 893: 82
 899: 19
 900: 164
 903: 166, 218

Habicht, *Asklepieion* (1969)
 54: 37

Habicht, 'Neue Inschriften aus Thessalien',
 Demetrias 5 (1987), 311–12
 95

Habicht, 'Samos weiht eine Statue des populus
 Romanus', *AthMitt* 105 (1990), 259–68
 47

Halasarna
 4: 35, 59

Hatzopoulos and Loukopoulou *Recherches sur les
 marches orientales* (1992)
 K2: 236
 K18: 239, 271

Haussoullier 'Inscriptions d'Halicarnasse', *BCH* 4
 (1880), 395–408
 no. 8: 191
 no. 13: 191

Haussoullier, 'Inscriptions d'Héraclée du Latmos',
 RevPhil 23 (1899), 283–4
 24

Helly, 'Décrets de Démétrias pour les juges
 étrangers', BCH 95 (1971), 543–59
 80

Hepding 'Pergamon 1904–1905' *Ath Mitt* 32 (1907),
 241–377

no. 10: 88
no. 69: 191

Hepding 'Pergamon 1908–1909' *Ath Mitt* 35 (1910),
401-93
no. 47: 85
no. 45: 175
no. 54: 85

Hereward, 'Inscriptions from Pamphylia and
Isauria', *JHS* 78 (1958), 57–9, no. 1
21

HGE
114: 20

HTC
56: 182

I. Adramytteion
17: 78

IAG
3: 23
20: 23
21: 23
22: 23
34: 23
35: 23
40: 23
41: 6, 39
44: 23
46: 6
47: 23
49: 23

I. Alexandreia Troas
5: 6
613: 33

IAph
12.206: 79

I. Arai Epitymbioi
155: 180

I. Assos
9: 33
18: 7, 306

I. Central Pisidia
57: 177

ID
290: 20, 245, 251
399: 264
442A: 245
1085: 164
1086: 164-5
1168: 201
1170: 164
1173: 164-5
1174: 164-5
1175: 201
1176: 201

1184: 201
1412: 26
1417A: 272
1517: 3, 72
1518: 250
1532: 116
1533: 185
1534: 185, 192
1547: 185
1548: 185
1550: 187
1552: 184
1563: 184
1569: 184
1570: 184
1572: 184
1573: 184
1576: 184
1582: 184
1613: 236
1622: 236, 237
1645: 115
1656: 170
1723: 190
1842: 187
1845: 187, 192, 230
1854: 287
1864: 170
1867: 170
1869: 192
1871: 171, 192
1872: 192
1891: 171
1892: 190
1907: 190
1929: 87
1930: 87
1957: 192
1962: 163
1963: 164
1965: 164
1968: 164
1969: 164, 192, 230
1978: 192, 214
1981: 190
1987: 48, 172, 204
1989: 192
1998: 183
1999-2004: 183
1999-2016: 204
2058: 170
2061: 170
2067: 170
2070: 170, 171, 174
2075: 84
2076: 84
2077: 84

ID (*cont.*)
2078: 84
2081: 84
2082: 84
2089: 163
2095-6: 203, 287

IDélos
1957: 231
1962: 164–5
1967: 165

I. Ephesos
6: 86, 87–8
2058: 91
2113: 134
3407: 20
3408: 20
3431: 236

I. Erythrai
6: 5
8: 5, 76, 85, 111
25: 45, 53
26: 45, 53
28: 6, 58, 77
43: 237
52: 244
87: 6
89a: 6
106: 73
341: 206
503: 60, 76, 134

I. Estremo Oriente
102: 24
140: 20
183: 24, 185
184: 185
185: 185
204: 185, 216
208: 24
219: 185
279: 216

IG
I³ 745: 196
I³ 1241: 196
I³ 1251: 196
I³ 1257: 196
II² 212: 35, 106
II² 380: 70
II² 405: 129
II² 450: 247
II² 555: 264
II² 646: 20, 245, 277, 278
II² 648: 94, 105, 245, 274, 278
II² 649: 120
II² 654: 243
II² 657: 94, 105, 243, 274
II² 668: 206

II² 672: 244
II² 682: 244
II² 793: 255
II² 844: 56–7, 248
II² 966: 72
II² 983: 243
II² 995: 199
II² 1006: 72
II² 1008: 72
II² 1009: 72
II² 1011: 72
II² 1012: 106
II² 1039: 72, 105
II² 1048: 256
II² 1214: 35
II² 1223: 243
II² 1236: 104–5
II² 1271: 84
II² 1299: 84
II² 1304: 244
II² 1327: 81, 84
II² 1330: 244
II² 1334: 81
II² 1955: 19
II² 2752: 106
II² 3109: 19
II² 3125: 23
II² 3206: 34
II² 3425: 22
II² 3427: 93
II² 3453: 170
II² 3455: 170
II² 3458: 169
II² 3462: 166, 170, 219
II² 3470–3: 170
II² 3474: 170, 174
II² 3479: 169, 206
II² 3483: 170
II² 3484: 170
II² 3494: 165
II² 3564: 170
II² 3601: 20
II² 3754: 299
II² 3775: 22, 106
II² 3776: 22
II² 3777: 22
II² 3778: 22
II² 3780: 168, 191
II² 3781: 192
II² 3782: 168
II² 3783: 168
II² 3800: 105
II² 3828: 198
II² 3829: 167, 198
II² 3830: 167, 182, 198, 225
II² 3838: 37, 167, 180, 198, 299
II² 3839: 219

II² 3841: 198, 206
II² 3843: 198
II² 3845: 22, 106
II² 3850: 175
II² 3854: 191, 206
II² 3860: 192, 205–6, 223
II² 3863: 169
II² 3864: 151, 163
II² 3868: 175
II² 3871: 191
II² 3872: 191
II² 3873: 191
II² 3876: 166
II² 3894: 163
II² 3901: 191
II² 3908: 175, 191
II² 3912: 198
II² 3965: 168
II² 4024: 198
II² 4025: 198
II² 4031: 203, 208
II² 4048: 168
II² 4076: 201
II² 4161: 41
II² 4256: 21
II² 4257: 21, 22
II² 4259: 21
II² 4260: 21
II² 4263: 21
II² 4264: 21
II² 4265: 21
II² 4266: 21, 22
II² 4267: 21, 22
II² 4268: 21, 22
II² 4364: 167
II² 4368: 167, 198
II² 4553: 27
II² 4669: 168
II² 4797: 21
II² 4881: 198
II² 4914: 198
4.428: 93
4.558B: 250
4.585: 31
4.588: 244
4.592: 31
4.656: 21
4.672: 73
4.682: 200
4.840: 178
4.846: 41–2
4² 1: 68, 142
4² 1.28: 175
4² 1.65: 129–30
4² 1.110A: 258
4² 1.144: 25
4² 1.208: 168

4² 1.210: 206, 222
4² 1.232: 160, 222
4² 1.234: 175, 224
4² 1.237: 198
4² 1.241: 167
4² 1.247: 222
4² 1.336: 222
4² 1.589: 80, 109
4² 1.590: 80
4² 1.615: 6, 31, 37, 80
4² 1.616: 80
4² 1.619: 38, 302
4² 1.620: 96
4² 1.621: 96
4² 1.623–4: 280
4² 1.624–5: 96
4² 1.630: 129, 312
4² 1.635: 222
4² 1.644: 96
4² 1.647–9: 68, 312
4² 1.654–5: 68
4² 1.656: 96
5.1.931: 245
5.1.1122: 20
5.1.1165: 6
5.1.1189: 157
5.1.1432: 128, 283
5.1.1455A: 94
5.2.269: 256
5.2.297: 225
5.2.304: 20, 280
5.2.312: 73
5.2.370: 20, 280
5.2.437: 249, 255
5.2.516: 84
5.2.537: 20, 279
5.2.538: 168
7.18: 35
7.54: 167, 199, 203
7.55: 167, 199, 203
7.60: 199, 203
7.61: 199, 203
7.190: 246
7.193: 24, 77, 129
7.528: 206
7.556: 25
7.564: 160
7.571: 160
7.579: 196
7.1831: 199, 259
7.1832: 190, 192
7.1834: 172
7.1872: 168
7.2471: 192
7.2472: 199
7.2473: 159
7.2489: 192

IG (*cont.*)

7.2520: 73
7.2553: 259
7.2711: 95
7.2795: 166, 192, 204
7.2835: 191
7.2837: 160
7.3380: 182
7.3422–7: 201
7.3490: 187
7.4160: 199
7.4177: 192
7.4247: 178
9.1.91: 95
9.1.101: 95
9.1.139: 172
9.1.287: 172
9.1² 1.75: 190
9.1² 2.238: 203
9.1² 4.786: 50
9.1² 4.789: 50
9.1² 4.791: 50
9.1² 4.792: 50
9.1² 4.1233: 35, 54–5
9.1² 4.1475: 244
9.2.32: 74
9.2.38: 61
9.2.59: 304
9.2.66A: 244, 247, 264
9.2.249: 259
9.2.489: 245
9.2.1103: 295
9.2.1107B: 84
9.2.1122: 172
10.1.1031: 186
10.2.1.1: 88
10.2.1.4: 61
10.2.1.5: 77
10.2.1.179: 73
10.2.1.134: 187
10.2.1.608: 180
11.2.287A: 258
11.3.665: 72
11.3.1053: 72
11.4.514: 19, 244
11.4.566: 250
11.4.1057: 120
11.4.1078: 265
11.4.1079: 91, 93
11.4.1080: 115
11.4.1081: 115
11.4.1082: 115
11.4.1083: 115
11.4.1086: 194
11.4.1087: 26, 87, 272
11.4.1106: 91, 191, 272
11.4.1107: 21, 226

11.4.1108: 21, 226
11.4.1109: 184
11.4.1137: 169
11.4.1166–7: 199, 229
11.4.1170: 192
11.4.1171: 192
11.4.1173: 194
11.4.1174: 194
11.4.1179: 192
11.4.1180: 192
11.4.1186: 192
11.4.1193–9: 227
11.4.1197–8: 163
11.4.1206–8: 21, 226
11.4.1299: 170
12.1.6: 244, 245
12.1.39: 26
12.1.72: 181
12.1.85: 260
12.1.104: 167
12.1.155: 36
12.1.680: 37
12.1.694: 223
12.1.847: 37
12.1.853: 37
12.1.857: 37
12.1.1032: 32, 36
12.2.497: 259
12.2.527: 78, 245
12.2.639: 184
12.3.211: 225
12.3.212: 6
12.3.237: 81
12.3.247: 32, 37, 59
12.3.249: 79, 301
12.3.258: 166, 199, 201
12.3.260: 166
12.3.268: 166, 201
12.3.269: 166
12.3.271: 166, 201
12.3.290: 201
12.3.327: 220
12.3.330: 178, 220, 221
12.3.444: 220
12.3.464: 220
12.3.485: 220
12.3.486: 220
12.3.487: 220
12.3.491–2: 204
12.3.494–9: 32
12.3.501–2: 32
12.3.514: 220
12.3.522: 116, 237
12.3.1097: 31
12.3.1116: 32
12.3.1407: 220
12.3, suppl. 215: 37

12.3, suppl. 1343: 221
12.3, suppl. 1344: 221
12.3, suppl. 1388: 220
12.4.1.34: 31
12.4.1.65: 250, 261, 264, 277
12.4.1.129: 34, 244
12.4.1.130: 34
12.5.129: 75, 116, 237
12.5.215: 197
12.5.273–7: 32
12.5.279–81: 32
12.5.294: 166
12.5.485–8: 229
12.5.514: 229
12.5.879: 181
12.5.916: 181
12.5.917: 18
12.5.918: 169, 181, 202
12.5.919: 164, 181, 202
12.5.920: 164, 181, 202
12.5.921: 164, 181, 202
12.5.922: 181
12.5.925: 181
12.5.1408: 229
12.6.1: 80
12.6.1.42: 6, 58
12.6.1.120: 184
12.6.1.293: 1
12.6.1.281: 22
12.6.1.284: 31, 38
12.6.1.285: 38–9, 41
12.6.1.286: 31, 38
12.6.1.327–8: 38
12.6.1.336: 24
12.6.1.338: 24
12.6.1.347: 26
12.6.1.350: 25
12.6.1.448: 173
12.6.1.452: 173
12.6.1.455: 164
12.6.1.464: 32
12.6.1.469: 184
12.6.2.1217: 31
12.7.22: 35
12.7.82: 168, 230
12.7.83: 168, 230
12.7.84: 168
12.7.231: 128
12.7.233: 85
12.7.234: 85
12.7.235: 88
12.7.269: 31
12.7.515: 88
12.8.441: 179
12.9.99: 80
12.9.140: 166
12.9.141: 166

12.9.196: 6, 58, 244, 245
12.9.198: 244
12.9.234: 89, 289
12.9.236: 58, 86, 88, 89, 108, 236, 244
12.9.237: 86, 88, 89
12.9.239: 89
12.9.276: 80
12.9.277: 80
12.9.278: 80, 108
12.9.280: 93
12.9.281: 183, 288
12.9.283: 175
12.9.899: 244
12.9.1189: 229
12.9.1233: 192, 229
12.9.1234C: 245
12.9.1235A: 245
12, suppl. 29B: 157, 175
12, suppl. 122: 86
12, suppl. 250: 88
12, suppl. 276: 177
12, suppl. 321: 181, 182
12, suppl. 331: 87
12, suppl. 383: 173
12, suppl. 382: 287
12, suppl. 384: 173
12, suppl. 553: 58, 86, 88
14.2: 20
14.287: 24
14.288: 24
14.353-5: 24
14.359: 24
14.366: 24
14.368-9: 24
14.448: 24

IGBulg
I² 13: 34, 74, 112
I² 307: 120
I² 315: 250
I² 320: 47
I² 388bis: 250, 255
I² 391: 72

IGLS
1261: 72

IGR
4.292: 251
4.1682: 90
4.1683: 81
4.1703: 74, 87, 88, 129
4.1793: 236

IGUR
6: 25
1491–1552: 21
1571–2: 49

IGUR (*cont.*)
 1580: 49

I. Iasos
 23: 31
 24: 88
 47: 129
 85: 7, 31, 33, 262, 306
 98: 256
 99: 23, 79
 119: 31
 120: 23
 153: 35
 248: 7

I. Ilion
 2: 73, 94
 12: 37, 94
 14: 94
 31: 20
 41: 182
 83: 187

I. Keramos
 5: 181
 5B: 156
 29: 169, 181
 30: 156

IKibyra
 67–74: 201

I. Kios
 2: 5 21
 5: 33
 6: 88
 22: 250

I. Knidos
 51: 236
 52: 38, 236
 53: 32, 38, 236
 54: 32, 236
 55: 32, 236
 59: 82, 88
 74: 244, 264
 89: 38
 101: 190
 102: 179
 103: 25
 111: 190, 200
 112: 190, 200
 113: 200
 114: 200
 115: 191, 200, 206, 214
 116: 160
 120: 159, 191, 200
 121: 191
 164: 194, 200
 165: 200, 204, 210, 259
 168: 259

 171: 181
 172: 190
 179: 166

I. Kyme
 13: 246
 19: 20, 32, 88
 25: 251
 31: 177

I. Perge
 2: 156, 177
 14: 7, 32
 23: 177

I. Metropolis
 1: 48-9, 77, 182

I. Miletupolis
 23: 126

I. Mylasa
 2: 5
 110: 31, 108
 119: 31
 121: 23, 45
 401: 33
 402: 117
 404: 45
 405: 45, 182
 406: 182, 183
 407: 182
 412: 45
 414: 45
 869: 84

Inschr. Bubon
 14: 37

Inschr. Didyma
 86: 173
 87: 173
 91: 173
 107: 80
 113: 80
 114: 80
 115: 80
 131: 250
 140: 80
 141: 31, 42, 80
 143: 80
 144: 80
 147: 80
 148: 80
 141: 42
 261: 250
 479: 73
 561: 21

Inschr. Dor. Inseln
 63: 79

Inschr. Kaunos:
46: 5, 27
47: 5, 27, 80
48: 80
49–53: 166, 181, 200, 212, 232
51: 299
53: 214
58: 259
81: 5
82: 22, 200
90: 33
92–6: 191, 217
92–3: 262, 306
98: 33
99: 33
102: 33, 80
103: 33, 236, 255
104-13: 33
104: 236, 255
106: 116
107–8: 80, 236
109–11: 80
112: 80
113: 80
114: 80
115: 33
119–22: 33

Inschr. Magnesia
92: 91, 93, 133, 137, 295
94: 107, 129, 243
101: 36, 250
102: 73, 88
126: 177
128: 177
129: 93, 137
131: 237
132A: 93
132B: 91
153: 237
160: 237
161: 237
162: 237
163: 237
166: 237
179: 246
188: 237
193: 246
312: 177
393: 177

Inschr. Olympia
148–238: 22
168: 22
177: 23
179: 22
186: 24
293: 198, 199

294: 97
297: 97
300: 97, 119
301: 97
302: 279
306: 184
307: 184
316: 97
318: 97
325: 69, 186
328: 97, 280
330: 178
396: 97
398: 97
402: 97
449–50: 280
614–8: 228

Inschr. Pergamon
29: 101, 184
45: 20
59: 184
61: 101
64: 3, 26, 101
123: 168
129: 101, 102
130: 101
164: 20
165: 184
167: 101, 174
170: 182, 226
180: 173
181: 101
198: 21
199: 21
200: 21
201: 21
202: 21
219: 182, 226
226: 101, 102
246: 45–6
252: 32, 73, 88
383: 26, 114
404: 102
408: 102
410: 32
411: 102
412: 102
413: 101
416: 102
417: 102
426: 102
453-5: 101
455: 32
459: 32
482: 237
489: 101
490: 101

Inschr. Pergamon (cont.)

491: 101
492: 101, 102, 237
494: 101
501: 237
516: 237

Inschr. Priene

3: 22, 35, 82, 99, 115, 250
13: 33
18: 35, 85, 98, 115, 119, 248
21: 35
37: 142
57: 128
65: 30, 33
81: 35
99: 99, 147, 191
100: 147, 164, 191
101: 147, 177, 191
102: 147, 191
103: 33, 147, 164, 191
104: 147, 191
108: 7, 33, 93, 246, 250
109: 7, 100, 246, 262, 306
112: 246
113: 99, 246
114: 99
117: 7, 36, 262, 306
132: 250
160: 173
162: 146, 164, 173, 191
172: 100
173: 100
180: 173
186: 142, 262, 271, 306
231: 22, 99
234: 99
236: 142, 262, 271, 306
237: 30, 42, 100, 143, 262, 306
240: 99
241: 100
244: 99
246: 100, 295
248: 146
251: 100
252: 99, 133
253: 133
254: 133
255: 29
262: 190
264: 191
265: 191
266: 175, 177, 191
267: 177, 191
268: 146, 177, 187, 191
269: 177, 191
270: 177
271: 177

272: 177, 190
273: 177, 187, 191
274: 177
275: 146, 177, 187, 191
277: 191
278: 22
283: 22, 187, 191
284: 146, 187, 191, 192
288: 179

Inscr. Alexandrie

26: 184
58: 185–6

Inscr. Bouthrotos:

180: 156

Inscr. Eleusis

59: 198
196: 84, 106
200: 106
211: 106
221: 104–5
238: 170
242: 170
244: 170
245: 170
246: 170
251: 170
252: 170
253: 170
266: 170
268: 170
270: 170
273: 170
275: 106, 170
276: 106
278: 170
280: 106
299: 170

Inscr. Lindos

1.42: 230
1.55: 199
1.56: 187, 199
1.58: 169
1.59: 169
1.60: 187
1.61: 169
1.68: 23
1.69: 187
1.73: 169
1.74: 169
1.78: 204
1.83: 271
1.93: 271
1.96: 169
1.97: 169
1.100: 169
1.101: 271

1.104: 169, 204
1.109: 167, 271
1.113: 167
1.123: 31, 37, 84, 261
1.125: 31, 37, 84, 261
1.129: 188
1.132: 167, 255
1.138: 204
1.142B: 255
1.145: 188
1.147: 188, 190
1.148: 167, 190
1.153: 167, 204
1.154: 188
1.155: 204
1.158: 167
1.162: 190
1.169: 31, 84, 255, 261
1.172: 169
1.189: 46
1.195: 46
1.197: 165, 181, 213, 239
1.234: 37, 261
1.260: 169–70
1.281: 261
1.243: 37, 261
1.244: 37, 165, 261
1.273: 37, 261
1.281: 37
2.284: 204
2.293: 165, 223
2.297: 261
2.299: 204
2.300: 165
2.305: 37, 261
2.309: 37, 261
2.330: 261
2.333: 37, 261
2.344: 201
2.345: 261
2.347: 174, 255
2.384: 37
2.404: 37
2.419: 7, 61, 74
2.622–3: 229
2.645: 199, 299
2.699: 23

Inscr. Napoli
30: 24
33: 24

Inscr. Scythiae Minoris
1.1: 129
1.59: 88
1.110: 156

Inscr. Thrac. Aeg.
4: 78

5: 78
6: 78
7: 78
9: 245
186: 20

Inscr. Tyr
18: 184, 227

IOSPE
I² 25: 24
I² 189: 173
I² 190: 167, 173
I² 191: 167, 173
I² 315: 250
I² 410: 167
II 5: 283
II 9: 180

I. Prusa
27: 305
30: 305
31: 305

I. Rhod. Peraia
8: 167
201: 71
402: 73, 244
552–3: 31, 215, 262, 306, 307
556: 31, 37
571: 33

Iscr. Cos
EV 19: 31
EV 150: 183

ISE
7: 6, 118
12: 275
13: 6
21: 22
33: 106, 307
37: 186
41: 129, 244
45: 53
46: 305
55: 284
56: 184
58: 24
60: 97, 280
62: 47–8, 96
69: 7, 48, 59, 119, 140, 178, 237, 271, 300
70: 7
80: 31
85: 178, 200
86: 235
98: 186
101: 95
106: 184
128: 2, 118, 249

ISE (*cont.*)
129: 80
136: 247
3.136: 7, 111

I. Side
267: 21

I. Smyrna
67: 51–3
516: 51, 53
577: 94
578: 85

I. Stratonikeia
7: 247
509: 32
527: 32
1010: 32
1025: 20
1418: 31, 95

I. Tralleis
18: 250

Jacobi *Clara Rhodos* 2 (1932) 184–5, no. 10
174

Jacobsthal 'Pergamon' *Ath. Mitt.* 33 (1908) 375–420
no. 1: 56, 88
no. 2: 88
no. 34: 175

Jacquemin *Offrandes Monumentales* (1999)
005: 97
011: 187
014: 187
075: 187
094: 187
107: 187
221: 187
239: 187
249: 187
291: 48, 58
329: 187

Jamot 'Fouilles de Thespies' *BCH* 26 (1902) 304
no. 29
182

Jannoray 'Inscriptions delphiques d'époque
tardive: Inscriptions de Lébadée' *BCH* 70
(1946), 254–9
no. 8. 187

Kienast and Hallof 'Ein Ehrenmonument für
samische Scribonii' *Chiron* 29 (1999), 205–23
80, 236

Kition
5, 2024: 185, 216
5, 2028: 185

Klaffenbach 'Neue Inschriften aus Aetolien'
*Sitzungsberichte der Preussischen Akdemie der
Wissenschaften* (1936) 367–70 no. 2

179

Knoepfler *Décrets érétriens de proxénie* (2001)
VII: 79, 82, 115, 129

Konstantinopoulou 'Epigraphai ek Rhodou',
ArchDelt 18/1 (1963) 1–36
no. 5: 49
no. 13: 38, 302
no. 17: 181

Kontorini 'Damagoras', *Chiron* 23 (1993) 83–99
161, 163

Kontorini 'Inscriptions inédites relatives à l'histoire
et aux cultes de Rhodes' *Rhodiaka* I (1983)
I: 190

Kotsidu Τιμὴ καὶ Δόξα (2000)
105: 236

Kourion
42: 236

La Carie
8: 32
10: 33
11: 32
13: 32
16: 26
41: 129
79–82: 296
175: 164

Lambrino 'Inscription de Priène' *BCH* 52
(1928) 399–406
179

Laum *Stiftungen* (1914)
42: 178, 221

Laurent 'Inscriptions grecques', *Echos d'Orient* 35
(1936) 220–33
187

Lazzarini *Dediche votive* (1976)
166: 27

LBW
141: 134
1594: 79

Löhr *Familienweihungen*
10: 196
13: 197
21: 197
23: 196
37: 196
70: 198
80: 198
88: 198
89: 198
96: 198, 199
103: 198
104: 198
106: 198

III: 198
134: 5
126: 198
127: 188, 198
128: 199
135: 198
139: 199
145: 180
151: 198
161: 198
170: 199

LSCG
43: 71
50: 72

Ma, *Antiochos III and the Cities of Western Asia Minor* (2002)
16: 48
37: 182

MAMA
4.151: 33
6.65: 129
6.68: 32
6.173: 88, 184
8.416: 21
8.464: 33
8.468: 33
8.469–73: 33
8.477: 33

Maiuri 'Esplorazione in Caria' *ASAtene*, 4-5 (1921–2) 467, no. 6
31

Marcadé *Signatures* (1953–7)
ii.82–96: 260
ii.89–96: 259

Meritt 'Greek Inscriptions' *Hesperia* 23 (1954) 252 no. 33
184, 192

Meritt, 'Greek Inscriptions' *Hesperia* 29 (1960) 40–5 no. 51
163

Michel
456: 87, 88, 237
534: 72
537: 72–3, 158, 230
538: 72–3
544: 245
545: 88
1016: 35, 134
1017: 116
1019B: 36
1065: 247

Migeotte *Emprunt* (1984)
93: 245
102: 237, 264

Miles, *The City Eleusinion* (1998)
no. 22: 105

Milet 1.3
32: 71
139: 120
151: 258
157: 169
158: 25
165: 190
168: 173, 177, 216
174: 177

Milet 1.7
244: 190, 200
245: 46
248: 31, 32
251: 177

Milet 1.9
368: 85

Milet 6
1.250: 173
3.1026: 244, 251
3.1086: 173, 174

Mitford 'Old Paphos', *ABSA* 56 (1961), 1–41
no. 10: 21
no. 11: 21
no. 17: 184
no. 19: 185
no. 23: 168
no. 40: 184
no. 41: 185
no. 43: 236
no. 44: 236
no. 45: 185, 236
no. 49: 185
no. 51: 184
no. 53: 184
no. 61: 163
no. 85: 185
no. 86: 185
no. 88: 184
no. 93: 184
no. 102: 185

ML
9: 23

New documents from Lydia
96: 84

Nigdelis, *Epigraphika Thessalonikeia* (2006), T14
186

Norwood, 'A Greek Inscription Copied from Gallipoli', *CQ* ns 11 (1917), 1–2
19

Nouveau Choix
 7: 73

Nuova Silloge
 19: 204, 214, 235
 29: 204
 30: 177
 31: 204
 458: 237

OGIS
 19: 200
 39: 184
 46: 245
 102: 185
 110: 184
 121: 49, 184
 122: 49, 184
 129: 243
 173: 185
 211: 19
 212: 20
 213: 73, 244, 245
 218: 119
 229: 77
 234: 48, 250
 248: 120
 266: 101
 289: 20
 309: 79
 317: 184
 320–1: 26
 332: 45-6, 81, 101, 250
 336: 250
 339: 58, 88, 243, 289
 438: 32
 439: 32
 483: 70
 731: 184

Oropos
 54: 140
 61: 140
 62: 140
 76: 140
 77: 140
 79: 140
 80: 140
 173: 140
 175: 48
 283: 139, 200
 294: 74, 112, 236, 244
 307: 34
 341: 198
 347: 21
 366: 6, 139
 375: 58, 139
 385: 261
 387: 261

 389: 6, 47–8, 96, 261, 271
 390: 261
 404: 204
 405: 172, 187
 415: 204, 227
 416: 261
 420: 139
 421: 140
 422: 172, 187, 221
 423: 221
 424: 163, 183, 187, 188–9, 207
 425: 163, 183, 187, 188–9, 207
 431: 161, 203, 208
 432: 187
 433–51: 246
 433: 34
 441: 140
 442: 82
 443: 112, 139
 444: 112, 140
 446: 140
 448: 126
 450: 139
 452: 139
 455: 49
 461: 18, 19
 502–510: 33

Peek 'Epigramme von Nisyros' *Wissenschaftliche Zeitschrift der Martin-Luther-Universität Halle-Wittenberg* 16 (1967) 374–6
 178–9

Pékary 'Inschriftenfunde aus Milet 1959' *IstMitt* 15 (1965) 118–19 no. 1
 177, 216

Pérée rhodienne
 3–4: 215, 262, 306, 307
 7: 31, 37
 45: 73, 244, 264
 102: 71
 195: 167

PH
 58: 73
 115: 238
 116: 237
 125: 173
 126: 183
 128: 6
 221: 22
 334: 128
 393: 26
 409: 31
 418: 300

Pharaklas, 'Enepigraphon vathron ex Akraiphniou', ArchDelt 23/1 (1968), 293–4

Plassart 'Fouilles de Thespies', *BCH* 50 (1926)
 no. 30: 168
 no. 32–7: 168
 no. 39: 191
 no. 54: 190

Queyrel 'Les Portraits des Attalides' (2003)
 287–9
 73

Queyrel, 'C. Ofellius Ferus', *BCH* 115 (1991),
 389–464
 284

Ramsay 'Inscriptions of Cilicia, Cappdocia and
 Pontus', *JPh* 11/21 (1882) 143
 177

Raubitschek 'Greek Inscriptions', *Hesperia* 12
 (1943) 74 no. 22
 201

Raubitschek, 'The Brutus Statue in Athens', in *Atti
 del terzo congresso internationale di epigrafia
 greca e latina* (1959), 15–21
 104

RC
 45: 184
 63: 264
 65: 182
 66: 182
 67: 182
 69: 250
 75: 185
 279: 185

Reinach, 'Une inscription grecque d'Eléonte',
 CRAI (1917), 29–30
 19

Richter 'New Signatures', *AJA* 75 (1971), 434–5
 49

Rhamnous
 10: 84, 106
 22: 129
 46: 129
 120: 19
 122: 19
 123: 187, 219
 133: 219
 186: 188, 198

RIJ
 2.24: 178, 221

Rigsby, *Asylia* (1996)
 178: 48
 179: 48

RO
 6: 128-9
 11: 5, 118
 20: 72

92: 235

Robert, *Coll. Froehner*
 52: 6, 58
 54: 73, 244, 245

Robert *OMS*
 ii. 1315: 20
 ii. 1368–70: 31
 ii. 1368–9: 155
 v. 561–83: 138
 vi. 22–3: 251

Robert *Études Anatoliennes* (1937), p. 366
 164

Robert *Hellenica* I, p. 7–17
 174

Robert *Hellenica* xi/xii, p. 117–25
 88

Robert *Nouvelles Inscriptions de Sardes* (1964)
 1: 20

Robert, in Dupont-Sommer and Robert, *La Déesse
 de Hieropolis-Castabala* (1964), p. 50
 236

Şahin, 'Recent Excavations at Stratonikeia' *EA* 41
 (2008), 53–81 no. 7
 33

Salamine de Chypre
 61: 184
 64: 184
 65: 184
 66: 184
 67: 184
 81: 185
 89: 185
 97: 185

Sardis
 8: 133
 8 XI: 111–2
 27: 7, 251, 262, 306
 51–52: 33

SEG
 1.374: 184
 3.414: 187
 4.184: 31
 6.814: 250
 8.529: 87
 8.641: 87, 245, 248
 8.694: 87
 9.62: 184
 9.63: 174
 9.64: 182
 9.65: 173
 9.66: 173
 9.67: 167
 9.70: 167
 9.71: 167

SEG (cont.)

9.359: 185
11.90: 23
11.954: 80
14.136: 104
14.474: 53
16.28: 97
16.193: 173
16.328: 24
17.75: 104
17.83: 198, 231
17.84: 167
18.26: 6
18.85: 190, 198
18.88: 168
18.222: 235
19.568: 283
20.467: 184
21.752: 167
22.266: 305
22.460: 27
23.220: 173, 174, 203, 204
23.447: 295
24.235: 120
24.449: 95
24.450: 95
25.112: 106
25.336: 199
25.542: 172, 287
26.555: 172
26.943: 116
26.944: 116
26.945: 116
26.1817: 129, 133
27.249: 4
27.551: 177
28.60: 244, 278
28.112: 120
28.541: 271
28.952: 94
28.953: 116, 134
28.1541: 173, 182
28.1817: 307
29.802: 245
30.164: 168
30.174: 198
30.364: 184, 192
30.1088: 159
31.518: 157, 172
31.899: 33
32.251: 30
32.794: 24
32.856: 25, 77, 108
33.127: 119, 243
33.197: 204
33.642: 184
33.644: 50-1

33.682: 250
33.963: 6, 77
33.794: 6
33.1035: 47, 251
33.1041: 236
34.589: 191
35.48: 27
35.141: 168
35.480: 5
36.943: 237
36.944: 237
36.945: 237
36.1046: 244
36.1133: 49
37.146: 33
37.492: 95
37.493: 95
37.866: 31
38.112: 119
38.143: 34
38.3412: 169
39.63: 264
39.187: 33
39.740-7: 169
39.748: 169
39.759: 159, 214, 223
39.972: 34
39.1133: 49
39.1174: 182
39.1243: 35, 56, 120, 247
39.1244: 35, 73
41.86: 84, 106
41.148: 33
41.332: 58, 84, 244
41.347: 86, 90
41.348: 86, 89
41.350: 169
41.827: 177
41.1003: 6, 19, 79, 250, 303
41.1037: 181
41.1053: 20
42.116: 73
42.173: 168
42.579: 236
42.596: 239, 271
42.785: 70
43.56: 188
43.451: 244
43.527: 163
44.643: 5
44.1550: 51
45.312: 78
45.1499: 237
45.1508: 235, 256
46.416-7: 191, 229
46.423: 90
46.1325: 49

46.1721: 31
47.393 78
47.395: 78
47.397: 87
47.399: 90
47.400: 87, 89
47.1218: 73
48.492: 93
48.494–7: 78
48.521: 76
48.781: 80
48.1416: 173, 174
49.423: 244
49.1195: 34
49.1423: 23
49.1559: 26
50.1: 84
50.522: 90
50.1195: 81, 250
51.215: 190, 198, 204, 231
51.427: 93
51.466: 244
51.566: 84
51.1224: 199
51.1442–4: 49
51.1504: 22
52.380: 91
52.401: 89
52.1333: 53
53.404: 93
53.1224: 169, 199, 214
53.1229: 95
53.1327–32: 85
53.1373: 73, 94
53.1697: 182
54.558: 95
54.724: 246
54.747: 35, 59
54.787: 35
54.1101: 45, 88
54.1406: 182
55.513: 22
55.929: 169
55.1251: 35, 86, 248
55.1251bis: 5, 22
55.1502: 161
55.1503: 251
56.1490: 217
57.1104: 25

Sinuri
16: 23, 84

Steinepigramme
iv 17/01/01: 253
iv 18/07/01: 177

Syll.
284: 2, 60, 128, 134, 246, 251, 301, 306
310: 34

339: 223
361: 6, 59, 299
368: 94, 244
485: 26, 84, 106, 244, 245
493: 34
535: 56–7, 248
577: 246
578: 246
587: 35
592: 6
602: 229
616: 6
624: 93
629: 236
630: 243
648A: 93
654: 6, 33
684: 280
730: 36, 129
762: 73, 112
912: 35
936: 70
1045: 35
1099: 35

TAM
2.283: 201
2.309: 201
2.310: 201
2.390: 178
2.495: 32
2.498: 31
2.499: 32
2.580: 32
2.593: 32
2.660: 32
2.760: 32
3.36: 32
3.56: 237
3.67: 237
3.125: 237
3.132: 237
5.48: 129, 236
5.374: 32, 133
5.468B: 7, 33, 133, 250
5.678: 33
5.688: 129, 236
5.702: 32
5.775: 32
5.901: 19
5.918: 32, 61
5.1261A: 25
5.1365: 32, 272
5.1427: 26

Thespies
350: 190
367: 157, 172
388: 182

Tit. Cal.
109: 26
121: 200
122: 200
123: 167, 200
124: 167, 200
125: 163, 164, 200
126: 163, 164, 200
127: 163, 164, 200
128: 167
129: 167
130: 181, 203, 213
131: 167
139-40: 31

Tit. Cam.
81: 188, 232
83: 32, 36
86: 38
92: 31
96: 37
106: 36
109: 223
110: 32, 36

Tod
II 120: 198

Tuchelt *Frühe Denkmäler* (1979)
Ephesos 02: 236
Magnesia 02–05: 236
Pergamon 023: 236

Tziafalas and Helly, 'Décrets inédits de Larissa (3)',
BCH 131 (2007), 423–5
289

von Gaertringen 'Theater von Magnesia', *AthMitt*
19 (1894), 1–53.
no. 5: 137
no. 6: 137
no. 14: 137

von Prott and Kolbe '1900–1901 Inschriften',
AthMitt 27 (1902), 44–151
no. 96: 22
no. 73: 101

Wallensten and Pakkanen 'A New Inscribed Statue
Base' *OpAth* 35 (2010), 156–65
25

Weidemann 'Drei Inschriften aus Kyme' *ArchAnz*
(1965) 446-466
236

Wilhelm *Inschriftenkunde*
i. 230: 71
i. 236: 173
i. 261-76: 77
i.502-8: 283
ii. 13–17: 182

Zimmer and Bairami, *Rhodiaka ergasteria*
(2008) 81, no. 34

259

Literary Sources
AISKHINES
1.24–6: 306
3.32-42: 34
3.183–5: 4
3.243: 5

ANDOKIDES
1.38: 4

Anth. Pal.
16.36: 253

ANTIPATER
Garland of Philip 41 Gow-Page
270

APULEIUS
Metamorphoses
3.1–13: 53–4
Apology
14: 54
Florida
15: 201
16: 54
16.36: 129

ARISTOPHANES
Ekklesiazousai
334: 301

ARISTOTLE
Constitution of the Athenians
50.2: 70
Politics
1260b 40–1: 70
1276a–b: 55
7.1330a–1331b: 70
1331a 30–b3: 79

ARRIAN
1.17.11: 5

ATHENAEUS
5.203b: 133
13.586c: 188, 198

CICERO
De Finibus
1.39: 88
Pro Flacco
31: 32
Verrines
2.8.21: 176
2.14.36: 176

Cod. Just.
1.24.4: 296

DEMOSTHENES
12.4: 4
18.90: 48

18.120–1: 34
18.122: 244
19.251–4: 306
20.64: 295
23.130: 5, 199
23.136: 5
42.7: 258
43.74: 206

DIO CHRYSOSTOM
31: 3, 7, 61, 305, 307
31.41: 247
31.43: 8
31.116: 105, 120

DIODORUS SICULUS
4.58: 232
20.46.2: 6, 270
20.93.6: 6

DIOGENES LAERTIUS
2.132: 188
2.5.43: 110
5.15: 176
5.51–2: 176
5.64: 176
5.71: 176
5.75–7: 6
6.2.35: 245
6.23: 274
7.182: 88, 136

FrGrHist
86 F 6 (Agatharchides of Knidos)
228

328 F 59 (Philochoros)
198

HERAKLEIDES PONTIKOS
Wehrli fr. 169
110

HERODAS
4.35–8: 200

HERODOTOS
1.31.1–5: 4
1.153: 79
3.139: 79

ISAIOS
fr. 21 Thalheim
4
5.41–2: 219

ISOKRATES
9.56–7: 5

JOSEPHUS
AJ
14.233: 173

JUSTIN
36.4.4: 252

LUCIAN
Anacharsis
17: 123

LIVY
31.14.7: 106
31.23: 6
31.44.4-8: 133
36.6: 248
36.20: 6, 95, 248
44.6.3: 80

LYKOURGOS
Leokrates
51: 76

MACROBIUS
Sat. 2.5: 250

NEPOS
Pelopidas 5.5: 5

Page Further Greek Epigrams
40: 4

PAUSANIAS
1.1.2: 197
1.2.4: 123
1.3.5: 104
1.8.2: 120
1.17.2: 88, 106
1.18.3: 106, 275
1.18.4: 106
1.18.8: 188, 198
1.21: 105
1.25.2: 275
1.26.1–2: 274
1.26.3: 106, 275
1.26.5: 170, 199
1.36.3: 4
2.7.5: 91
4.31.10: 5
4.32.1: 5
5.25.24: 4
5.27.6: 197
6.3.14–16: 5
6.3.14: 27
6.3.16: 5
6.4.8: 199
6.4.9: 5
6.11.1: 119
6.15.7: 5
6.16.2: 184
6.16.3: 48
6.17.1: 184
7.16.9-10: 280
8.9.1: 279
8.30.5: 3, 82
8.30.8: 279
8.30.9: 279
8.37.2: 80
8.44.4: 279

PAUSANIAS (*cont.*)
 8.48.8: 279
 8.49.1: 3
 8.50.1: 282
 9.12.6: 5
 9.15.6: 5
 9.22: 89
 9.27.5: 199
 10.33.3: 25, 97

PLATO
 Laws
 739a–740a: 70
 745b–e: 70
 847e: 70

PHILODEMOS
 PHerc 1021 col. 2 11-16 (*History of the Academy*)
 198

PHILEMON
 fr. 190 Kock
 110

PHOTIUS
 502.21: 110

PINDAR
 Olympian
 7.135: 232

PLAUTUS
 Curculio
 439–41: 253
 Miles Gloriosus
 1178: 270

PLINY *NH*
 34: 260
 34.27: 117
 34.52: 259
 34.76: 158
 34.92: 21
 34.134: 158
 34.136: 158
 34.143: 158
 35.28: 173, 232
 35.93: 270
 35.106: 176

PLUTARCH
 Alexander
 17.9: 76
 Antony
 60.2: 105
 Aratos
 23.3: 282
 53: 61
 Demetrios
 121

Demetrius
 39: 275
Demosthenes
 30.5: 276
 31.1–2: 276
Kimon
 1-2: 77
 2.2: 119, 128
 7.4–6: 4
Lysander
 1.1–3: 16

Moralia
 839b: 188, 198
 839d: 198
 843: 170, 199
 847a: 276
 847d-e: 106
 847e: 275
 850 F: 276
 851d-f: 278
 1033c: 158
 1033e: 88
Pelopidas
 31.4: 5
Philopoimen
 9.2: 282
 21.5: 281

POLYBIOS
 4.49: 248
 4.62.2: 80
 5.87.6: 184
 8.9.1–2: 81
 12.28.1: 279
 13.1.1: 228
 14.11: 185
 18.16: 119
 20.1–8: 226
 32.8.1–7: 226
 35.6.4: 279
 39.3.11 (Loeb): 280
 39.5.4 (Loeb): 279

POSEIDIPPOS (Austin and Bastianini *Posidippi*)
 no. 60: 301
 no. 63: 302

Scholion to Epicurus, *Kyriai Doxai* (Key Doctrines) 29
 1

SH
 705: 77

STRABO
 14.1.41: 77, 137-8

14.2.5: 89
14.2.24: 258

Suda
s.v. σαυτήν (Erbse 1950 208 σ 6)
110

THEOKRITOS
10.32-5: 232

THEOPHRASTOS
Characters
2.12: 199, 303

19.7: 267

VITRUVIUS
5.9.1: 93

XENOPHON
Constitution of the Athenians
3.4: 70
Memorabilia
2.2.10: 168
Poroi
4.8-9: 219

GENERAL INDEX

Abydos 73
accusative 28, 45, 49–50, 51–2, 217
 'being honoured' 50–5, 217, 295
Actium 225
Ada, *see* Idrieus and Ada
Adada 78
Adana 267
Adeimantos of Lampsakos (Friend of Demetrios
 Poliorketes) 129
Admetos son of Bokros (Macedonian from
 Thessalonike) 72, 115, 119
Adobogiona (Galatian princess) 81
agalma 2
agency 298
Agios Demetrios Katephores (church in Plaka) 191
agora 2, 75–9, 99–100, 107–8, 191–3
 as civic space 78
 formula implying statues set up in? 25n68
 in real life 79
 'to the gods' not implying statue set up in 190
Agrippa 75, 115
Aigai, *bouleuterion* 94
Aiskhines 34, 272
Aiskhylos 25
Akraiphia 48, 78n66, 118, 120, 237, 305
Alabanda 250
Alexander 22, 76, 119, 121, 200, 267, 270
Alexandros of Pherai 5
altars 19, 20, 46, 49, 56, 82, 97, 98, 101, 109, 115, 120,
 123, 125, 133, 148, 178, 188, 189
Amphiaraos 189
 on Amphiaraion esplanade 126, 127
Amphipolis:
 gymnasion 86, 90
Amyzon 230
anagraphai 34, 38
Anaphe 81, 179, 201
Anax (hero) 107
Anaxenor (benefactor at Magnesia on
 Maeander) 93, 137–9
anchisteia 210
Andros 78n65
Anthemokritos (Athenian herald) 4n14
Antigonos Gonatas 109, 305
Antigonos Monophthalmos, *see* Demetrios
 Poliorketes
Antileon 261
Antiochos I 73
Antiochos III 6, 48, 79, 95, 250

statue in Koroneia 248
Antiochos, son of Antiochos III 116
Antiochos IV 120
Antiphellos 155
Aphrodisias 230, 246, 270, 296
 bouleuterion 94
Apollodoros 214, 219, 229
Apollonia 80
Apollophanes (benefactor at Magnesia on
 Maeander) 137
Apuleius 53–4, 61
Archidamos III 5
Archippe of Kyme 47, 236, 246
Archippos son of Dion (on funerary stele) 217
architekton 128, 256
arete 27, 55, 62, 183
Argos 173, 304
Ariobarzanes II of Kappadokia 93
Aristoboulos (benefactor at Epidauros) 129
Aristogeiton, *see* Athens, tyrannicides
Aristonoe (priestess at Rhamnous) 170, 171,
 255, 287
Aristotle, will of 175–6
Arsinoe II 184
Arsinoe IV 140
art:
 local nature 257
 function of 302
art pompier 10
Artemidoros of Perge 220
Artemisia 27
artists 258
 and choices 260
 regional aura 259
 signature 49, 198, 261
 statue of 137–8
Asandros (Macedonian dynast) 129, 223, 247
Astydamas (poet) 106, 110
Astylaidas of Epidauros 224
Astypalaia 224
Athena Ilias, Confederacy of 37, 73, 94
Athenopolis of Priene 146
Athens 103–7, 202
 agora 68, 104, 115, 122n54, 149
 Akropolis 7, 80, 84, 103, 105, 196, 197, 219
 Akropolis Museum 196
 Asklepieion 106
 bouleuterion 104
 City Eleusinion 105, 190

Eponymous Heroes 123–4, 276
history of honorific statues in 106
Odeion 116
prytaneion 106
self-image 76
shrine of Demos and the Charites 68, 104, 151, 248
stoa of Zeus 104
Stoa Poikile 104, 124
theatre of Dionysos 105
tyrannicides 104, 113, 118, 119, 121, 270
athletics 51
Attalids 226
see also Philetairos, Eumenes I, Attalos I,
Eumenes II, Attalos II, Attalos III.
Attalos I 226, 272
Attalos II 115, 120
Attalos III 45, 103, 250
Augis (benefactor at Argos) 304–5
Augustus 114, 253

bases 3, 38–43, 46, 48, 49, 68, 112, 138, 254–5
and speakers' platforms 43
'floating' 139
jaunty 126, 128
'limpet' 135, 147, 197
pre-fabricated 255
Baxandall, M 243
Berenike 26
Billienus, C. (Roman official honoured at
Delos) 287–8
Biton, *see* Kleobis and Biton
Boiotia 244, 259
Boiotian League 95, 120, 248
Boubon 116
Brasidas 16
Brel, Jacques 45
bronze-working 252–3
as performance art 260
Brutus and Cassius, statues of 104, 118
Byzantion 248

C. Iulius Theopompus (Knidian benefactor) 236
C. Iulius Zoilos 47
C. Ofellius Ferus 284–5
C. Vaccius Labeo 88
Caesar, Julius 53
calligrammatic 28
cash, distributions of 246
Cassius, *see* Brutus and Cassius, statues of
casting pits 257–8
Chabrias 5
Chaironeia 60, 128, 201
character 58, 59
chariot-groups 270
Charites 56, 120
Chremonides of Athens 22
Chrysaorians, Koinon of 94

Chrysippos 286
citizen, good 55, 59, 108, 121, 125, 132, 260
city:
'cold' 58
'collage' 150
'hot' 58
clay 251–4, 262
Cn. Cornelius Scipio 90
Cn. Domitius Ahenobarbus 97
cold work 253
columns 117, 127, 188
confidence, social 227
conflict 219
consensualism 214–25
contracting 244
crowds 129
crown 2, 30, 33, 34, 59, 60, 79
frame 51
culture:
civic 38, 56, 62–3, 132, 196, 247, 296
curial 297
monumental 84
political 60, 62, 63, 84, 108, 195, 217, 238, 243,
249, 260, 296, 297
cuttings 188
Cyclades 226
Cyprus 72, 185, 226, 236
Cyrenaica 185
damnatio memoriae 133
Demetrios Poliorketes
see also erasure

Damokles and Astylaidas 224
Daochos 226
dative 18–19, 23, 38, 45
Deckplatte 40, 146
decree, honorific 56, 59–60, 62, 239, and *passim*
dedications 246, and *passim*
politics of 46–7
secret 140
definite article 45, 45n1
deicticity 54
Delos 87, 97, 184, 190, 201, 202, 214, 229, 233
Agora des Italiens 78, 285
agora of Theophrastos 115, 192, 230
Antigonid monument 226
dromos 136, 170, 193, 233
gymnasion 89
Kynthos 116
post-166 170, 204
tetragonal agora 114
theatre 91, 191
Delphi 16, 49, 95, 96, 122
Delphic Amphiktiony 17, 73, 95
under Aitolians 223
Demetrias 53, 257
Demetrios of Phaleron 279

Demetrios Poliorketes 119, 120, 128, 224
 and Antigonos Monophthalmos, statues in
 Athens 118, 270, 279
 statue of in Athens 116, 118
Demokratia 118, 121, 128
Demokrite of Oropos 163, 188, 207, 221
Demos 118, 129
Demosthenes 34, 276
Dermys and Kitylos (Tanagraian brothers) 196
Didyma 250
Diodoros of Sinope 274
Diodoros Pasparos 87, 102, 112, 116, 263
Diokles of Priene 146
Diomedes of Troizen 47, 139
Dion 80
Dionysian Artists 244
Dionysos 188
Dioskourides, see Kleopatra and Dioskourides
Diotimos of Sidon 6
Dodona 112, 126, 146, 262
Doidalses (Mysian athlete) 125
dokimasia 74
Drakon of Aitolia (father of Skorpion) 206
droplets 127

Ehrentafel 33
eikon 2, 9, 55, 59, 158, 303–4
El Paso International Airport 16
Eleusis 84, 106, 170, 275
elitism 63, 195, 225–33, 296
 constitution of the elite 237
 fragility 234
 place and limits of 233–9
 'tragedy of the elite' 133, 234, 293
Epameinondas 5
ephebes 104
Epicurean view on statues 1, 11, 307
Epidaurian Asklepieion 68, 80, 82, 97, 108–9, 122,
 127, 146, 193, 222, 224, 305
Epidauros Limera 245
epigram 27, 38, 48, 55, 120, 146, 166, 180, 205, 232,
 239, 271, 276, 280, 282, 299
'epigraphical pigeons' 141
Epikteta of Thera 177–8
epiphanestatoi topoi, see topos, epiphanestatos
Epirotes, Koinon of 95
equality 218
erasure 49, 140
Erechtheion 170
Eresos 78n65
Eretria 25, 58, 82, 86, 255, 288
 agora 77
 gymnasion 86, 183
 shrine of Artemis Amarysia 107
 territory 107
Erythrai 60, 76, 80, 111, 134, 246, 301
 statue of Philitas 306

Eteoboutads 170
Eteokles of Athens 106
eucharistia 55–6, 58, 61, 299
euergetism 2, 45, 63, 74, 85
 'new euergetai' 138
Eugnotos of Akraiphia 7, 48, 59n55, 61, 78n66, 119,
 120, 237, 300, 304
Eumaridas of Kydonia 56–7, 104, 151, 248
Eumenes I 191, 227
Eumenes II 101, 120
eunoia 55, 58, 62, 183
 towards the honorand 35n127
Eurykleides, see Mikion and Eurykleides
Euphranor of Rhodes 161, 194, 209–10
Evagoras of Salamis 5, 104, 118
examples, tiresome multiplication of 78, and passim
exedras 109, 114, 127, 131, 144, 145, 146, 147, 148,
 149, 163, 200, 216, 222, 230, 234, 255
 portfolio 194, 216, 230
exomis 282–3

face 269
family 156, 157, 158, 175–6, 195, 202–12
 adoption 211
 as cat's cradle 210
 as kindreds 209–10
 brothers 204, 208, 218, 239
 continuity 206–7, 223
 deceased offspring 211
 generational cycles 208, 212, 218
 grandchildren 204
 grandfathers 177, 182, 204, 211, 238, 271
 lineage 207
 my big fat Rhodian 209–10
 nuclear 203, 208, 212
 philostorgia 181–2, 203, 227, 231
 pride 194
 property 208, 218
 sons and fathers 186, 204–5, 207, 208
'family thinking' 238, 293
feet 3, 255, 284, 289
folklore 53n32
formula:
 dedicatory 24–30
 honorific 31–38
 Rhodian-style 31–33, 36
fountain 116
frames, Oxford type 256
friends 204
funerary honours 33, 88
funerary imagery 267

Geneleos group 27
'generation game' 210
Geneva 16n5
genitive 20–21
Geronthrai 20

gold 116
 gilding 253–4, 272
Gorgias 198
grave *stelai* 51
 'Smyrnian' 217
gymnasion 85–90
 as civic world 87
 at Eretria 58
 at Kolophon 35
 gymnasiarch 87–8, 272
 not second agora 89
 social life 87

habitus 229
Hadeia 119, 200
Halasarna 35
Halikarnassos 20n33, 87, 173, 174, 237
Harmodios, *see* Athens, tyrannicides
Harpalos 199
Hekatomnids 5, 22, 27, 53, 80, 81
Hekatomnos 27
Heliodoros 184
Herakleia under Latmos 24
Herakleitos 234–5
'Hermes Richelieu' 289
Herodas 200
Herodes Atticus 201, 228
Herodoras 277
high Hellenistic 6, 295
himation-man 123, 125, 137, 187, 217, 267, 284, 285, 289
 'Kos' style 269
'Hippodamian' grid-plan 70
Histria 118, 121, 122
honours:
 inflation of 133
 proclamation of 34–5, 43, 92–3
 topology of 112
hortative clauses 35, 56, 58, 59, 78
hunting 230
Hyampolis 95
Hypata 53, 74, 91
hyper 166, 202, 294
Hyrcanus, John 104n255, 151

'I love you' 307
Iasos 23
icons 256, 307
Idrieus and Ada 5, 27, 81
images 62, 298
 and text 15–17
 identity 18, 28, 143, 230
 religious function 18–19, 21, 26
incoherence, social 233
individualism 213
inequality 63, 231
inscriptions 120 and *passim*

as 'block of text' 40, 43
as public writing 34
CV 159–60, 161, 216, 218, 225
dedicator-honorand copula 30
layout 37, 40–2
nominative-accusative copula 26, 30, 36, 40, 46, 53
reading aloud 38, 39
workings of 16
Iphikrates 5
Ischyrias son of Ariston 205, 223
Isokrates 198
isolation 113–18

Jones, R.S. 19, 40
juxtaposition 138, 155, 167

Kalaureia 25n73, 41
Kalindoia 116, 236, 237, 238, 271
Kallias of Sphettos 122
Kallikrates (Achaian politician) 97, 119n43
Kallikrates son of Boiskos (Ptolemaic admiral) 184, 185, 227
Kalymnos 270
 Lady of 268, 272
Kameiros 37, 231
Karia 31, 33, and *passim*
Karneades 286
Kassope 78n65, 192, 257
Kaunos 27, 32–3, 79, 85, 112, 116, 166, 200, 214, 216, 218, 255
kausia 270
Kedreai 215
Kephisodoros of Athens 307
Keramos 181
Killos of Paros 237
kings 7, 19–20, 63, 77, 88, 104, 105, 118, 132, 183, 186, 200, 202, 213, 226–7, 293
 citizens looking like? 272
Kition 216
Kitylos, *see* Dermys and Kitylos
Klaros 17, 56, 59, 68, 80, 82, 120, 124, 127
Kleobis and Biton 4
Kleonikos of Eretria 255, 288
Kleopatra and Dioskourides 48, 172, 188, 214, 239, 287
Knidos 160, 181, 236
 no statues of priestesses 173
Knielauf position 196
Kolophon 43, 87, 248
Konon 5–6, 22, 27, 104, 118
korai 202
Koroneia, shrine of Athena Itonia 95
Kos 31, 72
kouroi 202
Kraton (Dionysiac Artist) 134
Kroisos 197, 232

Krypsippos syndrome 136
Kykizos 72, 94, 116, 134, 158
Kyme 88, 236

language, moderate visual 296
Laodike 250
Larichos 85, 98, 115, 119, 142, 248
late Classical period 295
laundry 232
Lefrebvre, Henri 111
Leukas 54, 84
Limoges 69
Lindos 7, 31, 84, 167, 188, 204, 223, 229, 239, 261, 271
localism 222, 259
Louis XIV 249, 259
Lucullus 60–1
luxury 219
Lykia 31
Lykortas (Achaian politician) 197
Lykosoura 80, 279
Lykourgos 76, 120, 121
Lysandros 4
Lysimachos 119
Lysippos 5

Macedonia, Roman 201
Magnesia on Maeander 107
 theatre 137–9
Mamurt Kale 226
Mantineia 78n65, 123, 225, 279
marble 246, 254
Maroneia 20
Mastaura 21
Maussolleion at Iasos 5n18
Maussollos 27, 76, 80, 85
Media 185
Megabyxos 35, 80, 82, 115, 261
Megakleides of Oropos 140
Megalepolis 248, 279
Melos 31
memorialisation 299
memory 10, 58, 60, 112, 131, 211, 232
 forgetting 61, 180
men, great 21, 22–23, 46, 53, 105, 125, 221, 291–2, 294, 296
Menander 22, 93, 105, 120, 272, 276–8
Menas of Sestos 249
Menippos of Kolophon 36, 60, 73, 116, 124
Messene 69, 88, 90, 111, 174, 229
 gymnasion 87, 89
metaphora 74
Q. Metellus Macedonicus 186
Metropolis in Ionia 20, 48, 77
Mikion and Eurykleides (Athenian
 politicians) 104, 151
Miletos 71, 73, 120, 177

mise en abyme 29
Mithradates of Pergamon 90
monument 40, 48, 141, 145, 211
 as embodiment of affection 35
 destruction of 49
 dynastic 211
 equestrian 16, 97, 108–9, 124, 205, 221, 223, 237, 245, 249, 267, 269
 moralizing 58, 62, 88
Moynier, Gustave 16
Q. Mucius Scaevola 25n71
Müslim Şanlı 107n272
Mylasa 108, 183

Nannion (Halikarnassian lady) 166, 190, 200, 218
narrative 58, 59, 61
Nassius, Lucius 74, 77, 87, 88
Nero 30
Nikomedes, son of Aristandros (officer of
 Antigonos Monophthalmos) 22
Nisyros 79, 178
nominative 21–3, 28, 46, 53, 167–8
 rare in votives 27n86
 respectful 53, 167, 193, 295
norms 55

oggetto parlante 27, 28, 302
Oinoanda 78
old age 208
Olganos (Macedonian hero) 15
Olymos 84
Olympia 23, 48, 97, 121, 124, 136, 148, 184, 279
 Echohalle 97, 126
Olympiodoros of Athens 105, 106, 274–5, 278
Onomarchos, see Philomelos and Onomarchos
Oradour-sur-Glane 69
Orchestraecken 91
Oropian Amphiaraion 7, 82, 95, 112, 115, 122, 139–42, 148, 150, 163, 188, 193, 198, 200–1, 221–2, 227, 261
ostentation 213
Otorkondeis 108

Pallantion 279
Panionion 94
paramilitary activities 89
Paramonos of Thessalonike 61, 249
parastema 47, 48, 55, 189
Paros 80, 81, 85, 237, 246
Patron of Lilaia 24, 30, 97
Pausanias 3, 103, 109, 119, 123, 274, 278
Peiraieus 106
Pella 77, 301
Pelopidas 5
performativeness 15, 59, 69, 150, 260
Pergamon 32, 49, 90, 101–3, 114, 226

as royal capital 101
Asklepieion 103
Great Altar 101, 103
Lower Agora 101
priestesses of Athena Polis 101
temple of Hera 81
Upper Agora 101
Upper Gymnasion 69, 86, 102–3
Perikles (Athenian politician) 4, 197
personalization 304
phama 39
Phaselis, agora 76
Philetairos 227, 272
Philip II 5
Philippides of Athens 274
Philitas 60, 301, 306
Philokles 22
Philomelos and Onomarchos 5
Philonides (Epicurean) 104n255
Philopoimen 93, 97, 281
Phistyon 179
Pholegandros 214
Phormis (Arkadian) 197
Phryne 199
pistachio shells 252
place 111–51, 130, 134, 151, 292
 isolation 113–18
 liminality 115–16
 proximity 118–21
 serialization, *see* series
plasis 262
Plutarch 16, 61, 119, 201
Polemaios of Kolophon 120
polis 70–1
 and conflict 151
 and harmony 219
 and power 132–3, 195
 and/as families 219–20
 as public actor 107, 194, 230, 292
 as society 219
 as state 150
 authority 141
 civic history 7–8, 113, 174–5, 233
 elitist 228
 ideology 45 63, 85, 118, 125, 150, 217, 243,
 277–8, 293
 interpretation 294
 Roman era 238, 296–7
 subdivisions 84
Polybios 80, 279–84
 body 283
 hairstyle 283
portraits, painted 86, 138, 198–200, 201, 250
 as luxury 228
 better than life 303
 'Fayoum' 263
 gilt 256

lack of resemblance 199
philosopher 267n2, 278, 286
resemblance 200, 260, 302
royal 267
Poseidippos 272
possessive, emphatic 182
Praxiteles 198, 231
presence 37, 301, 304
Priene 3, 80, 98–101, 179, 214, 228
 agora 1–2, 68, 112, 115, 142–8, 150, 191, 192,
 219, 234
 gymnasion 86, 100, 83–6
 shrine of Demeter 99
 small agora 79
 temple of Athena 81, 85, 119
 theatre 29, 91
priests 138, 169–75, 225, 271
private grave monuments, in Athens 218
private honorific statues 151, 155–94
 and adoption 175
 and centre of gravity 210
 and emotions 180, 225, 232
 and family life 158, 175–80, 194
 and friends 183
 and gratitude 175
 and inheritance 175
 and kings 184, 200
 and love 181
 and office 169
 and patrons 183
 and power 223, 228
 and priesthoods 169, 174
 and religion 225
 and social class 232, 233
 and Romans 186
 and vows 168–9, 232
 and wealth 228
 appearance 187–9
 as snapshots 211
 distributive 163
 epigrams 166
 epigraphy of 159
 function 212
 funerary 178, 180, 229
 history of 158, 196–202
 in agora 191–2
 in dialogue with public statues 158, 193–4, 195,
 212–25, 233–5
 in gymnasia 191
 in the nominative 167
 misrecognized 155–7
 multi-generational monument 160, 178, 215
 portfolios 147, 164, 216, 219, 222, 234, 270
 public nature of 213, 216
 reasons for setting up 168–87, 293–4
 religious character 189
 single monument 159

private honorific statues (*cont.*)
 surviving 286
 under the Roman empire 201
prohedria 272
promenade 195
Prostaennoi Pisidai 97
Protogenes of Kaunos 200, 299
Prousias I 248
proxeny decrees 139, 141
proximity 118–21
 baffling 128
Ptolemy I 200
Ptolemy II 120, 184
Ptolemy III 262
Ptolemy IV 140

T. Quinctius Flamininus 6

Regilla 201
relationality 41, 46, 186, 193, 212, 218, 228
replication 123
reproduction, social 59, 78, 299, 306
reuse 3, 9, 53 61–2, 68, 74, 101, 112, 139, 141, 146,
 150, 246
Rhamnous 18–19, 84, 106, 170, 255, 286
Rhodes 7, 174, 202, 235, 259
 prolixity in private honorific statue
 inscriptions 166
Rhodian Peraia 31, 71
rings 282–3
Robert, Louis 9, 11, 73, 155, 156, 180, 181, and *passim*
role assignment 303
royal order 26, 40, 52, 186
ruler-cult 19, 26, 53, 82, 148

sacred ways 82
Samos 31, 235, 236
 Heraion 8, 80, 82, 97, 196
 no statues of priestesses 173
Sardeis 111
Satyros 91
scripta exterior 34
sedimentation 135–7, 138, 150
 as free-for-all 136
 urban 135
segmentation 148–51, 230
Seleukos I 19, 121, 184
serial vision 149
series 121–30, 144, 147, 221, 230, 234,
 281, 293
 coherence 122
 in agora 122
 offering variation 144
Sestos 249
shape, privileging writing 40
shields 104, 201n53, 255

shoes 232, 271, 282, 301
shrines 79–85
 civic 107–8
 ecology of 141
 international 94–8, 261
 local 84
 of Triptolemos 105
 reasons for setting up statues in 84, 107
Sikyon 120
Sinuri 84
Skorpion of Aitolia, 178, 200, 206
Smyrna 85
soldiers, set up statues 3
Solon 124, 306
Sosibios (Ptolemaic minister) 190
Sosilos of Delos 87, 272
Soteles of Pagai 24, 165, 246
space 67–109, 292
 and language 131
 and movement 131, 149
 and orientation 131
 and power 132–4
 and viewing 131
 as lie 144
 as metaphor 131
 circulation 122
 crowding 116, 135, 146
 dead angles 145
 distinctions in use of 73
 diversity 85, 267–73
 elite capture 228, 230, 291
 experience of 111–13
 expressive 140
 important in constructing polis 8
 layering 141, 142
 production of 75
 public 70–5
 public control of 72–4, 129
 representational 125, 131, 144
squeeze 42
staffs 271
statuemania 10, 16n5
statues
 abroad 261
 and death in war 49, 178, 181, 224
 and family members 235
 and idealism 263, 302
 and naturalism 17, 21, 262, 278, 282,
 287, 301–3
 and officials 244
 and political work 249
 and religion 82, 283–4
 and rituals 134, 246
 appearance 1–2, 125, 250, 271, 306
 'archaeology' of 113
 as big fish 141, 150

as embedded art 260
as forest 15, 101n238, 109, 126, 290
as outcome of political process 243
as sign 179
as stand-in 168
as time capsule 306
as votives 82
children 272
clutter of 113
competition 194
cultic 19n18
delay in erecting 61, 248–9
desirable 307
disappearance 3
displacement of, *see metaphora*
diversity 58, 270, 290
'double-parked' 136, 138
ecology 150, 292
economies 228, 237, 257
ethical force 304
family pays 7, 237
for benefactors 5, 58, 88, 90, 101, 105, 106, 129,
 132, 224, 236, 295–6
for Romans 6, 7, 8, 53, 68, 90, 102,
 105, 106, 112, 114, 124, 187, 273
for victorious, powerful outsiders 4, 63
for women 85, 102, 125, 140, 199, 229–30,
 228n184, 263, 268, 286–7, 295, 303
'four-square' position 269, 284
honorand pays 2, 7, 249
in meeting-places 94
in temple 81
layering 138
meaning, shifting 138–9
multiplication of 89, 133, 143
naked 272, 284, 285
nameless 272
not masterpieces 259
of athletes 15, 22, 23, 46, 146
of citizens looking like kings? 272
of other cities 4
over life-size 81, 250, 253, 282
practices change in second century 7
private financing 247
privately dedicated 142, 143
public financing 245, 248
seated 271
seeding 146
shaping 251
speaking 299
stele next to 120
third-century practice 6, 106
toe-treading 119
viewing 117

see also private honorific statues
Stesileos of Delos 230
Sthennis of Olynthos (artist) 198
stone-working 254
stratigraphies, horizontal 113, 135–6, 141
style, civic 195
super-monuments 106, 117, 127
Susa 185
synecdoche 231, 234
syngenika 156
 definition 157–8

Tanagra 89, 160, 172, 196
teeth 253
Tegea 279
Teisias 215–16, 307
Tenos, linking with Rhodes 202
Teos 79
 bouleuterion 94
Terme ruler 268–9, 272, 304
'thank you' 11, 307
Thasos 70, 126, 17
 agora 68, 76, 114, 118, 123, 135, 148
 temple of Zeus Agoraios 115
Theangela 244, 248, 251, 261
theatre 54, 90–4
 Orchestraecken 137
 statues of poets 93, 105, 120; *see also* Menander
Theagenes of Thasos 114, 148
Themistokles 197
Theodektes, statue at Phaselis 76
Theokritos 232
Theophrastos 199, 303
Thera 177, 220, 229, 232, 234, 237
Thermon 117
Thermos 190
Thespiai 183, 199
Thessalian koinon 95
Thessalonike 61
Thessaly 79
Thraseas of Aspendos (Ptolemaic officer) 227
threpteria 218
Timanthis of Argos 173
Timotheos (Athenian general) 5, 104. 198 n19
Timotheos (Macedonian officer)
 at Eretria 82, 129, 245 n15,
topos 72–5, 85
 epiphanestatos 8, 107, 108, 109, 110,
 112, 117, 126, 129, 143, 146, 220, 233
Trafalgar Square, Fourth Plinth 40
train, electric 68
travelling commissioners 261
Troizen 261
Tyre 227

'unified statue theory' 294–7
Uruk 20

Venus de Milo 89

walking 123, 143, 149
wax 251–3, 262
 indirect lost-wax technique 252, 262
wealth 228, 228n184, 232

Wilhelm, A. *passim*

Xanthippos (Phokian general) 59
Xanthos 178
Xenokrates of Athens
 (artist) 261

Z/Menodotos (Seleukid courtier) 121
Zosimos of Priene 148

ADDENDA

4 n. 12, 104, 113 n. 9 On the Tyrannicides, V. Azoulay, *Les Tyrannicides d'Athènes: Vie et mort de deux statues* (Paris, 2014), notably on the crucial redefinition of the group as a proto-honorific, in the aftermath of the democratic restoration of 403 BC.

5 n. 28 On the statue of Chabrias, see the astonishing (if often overlooked) demonstration by P. Gauthier, *Bienfaiteurs*, 99–102, commenting Dem. 20.75–86 (a conspectus of Chabrias' deeds which Gauthier shows is almost certainly an extract from his official request for honours, including a statue).

6 n. 37 On the statue of Antileon of Chalkis, D. Knoepfler, 'Les Honneurs décernés par Samos à Antiléon de Chalcis et à son fils Léontinos: une autre lecture', *Dacia*, 51 (2007), 161–70 (but I do not agree that Antileon's statue was crowned with a high-value crown every year).

22–30 On the grammar of statue bases, and indeed on the workings of statue genres and monument in the context of civic-religious space, the long decree passed by the city of Aigai in 281 BC for Seleukos I and Antiochos I provides an extremely important example (*SEG* 59.1406, from H. Malay and M. Ricl, 'Two New Hellenistic Decrees from Aigai in Aiolis', *EA* 42 (2009), 39–60, at 38–47, with P. Hamon and M. Sève in *BE* 10, 522). The Aigaians decreed a temple for the two Seleukid kings, complete with statues and altars:

να-
[ό]ν τε οἰκοδομῆσαι ὡς κάλλιστ[ον] πρὸς τῶ
[ι] περιβόλωι τοῦ Ἀπόλλωνος καὶ [τό]πον πε-
ριβάλεσθαι καὶ ἀγάλματα ἀναθ[εῖ]ναι δύ-
[ο] ὡς κάλλιστα, ἐπιγράψαντας Σ[έ]λευκον κ-
αὶ ἀντίοχον, καὶ πρὸ ναοῦ στῆσαι ἄγα-
[λ]μα καὶ βωμὸν τῆς Σωτείρας· ἱδρύσασθαι
[δ]ὲ καὶ βωμὸν τοῦ ναοῦ κατεναντίον σωτη-
[ρ]ῶν ἐπιγραμμένον Σελεύκου καὶ ἀντι-
[ό]χου...

8

(it seemed good) to build a temple, as fine as possible, next to the precinct of Apollo, and to surround it with a space, and to dedicate two cult statues (agalmata), inscribing them 'Seleukos' and 'Antiochos', and to dedicate in front of the temple a cult statue and an altar of the Saviour Goddess; and to set up an altar, opposite the temple, of the saviours, inscribed 'Of Seleukos and Antiochos' . . .

The cult statues were inscribed with the bald name of the subjects, in the nominative (Sève; that they appear in the accusative in the decree is by attraction with the implicit object of the verb, the statues); their cultic nature was reinforced by the presence of the third statue, that of the goddess Soteira (which perhaps did not need

to be inscribed, since it was identifiable by iconography and attributes). The altars of the two kings were duly inscribed in the genitive, as belonging to the deified rulers.

It is likely that the Aigaians decreed to set up two more portraits of the Seleukid rulers—honorific and not cult portraits (Malay and Ricl, Sève). In fact, in the fragmentary lines 26–9, we may recognize such a decision, if we restore:

[ποιήσασθαι] δὲ καὶ ε[ἰκό]-
[νας χαλκέας ? δύο ? κ]αὶ στῆσαι ἐν τῶι πρυτανείωι
[e.g. ἐπιγράψαντας ὅτι “ὁ δῆμος ὁ Αἰγαιέων + names in accusative]- 28
[e.g. εὐνοίας ἕνεκεν τῆς] εἰς τὴν πόλιν ?

. . . [to make two bronze ?] s[tatues] and set them up in the *prytaneion* [with the inscription 'The people of the Aigaians . . . for their good will] towards the city (?)'

. . .

For the expression 'to make a statue and set it up', see *I. Erythrai* 6, *IG* II² 1299, *SEG* 45.1020 (probably). I do not presume to restore the exact form taken by the inscription on the base of the honorific statues (royal title or no), and wonder if there might be a whole line containing this formula, in the break between the two fragments, very worn at this spot, of the quite illegible stele (i.e. Malay and Ricl's line 28 to be separated into a 28 and a 28bis; it is difficult to judge from the published photograph). But I believe that a remnant of the formula can be recognized in the published reading *ΝΙΣΤΗΝΚΑΙ*, as amended here (or perhaps εἰς τὸν δ ῆμ [ον]), and further that the proclamation formula followed at lines 30ff. ([ποιήσασθ]αι δὲ τὴν ἀνα[γ | γελίαν]). The Aigaian decree thus makes clear the different workings and contexts of cultic and honorific statues.

31, 270–1 To the examples of the 'honorific formula' in use at Rhodes in the third century, add the third-century statue of the Rhodian Astyanax son of Astymedeus (V. Kontorini, 'Inscriptions de Rhodes pour des citoyens morts au combat, ἄνδρες ἀγαθοὶ γενόμενοι', *BCH* 136–7 (2012–13), 339–61:

Ὁ δᾶμος ἐτίμασε Ἀστυάνακτα
Ἀστυμήδευς Πεδιῆ εἰκόνι χαλκέαι,
ὅτι στραταγήσας κατὰ πόλεμον
ἀγωνιζόμενος ὑπέρ τοῦ δάμου καὶ 4
ἀνὴρ ἀγαθὸς γενόμενος ἐν τῶι
πολέμωι ἐτελεύτασε

The people has honoured Astyanax son of Astymedes, of the deme of the Pedieis, with a bronze statue, because, during his service as general in wartime, fighting for the people and proving a good man in the war, he died.

Astyanax did not receive the other honours (crown, *prohedria*) which are usually named with the statue, for the very good reason that he was dead by the time he was honoured; but the starkness of the single honour for the fallen general is matched by the final word of the inscription, insisting on his death in war (perhaps hostilities against Philip V in 201 or 197, or even the war against Byzantion in 220?). The traces on the base make clear that the general was represented striding forward, his weight resting on his right leg and his left leg trailing so that only the ball of his left foot touched the base—a dynamic position suited for the military statue, which makes for an excellent addition to the lost statues thronging this book.

48 n. 13 (also 250 n. 55) On the colossal statues of Antiochos III and the Demos of Alabanda at Delphi, especially on the size and location, G. Biard, 'Diplomatie et statues à l'époque hellénistique: A propos du décret de l'Amphictionie pyléo-delphique *CID* IV 99', *BCH* 234 (2010), 131–51.

69 n. 6, 81 n. 94 Studies by C. Leypold and M. Mathys (and for, that matter, myself) have now appeared in J. Griesbach, *Polis und Porträt: Standbilder als Medien öffentlicher Repräsentation im hellenistischen Osten* (Wiesbaden, 2014).

78 n. 65, 122 n. 55, 191 n. 220 On Kassope and the honorific statues in the agora (private and public, mostly atop exedras), see N. Katsikoudis, 'Paratiriseis stous chalkinous andriantes apto then agora tis Kassopis', in P. Adam-Veleni and K. Tzanavari (eds), *Diniessa: Timitikos tomos gia tin Katerina Rhomiopoulou* (Thessaloniki, 2012), 379–88.

90–1, 105–6, 273–4, Plan 2 On the statues in the Theatre of Dionysos in Athens, I have laid out some suggestions in 'The Statue of Menander in the Theatre of Dionysos in Athens, and its Neighbours', forthcoming in *Studi Ellenistici*, notably on the siting of the Roman poet Pompeius Capito next to the Menander (which I would maintain). But it is now clear that the position of the Menander, on the Ziller foundation, in fact reflects a reorganization of the statues in the *parodos* in the first century BC, which is also the date of the monumental marble entrance way: C. Papastamati-von Moock, 'The Theatre of Dionysus Eleuthereus in Athens: New Data and Observations on its "Lycurgan" Phase', in E. Csapo, H. R. Goette, J. R. Green, and P. Wilson (eds), *Greek Theatre in the Fourth Century BC* (2014), 15–76. Generally, the findings of the restoration work and the soundings in the Theatre of Dionysos are producing an exciting, rapidly changing picture which places our knowledge on a different basis. I most warmly thank C. Papastamati-von Moock for sharing some of these findings with me, in correspondence and during a visit.

93 On Ariobarzanes II and Athens, add *Inscr. Eleusis* 272, with commentary.

103, 191–2 The full publication of the material from the Athenian Agora in D. J. Geagan, *Inscriptions: The Dedicatory Monuments*, Athenian Agora, 18 (Princeton, 2011) gives a fascinating conspectus of a landscape of dedications, mingling votives and honorifics. The *Strategeion*, the shrine of the Hero Strategos, was an important place for military dedications and honours (Geagan notes that its traditionally proposed location, at the south-west end of the Agora, is not assured). Geagan proposes to locate private statue monuments in the Agora, notably in front of the stoa of Attalos, particularly the spectacular list of victories of the athlete Menodoros (C196, same document *IG* II² 3150, late second century; the monument is of course a doublet of a monument set up, clearly as a private honorific, on Delos: see 230–1 in the present work, and below for a forthcoming study of both monuments), and the exedra monument (single-dedicator and distributive) of a prominent Delian-Athenian family (H 329, *SEG* 19.207 from Meritt). However, there is no concrete indication of the original location, since the actual stones were found reused in later contexts.

104 n. 252 On the base for Lutatius, note Krumeich, 'Formen', 24, for bibliography, and the fact that the base was a *c.*7m tall column.

108 n. 79 and *passim* On the Asklepieion near Epidauros, see M. Melfi, *I Santuari di Asclepio in Grecia,* i (Rome, 2007), 17–209, on the monumental history of the shrine, including the shrine of Apollo Maleatas (for instance 61–2 on the possible 'percorso processionale' formed by monuments in the shrine).

117 n. 30, 122 The statue of Philip V was set up by the Macedonians in the shrine of the Great Gods on Samothrake, in front of the great Stoa at the precise midpoint; it later became part of a series of monuments. See B. D. Westcoat, 'James R McCredie and Samothracian Architecture', in O. Palagia and B. D. Westcoat (eds), *Samothracian Connections: Essays in Honor of James R. McCredie* (Oxford, 2010), 5–32 (reconstruction of the columnar monument, p. 9; the inscribed base, on top of the final drum of the column, stood more than 6m above ground level).

170 On *kanephoroi* and *arrhephoroi*, and commemoration of their service, add P. Wilson, *The Athenian Institution of the Khoregia: The Chorus, the City, and the Stage* (Cambridge, 2000), 26, 31 n. 69; *SEG* 59.216, from E.-L. Choremi, 'Anathimatiki epigraphi arrhiphorou (IG II² 3473 + IG II² 4283)', *Horos,* 17–21 (2004–9), 133–42, with list of all twenty-one known statues of women having served as *arrhephoroi*.

187 n. 184 For *SEG* 3.414, there is a better text by K. Hallof, K. Herrmann, and S. Prignitz in *Chiron,* 42 (2012), 231–2 (as an appendix to the improved republication of inscriptions of Olympia).

193 n. 229 S. Dillon's in-depth work on the Dromos is now published: S. Dillon and E. P. Baltes, 'Honorific Practices and the Politics of Space on Hellenistic Delos', *AJA* 117 (2013), 207–46. The cover of the present book is a reconstruction, published in this article.

214 Yet another example illustrating the attention paid to public service and honours in the private genre comes from late Hellenistic Athens (*SEG* 51.184). *C*.150 BC, two Athenian women, Philia and her daughter Archestrate, set up a statue of Euktimenos of Anagyrous, Philia's son (and Archestrate's brother: the monument is single-honorand, multi-generational). Beneath the private dedicatory formula, the statue base also indicates, within engraved crowns, honours for Euktimenos (the council and the people honoured him for service as a cavalry commander and in another capacity, the mention of which is now lost). The private monument here borrows an old trope from public monuments (the abbreviated honorific formula inscribed within a crown).

230–1 On the base of the athlete Menodoros son of Cnaios, with its commemoration of multiple victories, see N. Badoud, M. Fincker, J.-Ch. Moretti, 'La Base de Ménodôros', *BCH* 2011, 588. The monument is now localized as part of the dense cluster of bases at the north-east corner of the Agora of Theophrastos, at the entrance of the open space (the three-stepped socle had been interpreted as belonging to one of several equestrian monuments, on which see Mercuri, 'L'Agora di Teofrasto', 198). A study is forthcoming on both Delian and Athenian monuments for Menodoros.

240 n. 54 *IG* 9.2.489 (Phayttos, second century: *SEG* 28.526) mentions a four-cubit statue for a benefactor.

Printed and bound by CPI Group (UK) Ltd, Croydon, CR0 4YY